Barbara London and John Upton
PHOTOGRAPHY
SIXTH EDITION

LONGMAN

An imprint of Addison Wesley Longman, Inc.

New York • Reading, Massachusetts • Menlo Park, California • Harlow, England
Don Mills, Ontario • Sydney • Mexico City • Madrid • Amsterdam

Editor in Chief Priscilla McGeehon
Senior Acquisitions Editor Deirdre Cavanaugh
Editorial Assistant Kwon Chong
Development Editor Karen Dubno
Supplements Editor Tom Kulesa
Producer, New Media Tyler Steben
Executive Manager for Editing, Design, and Production Tom Farrell
Production Editor Lois Lombardo
Manager, Picture Research Nina Page
Senior Manufacturing Manager Willie Lane
Director of Marketing Marjorie Waldron
Executive Manager, Art Direction and Technology Mary McDonnell
Design Manager Linda Valentine
Text and Cover Designer Linda Valentine
Art Coordinator Linda Valentine
Art Production Tech Graphics; Anne Farrell
Printer and Binder Quebecor / Kingsport, Inc.
Cover Printer Coral Graphics Services, Inc.
Cover photo Ken Kay
Title page photo *False Starts* ©1997 Lorie Novak/Swanstock

Thanks for permission to use material from *Breaking Bounds: The Dance Photography of Lois Greenfield* by William A. Ewing ©1992 Thames and Hudson, Ltd, London

For permission to use copyrighted material, grateful acknowledgment is made to the copyright holders on pp. 392–393, which are hereby made part of this copyright page.

Library of Congress Cataloging-in-Publication Data

London, Barbara, (date)-
 Photography / Barbara London and John Upton. — 6th ed.
 p. cm.
 Includes bibliographical references and index.
 ISBN 0-321-01108-2
 1. Photography. I. Upton, John, (date)- . II. Title.
TR145.L66 1998
770--dc21 97-2017
 CIP

ISBN 0-321-011082

5678910-ARK-0099

Contents

Preface

This edition of *Photography* will mark the book's twentieth anniversary. Many people who have used this book are now professional photographers or photography instructors, or are continuing to pursue their personal interest in photography. Whatever your interest is in photography, this book is designed to teach the skills that you will need in order to use the medium confidently and effectively.

The emphasis of this edition continues to be in two major areas—technique and visual awareness. The technical material helps you learn how to control the photographic process, or as Ansel Adams put it, to "understand the way that the lens 'sees' and the film 'sees.'"

The previous organization of chapters has been preserved. Basic black-and-white photography is covered in Chapters 1 to 11. Chapters 9 to 14 cover special techniques, such as close-up photography, color photography, lighting, digital imaging, view camera use, and a specialized method of exposure and development, the Zone System.

Clarity and convenience have always been a focus of the book, but in this edition a special effort has been made to organize and format information so that it is even easier for beginning photographers to digest and is a quicker reference for those with more experience.

- The easy-to-use format of each two facing pages completing a single idea, skill, or technique has been maintained.
- Annotations with the table of contents of each chapter conveniently group and highlight topics in the chapter.
- Boldfaced topic sentences outline the text on every page.
- "More About..." boxes cross reference related topics in other parts of the book.
- Step-by-step demonstration images have been redrawn as line art to show techniques more clearly and to focus on key details. "Lights out" icons have been added at each point where room lights should be turned off.
- Increased information on handling chemicals safely has been added in Chapter 6, Developing the Negative, including a list of phone numbers to get more information or to get help in an emergency.
- A new, fully illustrated Troubleshooting Appendix groups together technical problems, their causes, and ways to prevent them, beginning on page 370.

Improving visual awareness is a major emphasis of the book. The choices that other photographers have made and that you can make when you raise a camera to your eye are fully explained and illustrated. Throughout the book you will find hundreds of illustrations by the best photographers showing how they have put to use various technical concepts. See, for example:

- The two photographs illustrating perspective on pages 58-59, or how one photographer uses simple portrait lighting setups on pages 244–245.
- Photographer at Work spreads throughout the book feature interviews with photographers who have each developed a successful career in everything from dance photography (pages 32–33) to using digital imaging to merge photography and illustration (pages 268–269).
- Chapter 15, Seeing Photographs (pages 315–339), deals with composition, tonality, sharpness, and other visual elements that will help you make better pictures yourself, and that will help you see other people's photographs with a more sophisticated eye.
- Chapter 16 surveys the history of photography (pages 341–369) so that you can place today's photography—and your own—in a historical context.

We have added several features that instructors and students have requested, in addition to a complete technical update:

- Chapter 3, Lens, has expanded coverage of using manual versus automatic focus.
- Chapter 7, Printing the Positive, has increased coverage of toning, including split toning.
- Chapter 9, Special Techniques, has expanded the information on alternative processes such as cyanotyping and hand coloring.
- Chapter 12, Digital Imaging, has been expanded to include information on pictures on the Internet and on a CD-ROM. References to digital imaging throughout the book point out when techniques, for example, spotting, might also be done with digital imaging.

We are pleased to announce an interactive web site. *Photography: The On-line Source,* will be an interactive web site for instructors and students using this book. Developed by Joe Ciaglia, Peggy Jones, and John Upton, the web site features a gallery that displays student photographs, a database of instructional information on photographic techniques and processes not covered in the text, plus interactive activities such as a camera exposure simulator and a darkroom printing simulator. *Photography: The On-line Source* helps you to stay abreast of the most recent developments in the field. The site can be reached through the Addison Wesley Longman web site, http://longman.awl.com/photosource.

An instructor's manual is available, written by Alma Davenport of the University of Massachusetts, Dartmouth, including learning objectives, classroom demonstrations, chap-

ter assignments, and quiz questions. Please call your local Addison Wesley Longman representative to request a copy or call Customer Service at 800-322-1377.

This sixth edition of *Photography* has been a collaborative effort. Instructors, students, photographers, manufacturers, editors, gallery people, and many others participated in it. They fielded queries, made suggestions, responded to material, and were unfailingly generous with their time, energy, and creative thinking.

Special thanks go to instructors, those who reviewed the previous edition of *Photography* before work on this one was started and those who completed our web site survey. They brought a particularly useful point of view, contributing many ideas on not only what to teach, but how to teach it:

Cris Bajart, University of New Mexico
Steven Bleicher, Marian College
Phillip S. Block, International Center of Photography
Aimee Bott, Ball State University
William Bradish, University of New Mexico
Rick Bruner, Shepherd College
Jerry Burchfield, Cypress College
Lionel Caron, Orange Coast College
Darryl J. Curran, California State University, Fullerton
Rudi Dietrich, Montana State University
Nancy Floyd, Georgia State University
Harris Fogel, College of the Desert
Roger Freeman, Alfred University
Jack Fulton, San Francisco Art Institute
Deirdre Garvey, Santa Monica College
John Hesketh, Orange Coast College
Alcina Horstman, Ansel Adams Outreach Programs
Susan Kae Grant, Texas Women's University
Kevin Kennedy, Louisiana Tech University
Jim Klein, Oakland Community College
Karen Halverson, University of Southern California
Leigh Anne Langwell, University of New Mexico
Corinne Martin, James Madison University
Peter Martin, University of Minnesota
Tom McGovern, Union College
Jerry McGrath, Irvine Valley College
Judy Natal, Nazareth College of Rochester
Joyce Neimanas, School of the Art Institute, Chicago
Jerome Nevins, Albertus Magnus College
Julie Newton, University of Texas, Austin
Kenda North, University of Texas
Arthur Okazaki, Tulane University
Michael Peven, University of Arkansas

Neal Rantoul, Northeastern University
Janet Roddy, Southern Illinois University, Carbondale
Edward J. Ross, Loyola College
R. Kim Rushing, Delta State University
Kevin Salemme, Merrimack College
Anne Savedge, Chesterfield Technical Center
Michael D. Sherer, University of Nebraska, Omaha
M.K. Simqu, Ringling School of Art and Design
Ken Slosberg, Orange Coast College
Jon Spielberg, Community College of Philadelphia
Brian R. Steele, University of New Mexico
Margaret Stratton, University of Iowa
Stan Strembicki, Washington University
Deborah Tharp, University of Alaska, Anchorage
Elizabeth Turk, Atlanta College of Art
Sylvia Vigliani, Eastchester High School
Al Wildey, University of Idaho

Without editorial and production assistance, a book of this size and complexity would be impossible to complete. Betsy Brill saved the day with picture permissions. Calumet Photographic, Inc. gave permission to use their summary of view camera movements. Joe Ciaglia, as usual, could answer any question about digital imaging. Sean Grout delivered a stack of Troubleshooting illustrations in record time. Suda House did a detailed and invaluable review of the entire book. Peggy Jones developed the material on the Internet, CD-ROMs, and much more. Liz Kay read the book one more time and provided encouragement many times. Ken Kobré generously gave many useful ideas that improved the book. Rick Reed was generous in giving access to Photo-Eye Books. Jim Stone reviewed the view camera chapter; the shake-your-head and other analogies about view camera movements are his. Thanks also to Richard Adams, Wendy Lewis, Karin Roth, Sean Upton, and Nyanko-chan; authors need all the help they can get. Special thanks to Linda Valentine for good humor even under deadlines.

This is a book that students keep. They refer to it long after they have finished the basic photo course for which it was purchased. Some of the people who contributed to this edition used the book themselves when they were studying photography, and still have their original, now dog-eared, copy. As you work with the book, you may have suggestions on how to improve it. They will be sincerely welcomed.

Dedicated to everyone who is part of this Twentieth Anniversary edition.

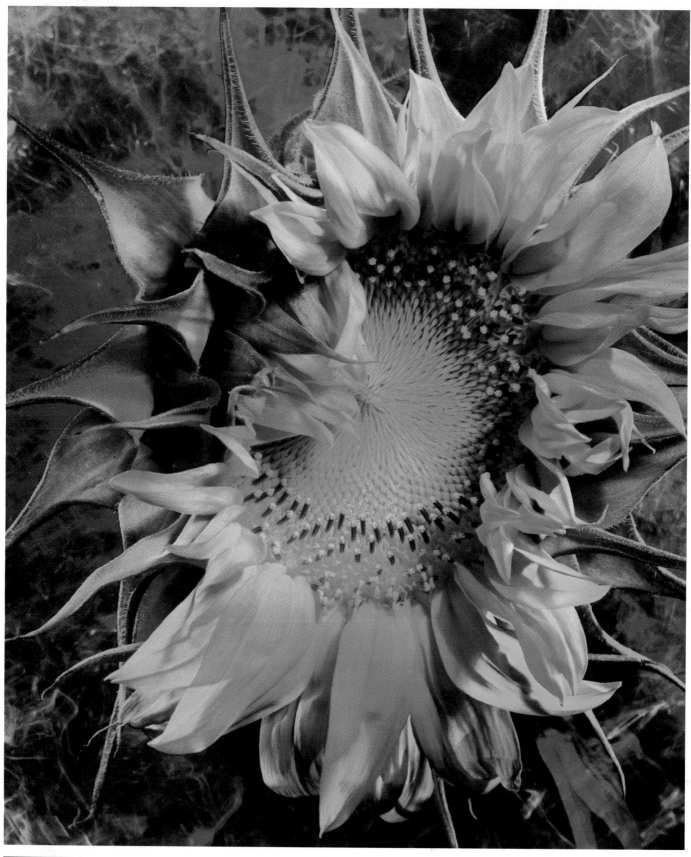

WILLIAM LESCH Sunflower

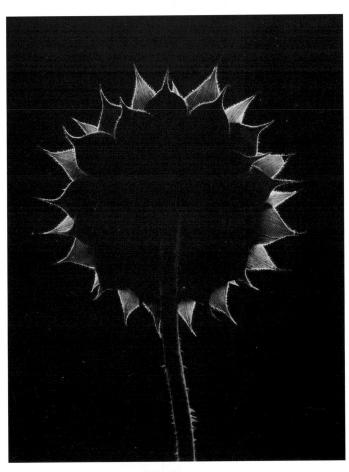

PAUL CAPONIGRO Sunflower, Winthrop, Massachusetts, 1965

How do you photograph a sunflower—or a landscape or a person or anything else? *There are as many ways as there are photographers. Opposite, the flower glows with intense and not quite realistic hues. William Lesch wanted to avoid the fixed feeling of stationary light. He used a single light that he moved across the subject during the exposure (a procedure called painting with light), simultaneously moving colored filters across the light. He also moved the background during the exposure. Lesch says he seeks to record the "flow of nature and reality," and to do so he uses moving lights, moving subjects, multiple exposures, and other means of going beyond static exposures.*

Above, the flower is reduced to a halo of leaves created by a single light behind the flower. Paul Caponigro became absorbed with photographing sunflowers after being given one by a friend. "Sunflower resounded in me," he said. "I worked and lived with the sunflower by day, and at night it followed me into my sleep. . . . Inwardly, silently, I was asking to see that aspect of the sunflower which the physical eye could not."

***I**f you are just getting started in photography, this chapter will walk you through the first steps of selecting and loading film, focusing an image sharply, adjusting the camera settings so your photographs won't be too light or too dark, and making your first exposures. You can go directly to Chapter 2 if you prefer more detailed coverage right away.*

***O**nce you know something about the technical basics, the interesting question is—What will you photograph? Here you will find some help in selecting a subject and in composing your photograph so that it effectively conveys what you saw.*

The steps in this chapter are a basic checklist. Cameras vary in design, so to find out exactly what button to push, it helps to read your instruction book or to ask someone who is familiar with your camera. Most of the steps apply to the camera you are likely to be using: a 35mm single-lens reflex. (You'll find more about different types of cameras beginning on page 13. See also the "More about . . . " boxes throughout the book. They will guide you to more information about various topics.)

Cameras have become increasingly automatic, with automatic exposure and automatic focus found on more and more models. But manual operation is a common alternative and not necessarily a second choice. Many photographers prefer to make their own exposure and focusing decisions, and under some conditions, manual operation is a necessity. If you are using this book in a photography class, your instructor may prefer that you operate the camera manually for your first exposures, because it's a good way to learn the basics of photographic controls. On the following pages, both manual and automatic operation are shown.

Once you have gotten the basics down, how do you get better? What's the best way to improve? Many of the photographers whose work appears in this book were asked that question. The advice they offered was surprisingly consistent. "Take more pictures." "Shoot, shoot, shoot." "Persevere." "Just keep after it; you can't help but improve if you do." If this sounds like obvious advice—no secrets or inside information—it seems to be advice that works. These photographers volunteered such comments often and with feeling. They knew how they had improved their skills, and they knew what you should do to get better, too.

Have fun.

Camera and Film

A camera's main functions are to help you **view** the scene so you can select what you want to photograph, **focus** to get the scene sharp where you want it to be, and **expose** the film so the picture is not too light or too dark.

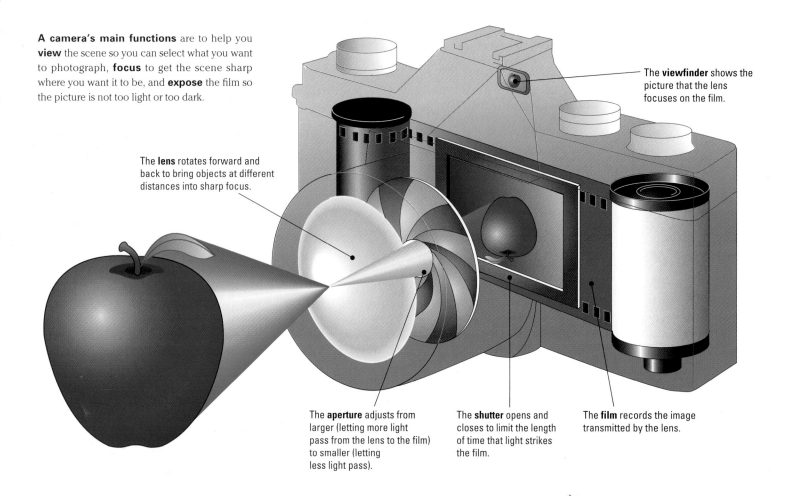

The **viewfinder** shows the picture that the lens focuses on the film.

The **lens** rotates forward and back to bring objects at different distances into sharp focus.

The **aperture** adjusts from larger (letting more light pass from the lens to the film) to smaller (letting less light pass).

The **shutter** opens and closes to limit the length of time that light strikes the film.

The **film** records the image transmitted by the lens.

Choose a film

If you want prints, select a negative film, either color or black and white. The film is developed to a negative image, then printed onto paper to make a positive one.

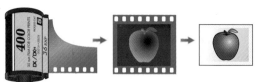

Negative film Negative Print

If you want slides or transparencies, select a reversal film, one that produces a positive image directly on the film that is in the camera. Most reversal films are for color.

Reversal (slide) film Positive transparency

Film speed (ISO 100, 200, and so on) describes a film's sensitivity to light. The higher the number, the more sensitive ("faster") the film, and the less light it needs for a correct exposure (one that is not too light or too dark). For your first exposures, choose a film with a speed of 100 to 200 for shooting outdoors in sunny conditions. In dimmer light, use film with a speed of 400 or higher.

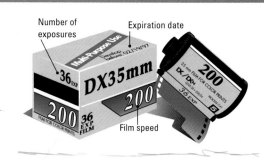

Number of exposures Expiration date

Film speed

More about . . .

- Camera controls, pages 14–15
- Film characteristics, pages 64–65

Open the camera

Make sure there is no film in the camera before you open it. Check that the film frame counter shows empty or that the film rewind knob (if there is one) rotates freely. If there is film in the camera, rewind it (see page 6).

A camera that loads film manually will have a rewind knob on the top. This type of camera usually opens by pulling up on the rewind knob.

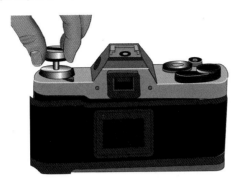

A camera that loads film automatically probably will have a release lever, not a rewind knob, to open the camera. Turn on the camera's main power switch. Open the camera by sliding the release lever to its open position.

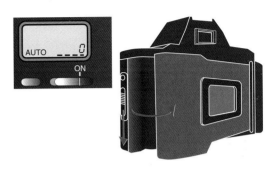

Insert and thread the film

Check for dust or small chips of film inside the camera. Clean, if needed, with a soft brush. Avoid touching the shutter at the center of the camera.

 Insert the film cassette. A 35mm single-lens reflex camera usually loads the film in the left side of the camera with the extended part of the cassette to the bottom. The film should lie flat as it comes out of the cassette; if needed, rotate the cassette to the right.

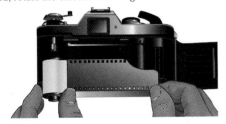

Manual loading. Push down the rewind knob. Pull out the tapered end of the film until you can insert it into the slot of the take-up spool on the other side of the camera. Alternately press the shutter release button and rotate the film advance lever until the teeth that advance the film securely engage the sprocket holes at the top and bottom of the film, and any slack in the film is reeled up by the take-up spool.

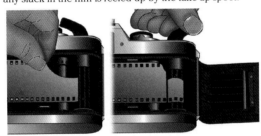

Automatic loading. Pull out the tapered end of the film until it reaches the other side of the camera. Usually a red mark or other indicator shows where the end of the film should be. The film won't advance correctly if the end of the film is in the wrong position.

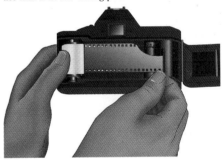

Advance film to the first frame

Close the camera back. You'll need to advance the film past the exposed film leader to an unexposed frame.

Manual film advance. With the camera back closed, alternately press the shutter release button and rotate the film advance lever. Repeat two times.

 If the film is advancing correctly, the film rewind knob will rotate counterclockwise as you move the film advance lever. If it does not, open the camera and check the loading. Don't rely on the film frame counter; it may advance even though the film does not move.

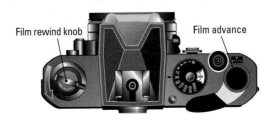

Film rewind knob Film advance

Automatic film advance. Depending on your camera, you may simply need to close the camera back to have the film advance to the first frame. Some cameras also require you to depress the shutter button.

 If the film has correctly advanced, the film frame counter will display the number 1. If it does not, open the camera back and check the loading.

Focusing and Setting the Exposure

Set the film speed

Film speed is a measure of a film's sensitivity to light. The higher the film speed number (the film's ISO number), the less light the film needs for an adequate exposure. The camera should be set to the speed of the film you are using. Film speed is marked on the film box and on the film cassette.

Film speed

Manually setting the film speed. On some cameras you must set the film speed manually. Turn the film speed dial (marked ISO or sometimes ASA) to the speed of your film. Here it is set to a film speed of 100.

Automatically setting the film speed. On some cameras the film speed is set by the camera as it loads the film. The film must be DX coded, marked with a kind of bar code that is read by a sensor in the camera. DX-coded films have "DX" printed on the cassette and box.

Focus

Focus on the most important part of your scene to make sure it will be sharp in the photograph. When photographing a person, this is usually the eye. Practice focusing on objects at different distances as you look through the viewfinder so that you become familiar with the way the camera focuses.

Manual focusing. As you look through the viewfinder, rotate the focusing ring at the front of the lens. The viewfinder of a single-lens reflex camera has a ground-glass screen that displays a sharp image of the in-focus parts of the scene. Some cameras also have a microprism, a small ring in the viewfinder in which an object appears coarsely dotted until it is focused. Other cameras have split-image focusing in which part of an object appears offset when it is out of focus.

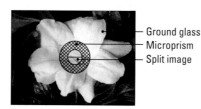

— Ground glass
— Microprism
— Split image

Automatic focusing. Usually this is done by centering the focusing brackets (visible in the middle of the viewfinder) on your subject as you depress the shutter release part way. The camera rotates the lens for you to bring the bracketed object into focus. Don't push the shutter release all the way down until you are ready to make an exposure.

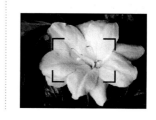

Shutter release button

Part way down: autofocus activated

All the way down: shutter released

Setting the exposure

Shutter speed

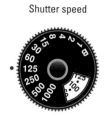

1/125 sec.

+

Aperture size

f/16

ISO 100

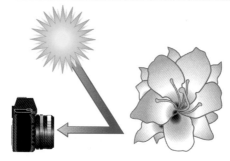

To get a correctly exposed picture, one that is not overexposed and too light or underexposed and too dark, you—or the camera—set the shutter speed and the aperture (lens opening) depending on the sensitivity of the film (its speed) and on how light or dark your subject is. The aperture size determines how bright the light is that passes through the lens; the shutter speed determines the length of time that the light strikes the film.

More about . . .
- Exposure and metering, pages 90–102
- Film speed, pages 66–71
- Focusing, pages 48–49
- Shutter speed and aperture, pages 16–25

Exposure readout

Exposure readout about the shutter speed and aperture appears in the viewfinder of many cameras that have a built-in exposure meter. Some cameras show the actual settings: here, 1/250 sec shutter speed, f/16 aperture.

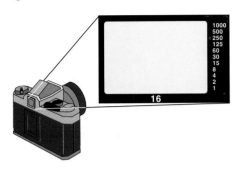

A data panel appears on some cameras, displaying shutter speed and aperture settings (here, 1/250 sec shutter speed, f/16 aperture), plus other information.

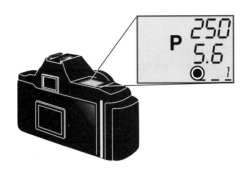

This needle-centering display doesn't show the actual shutter speed and aperture settings, but it does show when the exposure is correct. You change the shutter speed and/or the aperture until the needle is centered between + (overexposure) and − (underexposure).

Manually setting the exposure

With manual exposure, you set both the shutter speed and aperture yourself. How do you know which settings to use? At the simplest level you can use a chart like the one at right. Decide what kind of light is on the scene, and set the shutter speed and aperture accordingly.

The chart is based on what is sometimes called the Sunny 16 rule: On a sunny day, set the camera to the shutter speed that is closest to the film speed number, and set the aperture to f/16. If the film speed is 100, set the shutter speed to 1/125 sec and the aperture to f/16. The chart shows an equivalent exposure—a faster shutter speed at a wider aperture, 1/250 sec at f/11.

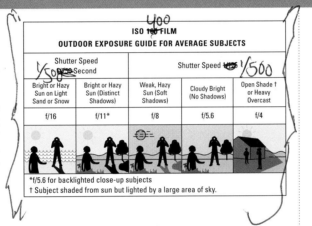

ISO 100 FILM OUTDOOR EXPOSURE GUIDE FOR AVERAGE SUBJECTS				
Shutter Speed 1/125 Second		Shutter Speed 1/125		
Bright or Hazy Sun on Light Sand or Snow	Bright or Hazy Sun (Distinct Shadows)	Weak, Hazy Sun (Soft Shadows)	Cloudy Bright (No Shadows)	Open Shade † or Heavy Overcast
f/16	f/11*	f/8	f/5.6	f/4

*f/5.6 for backlighted close-up subjects
† Subject shaded from sun but lighted by a large area of sky.

You can use a camera's built-in meter for manual exposure. Point the camera at the most important part of the scene and activate the meter. The viewfinder will show whether the exposure is correct. If it isn't, change the shutter speed and/or aperture until it is.

To prevent blur caused by the camera moving during the exposure (if the camera is not on a tripod), use a shutter speed of at least 1/60 sec. A shutter speed of 1/125 sec is safer.

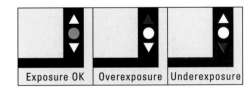

Exposure OK | Overexposure | Underexposure

Automatically setting the exposure

With automatic exposure, the camera sets the shutter speed or aperture, or both, for you.

With programmed automatic exposure, each time you press the shutter release button, the camera automatically meters the light, then sets both shutter speed and aperture.

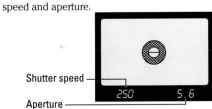

Shutter speed

Aperture

More about . . .
- Automatic exposure, page 93

With aperture-priority automatic exposure, you set the aperture (the f-stop) and the camera sets the shutter speed. To keep the picture sharp if you are hand holding the camera (it is not on a tripod) the shutter speed should be 1/60 sec or faster. If it is not, set the aperture to a larger opening (a smaller f-number).

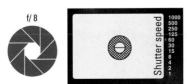

f/ 8

With shutter-priority automatic exposure, you set the shutter speed and the camera sets the aperture. To keep the picture sharp if you are hand holding the camera (it is not on a tripod), select a shutter speed of 1/60 sec or faster.

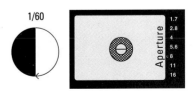

1/60

Exposing the Film

Hold the camera steady

For horizontal photographs, keep your arms against your body to steady the camera. Use your right hand to hold the camera, and your right forefinger to press the shutter release. Your left hand can be used to focus or make other camera adjustments.

For vertical photographs, support the camera in either your right or left hand. Keep that elbow against your body to steady the camera.

A tripod steadies the camera for you and lets you use slow shutter speeds, such as for night scenes or other situations when the light is dim.

Expose the film

Make an exposure. Recheck the focus and composition just before exposure. When you are ready to take a picture, stabilize your camera and yourself and **gently** press the shutter release all the way down.

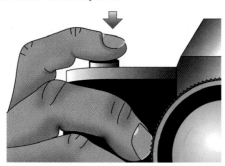

Make some more exposures. You might want to try several different exposures of the same scene, perhaps from different angles. See opposite page for some ideas.

Keep a record of your exposures. It will help you learn faster about exposure settings and other technical matters. For example, write down the frame number, subject, f-stop and shutter speed settings, direction or quality of light, and any other relevant information. This way you won't forget what you did by the time you develop and print the film.

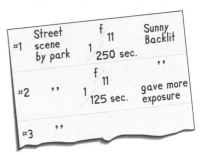

At the end of the roll, rewind the film

After your last exposure on the roll, rewind the film all the way back into the cassette before opening the camera. Store film away from light and heat until developed.

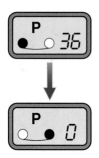

Manual rewind. You'll know that the roll of film is completely exposed when the film advance lever will not turn. The film frame counter will also show the number of exposures you have taken. Activate the rewind button at the bottom of the camera. Lift the handle of the rewind crank and turn it clockwise until its tension releases.

Automatic rewind. Your camera may automatically rewind the film after you make your last exposure. Or it may signal the end of a roll, then rewind when you press a film rewind button.

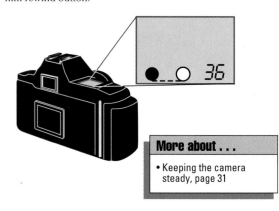

> **More about . . .**
> • Keeping the camera steady, page 31

Where do you start?

One place to start is by looking around through the viewfinder. A subject often looks different isolated in a viewfinder than it does when you see it surrounded by other objects. What interests you about the scene? Why do you want to photograph it?

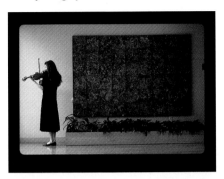

Look at the edges

How do the edges of the photograph intersect the subject? Does the top edge cut into the subject's head? Is the subject down at the bottom of the frame with a lot of empty space above it? See what you've got and see if you might want something a little different.

More about . . .

• Backgrounds, pages
 320–321
• The image frame, pages
 318–319
• Lighting, pages 223–251
• Selecting a subject, pages
 316–317

Get closer (usually)

Often people photograph from too far away. What part of the scene attracted you? Do you want a picture of your friend from head to toe, or are you interested in the expression on his face? Do you want the whole wall of a building, or was it the graffiti that caught your attention?

Look at the background (and the foreground)

How does your subject relate to its surroundings? Is there a telephone pole growing out of someone's head? Are you interested just in that old prairie church, or would it say more about it to have the church in the background and include those bales of hay in the foreground? Take a look.

Check the lighting

Is the light more or less even overall? If this is your first roll, you are most likely to get a good exposure if you photograph an evenly lit scene, not one where the subject is against a very light background, like a bright sky.

But why not experiment, too?

See what happens. Include a bright light in the picture (just don't stare directly at the sun through the viewfinder). Try a different angle. Instead of always shooting from normal eye-level height, try kneeling and looking up at your subject or getting up high and looking down at it.

A good portrait shows more than merely what someone looks like. It captures an expression, reveals a mood, or tells something about a person. Props or an environmental setting are not essential, but they can help show what a person does or what kind of person they are.

Put your subject at ease. To do this, you have to be relaxed yourself, or at least look that way. You'll feel better if you are familiar with your equipment and how it works so you don't have to worry about how to set the exposure or make other adjustments.

Don't skimp on film with portraits. Taking three, four, or a dozen shots to warm up can get your subject past the nervousness that many people have at first when being photographed.

Try to use a fast enough shutter speed, 1/60 second or faster, if possible, so you can shoot when your subject looks good. If you have to ask them to "hold it," they are likely to produce a wooden expression.

Photographing close to home can be an easy place to start—or a difficult one. Conventional portraits or snapshots are pleasant and fun, but someday you may want to move beyond them to a more personal image, one that reveals more about the person you are photographing or your relationship with them.

What makes a portrait? A tight cropping that shows only part of a scene can tell as much about people as a more conventional portrait.

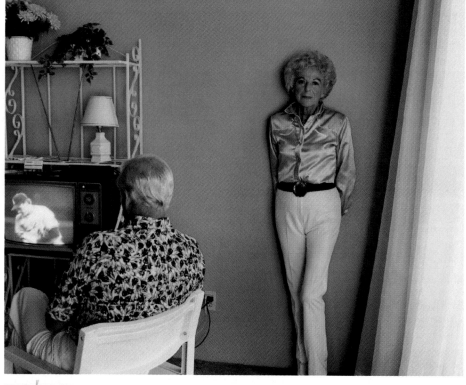

LARRY SULTAN My Mother Posing for Me, 1984

MICHAEL WILSON The Kiss

▲ *To see our parents is to see ourselves. It can reveal how we feel about them and about ourselves, as well as something about what we might or might not become. Larry Sultan's book* Pictures from Home *is a complex view of his family that contains old family snapshots, stills from home movies, text by Sultan, and commentary from his parents, in addition to the pictures he made of them.*

Sultan wrote about being in his parents' house, "All day long I've been scavenging, poking around in rooms and closets, studying them. I arrange my rolls of exposed film into long rows and count and recount them as if they were loot. . . . Is this why I've come here? To find myself by photographing them?"

Jeff Jacobson brings a strong sense of personal expression to his work as a photojournalist. In his book My Fellow Americans *he wrote, "I simultaneously feel deeply at home in this country and like a perpetual visitor to a strange and bizarre land. . . . These pictures do not come from careful calculation; they are immediate responses to the world. The best pictures I feel; they come from the heart and the gut as well as the head."*

Some pictures of people appear to be unplanned, made either without the subjects knowing they are being photographed or without seeming posed or directed by the photographer. It isn't always easy to tell if a photograph was posed or not, and most viewers will care more about what the photograph conveys than about exactly how it was made.

Set your camera's controls beforehand if you want to be relatively inconspicuous at a scene. Prefocus if you can, although that may not be possible with longer-focal-length lenses, which have less depth of field and so require more critical focusing than do shorter lenses. With zone focusing, you focus in advance by using a lens's depth-of-field and distance scales. A camera with automatic focus can help you work unobtrusively.

A fast shutter speed is even more important for unposed portraits than for planned ones. Your subject is likely to be moving and you are likely to be hand holding the camera rather than using a tripod. A fast film will be useful; ISO 400 works well in most situations.

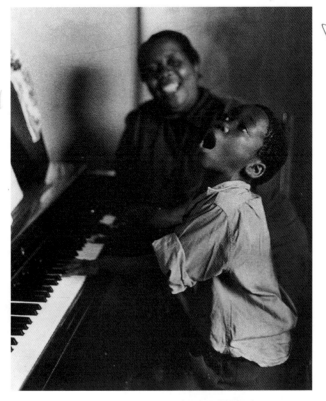

A music teacher and her pupil seem completely absorbed in their lesson. A viewer can't know—and most won't ask themselves—if the photographer told the child to play. You can create a candid feeling by asking a subject who is aware of your presence to perform some typical action. People are likely to behave more naturally if they have something to do that involves them.

More about . . .

• Zone focusing, page 54

How to you photograph a place? Most important is: What do you want to remember? What is the best—or worst—part of the place for you? Do you want a large vista or a close-up of a small part of a scene? Look at a scene from different angles, walking around it to view it from different positions. Get closer or step back to see a scene from farther away. When you are close to an object, even a slight change of position will alter its relation to the background. Change your point of view and a subject may reveal something you didn't see at first.

William Clift made many photographs in the quiet country of the Hudson River valley. Here, boxes of fruit circle a gnarled old apple tree.

WILLIAM CLIFT Old Rhode Island Greening Apple Tree, Milton, New York, 1986

Better known for her fashion photographs, Louise Dahl-Wolfe made this still life early in her career. Light from a window reflects off a piece of black oilcloth as a background for the apples.

LOUISE DAHL-WOLFE Apples on a Plate, 1915

Joe Deal photographs not the ideal landscape that we would like to see, but the landscape we have actually created for ourselves. Here, palm trees planted with geometric regularity nod their heads in a landscape of cement roadways and urban sprawl.

JOE DEAL Santa Ana Winds, Riverside, California, 1983

You don't have to go to exotic locations to find interesting photographs. Even your local pottery store may hold unexpected blessings.

JANE E. PHILLIPS Angels

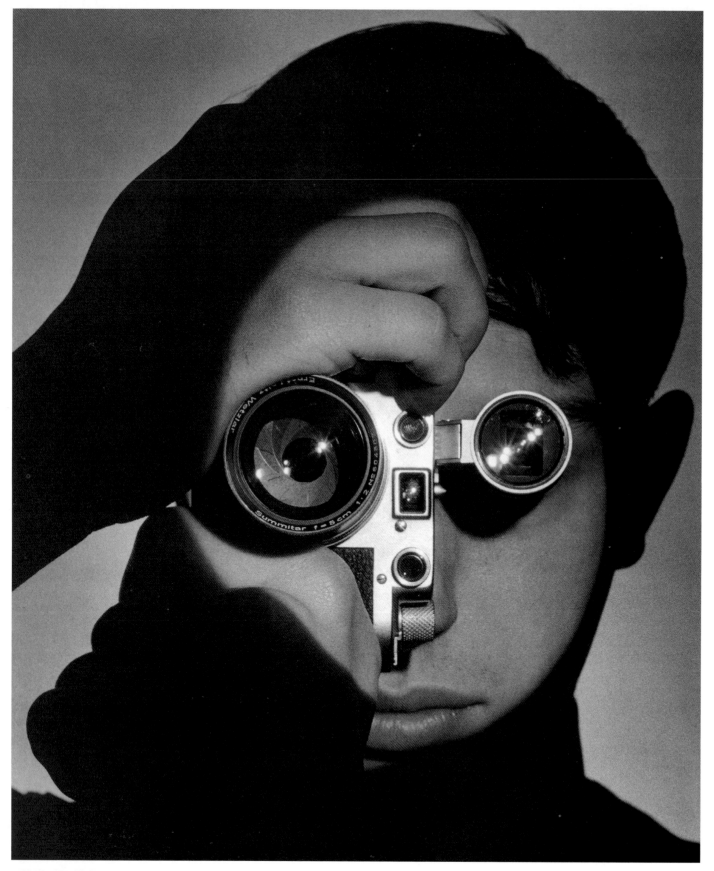

A merging of photographer and camera. Notice how the dark shadows isolate and emphasize the important part of the picture. "Making a good photograph requires genuine interest in the subject," Feininger said. "Without it, making a photograph sinks to the level of boring routine."

ANDREAS FEININGER Photojournalist, 1955

Camera 2

Why do you need to know how a camera works? Much of modern camera design is based on one of the earliest camera slogans—"You press the button, we do the rest." Automatic-exposure cameras set the shutter speed or aperture for you. Automatic-focus cameras adjust the lens focus. Automatic features such as these are increasingly built into the most popular of cameras—those that use 35mm film. However, no matter what technological improvements claim to make a camera "foolproof" or "easy to use," there are still choices to make at the moment a picture is taken. If you don't make the choices, the camera does, based on what the manufacturer calculates will produce the best results for an average scene. But average results may not be what you want. Do you want to freeze the motion of a speeding car or let it race by in a blur? Bring the whole forest into sharp focus or isolate a single flower? Only you can make these decisions.

If you are learning photography, many instructors recommend using manual operation at first because it will speed your understanding of f-stops, shutter speeds, and other basic camera controls. If you do have a camera with automatic features, this book tells not just what those features do, but even more important, when and how to override an automatic mechanism and make the basic choices for yourself.

Basic Camera Controls

The basic controls on any camera are similar, helping you to perform the same actions every time you take a picture. You'll need to see the scene you are photographing, decide how much of it you want to include, focus it sharply—where you want it to be sharp, and use the shutter speed (the length of time the shutter remains open) and aperture (the size of the lens opening) to expose the film to the correct amount of light.

One of the most popular types of cameras is shown here—the 35mm single-lens reflex. Other basic camera designs are described later in this chapter.

As the camera's settings change, the picture changes also. What will a scene look like at a faster shutter speed or a slower one? How do you make sure the background will be sharp—or out of focus, if you want it that way. Once you understand how the basic camera controls operate and what your choices are, you'll be better able to get the results you want, rather than simply pressing the button and hoping for the best.

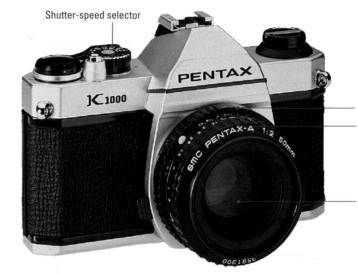

Shutter-speed selector

Aperture ring

Focusing ring

Interchangeable lens

Manually adjusted controls on this 35mm single-lens reflex camera let you set the shutter speed (the length of time the shutter remains open), select the lens aperture (the size of the lens opening), focus on a particular part of the scene, and change from one lens to another.

Data panel shows whether automatic or manual operation has been selected, displays shutter speed and aperture settings, and gives other information

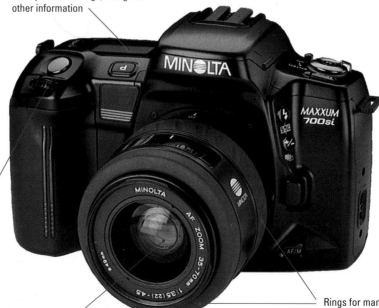

Control dial for manually selecting shutter speed or aperture

Interchangeable lens

Rings for manually focusing or zooming the lens

On automatic cameras, control keys often replace adjustable knobs or rings. This model automatically adjusts the focus, shutter speed, aperture, and lens focal length and fires a built-in flash when necessary. You can override the automatic features if you want to adjust the camera's settings yourself.

Viewfinder image

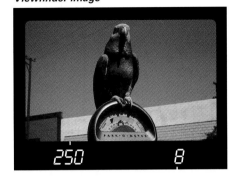

The viewfinder shows you the entire scene that will be recorded on the film and indicates which part of the scene is focused most sharply. The viewfinder may also display exposure information—here the shutter speed and aperture.

Slow shutter speed

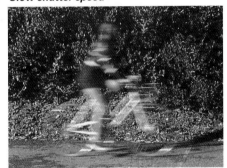

Fast shutter speed

The shutter-speed selector controls the length of time that the shutter remains open. The shorter that time is, the less likely a moving object will appear blurred.

Large aperture opening

Small aperture opening

The aperture selector adjusts the size of the lens opening—the diaphragm. The smaller the aperture opening, the greater the depth of field (the more of the scene from near to far that will be sharp).

Short-focal-length lens

Long-focal-length lens

Interchangeable lenses let you select the lens focal length, which controls the size of objects in the picture and the extent of the scene recorded on the film.

More about . . .

- Aperture and depth of field, pages 22–23
- Aperture, shutter speed, and exposure, pages 24–25
- Focusing, pages 48–49,
- Lens focal length, pages 38–39
- Shutter speed and motion, pages 18–19

Two controls adjust the amount of light that reaches the film: the shutter, described here, and the aperture. They need to be set correctly if your picture is to be neither too light nor too dark.

The shutter controls the amount of light by the length of time it remains open. Each shutter setting is half (or double) the time of the next one and is marked as the denominator (bottom part) of the fraction of a second that the shutter remains open: 1 (1/1 or one second), 2 (1/2 second), 4 (1/4 second), and so on through 8, 15, 30, 60, 125, 250, 500, and on some cameras up to 12,000. You may find a different sequence on older equipment: 1, 2, 5, 10, 25, 50, 100, 200. B or bulb setting keeps the shutter open as long as the release button is held down. T or time setting opens the shutter with one press of

the release, and closes it with another. Electronically controlled shutters can operate at any speed, for example, 1/38 second. These stepless speeds are set by the camera in automatic exposure operation; you usually can't dial them in yourself.

A focal-plane shutter (opposite page, right) is built into the camera body itself—just in front of the film, or focal, plane—while a leaf shutter is usually located between the lens elements. Interchangeable lenses for a camera with a focal-plane shutter can be less expensive, since a shutter does not have to be built into each lens.

A focal-plane shutter has a few drawbacks. It may have to be used with flash at a relatively slow shutter speed, which can cause existing light as well as light from the flash to register on the film. The maximum speed with flash with a 35mm camera may

be as slow as 1/60 second, up to 1/300 second with some models. At faster shutter speeds, the slit in the focal-plane shutter does not completely uncover the film at any one time; before the first part of the shutter is fully open, the second part starts to close, so the flash will only illuminate part of the film. Also, since the slit exposes one end of the film frame before the other, objects moving parallel to the shutter may be distorted. This is rare, but it can happen.

A leaf shutter (opposite page, left) is quieter than a focal-plane shutter and can be used with flash at any shutter speed. But since the leaf shutter has to open, stop, and then reverse direction to close again, most have top speeds of 1/500 second. The focal-plane shutter has a simpler mechanism that moves in one direction and permits speeds of up to 1/12,000 second.

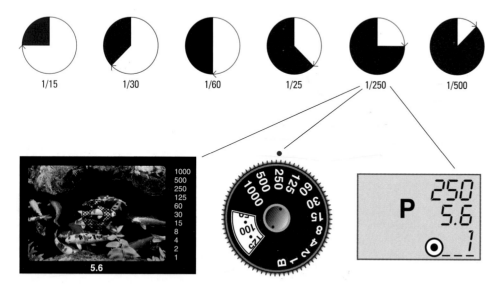

1/15 1/30 1/60 1/25 1/250 1/500

Shutter speeds are displayed in the camera's viewfinder (left), on the shutter-speed dial (center), or as data panel readout (right). Here, the camera is set to 1/250 sec. Notice that the camera displays only the bottom number of the fraction.

More about . . .

• The aperture and light, pages 20–21, 24–25

Leaf shutter

A leaf or between-the-lens shutter is generally located in the lens itself (a). *It consists of a number of small overlapping metal blades. As shown at left, when the shutter release is pushed, the blades open up and then shut again in a given amount of time. The total amount of light admitted during this cycle produces the fully exposed photograph.*

Focal-plane shutter

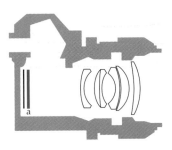

A focal-plane shutter is located directly in front of the film (a). *The shutter consists of two overlapping curtains that form an adjustable slit or window. When the shutter is released, the window moves across the film, exposing the film as it moves. The series at left shows how the film is exposed at fast shutter speeds. The slit is narrow and exposes only part of the film at any one time. Below, the effect of the entire exposure, with all sections of the film having received the proper amount of light. At slow shutter speeds, one edge of the slit travels across the film until the film is uncovered; then the other edge of the slit travels in the same direction, re-covering the film.*

The shutter shown here moves from side to side across the length of the film. Another type of focal-plane shutter moves from top to bottom across the film.

The faster the shutter speed, the more likely a moving subject will be sharp. A blurred image can occur when an object moves during an exposure, because the image projected onto the film by the lens will move. If the object moves swiftly, or if the shutter is open for a relatively long time, this moving image will blur and be indistinct. But if the shutter speed is increased, the blur can be reduced or eliminated. You can control this effect and use it to your advantage. A fast shutter speed can freeze a moving object, showing its position at any given instant. A slow shutter speed can be used deliberately to increase the blurring and accentuate the feeling of motion.

Shown below are the effects of varying shutter speed and camera movement. In the picture at far left, the bicycle moved enough during a relatively long exposure of 1/30 second to leave a broad blur on the film. In the next photograph, at a shutter speed of 1/500 second, the bicycle is much

sharper. A moving subject may vary in speed and thus affect the shutter speed needed to stop motion. For example, motion slows at the peak of a movement that reverses, such as the peak of a jump just before descent (opposite page, top), and even a relatively slow shutter speed will record the action sharply.

Other factors besides shutter and subject speed also affect the amount of blurring in a photograph. What matters is how far an image actually travels across the film during the exposure. In the photograph with the rider moving directly toward the camera (opposite page, left), the bicycle remains in virtually the same position on the film. Thus there is far less blurring even at 1/30 second. An object close to the camera that is moving slowly, such as a bicycle 10 feet away, will cross more of the film and appear to blur more than a fast-moving object far away, such as a jet in flight. A telephoto lens magnifies objects and makes them appear closer to

the camera; it will blur motion more than a normal lens used at the same distance.

Panning keeps a moving subject sharp while blurring the background (see opposite page, right). The camera was moved in the same direction the bicycle was moving. Since the camera moved at about the same speed as the bicycle, the rider appears sharp while the motionless background appears blurred. Successful panning takes both practice and luck. Variables such as the exact speed and direction of the moving object make it difficult to predict exactly how fast to pan. Decide where you want the object to be at the moment of exposure, start moving the camera a few moments before the object reaches that point, and follow your motion through as you would with a golf or tennis stroke. The longer the focal length of the lens, the less you will need to pan the camera; with a telephoto lens, a very small amount of lens movement creates a great deal of movement of the picture image.

 1/30 second

 1/500 second

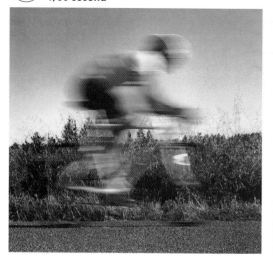

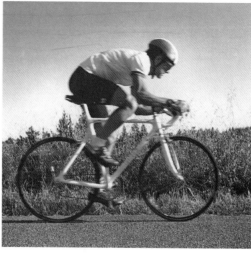

The direction of a moving object affects the amount of blur. When the object is traveling parallel to the plane of the film (this page), considerable movement is likely to be recorded on the film and the object blurred, unless the shutter speed is fast.

If the object is moving directly toward or away from the camera (opposite, bottom left), there is no sideways movement recorded on the film and so a minimum of blur is produced, even at a relatively slow shutter speed.

During panning the camera is moved in the same direction as the subject. The result is a sharp subject and a blurred background (opposite, right).

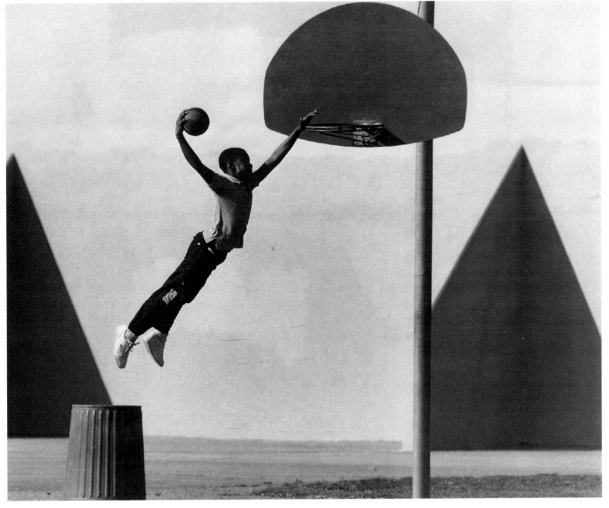

Motion slows at the peak of an action that reverses, such as a leap into the air. At that moment of slower movement, the shutter speed doesn't have to be as fast to show the motion sharply. Here a boy jumps from an overturned garbage can for a slam dunk.

The key word in photographing action is anticipation. What direction is the subject moving? Where should you be focused? When might an interesting moment occur? Think about what is going to happen, rather than trying to catch up to what has already happened.

CLIFFORD OTO Slam Dunk, 1990

1/30 second

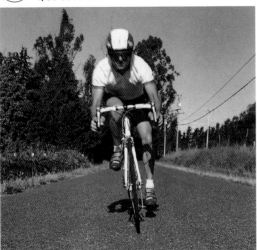

1/30 second camera panned

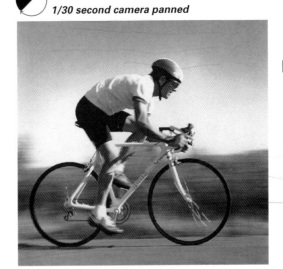

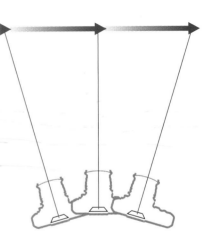

The aperture (the size of the lens opening) controls the brightness of the light that reaches the film. The aperture works like the pupil of an eye; it can be enlarged or contracted to admit more light or less. In a camera this is done with a diaphragm, a ring of thin, overlapping metal leaves located inside the lens. The leaves are movable and can be opened wide to let in more light or closed down to let in less (see opposite).

The size of an aperture is indicated by its f-number or f-stop. On early cameras the aperture was adjusted by individual metal stop plates that had holes of different diameters. The term "stop" is still used to refer to the aperture size, and a lens is said to be "stopped down" when the size of the aperture is decreased.

The standardized series of numbers on the f-stop scale runs as follows: f/1, f/1.4, f/2, f/2.8, f/4, f/5.6, f/8, f/11, f/16, f/22, f/32, f/45, f/64. The largest of these, f/1, admits the most light. Each f-stop after that admits half the light of the previous one. A lens that is set at f/4 admits half as much light as one set at f/2.8 and only a quarter as much as one set at f/2. (Notice that f-stops have the same half or double relationship that shutter-speed settings do.) The change in light over the full range of f-stops is large; a lens whose aperture is stopped down to f/64 admits less than 1/4000 of the light that comes through a lens set at f/1.

No lens is built to use the whole range of apertures. A general-purpose lens for a 35mm camera, for example, might run from f/1.4 to f/22. A camera lens designed for a large view camera might stop down to f/64 but open up only to f/5.6. The widest possible aperture at which a particular lens design will function well may not be a full stop from a standard setting. So a lens's f-stops may begin with a setting such as f/1.8, f/4.5, or f/7.7, then proceed in the standard sequence.

Lenses are often described as fast or slow. These terms refer to the width of the maximum aperture to which the lens can be opened. A lens that opens to f/1.4 opens wider and is said to be faster than one that opens only to f/2.

The term "stop" refers to a change in exposure, whether the aperture or the shutter speed is changed. To give one stop more exposure means to double the amount of light reaching the film (either by opening up to the next larger aperture setting or by doubling the exposure time). To give one stop less exposure means to cut the light reaching the film in half (stopping down to the next smaller aperture setting or halving the exposure time).

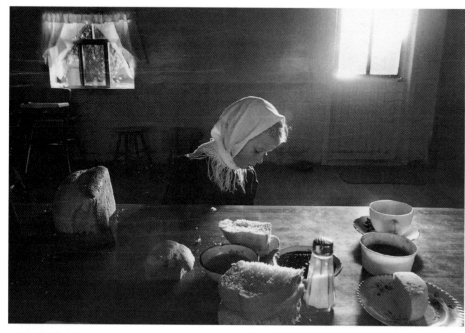

LARRY TOWELL Mennonite Colony, Zacatecas, Mexico

A fast lens, one that opens to a wide aperture, is useful in dim light, such as indoors. A wide aperture lets you set a shutter speed fast enough so that you don't have to use a tripod to keep the camera steady. It is also useful when photographing action by letting you shoot at a fast enough shutter speed to show moving subjects sharply.

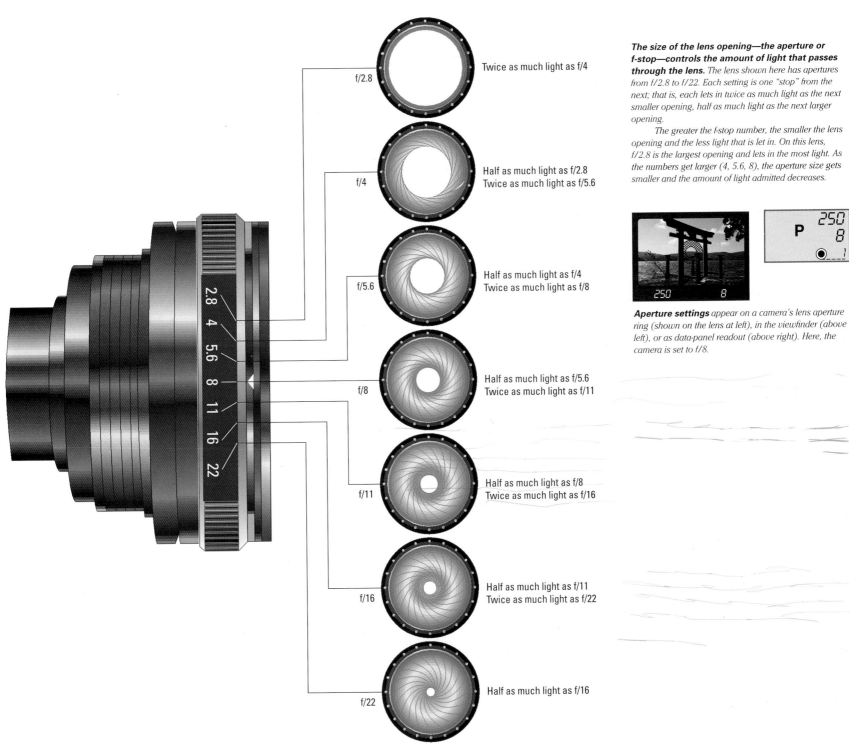

f/2.8 — Twice as much light as f/4

f/4 — Half as much light as f/2.8
Twice as much light as f/5.6

f/5.6 — Half as much light as f/4
Twice as much light as f/8

f/8 — Half as much light as f/5.6
Twice as much light as f/11

f/11 — Half as much light as f/8
Twice as much light as f/16

f/16 — Half as much light as f/11
Twice as much light as f/22

f/22 — Half as much light as f/16

The size of the lens opening—the aperture or f-stop—controls the amount of light that passes through the lens. *The lens shown here has apertures from f/2.8 to f/22. Each setting is one "stop" from the next; that is, each lets in twice as much light as the next smaller opening, half as much light as the next larger opening.*

The greater the f-stop number, the smaller the lens opening and the less light that is let in. On this lens, f/2.8 is the largest opening and lets in the most light. As the numbers get larger (4, 5.6, 8), the aperture size gets smaller and the amount of light admitted decreases.

Aperture settings *appear on a camera's lens aperture ring (shown on the lens at left), in the viewfinder (above left), or as data-panel readout (above right). Here, the camera is set to f/8.*

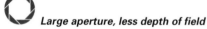
Large aperture, less depth of field

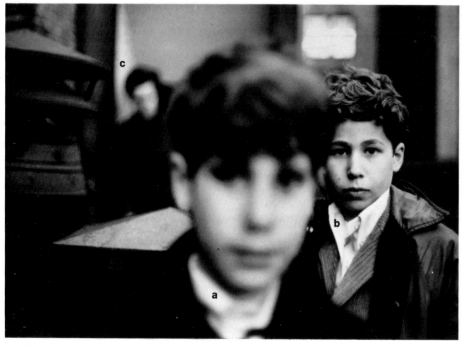

The smaller the aperture size, the more that a scene will be sharp from near to far. As the aperture is stopped down and gets smaller, more of the background and foreground in a given scene becomes sharp. The area of acceptable sharpness in a picture is known as the depth of field.

The two large photographs shown on these pages were taken under identical conditions but with different aperture settings. In the photograph above, the diaphragm was opened to its widest aperture, f/2, and the lens was focused on the boy (b) about seven feet away (see side view of photographer Duane Michals and his subjects, above right). The resulting

photograph shows a shallow depth of field; only the middle boy, (b) is sharp, while both the boy in front (a) and the man behind (c) appear out of focus. Using a small aperture, f/16, gives a different picture (opposite page). The lens is still focused on the middle boy, but the depth of field is now great enough to yield sharp images of the other figures as well.

Some types of cameras let you see the extent of the depth of field. A view camera views directly through the lens. As the lens is stopped down, the increasing sharpness is visible on the ground-glass viewing screen. A single-lens reflex camera also views through the lens. Most models

Depth of field is the area from near to far in a scene that is acceptably sharp in a photograph. As the aperture changes, the depth of field changes too. If your lens has a depth-of-field scale, you can use it to estimate the extent of the depth of field. On this lens, the bottom ring shows the aperture (f-stop) to which the lens is set. The top ring shows the distance on which the lens is focused. The paired numbers on the middle ring correspond to f-stops and show the nearest and farthest distances the depth of field covers when the lens is set at various f-stops.

Here, the lens is set to its widest aperture, f/2, and focused on the middle boy (see side view of scene above), who is at a distance of 7 ft. The depth of field extends from more than 6 ft to less than 8 ft; only objects within that distance will be acceptably sharp. If depth of field is shallow, as it is here, a lens can be sharply focused on one point and still not produce a picture that is sharp enough overall.

More about . . .

• Depth of field, pages 50–55

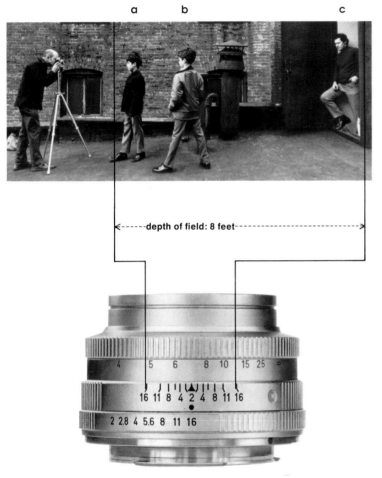

a b c

‹- - - - -depth of field: 8 feet- - - - - - - - - - - - - - - - - - ›

When the lens is stopped down to its smallest aperture, f/16, the depth of field increases. *Almost the entire scene—everything between about 5 ft and 13 ft—is now sharp at the same focusing distance of 7 ft.*

 A reminder: The bigger the f-stop numeral, the smaller the lens opening (you can see this illustrated on page 21). F/16 is a smaller aperture than f/2.

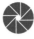

Small aperture, more depth of field

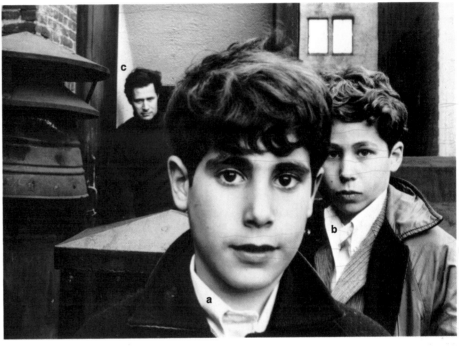

will automatically show the scene through the widest aperture, and so with the least depth of field. But some also provide a depth-of-field preview button that stops down the lens so that the viewfinder shows the depth of field at the aperture to which you have set the camera. However, in very dim light or at a very small aperture, the image may be too dark to be seen clearly once the lens is stopped down.

 A twin-lens reflex shows the scene only at the widest aperture of the viewing lens. There is no way to stop it down to check depth of field at other apertures. Through a simple viewfinder, objects at all distances appear equally sharp.

 Some lenses have a depth-of-field scale from which you can estimate the depth of field. This scale is printed on the lens as paired numbers that bracket the distances of the nearest and farthest points of the depth of field. As the lens is focused and the f-stop set, the scale shows approximately what part of the picture will be in focus and what part will not. (See the lenses at left.) The farthest distance on the lens appears as the symbol ∞. This infinity mark stands for all distances at a given point or farther from the lens. When the camera is focused on infinity or when infinity is within the depth of field, all objects at that distance or farther will be in sharp focus.

Using Shutter and Aperture Together

Both shutter speed and aperture affect the amount of light entering the camera. To get a correctly exposed negative (one that is neither too light nor too dark), you need a combination of shutter speed and aperture that lets in the right amount of light for a particular scene and film.

Once you know any single combination of shutter speed and aperture that will let in the right amount of light, you can change one setting as long as you change the other in the opposite way. Since each aperture setting lets in twice as much light as the next smaller size, and each shutter speed lets in twice as much light as the next faster speed, you can use a larger aperture if you use a faster shutter speed, or you can use a smaller aperture if you use a slower shutter speed. The same amount of light is let in by an f/22 aperture at a 1-second shutter speed, f/16 at 1/2 second, f/11 at 1/4 second, and so on.

Shutter speed and aperture also affect sharpness, and in this respect they act quite differently: Shutter speed affects the sharpness of moving objects; aperture affects the depth of field, the sharpness from near to far. Their different effects are shown in the three photographs at right. In each, the lens was focused on the same point, and shutter and aperture settings were balanced to admit the same total amount of light into the camera. But the three equivalent exposures resulted in three very different photographs.

In the first picture, a small aperture produced considerable depth of field that rendered background details sharply. However, the shutter speed needed to compensate for this tiny aperture had to be so slow that the rapidly moving flock of pigeons appears only as indistinct ghosts. In the center photograph, the aperture was wider and the shutter speed faster; the background is less sharp, but the pigeons are visible, though still blurred. At far right, a still larger aperture and faster shutter speed sacrificed almost all background detail, but the birds are now very clear, with only a few wing tips still blurred.

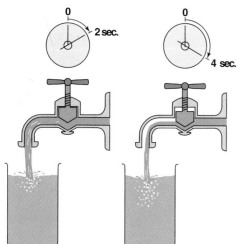

Aperture size + shutter speed = amount of light. The quantity of light that reaches a piece of film inside a camera depends on the aperture size (f-stop) and length of exposure (shutter speed). In the same way, the water that flows from a faucet depends on how wide the valve is open and how long the water flows.

If a 2-sec flow from a wide-open faucet fills a glass, then the same glass will be filled in 4 sec from a half-open faucet. If the correct exposure for a scene is 1/30 sec at f/8, you get the same total amount of exposure with twice the length of time (next slower shutter speed) and half the amount of light (next smaller aperture)— 1/15 sec at f/11.

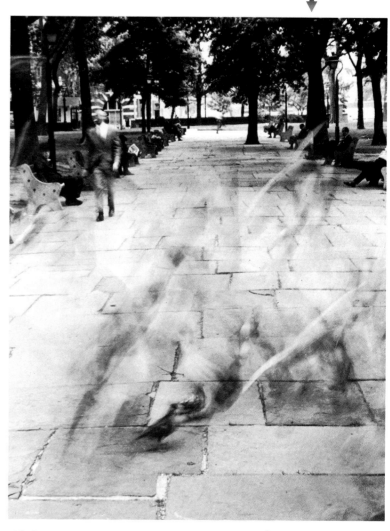

__Small aperture__ (deep depth of field), __slow shutter speed__ (motion blurred). In this scene, a small aperture (f/16) produced great depth of field; the nearest paving stones as well as the farthest trees are sharp. But to admit enough light, a slow shutter speed (1/8 sec) was needed; it was too slow to show moving pigeons sharply. It also meant that a tripod had to be used to hold the camera steady.

More about . . .
• Exposure, pages 89–103

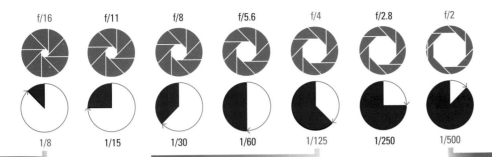

f/16 f/11 f/8 f/5.6 f/4 f/2.8 f/2

Equivalent exposures. *Each combination here of f-stop and shutter speed produces the equivalent exposure (lets in the same amount of light) but produces differences in depth of field and motion.*

1/8 1/15 1/30 1/60 1/125 1/250 1/500

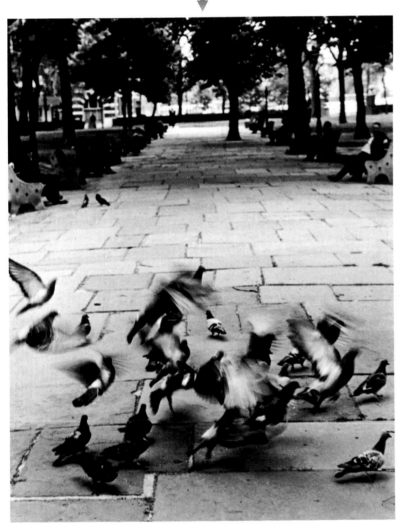

Medium aperture (moderate depth of field), medium shutter speed (some motion sharp). *A medium aperture (f/4) and shutter speed (1/125 sec) sacrifice some background detail to produce recognizable images of the birds. But the exposure is still too long to show the motion of the birds' wings sharply.*

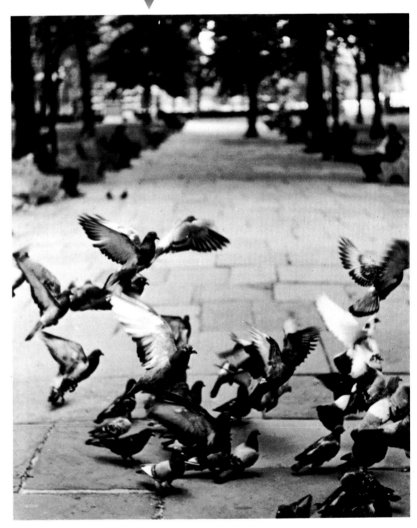

Large aperture (shallow depth of field), fast shutter speed (motion sharp). *A fast shutter speed (1/500 sec) stops the motion of the pigeons so completely that the flapping wings are frozen. But the wide aperture (f/2) needed gives so little depth of field that the background is now out of focus.*

The Major Types of Cameras

View camera

A view camera has direct, through-the-lens viewing and a large image on a viewing screen. It is the simplest and oldest basic design for a camera. A view camera is built something like an accordion, with a lens at the front, a ground-glass viewing screen at the back, and a flexible bellows in between. You focus by moving the lens, the back, or the entire camera forward or back until you see a sharp image on the ground glass.

Advantages: The image on the ground glass is projected by the picture-taking lens, so what you see is exactly what will be on the negative; there can be no parallax error (as in a rangefinder camera, below). The ground glass is large, and you can examine it with a magnifying glass to check sharpness in all parts of the picture.

The film size is also large (4 x 5, 5 x 7, or 8 x 10 inches or larger), which produces sharp detail. The camera parts are adjustable, and you can change the position of lens and film relative to each other so that you can correct problems of focus or distortion. Each picture is exposed on a separate piece of film, so you can give negatives individual development.

Disadvantages: The most serious are the bulk and weight of the camera and the necessity of using a tripod. Second, the image projected on the ground glass is not very bright, and to see it clearly you must put a focusing cloth over both your head and the back of the camera. Finally, the image appears reversed and upside down on the viewing screen. You get used to this, but it is disconcerting at first.

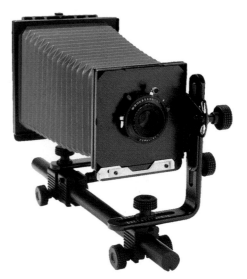

In a view camera, the light comes directly from the subject, through the lens to a ground-glass viewing screen. The image that the photographer sees comes directly from the lens, so it is reversed and upside down. Otherwise it is identical to what will appear on the film. As an aid in composing pictures, the ground glass may be etched with a square grid of hairlines.

Rangefinder/viewfinder camera

A viewfinder camera shows you the scene through a small window (the viewfinder). The viewfinder is equipped with a simple lens system that shows an almost—but not quite—exact view of what the picture will be. Many inexpensive point-and-shoot cameras have a viewfinder plus automatic focus.

A rangefinder camera has a viewfinder, plus a coupled rangefinder that lets you focus the camera manually instead of only relying on automatic focus. Most rangefinder and viewfinder cameras use 35mm film; a few use other film sizes.

Advantages: The camera is compact, lightweight, and fast handling. Compared to a single-lens reflex camera, it has few parts that move during an exposure, so it tends to be quieter and less subject to vibration during operation. A high-quality

rangefinder camera has a bright viewfinder image, which makes it easy to focus quickly, particularly at low light levels where other viewing systems may be dim.

Disadvantages: Because the viewfinder is in a different position than the lens that exposes the negative, the camera suffers from an inherent defect called parallax that prevents you from seeing exactly what the lens sees. The closer the subject to the camera, the more evident the parallax. Better cameras correct to some extent for parallax. Because complete correction is difficult at close range, a viewfinder is awkward for close-up work. Even when the edges of the picture are corrected for parallax, the alignment of objects within the picture will be seen from slightly different angles by the viewfinder and the lens that exposes the film.

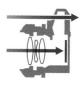

In a rangefinder or viewfinder camera, the image goes directly from the lens to the film but through a separate viewfinder to the eye. The difference between these two viewpoints creates parallax: you see a slightly different view of the scene from the one that is recorded on film. Better models correct for parallax except for subjects that are very near.

Single-lens reflex camera

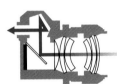

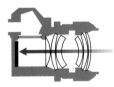

A single-lens reflex camera has a viewing system that is built around a mirror. During viewing, light coming through the camera lens is reflected by this mirror up to a viewing screen, then usually travels to a five-sided pentaprism that turns the inverted image around so it appears the correct way to the eye (diagram, top). When a picture is taken, the mirror swings up, permitting light to strike the film at the back of the camera (diagram, bottom). The image viewed through the lens is the same as the image produced on the film.

A single-lens reflex (SLR) camera shows you the scene directly through the lens. The camera has a mirror and pentaprism that lets you see through the taking lens to compose and focus the scene. You can frame the subject exactly, and with some cameras you can see how much of the scene will be sharp, from foreground objects to a distant background. Most SLRs use 35mm film, but medium-format sizes for 2 1/4-inch film are also popular.

Advantages: Because this camera views through the lens, it eliminates parallax and so is excellent for close-up work. Since the viewing system uses the camera lens itself, it works well with all lenses—from wide angle to supertelephoto; whatever the lens sees, you see. An exposure meter built into the camera measures the light passing through the lens, with the area being metered defined in the viewfinder.

Disadvantages: A single-lens reflex is heavier and larger than a rangefinder camera that uses the same size film. The camera is relatively complex, with more components that may need repair. Its moving mirror makes a comparatively loud click during exposure, especially in the medium-format models; this is a drawback if you are stalking wild animals or self-conscious people. When the mirror moves up during exposure, it momentarily blacks out the viewing image, also a distraction in some situations. And the motion of the mirror and shutter may cause vibrations that make the camera more difficult to hold steady at slow shutter speeds.

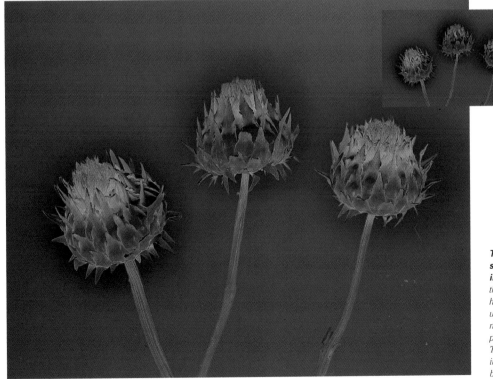

The size of the film used in the camera affects the size of the camera itself and the quality of the image the camera produces. Obviously, the smaller the film format, the smaller the camera can be. Sharp, high-quality images can be produced by 35mm film, which is only 1 1/2-inches wide. However, a 35mm negative has to be enlarged much more than, for example, a 4 x 5-inch negative to make the same size print. The larger the negative, the less film grain will be visible in print, and the better that image texture and detail will be rendered.

More about . . .

• Types of cameras, pages 28–30

Choosing a Camera

Choosing a camera will be easier if you first decide what kind of pictures you want to take, then think about which basic camera design best fits your needs. If your picture taking consists of occasional snapshots of family, friends, or sightseeing views, then an inexpensive, nonadjustable, point-and-shoot camera will be satisfactory.

If you are a photography student, a serious amateur, or just someone who would like to learn more about photography, you will want an adjustable camera. For most people this is a 35mm ("thirty-five millimeter" describes the film size used) single-lens reflex camera. A camera may have automatic features, but at a minimum it should also give you the option of manually selecting the focusing distance and either the shutter speed or aperture, preferably both.

Shop around to compare prices, accessories, and service. Make sure you like the way the camera fits in your hands, and that buttons and knobs are conveniently placed and easy to manipulate. With the more automatic models, see if it is convenient to override the automatic features. If you wear glasses, make sure you can see the entire image.

You may be able to find a good used camera at a considerable saving, but look over used equipment carefully. Avoid cameras with dents, scratched lenses, rattles, or gouged screw heads that could indicate a home repair job. If a dealer is reputable, you will be able to exchange a camera, new or used, if your first roll of film is unsatisfactory. Examine that first roll carefully for scratches, soft focus, or other signs of trouble.

Point-and-shoot cameras, also called compact cameras, dominate the low-priced end of the market. Most use 35mm film and are "auto everything": they read the speed of the film you put in the camera, advance it to the first frame, focus, calculate exposure, trigger a built-in flash if you need it, advance the film after each exposure, and rewind at the end of the roll. Many are nonadjustable and can only be operated automatically. Better-quality ones have a zoom lens and offer some control of focus, exposure, or flash functions. Point-and-shoot cameras are small, inexpensive, and easy to use, but they are easy to outgrow as soon as you become more seriously interested in photography.

A 35mm rangefinder camera with adjustable controls gives you more flexibility than a simple point-and-shoot model. You focus and set the exposure yourself, or with some models have the option to do so automatically. A high-quality 35mm rangefinder camera has long been a

favorite of experienced photographers who want to work inconspicuously and quickly. They value the camera's dependability and its fast and precise focusing.

Because the viewing system is separate from the lens that exposes the film, you do not see exactly what the lens sees, especially at close focusing distances. This type of camera is not your best choice if you want to make extreme close-ups or align objects within the picture precisely.

Medium-format rangefinder cameras combine a large (2 1/4-inch) film with compact rangefinder design. They are lightweight, with interchangeable lenses, a quiet shutter, and a bright, easy-to-focus viewfinder. They are popular with professionals and others who want a camera that is easy to carry in the field, but that delivers a high-quality negative larger than 35mm.

More about . . .

• View cameras, pages 281–301

35mm single-lens reflex (SLR) cameras are the most popular when a buyer moves beyond snapshot level. SLRs offer the greatest variety of interchangeable lenses, plus features such as through-the-lens metering and built-in flash. Since these cameras show you the scene directly through the lens, you see an exact view of what will appear on the film—an advantage with close-ups, microphotography, or other work where you want to see in advance exactly how the image will look.

Automatic features abound: automatic exposure, focus, flash, and film winding are standard on many models. Some cameras focus as soon as you put your eye to the viewfinder, focus in whatever direction your eye is looking, or continuously refocus on a moving object. Stop for a moment to think about what features will be really useful to you before you pay extra for some special feature you might need only once in a while.

Make sure the camera is one that allows you to manually override automatic features when you want to make exposure and focus choices yourself. For example, some cameras automatically set the film speed for you by reading the DX coding on the film cassette. That's convenient, but it's best to have a camera where you can override this feature when you want to select a film speed different from the nominal one. Also consider how convenient it is to select or override automatic features. Does the camera have easy-to-adjust, conveniently located knobs and dials or tiny, difficult-to-access, and even harder-to-read ones?

The 35mm film format produces a rather small negative, 1 x 1 1/2 inches (24 x 36 mm). You can make high-quality enlargements from 35mm negatives, but you need carefully exposed and processed negatives to do so. Many types of film, both black-and-white and color, are available in 35mm.

Medium-format single-lens reflex cameras are popular with photographers who want a negative larger than 35mm plus the versatility of a single-lens reflex—fashion or advertising photographers, for example. Not only are lenses interchangeable, but sometimes the camera's back is as well; you can expose part of a roll of black-and-white film, remove the back, and replace it with another loaded with color film. These cameras are bigger, heavier, and noisier than a 35mm single-lens reflex—and the price is higher, too. Most cameras make a 2 1/4-inch square (6 x 6 cm) negative; some models have a rectangular format, such as 2 1/4 x 2 3/4 inches (6 x 7 cm) or 2 1/4 x 1 5/8 inches (6 x 4.5 cm).

View cameras give the utmost in control over the image. You can adjust the plane of sharpest focus within the image, as well as the apparent shape and perspective of objects within the scene. The large-size negatives (4 x 5 inches and larger) make prints of maximum sharpness and minimum grain. Heavy, bulky, and slow to operate, the view camera is still the camera of choice for architectural photography, studio work, or any use where the photographer's first aim is carefully controlled, technically superior pictures.

Twin-lens reflex (TLR) cameras also deliver a negative larger than 35mm, usually 2 1/4-inches square. Lenses are not interchangeable (except on some older models). TLRs are quiet, reliable, and generally less expensive than other types of medium-format cameras. They are good for portraits or other fairly conventional photographic situations, but don't expect the speed of a rangefinder or the flexibility of a single-lens reflex. Few models are made.

Special-Purpose Cameras

Special-purpose cameras fill a variety of needs. You can use them to see a picture right away, take photographs underwater, or produce a non-standard format.

Instant cameras produce a print within a few seconds, if not instantly. Polaroid makes instant films for its own cameras, as well as for view cameras and for 35mm cameras.

Electronic cameras don't use film. Instead they use electronic circuitry to capture an image in a digital form that can then be manipulated by a computer. You get immediate readout with an electronic camera, but you don't need one for digital imaging. A scanner can be used to convert ordinary film images into a digital format.

Stereo cameras take two pictures at the same time through side-by-side lenses. The result, a stereograph, gives the illusion of three dimensions when seen in a stereo viewer.

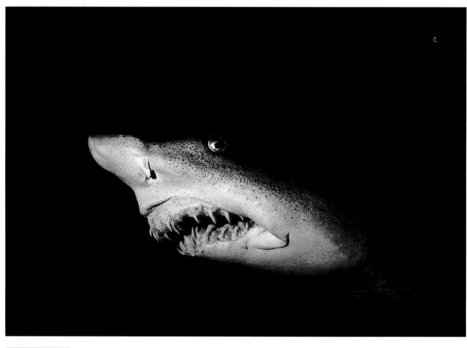

JEFF ROTMAN Shark! 1979

Underwater cameras are mostly for use underwater but also for situations where a camera is likely to get extremely wet. Some cameras are water resistant, rather than usable underwater.

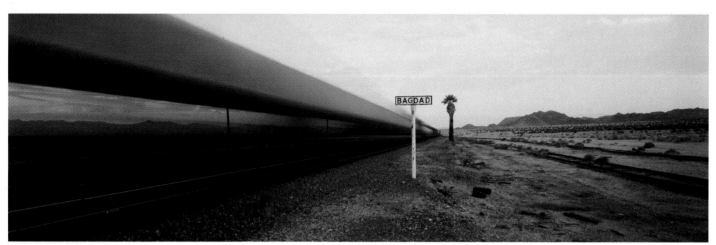

TIMOTHY HEARSUM Bagdad, California

Panoramic cameras make a long, narrow photograph that can be interesting, for example, for landscapes. Some of these cameras crop out part of the normal image rectangle to make a panoramic shape. Others use a longer-than-normal section of roll film or rotate the lens from side to side during the exposure.

More about . . .
- Electronic cameras, page 257
- Instant cameras, pages 72–73, 195

To hand hold a camera, *press one arm (preferably both) against your body. Hold your breath and squeeze the shutter release gently to avoid jerking the camera.*

With the camera in a vertical position, *the right hand can hold the camera and release the shutter. The left hand can focus the lens. Winding the camera strap around your wrist prevents dropping the camera and can help steady it.*

With a long lens *or at a relatively slow shutter speed without a tripod, try to find some extra support such as a stool, chair, or other object to brace yourself against.*

A tripod provides the steadiest support for a camera. *It is essential for slow shutter speeds. Some tripods have a center shaft that can be removed and reversed; the tripod head and camera can then hang upside down so the camera will be at a low angle.*

A cable release lets you trigger the shutter without jarring the camera. Leave a little slack in the cable instead of pulling it taut.

Keep the camera steady during an exposure. Even with the finest camera and lens, you won't be happy with the pictures you take if you don't keep the camera steady enough during the exposure. Too much camera motion during exposure will cause sharpness problems ranging from a slight lack of sharpness to hopeless blurring.

How much camera movement is too much? That depends partly on how much the image is enlarged, since any blur is more noticeable in a big enlargement. It also depends on the shutter speed and the focal length of the lens. The faster the shutter speed, the less you have to worry about camera movement. The longer the focal length of the lens, the more movement becomes apparent because longer lenses magnify objects—and camera movements—more.

If you are hand holding a camera, use a shutter speed faster than the focal length of the lens: 1/60 second or faster with a 50mm lens, 1/250 second or faster with a 200mm lens, and so on. Squeeze the shutter release gently and smoothly. If you can, brace your body in some way—put your back against a wall or your elbows on a table, fence, or other support.

Using a tripod and cable release is the best way to prevent camera movement. The tripod should be sturdy enough for the camera; if you balance a large, heavy camera on a flimsy, lightweight tripod, your camera can end up on the floor. When making portraits, putting the camera on a tripod lets you bring your eye away from the viewfinder and establish more rapport with your subject.

Miniature tripods are sometimes useful; their very short legs can be steadied on a table or car fender or even against a wall. A monopod, a single-leg support, or a hand grip gives extra stability if you have to keep moving, for example, along a football sideline.

Photographer at Work: Dance Photography

"The root of my interest is movement," says dance photographer Lois Greenfield, "or rather how movement can be interpreted photographically. And dance provides a perfect opportunity for this. You might say that dance is my landscape."

In Greenfield's landscape, dancers dispense with gravity as they walk on air, hang in space, and intersect the image frame and each other in improbable movement. No tricks are involved: no wires holding up the dancers, no unusual point of view making it look as if the dancers are in the air when they are not, no composite of dancers stripped in from different shots. "They're just straightforward snapshots," she says disarmingly. These are snapshots, however, that require an intense collaboration between dancer and photographer.

Greenfield approaches her work differently from conventional dance photographers who often have the choreographer arrange a pose for them or who simply capture the peak moment of a movement. She says of her earlier work, "People would look at one of my pictures of Baryshnikov in a spectacular leap ten feet off the ground and say, 'What a great photograph!' But I knew that it wasn't; it was merely a great dance moment competently captured." Her dissatisfaction with merely recording dance choreography led her to explore other ways of working with dancers. She quotes a Duane Michals comment she heard at a lecture as part of her inspiration: "I want to create something that would not have existed without me."

She began collaborating with dancers David Parsons and Daniel Ezralow, encouraging them to see how their bodies moved, independent of the choreography they had been trained to perform. That left the dancers free to soar, leap, lunge, and fall,

and Greenfield free to explore her personal vision. Each of them had an active career: Greenfield photographed for newspapers, magazines, and commercial clients; Parsons and Ezralow were prominent dancers with the Paul Taylor Dance Company. But when they got together, Greenfield says, something new happened. It felt, "as if we were toys which came to life when the toymaker went to sleep. At night the toys played!" (One of those photographs of Parsons appears on page 236.)

Recording motion sharply is vital to Greenfield's stop-action photography. She uses a Broncolor Pulso A2 electronic flash because she can adjust it to a very short flash duration for the crispest possible image. She had been working with a 35mm single-lens reflex camera, but switched to a Hasselblad camera, a 2 1/4-inch-square single-lens reflex. The camera synchronized with flash at a faster shutter speed than her 35mm camera, which meant that she was less likely to have problems with existing light registering on the film and causing blurred motion. When she switched cameras, she discovered a bonus: the square format improved the composition by giving equal emphasis to all sides of the image, compared to the bottom-heavy 35mm, which could seem to pull the image—and the dancers—down.

Greenfield's dancers are sharply photographed, but not simply frozen in time. Questions about the past and future enter the pictures, too. "Because of the seeming impossibility of what my dancers are doing, you can't help asking yourself, 'Where are they coming from? Where are they going?' Or even, 'How are they going to land in one piece?'"

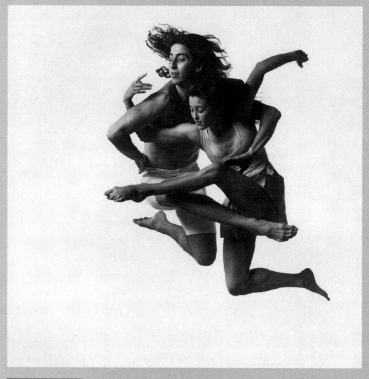

LOIS GREENFIELD Daniel Ezralow and Ashley Roland, 1988

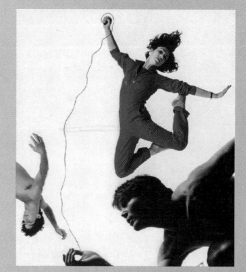

LOIS GREENFIELD Self Portrait with Daniel Ezralow and David Parsons, 1983

Lois Greenfield thinks of the dancers she photographs as her collaborators, not just as performers who are demonstrating choreographed moments from a particular dance. Above, Daniel Ezralow described himself as "a piece of clay which he would throw up in the air to make a different shape each time."

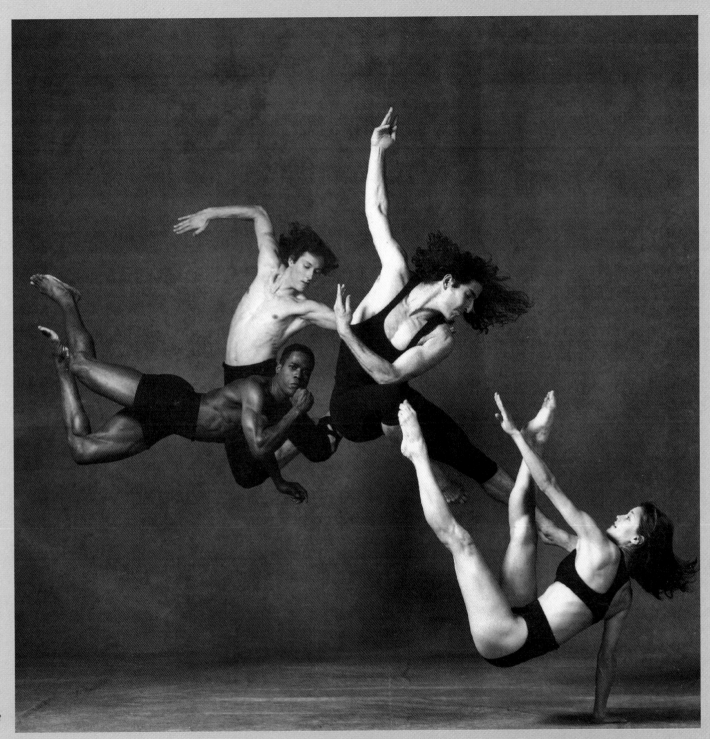

"I was trying for effects that would disorient the viewer," Greenfield said, " trying to make things look impossible by providing contradictory information or clues as to what is up or down, on or off balance."

LOIS GREENFIELD Niahal "Flipper" Hope, Jack Gallagher, Daniel Ezralow, and Ashley Rowland, 1993

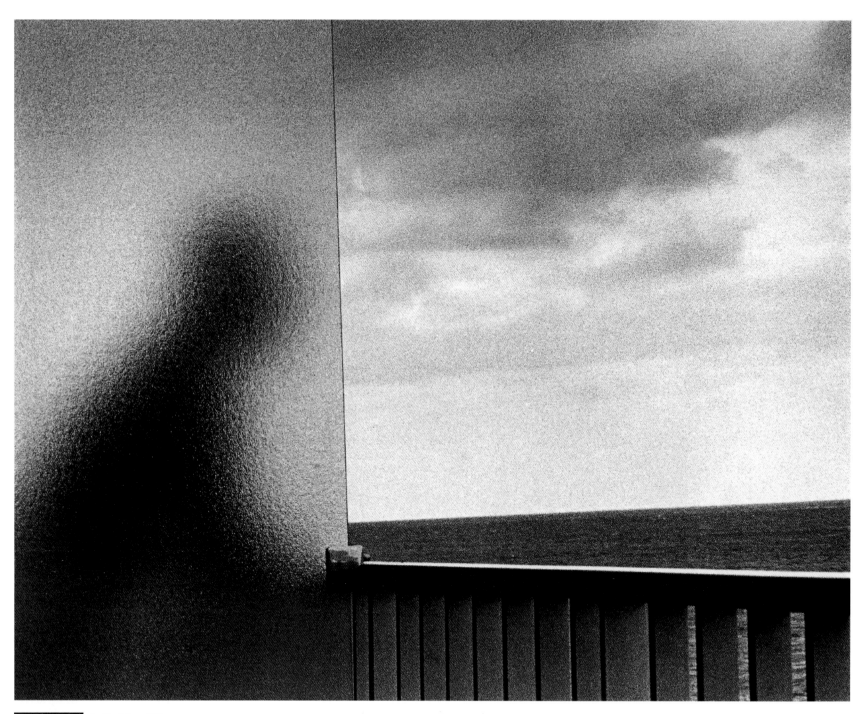

ANDRÉ KERTÉSZ On Martinique, 1972

On the island of Martinique, an anonymous figure looks out over an anonymous ocean. Glass, sky, ocean, and railing divide the scene in a geometry of angles and gray shapes that the eye takes pleasure in comparing and measuring. The print is relatively grainy, echoing the granularity of the glass. The scene is quite understandable—we have all seen figures or shapes behind translucent glass—but the picture invites other associations. Landscapes by the surrealist painter René Magritte come to mind, and one can imagine that just out of sight a giant rock is floating across the sky.

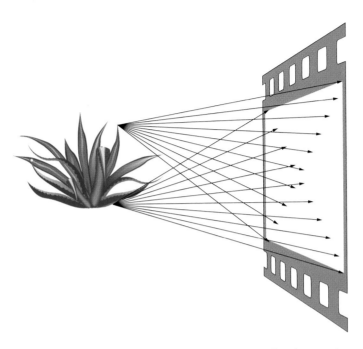

Light must be controlled if our eyes or our cameras are to form images of objects. *You can't simply place a square of sensitized film in front of a subject and hope that an image will appear on the film. The rays reflecting from the subject would hit the film in a random jumble, resulting not in a picture but in a uniform exposure over the entire surface of the film. For simplicity's sake, the drawing above shows only a few rays coming from only two points on the plant, but their random distribution over the entire film makes it clear that they are not going to produce a useful image. What is needed is some sort of light-control device in front of the film that will select and aim the rays, putting the rays from each part of the plant where they belong, resulting in a clear picture.*

All photographic lenses do the same basic job: they collect light rays coming from a scene in front of the camera and project them as images onto a piece of film at the back. This chapter explains how this happens and how you can use lens focal length (which controls the magnification of a scene), lens focus (which controls the sharpest part of an image), lens aperture, and subject distance to make the kinds of pictures you want.

From Pinhole to Lens

Although all the light rays reflected from an object cannot produce an image, a selection of rays can. If the rays reach a barrier with a small pinhole in it, like that in the drawing top right, all but a few rays from each point are deflected by the barrier. Those few rays that do get through, traveling in straight lines from the subject, can make an image when they reach a flat surface, like the film at the back of a camera. Everything that was at the top of the subject appears at the bottom of the image on the film and everything at the bottom appears at the top. Similarly, left becomes right and right becomes left.

The trouble with a pinhole camera is its tiny opening. It admits so little light that very long exposures are needed to register an image on film. If the hole is enlarged, the exposure becomes shorter, but the image becomes much less sharp, like the photograph center right.

A pinhole, small as it is, actually admits a cluster of light rays. Coming at slightly different angles, these rays continue through the hole in slightly different directions. They fan out, so that when they hit the film they cover a small circular area called a circle of confusion. As the size of the hole is increased, a larger cluster of light rays gets through to the film and will cover a wider circle. The larger the circles are, the more they overlap their neighbors and the less clear the picture will be.

A lens creates a sharp image with a relatively short exposure. To get sharp pictures, the circles of confusion should be as small as possible. But the only way to achieve that with a pinhole camera is to use a very small opening, which admits little light and requires long exposure times. To admit more light and to make a sharper picture than even the smallest pinhole, a different method of image formation is needed. That is what a lens provides.

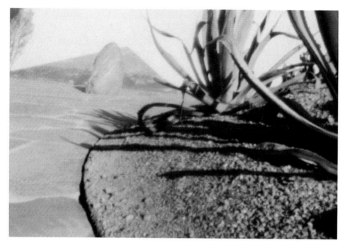

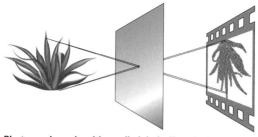

Photograph made with small pinhole. *To make this picture, the lens of the camera was replaced with a thin metal disk pierced by a tiny pinhole, equivalent in size to an f/182 aperture. Only a few rays of light from each point on the subject get through the tiny opening, producing a soft but acceptably clear photograph. Because of the small size of the pinhole, the exposure had to be 6 sec long.*

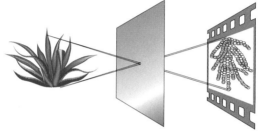

Photograph made with larger pinhole. *When the size of the pinhole was increased to f/65, the result was an exposure of only 1/5 sec, but an extremely out-of-focus image. The larger hole let through more rays from each point on the subject. These rays spread before reaching the film, making large circles that ran into one another, creating an unclear image.*

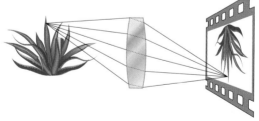

Photograph made with lens. *This time, using a simple convex lens with an f/16 aperture, the scene is sharper than the one taken with the smaller pinhole, but the exposure time is much shorter, only 1/100 sec. The lens opening was much bigger than the pinhole, letting in far more light, but focusing the rays from each point on the subject so that they are sharp on the film.*

More about . . .
• How to make your own pinhole camera, pages 176–177

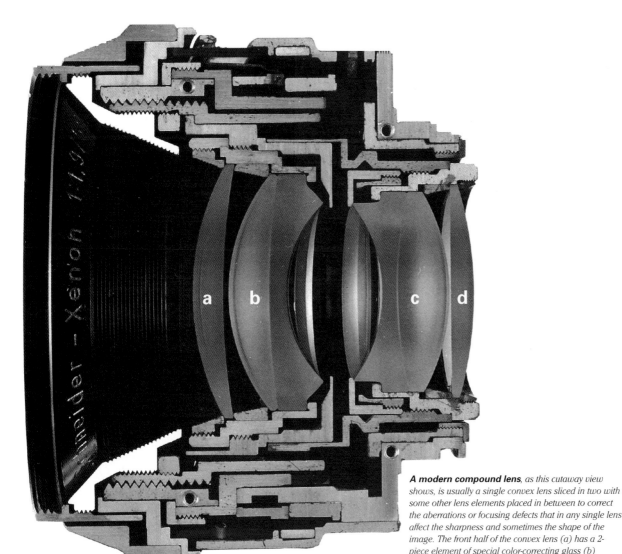

Most modern photographic lenses are based on the convex lens. Thicker in the middle than at the edges, a convex lens can collect a large number of light rays from a single point on an object and refract, or bend, them toward each other so that they converge at a single point (diagram, below). This point of convergence, the focal point, falls on a surface called the focal plane. In a camera, a strip of film is stretched across the focal plane, which is now the film plane. The film records an image formed by light rays from an infinite number of tiny circles of confusion.

How does a lens refract (bend) light to form an image? When light rays pass from one transparent medium, such as air, into a different transparent medium, such as water or glass, the rays may be bent, or refracted. Look at the shape of a spoon half submerged in a glass of water and you will see a common example of refraction: rays of light reflected by the spoon are bent by the water and glass so that part of the spoon appears displaced.

For refraction to take place, light must strike the new medium at an angle. If it is perpendicular to the surface when it enters and leaves the medium (diagram, 1), the rays pass straight through. But if it enters or leaves at an oblique angle (2), the rays will be bent to a predictable degree. The farther from the perpendicular they strike, the more they will be bent.

When light strikes a transparent medium with a curved surface, such as a lens, the rays will be bent at a number of angles depending on the angle at which each ray enters and leaves the lens surface. They will be spread apart by concave surfaces (3) and directed toward each other by convex surfaces (4). Rays coming from a single point on an object and passing through a convex lens (the simplest form of camera lens) will cross each other—and be focused—at the focal point.

A modern compound lens, as this cutaway view shows, is usually a single convex lens sliced in two with some other lens elements placed in between to correct the aberrations or focusing defects that in any single lens affect the sharpness and sometimes the shape of the image. The front half of the convex lens (a) has a 2-piece element of special color-correcting glass (b) behind it. Farther back is another color-correcting element (c) and finally the back half of the convex lens (d).

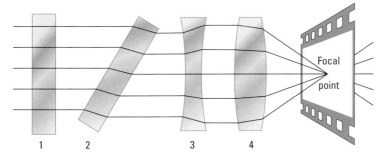

How refraction works is shown in this diagram of beams of light passing through four glass blocks. The beams, entering from the left, strike the first block head on and are therefore not refracted. But the next block has been placed at an angle, so that the rays are refracted, resuming their former direction on the other side. The concave surfaces of the third block spread the beams apart, but the last block—a convex lens like the basic light-gathering lenses used in cameras—draws the rays back together so that they cross each other at the focal point.

Lens Focal Length

The most important way lenses differ is in their focal length. Since most cameras can be used with interchangeable lenses, you can choose which lens to buy or use. A lens is often described in terms of its focal length (a 50mm lens, a 12-inch lens) or its relative focal length (normal, long, or short). Technically, focal length is the distance between the lens's rear nodal point and the focal plane when the lens is focused on infinity (a far distance from which light reaches the lens in more or less parallel rays).

Focal length controls magnification, the size of the image formed by the lens. The longer the lens the greater the size of objects in the image (see diagrams right).

Focal length also controls angle of view, the amount of the scene shown on a given size of film (see photographs opposite). A long-focal-length lens forms a larger image of an object than a short lens. As a result, the long lens must include on a given size of film less of the scene in which the object appears. If you make a circle with your thumb and forefinger and hold it close to your eye, you will see most of the scene in front of you—the equivalent of a short lens. If you move your hand farther from your eye—the equivalent of a longer lens—the circle will be filled by a smaller part of the scene. You will have decreased the angle of view seen through your fingers. In the same way, the longer the focal length, the smaller the angle of view seen by the lens.

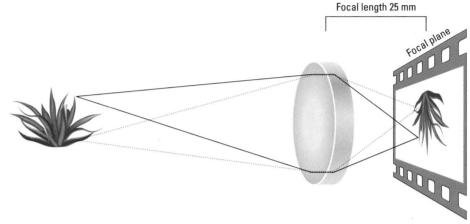

Focal length 25 mm

Focal plane

A lens of short focal length bends light sharply. *The rays of light focus close behind the lens and form a small image of the subject.*

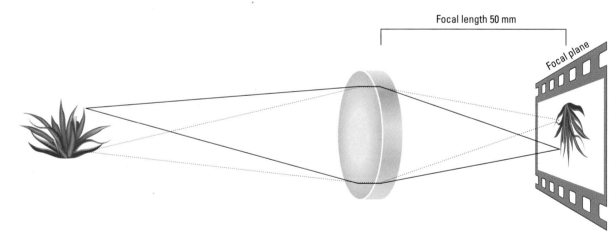

Focal length 50 mm

Focal plane

A lens of longer focal length bends light rays less than a short lens does. *The longer the focal length, the less the rays are bent, the farther behind the lens the image is focused, and the more the image is magnified. The size of the image increases in proportion to the focal length. If the subject remains at the same distance from the lens, the image formed by a 50mm lens will be twice as big as that from a 25mm lens.*

17 mm

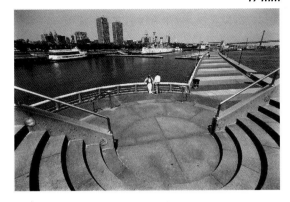

28 mm

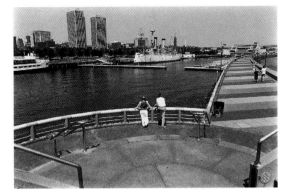

50 mm

85 mm

135 mm

300 mm

500 mm

1000 mm

1000 mm — 2¹/₂°
500 mm — 5°
300 mm — 8°
135 mm — 18°
85 mm — 28°
50 mm — 47°
28 mm — 75°
17 mm — 104°

The effect of increasing focal length while keeping the same lens-to-subject distance: *an increase in magnification and a decrease in angle of view. Since the photographer did not change position, the sizes of objects within the scene remained the same in relation to each other. The diagram shows the angle of view of some of the lenses that can be used with a 35mm camera.*

Normal-Focal-Length Lenses

A normal-focal-length lens, also called a standard-focal-length lens, approximates the impression human vision gives. One of the greatest of modern photographers, Henri Cartier-Bresson, who described the camera as "an extension of my eye," almost always used a normal lens. In his picture opposite, the angle of view is about the same as what the eye can see clearly from one position, and the relative size of near and far objects seems normal.

A lens that is a normal focal length for one camera can be a long focal length for another camera. Film size determines what will be a "normal" focal length. The larger the size of the film format, the longer the focal length of a normal lens for that format. A camera using 35mm film takes a 50mm lens as a normal focal length; a camera using 4 x 5-inch film requires a 150mm lens. Usage varies somewhat: for example, lenses from about 40mm to 58mm are also referred to as normal focal lengths for a 35mm camera.

A lens of normal focal length has certain advantages over lenses of longer or shorter focal length. Most normal lenses are faster, that is, they open to a wider maximum aperture, and so can be used with faster shutter speeds or in dimmer light than lenses that do not open as wide. They often are less expensive, more compact, and lighter weight.

Choice of focal length is a matter of personal preference. Some photographers habitually use a shorter focal length because they want a wide angle of view most of the time; others prefer a longer focal length that narrows the angle of view to the central objects in a scene. If you have a 35mm camera, a 50mm lens is a good focal length to start with, but it may not be the one that you will eventually prefer to use.

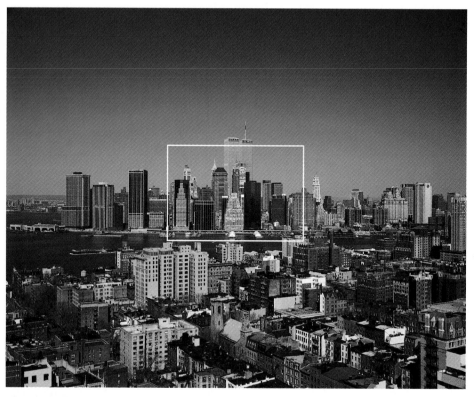

RAFAEL MACIA **Lower Manhattan Skyline**

A lens of a given focal length may be considered normal, short, or long, depending on the size of the film you are using. If the focal length of a lens is about the same as the diagonal measurement of the film (broken line), the lens is considered "normal." It collects light rays from an angle of view of about 50°, the same as the human eye.

The photograph above was taken with a 4 x 5 view camera using a 150mm lens. The diagonal measurement of 4 x 5-inch film is about 150 mm, so a 150mm lens is considered a normal focal length for that size film. But 150 mm is much longer than the diagonal of 35mm film (inner rectangle on photograph). A 150mm lens is considered a long lens for a 35mm camera.

More about . . .

• Normal, short, and long focal lengths for different film sizes, page 60

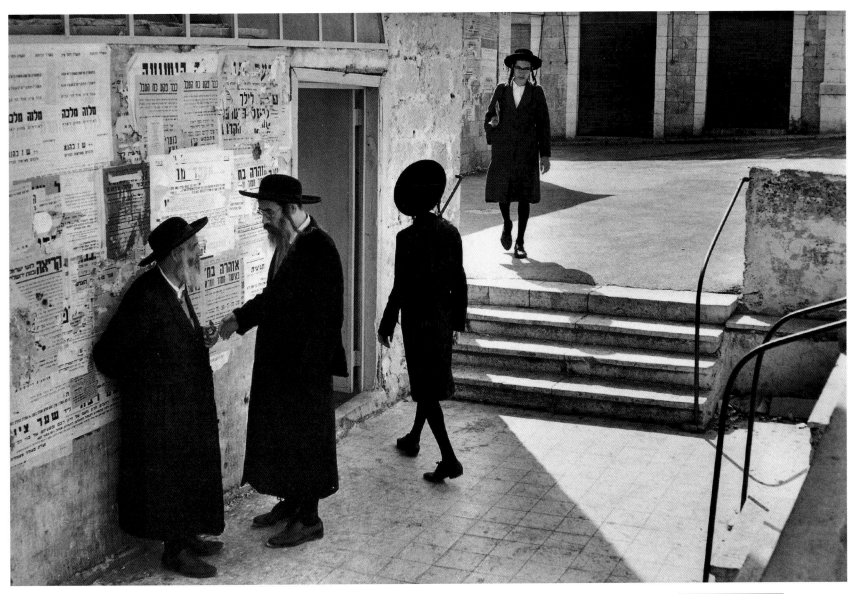

This photograph of Hasidic Jews in Jerusalem shows Henri Cartier-Bresson's characteristic use of a normal-focal-length lens. The photographer was at a medium distance, so all four figures appear to be of normal size and perspective relative to each other. There is no distortion of perspective as there might have been had a shorter lens been used up close or a longer lens been used from far away. Most of the scene is sharp because at a medium distance a normal-focal-length lens provides considerable depth of field.

A long-focal-length lens provides greater image magnification and a narrower angle of view than a normal lens. For a 35mm camera, a popular and useful long focal length is 105 mm. For a camera using 2 1/4 x 2 1/4-inch film, the comparable focal length is 150 mm. For a 4 x 5 view camera, it is about 300 mm.

Long lenses are excellent when you cannot or do not want to get close to the subject. In the photograph opposite, the photographer seems to be in the middle of the action even though he is standing on the sidelines. Long lenses make it possible to photograph birds and animals from a distance. They are excellent for portraiture; most people become self-conscious when a camera is too close to them so their expressions are often artificial. A long lens also avoids the kind of perspective distortion that occurs when shorter lenses used close to a subject exaggerate the size of whatever is nearest the camera—in a portrait, usually the nose (below).

There are subtle qualities that can be exploited when you use a long lens. Because a long lens has less depth of field, objects in the foreground or background can be photographed out of focus so that the sharply focused subject stands out clearly and powerfully. Also, a long lens can be used to create an unusual perspective in which objects seem to be closer together than they really are (see opposite and page 58).

Long lenses have some disadvantages, and the longer the lens the more noticeable the disadvantages become. Compared to a lens of normal focal length, they tend to be heavier, bulkier, and usually more expensive. Because of their shallow depth of field, they must be focused accurately. They usually do not open to a very wide aperture; a maximum aperture of f/4 is typical for a 200mm lens. They are difficult to use for hand-held shots since they magnify lens movements as well as subject size. The shutter speed for a medium-long lens, such as a 105mm lens on a 35mm camera, should be at least 1/125 second if the camera is hand-held; otherwise, camera movement may cause blurring. A tripod or some other support is even better.

Photographers commonly call any long lens a telephoto, or tele, although not all long lenses are actually of telephoto design. A true telephoto has an effective focal length that is greater than the distance from lens to film plane. A tele-extender or teleconverter contains an optical element that increases the effective focal length of a lens. It attaches between the lens and the camera body.

Long lenses often produce better portraits. A moderately long lens (such as an 85mm or 105mm lens on a 35mm camera) used at least 6 ft from the subject (near right) makes a better portrait than a shorter lens used close to the subject (far right). Compare the sizes of nose and chin in the pictures. Photographing a person at too close a lens-to-subject distance makes features nearest the camera appear too large and gives an unnatural-looking dimension to the head.

Long lens, moderate distance

Short lens, up close

More about . . .
• Perspective, pages 56–59

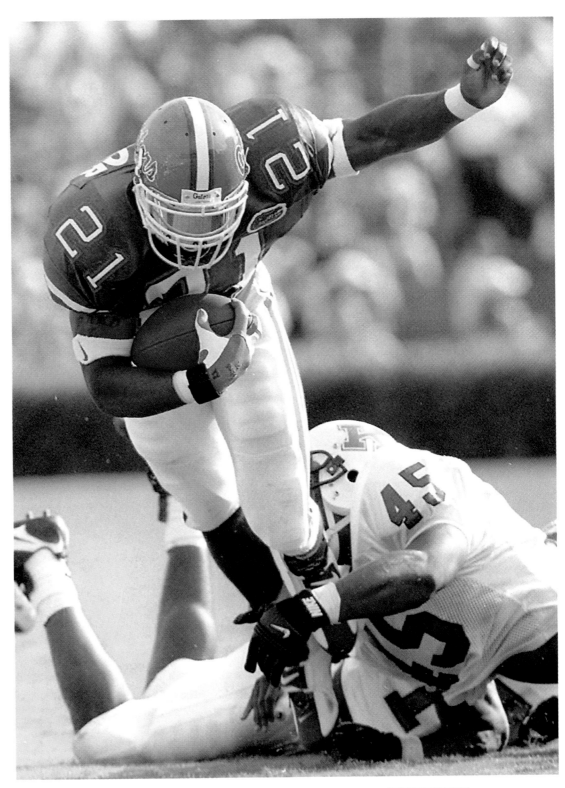

This photograph of a grab for the quarterback's shoes also shows two characteristics of the long lens. Although the photographer was standing on the sidelines, a long lens on his 35mm camera includes only a narrow angle of view, magnifying the image to fill the frame with action. The long lens also has shallow depth of field, which isolates the action sharply against an out-of-focus background.

BRUCE ACKERMAN Shoestring Tackle, 1996

Short-Focal-Length Lenses

A short-focal-length lens increases the angle of view and shows more of a scene than a normal lens used from the same position. A short lens (commonly called a wide-angle lens or sometimes a wide-field lens) is useful when you are physically prevented (as by the walls of a room) from moving back as much as would be necessary with a normal lens. For a 35mm camera, a commonly used short focal length is 28 mm. A comparable lens for a camera using 2 1/4 x 2 1/4-inch film is 55 mm. For a 4 x 5 view camera, it is 90 mm.

Wide-angle lenses have considerable depth of field. A 24mm lens focused on an object 7 feet away and stopped down to f/8 will show everything from 4 feet to infinity in sharp focus. News photographers or others who work in fast-moving situations often use a moderately wide lens, such as a 35mm lens on a 35mm camera, as their normal lens. They don't have to pause to refocus for every shot because so much of a scene is sharp with this type of lens. At the same time it does not display too much distortion, which is the wide-angle lens's other main characteristic.

Pictures taken with a wide-angle lens can show both real and apparent distortions. Genuine aberrations of the lens itself such as curvilinear distortion are inherent in extremely curved or wide elements made of thick pieces of glass, which are frequently used in wide-angle lenses. While most aberrations can be corrected in a lens of a moderate angle of view and speed, the wider or faster the lens, the more difficult and/or expensive that correction becomes.

A wide-angle lens can also show an apparent distortion of perspective, but this is actually caused by the photographer, not the lens. An object that is close to a lens (or your eye) appears larger than an object of the same size that is farther away. Since a wide-angle lens can be focused very close to an object, it is easy to get this kind of exaggerated size relationship (photograph, right). The cure is to learn to see what the camera sees and either minimize the distortion, or use it intentionally.

A lens of very short focal length requires some design changes for use in a single-lens reflex camera, because the lens is so close to the film plane that it gets in the way of the mirror used for viewing. A retrofocus (reversed-telephoto) lens solves this problem with a design that is the reverse of that of a telephoto lens. The result is a lens of very short focal length that can be used relatively far from the film plane and out of the way of the camera's viewing mirror.

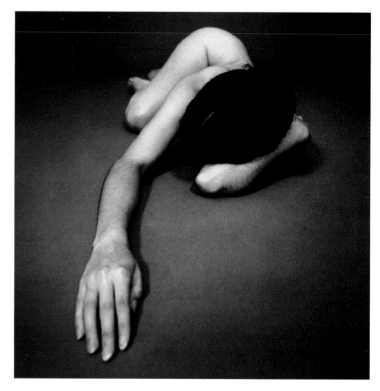

Short lenses can distort the size and shape of a subject. *The exaggerated size of the model's hand, her rapidly receding arm, and her unnaturally undersized body were all created by photographing an average-size model with the camera close to her outstretched fingertips. This kind of apparent distortion is a result of the short distance from lens to subject and is easy to achieve—intentionally or otherwise—with a wide-angle lens, which can be focused very close to a subject.*

More about . . .
• Perspective, pages 56–59

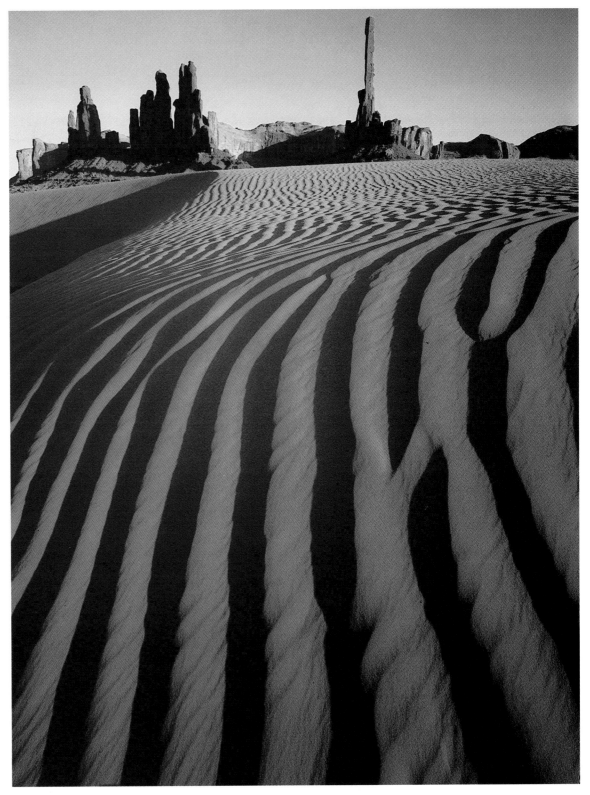

With a 75mm lens on his 4 x 5 view camera (a wide-angle lens for that format), David Muench positioned his camera relatively close to the furrows of sand in the foreground. The result was to increase the apparent size of the furrows nearest the camera and to create an impression of great distance from the foreground to the background. *See page 59 for a similar effect with a different subject.*

DAVID MUENCH Sand Dunes, Monument Valley, Arizona, 1985

Zoom Lenses

Zoom lenses are popular because they combine a range of focal lengths into one lens. Using a 50–135mm zoom, for example, is like having a 50mm, 85mm, and 135mm lens instantly available, plus any focal length in between. The glass elements of a zoom can be moved in relation to one another; this changes the focal length and therefore the size of the image.

It's convenient to be able to frame an image merely by zooming to another focal length rather than by changing camera position or changing lenses. Many photojournalists now carry only two lenses: a 24–80mm zoom and a longer 80–200mm zoom. A zoom lens is particularly useful for making color slides, since cropping the image later is not easy.

A zoom has some disadvantages: Compared to fixed-focal-length lenses, zooms are somewhat more expensive, bulkier, and heavier. However, one of them will replace two or more fixed-focal-length lenses.

Zoom lenses are best used where light is ample because they have a relatively small maximum aperture. More expensive zooms keep the same maximum aperture at all focal lengths, but many zooms reduce the size of the maximum aperture as focal length increases. For example, a 28–80mm zoom may open to f/4 when it is set to 28mm, but only to f/5.6 at 80mm focal length.

Image quality used to be more of a problem than it is today; new designs produce a much sharper image than did earlier zoom lenses, which were significantly less sharp than fixed-focal-length lenses.

The best prices and fewest drawbacks are found with a modest zooming range, from 35mm to 105mm, for example. The greater the zooming range, the more that disadvantages become evident.

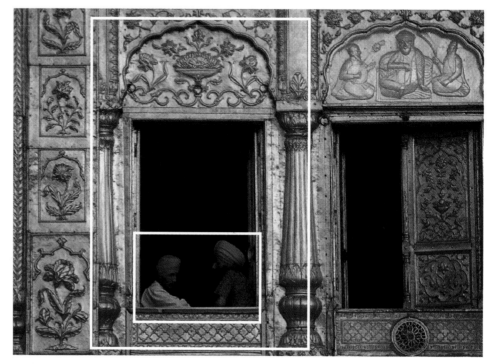

KEN KOBRÉ Golden Temple, Amritsar, India

A zoom lens gives you a choice of different focal lengths. *The rectangles overlaid on the picture show some of the ways you could have made this photograph by zooming in to shoot at a long focal length or zooming back to shoot at a shorter one.*

A macro lens is useful for photographing very close to a subject without having to use other accessories such as extension tubes. When you photograph close to a subject, depth of field is very shallow—only a narrow distance from near to far will be sharp. Here, to make the photograph sharp, the photographer sliced and positioned the mushrooms so that their front surfaces lined up evenly, parallel to the film plane.

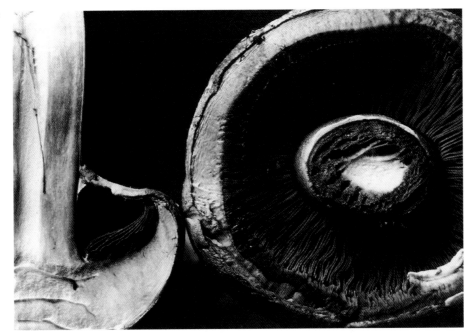

JOHN NEUBAUER Le Champignon, 1979

A fisheye lens shot this global view of a new IBM regional sales office where salespeople, instead of having a permanent desk, use their laptop computer to sign in at any desk that is available. The photograph illustrates a fisheye lens's characteristics: very deep depth of field, extreme differences in size between objects very close to the camera and those in the background, and barrel distortion curving the straight lines at the edges of the image.

MARILYN STERN Plug-in Office

More about . . .
• Macro lenses in close-up photography, page 172

For the widest of wide-angle views, consider the fisheye lens. A fisheye has a very wide angle of view—up to 180°—and exaggerates to an extreme degree differences in size between objects that are close to the camera and those that are farther away. Inherent in its design is barrel distortion, an optical aberration that bends straight lines into curves at the edges of an image. Fisheye lenses also produce great depth of field. Objects within inches of the lens and those in the far distance will be sharp. It is not a lens for every—or even many—situations, but it can produce startling and effective views (see left, bottom).

A macro lens is useful for extremely close shots, such as that of the mushroom, left, top. The lens is built into a lens barrel that can be extended extra far so that the lens can be focused at very close range. It is corrected for the aberrations that occur at close focusing distances. The lens is sometimes called, somewhat inaccurately, a micro lens.

Aberrations are deliberately introduced in a soft-focus lens, also called a portrait lens. The goal is to produce an image that will diffuse and soften details such as facial wrinkles.

A catadioptric or mirror lens is similar in design to a reflecting telescope. It incorporates curved mirrors as well as glass elements within the lens. The result is a very long focal length that is much smaller and lighter than a lens of equivalent focal length that uses only glass elements. The front mirror in the lens has the unusual effect of causing out-of-focus highlights to take on a donut shape rather than the usual disk shape produced by an ordinary lens. A cat lens has a fixed aperture, usually rather small—f/8 or f/11 is typical.

Sharp focus attracts the eye. When you are photographing, it is natural to focus your eyes—and the camera—on the most important area. Sharp focus is a signal to pay attention to a particular part of the image, especially if other parts are not as sharp.

Automatic focus does the focusing for you. In the simplest design, you push down the shutter-release button and the camera adjusts the lens to focus sharply on whatever object is at the center of the frame. This type of automatic focus works well in situations where the main subject is—and stays—at the center of the frame.

Some focusing systems feature more elaborate electronics, such as predicting where the subject is likely to be next or even focusing in the direction that your eye is looking. They can lock on a subject and track the focus if the subject moves closer to or farther from the camera. Some cameras have multiple focusing brackets so that the subject doesn't have to be in the middle of the frame for the lens to focus on it.

Sometimes you will want to focus the camera manually. The most common problem with automatic focus occurs when your subject is at the side of the frame, not at the center (see photos at right). A camera may have problems focusing if a subject has very low contrast, is in very dim light, or consists of a repetitive pattern.

Moving subjects can also cause problems. The camera does not know what you are trying to photograph, so random action, like children running on a playground, can cause the lens to focus on the wrong subject. The adjustment of some autofocus systems may take long enough for a fast-moving subject, such as a race car, to move out of range. The lens may "hunt" back and forth, unable to focus.

Some cameras have more sophisticated electronics and deal with these problems better. Read your camera's instructions so you know how its autofocus mechanism operates and when you would be better off focusing manually.

Subject off center—and out of focus. Automatic-focus cameras often focus on the center of a scene. This can make the main subject (or subjects) out of focus if it is off to one side and at a different distance from whatever is at the center. Here, small brackets at the center of the viewfinder indicate the focused area.

Focusing on the main subject. To correct this in autofocus mode, first focus by placing the autofocus brackets on the main subject; this can be done with many cameras by holding down the shutter button part way. Lock the focus by keeping partial pressure on the shutter release.

Holding the focus to keep the subject sharp. Then reframe your picture while keeping partial pressure on the shutter release. Push the shutter button all the way down to make the exposure. You can get the same results—a sharply focused main subject—by simply focusing the camera manually.

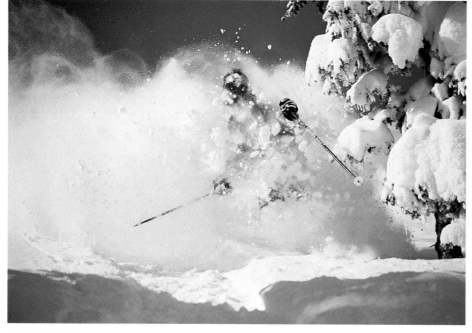

MARC MUENCH Taos Skier

Sports photographers and others who need fast focusing often rely on automatic focus. The best systems can be faster than the eye-hand coordination needed to focus manually on a scene. Automatic focus relieves the photographer of the mechanics of focusing, freeing attention for what's happening. It is useful if eyeglasses get in the way, if the sun is in your eyes, and in similar situations where seeing is not ideal.

With manual focusing, you adjust the lens to select the part of the scene you want to be the sharpest. What is the most important part of the scene to be sharp? What do you want to emphasize? What do you expect viewers to look at first? If you are photographing a person, focus on the eye. If the person is at an angle and you are up close, both eyes may not be sharp in the photograph. Depending on the scene, it may be more important to have the near eye or the far eye sharp.

The nearer you are, the more important it is to focus critically. If you are 2 feet away, focus is critical because depth of field is shallow; only a narrow area from near to far will be sharp. If you are 200 feet away, everything at that distance is likely to be sharp as long as you are focused on something at that distance.

Focus an image like you would tune a guitar. Go a little past the point you think is correct, then come back. If you adjust the focus until the image looks sharp, then adjust it a little more until the subject looks unsharp, then go back to sharp, you'll know exactly when your subject is at its sharpest.

Follow focus lets you keep a subject that is moving toward you well focused. If a runner is coming toward you, you have to adjust the focus at about the same rate that the runner's distance is changing. One way to learn how to follow focus is to sit on a street bench, for instance, and practice focusing on people moving toward and away from you. Then practice on faster things, such as car license plates. You don't need this skill if still lifes are your only subject, but it is vital if you want to photograph football games, auto races, dancers, or anything else that moves fast.

Don't forget that shutter speed plays an important role in making a moving object sharp. If your shutter speed isn't fast enough, a moving object will appear blurred in a photograph, no matter how sharply focused it was.

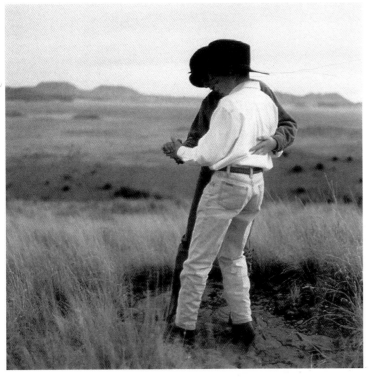

KEITH CARTER The Waltz, 1994

Sometimes the decision of what to focus on is easy. For example, you would probably want the two figures to be sharp. There are always exceptions: imagine the background sharp and the two figures slightly blurred.

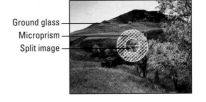

Ground glass —
Microprism —
Split image —

A ground-glass viewing screen is found on single-lens reflex and view cameras. Light from the camera hits a pane of glass that is etched, or ground, to be translucent. This ground glass creates a surface on which a viewer, looking at it from the other side can see an image and focus it.

Reflex cameras may also include a microprism, a circle that appears coarsely dotted until it is focused, and sometimes a split-image focusing aid that appears offset until the image is focused.

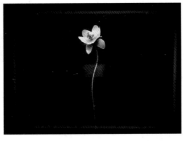

Split-image focusing is used on rangefinder cameras. It operates by superimposing two images of the same subject. One image passes through a viewfinder and one is reflected by a rotating prism connected to the lens. The two images appear exactly superimposed only when the lens focuses sharply on the subject.

Focus and Depth of Field

What exactly is sharpness, and how much can it be controlled? In theory, a lens can only focus on one single distance at a time (the plane of critical focus) and objects at all other distances will be less sharp. But, in most cases, part of the scene will be acceptably sharp both in front of and behind the most sharply focused plane. Objects will gradually become more and more out of focus the farther they are from the most sharply focused area.

Depth of field is the part of a scene that appears acceptably sharp in a photograph. Depth of field can be shallow, with only a narrow band across the scene appearing to be sharp, or it can be deep, with everything sharp from near to far. To a large extent, you can control just how much of it will be sharp. There are no definite endings to the depth of field; objects gradually change from sharp to soft the farther they are from the focused distance.

Images are composed of circles of confusion. Think of a subject as being composed of a number of infinitely small points located at various distances from the lens. No lens is optically perfect, so even when a lens focuses a single subject point as sharply as it can, the point actually appears in the image as a very small disk called a circle of confusion. When the circles are small enough, the eye sees them as points, and that part of the image will appear to be sharp; it will be within the depth of field.

The larger the circles of confusion, the more likely an object will be out of focus. Since a lens can critically focus on only one distance at a time, another point located in front of or behind the critically focused one appears as a slightly larger circle of confusion. The farther that any point is from the sharply focused distance, the larger its circle of confusion. As the circles increase in size, eventually that part of the image will appear to be out of focus. The larger the circles, the more out of focus that part of the image will be.

In general, the more a print is enlarged, the less sharp it appears because the enlargement has increased the size of each circle of confusion. But sharpness is also affected by viewing distance: a mural-size print placed high on a wall and viewed at a distance of 20 feet may appear sharp; the same print viewed up close may not.

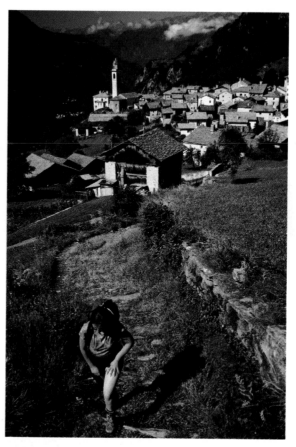

MARILYN STERN Hiker, Soglio, Switzerland

Depth of field—the area in a scene in which objects appear sharp—can be deep or shallow. In the photograph above, everything is sharp from the hiker to the town in the distance.

In the photograph opposite, the depth of field includes only a few of the figures, while others are increasingly out of focus the farther they are from the plane of critical focus.

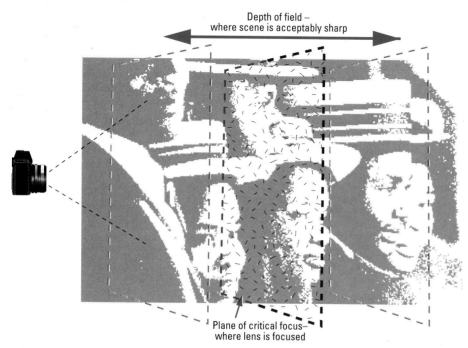

Depth of field –
where scene is acceptably sharp

Plane of critical focus—
where lens is focused

◄ *The lens focuses on the plane of critical focus.* Imagine the distance on which your lens is focused to be like a pane of glass parallel to the camera stretching across the scene in front of you. Everything at this distance (the plane of critical focus) will be sharp in the photograph. In front and in back of the plane lies the depth of field, the area that appears acceptably sharp.

The farther that objects are from the plane of critical focus, either toward the camera or away from it, the less sharp they will be. Eventually, when objects are far enough from the plane of critical focus, they will be outside the depth of field and will appear noticeably out of focus. Usually the depth of field extends about one-third in front of the plane of critical focus, two-thirds behind it. This is true at normal focusing distances, but, when focusing very close to a subject, the depth of field is more evenly divided, about half in front and half behind the plane of critical focus.

More about . . .

• Controlling depth of field, pages 52–55

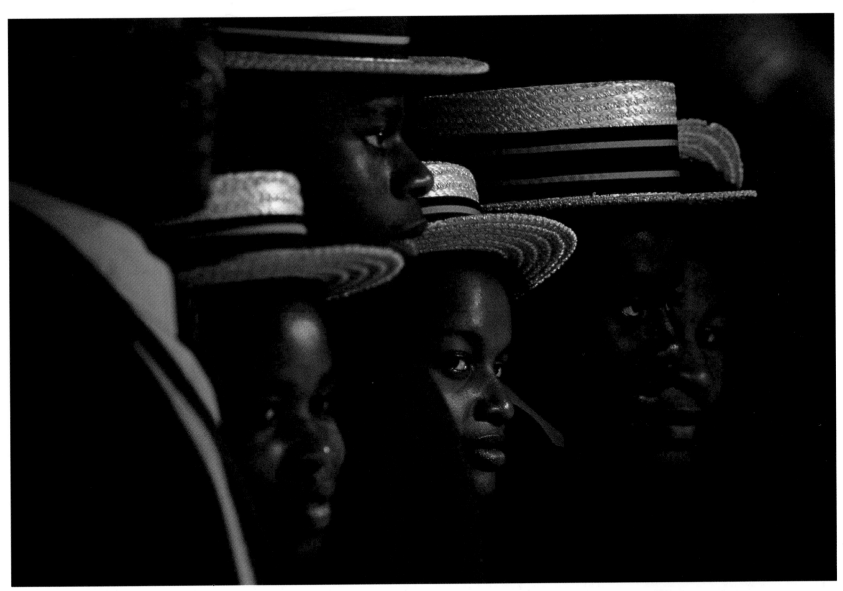

ELI REED Students in a Malawi School, South Africa

Evaluating and controlling the depth of field is more important in some situations than in others. If you are relatively far from the subject, the depth of field (the distance between the nearest and farthest points in a scene that appear sharp in a photograph) will be greater than if you are up close. If you are using a short-focal-length lens, you'll have more depth of field than with a long lens. If the important parts of the scene are more or less on the same plane left to right, they are all likely to be sharp as long as you have focused on one of them. But, photograph a scene up close, with a long lens, or with important parts of the subject both near and far, and you may want to increase the depth of field. Sometimes you will want to decrease the depth of field, such as to eliminate a distracting background that draws attention away from the main subject.

There are several ways to control the depth of field. If you want to increase the depth of field so that more of a scene is sharp, setting the lens to a small aperture is almost always the first choice. This is the case even though you have to use a correspondingly slower shutter speed to maintain the same exposure, which can be a problem if you are photographing moving objects. You can also increase the depth of field by changing to a shorter focal length lens or stepping back from the subject, but that will change the picture in other ways as well (opposite). To decrease the depth of field and make less of the scene sharp, use a wider aperture or a longer lens, or move closer to the subject.

Why does a lens of longer focal length produce less depth of field than a shorter lens used at the same f-stop? The answer relates to the diameter of the aperture opening. The relative aperture (the same f-stop setting for lenses of different focal lengths) is a larger actual opening on a longer lens than it is on a shorter lens. For example, f/8 on a 50mm lens is an aperture of larger diameter than f/8 on a 28mm lens. The diagram below shows why this is so. Since at the same f-stop setting, the aperture diameter of the longer lens is larger than that of the shorter lens, the circles of confusion for the longer lens will also be larger and the image will have less depth of field.

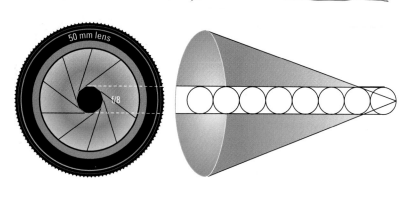

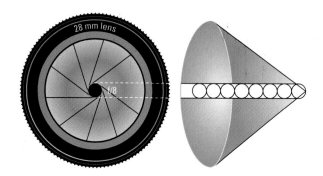

Any f-stop—for example, f/8—requires a larger aperture diameter for a longer-focal-length lens than for a shorter lens in order to let the same amount of light reach the film. The two lenses, left, are both set at f/8, but the actual opening in the 50mm lens (top) is larger than the opening in the shorter 28mm lens (bottom). As focal length increases, the amount of light that reaches the film decreases. Therefore, a long lens will form a dimmer image than a short lens unless more light is admitted by the lens.

The sizes of the aperture openings are determined so that at a given f-stop the same amount of light reaches the film no matter what the focal length of the lens. The f-stop number, also called the relative aperture, equals the focal length of the lens divided by the aperture diameter:

$$f\text{-stop} = \frac{\text{lens focal length}}{\text{aperture diameter}}$$

If the focal length of the lens is 50mm, at f/8 the actual diameter of the aperture will be 6.25mm:

$$f/8 = \frac{50}{6.25}$$

For a 28mm lens, at f/8 the actual diameter of the aperture will be only 3.5mm:

$$f/8 = \frac{28}{3.5}$$

The diagrams, by actually lining up eight aperture-sized circles and fitting them into the focal length of each lens, show the larger aperture diameter for the longer focal length.

More about . . .

- How to evaluate depth of field, pages 22–23
- Ways to control depth of field, pages 54–55

Less depth of field

More depth of field

The smaller the aperture, the greater the depth of field. *Here the photographer focused on the mooring buoy. Near right: with a wide aperture, f/2, the depth of field was relatively shallow; only objects that were about the same distance from the lens as the mooring buoy are sharp; other objects that were nearer or farther are out of focus.*

Far right: using the same focal length and staying at the same distance, only the aperture was changed— to a much smaller one, f/16. Much more of the scene is now sharp. Changing the aperture is usually the easiest way to change the depth of field.

Wider aperture f/2

Smaller aperture f/16

The shorter the focal length of the lens, the greater the depth of field. *Near right: with a 200mm lens, only two gravestones are sharp.*

Far right: with a 35mm lens at the same distance, set to the same aperture, and focused on the same point as the previous shot, a bigger section of the cemetery is now sharp. Notice that changing the focal length changes the angle of view (the amount of the scene shown) and the magnification of objects in the scene. The kind of picture has changed as well as the sharpness of it.

Longer focal length 200 mm

Shorter focal length 35 mm

The greater the distance from the subject, the greater the depth of field. *Near right: with the lens focused on the horse about 5 ft away, only a narrow band from near to far in the scene is sharp.*

Far right: using the same focal length and aperture, but stepping back to 15 ft from the horse and refocusing on it made much more of the scene sharp. Stepping back has an effect similar to changing to a shorter focal length lens: more of the scene is shown.

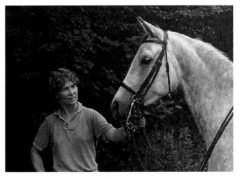

Closer to subject 5 feet

Farther from subject 15 feet

Zone Focusing and Focusing on the Hyperfocal Distance

Two more techniques let you control the depth of field, the extent of a scene near to far that will be sharp. For these you need a lens with a depth-of-field scale. A fixed-focal-length lens is more likely to have one; a zoom lens may not. You also need a camera that can be focused manually, not one that only works automatically.

Zone focusing lets you set the depth of field in advance of shooting. It is useful when you want to be able to shoot rapidly without refocusing, and can be used as long as you can predict approximately where, if not exactly when, action will take place. It is also useful if you want to be relatively inconspicuous and don't want to spend time with your camera to your eye focusing (for example, when photographing strangers on the street).

To zone focus, use the depth-of-field scale on your lens to find the f-stop and distance setting you will need in order to get adequate depth of field (see lens, below). Everything photographed within the near and far limits of that depth of field will be acceptably sharp; the precise distance at which something happens is not important because the whole area will be sharp.

Focusing on the hyperfocal distance will give you maximum depth of field, with objects as sharp as possible from the foreground to the far distance. When a scene extends into the distance, you may find that you tend to focus on a part of the scene that is quite far away. In photographic terms, you have focused on infinity, which, depending on the lens, extends from about 40 feet or so to as far as the eye can see. (Infinity is marked ∞ on the lens distance scale.)

But for maximum depth of field in a scene that extends to a far distance, don't focus on infinity. Instead turn the focusing ring so that the infinity mark falls just within the depth of field for the f-stop you are using (see opposite page). You are now focused on a distance that is closer to the lens than infinity (the hyperfocal distance). Everything from the infinity distance and farther will still be sharp, but more of the foreground will be in focus.

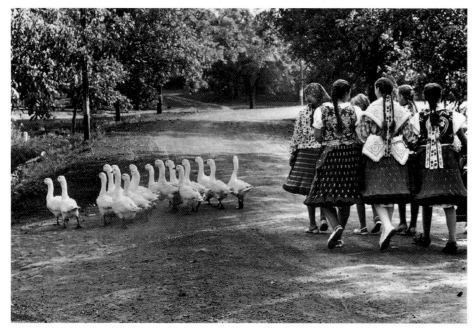

ELLIOTT ERWITT Sunday in Hungary, 1964

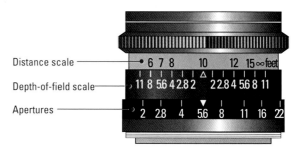

Distance scale

Depth-of-field scale

Apertures

Zone focusing uses a lens's depth-of-field scale so you can be ready to shoot without focusing before every shot. Suppose the nearest point you want sharp is 7 ft away and the farthest is 13 ft away. Turn the focusing ring until those distances on the distance scale fall opposite a matched pair of f-stops on the depth-of-field scale. If you set your lens aperture to that f-stop, objects between the two distances will be in focus. Here, the two distances fall opposite a pair of f/5.6's. With this lens set to f/5.6 or a smaller aperture (f/8 or f/11), everything between 7 ft and 13 ft will be sharp. No further focusing need be done as long as the action stays between these distances.

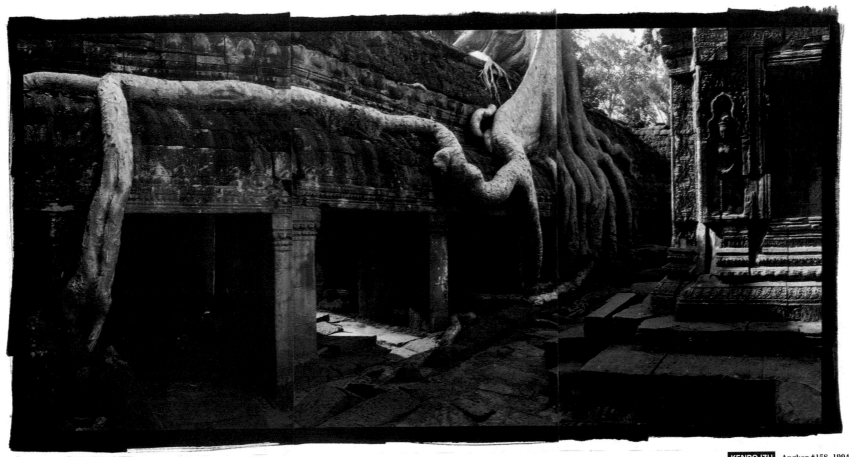

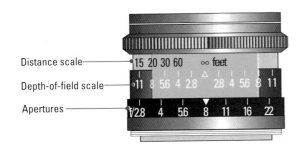

Distance scale

Depth-of-field scale

Apertures

For maximum depth of field in a scene that extends to the far distance (infinity in photographic terms, marked ∞ on the lens distance scale) don't focus on the infinity mark, as has been done with the lens at left. With this lens, if the aperture is f/8 and the lens is focused on infinity, everything from 20 ft to infinity will be sharp.

Instead, set the distance scale so that the infinity mark lines up opposite your f-stop on the depth-of-field scale (lens, right). Now, with the lens still set to f/8, everything from 10 ft to infinity will be sharp.

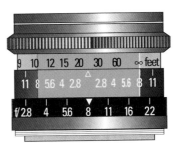

Perspective

The camera image can seem surprisingly different from reality, so it is vital to see things the way the camera sees them. A long lens used far from the subject gives a so-called telephoto effect—on page 51, for example, the line of people seems compressed, in impossibly close formation. A short lens used close to the subject produces what is known as wide-angle distortion—on page 44, it apparently stretches a human form to unnatural proportions. See also the photographs on pages 58–59. Those photographs seem to show distortions in perspective—in the relative size and depth of objects within an image.

Perspective is controlled by the lens-to-subject distance, not by the focal length of the lens. The closer a camera moves to a subject, the larger that objects in the foreground will appear, while those in the background will change relatively little in size. The brain judges depth in a photographed scene mostly by comparing the size of objects, so the depth seems to increase if foreground objects appear larger than background ones.

The pictures in the top row were taken from the same distance with lenses of different focal lengths. The shortest lens produced the widest view of the scene; the longest lens gave the narrowest view, simply an enlargement of the scene.

The pictures in the bottom row were taken with the same lens but from different distances. The closer the lens came, the bigger the foreground objects (the eggs and nest) appear relative to the background one (the cage).

In one sense, the focal length of a lens does affect the perspective. A short lens can focus closer to an object than a long lens. Consequently, a short lens can produce wide-angle distortion because it is easy to focus it up close. A long lens can produce a telephoto effect because you are more likely to shoot from relatively far away. But the lens isn't creating the effect, the distance from the subject is doing so.

Focal length changes, camera position stays the same

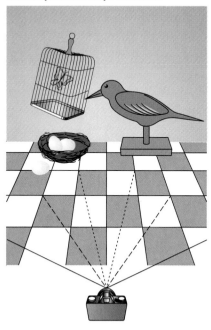

Focal length stays the same, camera position changes

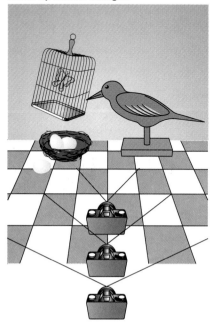

Short-focal-length lens, far from subject

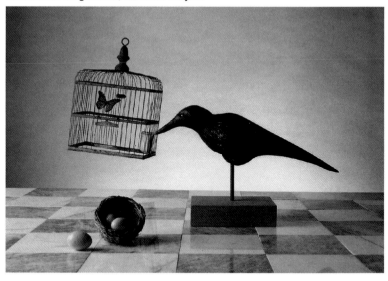

Lenses of different focal lengths change the size of all the objects in a scene. They don't change the size of one object compared to another. The first picture was taken with a short-, the next with a medium-, and the third with a long-focal-length lens. All were taken from the same camera position. Eggs, bird, and cage all increased in size the same amount.

Short-focal-length lens, far from subject

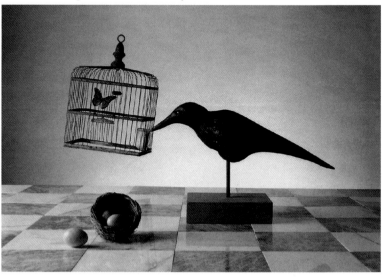

Changes in a lens's distance from a scene change the relative size of near and far objects. As the lens came closer to the scene, foreground objects enlarged more than background ones to give three different perspectives. The nest is smaller than the cage in the first picture, bigger than the cage in the last picture.

Medium-focal-length lens, far from subject

Long-focal-length lens, far from subject

Short-focal-length lens, medium distance from the subject

Short-focal-length lens, close to subject.

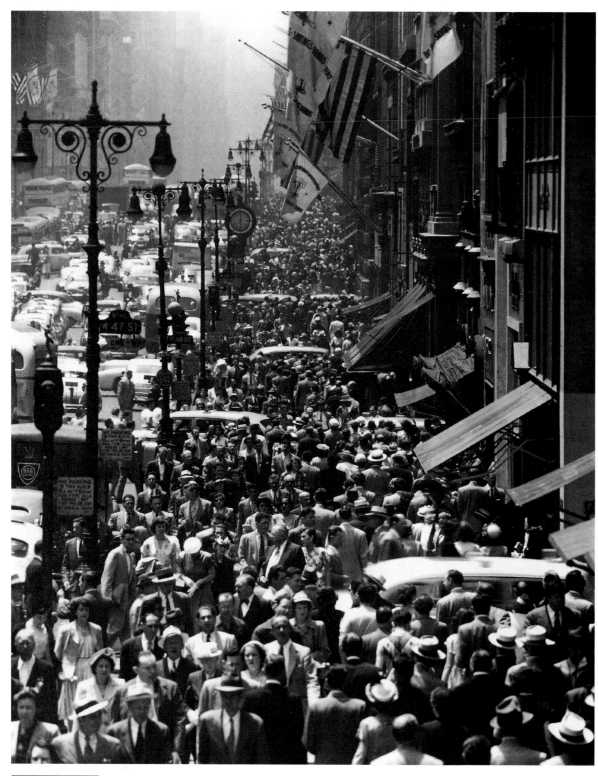

ANDREAS FEININGER | Midtown Fifth Avenue at Lunch Hour, New York, 1950

Exaggerating the perspective, the impression of depth in a photograph, is one way to add impact to an image or to communicate an idea visually.

A long-focal-length lens used far from a subject produces what is known as telephoto effect. It seems to compress the objects in a scene into a crowded mass. Andreas Feininger made many photographs of New York that conveyed its beehive crowding and intense activity. The super-long lens he used for these pictures was so long that he had to add a two-legged extension to his tripod to support the lens.

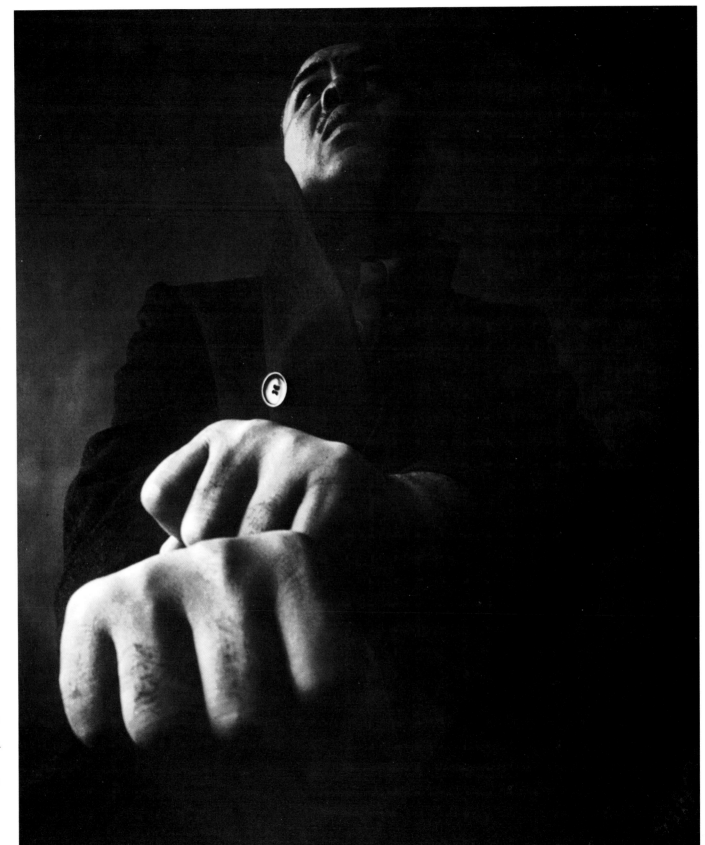

A short-focal-length lens used up close increases the apparent size of the part of the subject that is closest to the camera, producing what is called wide-angle distortion. Like telephoto effect (shown opposite), this is caused by the distance of the lens to the subject, not by the lens itself. Right, the fists that brought the world heavyweight championship to Joe Louis are emphasized in this brooding portrait taken after the fighter had lost his title and fallen on hard times.

ART KANE Joe Louis, 1964

Choosing Lenses

The "speed" of a lens affects its price. Lenses made by reputable manufacturers can be assumed to be reasonably good. And yet two lenses of the same focal length, perhaps even made by the same company, may vary widely in price. This price difference probably reflects a difference in the speed of the lens. One will be faster—it will have a wider maximum aperture and admit more light than the other. The faster and more expensive lens can be used over a wider range of lighting conditions than the slower one but otherwise may perform no better. It may, in fact, perform less well at its widest aperture because of increased optical aberrations.

Following are some guidelines for buying camera lenses.

1. *Start with a normal lens or a zoom lens with a moderate-focal-length range if you are getting a camera with interchangeable lenses.* (This is the one that ordinarily comes with the camera anyway.) Don't buy more lenses until you feel a strong need to take the different kinds of pictures that other focal lengths can provide.

2. *Get your lenses one at a time and think ahead to the assortment you may someday need.* Begin by buying lenses in increments of more or less two times the focal length; for example, a good combination for a 35mm camera is a 50mm normal lens for general use, a 28mm wide-angle lens for close-in work, and a 105mm long lens for portraits and for magnifying more

distant subjects. Be wary of ultra-wide-angle (24mm or below) and extra-long (above 200mm) lenses. They may be considerably more expensive than the less extreme types and are so specialized that their usefulness is limited.

3. *Don't spend money on extra-fast lenses unless you have unusual requirements.* A couple of extra f-stops may cost you an extra couple of hundred dollars. With modern high-speed film, a lens that can open to f/2.8 is adequate in all but the dimmest light.

4. *Consider a secondhand lens.* Many reputable dealers take used lenses in trade, and they may be bargains. But look for signs of hard use, such as a dented barrel, scratched lens surface, or a slight rattling that may indicate loose parts, and be sure to check the diaphragm to see that it opens smoothly to each f-stop over the entire range of settings.

5. *Test your lens.* The only sure way is to take pictures with it in your own camera at various f-stops, so insist on a trial period or a return guarantee. If you plan to buy several lenses eventually, a good investment is a standardized test chart that can give an accurate reading of a lens's sharpness.

6. *A lens shade is a very desirable accessory to attach to the front of the lens to prevent flare.* Buy one that is matched to the focal length of the lens; too wide a shade is inefficient, too narrow a shade will vignette or cut into the image area.

Focusing ring rotates to bring different parts of the scene into focus.

Dept of-field scale shows how much of the scene will be sharp at a given aperture.

Aperture-control ring selects the f-stop or size of the lens opening.

Distance marker indicates on the **distance scale** the distance on which the lens is focused.

On the lens barrel (as shown above) are controls such as a ring that focuses the lens. Cameras and lenses vary in design, so check the features of your own camera. For example, some cameras have push-button controls on the camera body instead of an aperture control ring on the lens. Engraved around the front of the lens (shown below) are its focal length and other information.

Focal length. The shorter the focal length, the wider the view of a scene. The longer the focal length, the narrower the view and the more the subject is magnified

Manufacturer

Maximum aperture. The lens's widest opening or speed. Appears as a ratio here 1:2. The maximum aperture is the last part of the ratio, f/2.

Filter size. The diameter in mm of the lens, and so the size of filter needed when one is added onto the lens.

Typical focal lengths for cameras using various sizes of film					
Film size	**35mm**	**2 1/4 x 2 1/4 inch**	**2 1/4 x 2 1/4 inch**	**4 x 5 inch**	
Short focal length	35mm or shorter	55mm or shorter	75mm or shorter	90mm or shorter	*Focal lengths are sometimes stated in inches, sometimes in millimeters. There are approximately 25mm to an inch.*
Normal focal length	50mm	75mm, 80mm	100mm	150mm (6 inch)	
Long focal length	85mm or longer	120mm or longer	150mm or longer	250mm (10 inch) or longer	

Protecting and cleaning your camera and lens

Protect from dust and dirt. The best way to keep equipment clean is not to get it dirty in the first place. Cases and bags protect cameras and lenses from bangs and scratches as well as keep them clean. A UV or skylight filter on the lens can help protect it in extreme conditions of blowing water, sea spray, or sand. Keep a cap on the lens when it is not in use, and if you take a lens off a camera, protect both front and back lens surfaces either by placing the lens in a separate lens container or by capping both ends. Sand is a particular menace; clean the camera well after using it on the beach.

Protect from moisture. Most modern cameras are packed with electronic components that can corrode and malfunction if exposed to excessive humidity or moisture, especially salt water. On a boat or at the beach, keep equipment inside a case when it is not in use. If you use it where salt spray will get on it, wrap it in a plastic bag so just the lens pokes out.

Protect from temperature extremes. Excessive heat is the worst enemy. It can cause parts to warp, lubricating oil inside the camera to get where it shouldn't be, and film to deteriorate. Avoid storage in places where heat builds up: in the sun, inside an auto trunk or glove compartment on a hot summer day, or near a radiator in winter.

Excessive cold is less likely to cause damage but can make batteries sluggish. If you photograph outdoors on a very cold day, keep your camera warm inside your coat until you are ready to use it. Moisture can condense on a camera, just as it does on eyeglasses, if metal or glass that has gotten cold outdoors meets warm, humid air when it comes indoors. Keep a cold camera wrapped up until it comes to room temperature.

Protect during storage. If you won't be using the camera for a while, release the shutter, make sure the meter is off, and store in a clean, dry place. If humidity is high, ventilation should be good to prevent a buildup of moisture on electronic components. Cock and release the shutter once in a while; it can become balky if not used for long periods of time. For long-term storage, remove batteries to prevent possible damage from corrosion.

Check the battery strength regularly (see manufacturer's instructions). Batteries provide the power for a camera's metering system, readout data, automatic functions, and sometimes the shutter.

Use professional care for all but basic maintenance. Never lubricate any part of the camera yourself or disassemble anything for which the manufacturer's manual does not give instructions. Cameras are easier to take apart than they are to reassemble.

Cleaning inside the camera. If you are cleaning the lens or changing film, also check inside the camera for dust that can settle on the film and cause specks on the final image. Blow or gently dust along the film path, particularly along the winding mechanisms, tilting the camera so the dust falls out and isn't pushed farther into the camera. With a single-lens reflex, be careful not to damage the shutter curtain in the body of the camera or the film pressure plate on its back. The shutter curtain is particularly delicate; don't touch it at all unless absolutely necessary.

Cleaning the lens. First, blow or brush any visible dust off the lens surface (left). Holding the lens upside down helps the dust fall off the surface instead of just circulating on it. Be especially careful with granular dirt, like sand, which can scratch the lens surface badly. To clean grease or water spots from the lens, wad a clean piece of camera lens tissue into a loose ball and moisten it with a drop or two of lens cleaner solution. Don't put drops of solution directly on the lens; they can seep along the edges of the lens to the inside. Wipe the lens gently with a circular motion (right). Finish with a gentle, circular wipe using a dry lens tissue. Don't use any products designed for cleaning eyeglasses.

Cameras and lenses are rugged, considering what precision instruments they are. Common-sense care and a little simple maintenance will help keep them running smoothly and performing well.

Stopping down the lens aperture often improves the image by eliminating rays from the edges of the lens where certain aberrations occur. Even a well-designed lens may have some aberrations that were impossible to overcome in manufacture. This is especially so if it is a zoom, extremely wide-angle, or telephoto lens, or if it has a very wide maximum aperture or is used very close to the subject.

There is a limit to the improvement that comes with stopping down. As light rays pass across a sharp, opaque edge, like the edge of the diaphragm opening, the rays bend slightly. As the lens is stopped down and the aperture becomes smaller, this edge bending or diffraction can cause a point of light to appear as a blurred circle and the whole image to appear very slightly less sharp. The optimum aperture at which most lenses perform best is two or three f-stops stopped down from the widest aperture. This is enough to minimize aberrations but not enough to cause noticeable diffraction. Of course, in a particular situation you may prefer the increased depth of field that results if the lens is stopped down all the way.

A clean lens performs better than a dirty one. Dust, grease, and drops of moisture all scatter the light that passes through a lens and soften the sharpness and contrast of the image. However, although a lens should be kept clean, too frequent or too energetic cleaning can produce a maze of fine scratches or rub away part of the lens coating. Manufacturers coat lens surfaces with a very thin layer of a metallic fluoride that helps reduce reflections and subsequent flare. The coatings are extremely thin—as little as 0.0001 mm—and relatively delicate. Treat them with care when cleaning the lens.

More about . . .

• Preventing or solving camera and lens problems, pages 370–373

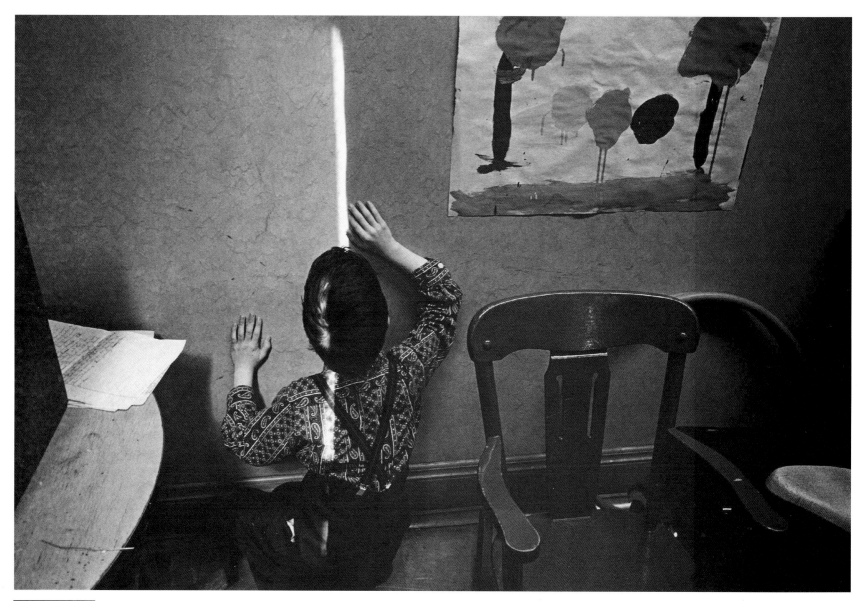

CHARLES HARBUTT Blind Boy, New York City, c. 1960

The spectrum contains heat as well as light, *and you can feel the sun even if you can't see it. Charles Harbutt's photograph is an interesting picture even without the title. But the words add a poignant meaning that greatly strengthens the photograph; without the words there is no clue that the child can't see.*

This picture is one of a series Harbutt made of children at The Lighthouse in New York City, an organization that aids the blind. Harbutt had noticed that every day the boy used his hands to feel for the warmth created by the rays of sunlight that threaded the narrow space between two buildings each afternoon at about the same time.

400 nanometers

Gamma rays

X-rays

Ultraviolet

Visible spectrum

Infrared

Heat

Radar

Television
and radio waves

Violet

Blue

500 nanometers

Green

Yellow

600 nanometers

Red

700 nanometers

Wave length

*C*amera stores offer a wide variety of film. Which one should you buy? This chapter tells how to select the right film for your use, and especially covers the important characteristic of film speed.

*D*ifferent films respond to visible light—and to other parts of the electromagnetic spectrum—in different ways. Infrared film, for example, is sensitive to wavelengths that the eye cannot see, and so can produce slightly unrealistic and very beautiful images.

*F*ilters (which attach to the front of a lens) change the nature of the light that reaches the film. For example, with black-and-white film a filter can darken the blue part of a sky and make white clouds stand out more clearly.

Film is sensitive to light. Silver compounds in film undergo a physical change when exposed to light. But what is light? The light that we see and that can form an image on film is only a small part of the vast range of energy called the electromagnetic spectrum (diagram, left), which also includes, for example, X-rays, heat, and radio waves. This energy can be described as waves that spread from a source in the same way that ripples spread when a stone is dropped in a pond of water. The different forms of energy differ only in their wavelength, the distance from the crest of one wave to the crest of the next.

The human eye is sensitive to a very small group of waves near the middle of the spectrum. When waves in this visible part of the spectrum strike the eye, the brain senses light. Most films are manufactured to respond to about the same wavelengths that the eye sees. However, film can respond to additional wavelengths that the eye cannot see, such as ultraviolet and infrared light.

Light is part of the electromagnetic spectrum, *a continuum of wavelike energy from gamma waves through visible light to radio waves. The waves can be measured; the wavelength or distance from crest to crest ranges from 0.000000001 millimeter for some gamma rays to six kilometers for some radio waves. The human eye—and most films—will respond to wavelengths from about 400 nanometers (billionths of a meter) to 700 nanometers.*

Camera stores offer a wide variety of films. Which one you select depends on only a few basic choices.

Do you want black-and-white or color? Most of the information below applies to both black-and-white and color.

Color balance is one basic choice concerning only color film. Daylight-balanced color films produce the most natural colors in the relatively bluish light of daylight or electronic flash. Tungsten-balanced color films give the best results in the relatively reddish light from incandescent light bulbs.

Do you want a print? Negative films produce an image on the film in which the tones (or colors) are the reverse of those in the original scene: light areas in the scene are dark in the negative, dark areas are light. Later the image is printed, usually onto paper, to make a positive image, with tones the same as in the original scene.

Do you want a transparency? Reversal films produce a transparency, a positive color image on film, or a slide, a 35mm transparency mounted in a small frame of cardboard or plastic so that it can be inserted into a projector or viewer. Most reversal films are color, but a few black-and-white films can be given reversal processing, such as Kodak T-Max 100 processed in a T-Max 100 Direct Positive Film Developing Outfit.

What film speed do you want? The faster the film speed, the less light you need for a correct exposure, but the grainier your pictures will be.

What film size should you buy? The size of film to buy and the film format, the dimensions of the image produced on the film, depend on the camera you use.

35mm films are packaged in cassettes of 12, 24, or 36 1 x 1 1/2-inch exposures per roll. 35mm film is listed as 135 film in product lists and on the film box because 135 was the original Kodak product number for this film size. Other manufacturers later adopted the designation.

Some 35mm films can be purchased in 50- or 100-foot rolls, then bulk loaded into separately purchased cassettes. This reduces the cost per exposure and, if you use a great deal of film, can be worthwhile.

Roll films are wound around a spool and are backed with a separate strip of opaque paper to protect the film from light. (The term "roll" is also used in a general sense to refer to any film that is rolled, rather than being a flat sheet.) Depending on the camera, 120 roll film makes 12 2 1/4 x 2 1/4-inch exposures or 8, 10, or 16 rectangular ones. Some cameras accept 220 roll film, which has paper only on the end; this reduces the thickness of the roll so that more film can be wound on the roll.

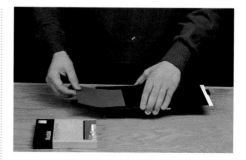

Sheet films or cut films for view cameras are made in 4 x 5-inch and larger sizes. They are packed 10 or more sheets to a box and must be loaded in film holders before use.

Miniature-format films, like disc film or 110 film, are made primarily for amateur cameras such as the Kodak Instamatic.

More about . . .

• Color films, page 194
• Film speed, pages 66–71

Storing and handling film

Store film away from heat. Heat affects any film badly, so don't leave it where temperatures may be high, such as in the glove compartment of a car on a hot day or near a heater in winter.

For longer storage, refrigerate film. Refrigeration extends the life of film. Room temperature is fine for short-term storage, but for longer storage, especially in warm weather, a refrigerator or freezer is better for most films. (Don't freeze Polaroid instant-picture film.) Make sure that the dealer has refrigerated film if that is recommended by the manufacturer, as it is for infrared film and professional color film.

Protect film from moisture. The original film packaging should be moisture proof, but if you refrigerate the film after opening the packaging, put the film in a moisture-proof container such as a tightly closed plastic bag. Let refrigerated film warm to room temperature before using it, so moisture does not condense on the film surface. One roll of film or a 10-sheet box of sheet film needs about an hour to warm up; a 100-ft roll of bulk-load 35mm film or a 100-sheet box of sheet film needs about 4 hours.

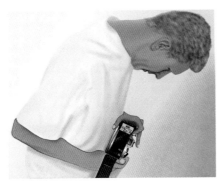

Load and unload your camera out of strong light. If you are outdoors, at least block direct sun by shading the camera with your body. Put exposed film where strong light won't reach it. Light can ruin your pictures by fogging them with unwanted exposure if the light leaks around the edges of the film spool or into the opening out of which the film feeds.

Check the film's expiration date before buying. There is a steady decline in film quality after the expiration date, especially if stored at room temperature. Camera stores will discount film that is about to expire, which can make it a bargain. Freeze film if it is close to its expiration date. The date is listed on the side of the film package.

Consider protecting your film from airport security X-ray machines. These devices are supposed to be safe for film, but can fog undeveloped film if the machine is not adjusted correctly. This is more likely to be a problem with very high-speed film (more than ISO 1000) than with slower-speed films, especially if your travel takes you to several airports and exposes the same film to X-rays several times. You can ask to have film (and camera, if it is loaded) inspected by hand rather than passing it through a machine. Most airports in the United States, but not all foreign airports, will do this. Camera stores sell lead-foil bags for film, which can offer additional protection.

More about . . .
- Infrared film, pages 80–81
- Instant black-and-white films, pages 72–73
- Instant color film, page 195

Do you want a film for a special purpose?

Instant films let you produce a picture without going into the darkroom. The film packaging itself contains the chemicals that process each picture.

High-contrast films produce only two tones, the clear film base and black, without intermediate tones of gray.

Infrared films respond to infrared wavelengths that the human eye cannot see.

Chromogenic black-and-white films, such as Ilford XP2, produce a dye image rather than a silver one. They have great exposure latitude, which means you can expose individual frames at different film speeds. Frames exposed at about ISO 100 will have finer grain, but frames on the same roll of film can be exposed at speeds as high as ISO 800 and still produce printable negatives. This is unlike conventional films, which should be exposed at a single film speed. Unfortunately, the film must be developed as if it were a color negative (in Kodak's C-41 chemistry or Ilford's version of the same process), which is more complicated and more expensive than conventional black-and-white film development.

Professional films sometimes have characteristics that meet the needs of professional photographers, although you don't have to be a professional to use them. Sometimes the word "professional" in a film name is merely a marketing strategy. Professional black-and-white films differ from general-purpose black-and-white films in relatively minor ways. Tri-X Pan Professional Film, for example, has a film base that can be retouched. The differences between professional and nonprofessional color films are more important.

Advanced Photo System films facilitate commercial photofinishing services. The film has a magnetic layer that, when used in suitable cameras, records the format you want the print to be, the date, frame number, and other data.

The faster the film speed, the less light required to produce an image. Therefore, faster film can be used in dimmer light or with faster shutter speeds or smaller apertures. A fast film is useful, for example, indoors, especially if you use only the existing light in the room and do not supplement it with electronic flash or photofloods. A slower film is good for brightly lit scenes, such as outdoors in bright sun. The faster the film, the higher its film speed number (see box, right).

What film speed should you use? Faster films tend to produce grainier pictures (as shown, opposite), so theoretically you will get the best results by selecting the slowest film usable in each situation. In practice, however, it is inconvenient and unnecessary to work with several film speeds. Some photographers use a relatively fast, ISO 400 film for almost all their work. One type of film may not be enough, but two—a fast one and a slower, finer-grain one—are enough for most situations.

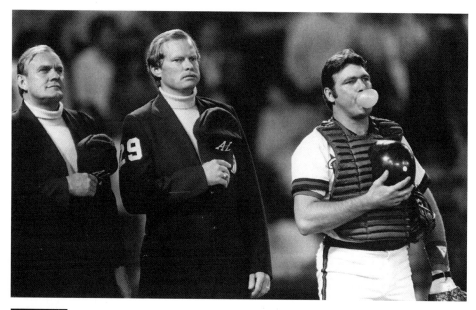

Bonnie Kamin National Anthem

When is a fast film useful? *Here, for example, when the photographer was using a long lens and hand holding the camera (which made a fast shutter speed desirable), and waiting for just such a fleeting insight into the heart of baseball.*

Film speed rating systems

A film speed number tells how sensitive that film is to light. There are several rating systems for film speed. The most common in English-speaking countries are **ISO** (International Organization for Standardization) and **EI** (exposure index). **ASA** (American Standards Association) is an older rating system that is still sometimes mentioned. All use the same numerical progression: the film speed rating doubles each time the light sensitivity of the film doubles.

The higher the number in a given system, the faster the film, and the less light needed for a correct exposure. An ISO—or EI or ASA—200 film is twice as fast as an ISO 100 film (one stop faster), half as fast as an ISO 400 film (one stop slower). For a correct exposure, the ISO 200 film needs half as much light as (one stop less than) the ISO 100 film, twice as much light as (one stop more than) the ISO 400 film.

Film speed	Light needed
ISO 100	✧ ✧ ✧ ✧
ISO 200	✧ ✧
ISO 400	✧

Sometimes the ISO rating includes the European **DIN** (Deutsche Industrie Norm) rating; for example, ISO 200/24°. The DIN rating adds 3 each time the film speed doubles. DIN 24 (equivalent to ISO 200) is twice as fast as DIN 21, half as fast as DIN 27. Except for the unlikely case of using a piece of equipment marked only with DIN numbers, you can ignore the DIN part of an ISO rating.

Some typical film speeds and their uses are:

Slow: ISO 50 or less	Brightly lit subjects. Finest grain.
Medium-speed: About ISO 100	General outdoor use. Medium-fine grain.
Fast: About ISO 400	Indoor or dimly lit scenes, bright scenes with fast moving subjects. Medium grain.
Extra fast: More than ISO 400	Very dark scenes, especially with moving subjects. Coarsest grain.

More about . . .

• Fast films, pages 68–69
• Medium-speed and slow films, pages 70–71

ISO 25 film speed

ISO 400 film speed

ISO 400 film speed
T-grain film

ISO 1600 film speed

Film speed and grain. In general, the slower the film (the lower its ISO number), the finer the grain structure of the film and the smoother and more detailed the image that the film records. The exception is T-grain films, which have reduced graininess for their speed. Compare these enlargements of a segment from the scene at right.

The faster the film, the more visible its grain. The light-sensitive part of film consists of many tiny particles of silver halide spread throughout the film's emulsion. A fast film is fast because it has larger crystals than a slower film. When the fast film is developed, its larger crystals yield larger bits of silver. The advantage is that the film needs less light to form an image. The potential disadvantage is that these larger crystals in very fast films reproduce what should be uniform gray areas not as smooth tones but with distinctly visible specks or grain.

The relationship between speed and graininess can be seen in the enlarged segments of photographs shown at left, which were made with films of different speeds. In general, each increase in speed also increased graininess. If maximum sharpness and minimum graininess are your desire, select slower rather than faster films. Extreme grain is not always to be avoided; it can be used for special effect.

Some newer films have reduced graininess. Recent advances in technology have changed what used to be a fairly direct relationship between film speed and grain. The silver halide crystals in T-grain or core-shell emulsions, such as in Kodak's T-Max or Ilford Delta films, have a flattened surface that exposes more of each crystal to light. The result is film with significantly reduced grain for its speed.

Standard films continue to be popular, however. For example, although Kodak Tri-X (ISO 400) doesn't have as fine grain as Kodak T-Max 400 (same film speed), Tri-X continues to be used because it maintains detail in bright highlights better than T-Max 400 does. Also, processing is easier with standard films. Even a slight increase in time, temperature, or agitation during development of T-Max films can cause an increase in film contrast.

Other factors also affect grain. Graininess is more obvious in areas of uniform tone, such as the sky, than it is in textured areas. It becomes more apparent the more that a picture is enlarged, which is why a print from a 35mm negative usually looks grainier than the same size print from a larger negative. Grain is also affected by factors such as the film developer, the printing paper, and the type of enlarger used. Graininess increases when the negative is overdeveloped or overexposed. If you have persistent problems with grain, check the temperatures of your developing solutions; if they vary from each other more than a few degrees, grain can increase sharply.

Certain film and developer combinations enhance fine grain; for example, Kodak Technical Pan 2415 film used with Technidol developer produces extremely fine grain and high resolution of detail. The film lets you make very big enlargements without loss of quality, so much so that an enlargement from a 35mm negative can look as if it were made from a 4 x 5-inch one.

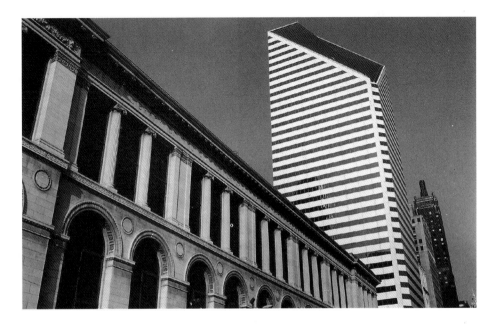

Fast Film—When Speed is Essential

A fast film, ISO 400 or higher, is an asset in dim light. Because a fast film needs less light to produce a printable image, it makes photography easier indoors, at night, or in other low-light situations (such as for the picture below). If you increase the development, you can "push" the film speed and expose it at a speed even higher than the one designated by the manufacturer.

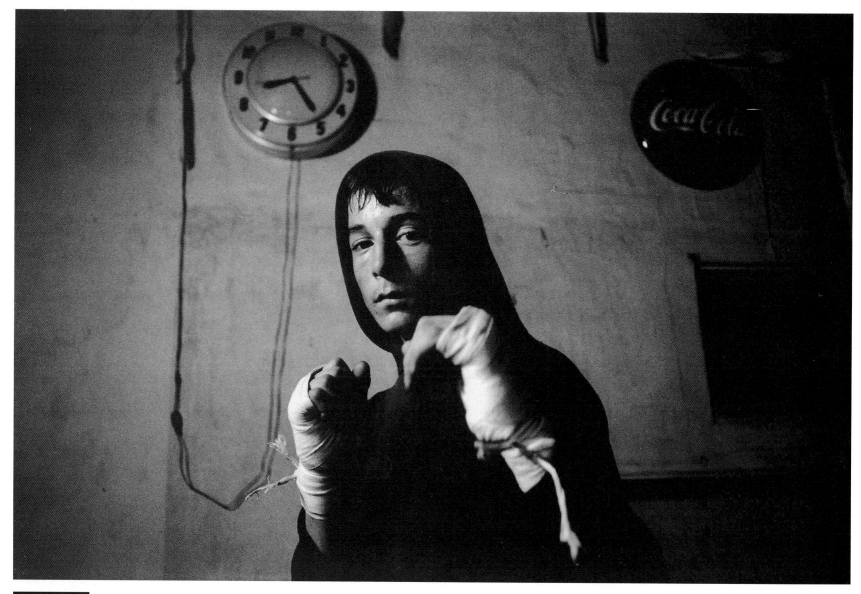

MIGUEL GANDERT Victor Romero, Albuquerque, New Mexico, 1976

A fast film is useful for stopping motion. Since it requires less light than a slower film, you can use a faster shutter speed, which will record a moving subject more sharply than a slow shutter speed will.

How fast is fast? The film speed of Kodak's T-Max P3200 film, for example, starts at 800. Its speed can be pushed to 3200, and with a sacrifice of image quality, up to 25,000. A fast film may show increased grain and loss of image detail, especially if you push the film, but the advantages of fast film can outweigh its disadvantages when you need the speed.

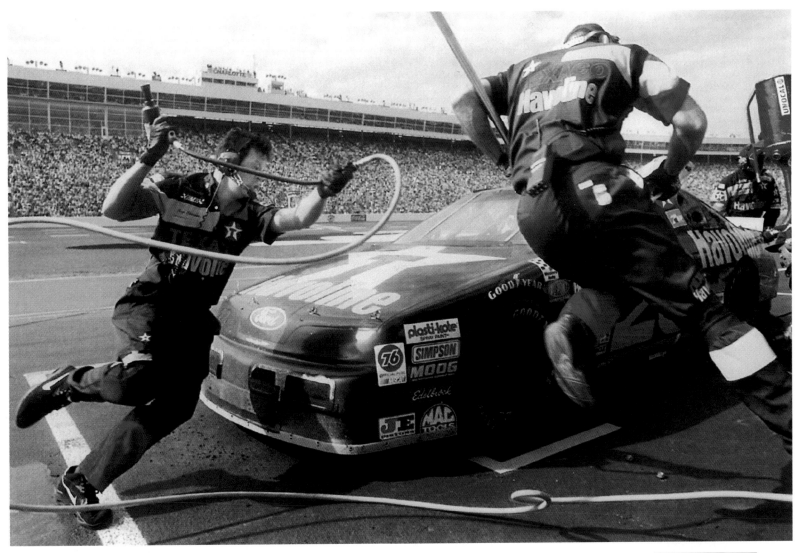

CHRISTOPHER A. RECORD Pit Crew

A medium-speed film, around ISO 100, delivers better sharpness and detail than faster films. It is useful when you want to show fine detail or want to enlarge a negative considerably with a minimum of grain. The film has smaller silver halide crystals and a thinner emulsion compared to fast films, which increase its ability to render detail sharply.

If light is moderately bright, a film of medium speed still lets you use a relatively fast shutter speed so you can hand hold the camera or record moving objects sharply. The slowest film speeds would often require a tripod to hold the camera steady during a longer exposure of the same scene. Medium-speed films are also useful if you want to maximize depth of field by using a small aperture, which is not always feasible with a very slow film.

Slow speeds, ISO 50 or less, are found mostly in color films. A slow-speed color film produces brighter colors and a crisper image than faster color films. Grain has been reduced so much in black-and-white films that few are still available at speeds under ISO 100.

DAVID GRANT NOBLE Petroglyph, Galisteo Basin, New Mexico, 1988

Fine gradations of tonality are rendered best with medium-speed or slow film. Here, the light shines through the petals as well as on them, and they are luminous with delicate tones of gray. Imogen Cunningham made a number of close-ups of plant forms in the 1920s. Commonplace objects such as flowers and leaves were photographed in heroic terms, oversized and isolated in the picture and explored for their design and structure, not as strictly botanical specimens. Edward Weston's Pepper No. 30 (page 362) is a similar image.

◄ *At an ancient Pueblo Indian site, a medium-speed film captured the delicate detail in grasses growing near a petroglyph cut into the rock.*

Magnolia Blossom, 1925

Instant films give you a visible image almost at once. You don't have to wait to have your film developed and printed to see the results. Polaroid films, like the one diagrammed at right, have a negative emulsion, positive paper, and processing chemicals in one packet. After the picture is exposed, the negative and positive are tightly sandwiched together by being pulled between metal rollers. The image is transferred from the negative to the positive by chemicals at the center of the sandwich that develop the image.

Polaroid makes instant materials in many formats. In addition to the pack film made for amateur cameras, individual sheets of 4 x 5-inch or 8 x 10-inch film can be used (with a special film holder) in a view camera. Polaroid instant 35mm transparency film can be exposed in any 35mm camera and then, using a special processor, be processed in a few minutes to make color or black-and-white slides.

Instant film is popular with professional photographers, who use it to make a quick check of a setup. An exposure can be made and evaluated on the spot to avoid a mistake when the picture is taken with standard film. Some photographers also use Polaroid film as an end product.

ALAN ROSS Onion, 1976

Instant films for view cameras

Polaroid makes films for use with view cameras. A packet containing a sheet of film is loaded into a film holder that is inserted in the camera like an ordinary view camera film holder.

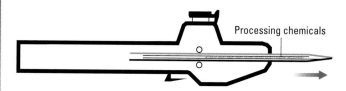

Processing chemicals

To process the film, after it is exposed, the packet is pulled out of the holder between rollers that break a pod of processing chemicals within the packet. The chemicals spread evenly within the packet to develop and fix the picture.

◀ *Instant-print materials can produce beautiful images. Polaroid Polapan 400 4 x 5 film has a very smooth gradation of tones. An original Polapan 400 print can have a subtle luminosity that is almost impossible to achieve with conventional black-and-white materials.*

More about . . .

• Instant color films, page 195

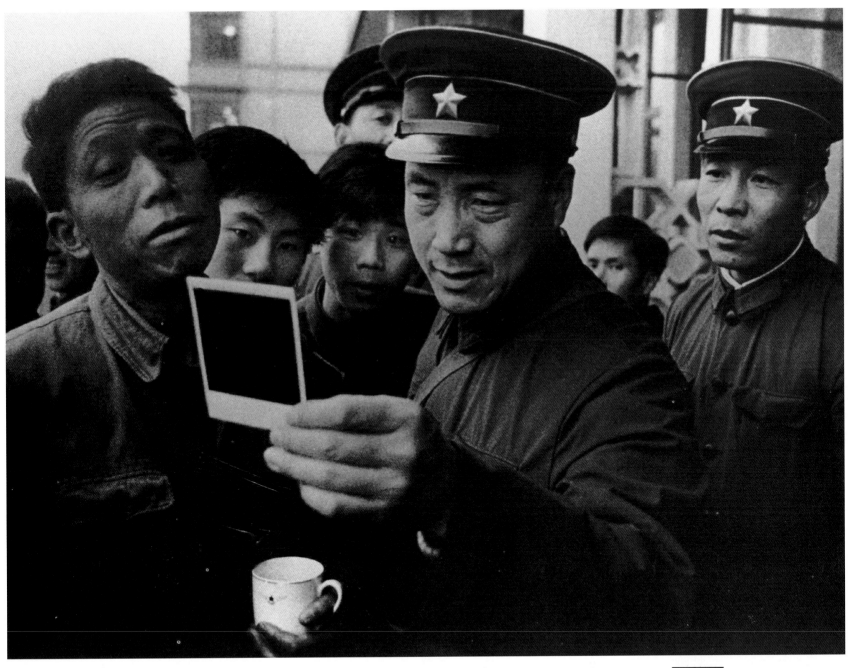

Their First Polaroid, China, 1979

The special pleasure of instant photography: *a group of Chinese soldiers sees for the first time a Polaroid picture developing its image. The Polaroid photograph is of the soldiers themselves, taken by a Western tourist just a few moments before. This scene has a naturalness and ease that is not always easy to get when the photographer is obviously a foreigner. The soldiers have forgotten the photographer and become engrossed in the instant magic of the instant picture—objects taking shape, colors brightening and getting richer while they watch.*

How Film Responds to Light

Recording an image on film involves a reaction between light and silver halide crystals. The crystals, spread through the gelatin of the emulsion, are a compound of silver plus a halogen such as bromine, iodine, or chlorine. If a crystal were a perfect structure lacking any irregularities, it would not react to light. However, a number of electrically charged silver ions are also in the structure and move about when light strikes the emulsion, eventually forming an image. The crystal also contains impurities, such as silver sulfide, that play a role in the trapping of light energy.

As shown in the diagrams opposite, an impurity—called a sensitivity speck—and the free-moving silver ions build a small collection of uncharged atoms of silver metal when the crystal is struck by light. This bit of metallic silver, too small to be visible even under a microscope, is the beginning of a latent image. Developing chemicals use the latent image specks to build up density, an accumulation of enough metallic silver to create a visible image.

A chromogenic film is somewhat different from the conventional silver halide film described above. A chromogenic emulsion contains dye couplers as well as silver halides. During development, the presence of silver that has been exposed to light leads to a proportional buildup of dyes. The original silver is then bleached out, leaving the dyes to form the visible image. Most color materials use chromogenic development to produce the final color image, as does one type of black-and-white film, which produces black dye instead of colors.

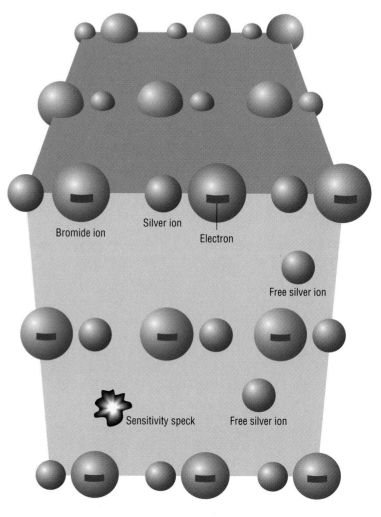

Bromide ion Silver ion Electron

Free silver ion

Sensitivity speck Free silver ion

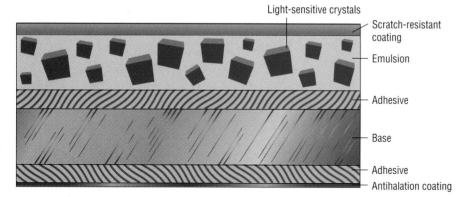

Light-sensitive crystals
Scratch-resistant coating
Emulsion
Adhesive
Base
Adhesive
Antihalation coating

Black-and-white film consists of several layers.
　The surface is a thin protective coating to prevent scratches on the emulsion layer below.
　The emulsion, where the image is formed, consists of about 60 percent gelatin and 40 percent light-sensitive crystals. (Chromogenic film also contains dye couplers in the emulsion.) An adhesive bonds the emulsion to the film base.
　The base is a firm but flexible plastic that provides support.
　An antihalation coating bonded to the base by adhesive prevents light from reflecting back through the emulsion, a phenomenon that can cause halos around bright parts of the picture.

A silver bromide crystal (above) has a cubic structure somewhat like a jungle gym, in which silver (small balls) and bromine (large balls) are held in place by electrical attraction. Both are in the form of ions—atoms possessing electrical charge.
　Each bromide ion has an extra electron (small box)—that is, one more electron than an uncharged bromine atom, giving it a negative charge; each silver ion has one electron less than an uncharged silver atom and is positively charged.
　The irregularly shaped object in the crystal represents a "sensitivity speck." In actuality, each crystal possesses many such specks, or imperfections, which are essential to the image-forming process (diagrammed opposite).

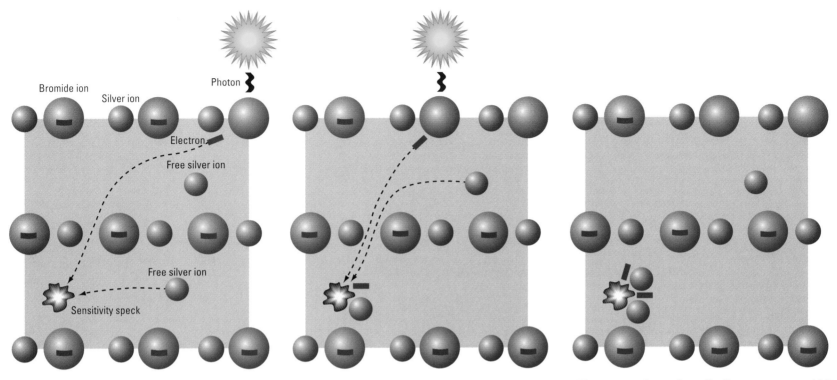

Image formation begins when a photon of light strikes a silver bromide crystal. *The photon gives its energy to a bromide ion's extra electron, lifting it to a higher energy level. Then the negatively charged electron can roam the structure of the crystal until it reaches a sensitivity speck. There its electrical attraction pulls a positively charged free silver ion to it.*

More silver migrates to the sensitivity speck as additional photons of light strike other bromide ions in the crystal and release electrons. *The electrons join up with the silver ions, balancing their electrical charges and making them atoms of silver metal. However, if the crystal were examined through a microscope at this stage, no change would be seen.*

The presence of several metallic silver atoms at a sensitivity speck constitutes a latent image—*an invisible chemical site that will serve as the starting point for the conversion of the whole crystal to silver during development. The developer enormously magnifies the slight chemical change caused by light energy and creates the visible photographic image.*

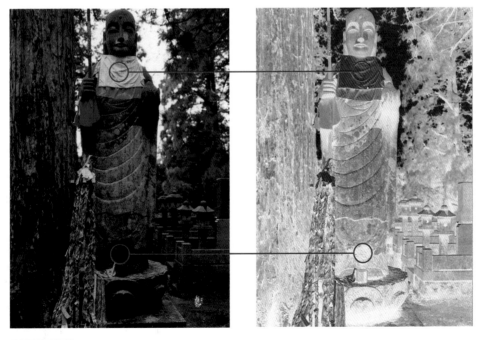

PEGGY JONES Jizo (Statue of a Protector of Children), Japan

A conventional black-and-white negative forms when millions of exposed crystals are converted to silver metal by the developer. *The result is a record of the scene in which the parts of the film struck by the most light are darkened by metallic silver, while the parts struck by no light remain transparent after processing because they contain no silver. Intermediate tones produce varying amounts of silver, creating shades of gray. Compare the light and dark areas of the scene with the tones of those areas in the negative. When the negative is printed the tones will reverse: dark areas in the negative will hold back light from the printing paper to produce light tones similar to those in the original scene, and vice versa.*

Characteristic Curves

The more light that reaches film, the denser with silver (or dyes) the developed negative will be. The pictures opposite were all taken at the same aperture and shutter speed. As more and more light bulbs shine on the head of Buddha, the negatives (bottom row) become denser and darker. The negatives are the opposite of their positive prints (top row); the darkest parts of the negative are the lightest in the print.

The response of a particular film to light can be diagrammed as its characteristic curve, which shows to what degree silver density increases as the amount of light reaching the film increases. The graph on the next page represents the characteristic curve for the film used in taking those pictures.

That characteristic curve plots seven different pictures. But imagine the seven pictures as all part of the same scene, each representing an object of a different tone ranging from a dark, shadow area (Buddha at left) to a brilliant, highlight area (Buddha at right). If you take a picture of such a scene, the film will record different densities depending on the lightness or darkness of the various objects and on the portion of the characteristic curve in which they fall.

The curve and photos show that density does not increase in exact proportion to the amount of light reaching the film. Although the light was doubled for each exposure, the negative densities increased slowly for the first few exposures (the toe of the curve), increased more rapidly for the middle exposures (the straight-line portion), then leveled off again for the last exposures (the shoulder).

In the straight-line portion of the curve, an increase in light will cause a proportionate increase in density, but in the toe and shoulder portions an increase in light will cause a much smaller increase in density. This means that in the straight-line portion, tones that were different in the original scene will look that way in the final print. The tonal separation will be good for these areas and the print will seem to represent the scene accurately.

When film is underexposed and receives too little light, the tones move toward the toe of the curve. Here only small increases in silver density occur. With considerable underexposure, shadow areas and midtones are thin, tonal separation poor, and detail lost. Only light areas of the original scene are on the straight-line portion and show good tonal separation and detail. Tones are reversed in the positive print, so a print will tend to be too dark.

When film is considerably overexposed and receives too much light, the tones move toward the shoulder of the curve. Midtones and bright values are too dense with silver; they "block up" without tonal separation, and details again are lost. Only the shadow values show tonal separation and detail. A print will tend to be too light.

Exposure is not the only process that affects the density of a negative. The developer used and the development time, temperature, and agitation also affect density, especially for bright areas in the original scene. The Zone System is one method used by some photographers for controlling densities in a negative by making adjustments in exposure and development. Some adjustments can also be made to an image during printing, but a very thin or very dense negative will never make a print with the richness and clarity of a print made from a properly exposed negative with good tonal separation.

Characteristic curve for a high-contrast film

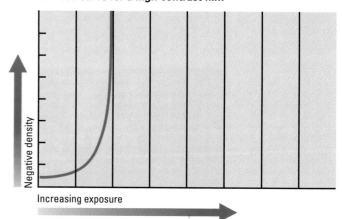

Increasing exposure

Different films have different characteristic curves. *The negative above, made with high-contrast film, consists of two tones, maximum black and maximum white. High-contrast film has a curve that rises almost straight up. Silver density increases rapidly in the negative so that tones above a certain light level are recorded as very dense areas; they will appear in a print as white. Tones below a certain light level are recorded mostly as clear areas in the negative; they will appear in a print as black. Compare this to the curve for the normal-contrast film at right, in which density increases gradually and many midtones are produced.*

More about . . .

• The Zone System, pages 303–313

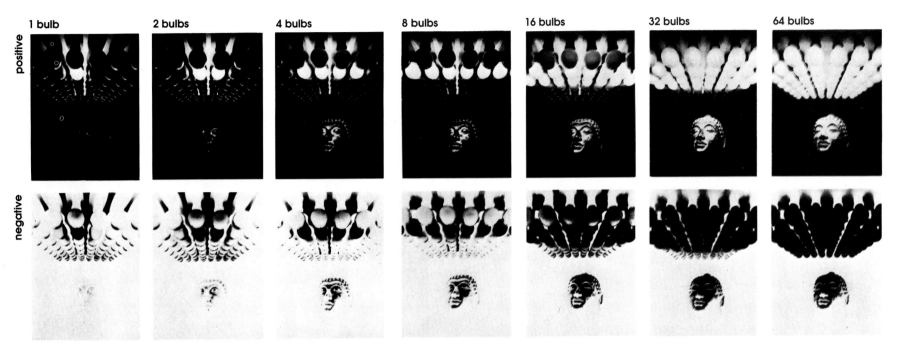

positive

| 1 bulb | 2 bulbs | 4 bulbs | 8 bulbs | 16 bulbs | 32 bulbs | 64 bulbs |

negative

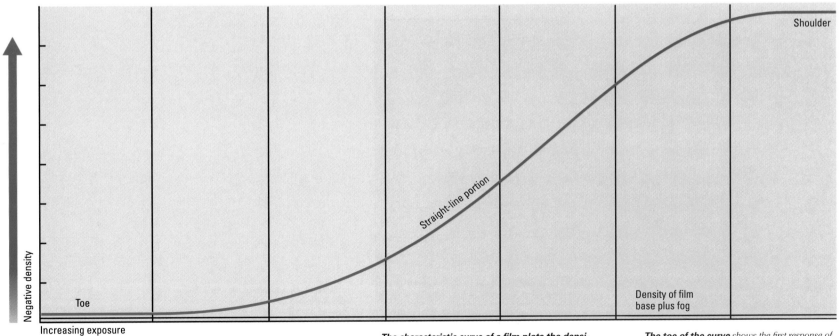

Characteristic curve for a normal-contrast film

Shoulder

Straight-line portion

Density of film base plus fog

Negative density

Toe

Increasing exposure

The characteristic curve of a film plots the density in a negative. *Density is produced by increases in exposure, as well as by development time, temperature, and agitation. Even without exposure, some density is always present due to film base plus fog, the slight density caused by the base material of the film plus the fog caused by development.*

The toe of the curve *shows the first response of the film to light. Density increases gradually with each increase in exposure.*

At the straight-line portion, *density increases significantly with each exposure increase.*

At the shoulder, *density increases less with each exposure increase than at the straight-line portion.*

How Black-and-White Film Records Color

Different black-and-white films react differently to colors in a scene. Black-and-white films record colors as various shades of gray. The silver halide crystals that are the light-sensitive part of film respond primarily to the shorter wavelengths of ultraviolet, violet, and blue, but dyes added to the film can increase the film's range of sensitivity.

Panchromatic film is the most commonly used black-and-white film and is available in the widest range of film speeds. It is sensitive to ultraviolet radiation and all colors of light, although the film's response is not exactly like that of the eye. Panchromatic films are more sensitive to bluish colors than the eye is, which can cause a blue sky, for example, to seem to be too light in a photograph or red apples to have the same tone as green leaves. This imbalance can be corrected with filters, if desired.

Orthochromatic film is sensitive to ultraviolet, blue, and green. Its main use is for copy and graphic arts work.

Blue-sensitive film is much like orthochromatic film. It is sensitive only to ultraviolet and blue. Early photographic emulsions responded mostly to these shorter wavelengths and rendered blue objects as very light in tone. See, for example, how light the skies appear in the photographs on pages 350–351. Today, blue-sensitive film is used for copy work.

Infrared film records invisible infrared wavelengths in addition to all the visible colors. The results can be unusual and beautiful.

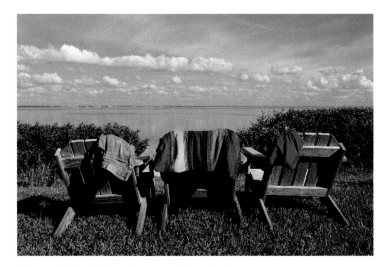

How do black-and-white films record the colors in a scene? Depending on the film, colors may seem lighter or darker than they appear to the eye when looking at the actual scene. Compare the tones of the sky, water, grass, and colored clothing above and in the illustrations opposite.

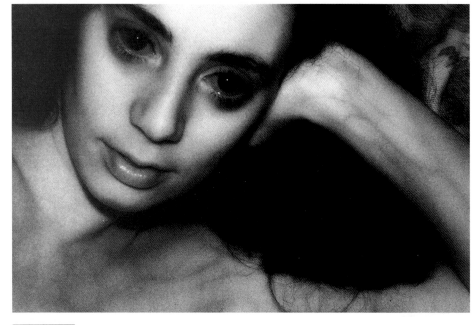

LUTHER SMITH **Brenda, 1976**

Infrared black-and-white film makes skin tones very light and luminous. The photographer used flash, taping a #87 gelatin filter (which passes only infrared radiations) over his flash head.

More about . . .

- Filters to change the rendition of colors, pages 82–84
- Infrared photography, pages 80–81

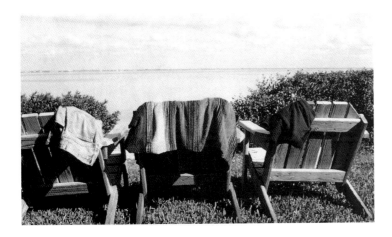

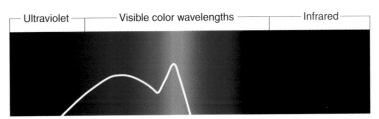

Orthochromatic film *is most sensitive to blue, green, and yellow light (so will record them as relatively light tones), is less sensitive to orange, and does not respond to red (which will appear relatively dark). Notice how light the sky, water, and blue clothing appear in the photograph. The graph charts the film's response to different colors, peaking where the film is most sensitive.*

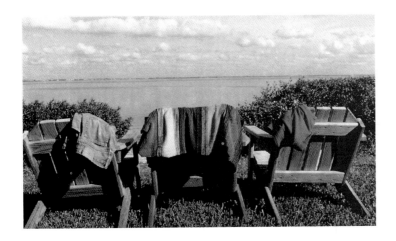

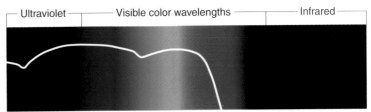

Panchromatic film *records most colors about the way the eye perceives them, although blues, such as in the sky, may be lighter than expected. The graph shows how the film's sensitivity drops off sharply at the red end of the spectrum where wavelengths are longest.*

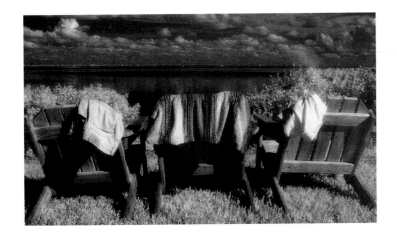

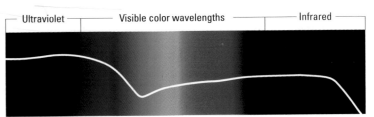

Infrared film, *as the graph shows, records all the colors of the visible spectrum as well as some wavelengths that are not visible to the eye. Compare the tones of sky, water, grass, and the blue and red clothing to those in the other photographs. There is no consistent relationship between the color of an object and the amount of infrared rays that are reflected. For example, the blue clothing appears much lighter than the blue sky.*

Infrared Film

Infrared film can produce unusual photographs, particularly in black and white. In a landscape, blue sky will appear very dark, with green foliage unexpectedly light (see opposite). In a portrait, skin tones will have a luminous, almost unearthly glow (see page 78). Infrared color film produces interesting color variations but not always with such visually appealing results as black-and-white film.

How infrared film works. Infrared film is sensitive to visible light and to invisible infrared wavelengths that are slightly longer than the visible waves of red light. These near-red waves often create unusual photographic effects because they are not absorbed or reflected in the same amounts as visible light. Objects that appear light to the eye may not reflect much infrared radiation, so infrared images may have unexpected, even surreal, tonal relationships. These effects are particularly evident when a deep red filter is used on the lens; the filter blocks most visible wavelengths so that the photograph is taken mostly with infrared waves.

Leaves, grass, and skin in an infrared photograph will be white because they reflect infrared very strongly. Water particles in clouds also reflect infrared, making clouds very light. But blue sky becomes very dark, because its blue light is mostly blocked by the deep red filter. The film has a grainy look that softens surface detail and can produce an overall texture. Details are also diffused by halation, a diffuse, halolike glow that surrounds very light objects, especially with overexposure.

Uses for infrared film. Sometimes photographers use infrared film to reduce haze in landscapes. Haze is caused by the scattering of visible light by very small particles of water and smoke in the air. However, these particles do not scatter infrared radiation, which can pass right through them as if they did not exist. A hazy scene photographed with infrared film thus looks perfectly clear.

Infrared has many scientific and technical applications. Aerial photographers utilize its ability to penetrate haze. Water pollution, timber resources, lava flow, and many other phenomena can be tracked with infrared. It can be used to decipher charred documents, detect forgeries, photograph in the dark, and for many other purposes.

Some films are not true infrared but have extended red sensitivity. Ilford SFX 200, for example, produces results similar to infrared but can be loaded into the camera in subdued light, rather than in the total darkness that is required to prevent fogging true infrared film.

Using infrared film

Storage. Exposure to heat will fog infrared film with unwanted exposure. Buy infrared film only if it has been refrigerated by the dealer, and keep it under refrigeration yourself as much as possible. Let the film come to room temperature before opening the package.

Handling. Even slight exposure to infrared radiation will fog the film, so load and unload the camera in total darkness, either in a darkroom or in a changing bag (a light-tight cloth sack into which you put your hands, the camera, and the film). The slot through which 35mm film leaves its cassette does not block infrared radiation, so only open the film's can to take out the cassette in total darkness. Put exposed film back in the can before you bring it into the light.

Focusing. A lens focuses infrared wavelengths slightly differently than it focuses visible light; so if you focus sharply on the visible image, the infrared image will be slightly out of focus. With black-and-white film, focus as usual, then rotate the lens barrel very slightly forward as if you were focusing on an object just a little closer. A lens may have a red indexing mark on the lens barrel to show the adjustment needed. Make this correction if depth of field is very shallow, for example, if you are using a long-focal-length lens at a wide aperture or if you are focusing on a point very close to the lens. But the difference is so slight that you don't need to adjust for it otherwise; the depth of field will be adequate to keep the image sharp, even if the critical focusing point is slightly off. No adjustment is necessary with color infrared film.

Filtration. See manufacturer's instructions. Kodak recommends a #25 red filter for general use with black-and-white infrared film. This increases the infrared effect by absorbing the blue light to which the film is also sensitive. Kodak recommends a #12 minus-blue filter for general use with color infrared film.

Exposure. Infrared wavelengths are not accurately measured by ordinary light meters, whether built into the camera or hand-held. You can try setting a film speed of 50, metering the scene, then bracketing. If your meter is built into the camera, meter without a filter over the lens. Kodak recommends the following manually set trial exposures for average, front-lit subjects in daylight.

Kodak High-Speed Infrared black-and-white film used with #25 filter: distant scenes—1/125 sec at f/11; nearby scenes—1/30 sec at f/11.

Kodak Ektachrome Infrared color film used with #12 filter: 1/125 sec at f/16.

Flash exposures. You can use infrared film with flash simply by putting a red filter on the lens and using your flash in the usual way. Or you can cover the flash head with a #87 filter, which passes only infrared radiation. You can also buy a special infrared flash unit that emits mostly infrared light. Make a series of trial exposures to determine the best starting exposure with your unit.

Bracketing. Consider any infrared exposure as an estimate that should be bracketed. Start with four additional exposures: 1/2 stop more exposure, 1 stop more, 1/2 stop less, and 1 stop less. Even greater bracketing can be useful: all of the above exposures plus 1 1/2 and 2 stops more exposures, 1 1/2 and 2 stops less. Once you have some experience with the film, you may be able to reduce the amount of bracketing.

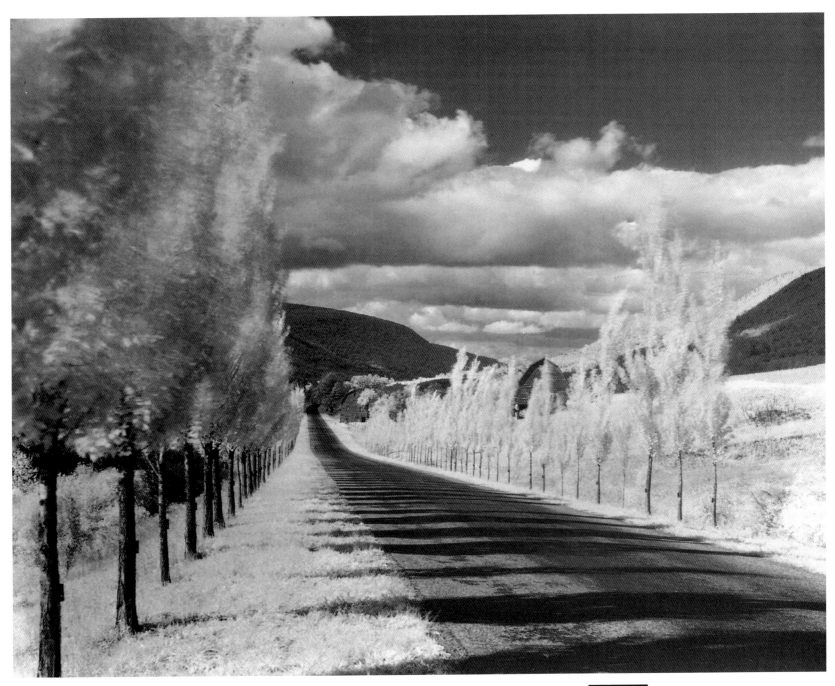

MINOR WHITE Road and Poplar Trees, Upstate New York, 1955

Infrared film helped make this landscape look more like a dreamscape. *The perspective of the converging lines of road and trees funnels the eye down the road to the dark mountains beyond. The repeated shadows of the trees reinforce the depth in the scene as the distance between them apparently diminishes. The altered tonalities of the infrared film, which render the foliage as extremely light, make the whole scene slightly unrealistic.*

Minor White often found the sublime in the ordinary. There is no sure way to make a landscape like this happen out of a road lined with trees, no matter what film you use. The landscape itself has to cooperate. White often put forth his basic rule of composition: Let the subject generate its own composition.

Using Filters

Attach a filter to the front of a lens, and you change the light that reaches the film. The name—filter—describes what most filters do: they remove some of the wavelengths of light reflected from a scene and so change the way that the scene looks in a photograph. Because some of the light is removed, you generally need to increase the exposure for a filtered scene or the film will be underexposed.

Gelatin or plastic filters are taped to the front of the lens or placed in a filter holder. They come in many colors and may cost less than glass but can be damaged relatively easily. Handle them by the edges only to avoid abrasions or other damage to their surfaces.

Glass filters screw or clamp onto the front of the lens. They are made in sizes to fit various lens diameters. To find the diameter of your lens, look on the ring engraved around the front of the lens. The diameter (in mm) usually follows the symbol Ø. Glass filters are convenient to use and sturdier than gelatin or plastic filters but are often more expensive.

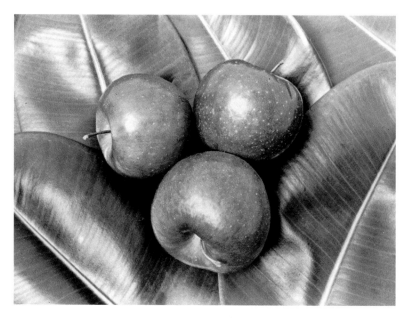

Colors that appear very different to the eye can be confusingly similar in tone in black and white, such as the red apples on the green leaves, above. A colored filter can correct this by absorbing certain colors and making those colors darker in a black-and-white print.

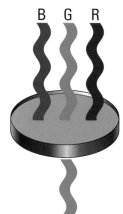

A green filter #58 was used to take the picture below. It absorbs much red light, making the red apples darker than the leaves, a natural-looking appearance.

Types of filters

Colored filters let you control the relative lightness and darkness of tones in a black-and-white photograph. They absorb light of certain colors and thus make objects of those colors appear as darker tones of gray. The more light the filter absorbs, the less light reaches the film, and the darker those colors will appear to be. It is easier to predict the effect of a colored filter if you think of it as subtracting (and darkening) colors, not adding them. For example, if you look through a red filter, it seems to tint the entire scene red. But the filter isn't adding red; it is removing blue and green. As a result, blue and green objects will appear darker.

A colored filter absorbs its complementary color, the color or colors opposite it on a color wheel (see color wheel illustrated on page 215): a yellow filter absorbs blue, a green filter absorbs red and blue, and so on. A colored filter can appear to lighten objects of its own color, but this is because it makes other colors darker, and by comparison, objects that are the color of the filter seem lighter.

Contrast filters are colored filters that change the relative brightness of colors that would otherwise be too similar in tone in black and white. In color, red apples contrast strongly against a background of green leaves, but in black and white the apples and leaves can be almost the same gray tone. A green filter, which absorbs red, darkens the apples so that they look more natural (see illustrations, right).

Correction filters are colored filters designed to correct the response of film so that it shows the same relative brightnesses that the human eye perceives. For example, film is more sensitive to blue and ultraviolet wavelengths than the eye is. A blue sky photographed without a filter can look too light in a black-and-white photograph, almost as light as clouds that appeared at the scene to be much lighter. A yellow filter, which absorbs blue, darkens the blue part of the sky so that clouds stand out (see opposite page).

Neutral-density filters absorb a quantity of all wavelengths of light. They reduce the overall amount of light that reaches the film while leaving the color balance unchanged; they can be used with either black-and-white or color film. Their purpose is to increase the exposure needed for a scene, so that you can use a slower shutter speed (to blur motion) or a larger aperture (to decrease depth of field).

A polarizing filter affects only light vibrating at certain angles. It can be used with either black-and-white or color film to remove reflections, darken skies, and intensify colors.

Some filters or lens attachments produce special effects. A cross-screen attachment causes streamers of light to radiate from bright lights such as light bulbs. A soft-focus attachment softens details and makes them slightly hazy.

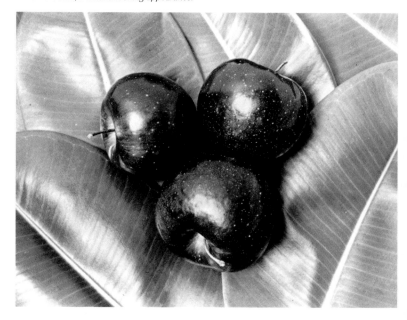

One of the most common uses for a filter in black-and-white photography is to darken a blue sky. Colored filters work for this purpose only when the sky is actually blue. They do not darken the sky on an overcast or hazy day.

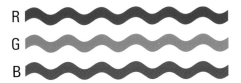

Without any filter, *the sky in this photograph appears very light, with clouds barely visible. Black-and-white film is very sensitive to blue and ultraviolet light; this often causes skies to appear too light in a black-and-white photograph.*

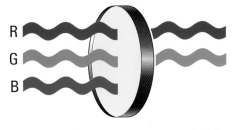

A yellow filter *#8 absorbs some of the sky's blue light, making the sky in the picture at right appear somewhat darker than it does above.*

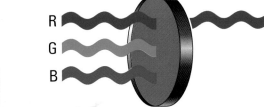

A red filter *#25 absorbs nearly all blue as well as green light, making the sky in the picture at right much darker than it normally appears and also darkening foliage. Shadows, too, appear darker than in the unfiltered view, because they are illuminated largely by blue light from the sky that the red filter blocks.*

More about . . .

- Exposure increases with filters, page 84
- Filters for black-and-white film, page 84
- Filters for color film, pages 200–201
- Polarizing filters, page 85
- Filters for special effects, page 86

Filters for Black-and-White Film

You need to increase the exposure when using a filter. Filters absorb part of the light that passes through them, so the film will be underexposed if the exposure is not increased. The chart shows the effect of various filters on black-and-white film and the number of stops to increase the exposure for each.

In manual exposure operation, for each full stop of increased exposure recommended for a given filter, change the shutter to the next slower speed or the aperture to the next wider setting. Use the aperture to make fractional changes.

In automatic exposure operation, you may encounter some problems. If you have a camera that meters through the lens, it would be convenient if you could simply meter the scene through the filter and let the camera set the exposure automatically. But some types of meters do not respond to all colors, so you may get an incorrect reading if you meter through a filter, particularly through a dark filter. A #29 deep-red filter, for example, requires 4 stops additional exposure, but some cameras only produce a 2 1/2-stop increase when they meter through that filter, which will underexpose the film by 1 1/2 stops.

You can meter through a filter if you run a simple test first. Select a scene with a variety of colors and tones. Meter the scene without the filter and note the shutter speed and aperture. Then meter the same scene with the filter over the lens. Compare the number of stops that the camera's settings changed with the number of stops that they should have changed according to the chart. Adjust the settings as needed whenever you use that filter.

Some sources list the exposure increase as a filter factor, not directly in stops. The end result is the same, but the calculation is a little different. The factor tells how many times the exposure should be increased. A factor of 2 means the exposure should be doubled (the same as a 1-stop change); a factor of 4 means the exposure should be increased four times (a 2-stop change), and so on. See bottom of chart.

The increase for tungsten light (from light bulbs) is different from the increase for daylight because tungsten is more reddish, while daylight is more bluish. Specific films may vary somewhat from these listings; see film instructions.

Filters for black-and-white film

Number or designation	Color or name	Physical effect	Practical use	Exposure increase for black-and-white film	
				Daylight	Tungsten
8	yellow	Absorbs ultraviolet and blue-violet	Darkens blue sky to bring out clouds. Increases contrast by darkening bluish shadows. Reduces bluish haze.	1 stop	2/3 stop
15	deep yellow	Absorbs ultraviolet, violet, and most blue	Lightens yellow and red subjects such as flowers. Darkens blue water and blue sky to emphasize contrasting objects or clouds. Increases contrast and texture and reduces bluish haze more than #8 filter.	1 1/3 stops	2/3 stop
25	red	Absorbs ultraviolet, blue-violet, blue, and green	Lightens yellow and red subjects. Darkens blue water and sky considerably. Increases contrast in landscapes. Reduces bluish haze more than #15 filter. Used with infrared film.	3 stops	2 1/3 stops
11	yellowish green	Absorbs ultraviolet, violet, blue, and some red	Lightens foliage, darkens sky. For outdoor portraits, darkens sky without making light skin tones appear too pale. Balances values in tungsten-lit scenes by removing excess red.	2 stops	2 stops
47	blue	Absorbs red, yellow, green, and ultraviolet	Lightens blue subjects. Increases bluish haze.	2 2/3 stops	3 2/3 stops
1A or UV	skylight or ultraviolet	Absorbs ultraviolet	Little or no effect with black-and-white film. Used by some photographers to protect lens surface from damage.	0	0
ND	neutral density	Absorbs equal quantities of light from all parts of the spectrum	Increases required exposure so camera can be set to wider aperture or slower shutter speed. Comes in densities from 0.1 (1/3 stop more exposure) to 4 (13 1/3 stops more exposure).	varies with density	
—	polarizing	Absorbs light waves traveling in certain planes relative to the filter	Reduces reflections from nonmetallic surfaces, such as water or glass. Penetrates haze by reducing reflections from atmospheric particles. Darkens sky at some angles.	1 1/3 stops	1 1/3 stops

If filter has a factor of . . .	1	1.2	1.5	2	2.5	3	4	5	6	8	10	12	16	32
Then increase the exposure (in stops) . . .	0	1/3	2/3	1	1 1/3	1 2/3	2	2 1/3	2 2/3	3	3 1/3	3 2/3	4	5

If you use two or more filters together, add the number of stops of change (1 stop + 1 stop = 2 stops) or multiply the filter factors (factor of 2 x factor of 2 = factor of 4, equivalent to 2 stops).

More about . . .

• Filters for color film, pages 200–201

Reflecting surface

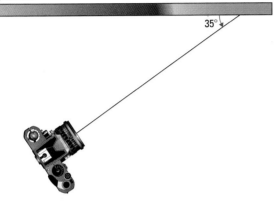

Reducing reflections from shiny surfaces. *A polarizing filter used to block reflections from a shiny surface like glass or water is most efficient at an angle of about 35° to the reflecting surface. Directly in front of the surface, the filter has no effect.*

The photograph at top was taken without any filter. The reflection in the window was removed by adjusting a polarizing filter over the lens.

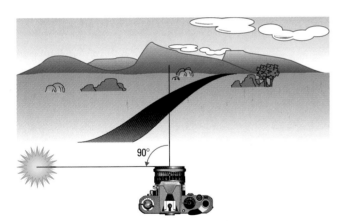

Reducing reflections from the atmosphere. *A polarizing filter can darken a blue sky or reduce haze by blocking light reflected from particles in the atmosphere. For this purpose, the filter works best when you are taking pictures at approximately a right angle to the sun.*

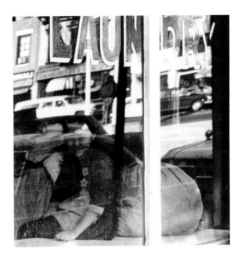

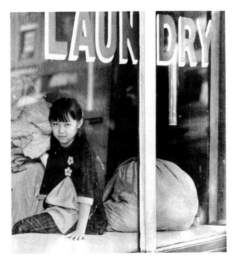

A polarizing filter can remove or reduce reflections from water, or any smooth surface except metal. This is possible because light waves ordinarily vibrate in all directions perpendicular to their direction of travel. But light reflected from non-metallic smooth surfaces has been polarized—the light waves vibrate in only one plane.

A polarizing filter contains submicroscopic crystals lined up like parallel slats. Light waves that are parallel to the crystals pass between them; waves vibrating at other angles are blocked by the crystals (center diagram, left). Since the polarized light is all at the same angle, the filter can be turned so as to block it.

The filter can also decrease reflections from tiny particles of dust and water in the atmosphere. This will darken the sky and make a distant scene look more distinct and more vividly colored. It is the only filter that will darken the sky in a color picture without changing the color balance.

To use a polarizing filter, look through it and rotate it until the unwanted reflection is reduced. Then place the filter in the same position over the lens. (With a single-lens reflex or view camera, the filter can be adjusted while it is in place over the lens.) Because of the partial blockage of light by the filter, the exposure should be increased by 1 1/3 stops.

The photograph at top was taken without any filter. Bottom, the reflections in the window were removed by adjusting a polarizing filter over the lens. Center, the drawing shows how the filter works. It passes only those light waves that are parallel to its picketlike crystals; it blocks all other light waves angled across the pickets. Light reflected from non-metallic surfaces, like the glass in the photographs, is traveling in only one plane, so it can be blocked while letting light from the rest of the scene pass to the film.

Filters for Special Effects

Some lens attachments manipulate or change the image itself. A soft-focus attachment blurs details slightly to make them appear hazy, as if seen through a filmy screen (below). A cross-screen attachment (star filter) causes streamers of light to radiate from bright light sources, such as light bulbs, reflections, or the sun (right). Other lens attachments produce multiple images, vignette the image, give the illusion of blur caused by motion, or create other special effects.

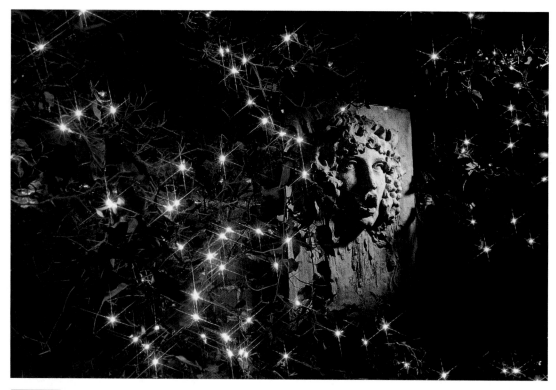

KEN KOBRÉ Sparkle Plenty, 1997

A cross-screen lens attachment, sometimes called a star filter, put the bright rays of light in the photograph above. A six-ray attachment created the rays around the lights. Other cross screens produce four, eight, or other numbers of rays.

A soft-focus lens attachment, also known as a diffusion filter, fog filter, or by other names, scatters some of the light to soften an image.

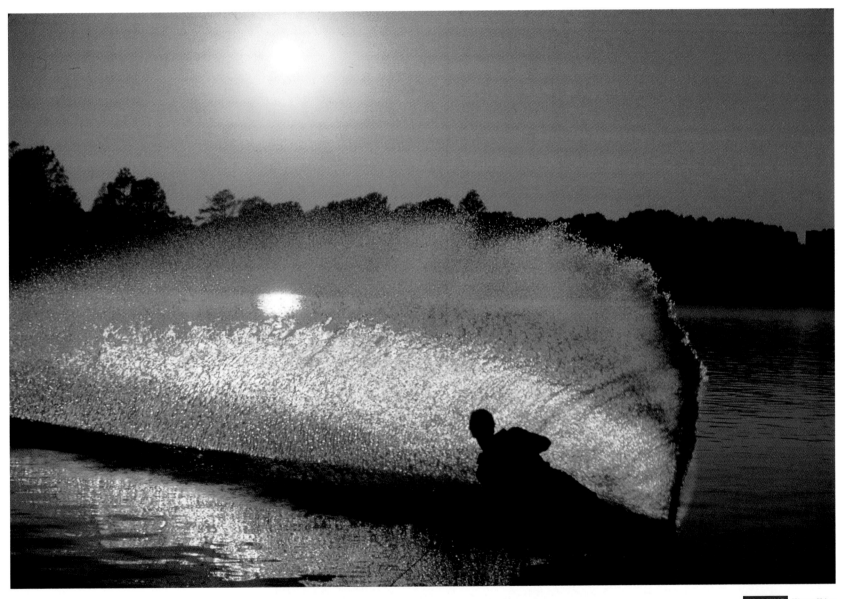

TOM KING Water Skier

Photographer Tom King specializes in water skiing and other action on the water. An orange filter on his lens increased the warm, late-day colors of the scene. Back lighting silhouetted the skier and helped define the spray.

More about . . .

• Filters for color film, pages 200–201

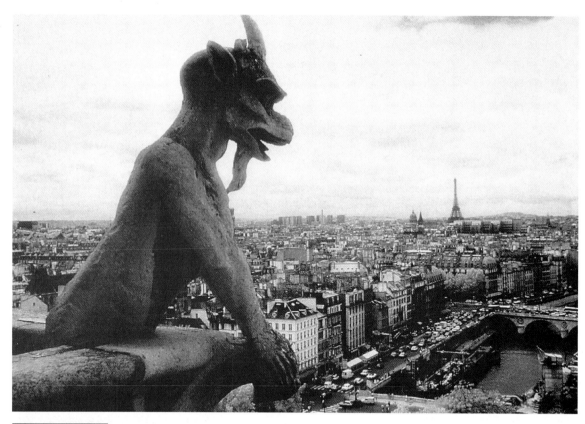

STEPHEN PETEGORSKY Gargoyle

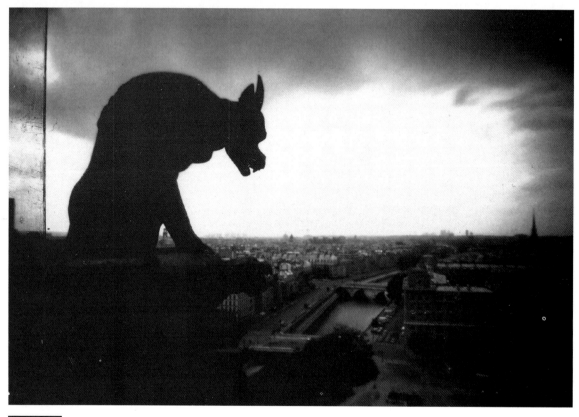

DIANNE BOS Gargoyle, Notre Dame, Paris, 1991

The exposure (how much light reached the film) made one gargoyle fully detailed and the other darkly silhouetted. When you select an exposure, you can choose to a great extent how an object will appear, and that in turn can affect the feeling the object conveys. One gargoyle simply looks out over the city, the other is a darker figure, literally and psychologically.

Exposing film properly, letting the right amount of light into the camera, involves understanding just three things:

Shutter speed Aperture size

1. How the shutter speed and the size of the lens opening (the aperture) work together to control the amount of light that reaches the film.

2. The sensitivity of your film to light—the film's speed.

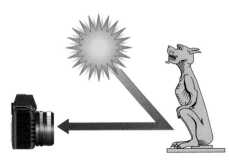

3. How to meter the amount of light and then set the camera's controls, either automatically or manually.

More about . . .

• Film speed, page 66
• Metering, setting the exposure, pages 90–102
• Shutter speed and aperture combinations, pages 24–25

An exposure meter is the essential tool required for a good exposure.

How you use a meter depends on the type of scene you are photographing.

To get a rich image with realistic tones, dark but detailed shadows, and bright delicate highlights, you need to expose your film correctly. That is, you need to set the shutter speed and aperture so they let in the right amount of light for a given film and scene. Most negative films have a tolerance, or latitude, for a certain amount of exposure error; they allow for a range of exposures all of which will produce satisfactory negatives. However, the best prints, especially if enlargements are made, are produced from properly exposed negatives. Greatly overexposed negatives (much too much light reached the film) are difficult to print and produce grainy and unsharp prints. Badly underexposed negatives (much too little light reached the film) show no detail in the shadows—something that cannot be remedied when the negative is printed. Color reversal films have very little latitude, especially for overexposure; as little as one stop overexposure makes a distinctly inferior color slide.

Personal judgment is important even though cameras with automatic exposure are common. Built-in meters measure the intensity of the light; electronic circuitry sets the lens aperture and shutter speed automatically. But personal judgment is still important. Equipment is programmed for "average" conditions, so you may have to change the recommended settings if you are photographing a backlit scene, a snowy landscape, or other nonaverage situation. This chapter tells when you can rely on automatic exposure and when you need to override it.

One of the best cures for exposure problems is experience. The most expensive meter or camera, complicated exposure strategy, or detailed charts will never replace the sureness you will have when you photograph something for the second—and, even better, the third or fourth—time.

Exposure = Intensity x Time. Exposure is a combination of the intensity (brightness) of light that reaches the film (controlled by the size of the aperture) and of the length of time the light strikes the film (controlled by the shutter speed). The more light that reaches the film, the greater the buildup of silver density in the negative. You can adjust the exposure by changing the shutter speed, aperture, or both.

You'll need an exposure meter in order to consistently expose your film correctly so that it is neither too light nor too dark. Exposure meters (commonly called light meters) vary in design, but they all perform the same basic function. They measure the amount of light; then, for a given film speed, they calculate f-stop and shutter-speed combinations that will produce a correct exposure for a scene that has an average distribution of light and dark tones.

Exposure meters are designed to measure middle gray. The assumption is that most scenes, which consist of a variety of tones including very dark, medium gray, and very light, average out to a medium gray tone. Most scenes, in fact, do. The meter calculates an exposure that would reproduce the overall level of light as a medium-gray tone in the final photograph. Some meters built into cameras are capable of more sophisticated calculations, such as comparing the brightness of one part of a scene to another and calculating an exposure based on preset patterns.

Reflected-light meters measure the light reflected from a subject. Most hand-held meters and all those built into cameras are reflected-light meters. They measure luminance, the light reflected from (or emitted by) the subject. The meter is pointed at the subject, or at the particular part of the subject the photographer wants to measure at close range, and the reading is made. The light-admitting opening of a hand-held reflected-light meter typically reads the angle of view of a normal-focal-length lens, about 30° to 50°.

A spot meter reads reflected light from only a very small angle. The angle of light admitted may be as little as 0.5° so that readings of very small areas can be made. The side of a building from several blocks away, a person's face at 20 feet, or a dime at 1 1/2 feet can all be read with a 1° spot meter. Very accurate exposures can be calculated with a spot meter, but it is important to carefully select the areas that are read.

Incident-light meters measure the light falling on a subject. They measure illuminance, the light incident on (falling on) the subject. An incident-light meter is pointed not toward the subject but toward the camera from the position of the subject, so that the meter receives the same light that the subject does. Incident-light meters are all hand-held and have a very wide angle of view, about 180°.

Some meters can make either reflected or incident readings. When the sensing cell is open to direct light, it is a reflected-light meter. When a dome-like diffuser is slid over the sensing cell, it becomes an incident-light meter.

Special-purpose meters. Most meters measure a continuously burning source of light, such as the sun or a tungsten lamp, but flash meters measure the output from the brief burst of light from electronic flash. Color temperature meters measure the color temperature of light rather than its intensity and are used to calculate the filters needed when a specific color balance is required.

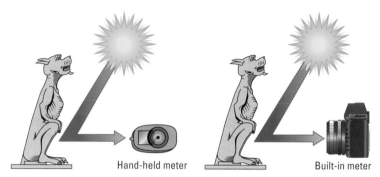

A reflected-light meter can be hand held (left) or built into a camera (right) and is aimed at a subject to make a reading. It measures the luminance (commonly called the brightness) of a subject—here the light reflected from the statue of a gargoyle.

Hand-held meter

Built-in meter

An incident-light meter is faced toward the camera from the position of the subject to make a reading. It measures the light falling on a subject as seen by the camera.

Measuring the light. A photoelectric cell is the light sensitive part of the meter. It converts the energy of light into a measurable quantity of electrical energy.

A basic meter, like this one uses that energy to move a needle across a gauge. The brighter the light, the farther the needle moves. The numbers on this gauge are one stop apart: each number indicates a light level twice as high as the preceding number. In this case, the reading is 7—twice the light level at 6, half the level at 8.

Batteries. Many hand-held meters and all meters built into cameras are battery powered. Check batteries regularly. A worn down or exhausted battery can give a wrong reading and eventually will cease functioning altogether.

Film speed. The speed of the film being used, here ISO 400, must be set into the meter.

Exposure value (EV) scale. Some hand-held meters (and a few cameras) also display an EV scale of equivalent shutter speeds and apertures. EV 1, for example, indicates f/1.4 at 1 sec. and all other combinations of f-stops and shutter speeds that deliver the same amount of light.

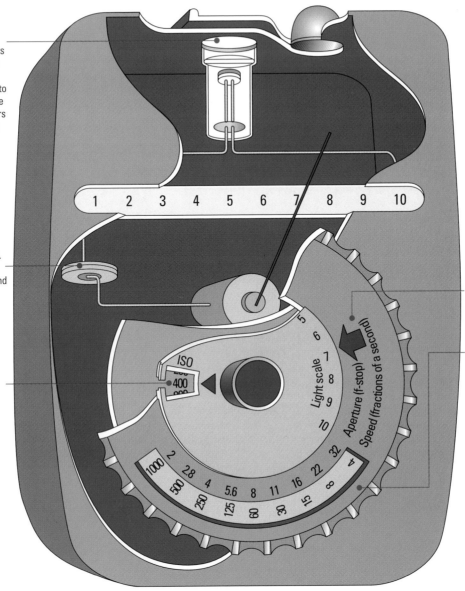

To convert the light measurement into an exposure setting, a rotating dial is turned until its arrow points to the number shown by the needle that measures the light.

This matches apertures (f-stops) with shutter speeds to recommend an exposure for that light intensity: here, f/32 at 1/4 sec, f/22 at 1/8 sec, or any combination shown would give the same exposure.

Some models save you the trouble of lining up the arrow. They automatically suggest an f-stop and shutter speed combination on a digital display.

Exposure changes are measured in stops, a doubling (or halving) of the exposure

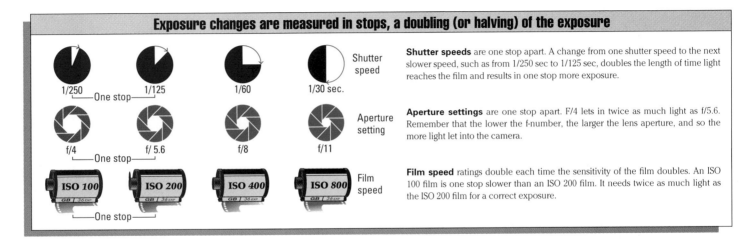

Shutter speeds are one stop apart. A change from one shutter speed to the next slower speed, such as from 1/250 sec to 1/125 sec, doubles the length of time light reaches the film and results in one stop more exposure.

Aperture settings are one stop apart. F/4 lets in twice as much light as f/5.6. Remember that the lower the f-number, the larger the lens aperture, and so the more light let into the camera.

Film speed ratings double each time the sensitivity of the film doubles. An ISO 100 film is one stop slower than an ISO 200 film. It needs twice as much light as the ISO 200 film for a correct exposure.

Built-in Meters

Meters built into cameras measure the light reflected or produced by objects in their view and then calculate an exposure setting. To use a built-in meter, you look through the camera's viewfinder while pointing the meter at the scene or at the part of the scene that you want to meter. Shutter speed and/or aperture settings may be displayed in the viewfinder or in a camera's data panel. An automatic camera sets the shutter speed, aperture, or both for you based on the meter reading (see opposite page).

Many built-in meters are averaging meters and are center-weighted. The meter averages all the light in the scene but weights its average to give more emphasis to the area at the center of the viewfinder than to the surrounding area. This system is based on the assumption—usually, but not always, correct—that the most important part of the subject is in the center of the scene. A center-weighted meter can give an inaccurate reading if the subject is at the side of the frame, for instance, and the surroundings are much lighter or darker.

Some cameras have multi-segment meters. They make individual readings from different parts of the viewfinder image, instead of averaging together readings from all parts of the image. These cameras are programmed by the manufacturer to adjust for some potential exposure problems, such as a backlit subject.

A camera may offer several different metering modes, such as multi-segment metering, center-weighted metering, and spot metering. See the manufacturer's instructions.

Certain scenes can cause a meter to produce the wrong exposure. Most meters are designed to calculate an exposure for scenes that include both light and dark areas in a more or less equal balance that averages out to a middle gray tone. If a scene is uniformly light (such as a snow scene), the meter still calculates an exposure as if it were reading middle gray. The result is not enough exposure and a photograph that is too dark. The following pages tell how to identify such scenes and how to set your camera for them.

Meters built into cameras can emphasize different parts of a scene when measuring light to calculate exposure settings.

An averaging meter reads most of the image area and computes an exposure that is the average of all the tones in the scene.

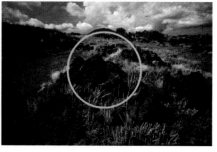

A center-weighted meter favors the light level at the center of an image, which is often the most important part to meter.

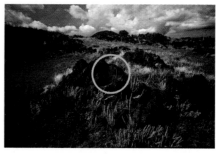

A spot meter reads only a small part of an image and is useful for exact measurements of individual areas.

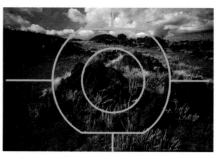

A multi-segment meter divides the scene into areas that are metered individually and then evaluated against a series of patterns stored in the camera's memory. The resulting exposure is more likely to avoid problems such as underexposure of a subject against a very bright sky.

What you see in the camera's viewfinder

What an averaging meter system "sees"

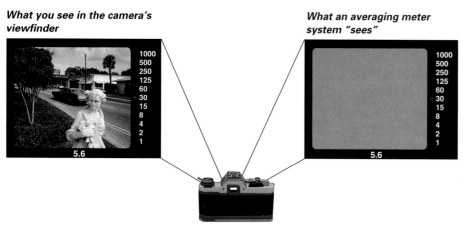

In a camera's viewfinder, you can see details of the scene, but a built-in meter does not. Many meters average together light from all parts of a scene and as a result "see" only the overall light level. Even if a meter is programmed to emphasize one or more key areas (such as the central part of a scene), it can't predict every time how you want a scene to look. Sometimes you will want to override the meter's settings.

Overriding automatic exposure

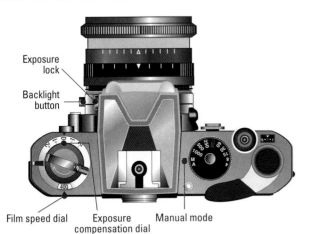

Exposure lock

Backlight button

Film speed dial | Exposure compensation dial | Manual mode

Automatic exposure works well much of the time, but for some scenes you will want to alter the exposure set by the automatic circuitry. You may want to increase the exposure to lighten one picture or decrease the exposure to darken another. Most cameras have one or more of the following means of allowing you to do so. Camera design and operation vary. For example, some cameras have push-button controls and a data panel to show the settings selected, instead of the dial-operated controls shown here. See the manufacturer's instructions for your model.

Manual mode. An option on many automatic cameras. You adjust both shutter speed and aperture settings to lighten or darken the picture as you wish.

Exposure compensation dial. Moving the dial to +1 or +2 increases the exposure one or two stops and lightens the picture (some dials say x2 or x4 for comparable settings). Moving the dial to –1 or –2 (x1/2 or x1/4 on some dials) decreases the exposure one or two stops and darkens the picture.

Backlight button. May be on the camera if an exposure compensation dial is not. Depressing the button adds a fixed amount of exposure (usually one to one and a half stops) to lighten a picture. It cannot be used to decrease exposure. As its name indicates, it is useful for backlit scenes in which the main subject is against a much lighter background.

Exposure lock. The switch temporarily locks in a shutter speed and aperture combination. You move close to meter the most important part of the scene, lock in the settings, then recompose the picture and photograph the entire scene at that exposure.

Film speed dial. Resetting the film speed dial causes the camera to give the film less or more exposure than normal. To lighten a picture, decrease the film speed: halving an ISO film speed (for example, from 400 to 200) increases the exposure one stop. To darken a picture, increase the film speed: doubling the film speed (for example, 400 to 800) decreases the exposure one stop.

Even if you can't manually change a film-speed dial, there may still be a way to change the film speed for a whole roll of film. Some camera stores sell foil stickers that let you change the DX film-speed coding on the film cassette. Doing so rearranges the black and silver squares that tell the camera's electronics the film speed.

Many cameras incorporate automatic exposure. If your camera is an automatic one, a meter built into the camera measures the average lightness or darkness of the scene in your viewfinder. Electronic circuitry within the camera automatically calculates an exposure that would be correct for an average scene, and then sets shutter speed, aperture, or both, based on the speed of the film you are using. Some cameras are more sophisticated. Their multi-segment meters compare readings from different parts of the scene, then adjust the exposure or warn you of possible problems. The basic modes of automatic exposure are listed below. Your camera may operate in only one of these modes or in several. See the manufacturer's instructions for details.

Sometimes automatic exposure can underexpose or overexpose your subject because it is giving you an "average" exposure rather than one that is best for a specific scene. A typical example is when a subject is against a much lighter background such as a bright sky. An automatic system can underexpose such a backlit scene, just as a non-automatic system will if you simply make an overall reading. Unless your camera has a metering system that adjusts for such scenes, you will have to override the automatic exposure mechanism to get the exposure you want. Various means to do this are listed in the box at left.

Exposure modes

Aperture-priority automatic. You select the aperture and the camera adjusts the shutter speed.	You set aperture	f/5.6	f/8	f/11
	Camera adjusts shutter speed	1/250 sec	1/125	1/60
Shutter-priority automatic. You select the shutter speed and the camera adjusts the aperture.	You set shutter speed	1/250 sec	1/125	1/60
	Camera adjusts aperture	f/5.6	f/8	f/11
Programmed (fully) automatic. The camera adjusts both shutter speed and aperture based on a built-in program. Depending on the program, the camera may select the fastest possible shutter speed or go to slower shutter speeds rather than opening the lens to the widest aperture.	Camera adjusts aperture	f/5.6	f/8	f/11
	Camera adjusts shutter speed	1/250 sec	1/125	1/60
Manual. You set both shutter speed and aperture. The camera's built-in meter still can be used to calculate the correct settings.	You set aperture	f/5.6	f/8	f/11
	You set shutter speed	1/250 sec	1/125	1/60

How do you get a good exposure—that combination of f-stop and shutter speed that lets just the right amount of light reach the film, so that your picture is not underexposed and too dark or overexposed and too light? For many scenes, the correct exposure is easy to calculate: you use a reflected-light meter to make an overall reading of the objects in the scene (opposite, left and center). If you have an incident-light meter, you make a reading of the overall amount of light falling on the scene (opposite, right).

An overall reading works well for metering average scenes, where light and dark tones are of more or less equal distribution and importance, especially if the scene is evenly illuminated, either by light that is coming from behind the camera or by light that is evenly diffused over the entire scene. But a meter is only a measuring device—it cannot interpret what it reads, nor does it know whether a scene is average or if you want the subject to be light or dark. So in some cases you have to think for the meter and override the settings it recommends. The following pages will tell when to do so.

A reflected-light meter (built into the camera or hand-held) typically acts as if the scene it is metering is middle gray. It averages all the tones in its angle of view and then calculates an f-stop and shutter speed combination that will produce middle gray in a print. The assumption is that the average of all the tones from light to dark in a scene will be a middle gray, so an exposure for middle gray will be approximately correct for the entire scene. This method does give a good exposure in a large number of situations.

Make sure that the meter is reading only the light you want it to read. If your meter is built into the camera, you can see in the viewfinder the area that the meter is reading. Some hand-held meters have a small viewfinder through which you look at the scene, but if yours does not, you can estimate the area the meter is covering. For most reflected-light hand-held meters, the angle is 30° to 50°, about the coverage of a normal-focal-length lens.

An overall reading may not work well for contrasty scenes. You may get a deceptively high reading (and subsequently a too-dark picture) if the scene contains very light areas like a bright sky or light sources like the sun or a lamp. Your reading may be too low (and the resulting picture too light) if a very large dark area surrounds the subject.

An incident-light meter reads only the light falling on a subject. Its reading is not altered if the subject is against a much lighter or darker background. An incident-light meter is preferred by many commercial photographers to balance the illumination in studio setups where lights can be arranged at will. It is also quick and easy to use and therefore useful in fast-moving situations. However, it cannot measure the tones of individual objects in a scene, and it cannot give an exposure for an object that is itself emitting light, such as a neon sign or a lamp.

To use an incident-light meter, point it in the direction opposite from the one the lens is pointing (see opposite, right). This aligns the meter so that it receives the same amount of light as is falling on the subject as seen from camera position. Move close enough to the subject so that you do in fact read the same light that is falling on it. Indoors, for example, don't take a reading near a sunny window if your subject is standing in a dark corner.

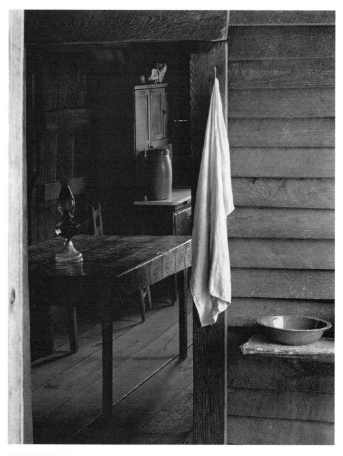

WALKER EVANS Hale County, Alabama, 1936

Most exposure meters assume that the scene you are metering contains an "average" distribution of tones from light to dark. *A meter reading of the overall scene produces a good exposure if this, in fact, is so, and if light and dark areas are of more or less equal importance. You can make an overall reading with a meter built into the camera or one that is hand-held (see opposite).*

More about . . .
- How to meter contrasty scenes, pages 96–97

Using a meter built into a camera

1. Set the camera to the film speed (the ISO rating) of the film you are using.

2. Set the exposure mode of the camera, if you have a choice: (a) aperture-priority automatic, (b) shutter-priority automatic, (c) programmed automatic, or (d) manual.

3. Look at the scene through the camera's viewfinder and activate the meter.

4a. In aperture-priority automatic operation, select an aperture small enough to give the desired depth of field. The camera will adjust the shutter speed. If your subject is moving or if you are hand-holding the camera, check the viewfinder readout to make sure that the shutter speed is fast enough to prevent blur. The wider the aperture you select, the faster the shutter speed that the camera will set. (Remember that a wide aperture is a small number: f/2 is wider than f/4.)

4b. In shutter-priority automatic operation, select a shutter speed fast enough to prevent blur. The camera will adjust the aperture. Check that the aperture is small enough to produce the desired depth of field. The slower the shutter speed you select, the smaller the aperture will be.

4c. In programmed automatic operation, the camera will adjust both shutter speed and aperture.

4d. In manual operation, you select both shutter speed and aperture. You can use the camera's built-in meter or a hand-held meter to calculate the settings.

Using a hand-held, reflected-light meter

1. Set the meter to the ISO rating of the film you are using.

2. Point the meter's photoelectric cell at the subject from the direction of the camera. Activate the meter.

3. Line up the number registered by the meter's indicator needle with the arrow on the calculator dial. (Not necessary with meters that automatically provide shutter-speed and f-stop combinations.)

4. Choose one of the combinations of shutter speed and f-stop shown on the calculator dial or provided as digital readout, and set the camera accordingly. Any combination shown by the meter lets in the same amount of light and produces the same exposure.

Using an incident-light meter

1. Set the meter to the ISO rating of the film you are using.

2. Point the meter's photoelectric cell away from the subject, in the opposite direction from the camera lens. Activate the meter. You want to measure the amount of light falling on the subject, so make sure that the meter is in the same light as the subject. For example, don't shade the meter if your subject is sunlit.

3. Line up the number registered by the meter's indicator needle with the arrow on the calculator dial. (Not necessary with meters that automatically provide shutter-speed and f-stop combinations.)

4. Choose one of the combinations of shutter speed and f-stop shown on the calculator dial or provided as digital readout, and set the camera accordingly. Any combination shown by the meter lets in the same amount of light and produces the same exposure.

Metering Scenes with High Contrast

The most common situation in which overall metering does not work is one with a subject against a much lighter background, for example, a portrait outdoors with a bright sky in the background. Suppose you are using a reflected-light meter, either built into the camera or hand held, one that averages all the tones in its angle of view. If you meter the scene overall, the bright sky will increase the entire reading too much. The meter will calculate an exposure that will underexpose the main subject and make it too dark.

Meter up close to prevent problems with contrasty scenes. If a subject is against a much lighter background, such as a bright sky, a very light wall, or a bright window indoors during the day, move in close enough so that you are metering mostly the main subject rather than the lighter background. Set the aperture and shutter speed from the up-close reading before you move back to take the picture (this page and opposite, top). Similarly, try not to include light sources, such as the sun or a lighted lamp, in a meter reading.

If you are metering a landscape, cityscape, or other distant scene, tilt the camera or meter down. That will exclude most of a bright sky from the reading; the lower reading will give a more accurate exposure for the land elements in the scene (opposite, bottom). Of course, if your main subject is the sky itself, such as a cloud formation, take your reading directly from the sky.

Less common, but sometimes a problem, is a subject against a much darker background, especially if the subject occupies only a small part of the image. Metering such a scene overall with a reflected-light meter would produce a reading that is too low and an overexposed and too-light picture. Prevention is the same: move in close to meter mostly the main subject.

How do you use an automatic camera to expose a picture with a background much lighter or darker than the subject? You can't simply meter the scene up close and then step back to take the picture. The camera will automatically recalculate the exposure from farther away, including the light or dark background that you want to exclude from the metering. You can change from automatic to manual operation, if that is possible with your camera, so that you can meter up close and then set both shutter speed and aperture yourself. Or use one of the means of overriding automatic exposure described on page 93.

If you are using an incident-light meter to determine the exposure for a scene that has both brightly lit and shaded areas, decide whether the light or dark areas are more important. If shaded areas are more important, make your reading in the shadows or with the meter shaded by your body or hand. If brightly lit areas are more important, make a reading with the meter held in the light.

Metering up close gives good results when contrast is high and the most important part of the scene is much darker or much lighter than its surroundings.

With a meter built into a camera, *move in until the main subject fills the viewfinder (be careful not to block the light on the subject). Make the reading, set the shutter speed and aperture, then move back to the original position to take the picture. With an automatic camera, set the camera for manual operation or override the automatic exposure.*

With a hand-held, reflected-light meter, *move in close enough to meter mostly the main subject, but not so close that you block the light. A spot meter, which reads a very narrow angle, can be used to meter a small part of a scene from farther away.*

An overall reading of a subject against a much lighter background often produces an underexposed (too dark) subject. *In this exposure, a large expanse of light sky was included in the area metered, which indicated a relatively high level of light. But the figure of the man was much darker than the sky; he did not receive enough exposure and came out very dark.*

Move in close to meter a subject against a much lighter background. *Come close enough so that the meter reads mostly the subject, but not so close that you cast a shadow on the area you are metering.*

A better exposure for the scene. *Having metered up close and set the correct exposure for the main subject, return to the original position to make the photograph. Now the face was more accurately rendered. A camera that automatically sets f-stops or shutter speeds must sometimes be manually overridden, as it was here, to get the exposure you want.*

An overall reading of a landscape that includes bright sky can underexpose the scene. *So much light comes from the sky that the reading produces too little exposure for the land elements in the scene. Here the sky is properly exposed but the buildings are too dark and lack detail.*

Tilt the meter down to exclude a bright sky when you meter a landscape. *For a proper exposure for the buildings, light reflected from them should be dominant when the reading is made. Point the camera or hand-held reflected-light meter slightly down so that the meter "sees" less of the sky and more of the buildings.*

A better exposure for the scene. *Having set the correct exposure by measuring the light reflected from the buildings, tilt the camera up to its original position. This time the buildings are lighter and reveal more detail. The sky is lighter also, but there is no significant detail there at either the lighter or darker exposures. Light areas, such as the sky, can easily be darkened when a print is made.*

You can decide in advance exactly what tone an important area will have in the final photograph. This is possible if you know that a reflected-light meter always recommends an exposure that will render any single metered area as middle gray. If you take three meter readings to make three different photographs—first of white lace, then of medium-gray tweed, and finally of black satin—the meter will indicate three different exposures that will record each subject as middle gray (photographs, this page).

You can choose how light or dark an area will appear by adjusting the exposure indicated by the meter. If you give more exposure than the meter indicates, the area metered will be lighter than middle gray in the final print. Less exposure will make an area darker than middle gray. For example, if you want the white lace to appear realistically as very light but still show substance and texture, expose two stops more than the meter recommends. (Snow scenes are a typical situation in which you might want to increase the exposure a stop or two because an overall reading can make the scene too dark.) If you want the black satin to appear rich and dark with full texture, expose two stops less than the meter recommends.

One area often metered when calculating exposures for a portrait is skin tone. While clothing and background can vary from very light to very dark, most people's skin tones are realistically rendered within only about a three-stop spread. Dark skins seem natural when they are printed

as middle gray or slightly darker. Average light-toned skins appear natural one stop lighter than middle gray. Extremely light skins can appear as light as two stops above middle gray. To use a skin tone as the basis for exposure, meter the lighter side of the face (if one side is more brightly lit than the other). For dark skin, use the exposure indicated by the meter; for medium light, give one stop more exposure; for unusually pale, give two stops more.

The other area often metered to determine exposure is the darkest shadow area in which it is important to retain texture and detail. In the photograph opposite, this is the woman's hair and the shadowed part of the wall to her right. If you want a major shadow area to appear very dark but with objects and details still clearly visible, meter the shadow area and then expose two stops less than the meter indicates.

Changing the exposure affects all the values in the print, not just the one you meter. One area will stay relatively lighter or darker than another—the woman's face (opposite) will always be lighter than her hair or the wall—but all will be either lighter or darker as the scene is given more or less exposure.

When shooting negative film, it is better to overexpose the film than to underexpose it. Detail in slightly overexposed highlights can be printed in, but detail that is missing from underexposed shadow areas cannot be added later on. (The opposite is true with color slides; see page 197.)

White lace given exposure suggested by meter

White lace given 2 stops more exposure

Gray tweed given exposure suggested by meter

Black satin given exposure suggested by meter

Black satin given 2 stops less exposure

Reflected-light meters calculate exposures for middle gray (see the three photographs above left). If you want a specific area to appear darker or lighter than middle gray, you can measure it and then give less or more exposure than the meter indicates (above right). The gray scale and chart opposite show how much to change the meter reading to get a specific tone. The chart is based on material developed by Ansel Adams.

More about . . .

- The Zone System, a method of controlling tones by adjusting exposure and development, pages 303–313

How to expose black-and-white film for specific tones. *If one area in a scene is particularly important, you can meter it, then find the exposure that will render that area as dark or as light as you want it to be in the final print.*

Five stops more exposure than indicated by meter. *Maximum white of the paper base. Whites without texture, glaring white surfaces, light sources.*

Four stops more exposure. *Near white. Slight tonality but no visible texture. Snow in flat sunlight.*

Three stops more exposure. *Very light gray. Highlights with first sign of texture, bright cement, textured snow, brightest highlights on light skin.*

Two stops more exposure. *Light gray. Very light surfaces with full texture and detail, very light skin, sand or snow acutely sidelit.*

One stop more exposure. *Medium-light gray. Lit side of average light-toned skin, shadows on snow in a scene with both shaded and sunlit snow.*

Exposure indicated by meter. Middle gray. *The tone that a reflected-light meter assumes it is reading. Neutral gray test card, dark skin, clear north sky.*

One stop less exposure. *Medium-dark gray. Dark stone, average dark foliage, shadows in landscape scenes, shadows on skin in sunlit portrait.*

Two stops less exposure. *Dark gray. Shadows with full texture and detail, very dark soil, very dark fabrics with full texture.*

Three stops less exposure. *Gray-black. Darkest gray in which some suggestion of texture and detail appears.*

Four stops less exposure. *Near black. First step above complete black in the print, slight tonality but no visible texture.*

Five stops less exposure than indicated by meter. *Maximum black that paper can produce. Doorway or window opening to unlit building interior.*

Some scenes can't be metered in the usual way. If there is light enough to see by, there is probably light enough to make a photograph, but the light level may be so low that you may not be able to get a reading from your exposure meter. Try metering a white surface such as a white paper or handkerchief; then give two stops more exposure than indicated by the meter.

If metering is not practical at all, the chart below, right, gives some starting points for exposures with ISO 400 film. Since the intensity of light can vary widely, bracket your exposures by making several shots at different exposures (see chart opposite). One of the exposures should be printable, and the range of exposures will bring out details in different parts of the scene.

Very long exposures can cause underexposure. If the exposure time is one second or longer, you may find that the film does not respond the same way that it does in ordinary lighting situations. In theory, a long exposure in very dim light should give the same result as a short exposure in very bright light. According to the photographic law of reciprocity, light intensity and exposure time are reciprocal; an increase in one will be balanced by a decrease in the other. But in practice the law does not hold for very long or very short exposures.

Reciprocity effect occurs at exposures of one second or longer (and at exposures shorter than 1/1000 second); you get a decrease in effective film speed and consequently underexposure. To make up for the decrease in film speed, you must increase the exposure. The exact increase needed varies with different types of film, but the chart below, left, gives approximate amounts. Bracketing is a good idea with very long exposures. Make at least two exposures: one as indicated by the chart, plus one more giving at least a stop additional exposure. Some meters are designed to calculate exposures of several minutes' duration or even longer, but they do not allow for reciprocity effect. The indicated exposure should be increased according to the chart.

Very long exposure times cause an increase in contrast since the prolonged exposure has more effect on highlights than on shadow areas. This is not a problem in most photographs, since contrast can be controlled when the negative is printed. But where contrast is a critical factor, it can also be decreased by decreasing the film development time. The amount varies with the film; exact information is available from the film manufacturer or see the chart below. Kodak's T-Max films require no development change. The reciprocity effect in color film is more complicated since each color layer responds differently, changing the color balance as well as the overall exposure.

Preventing reciprocity effect: Corrections for long exposures

Indicated exposure	With most black-and-white films				With Kodak T-Max films	
	Open up aperture or	Increase exposure time to also		Decrease development time	Open up aperture or	Increase exposure time to
1 sec	1 stop more	2 sec		10%	1/3 stop more	No increase
10 sec	2 stops more	50 sec		20%	1/2 stop more	15 sec
100 sec	3 stops more	1200 sec		30%	1 1/2 stops more with T-Max 400; 1 stop more with T-Max 100	300 sec with T-Max 400; 200 sec with T-Max 100

At exposure times of 1 sec or longer, film does not respond exactly as it does at shorter shutter speeds. One unit of light falling on film emulsion for 1 sec has less effect than 10 units of light falling on the same emulsion for 1/10 sec. This reciprocity effect during long exposure times means that exposures must be increased or the film will be underexposed, particularly in shadow areas.

To compensate for this, increase the indicated exposure as shown in the chart above. Highlights are less subject to reciprocity effect during long exposures with some films, so to prevent too dense highlights when you increase exposure, decrease development time if shown in the chart.

Exposing hard-to-meter scenes

Situation	Approximate exposure for ISO 400 film	
Stage scene, sports arena, circus event	1/60 sec	f/2.8
Brightly lighted downtown street at night, lighted store window	1/60 sec	f/4
City skyline at night	1 sec	f/2.8
Skyline just after sunset	1/60 sec	f/5.6
Candlelit scene	1/8 sec	f/2.8
Campfire scene, burning building at night	1/60 sec	f/4
Fireworks against dark sky	1 sec (or keep shutter open for more than one display)	f/16
Fireworks on ground	1/60 sec	f/4
Television or computer monitor image: Focal-plane shutter speed must be 1/8 sec or slower to prevent dark raster streaks from appearing in photographs of the screen	1/8 sec	f/11
Leaf shutter speed must be 1/30 sec or slower to prevent streak	1/30 sec	f/5.6

On Broadway at night, Lisl Dennis took a preliminary meter reading off the stone of the statue base because she wanted to make sure that the inscription would show. From that point, she "bracketed like a bandit." The original of this picture was on color transparency film, which has very little tolerance for under- or overexposure, so Dennis bracketed in half-stop increments. Larger increments are satisfactory with black-and-white film. The backward tilt to the statue and the buildings comes from angling a short-focal-length lens upward.

LISL DENNIS Broadway at Night, 1982

Bracketing exposures

Bracketing helps if you are not sure about the exposure, by producing lighter and darker versions of the same scene. To bracket, you make several exposures of the same scene, increasing and decreasing the exposure by adjusting the aperture, shutter speed, or both. Among several different exposures, there is likely to be at least one that is correct. Professional photographers often bracket as protection against having to repeat a whole shooting session because none of their exposures was quite right.

To bracket, first make an exposure with the aperture and shutter speed set by the automatic system or manually set by you at the combination you think is the right one. Then make a second shot with one stop more exposure and a third shot with one stop less exposure.

Bracketing is easy if you set the exposure manually: For one stop more exposure, either set the shutter to the next slower speed or the aperture to the next larger opening (the next smaller f-number). For one stop less exposure, either set the shutter to the next faster speed or the aperture to the next smaller opening (the next larger f-number).

How do you bracket with an automatic exposure camera? In automatic operation, if you change to the next larger aperture, the camera will simply shift to the next faster shutter speed, resulting in the same overall exposure. Some cameras have exposure compensation features that override automatic exposure in order to provide bracketing. See page 93 for other means of overriding the camera's automatic system. Even better, see your manufacturer's instruction book for how to do so with your particular camera.

Original exposure. Suppose an exposure for a scene is 1/60 sec shutter speed at f/5.6 aperture.

1/8	1/15	1/30	1/60	1/125	1/250 sec shutter speed
f/16	f/11	f/8	f/5.6	f/4	f/2.8 aperture

Bracketing for one stop less exposure. To lighten a negative (darken a slide) by giving one stop less exposure, keep the shutter speed at 1/60 sec, while changing to the next smaller aperture, f/8. (Or keep the original f/5.6 aperture, while changing to the next faster shutter speed, 1/125 sec.)

1/8	1/15	1/30	1/60	1/125	1/250 sec shutter speed
f/16	f/11	f/8	f/5.6	f/4	f/2.8 aperture

Bracketing for one stop more exposure. To darken a negative (lighten a slide) by giving one stop more exposure, keep the shutter speed at 1/60 second while changing to the next larger aperture, f/4. (Or keep the original f/5.6 aperture, while changing to the next slower shutter speed, 1/30 sec.)

1/8	1/15	1/30	1/60	1/125	1/250 sec shutter speed
f/16	f/11	f/8	f/5.6	f/4	f/2.8 aperture

What do you do if you can't get close enough to the subject to make a reading and you don't have a spot meter that can make a reading at a distance? The solution is to make a substitution reading. Suppose you are photographing a boat, but water between you and it makes it impossible to walk over to make a reading directly. You can often find an object with a similar tone and in similar light nearby to meter instead.

One object always with you that can be metered is the palm of your hand. Average light-toned skin is about one stop lighter than the middle-gray tone for which meters calibrate an exposure, so if your skin is light, give one stop more exposure than the meter indicates. If the skin of your palm is dark, use the indicated exposure. Even better, calibrate your palm: meter it, then meter a gray card (described below) and see how much the readings differ.

Another useful substitution reading is from a gray card, a test card of a standard gray tone. This is a piece of 8 x 10-inch cardboard with a gray side that reflects 18 percent of the light falling on it and a white side that reflects 90 percent of the light. Since light meters are calibrated for a middle-gray tone of about 18 percent reflectance, a reading from a gray card produces an accurate exposure if the card is placed so that it is lit from the same angle as the subject. If the light is very dim, make a reading from the white side of the card; it reflects five times as much light as middle gray, so increase the indicated exposure five times (two and one-third stops).

A gray card is often used to balance the light in a studio setup or when copying an object such as a painting. It is also useful in color photography as a standard against which the color balance of a print can be matched.

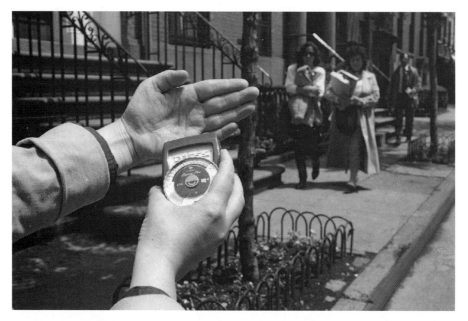

Metering the palm of your hand makes a quick substitution reading, for example when photographing fast-moving situations such as street scenes. Hold your palm so that the light on it is about the same as on the people or objects you want to photograph. If your skin is an average light tone, expose one stop more than the meter indicates.

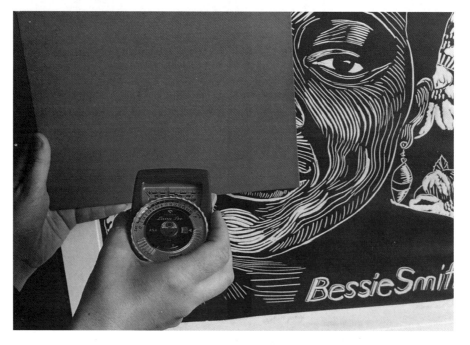

An exposure can be calculated by metering the light reflected from a standard-gray test card. Place the card at the same angle to the light as the front of the subject. Meter the card from the direction that the camera will be when you are shooting. Don't meter at an angle if the camera will be shooting head on. When you meter any object at close range, hold the meter or camera so that it does not cast a shadow on the subject.

In a silhouette, the subject is underexposed against a much lighter background. This is a deliberate version of the same effect that makes a subject very dark if a very light background such as the sky is included during metering (see page 97). President Kennedy leaned on the table in his oval office while he read a paper. The windows were so much brighter than the rest of the scene that Tames was able to turn a relatively ordinary scene into a graphic silhouette. Several stops more exposure would have produced a normal rendering of the interior of the office, with the windows probably appearing white.

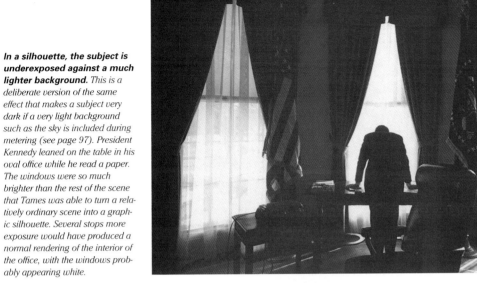

GEORGE TAMES The Loneliest Job, President John F. Kennedy, Oval Office, 1961

Before making an exposure, stop for a moment to visualize how you want the final print or slide to look. Do this especially if you are using a camera in an automatic exposure mode. Using many automatic exposure cameras is like using a hand-held reflected-light meter to make a reading of the overall scene. If the scene has an average tonal range, an overall reading produces a good exposure. But many scenes (like the one on this page, bottom) do not have an average range of tones. You can use automatic exposure or make an overall reading when an overall exposure will work well; when it won't, make the metering decisions yourself.

Sometimes you will want an out-of-the-ordinary interpretation, like a silhouette (this page, top), which is produced by underexposing part of a scene. Terminology like "underexposed" implies that there is a "correct" exposure. There is—when you want it that way. Don't let anything stop you from experimenting or doing something differently if that is what you want.

If a scene is high key—light overall, the reading recommended by a hand-held reflected-light meter or by a meter built into a camera will probably make the scene too dark. Meters calculate exposures based on the assumption that the tones in a scene average out to middle gray. If a scene has many very light tones (such as a snow scene) or if you want most of the tones in a scene to appear lighter than average in a print, try giving one or two stops more exposure. Bracket the exposures if you are not sure.

ELLEN LAND-WEBER Greece

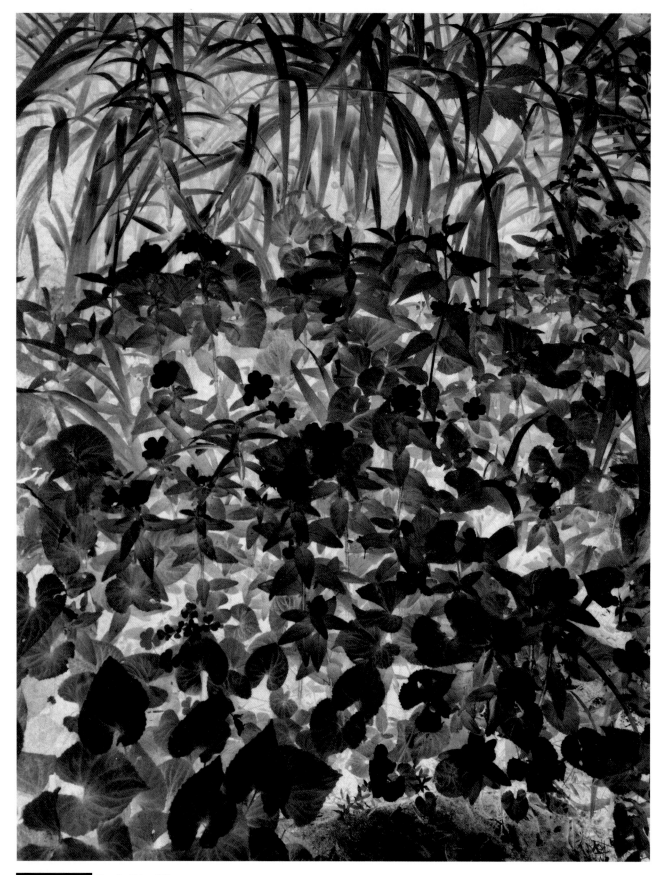

Printing a photograph as a negative image instead of as a positive one often makes the literal recording of a scene less important (as with the spring wildflowers, opposite) and strengthens the graphic elements of line and form. The dark shadow areas in the original scene (or in a positive print) become light so that light seems to come from behind or within the subject. The dark objects in this print (light-toned flowers in the original scene) appear to float on the surface of the print.

PAUL CAPONIGRO Negative Print, 1963

Developing the Negative 6

Once your image has been exposed, your next step is to make it visible. In one sense, the moment the camera shutter exposes the film, the picture has been made. Yet nothing shows on the film; the image is there, but it is latent or invisible. Not until it has been developed and printed is the image there to be enjoyed. How enjoyable it will be depends to a great extent on the care you use when you do darkroom work.

There are many opportunities in developing and printing to control the quality of the final photograph. This control begins with the development of the negative. The techniques are simple and primarily involve exercising care in following standard processing procedures and in avoiding dust spots, stains, and scratches. The skills needed to develop good negatives are quickly learned and the equipment needed is modest, but the reward is great—an increased ability to make the kind of pictures you want.

How to Process Black-and-White Roll Film
Equipment and Chemicals You'll Need

Equipment to load film

Developing reel holds and separates the film so that chemicals can reach all parts of the emulsion. Choose a reel to match the size of your film, for example, 35mm, or the larger 120 roll-film size. Some plastic reels can be adjusted to different sizes.

Stainless-steel reels are somewhat more difficult to learn to load than are plastic reels. However, many photographers use them because they are durable and easy to clean of residual chemicals.

Developing tank accepts the reel loaded with film. Loading has to be done in the dark, but once the film is inside and the light-tight top is in place, processing can continue in room light. A light-tight opening in the top of the tank lets you pour chemicals in and out.

Ideally, the cover should allow you to turn the tank upside down to agitate the solution inside during processing. Some tanks hold only one reel; larger tanks are made that hold two or more reels.

Bottle-cap opener pries off the top of a 35mm film cassette. Special cassette openers are also available.

Scissors trim the front end of 35mm film square and cut off the spool on which the film was wound.

Optional: **Practice roll of film** lets you get used to loading the developing reel in room light before trying to load an actual roll of film in the dark. Light striking the practice roll will ruin it, so don't use a roll you want to develop.

A completely dark room is essential for loading the film on the reel. Even a small amount of light can fog film. If you can see objects in a room after 5 minutes with lights out, the room is not dark enough.

If you can't find a dark enough room, use a changing bag, a light-tight bag into which fit your hands, the film, reel, tank, cover, opener, and scissors. After the film is in the tank with the cover on you can take the tank out of the bag into room light.

Equipment to process film

Tri-X film	65° F min	68° F min
HC-110 (Dilution B)	8 1/2	7 1/2
D-76	9	8
D-76 (1:1)	11	10
Microdol-X	11	10

Manufacturer's instructions included with the film or developer give recommended combinations of development time and developer temperature.

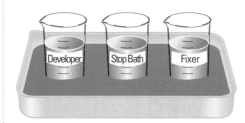

Containers for working solutions must be large enough to contain the quantity of solution needed during processing. Measuring graduates are convenient to use. Have three for the main solutions—developer, stop bath, and fixer. It is good practice to reserve a container for developers only; even a small residue of stop bath or fixer can keep the developer from working properly.

Optional: **Tray or pan** can be used as a water bath for the containers of working solutions to keep them at the correct temperature.

Timer with a bell or buzzer to signal the end of a given period is preferable to a watch or clock that you must remember to consult. An interval timer can be set from 1 sec to 60 min and counts down to zero, showing you the amount of time remaining.

More about . . .

- Mixing and handling chemicals, including chemical safety, pages 108–109

Film washer is the most efficient way to wash the film. If one isn't available, you can insert a hose from a water tap into the core of the reel in the processing tank.

Film clips attach washed film to a length of string or wire to hang to dry. Spring-loaded clothespins will do the job. A dust-free place to hang the wet film is essential. A school darkroom usually has a special drying cabinet; at home, a bathroom shower is good.

Optional: **Photo sponge** wipes down wet negatives so that they dry evenly.

Negative storage pages protect the dry film.

Chemicals to process film

You will need three basic chemical solutions to process black-and-white film—developer, stop bath, and fixer. In addition a, washing aid is highly recommended; a wetting agent is optional.

Developer converts the latent (still invisible) image in exposed film to a visible image. Choose a developer designed for film, not for prints.

An all-purpose developer is your best choice for general use and for your first rolls of film, for example, Edwal FG7, Ilford ID-11, or Kodak D-76 (T-Max developer if you use T-Max films).

Fine-grain developers, such as Edwal Super-20, Ilford Ilfotec HC, or Kodak Microdol-X, produce finer grain, but with possible loss in contrast and apparent sharpness; some dilutions cause a loss in film speed. See manufacturer's data.

The life of a developer depends on the type of developer, storage conditions, and other factors. See Handling Chemicals, page 108.

Stop bath stops the action of the developer. Some photographers use a plain water rinse for a stop bath. Others prefer a mildly acid bath prepared from about 1 1/2 oz of 28 percent acetic acid per quart of water.

An indicator-type stop bath is available that changes color when it is exhausted, but many photographers simply mix the stop bath fresh each time.

Fixer (also called hypo) makes film no longer sensitive to light, so that when fixing is complete the negative can be viewed in ordinary light. Use a fixer with hardener, which makes film more resistant to surface damage. Use a rapid fixer with T-Max films.

Fresh fixer treats about 25 rolls of film per quart of working solution (fewer rolls with T-Max films). The age of the solution also affects its strength.

Fixer check or hypo check is the best test of fixer strength. A few drops of the test solution placed in fresh fixer will stay clear; the drops turn milky white in exhausted fixer.

Highly recommended: **Washing aid** (also called a clearing bath, clearing agent, or fixer remover) such as Heico Perma Wash or Kodak Hypo Clearing Agent. After the film has been fixed, immersing it in the washing aid solution, then washing in running water provides more effective washing in much less time than washing in water alone. The shortened wash time also reduces swelling and softening of the emulsion and makes the wet film less likely to be damaged.

Different brands vary in capacity and storage; see manufacturer's instructions.

Optional: **Wetting agent,** such as Kodak Photo-Flo, used after washing, reduces the tendency of water to cling to the surface of the film and helps prevent water spots during drying, especially in hard-water areas.

A small amount of wetting agent treats many rolls of film. Discard the diluted solution periodically.

Handling Chemicals

Equipment to mix and store chemicals

Source of water is needed for mixing solutions, washing film, and cleaning up. A hose on a faucet splashes less than water straight from the faucet.

Photographic thermometer measures the temperature of solutions. An accurate and easy-to-read thermometer is essential because temperatures must be checked often and adjusted carefully. You will need a temperature range from about 50° to 120°F.

Graduated containers measure liquid solutions. Two useful sizes are 32 oz and 8 oz. Graduates can be used for mixing and for holding the working solutions you will need during processing.

Mixing containers hold solutions while you mix them. You can use a graduated container for smaller quantities or a storage container with a wide mouth for larger ones.

Storage containers hold chemical solutions between processing sessions. They should be of dark glass or plastic to keep out light. Caps should close tightly to minimize contact with air, which causes oxidation and deterioration of chemicals. Some plastic bottles can be squeezed and capped when partially full to expel excess air.

Stirring rod mixes chemicals into solution. The rod should be of an inert and nonabsorbent material such as hard plastic that will not react with or retain chemicals.

Funnel simplifies pouring chemicals into storage bottles.

Safety equipment, such as rubber gloves and safety goggles, protects you from unwanted exposure to chemicals. See details opposite.

How to mix and handle chemicals

Record keeping. After processing film, write down the number of rolls developed on a label attached to the developer bottle—if you are not using a one-shot developer (see below). The instructions that come with developers tell how many rolls can be processed in a given amount of solution and how to alter the procedure if the solution is reused. Each succeeding roll of film requires either extra developing time or, with some developers, addition of a replenisher. Also record the date the developer was first mixed, because even with replenishing most developers deteriorate over time. Check the strength of the fixer regularly with a testing solution made for that purpose.

Replenishing developers. Some developers can be used repeatedly before being discarded if you add additional chemicals to them to keep the solution up to full strength. Carefully follow the manufacturer's instructions for replenishment.

One-shot developers. These developers are designed to be used once and then thrown away. They simplify use (in that no replenishment is needed), and they can give more consistent results than a developer that is used and saved for a long time before being used again.

Mixing dry chemicals. Add dry chemicals to water at the temperature suggested by the manufacturer. Stir gently until dissolved. If some of the chemicals remain undissolved, let the solution stand for a few minutes. Be sure the solution has cooled to the correct temperature before using.

Diluting a stock solution to a working solution. Chemicals are often sold or mixed first as concentrated liquids (stock solutions). When the chemical is to be used, it is diluted into a working solution, usually by the addition of water. The dilution of a liquid concentrate may be given on an instruction sheet as a ratio, such as 1:3. The concentrate is always listed first, followed by the diluting liquid. A developer to be diluted 1:3 means 1 part developer and 3 parts water. To fill a 16-oz developing tank with such a dilution, use 4 oz developer and 12 oz water.

Adjusting temperatures. To heat up a solution, run hot water over the sides of the container (a metal one will change temperature faster than glass or plastic) or

place it in a pan of hot water. Placing a container in a tray of ice water will cool down a solution in just a few minutes; cooling by running tap water over the container can take a long time unless the tap water is very cold. Stir the solution gently from time to time; the temperature of the solution near the outside of the container will change faster than at the center.

Avoid unnecessary oxidation. Oxygen speeds the exhaustion of most chemicals. Don't use the "cocktail shaker" method of mixing chemicals by vigorously shaking the solution; this adds unwanted oxygen. Store all chemicals in tightly closed containers to prevent their exposure to air. Developers are also affected by light and heat, so store them in dark-colored bottles at temperatures around 70° F, if possible.

Contamination—chemicals where they don't belong—can result in many darkroom ills. Fixer on your fingers transferred to a roll of film being loaded for development can leave a neat tracery of your fingerprints on the film. A residue of the wrong chemical in a tank can affect the next solution that comes into contact with it. Splashes of developer on your clothes will slowly oxidize to a brown stain that is all but impossible to remove. These problems and more can be prevented by taking a few precautions:

Rinse your hands well when chemicals get on them and dry them on a clean towel; be particularly careful before handling film or paper. It isn't enough just to dip your hands in the water in a temperature-control pan or print-holding tray; that water may also be contaminated.

Use lint-free paper towels for drying, since cloth ones quickly become loaded with chemicals. If you are conservation minded, use a cloth towel, but wash it frequently.

Rinse tanks, trays, and other equipment well both before and after use. Be particularly careful not to get fixer or stop bath into the developer; they are designed to stop developing action, and that is exactly what they will do. Make sure reels, especially plastic ones, are completely dry before loading film.

Wear old clothes or a lab apron in the darkroom.

Keep work areas clean and dry. Wipe up spilled chemicals and wash the area with water.

Photographic chemicals should be handled with reasonable care, like all chemicals. The following guidelines—in many cases, simple common sense—will prevent problems and minimize injury if problems occur. If you have allergies, asthma, sensitive skin, or are pregnant, consult your doctor first.

The goal is to avoid getting chemicals onto, and especially into, your body. Preventing problems is much better than fixing them. The more often you expose yourself to a chemical, the more likely you are to eventually have a problem.

Know what you are handling. Read labels before using any new product so you know what hazards might be present and what to do if problems occur.

Material Safety Data Sheets (MSDSs) provide valuable additional information. Your camera store should provide these for any photochemical they sell. If they don't, you can request them from the manufacturer.

Additional information is available from manufacturers, professional organizations, and other groups. See box on this page for some phone numbers and the Bibliography for safety publications and where to get them.

Avoid skin contact. Look for label warnings such as, "Harmful if absorbed through the skin."

Dermatitis (reddening, itching, peeling, or other skin disorders) can be caused by repeated contact with chemicals, especially Metol-based developers. Several Metol-free developers are available, which may reduce the problem: for example, for film—Cachet AB-55, Edwal FG7, Ilford Ilfotec HC, and Kodak Xtol; for paper—Cachet Professional Plus, Edwal "G," and Ilford Multigrade.

Rubber gloves and printing tongs will keep chemicals off your hands. Thin disposable gloves provide inadequate protection; heavier rubber ones are better. Rinse gloves thoroughly before taking them off so you don't get chemicals onto your hands. A waterproof apron will keep chemicals off your clothes.

If you do get chemicals on your skin, wash immediately. Developers, which are alkaline, should be washed off with a pH-balanced soap such as Phisoderm. Replace skin oils with a good hand lotion.

Avoid getting chemicals in your eyes.

Protective goggles are the best defense when handling toxic substances.

If you do get chemicals in your eye, immediately rinse the open eye for 15 minutes in cool running water. Keep a hose attached to the cold water tap for just this purpose. A permanent eye-wash station is even better. Get medical attention immediately.

Avoid getting chemicals in your mouth.

Don't eat or drink in the darkroom. It's too easy to get chemicals on your hands, then into your mouth.

Don't smoke in the darkroom. Not only can you get chemicals onto a cigarette and into your mouth, but inhaling will carry chemical dust and fumes deep into your lungs.

Wash your hands after handling chemicals, especially before eating, so you don't carry chemicals out of the darkroom onto your plate.

Avoid inhaling chemicals. Using liquid chemistry rather than mixing dry chemicals will prevent accidental inhalation of chemical dust.

Adequate ventilation is vital wherever chemicals are used. Ideally, the ventilation system should replace the air once every five minutes.

A particle mask or respirator can prevent inhalation of chemicals. A particle mask can block some chemical dust. A respirator may be useful in certain situations, such as when handling large quantities of dry chemicals or cleaning up a toxic spill. Proper fitting of the respirator is essential, as is training for its maintenance and use.

Clean up chemical spills promptly, safely, and thoroughly.

Rinse well areas that came in contact with chemicals, and rinse well the equipment you used for cleanup. Clean your clothing, including your shoes, if they came in contact with the spill.

Additional measures. Depending on the extent of the spill and the toxicity of the chemical, you may also need to increase ventilation to the area and make use of protective gear, including a respirator. Discard sponges, mops, or cloths used to clean up toxic chemi-

cals; you don't want to use them again and accidentally spread chemicals over another surface. Don't hesitate to call 911 if the spill is so toxic that you feel you can't clean it up safely, for example a large spill of concentrated acid.

Be cautious when using any acid, particularly in a concentrated form.

Add acid to water, never water to acid. This will decrease the possibility of concentrated acid splashes.

For external contact with a concentrated acid, flush with cold water immediately—do not scrub—until the area is completely clean. Do not use ointments or antiseptic preparations. Cover with a dry, sterile cloth until you can get medical help.

For eye contact, immediately flood the eye with running water for at least 15 minutes. Then always get medical help.

For internal contact, do not induce vomiting. Instead dial 911 or get medical help immediately.

Take extra precautions with certain chemicals. Concentrated acids, strong alkalis, color chemistry, and intensification, bleaching, reduction, and toning chemicals are particularly likely to cause problems if you splash them onto yourself.

Store chemicals safely and out of the reach of children. Mark bottles clearly, close them tightly, and keep them where others, especially children, won't mistake them for juice or other everyday substances. Don't reuse milk bottles or juice containers that might confuse children. Be aware that children are more sensitive to toxic chemicals than adults are.

If you do have a problem, don't try to self-medicate. A little skin rash is worth a visit to the doctor before it grows into a major problem. Avoid over-the-counter medications, especially those advertised for reducing itching; they can make the problem worse.

Dispose of chemicals properly.

Small amounts of most photo chemicals can be safely discarded into a public sewer system if local regulations don't forbid it. Kodak recommends mixing the developer (a base) with the fixer (an acid), which will neutralize the pH of the two. Flush down the drain with running water. Only very small amounts of photo waste should go into a septic tank; it's better to have the solutions hauled away by a commercial waste-collection company.

Larger users, like schools, must comply with federal, state, and local environmental regulations. They may require silver recovery programs and commercial waste collection.

If you have questions, don't guess. Call Kodak's environmental hotline (see box, this page) or check with local environmental agencies.

How to develop film successfully.
Developing film is a relatively straight-
forward procedure, and a little attention to
detail will go a long way toward producing
consistent and satisfactory results.

Orderliness will make development
simpler. Developing your first (and all
future) rolls of film will be simplified if you
arrange your equipment in an orderly and
convenient way. The process starts in total
darkness and, once begun, moves briskly.

Consistency also pays off: if you want
to avoid unpredictable results such as too
dense, too thin, or unevenly developed
negatives, mix your solutions accurately,
adjust their temperatures within a degree
or two, agitate film at regular intervals dur-
ing processing, and watch processing times
carefully.

Cleanliness of your hands, containers,
surfaces, and anything else your film and
chemicals contact will prevent inconsistent
development, mysterious stains, and gener-
al aggravation. Darkrooms usually have a
dry side where film is loaded and printing
paper exposed, and a wet side with sinks
where chemicals are mixed and handled.
Keep chemicals and moisture away from
the dry side and off your hands when you
are loading film.

Preparation

Kodak T-Max 400 Professional Film

KODAK Developer	Small-Tank Developing Time in Minutes				
	65° F (18° C)	68° F (20° C)	70° F (21° C)	72° F (22° C)	75° F (24°C)
T-Max	—	7	6 ½	6 ½	6
D-76	9	8	7	6 ½	5 ½
D-76 (1:1)	14 ½	12 ½	11	10	9
HC-110 (Dil B)	6 ½	6	5 ½	5	4 ½
Microdol-X	12	10 ½	9	8 ½	7 ½

The development times in bold type are the primary recommendations

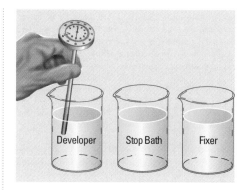
Developer Stop Bath Fixer

**1 Select a time and temperature for your film
and developer combination.** See the manufac-
turers' charts that accompany films and developers. If a
chart lists different times for large tanks and small tanks
(also called reel-type tanks), use the small-tank times.

The preferred temperature (listed on the chart in
bold type) is usually 68° F. Use a higher temperature
(and shorter development time) if your tap water is
very warm. Ideally, wash water should be within about
5° F of the developer temperature.

Set the timer to the selected time, ready to
start at the beginning of the development.

**2 Mix the developer, stop bath, and fixer to
their working strength and adjust their tem-
peratures.** Mix at least enough solution to completely
cover the reel (or reels) in the tank. Using protective
gloves, especially while handling developers, is a sensi-
ble precaution against skin irritations.

Adjust the temperature of the developer exactly;
the other solutions should be within about 3° F of the
developer. Excessive temperature changes can cause
increased graininess and other problems in the film.
Rinse the thermometer between chemicals.

Loading the film

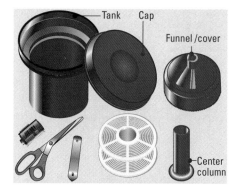
Tank Cap
Funnel /cover
Center column

3 Set out materials for loading the film.
Arrange in a light-tight area the film cassette,
bottle-cap opener, scissors, reel, and developing tank.
Make sure you have all the parts to the tank. The film is
loaded onto the reel in the dark and has to be put into
the tank and covered before you turn on the lights.

All the materials, the working surface, and your
hands should be clean and dry. If the reel adjusts to dif-
ferent sizes of film, set it to the size you are using.

4 Lock the door and turn out all the lights,
including any darkroom safelights, before you
open the film. Remove gloves, if you used them to pre-
pare chemicals.

**To remove film from a standard 35mm cas-
sette,** find the spool end protruding from one end of
the cassette. Hold the cassette by this end while you pry
off the other end with the bottle-cap opener. Slide the
spool of film out of the cassette.

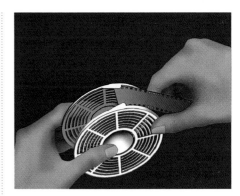

ALTERNATE PROCEDURE

Opening 2 1/4-inch roll film

Break the paper seal and unwind the paper until you reach the film. Let the film roll up as you continue unwinding the paper. When you reach the end of the film, gently pull it free of the adhesive strip that holds it to the paper. Do not unroll film too rapidly or you may generate static electricity that produces enough light to streak the film.

5 **Use the scissors to cut off the half-width strip at the beginning of a roll of 35mm film.** Try to cut between the sprocket holes, not through them, or the film may not load properly onto the developing reel. Or you can cut straight across the film, then clip the corners at an angle to cut off the first sprocket holes.

To test the cut, run your finger along the squared-off end of the film. (Remember, you are doing this in the dark.) If you feel a snag, make another cut close to the end of the film. When the end feels smooth, the cut is correct.

6 **Align the film to the reel and insert.** Hold the spool of film in either hand so that the film unwinds off the top. Hold the reel vertically in your other hand with the entry flanges at the top, evenly aligned and pointing toward the film.

Insert the end of the film just under the entry flanges at the outermost part of the reel. Push the film forward about half a turn of the reel.

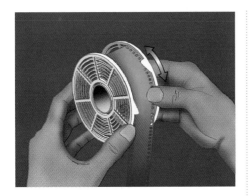

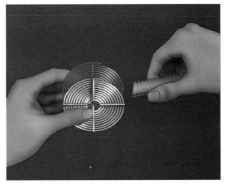

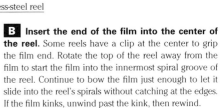

7 **Hold the reel in both hands and turn the two halves of the reel back and forth** in opposite directions to draw the film into the reel.

ALTERNATE PROCEDURE

Loading a stainless-steel reel

A **Align the film to the reel.** Hold the spool of film in either hand so that the film unwinds off the top. Unwind about 3 inches and bow it up slightly between thumb and forefinger. Hold the reel vertically in your other hand with the ends of the reel's spiral coils at the top, pointing toward the film.

B **Insert the end of the film into the center of the reel.** Some reels have a clip at the center to grip the film end. Rotate the top of the reel away from the film to start the film into the innermost spiral groove of the reel. Continue to bow the film just enough to let it slide into the reel's spirals without catching at the edges. If the film kinks, unwind past the kink, then rewind.

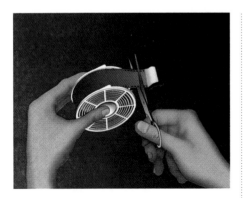

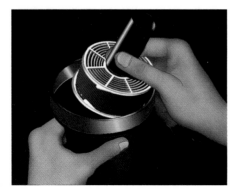

Development

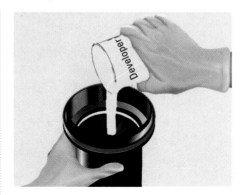

8 **When you reach the end of the roll,** use the scissors to cut the film free from the cassette's spool.

9 **Assemble the tank and reel.** With this type of tank, put the loaded reel on the tank's center column and put both into the tank. Put the funnel/cover over the center column. Twist the cover to lock it in place.

Developing one reel of film in some two-reel tanks (usually a stainless-steel tank) requires putting an empty reel on top of the loaded one to keep the loaded reel from bouncing around as you agitate it.

With the funnel/cover in place, the film is protected from light. You can now turn on the lights or take the tank to the developing area.

10 **Check the solution temperatures.** If necessary, adjust them before pouring the developer into the tank.

A tray filled with water at the developing temperature will help maintain solution temperatures, especially in a cold darkroom. Leave each container of chemicals in the tray until you are ready to use it.

Start the timer and quickly pour the developer into the tank. Keep the tank cover in place as you pour chemicals in or out through its funnel opening. Some tanks fill more quickly if the tank is tilted slightly.

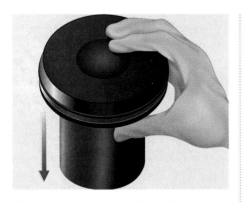

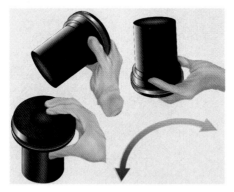

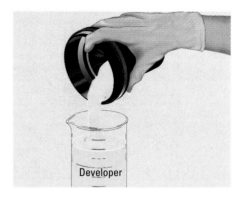

11 **Start agitation immediately.** Put the cap on the tank to keep liquids from leaking. First, rap the bottom of the tank sharply against the sink or counter several times to dislodge any air bubbles that may have attached themselves to the film.

12 **Begin the regular agitation pattern to be followed throughout the development time:** Gently turn the tank upside down, then right side up again 5 times, with each of the 5 inversions taking about 1 sec.

Let the tank rest for the remainder of the first 30 sec.

Continue to agitate by inverting the tank for 5 sec out of every 30 sec of the remaining development time.

13 **Remove only the tank cap so you can pour out the developer.** Leave the funnel/cover in place to protect the film from light.

Begin pouring out the developer a few seconds before the timer signals that development is completed.

Stop bath

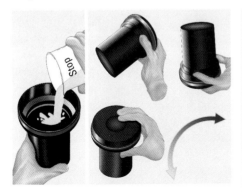 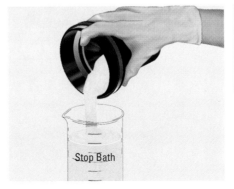

14 **Quickly pour the stop bath into the tank through the funnel opening in the cover.** Replace the cap on the tank. Agitate continuously for about 30 sec.

15 **Remove the tank cap, leaving the funnel/cover in place, and pour out the stop bath.** Discard a plain water stop bath. You can save an acetic acid stop bath for reuse, but some photographers throw it out because it is inexpensive and easier to store as a concentrated solution.

Fixing

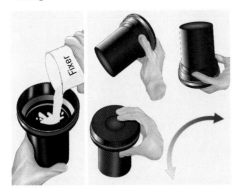 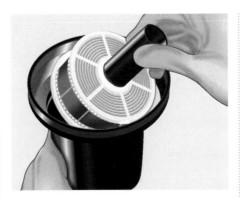 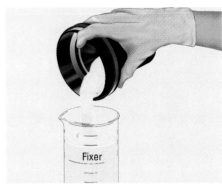

16 **Pour fixer into the tank through the funnel opening in the cover.** Replace the cap on the tank. Agitate the fixer continuously for the first 30 sec of the recommended fixing time, then at 30-sec intervals. Fixing takes 5–10 min with regular fixer, 2–4 min with rapid fixer.

17 **Check that the film is clearing.** About halfway through the fixing period, open the tank to take a quick look at the end of the roll. If the film has a milky appearance, the fixer is weak and should be discarded. Keep the tank covered and refix the film in fresh fixer. The tank can be uncovered when the milky appearance is gone.

18 **Pour out the fixer,** saving it for future use. Either keep track of the number of rolls processed in the fixer, discarding the fixer when the manufacturer's recommended limit is reached, or test the fixer regularly with a fixer check solution, which indicates when the fixer is exhausted and should be discarded.

Washing and drying

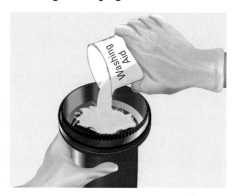

19 **Treat the film with a washing aid solution before washing.** This optional, but highly recommended, treatment greatly reduces washing time and removes more of the fixer from the film than water alone can remove.

Follow manufacturer's directions for use, usually a 30-sec rinse in running water, followed by immersion in the washing aid solution for about 2 min. Agitate at 30-sec intervals.

20 **Wash the film.** Adjust faucets to provide running water within about 5° F of the development temperature. Leave the reel in the open tank in the sink and insert the hose from the tap into the core of the reel. Let the water run fast enough to completely change the water in the container every 5 min. Empty the water and refill several times.

Wash the film about 30 min if you did not use washing aid, about 5 min if you did.

If one is available you can use a specially designed—and more efficient—film washer.

21 **After washing, treat the film with a wetting agent,** such as Kodak Photo-Flo. This procedure is optional, but is useful to help prevent water spots, especially in hard-water areas. Follow manufacturer's directions for use, especially for the dilution.

22 **Unwind the film from the reel and hang it up to dry.** Attach a clip or clothespin to the bottom end of the film to keep the film from curling. Let dry in a dust-free place. A film-drying cabinet is the best place. At home, a good dust-free location is inside a tub or shower with shower curtain or door closed.

23 **If water spots are a problem,** even if a wetting agent is used, try removing excess water by very gently running a damp, absolutely clean photo sponge or squeegee down the film.

Handle wet film very gently; the wet emulsion, in particular, is soft and and easily scratched. Resist the temptation to examine the negatives until they are dry; dust quickly accumulates on wet film.

24 **Protect the dry negatives and clean up the darkroom.** When the film is dry, cut it into appropriate lengths to fit into protective sleeves. Hold film only by its edges to avoid fingerprints or scratches. Careful treatment of negatives now will pay off later when they are printed.

Discard a one-shot developer or save and replenish developer that can be reused. Store solutions that you want to save in tightly closed containers. Clean your hands, the reel, tank, containers, and any other equipment that came in contact with chemicals.

Processing black-and-white roll film—A summary

Step	You'll Need	Procedure
1–2. Preparation *(numbered steps begin on page 110)*	Developer, stop bath, fixer, time-and-temperature chart, thermometer, containers for chemicals. Rubber gloves will protect against possible skin irritation.	Select a developing time and developer temperature from the time-and-temperature chart.
		Dilute the chemicals to working strength. Adjust the developer temperature exactly. Adjust the stop bath and fixer to within 3° F of the developer.
3–9. Loading the film	Film, developing reel and tank (with cover), bottle-cap opener, scissors, a completely dark room	Set out the items needed. Make sure your hands and equipment are clean and dry.
		TURN OUT ALL LIGHTS. Load the film onto the reel, put in the tank, and put on the tank cover. Lights can be turned on when the tank is covered.
10–13. Development	Developer at the selected temperature, timer	Check the solution temperatures and adjust, if needed. Start the timer.
		Pour the developer into the tank through the pouring opening in the tank cover. DO NOT REMOVE THE TANK COVER. Cap the tank opening so it can be agitated without leaking.
		Rap tank bottom against a solid surface to dislodge any air bubbles. Agitate by inverting the tank several times for 5 sec, then during 5 sec out of every 30 sec of development time.
		A few seconds before the development time ends, pour out the developer through the pouring opening in the cover. DO NOT REMOVE ENTIRE COVER.
14–15. Stop bath	Stop bath within 3° F of developer temperature	Immediately fill tank through pouring opening with stop bath. Agitate for 30 sec.
		Pour out through pouring opening. DO NOT REMOVE ENTIRE COVER.
16–18. Fixing	Fixer within 3° F of developer temperature	Fill tank through pouring opening with fixer. Agitate for 30 sec, then every 30 sec for the recommended time, about 5–10 min with regular fixer, 2–4 min with rapid fixer. The tank cover can be removed when fixing is complete.
19. Washing aid (highly recommended)	Running water plus washing aid (diluted to working strength) within 5° F of developer temperature	Rinse 30 sec in running water, then immerse in the washing aid solution for about 2 min (check manufacturer's instructions). Agitate at 30-sec intervals.
20. Washing	Running water within 5° F of developer temperature	Wash for 5 min if you used a washing aid, 30 min if you did not. Wash water should flow fast enough to fill tank several times in 5 min. Dump water out of the tank several times during the washing period.
21. Wetting agent (optional)	Wetting agent (diluted to working strength) within 5° F of developer temperature	Immerse the film in the wetting agent, agitating gently for about 5 sec.
22–23. Drying	Clothespins or film clips, a dust-free place to hang the film	Remove film from reel and hang to dry. Handle gently; wet film is easily scratched.
24. Protect the dry negatives. Clean up.	Scissors, negative storage pages	Cut the film into lengths to fit your storage pages. Rinse all processing equipment well.

More about . . .

• Chemicals to process film, page 107

A general knowledge of developer chemicals is useful background information because you may sometimes want to mix a developer from a formula. Photo supply stores sell a variety of developers that only need to be dissolved in water; all the chemicals are present in the proper amount.

The most important ingredient in any developer formula is the reducing agent, also called the developing agent. Its job is to free metallic silver from the emulsion's crystals so it can form the image. These crystals contain silver atoms combined with halides such as bromine in light-sensitive compounds, in this case silver bromide. When struck by light during an exposure, the silver bromide crystals undergo a partial chemical change. The exposed crystals (forming the latent image) provide the developing agent with a ready-made working site. The reducer cracks the exposed crystals into their components: metallic silver, which stays to form the dark parts of the image (see pictures, this page), and bromine, which unites chemically with the developer. In a chromogenic film, the silver is later replaced by dyes.

Some reducing agents are used alone, but often two together assist each other. Many formulas consist of a combination of the compounds Metol and hydroquinone (called M.Q. formulas). The Metol improves film speed and tonal gradation while the hydroquinone increases density and contrast. Other reducing agents are glycin and para-aminophenol (in fine-grain formulas) and phenidone (like Metol but less irritating to the skin).

Most reducing agents work only in an alkaline solution, so an alkaline salt such as borax or sodium carbonate is usually added as an accelerator. Some developers are so active that they will develop the unexposed as well as the exposed parts of the emulsion, thus fogging the negative; to prevent this, a restrainer, usually potassium bromide, is added to some formulas. The bromide that is released by the reducing agent from the silver bromide crystals also has a restraining effect. Finally, since exposure to oxygen in the atmosphere causes a developer to lose its effectiveness, a preservative such as sodium sulfite is sometimes added to prevent the solution from oxidizing too rapidly.

Exposed crystals of silver bromide are converted to pure silver during development, as shown in this electron microscope image (5,000x magnification). At first (top) the crystals show no activity (dark specks on some crystals are caused by the microscope procedure). After 10 sec, parts of two small clusters (arrows) have been converted to dark silver. After a minute, about half the crystals are developed, forming strands of silver. In the bottom picture all exposed crystals are developed; undeveloped crystals have been removed by fixer, and the strands now form the negative image.

Undeveloped silver bromide crystals

Developed 10 seconds

Developed 1 minute

Developed 5 minutes and fixed

After development, fixer sets the image permanently on the film. Without fixing, the entire negative will turn dark if exposed to light. The fixing agent is needed because the negative image contains leftover crystals of silver bromide. These crystals were mostly part of shadow areas in the image, so were not exposed, but they are still light sensitive and, if allowed to remain, will darken the negative (below left). The fixer prevents this by dissolving these crystals out of the emulsion.

The active agent in fixer is sodium thiosulfate. (The early name for this substance was sodium hyposulfite, and hypo is still a common name for fixer.) Ammonium thiosulfate, a fast-acting fixer, can also be used. A hardener is generally part of the fixer solution. This prevents the film emulsion from becoming so soft or swollen that it is damaged during the washing that follows fixing. A rapid fixer needs less time to work than a standard fixer. Kodak recommends using a rapid fixer with T-Max films to facilitate complete fixing.

Follow fixer instructions carefully. If used correctly, the fixer dissolves only the unexposed crystals of silver bromide and does not affect the metallic silver making up the image itself. But if film is left too long in the fixer the image eventually bleaches (below right).

Ordinarily, however, the danger is not too much fixing but too little. If the film is not left in the fixer long enough, if it is not agitated during fixing, or if the fixer is exhausted, silver bromide crystals are left that will later darken the film. Negatives should be fixed about twice the time it takes to clear their milky appearance.

Not enough fixing

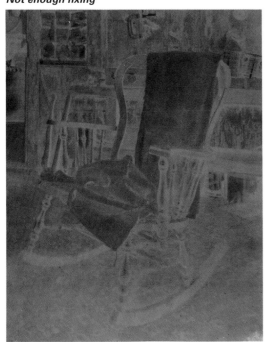

Normal fixing

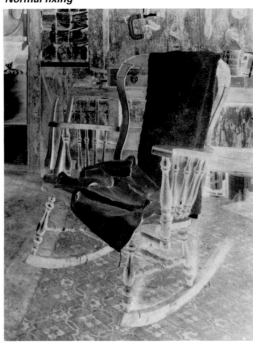

Too much fixing

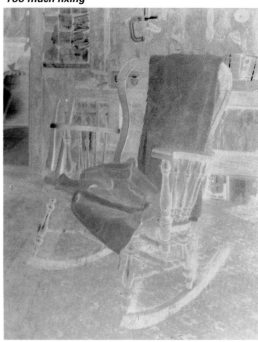

How Time and Temperature Affect Development

The longer the developing time, the darker and more contrasty the negative becomes. The pictures on the opposite page show that the density in an image does not increase uniformly. Increasing the development time causes a great deal of change in those parts of the negative that received the most exposure (the bright areas in the original scene). It causes some changes in those areas that received moderate exposure (the midtones), but only a little change in areas that received little exposure (the shadow areas). In any negative, lengthening or shortening development time has a marked effect on contrast—the relationship between light and dark tones.

Development time controls contrast and density. The crystals of silver bromide that will develop into the negative image lie both on and below the surface of the emulsion. As exposure increases, the number of exposed crystals and their depth in the emulsion also increase. When the developer goes to work, it gets at the surface crystals immediately but needs extra time to soak into the emulsion and develop the crystals below the surface, as illustrated on this page. Thus the total amount of time the developer is allowed to work determines how deeply it penetrates and how densely it develops the exposed crystals, while the original exposure determines how many crystals are available to be developed. This is why simply increasing the development time (pushing the film) can partially rescue an underexposed negative, but won't make it look like a normally exposed one.

The rate of development changes during the process, as is shown in the examples opposite (left column). During the first seconds, before the solution has soaked into the emulsion, activity is very slow; the strongest highlights have barely begun to show up (top). Soon the solution soaks in enough to develop many of the exposed crystals; during this period a doubling of the development time will double the density of the negative (center). Still later, after most of the exposed crystals have been developed, the pace slows down again so that a tripling, or more, of the time adds proportionately less density than it did before (bottom).

Developer temperature also affects development. Most photographic chemicals and even the wash water take longer to work as their temperatures drop. All solutions work faster at higher temperatures, but at around 80° F, the gelatin emulsion of the film begins to soften and becomes very easily damaged. The effects of temperature on the rate of development are shown on the opposite page in the right column.

Time-and-temperature charts that accompany films and developers show suggested development times at various temperatures—the higher the temperature, the shorter the development time needed (see chart at right). The temperature generally recommended is 68° F; this temperature combines efficient chemical activity with the least softening of the film emulsion and is a practical temperature to maintain in the average darkroom. A higher temperature can be used when the tap water is very warm, as it is in many areas during the summer.

A chart may list one set of times for small or reel-type tanks and another for large tanks. A small tank holds from one to four reels and is agitated by inverting it (as shown in step 12 on page 112) or by cranking a handle that rotates the reel. A large tank is agitated by lifting the reels out of the developer on a central spindle.

Developed for 2 minutes **Developed for 5 minutes** **Developed for 15 minutes**

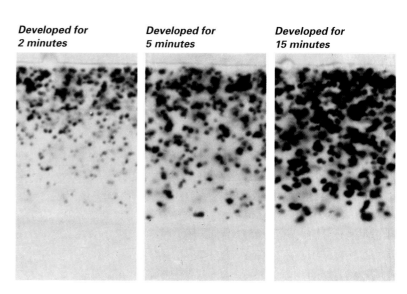

Grains of silver in the negative emulsion get denser as development time increases. In this cross section of film emulsion (enlarged about 2,500x) grains near the surface (top) form first and grow in size. As developer soaks down, subsurface grains form.

Kodak T-Max 400 Professional Film

EI (Film Speed)	KODAK Developer	Developing Times (Minutes)—Roll Film									
		Small Tank (Agitation at 30-Second Intervals)					Large Tank (Agitation at 1—Minute Intervals)				
		65° F (18° C)	68° F (20° C)	70° F (21° C)	72° F (22° C)	75° F (24° C)	65° F (18° C)	68° F (20°C)	70° F (21° C)	72° F (22° C)	75° F (24° C)
400	T-Max	NR	7	6 1/2	6 1/2	**6**	NR	7	6 1/2	6 1/2	**6**
400	D-76	9	**8**	7	6 1/2	5 1/2	10	**9**	8	7 1/2	6 1/2
400	D-76 (1:1)	14 1/2	**12 1/2**	11	10	9	—	—	—	—	—
320	HC-110 (Dil B)	6 1/2	**6**	5 1/2	5	4 1/2	8	**7**	6 1/2	6	5
200	Microdol-X	12	**10 1/2**	9	8 1/2	7 1/2	13	**11 1/2**	10	9	8
320	Microdol-X-1:3	NR	NR	20	18 1/2	**16**	—	—	—	—	—

Note: The primary development times are in bold face. NR—Not recommended

A time-and-temperature chart for development is provided by film and developer manufacturers. 68° F, shown in boldface type, is the recommended temperature for most of the developers listed on this chart. The exceptions are T-Max developer and Microdol-X diluted 1:3, for which the recommended temperature increases to 75° F. A change in temperature of even a few degrees can cause a significant change in the rate of development and therefore requires a change in the development time. Note that the EI (film speed), shown in the chart's far left column, decreases with some developers.

More about . . .

• The effects of exposure and development, pages 122–123
• Pushing film, pages 124–126

Changing time

Negative developed for 45 seconds at 68° F

Negative developed for 6 minutes at 68° F

Negative developed for 30 minutes at 68° F

Changing temperature

Negative developed at 40° F for 6 minutes

Negative developed at 68° F for 6 minutes

Negative developed at 100° F for 6 minutes

Monitor development time and temperature carefully. *The longer the film is in the developer at a given temperature, the darker the negative image becomes (photos, left). The negative also becomes darker when development takes place at higher temperatures, if development time stays the same (photos, right).*

The Importance of Proper Agitation and Fresh Solutions

The purpose of agitation is to supply fresh chemicals to the emulsion at regular intervals. Agitation does this by moving the solution inside the developing tank, as shown in step 12, page 112. Agitation is vital while the film is in the developer and is also important during later processing stages.

Too much or too little agitation can create problems. Inadequate agitation in the developer causes the chemicals next to the emulsion, after performing their share of the chemical reaction, to stop working and form a stagnant area where development activity slows down and eventually stops. This is particularly likely to happen in areas of the film that received a large amount of exposure, because many silver halide crystals are reduced there. Exhausted chemicals are heavier than the rest of the solution and will slowly sink to the bottom of the tank, causing what is called bromide drag—streaks of uneven development as the exhausted chemicals slide down the surface of the film (below left).

Too much agitation creates problems even more often than too little agitation. In addition to general overdevelopment, turbulence patterns can force extra quantities of fresh developer along the edges of the film, causing uneven development (below right).

To avoid these problems, agitate gently at regular intervals. A pattern often recommended is to agitate for 5 out of every 30 seconds. Follow the manufacturer's directions if another pattern is recommended for a specific product. If possible, agitate in two or more different directions during each agitation period. This avoids setting up a repetitive pattern of flow across the face of the film. If you are developing one reel of film in a two-reel tank, put in an extra empty reel so that the loaded one does not bounce up and down excessively when you invert it.

Always use fresh solutions. You may be tempted someday to try to process one or two more rolls or sheets of film in exhausted developer or fixer rather than remixing fresh solutions, but doing so is a mistake, as shown on the opposite page. A properly exposed negative can be damaged or completely ruined because the chemicals in the solutions are exhausted from overuse or aging. Black-and-white films have a milky look if they were grossly underfixed, but even apparently normal-looking film can have problems over time if the fixer was not fresh. Prevention is easy enough: never use exhausted developer or fixer. Developer manufacturers specify how much film may be processed per quart of solution and, usually, how long the solution can be stored. Fixers can be checked for strength with an inexpensive testing solution that indicates when the fixer should be discarded.

Exhausted developer produces underdeveloped negatives. There is just not enough active developing agent left to build up density. With partially exhausted developer, details, particularly in shadow areas, may be weakened, but with greater exhaustion the image is seriously damaged (opposite, left). Damage may be worse than that caused by underdevelopment because impurities in the exhausted solution may stain the negative.

Too little agitation in developer

Too much agitation in developer

Exhausted fixer produces a negative that seems flat in contrast compared to a normal one. The fixer is unable to dissolve unexposed silver bromide crystals from the negative. These leftover crystals turn dark and increase density in the negative (opposite left). As shadow areas (in the model's hair, for example) darken, the overall image grows flat; details such as individual strands of hair are obscured and a grayish density fogs the entire negative, even clouding unexposed borders.

Poor agitation of film during development can cause problems. Above left, the film was not agitated enough. Exhausted chemicals from dense areas of the negative (the white letters in the positive print shown here) slid down the surface of the film, causing streaks of uneven development below the letters. Above right, a roll of film was agitated too much and too vigorously. Fresh developer forced through the film's sprocket holes caused the edges of the film to be overdeveloped (denser in the negative) and consequently lighter in the print.

Developer exhaustion

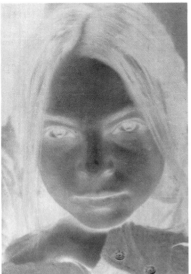

Negative developed in exhausted solution

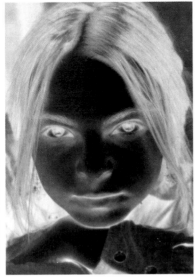

Negative developed in fresh solution

Film can fade or turn yellow if it is not thoroughly washed after fixing. The cause of this damage is the fixer itself. The fixing solution contains dissolved sulfur compounds that tarnish the silver image of the negative if they are not removed. It is exactly the same kind of reaction that causes silverware to tarnish. The unexposed silver compounds that are dissolved in the fixer will tarnish too. Worse still, the tarnish often becomes soluble in the moisture in the air, gradually causing the negative image to dissolve and fade.

Careless drying also damages negatives and shows immediately (see below). Just-washed film is delicate and easily scratched. Dust clings to wet film, sometimes implants itself in the emulsion, and can be impossible to remove even if the negative is rewashed.

Proper washing and drying is relatively easy. Water for washing must be clean, near the temperature of the earlier solutions, and kept constantly moving across the surface of the film to flush away fixer that has soaked in. Dump the water and refill the tank often; fixer is heavier than water and accumulates at the bottom of the tank. Although much of the fixer can be washed away with water alone if the film is washed long enough, it is best to use a washing aid (also called hypo neutralizer or clearing agent). In addition to working more efficiently than plain water, it greatly reduces washing time and avoids the swelling caused by a long washing period.

Damage during drying is even easier to avoid. Handle the film as little as possible while it is wet and hang to dry in a clean place free from drafts.

Fixer exhaustion

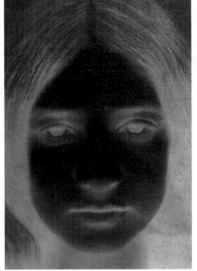

Negative fixed in exhausted solution

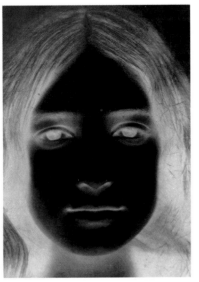

Negative fixed in fresh solution

Carelessly handled negative

Normal negative

Exposure and Development: Under, Normal, Over

A correctly exposed and properly developed negative will make your next step—printing—much easier. You are likely to produce a printable negative if you simply follow the manufacturer's standard recommendations for exposure (film speed) and development (time and temperature). But, after you have a grasp of the basic techniques, you may want to adjust your exposure or development. If you are just beginning in photography, you can come back to this material after you have had some experience printing. For a method of controlling density and contrast exactly by making exposure and development changes, see the Zone System chapter.

Expose for the shadows, develop for the highlights. This old photographic rule is based on the fact that the amount of exposure and the amount of development both affect the negative, but in different ways.

Changing the development time has little effect on shadow areas, but it has a strong effect on highlight areas. The longer the development at a given temperature, the denser the highlights become; the greater difference between the density of the highlights and that of the shadows increases the contrast of the negative overall. The reverse happens if you decrease development time: the less the difference between highlights and shadows, and the less the overall contrast of the negative.

Changing the exposure affects both highlight and shadow areas: the greater the exposure, the denser they both will be. But exposure is particularly important to shadow areas because increasing the development time does not significantly increase the density of shadow areas. They must receive adequate exposure if you don't want them to be so dark that they are without detail in the print.

The practical application of these relationships lets you alter exposure or development if you have persistent difficulty printing your negatives. The illustrations opposite show a negative with good density and contrast (top) plus negatives that are thin, dense, flat, and contrasty—and tell what to do if too many of your negatives look that way. Before making changes, see if you can find the cause of the problem. For example, check your meter if your negatives are often underexposed. Getting the meter repaired can be easier than always altering the film speed.

Controlling the contrast of individual scenes

You can adjust exposure and development for individual scenes. You can adjust contrast during printing by using a higher or lower contrast grade of printing paper, but adjusting the contrast of the original negative can give you even more control over the final results.

What changes are feasible with roll film? Changing the development for individual scenes is easiest with a view camera, which accepts single sheets of film. With roll film you have to develop the entire roll in the same way. This might be feasible if you plan to shoot a whole roll of film at the same location in the same type of light.

Increasing the development time with small-format roll film may increase the grain more than you want. Increased grain is seldom a problem with larger-format sheet film.

Kodak T-Max films respond more rapidly to changes in development time than other films do. Smaller time adjustments are needed to produce comparable changes.

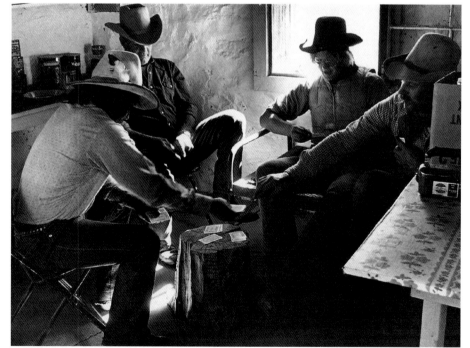

SUZI JONES Cowboys, Paradise Valley, Nevada, 1978

A high-contrast scene (for example, a sunlit scene in which you want to see detail in both lit and shaded areas) can easily have a nine-stop or greater range between shadows and highlights—too much for details to show in both light and dark areas. In such a very contrasty situation, you can give enough exposure to maintain details in the shadows, then decrease the development to about 80 percent of the normal time to keep highlights from being overly dense.

More about . . .

- Negative contrast and printing paper contrast, pages 150–151
- Zone System, pages 303–313

A negative with normal density and contrast. *Good separation of tones in highlights, midtones, and shadows (with a scene of normal contrast). Prints well on normal-contrast paper. Grain is normal for film.*

A dense negative *has dense highlights and more than adequate density in shadows. Grain will be increased, and printing times will be long.*

Negatives that are dense overall were probably overexposed. If negatives are often dense, decrease exposure by setting the camera to a higher film speed (multiply film speed by 2 to decrease exposure 1 stop).

A thin negative *has little detail in shadow areas and somewhat low contrast overall. Printing times will be short.*

Negatives that are thin overall were probably underexposed. If negatives are often thin, increase exposure by setting camera to a lower film speed (divide film speed by 2 to increase exposure 1 stop).

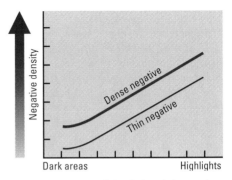

Density *is the amount of silver built up in the negative overall or in a particular part of the negative. A dense negative will have more density overall compared to a thin negative.*

A contrasty or high-contrast negative *has a great deal of difference between highlights and shadows. Highlights will be very dense and shadows very thin. Grain will be increased. To get a normal-looking print from a high-contrast negative, you have to print it on a low-contrast (#1 or lower) paper.*

High contrast can be the result of high contrast in the original scene or from overdeveloping the negative. If negatives are often contrasty, decrease film development; try 80 percent of the normal time (make less change for T-Max films).

A flat or low-contrast negative *has highlights that are not very much denser than the shadows. To get a normal-looking print from a low-contrast negative, you have to print it on a high-contrast (#3 or higher) paper.*

Low contrast can be the result of low contrast in the original scene or from underdeveloping the negative. If negatives are often flat, increase film development; try developing 20 percent more than the normal time (make less change for T-Max films).

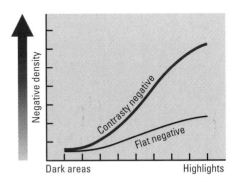

Contrast *is the difference in density between the thinner parts of the negative (such as shadow areas) and the denser ones (bright highlights). A contrasty negative will have a greater difference in density.*

Push Processing

What do you do when the light is too dim for a fast enough shutter speed, even when you are using a fast film? For example, suppose you are shooting indoors and have loaded ISO 400 film in the camera. With the lens wide open you might still have to use a shutter speed of only 1/30 second, not quite fast enough to hand hold the camera without risk of camera motion blurring the picture.

Pushing film lets you shoot at a higher-than-normal film speed if you increase the film development. In this case, you could shoot as if your film was ISO 800 (one stop faster), which would let you shoot at 1/60 second, fast enough to hand hold the camera more confidently.

Even a very fast film may not give enough speed without pushing. Sports events, especially in local playing fields at night or in school gyms, are often dimly lit—at least as far as photography is con-

cerned. Furthermore, if the photographer is on the sidelines, a long lens is a necessity, and the longer the lens, the smaller the maximum aperture; f/4 or f/5.6 is typical for a 400mm lens. Given the problem of dim light, a relatively small aperture, and the need for a fast shutter speed to stop action, the answer is a film such as Kodak T-Max P3200, which has a nominal film speed of 1000, but can readily be pushed to 3200, or even higher.

Rather than truly increasing film speed, push processing simply underexposes and overdevelops the film. This produces a negative with more contrast and grain than a normally exposed, normally developed negative resulting in some loss of detail, especially in dark areas, compared to normal exposure and development (in the pair of photographs opposite, notice how much darker the floorboards are in the pushed photograph).

Pushing film is useful for any moving subject in dim light, such as at a concert, a political meeting, or on the street when light is low—any situation when you don't want to or can't use flash. Pushing is so commonly used by photojournalists as a way to maximize film speed that some push all of their film unless they are in bright sunlight or using flash.

Contrasty scenes show the most increase in contrast when pushed; shadow detail can all but disappear, with only highlights still visible. See, for example, the stage scene on page 126. Scenes where the contrast is low, such as under fluorescent lighting, will look contrastier than normal, but will still hold some shadow detail. The more you push the film (the higher you rate the film speed), the more contrast and grain you will have. But these disadvantages are offset by the increase in working film speed when you must have it.

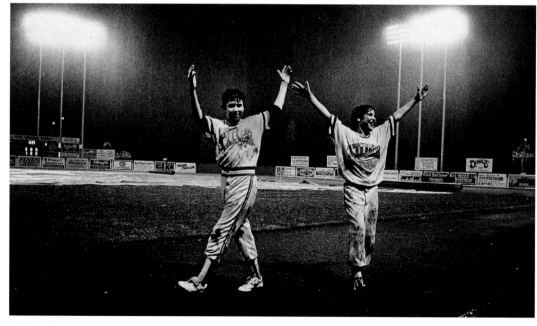

On assignment for the newspaper The Virginian-Pilot, *Michele McDonald often photographed baseball at the Metropolitan Stadium in Norfolk, Virginia. The stadium's lighting—or lack of it—makes pushing film a standard procedure for photographing night games there. At left, rain had canceled a game, which gave two bat boys a chance to enjoy acting like big stars—even though they were playing to empty stands.*

MICHELE MCDONALD Rainy Night Stars, 1984

To develop pushed film, you can increase the development time or temperature so that it is greater than normal or use a high-energy developer such as Acufine, Diafine, or Microphen. Some standard developers can be used at concentrations that let you shoot at higher-than-normal film speeds—Edwal FG7 diluted 1:3, for example. Kodak Xtol developer is designed to produce good shadow detail with pushed film.

In general, for a push of one stop, increase the normal development time 25–50 percent; for a two-stop push, double the development time (Kodak T-Max films need less increase in development time). See chart, below, and manufacturer's instructions, but test first for best results.

There are limits to the amount that film can be pushed. A one- to two-stop push is generally practical. A three-stop or greater push creates a definite loss in image quality but can be acceptable if your only other choice is a blurred image. Because of the loss of image quality, it isn't a good idea to push a film unnecessarily. For instance, don't push ISO 400 film to 3200, unless you are stuck without access to a faster film. You'll get better results if you simply use the higher-speed ISO 3200 film.

Sometimes you can push film one stop simply by underexposing it. For example, an ISO 400 film might be exposed at 800 and then developed normally. Kodak says this is feasible for a one-stop push for their T-Max 400 and Tri-X films. They feel that these films will tolerate one stop of underexposure without the need for extra development.

Pushing color films is also possible. You will get some color shifts, as well as the increase of contrast and grain that comes with pushing black-and-white film. Color slide films such as Kodak Ektachrome 400X and Ektachrome P1600 or Fujichrome Provia 400 and Provia 1600 that are processed in E-6 chemicals can be pushed by extending time in the first developer. You can do this yourself if you process your own color film (see manufacturer's recommendations), or a commercial lab will do it.

Some color negative films cannot be chemically pushed because they develop fully with normal processing. But because color negative film has some exposure latitude, you can simply underexpose one stop with relatively little loss in quality (see illustrations on page 197). Kodak Ektapress Multispeed, for example, can be exposed at speeds from 100 to 1000 without a change in processing.

Pushing black-and-white films

Film (normal speed ISO 400)	Developer	To push film speed 1 stop to 800	To push film speed 2 stops to 1600
Kodak T-Max 400	Kodak T-Max 75° F	develop normally 6 min	8 min
	Kodak Xtol 1:1 68° F	develop normally 8 ¾ min	10 ¾ min
Kodak Tri-X	Kodak T-Max 75° F	develop normally 5 ½ min [or increase time to 6 ½ –7 min]	8 ½ min
	Kodak Xtol 1:1 68° F	develop normally 8 ¾ min [or increase time to 10 min]	11 ¾ min
Ilford HP5 Plus	Ilford Microphen 68° F	8 min	11 min
Fuji Neopan 400	Kodak T-Max 75° F	5 ¼ min	8 min
Film (nominal film speed of 1000)	**Developer**	**To push film speed to 6400**	**To push film speed to 12,500**
Kodak T-Max P3200	Kodak T-Max 75° F	11 min	12 ½ min

Some manufacturers' development recommendations for pushing film are shown above. These development times are a starting point from which you should experiment to determine your own combinations. Many photographers, for example, increase development when Tri-X is pushed from ISO 400 to 800 [times shown in brackets], even though Kodak says an increase is not necessary.

Normal exposure and development

Film pushed two stops

Pushing film gives you a higher working film speed when taking pictures in dim light. *You deliberately underexpose the film by using a film speed that is double or more the normal rating, then compensate for the underexposure by increasing the film development (see chart). Pushing increases graininess and contrast, but it is valuable when more film speed is needed than normal processing can provide.*

Bruce Springsteen in Concert, 1984

Both exposure and development choices were made for this photograph of Bruce Springsteen in concert. *Stage lighting is often too dim for an adequately fast shutter speed, so photographer Scott Goldsmith used an ISO 400 film, which he planned to push to a film speed of ISO 800. He would expose the film as if it were one stop more sensitive to light than it actually was, then make up for the resulting underexposure by overdeveloping the film. This would let him use a shutter speed one stop faster than normal.*

Goldsmith did not make an overall meter reading that averaged all the tones of the scene, because that would have given unpredictable results. The picture could have been too light because of the dark stage areas behind the performers, or the picture could have been too dark because the meter might be overly influenced by the bright lights visible behind them. To prevent both of these problems, he made a spot reading of Springsteen's face and based his exposure on that.

Normally developed negative

Underdeveloped negative

Intensified negative

Overdeveloped negative

Reduced negative

More about . . .
- Digital imaging for contrast control, page 261
- Handling chemicals safely, page 109

You can sometimes improve a completely processed negative that is too dense or too thin. Thin negatives can be made darker (middle row) by a process called intensification. A very dense negative can be thinned down (bottom row) by a solution called a reducer. There are, however, disadvantages. Intensification can increase grain—quite noticeably in an enlargement from a small negative. And both processes involve some danger of staining or otherwise ruining the negative. Unfortunately, the only negatives worth the trouble of intensification or reduction are usually so important that ruining them is worse than having a poor print. Making the best print you can before you treat the negative in any way is insurance against total loss.

Intensification increases the density of a negative by adding minute particles of another metal (such as chromium) on top of the silver that already forms the negative image. The amount of intensification is usually proportional to the existing amount of silver, which means that the denser (highlight) areas will be intensified more than the thinner (shadow) areas. The result is a greater separation between light and dark parts of the negative and an increase in contrast. Intensification improves a negative that is thin because of underdevelopment or moderate underexposure. It probably won't help a negative that is seriously underexposed, since it

can't put back detail that isn't there in the first place.

Reduction decreases the density of a negative by dissolving some of the metallic silver that forms the image. A cutting or subtractive reducer removes approximately equal amounts of silver from all parts of the image and has little or no effect on contrast; it is useful for treating fogged or overexposed negatives. A proportional reducer decreases density in proportion to the existing amount of silver, thus reducing contrast; this is useful for a negative that has been overdeveloped. A super-proportional reducer removes much more silver from dense areas than it does from the thin areas, thus reducing contrast without affecting the thinner areas of the negative; this would improve an overdeveloped negative of a contrasty subject.

You can purchase intensifiers and reducers or mix them yourself. Farmer's Reducer, for example, is a subtractive reducer, available in photo supply stores, that can be used either for all-over reduction of negative density or for local reduction of smaller areas in negatives or prints. Follow manufacturer's safety instructions carefully when using these chemicals.

You could also scan the image into a computer. Digital-imaging software will let you alter the density or contrast to a great degree. Then you can write the image to film for printmaking.

Toning to intensify a negative

Toning in selenium intensifies and adds contrast to a negative. It does not increase grain as some other intensifiers do. See page 312 for an example of a print that was toned at the negative stage to increase contrast.

Preparation: The negative should be completely washed and dried. Bring all solutions to 68° F.
　Dilute Kodak Rapid Selenium Toner with 2 parts working-strength Kodak Hypo Clearing Agent. Immerse negative in water for 3 min.

Optional: To prevent staining caused by possible improper fixing during the original processing of a negative, immerse for 3 min in a plain hypo bath of 8 oz sodium thiosulfate per quart of water.

Processing: Immerse in the toner for up to 10 min. Immerse in Hypo Clearing Agent for 3 min. Wash and dry as usual.

Don't be surprised if Walter Iooss comes up to you at your next baseball game and offers to trade your seat for his pass to the section reserved for photographers. He does this from time to time because the last place he likes to sit is where all the other photographers are.

Iooss looks for something to make his sports photographs more than simple action shots. Maybe it is the graphic interest of an unusual point of view (photo opposite). Maybe it is human interest (this page, top). Maybe it is an interesting background against which, if he is lucky, some action will happen or against which he can position a player. He has been willing to gamble a whole game on that, waiting in a particular spot for the action to move to just the place he wants. He often goes to a stadium the day before a game to see where the light is best or what setting might be good. "I really enjoy going to places that photographers have been to time and again—and finding a picture that no one has taken before."

Many sports photographers stay in predictable positions because they know they will get at least something from there: at a basketball game they stay right under the basket or just to one side of it; at a baseball game they keep to the first-base or third-base lines. Iooss prefers to take the chance he will find something even better elsewhere. "I have always been interested in what goes on at a sport's perimeters— the sidelines, a vendor, the fans—not just a guy sliding into third base."

If he is going to be with a team for several days, he likes to move in gradually. He talks to a few players, tells them what he's doing so the word filters around.

Professional sports figures are used to photographers, but they still may need to loosen up and relax, especially if you are trying to pose them. "The first roll or two may not be very good until they feel comfortable with you."

Iooss says that you don't have to go to professional games to make great sports pictures. "Go to a kids' football game. It's late in the afternoon, the light is terrific, you have kids crying, screaming, sweating—and their parents doing the same. It's better than professional football." Spring training in baseball is another good time to photograph. It is open to anybody, and you often have opportunities there to be with the players. "Spring training is great because you have more freedom there than at any other sport. Players move between the fields, which means they are moving between the fans. They talk to you, just like players in the old parks where the fans were very close to the players. Baseball years ago was an intimate spectacle, and it still is at spring training."

His advice if you are interested in sports photography: "You have to shoot constantly. If you look at top performers— athletes or photographers—they do what they do all the time. I'm always working, shooting, thinking pictures. If you are really interested in doing well at anything, you have to give yourself to it."

"Sometimes you work and work to make a picture," he says. "At other times, it's just seeing and being ready to shoot during those few moments when everything is just perfect, and you feel, 'This is it.' But I may have been shooting for an hour leading up to that moment. Chance favors you—if you're prepared."

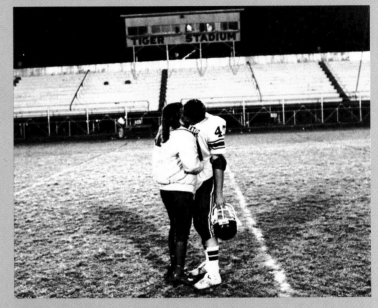

WALTER IOOSS, JR. After the Game, 1980

Human interest (above) and graphic interest (opposite) are both part of what makes sports photography interesting to Walter Iooss, Jr.

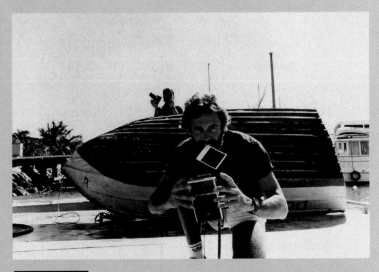

DAN JENKINS, JR. Walter Iooss, Jr., 1985

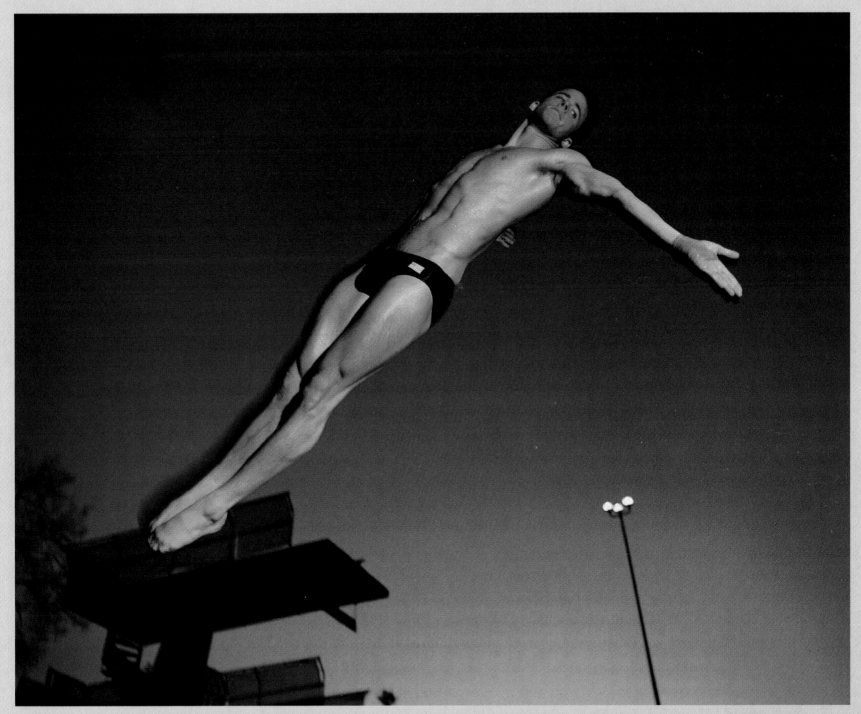

WALTER IOOSS, JR. Diver, 1995

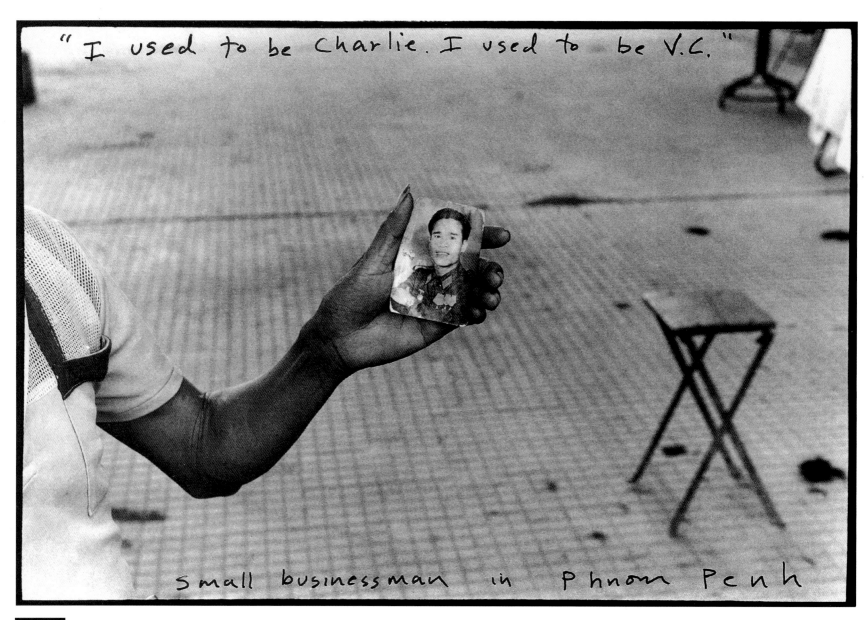

"I used to be Charlie. I used to be V.C."

small businessman in Phnom Penh

BILL BURKE I Used to Be Charlie, Cambodia, 1994

A businessman in Cambodia, once a revolutionary Viet Cong soldier, holds an old photograph of himself in his uniform and medals. The photographic print is more than just a picture of the person. It holds the image of the life he used to lead. "Charlie" was the slang term used by U.S. Army soldiers to mean any Viet Cong soldier.

Negative

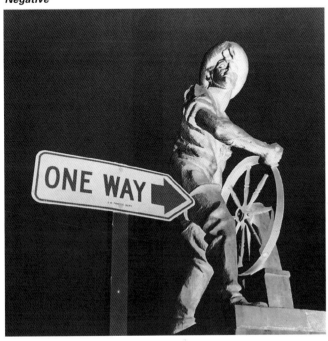

*M*aking a black-and-white print is one of the basic skills in photography. Here is where to find details on the equipment and materials used in printing.

*T*his section takes you through printmaking step by step, from making the contact sheet that lets you see a positive image of your negatives for the first time, to making an enlarged print, plus how to process prints.

*T*here are many ways you can control the printing process so that you get exactly the results you want.

Positive

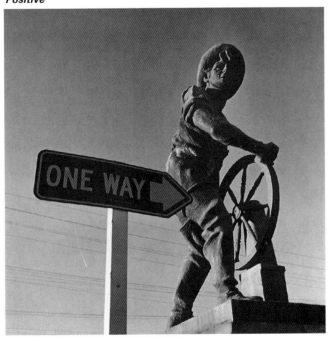

Printmaking is one of the most pleasurable parts of photography. Unlike film development, which requires rigid control, printmaking lends itself to leisurely creation. Mistakes are inevitable at first, but a wrong choice can be easily corrected by simply making another print.

Like film, printing paper is coated with an emulsion containing light-sensitive silver compounds. Light is passed through the negative and onto the paper. After exposure, the paper is placed in a developer where chemical action converts into visible metallic silver those compounds in the paper's emulsion that have been exposed to light. A stop bath halts the action of the developer; a fixer removes undeveloped and unexposed crystals; finally the print is washed and dried.

The negative is a reversal of the tones in the original scene. Where the scene was bright, the negative contains many dense, dark grains of silver that hold back light from the paper, prevent the formation of silver in the paper's emulsion, and so create a bright area in the print. Where the scene was dark, the negative is thin or even clear, and passes much of the light to the paper, creating dense silver in the emulsion and a dark area in the print. Compare the illustrations at left.

Black-and-White Printing: Equipment and Chemicals You'll Need

Darkrooms for printing are set up with a dry side and a wet side. On the dry side, photographic paper is exposed to make a print. On the wet side, the exposed paper is processed in chemicals similar to those used for developing negatives.

Dust is the most common problem on the dry side. Every dust speck on your negative produces a white spot on your print. Remove dust from negatives each time you print them, and keep working surfaces and equipment clean. Handle negatives by their edges to avoid fingerprints. Dust and fingerprints on enlarger lenses or condensers decrease the contrast and detail in a print; clean them as you would a camera lens.

Contamination can cause a plague of spots, stains, and weakened chemicals. A typical printing session involves many trips from enlarger to developing trays and back again, so it's important to keep chemicals away from places where they don't belong. Put a wet print into a dry, clean tray if you want to take it to another room; don't let it dribble onto dry counters, floors, or your clothes. After handling chemicals, wash and dry your hands before picking up negatives or printing paper. Drain a print for a few seconds as you transfer it from the developer to the stop bath or fixer so that you don't slosh an excess of one solution into the next. Even more important, don't get stop bath or fixer into the developer; they are designed to stop developer action—and they will.

Equipment for printing

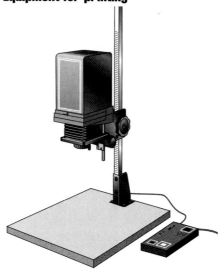

Enlarger projects light through the negative onto the printing paper. You can use it to make enlarged prints or, with a printing frame, to make contact prints that are the same size as the negative.

Enlarger timer is connected to the enlarger, activating the enlarger light source to turn it on, then off when the set time has expired.

Printing paper is coated with a light-sensitive emulsion onto which the image is exposed.

Printing frame holds negatives and paper tightly together for contact prints. A sheet of plain glass can be used as a substitute.

Easel holds printing paper flat on the enlarger's baseboard for enlargements. This easel has adjustable sides for cropping the image and creating white borders.

Safelight. Printing paper is exposed and developed under safelight, not ordinary room light. A relatively dim amber safelight produces enough light for you to see what you are doing, but not so much that the paper becomes fogged with unwanted exposure. A suitable safelight for most papers is a 15-watt bulb in a fixture covered with a light amber filter (such as Wratten OC) placed at least four feet from working surfaces. Check the manufacturer's instructions if you use any special-purpose papers; safelight filters vary for different types of papers.

Means of cleaning the negative. To remove dust, use a soft, clean brush, or, if you use compressed gas, buy a type such as Dust-Off, which does not contain environment-damaging chlorofluorocarbons. Use a liquid film cleaner to remove fingerprints or other sticky dirt; even better—handle negatives by their edges so they don't get dirty in the first place.

Focusing magnifier enlarges the film grain or the projected image when setting up an enlargement so that you can focus sharply.

Paper cutter or scissors cuts paper for test strips or small prints.

Equipment to process the print

Trays hold solutions during processing. For 8 x 10-inch prints, you'll need three trays of that size for developer, stop bath, and fixer, plus a larger tray to hold fixed prints until you are ready to wash them.

Tongs lift prints into and out of solutions, keeping your hands clean so that you don't need to wash and dry them so often. You'll need two sets, one for the developer only, one for stop bath and fixer

Timer or clock with sweep second hand times the processing.

Print washer circulates fresh water around prints to remove fixer during washing.

Washing siphon is a simple means of washing. It clamps onto a tray, pumps water into the top of the tray, and removes it from the bottom.

Sponge or squeegee wipes down wet prints to remove excess water before drying.

Drying racks or other devices dry prints after processing.

Chemicals to process the print

Developer converts into visible metallic silver those crystals in the paper's emulsion that are exposed to light. Choose a developer made specifically for use with paper. Neutral or cold-tone developers such as Kodak Dektol produce a neutral or blue-black tone when used with neutral or cold-tone papers. Warm-tone developers such as Kodak Selectol increase the brown-black tone of warm-tone papers.

A concentrated stock solution lasts from 6 weeks to 6 months, depending on the developer and how full the storage container is; the more air in the container, the faster the solution deteriorates. Discard the diluted developer working solution if it turns dark after about 20 8 x 10-inch prints have been developed per quart of working solution, or at the end of a working day.

Stop bath halts the action of the developer. A stop bath can be prepared from about 1 1/2 oz of 28 percent acetic acid to 1 quart of water. Stop bath stock solution lasts indefinitely. Discard the diluted working solution after treating 20 8 x 10-inch prints per quart. An indicator stop bath changes color when exhausted.

Fixer removes undeveloped silver halides from the emulsion. A fixer with hardener prevents softening and possible damage to the emulsion during washing, especially when the tap water temperature is high. A rapid fixer is faster acting than regular fixer.

Fixer stock solution lasts 2 months or more. Working solution lasts about a month in a full container and will process about 25 8 x 10-inch prints before it should be discarded. A testing solution called hypo check (or fixer check) is the best test of fixer exhaustion.

Washing aid (also called fixer remover, hypo clearing bath, or hypo neutralizer), such as Heico Perma Wash or Kodak Hypo Clearing Agent, is optional but highly recommended for fiber-base prints. It is not used with RC (resin-coated) papers. It removes fixer better and faster than washing alone.

Capacity and storage time vary depending on the product; see manufacturer's instructions.

More about . . .

- Enlargers, pages 134–135
- Printing papers, pages 136–137
- Mixing, storing, and handling chemicals safely, pages 108–109
- Drying prints, page 146

An enlarger can produce a print of any size—larger, smaller, or the same size as a negative, so it is sometimes more accurately called a projection printer. Most often, however, it is used to enlarge an image. An enlarger operates like a slide projector mounted vertically on a column. Light from an enclosed lamp shines through a negative and is then focused by a lens to expose an image of the negative on printing paper placed at the foot of the enlarger column. Image size is set by changing the distance from the enlarger head (the housing containing lamp, negative, and lens) to the paper; the greater the distance, the larger the image. The image is focused by moving the lens closer to or farther from the negative. The exposure time is controlled by a timer. To regulate the intensity of the light, the lens has a diaphragm aperture with f-stops like those on a camera lens.

An enlarger should spread light rays uniformly over the negative. It can do this in several ways. In a diffusion enlarger, a sheet of opal glass (a cloudy, translucent glass) is placed beneath the light source to scatter the light evenly over the negative or the light rays are bounced within a mixing chamber before reaching the negative. In a condenser enlarger, lenses gather the rays from the light source and send them straight through the negative. Sometimes a combination of the two systems is used (see diagrams, right).

The most noticeable difference between diffusion and condenser enlargers is in contrast. A diffusion enlarger produces less contrast in a print than a condenser enlarger. A diffusion system has the advantage of minimizing faults in the negative, such as minor scratches, dust spots, and grain, by lessening the sharp contrast between, for example, a dust speck and its immediately surrounding area. Some photographers believe that this decreasing and smoothing of contrast can also result in a loss of fine detail and texture in a print, especially when a negative is greatly enlarged; however, many photographers find no evidence to support this.

The focal length of the enlarger lens must be matched to the size of the negative, as shown in the chart below. If the focal length is too short, it will not cover the full area of the negative, and the corners will be out of focus or, in extreme cases, vignetted and too light in the print. If the focal length is too long, the image will be magnified very little unless the enlarger head is raised very high.

Condensers must be matched to the negative and lens for even illumination. Depending on the enlarger, this is done by changing the position of the negative or condensers or by using condensers of different sizes.

The light source in an enlarger is usually a tungsten or quartz-halogen bulb, although in some diffusion enlargers a cold-cathode or cold-light source (fluorescent tubing) is used. Fluorescent light is usually not recommended for use with variable contrast papers or color printing papers.

A stable and correctly aligned enlarger is a vital link in the printing process. The best camera in the world will not give good pictures if they are printed by an enlarger that shakes when touched or tends to slip out of focus or alignment. School enlargers, which get heavy use by a multitude of people, are particularly prone to problems. If you are doubtful about your enlarger's alignment, try setting its lens to a relatively small f-stop such as f/11 or f/16. This will increase the depth of field in the projected image, overcoming problems caused by the enlarger's stages not being exactly parallel.

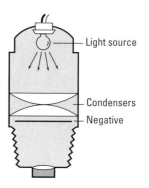

A condenser enlarger uses one or more lenses to concentrate light directly on the negative. Exposures are shorter and black-and-white print contrast higher than with a diffusion enlarger. If color filters are inserted, the enlarger can be used for color printing.

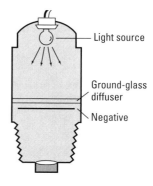

A diffusion enlarger scatters unfocused light over the negative. Black-and-white image contrast is lower, and the effect of dust on the film and other defects is minimized. In this simple diffusion system, light from an incandescent bulb passes through a sheet of cloudy glass onto the negative. In a cold-light system, which can be used only for black-and-white printing, the light source is a grid of neon-like tubes.

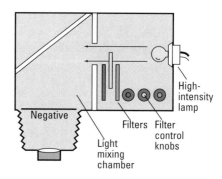

Another type of diffusion enlarger bounces light from a high-intensity tungsten-halogen bulb into a diffusion chamber. In this dichroic color head, three color filters are built into the head for color printing or variable-contrast black-and-white printing. When the desired amount of filtration is dialed in, the filters move into or out of the light beam.

Enlarger lens focal length	
Negative size	Focal length to use (in mm)
35 mm	50–63
2 1/4 x 2 1/4 inches	75–80
2 1/4 x 2 3/4 inches	90–105
4 x 5 inches	135–165

More about . . .

• Enlargers for printing color, page 210

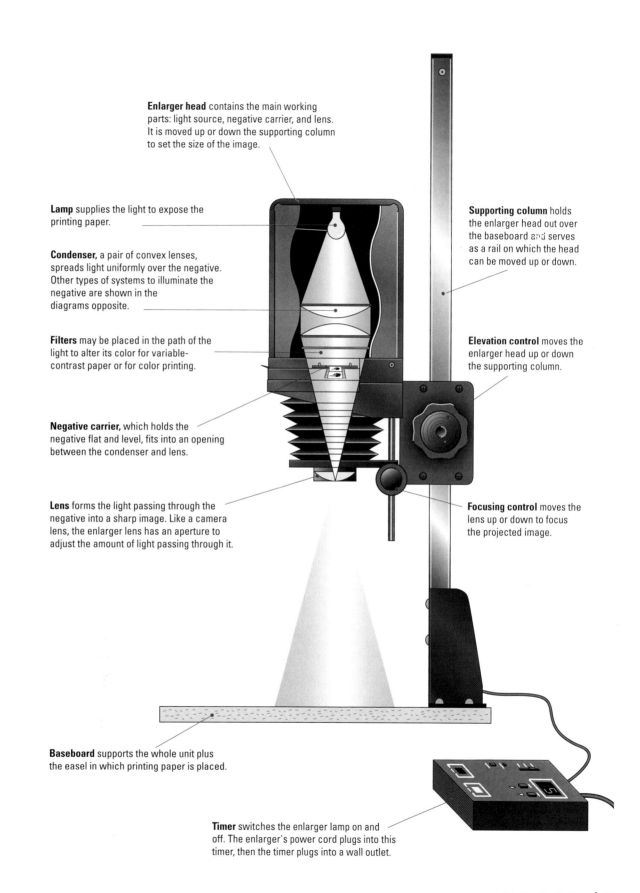

Enlarger head contains the main working parts: light source, negative carrier, and lens. It is moved up or down the supporting column to set the size of the image.

Lamp supplies the light to expose the printing paper.

Condenser, a pair of convex lenses, spreads light uniformly over the negative. Other types of systems to illuminate the negative are shown in the diagrams opposite.

Filters may be placed in the path of the light to alter its color for variable-contrast paper or for color printing.

Negative carrier, which holds the negative flat and level, fits into an opening between the condenser and lens.

Lens forms the light passing through the negative into a sharp image. Like a camera lens, the enlarger lens has an aperture to adjust the amount of light passing through it.

Baseboard supports the whole unit plus the easel in which printing paper is placed.

Supporting column holds the enlarger head out over the baseboard and serves as a rail on which the head can be moved up or down.

Elevation control moves the enlarger head up or down the supporting column.

Focusing control moves the lens up or down to focus the projected image.

Timer switches the enlarger lamp on and off. The enlarger's power cord plugs into this timer, then the timer plugs into a wall outlet.

Black-and-white printing papers vary in texture, color, contrast, and other characteristics (see box, opposite). Choices are extensive, but rather than buying a different type of paper every time, start with one type and explore its capabilities before trying others. For your first prints, a package of variable-contrast, glossy, resin-coated (RC) paper will work well.

Variable-contrast paper is more economical than graded-contrast paper because you have to purchase only one package of paper. Eventually you may want to take advantage of the greater variety of graded papers. With a variable-contrast paper, you change contrast by changing the color of the enlarger light, so you will also need a set of variable-contrast filters or an enlarger with built-in filtration.

Many photographers prefer a glossy surface, smooth-textured paper because it has the greatest tonal range and brilliance. Prints are seen by reflected light, and a matte surface or rough texture scatters light and so decreases the tonal range between the darkest blacks and the whitest highlights.

Resin-coated (RC) papers require much less washing time than fiber-base papers. They are often used in school darkrooms and are also popular for contact sheets and general printing. However, many photographers do not use RC papers for their better prints because they prefer the tonality and surface quality of fiber-base papers. The latter are also better for long-term archival preservation, a factor primarily of interest if prints are sold to museums and photography collectors.

Paper storage is important because stray light fogs unprocessed paper, giving it an overall gray tinge. Time and heat do the same. Store paper in a light-tight box in a cool, dry place. Open a package of paper only under darkroom safelight. Most papers last about two years at room temperature, considerably longer if kept refrigerated. Check the expiration date on the package.

Reproduced from a glossy print

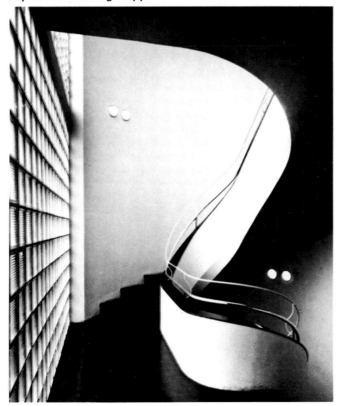

Reproduced from a matte print

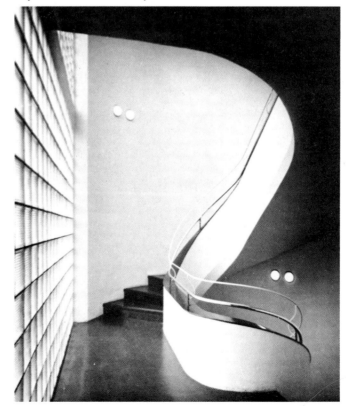

A glossy surface paper produces denser blacks and more contrast than a matte surface paper. *Compare the two prints at left of an architectural photograph.*

Reproduced from a cold-tone print

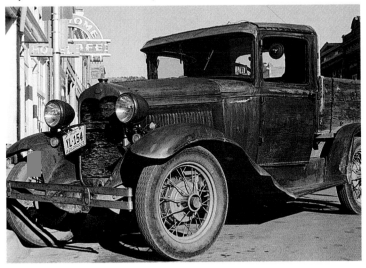

Reproduced from a warm-tone print

Cold-tone papers produce a blue-black image, warm-tone papers produce a brown-black image. *The developer used can emphasize the paper tone.*

Black-and-white printing paper characteristics

Physical characteristics

Texture. The surface pattern of the paper. Ranges from smooth to slightly textured to rough. Some finishes resemble canvas, silk, or other materials. Smoother surfaces reveal finer details in the image and any graininess of the negative more than rougher surfaces do.

Gloss. The surface sheen of the paper. Ranges from glossy (greatest shine) to luster (medium shine) to matte (dull). The dark areas of glossy papers appear blacker than those of matte papers; therefore, the contrast of glossy papers appears greater. Glossiness shows the maximum detail, tonal range, and grain in a print. Very high gloss can cause distracting reflections.

Paper base tint. The color of the paper stock. Ranges from pure white to off-white tints such as cream, ivory, or buff. Many papers contain optical whiteners to add brilliance to highlights.

Image tone. The color of the silver deposit in the finished print. Ranges from warm (brown-black) to neutral to cold (blue-black). Can be emphasized by the print developer used; a developer that helps produce a noticeably warm or cold tone indicates this on the package.

Weight. The thickness of the paper stock. Fiber-base papers are available in single weight and double weight. Single-weight papers are suitable for contact sheets and small prints. Double-weight papers are easier to handle during processing and mounting of large prints. RC papers come in a medium-weight base that is between single and double weight.

Size. 8 x 10 inches is a popular size. You can cut this into four 4 x 5-inch pieces for small prints. Some commonly available precut sizes include 4 x 5, 5 x 7, 11 x 14, 14 x 17, 16 x 20, and 20 x 24 inches.

Resin coating. A water-resistant, plasticlike coating applied to some papers. Resin-coated (RC) papers absorb very little moisture, so processing, washing, and drying times are shorter than for fiber-base papers. They also dry flat and stay that way, unlike fiber-base papers, which tend to curl. Too much heat during drying or mounting RC papers can damage the surface; see manufacturer's directions.

Photographic characteristics

Printing grade. The contrast of the emulsion. **Graded papers** are available in packages of individual contrast grades ranging from grade 0 (very low contrast) through grade 6 (very high contrast). Grade 2 or 3 is used to print a negative of normal contrast. With **variable-contrast papers,** only one kind of paper is needed; contrast is changed by changing filtration on the enlarger.

Speed. The sensitivity of the emulsion to light. Papers designed solely for contact printing are slow—they require a large amount of light to expose them properly. Papers used for enlargements are faster since only a rather dim light reaches the paper during the projection of the image by the enlarger. Enlarging papers are also commonly used for contact prints.

Color sensitivity. The portion of the light spectrum to which the emulsion is sensitive. Papers are sensitive to the blue end of the spectrum; this makes it possible to work with them under a yellowish safelight. Variable-contrast papers are also somewhat green sensitive, with contrast being controlled by the color of the filter used on the enlarger. Panchromatic papers are sensitive to all parts of the spectrum; they are used to make black-and-white prints from color negatives.

Latitude. The amount that exposure or development of the paper can vary from the ideal and still produce a good print. Most printing papers (especially high-contrast papers) have little exposure latitude; even a slight change in exposure affects print quality. This is why test strips are useful in printing. Development latitude varies with different papers. Good latitude means that print density (darkness) can be increased or decreased somewhat by increasing or decreasing development time. Other papers have little development latitude; changing the development time to any extent causes uneven development, fogging, or staining of the print.

Premium papers. A few papers, which cost more than conventional papers, are capable of producing richer blacks and a greater tonal range. They contain extra silver in the emulsion or otherwise enhance the tonal range. Brands include Agfa Insignia, Cachet Fine Art, Forte Fortezo Elegance, Ilford Ilfobrom Galerie, and Kodak Elite Fine-Art.

More about . . .

• Printing paper contrast, pages 150–153

A contact sheet or proof is useful when you want to choose a negative to enlarge. In contact printing, negatives are pressed against a sheet of photographic paper. A print is made by shining light through the negative to expose the paper. The result is a print that is the same size as the negative.

Don't be tempted to skip the contact printing stage and select a negative to be enlarged by looking at the film itself. Pictures are often difficult to judge as negatives, and small size compounds the difficulty with 35mm negatives. If you made several shots of the same scene, they may differ only slightly from one another, so make contacts carefully enough to compare similar pictures.

Contact sheets are easy to make. An entire roll (36 negatives of 35mm film or 12 negatives of 2 1/4 x 2 1/4 film) just fits on a single sheet of 8 x 10 paper. The contact sheet then becomes a permanent record of negatives on that roll. The procedure for making a contact print shown here uses a printing frame to hold the film and paper, with an enlarger as the light source. Another method uses a contact printer—a box containing a light and having a translucent surface on which the negatives and paper are placed.

Making a test strip will help you determine the correct exposure for your first contact prints. A test strip has several exposures on the same piece of printing paper so you can choose the best one for the complete contact print.

Make your test and contact print on a medium-contrast paper. Use a variable-contrast paper with a number 2 filter in the enlarger or a number 2 graded-contrast paper.

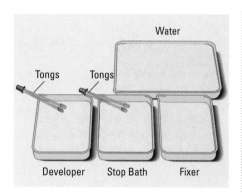

1 **Prepare the developing solutions.** Mix developer, stop bath, and fixer and set them out in trays along with a tray of water so they will be ready to use as soon as the print is exposed. Set out tongs, if you use them. See steps 1 and 2, page 144.

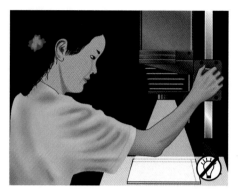

2 **Prepare the enlarger.** Insert an empty negative carrier and lower the enlarger head onto the carrier. If you will be using variable-contrast paper, insert a #2 filter into the enlarger's filter drawer. Turn on the enlarger lamp and raise the head until the light that is projected covers slightly more than the entire contact frame. Turn the lamp off. Open the lens aperture to f/4.

3 **Identify the emulsion side of the film.** The emulsion side of the film must face the emulsion side of the paper or your prints will be reversed left to right. Film tends to curl toward its emulsion side, which is usually duller than the backing side. You are looking at the emulsion if the frame numbers on the edge of the film read backwards.

4 **Identify the emulsion side of the paper.** Darkroom safelights should be on, with room lights and enlarger lamp off, before opening the package of paper. The emulsion side of paper is shinier and, with glossy papers, smoother than the back. Fiber-base paper curls toward the emulsion. RC paper curls little, but may have a visible manufacturer's imprint on the back.

You'll need only a small piece of paper to test the exposure. Cut an 8 x 10-inch sheet of printing paper into strips, about 2 x 5 inches each. Put all but one strip back in the package and close it.

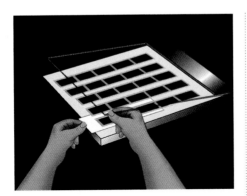

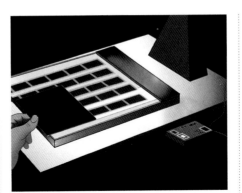

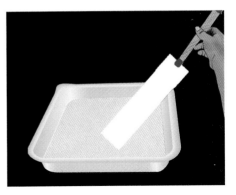

5 **Place negatives and test strip in the printing frame.** You can leave the negatives in clear plastic storage pages, if you wish. The contact print will not be quite as sharp, but leaving the negatives in the page minimizes handling and protects against accidental damage.

The paper goes inside the frame, emulsion side up. The negatives go above the paper, emulsion side down. The glass top of the frame sandwiches the negatives and paper together tightly. If you don't have a frame, you can simply put the paper on the enlarger baseboard, the negatives on top, and a plain sheet of glass over all.

6 **Expose the test strip.** Set the enlarger timer to 5 sec. Press the timer button to turn the enlarger light on and expose the entire test strip. Cover about 1/5 of the strip with a piece of cardboard. Expose for 5 sec. Give the strip three more 5-sec exposures, covering an additional 1/5 of the strip for each exposure. Your finished test strip will have five exposures of 5, 10, 15, 20, and 25 sec.

7 **Process the test strip** as shown on pages 144–147.

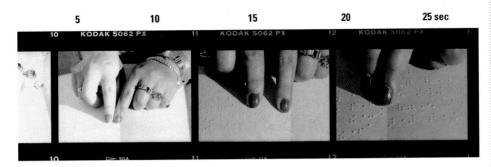

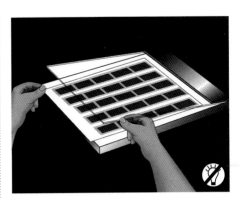

8 **Evaluate the test strip in room light to select a printing time.** Look at the sprocket holes along the film edges. Choose the segment that just barely shows a difference between the sprocket holes and the surrounding film.

Don't be influenced by the images on the test strip. Standardizing the exposure of the contact print will give you a better guide to the negatives. When you are ready to make an enlarged print, it will be useful to see, for example, which images are too dark on the contact sheet (negative was underexposed) or too light (overexposed).

9 **Make a complete contact print.** Insert a full sheet of printing paper in the printing frame and expose for the selected time. Process the print.

Setting Up an Enlargement

Personal judgments are important when selecting negatives for enlargement when you have many shots of the same scene. Which had the most pleasing light? Which captured the action most dramatically? Which expressions were the most natural or most revealing? Which is the best picture overall? Use a light-colored grease pencil to mark the contact sheet as a rough guide for cropping.

Consider technical points as well. For example, is the negative sharp? With a magnifying glass, examine all parts of the contact prints of similar negatives to check for blurring caused by poor focusing or by movement of the camera or subject. If the negative is small—particularly if it is 35mm—even slight blurring in the contact print will be quite noticeable in an 8 x 10-inch enlargement because the defects will be enlarged as well.

Standardized exposure and development of your contact sheets will help you evaluate the individual frames on them. On the contact sheet, sprocket holes should be black against just barely visible film edges, as shown in step 8, page 139. If a negative was considerably underexposed in the camera (shown on the contact sheet as a picture that is very dark) or considerably overexposed (a picture that are very light) it will be difficult or even impossible to print successfully. However, minor exposure problems (a picture a little too light or dark on the contact sheet) can be remedied during enlargement.

A standardized contact sheet can also help you estimate what filter to use with variable-contrast paper or what contrast grade of graded paper to use. The contrastier the image on the contact sheet, the lower the filter or the lower the contrast grade of paper you'll need.

1 **Select a negative for printing.** Under bright light, examine the processed contact sheet with a magnifying glass or loupe to determine which negative you want to enlarge.

2 **Insert the negative in the enlarger's carrier.** Place the negative over the window in the carrier and center it. The emulsion side must face down when you put the carrier in the enlarger.

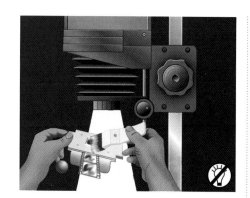

3 **Clean the negative.** Use an antistatic brush or compressed air to dust the negative and the carrier. Look for dust by holding the negative at an angle under the enlarger lens with the lamp on; it is often easier to see dust with room lights off. Dusting is important because enlargement can make even a tiny speck of dust on the negative big enough in the final print to be visible.

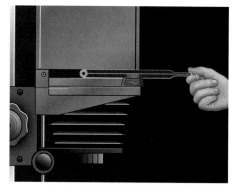

4 **Insert the negative carrier in the enlarger.** If you work in a darkroom with others, turn the enlarger lamp off whenever you insert or remove the negative carrier so that stray light doesn't fog other people's undeveloped paper. Room lights should be off so that you can see the image clearly for focusing.

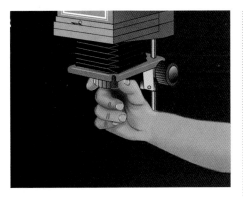

5 **Open the enlarger's aperture.** Set the lens to its largest f-stop so you will have maximum light for focusing. Turn on the enlarger lamp.

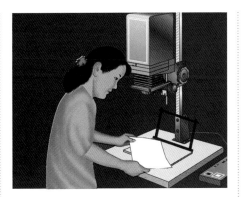

6 **Insert a piece of white paper in the easel.** Paper shows the focus better than even a white easel surface.

7 **Adjust the masking blades of the easel.** Set them first to hold the size of the paper being used and later to crop the image.

8 **Arrange the picture.** Raise or lower the enlarger head to get the desired degree of image enlargement, adjusting the easel as needed to compose the picture.

9 **Focus the image.** Focus by turning the knob that raises and lowers the lens. Shift the enlarger head only if you want to change the size of the enlargement.

10 **A magnifier helps make the final adjustments in focus.** Some types magnify enough for you to focus on the grain in the negative.

A Test Strip for Your Final Print

A test strip will give you some exposure choices for your final print. The test will show strips of your image exposed for increasing times. The test print shown here exposes each strip 5 seconds longer than its neighbor and produces total exposures of 5, 10, 15, 20, and 25 seconds.

For a medium-contrast print, use a number 2 enlarger filter with variable-contrast paper or use a number 2 graded-contrast paper.

Stop down the enlarger lens a few stops from its widest aperture. This gives good lens performance plus enough depth of focus to minimize slight errors in focusing the projected image.

Due to the intermittency effect, five separate exposures of 5 seconds each may not produce exactly the same effect as a single 25-second exposure. However, the procedure described here is satisfactory for all but the most exacting purposes. If you ever need to do critical testing, you can prevent any possible variation by uncovering only a single segment of the test strip at a time and exposing it for the full length of the desired exposure.

1 **Insert paper for a test strip.** Before you turn the enlarger lamp off, locate an important high-light in the image, a light tone (dark in the negative) such as light-colored skin, clothing, or some other light area in the scene. Turn the enlarger lamp off. Remove a strip of paper (a 2 x 5-inch strip will be adequate) and place it, emulsion side up, approximately where the light-toned part of the image is.

2 **Expose the test strip.** Set the enlarger timer to 5 sec. Press the timer button to turn the enlarger light on and expose the entire test strip. Cover about 1/5 of the strip with a piece of cardboard. Expose for 5 sec. Give the strip three more 5-sec exposures, covering an additional 1/5 of the strip each time. Your finished test strip will have five exposures of 5, 10, 15, 20, and 25 sec.

For a test print with a greater range of tones, double the exposure of each strip. For example, exposing the strips for 2 1/2, 2 1/2, 5, 10, and 20 sec gives total exposures of 2 1/2, 5, 10, 20, and 40 sec.

5	10	15	20	25 sec

3 **Process the test strip** as shown on pages 144–147.

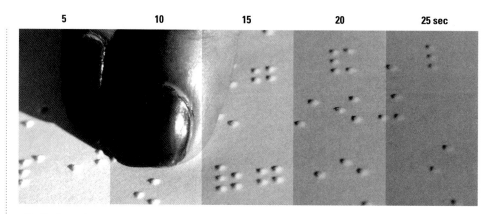

4 **Evaluate the test strip in room light to select a printing time.** Look for the time that produced good texture and detail in lighter areas. Remember that the greater the printing exposure, the darker the print will be.

Time, rather than aperture setting, is generally changed when adjusting the exposure during printing.

If the negative is badly overexposed or underexposed, however, change the lens aperture to avoid impractically long or short exposure times.

If you bring the wet print away from the darkroom sink, put it in a tray or on a paper towel so it doesn't drip fixer where you don't want fixer to be.

Now you are ready to make a full-size print. Don't be discouraged if the print is less than perfect on the first try. Often several trials must be made.

Evaluate the print under ordinary room light. Darkroom safelight illumination makes prints seem darker than they actually are. A dry print will dry down and be 5–10 percent darker than a wet print; you can reduce the exposure time accordingly to allow for that. If you change print contrast, the printing time may change, so make another test strip for the new contrast grade.

Dodging and burning in. Most prints need some local control of exposure to lighten or darken specific areas, which you can provide by holding light back (dodging) or adding light (burning in).

When you are satisfied with a print, complete the fixing, washing, and drying. To make reprints simpler, make a note of the final aperture, exposure time, and burning and dodging times.

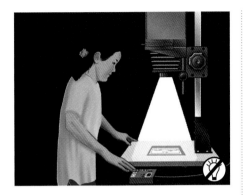

1 Expose a full-size trial print. Recheck the focus. Set the timer to the exposure indicated by the test strip. Insert a full sheet of paper in the easel and expose.

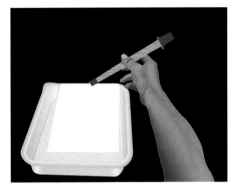

2 Process the print as shown on pages 144–147. After fixing for about half the total fixing time, you can evaluate the print in room light.

3 Look at the highlights to confirm the exposure time. Are light-toned areas bright, but with good texture and detail? It is not always possible to tell from a test strip how all areas of the print will look.

When highlights are right, look at the shadows to evaluate the contrast. Are shadows inky black with little or no detail? Decrease the contrast by using a lower number filter with variable-contrast paper or a lower grade with graded-contrast paper. Are shadows flat and gray looking? Increase the contrast by using a higher number variable-contrast filter or a lower grade of graded-contrast paper.

If you are not sure whether or not the contrast should be changed, test by exposing a small piece of printing paper with increased (or decreased) contrast. Expose the paper across a dark area of the image, process it, then see if it improves the dark values.

More about . . .
- Evaluating a print, pages 148–149
- Dodging and burning in, pages 154–155

Processing a Black-and-White Print

Preparation

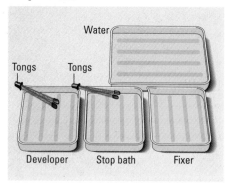

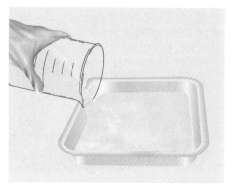

1 **Set out trays and tongs.** Set out four trays—one each for developer, stop bath, fixer, and water. If you use tongs, use two pairs: one for the developer and one for stop bath and fixer. Do not interchange them. Until the print is fixed, expose it only to safelight, not ordinary room light.

2 **Prepare the solutions.** Mix the processing solutions and adjust their temperatures. Solution temperatures are not as critical as in film development. Manufacturers often recommend about 68° F for the developer, 65° to 75° F for stop bath and fixer.

Development

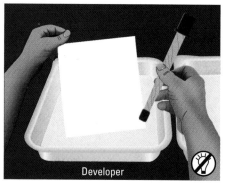

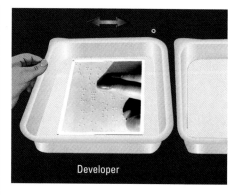

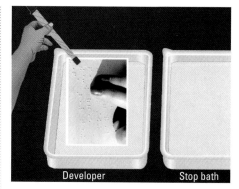

3 **Begin development.** Turn darkroom safelights on, room lights off. Slip the exposed printing paper smoothly into the developer, emulsion side up, immersing the surface of the print quickly.

4 **Agitate the print gently in the developer.** Rock the developer tray gently and continuously to agitate the print. If you must use tongs to agitate the print because the tray is too big to rock, avoid touching the print's image area with the tongs. Tongs can leave scratch marks on the print. Develop for the time recommended for the developer and paper. If the print develops too rapidly or too slowly, process for the standard time anyway. After processing, you can examine the print and change exposure as needed.

5 **Drain developer from the print.** Hold the print above the tray for a few seconds so that the developer solution, which weakens the stop bath, can drain away.

More about . . .

• Chemicals for processing, page 133
• Mixing, storing, and handling chemicals safely, page 108–109

Stop bath

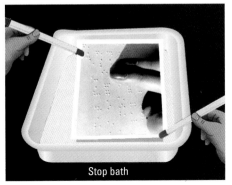

Stop bath

6 **Transfer the print to the stop bath.** The stop bath chemically neutralizes the developer on the print, halting development. Keep developer tongs out of the stop bath.

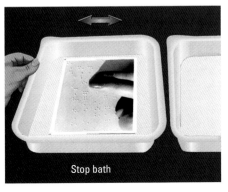

Stop bath

7 **Agitate the print in the stop bath.** Keep the print immersed in the stop bath for 30 sec (5–10 for RC resin-coated paper), agitating it gently. Use stop bath-fixer tongs in this solution.

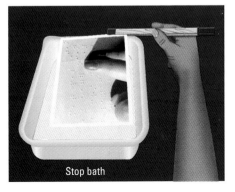

Stop bath

8 **Drain stop bath from the print.** Again lift the print so that solution can drain into the stop-bath tray. Don't let stop-bath solution splash into developer.

Fixing

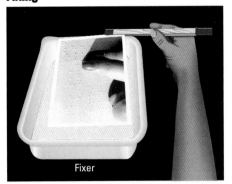

Fixer

9 **Transfer the print to the fixer.** Slip the print into the fixer and keep it submerged. The same tongs are used for stop bath and fixer, which are compatible solutions.

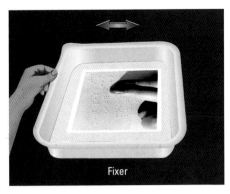

Fixer

10 **Agitate the print in the fixer.** Continuous agitation is not necessary, but agitate the print frequently so that fresh fixer remains in contact with the print. Fix the print as recommended by the manufacturer, as little as 30 sec for RC paper to as much as 5 to 10 min for fiber-base paper. Room lights can be turned on after about half the fixing time and the print examined. Make sure your package of printing paper is closed before turning on the lights.

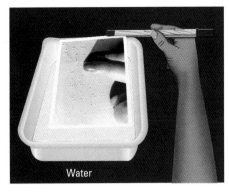

Water

11 **Remove the print from the fixer.** After fixing, transfer the print to a water-filled holding tray until you are ready to wash.

Washing and drying

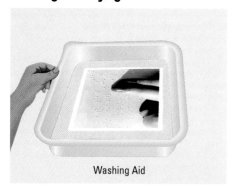

Washing Aid

12 **Treat a fiber-base print in a washing aid.** This step is optional but highly recommended for fiber-base papers because it greatly reduces the washing time required. A washing aid is not needed with RC (resin-coated) papers.

13 **Wash the print.** Wash an RC print for 4 min. Wash a fiber-base print that has been treated with a washing aid for 10 min (single-weight paper) to 20 min (double-weight paper), or as recommended by manufacturer. Wash a fiber-base print that has not been treated with a washing aid for at least 60 min.

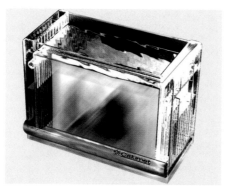

14 **Remove surface water from the print.** Place the print on a clean sheet of plastic or glass. An overturned tray will do if you clean it well and the tray bottom is not ridged. Use a clean photo sponge or squeegee to gently wipe down first the back of the print, then the front.

15 **Dry the print.** Drying methods range from temperature-controlled automated dryers (above) to simply letting the print air dry.

Make sure any drying surface that the print comes in contact with is clean. One poorly washed print still loaded with fixer and placed in a dryer will contaminate and stain other prints that are dried in the same position.

Drying racks covered with fiberglass screening let prints air dry at room temperature. Place fiber-base prints face down, RC prints face up. Wash the screening from time to time to keep it clean.

You can dry RC papers simply by placing them face up on a clean surface.

A blotter roll made for photo use is one way to dry fiber-base papers. Replace any blotter that becomes tinged with yellow, a sign of fixer contamination.

Processing black-and-white prints—A summary

Step	You'll need	Procedure	Tips for better prints
1–2. Preparation *(numbered steps begin on page 144)*	Developer (suitable for papers), stop bath, and fixer; a washing aid is recommended for fiber-base prints. Manufacturer's recommendations for dilutions and processing times. Trays, two pairs of tongs, thermometer.	Mix the chemical stock solutions needed. Dilute to working strength and adjust temperature as recommended by manufacturer.	Temperature control is less critical for black-and-white printing than for negative development. 65°–70° F is ideal; 60°–75° F is acceptable. Below 65° F, chemicals take longer to work. Much above 75° F, the developer can fog or gray the highlights, and the paper emulsion softens and is more easily damaged.
3–5. Development	Developer	After exposing the paper, slip it quickly and completely into the developer. Development times can range from 45 sec to 4 min (see manufacturer's directions). Agitate gently and constantly with tongs or by rocking the tray. If two or more prints at a time are processed, rotate individual prints from bottom to top of the stack in the tray.	Do not cut short the development time to salvage a print that darkens too rapidly; uneven development, mottling, and loss of contrast will result. If the print is too dark, make another with less exposure. Development time for some papers can be extended to slightly darken a too-light print, but this can also cause staining. If the print is too light, make another with more exposure.
Selective development		You can darken part of a print during development by gently rubbing the area while holding the print out of the tray or by pulling the print out of the tray, rinsing it with water, and swabbing the area with cotton dipped in warm or concentrated developer.	Prints kept too long out of the developer will stain. Darkening individual areas by burning in during exposure works better.
6–8. Stop bath	Stop bath	Agitate prints in stop bath for 30 sec (5–10 sec for RC paper). Agitation during the first few seconds is important.	Keep stop bath fresh by draining developer from print for a few seconds before putting print into stop bath. Avoid getting stop bath or fixer into the developer; use developer tongs only in developer tray, stop bath-fixer tongs only in those trays.
9–11. Fixing	Fixer	Fix for the time recommended by manufacturer, as little as 30 sec for RC paper to as much as 5–10 min for fiber-base paper. Agitate frequently. If several prints are in the fixer at one time, agitate more often and rotate individual prints from bottom to top of the stack. If fixer becomes exhausted during a printing session, refix all prints in fresh fixer.	The most complete and economical fixing uses two trays of fixer. Fix the print in the first tray for half the fixing time. Then transfer the print to the second tray for half the fixing time. When the fixer in the first tray is exhausted, replace it with the solution from the second tray. Mix fresh fixer for the second tray.
Holding until wash	Tray of water	After fixing, place prints in a large tray filled with water until the end of the printing session. Gently run water in tray or dump and refill frequently. Wash RC paper promptly for best results; ideally total wet time should not exceed 10 min.	Remove prints promptly from fixer at the end of the fixing time or they will take longer to wash and may bleach or stain.
12. Washing aid *(highly recommended for fiber-base prints)*	Washing aid	Rinse prints in running water for about 1 min (or as directed). Then agitate prints in the washing-aid solution for the time indicated by the manufacturer—usually just a few minutes. Do not use a washing aid with RC paper.	While using a washing aid with fiber-base paper is optional, it is a very good practice. Prints treated with a washing aid will be washed cleaner of residual chemicals than untreated prints and in much less time.
13. Washing	Source of running water. A washer designed for prints or a tray and siphon.	Wash RC paper 4 min; change water several times. If a washing aid is used with fiber-base prints, wash 10–20 min (or as directed). Otherwise, wash for at least 1 hr. Adjust the water flow or dump and refill the tray so that the water changes at least once every 5 min.	If several prints are washed at one time, they must be separated or circulated so that fresh water constantly reaches all surfaces. Some print washers do this automatically. In a tray, it must be done by hand.
14–15. Drying	Sponge or squeegee. A means of drying the prints, such as a blotter roll, a heated dryer, drying racks, or simply a clean surface.	Sponge or squeegee excess water off each print. RC paper dries well on racks. Fiber-base paper can be dried on racks, on a heated dryer, or between blotters.	

More about . . .

- Materials and chemicals you'll need, page 133
- Mixing, storing, and handling chemicals safely, pages 108–109

Evaluating Density and Contrast in a Print

Prints are judged—and adjusted—for density and contrast. The goal during printing is usually to make a full-scale print—one that has a full range of tones (rich blacks, many shades of gray, brilliant whites) and a realistic sense of texture and substance (opposite page, top right). You may deliberately depart from this goal at times, but first learning how to make a full-scale print will give you control over your materials so that later you can produce whatever kind of print you want. When you are evaluating a print and deciding how to improve it, do your judging under ordinary room light because prints look darker under safelight.

Density refers to the overall darkness or lightness of the print (opposite, top left). It is controlled primarily by the amount of exposure given the paper—the greater the exposure, the greater the density of silver produced and the darker the print. Exposure can be adjusted either by opening or closing the enlarger lens aperture or by changing the exposure time.

Contrast is the difference in brightness between light and dark areas within the print (opposite, bottom left). A low-contrast or flat print seems gray and weak, with no real blacks or brilliant whites. A high-contrast or hard print seems harsh and too contrasty: large shadow areas seem too dark and may print as solid black; highlights, very light areas, seem too light and may be completely white; texture and detail are missing in shadows, highlights, or both. The contrast of a print is controlled mainly by the contrast grade of the paper used or, with variable contrast paper, by the printing filter used.

How to proceed. To evaluate a print for density and contrast: First, judge the density to find the correct exposure. Then, judge the contrast to find the correct contrast grade of printing filter or paper. Finally, evaluate the print overall. With some experience, you can judge both density and contrast at the same time, but it is easier at first to adjust them separately.

Judge the density. Examine the test strip or trial print for an exposure that produced highlights of about the right density, especially in areas where you want a good sense of texture. If all sections of a test strip seem too light, make another set of strips with more exposure by opening the enlarger aperture a stop or two. If all seem too dark, make a test with less exposure by stopping down the aperture.

If you are printing a portrait that is mostly a close-up of the person's face, the skin tones are important. Adjust the exposure so that bright skin areas are not completely textureless, but show a little detail. Then, if necessary, adjust the contrast. Beginners tend to print skin tones too light, without a feeling of substance and texture.

Judge the contrast. When the highlights seem about right in one strip, examine the shadow areas. If they are too dark (if you can see details in the negative image in an area that prints as solid black), your print is too contrasty. Make another test strip or trial print on a lower-contrast paper. If your shadow areas are too light and look weak and gray, your print does not have enough contrast. Make another trial print on a higher-contrast paper.

Evaluate the print overall. When one of the tests looks about right, expose the full image so you can judge both the density and contrast of the entire print. It can be difficult to predict from a small strip in a test exactly how an entire print will look, so now take a look at the density and contrast of the print overall. Examine the print for individual areas you may want to darken by burning in or lighten by dodging. Prints, especially on matte-finish papers, tend to dry down, or appear slightly darker and less contrasty when dry. Experience will help you take this into account.

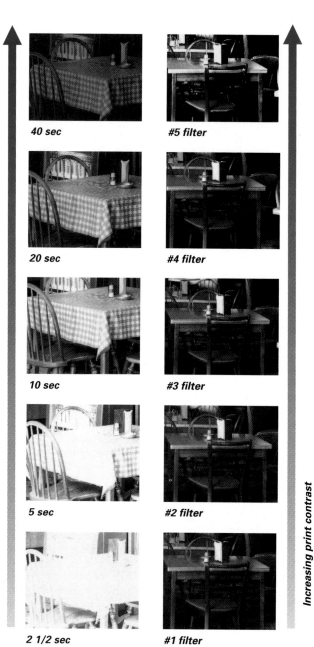

Increasing printing time

40 sec

20 sec

10 sec

5 sec

2 1/2 sec

Increasing print contrast

#5 filter

#4 filter

#3 filter

#2 filter

#1 filter

Test prints help you judge the density (darkness) and contrast of a print. *First, choose the exposure that renders good detail in important highlight areas, here, the tablecloth. Then, look at dark areas; if they appear neither too dark and harsh nor gray and flat, the contrast of the print is correct.*

A full-scale print of normal density and contrast, with texture and detail in both major highlights and important shadow areas, is shown at right. With a little printing experience, you will be able to judge whether a print is too light, too dark, too flat, or too contrasty (see below).

This photograph was made on Polaroid Type 55 4 x 5 film, which produces both a positive print and a negative. Stone later reprinted the negative in a 5 x 7 glass negative carrier so that the entire edge of the negative shows.

Density

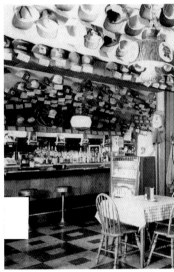

Too light. Increase exposure.

Too dark. Decrease exposure.

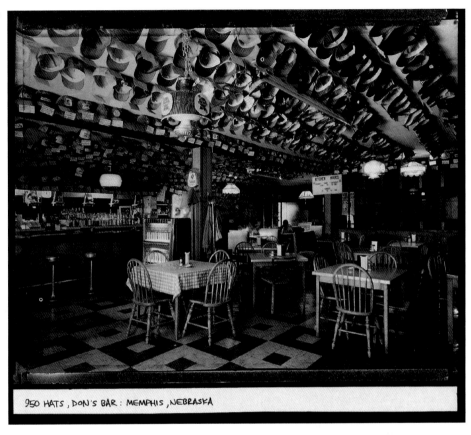

JIM STONE Don's Bar, 1983

Contrast

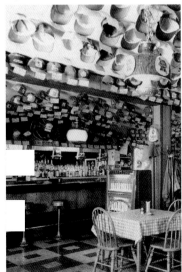

Too flat. Use higher contrast print filter or paper grade.

Too contrasty. Use lower contrast print filter or paper grade.

Black-and-white test patches

Black-and-white test patches are an aid in judging a print. To evaluate the density and contrast of a print, you need standards against which to compare the tones in your print, since the eye can be fooled into accepting a very dark gray as black or a very light gray as white, enough to make the difference between a flat, dull print and a rich, brilliant one. Two small pieces of printing paper, one developed to the darkest black and the other to the brightest white that the paper can produce, are an aid when you are first learning how to print as well as later when you want to make a particularly fine print. By placing a black or white patch next to an area, you can accurately judge how light or dark the tone actually is.

As a bonus, the black patch indicates developer exhaustion; the developer should be replaced when you are no longer able to produce a black tone in a print as dark as the black patch no matter how much exposure you give the paper. The white patch will help you check for the overall gray tinge caused by safelight fogging.

Make the patches at the beginning of a printing session when developer and fixer are fresh. Cut two 2-inch-square pieces from your printing paper. Use the enlarger as the light source to make the black patch. Set the enlarger head about a foot and a half above the baseboard. The patch should be borderless, so do not use an easel. Expose one patch for 30 seconds at f/5.6; do not expose the other. Develop both patches with constant agitation for the time recommended by the manufacturer. Process as usual with stop bath and fixer. Remove promptly from fixer after the recommended time, then store in fresh water. To avoid any possible fogging of the white patch, cut and process the paper in a minimum amount of safelight.

Papers that Control Contrast
Graded-Contrast Papers

Contrast—the relative lightness and darkness of areas in a scene—is important in any photograph. Frequently you will want normal contrast—a full range of tones from black through many shades of gray to pure white. Sometimes, however, you may feel that a particular scene requires low contrast—mostly a smooth range of middle grays (such as a scene in the fog). For another scene (perhaps a fireworks display) you may want high contrast—deep blacks and brilliant whites and limited detail in between. By the time you are ready to make a print, the contrast of the negative has been set, mostly by the contrast in the subject itself, the type of film, and the way it was developed.

You can adjust the contrast of the final print by changing the contrast of the printing paper. As shown on the opposite page, a paper of normal contrast produces a print of normal contrast from a negative of normal contrast. A paper of high contrast increases the contrast; a paper of low contrast decreases it. This can help when printing a problem negative that is very low or very high in contrast.

Suppose you shot a scene in very contrasty light. Your negative would probably have large differences between its thinnest and densest areas, producing too-dark shadows and overly bright highlights. Printing on a low-contrast paper will decrease this contrast, making shadows not so dark, highlights not so bright.

The reverse is true if you shot in flat, dull light. Your negative might have rela-tively small differences between its thinnest and densest areas, producing weak shadows and grayish highlights. Printing the negative on a high-contrast paper, however, would create greater differences between the darkest and lightest areas and so more contrast overall.

There are two ways to change the paper contrast. You can use a variable-contrast paper, with which you alter the contrast by changing the filtration of the enlarger light. Or you can use a graded-contrast paper, each grade of which has a fixed contrast.

Many photographers prefer to work with graded papers, even though you have to purchase each contrast grade separately, because graded papers are made in a greater variety of surface finishes than variable-contrast papers are. Graded-contrast papers are available in grades 0 and 1 (low or soft contrast) through grade 2 (normal or medium contrast), grade 3 (often used as the normal contrast grade for 35mm negatives), and grades 4 and 5 (high or hard contrast). Not all papers are made in all contrast grades and not all manufacturers use the same grading system, so some experimentation may be needed with a new brand of paper.

Other factors besides the printing paper affect contrast: the enlarger, the surface finish of the paper, and the type of paper developer (Kodak Selectol-Soft, for example, lowers contrast). But the basic way of changing contrast in a print is to use a different contrast grade of paper.

Depending on the contrast of the printing paper used, a print will show more, less, or about the same amount of contrast as is in the negative. ▶
Compare the range of tones in the three prints at far right. The normal print contains small areas of black and white plus a wide range of gray tones. A low- contrast print has tones that cluster mostly around middle gray. A high-contrast print has large areas that are strongly black or brilliantly white but has relatively few gray midtones.

More about . . .

• Variable-contrast papers, pages 152–153

Low-contrast negative

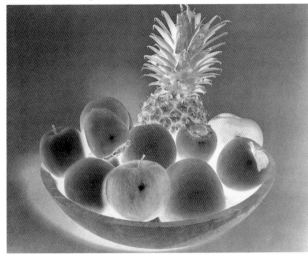

Normal-contrast negative

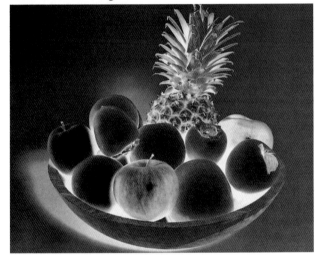

High-contrast negative

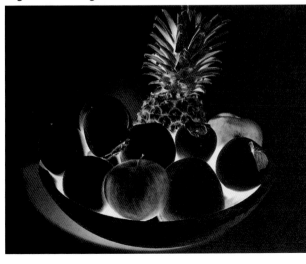

Normal-contrast paper

High-contrast paper

Low-contrast paper

Normal-contrast paper

High-contrast paper

Low-contrast paper

Normal-contrast paper

Low-contrast print

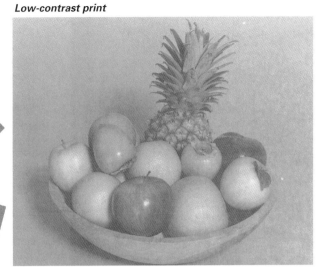

Normal-contrast print

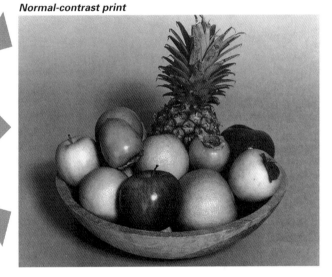

High-contrast print

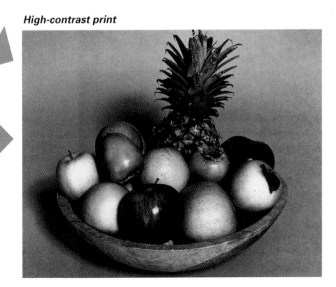

Number 0 filter

Number 1 filter

Number 2 filter

No filter

A variable-contrast or selective-contrast paper can be used at different contrast grades. The paper is coated with two emulsions. One, sensitive to yellow-green light, produces low contrast; the other, sensitive to blue-violet light, produces high contrast. You change the contrast of your print by inserting appropriately colored filters in the enlarger. The filter affects the color of the light that reaches the printing paper from the enlarger light source and thus controls print contrast. The lower the number of the filter, the less the contrast. If you have an enlarger with a dichroic head,

used for color printing, you can dial in the filtration.

Variable-contrast paper is convenient and economical because you buy only one kind of paper. You can get a range of contrast out of one package of paper and a set of filters instead of having to buy several different packages of graded-contrast paper. The filters come in half steps so it is easy to produce intermediate contrast grades. You can also fine-tune the contrast by burning in or dodging with different filters or by printing with more than one filter (see opposite).

Print exposure must be changed with some filters. Filters 0 to 3 1/2 all require about the same printing exposure, but filters 4 to 5 need an additional stop of exposure. You'll need to either double the exposure time or open the lens aperture to the next widest setting if, for example, you made a test print with a number 3 filter, then change to a number 4 filter. With a color enlarger head, you change the exposure each time you dial in a new filtration. You can check the manufacturer's instructions for guidelines or make a test strip for the exposure at the new filtration.

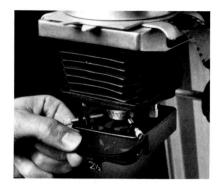

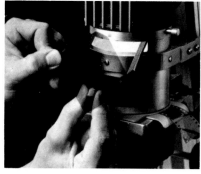

Two ways of inserting filters in enlargers. *A filter holder can be attached below the enlarger lens, and a gelatin filter slipped into the holder (left). Some enlargers have a filter drawer (right) between the lamp and the negative; an acetate filter is used here. This latter system is preferable because the filter is above the lens, and so interferes less with the focused image.*

Filtration with a dichroic color head enlarger

With a color head you dial in the filtration instead of inserting individual filters. Kodak gives the following approximate equivalents for their Polymax filters, but the exact filtration depends on the enlarger and the paper used and can vary considerably from this list. See the paper or enlarger manufacturer's instructions, or test your enlarger's settings using the following as starting points.

Filter	Dichroic equivalent
Number 1	40 yellow
Number 1 1/2	10 yellow
Number 2	No filter
Number 2 1/2	40 magenta
Number 3	60 magenta
Number 3 1/2	100 magenta
Number 4	200 magenta

Number 3 filter

Number 4 filter

Number 5 filter

Variable-contrast paper produces different degrees of contrast by filtering the enlarger light (photos, left). *A typical filter set has eleven filters numbered 0, 1/2, 1, 1 1/2 , 2, and so on, rising by half steps to number 5. The number 2 filter is about equal to a grade 2 in a graded-contrast paper. Printing without a filter also produces about a grade 2 contrast, but it's usually better to use a filter for all prints in order to avoid an exposure change.*

Split filter printing

Split filter printing lets you fine-tune print contrast. It uses a number 0 (very low contrast) filter to control bright areas and a number 5 (very high contrast) filter to control dark areas.

1. Make a test strip with the number 0 filter in place. Choose the correct exposure for the highlights.

2. Make a second test strip with the number 5 filter. Choose the correct exposure for the dark areas.

3. Make a full print first through the number 5 filter, then on the same piece of paper through the number 0 filter. Be sure to use the number 5 filter first or the highlights will be too dark.

 In this photograph, the two filters produced rich blacks plus good detail in the sky.

Test strip with number 0 filter

Test strip with number 5 filter

Combined exposure

Dodging and Burning In

You can give different exposures to different parts of a print by dodging and burning in. Often, the overall density of a print is nearly right, but part of the picture appears too light or too dark—an extremely bright sky or a very dark shadow area, for example.

Dodging lightens an area that prints too dark. That part of the print is simply shadowed during part of the initial exposure time. A dodging tool is useful; the one shown below is a piece of cardboard attached to the end of a wire. Your hand (opposite page), a finger, a piece of cardboard, or any other appropriately shaped object can be used. Dodging works well when you can see detail in shadow areas in the negative image. Dodging of areas that have no detail or dodging for too long merely produces a murky gray tone in the print.

Burning in adds exposure when part of a print is too light. After the entire negative has received an exposure that is correct for most areas, the light is blocked from most of the print while the area that is too light receives extra exposure. A large piece of cardboard with a hole in it (below center) works well. A piece of cardboard or your hands can be used—cupped or spread so that light reaches the paper only where you want it to.

If you want to darken an area considerably, try flashing it—exposing it directly to white light from a small penlight flashlight (below right). Unlike burning in, which darkens the image, flashing fogs the paper: it adds a solid gray or black tone. Tape a cone of paper around the end of the penlight so it can be directed at a small area. Devise some method to see exactly where you are pointing the light. Either do the flashing during the initial exposure or add the flashing afterward with the enlarger light on and an orange or red filter held under the lens. The filter prevents the enlarger light from exposing the paper but lets you see the image during the flashing. With variable-contrast paper, the filter may not block all the light that the paper is sensitive to, so keep the enlarger light on for a minimum of time.

Keep the dodging or burning tool, your hands, or the penlight moving. Move them back and forth so that the tones of the area you are working on blend into the rest of the image. If you simply hold a dodging tool, for example, over the paper, especially if the tool is close to the paper, an outline of the tool is likely to appear on the print.

Many prints are both dodged and burned. Depending on the print, shadow areas or dark objects may need dodging to keep them from darkening so much that important details are obscured. Sometimes shadows or other areas are burned in to darken them and make distracting details less noticeable. Light areas may need burning in to increase the visible detail. Skies are often burned in, as they were on the opposite page, to make clouds more visible. Even if there are no clouds, skies are sometimes burned in because they may seem distractingly bright. They are usually given slightly more exposure at the top of the sky area than near the horizon. Whatever areas you dodge or burn, blend them into the rest of the print so that the changes are a subtle improvement rather than a noticeable distraction.

Dodging

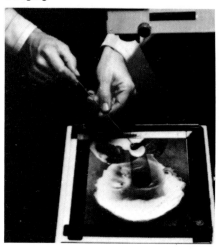

Burning in

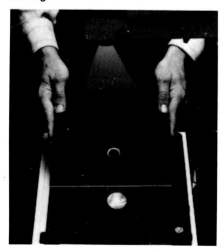

Flashing

Dodging (far left) holds back light during the basic printing exposure to lighten an area. Burning in (center) adds light after the basic exposure to darken an area. Flashing (near left) exposes part of the print to direct light and adds an overall dark tone wherever the light strikes the paper.

3 **6** **9** **12** **15** **18 seconds**

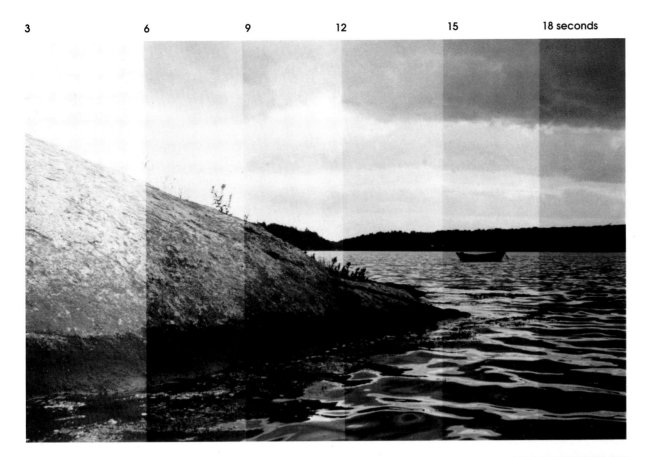

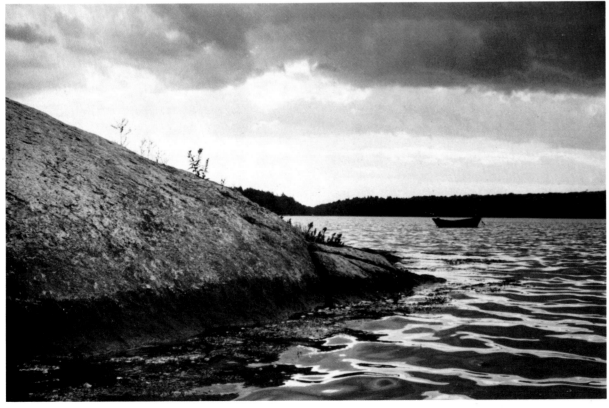

This photograph of a Maine inlet was dodged to lighten certain areas and burned in to darken others. *The exposures for the test print (top) ranged from 3 to 18 sec. The dark rock showed the best detail and texture at an exposure of about 6 sec, the water looked best at about 9 sec, and the sky needed about 18 sec of exposure to bring out detail in the clouds. The photographer gave the print a basic exposure of 9 sec, while dodging the rock for 3 sec (below). Then the sky was burned in for another 9 sec while the rock and water were shielded from light.*

Cropping

Eventually you must decide on cropping—what to leave out and what to include along the edges of a photograph. Some photographers prefer to crop only with the camera; they use the ground glass or viewfinder to frame the subject, and do not change the cropping later. Most photographers, however, do not hesitate to crop while printing if it improves the image.

Sometimes cropping improves a picture by eliminating distracting elements. Sometimes a negative is cropped to fill a standard paper size; square negatives may be cropped so that when enlarged they fit a rectangular format. Cropping can direct the viewer's attention to the forms and shapes as the photographer saw them.

Cropping by enlarging a very small part of a negative can create problems because the greater the enlargement, the more grain becomes noticeable and the more the image tends to lose definition and detail. But within reasonable limits, cropping can improve many photographs.

Two L-shaped guides will help you decide how to crop a picture. Place them over the photograph to try various croppings, as shown at right. Think of the photograph as a window and notice how the edges of the frame cut or encircle the objects in the picture. You can experiment to some extent on the contrast sheet although the image there is small, but you will probably want to refine your cropping when you enlarge the image. Making an enlargement of the entire negative before doing any cropping can be useful because there may be potentials in the print you would not otherwise see.

Two L-shaped pieces of paper are a useful cropping tool. *Lay them over a photograph to help you visualize different croppings.*

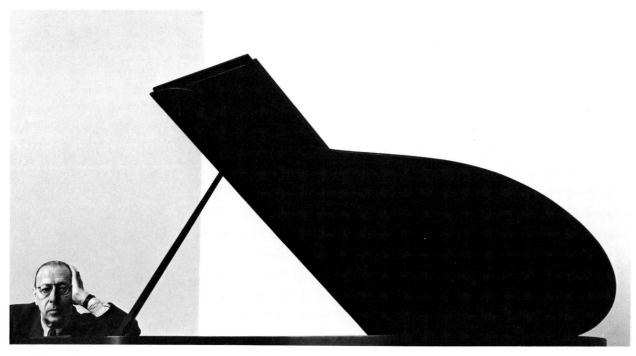

ARNOLD NEWMAN Igor Stravinsky, 1946

Arnold Newman is famous for portraits that use graphic and symbolic elements to suggest what a person does. *One of his best-known photographs is of the composer Igor Stravinsky, a portrait that Newman cropped to its essentials. Newman knew what he wanted to do, but, just starting out at the time, he didn't have the focal length lens he needed. He moved back until he had what he wanted in the frame, then cropped the photograph later. Newman says that the image "echoed my feelings about Stravinsky's music: strong, harsh, but with a stark beauty of its own." (Page 223 shows Newman at work.)*

More about . . .

• Cropping, page 318

Archival print processing

Following is one standard procedure for archival processing. Ilford has developed another method that shortens processing times considerably. Details can be found with Ilfobrom Galerie printing paper.

Paper. Use a fiber-base paper. RC papers are not recommended for archival processing because of the potential instability of the polyethylene that coats them.

Exposure and development. Expose the print with a wide border—at least 1 inch around the edges. Develop for the full length of time in fresh developer at the temperature recommended by the manufacturer.

Stop bath. Agitate constantly for 30 sec in fresh stop bath.

Fixing. Use 2 baths of fresh fixer. Agitate constantly for 3–5 min in each bath. You can agitate a print in the first bath and store it in gently running water (or in several changes of water) until a number of prints have accumulated. Then all prints can be treated for 4 min in the second bath by constantly shuffling one print at a time from the bottom to the top of the stack.

Protective toning. Use the selenium toner formula on page 158, which includes a washing aid. If no change in image tone is desired, mix toner at 1:20 to 1:40 dilution.

Washing. Rinse toned prints several times. Wash at 75°–80° F. Separate the prints frequently if the washer does not. Ideally, the water in the washer should completely change at least once every 5 min. Wash until the prints test acceptably free of hypo (see test procedure below), which will take 30 min to 1 hr or longer, depending on the efficiency of the washer.

Testing for hypo. Mix the hypo test solution below or use Kodak's Hypo Test Kit. Cut off a strip from the print's margin and blot dry. With a dropper, place a drop of test solution on the strip and allow to remain for 2 min. Blot off the excess and compare the stain that appears with the comparison patches in Kodak's Black-and-White Darkroom Dataguide, their publication R-20. The stain should be no darker than the recommended comparison patch.

Kodak Hypo Test Solution HT-2
> 750 ml distilled water
> 125 ml 28% acetic acid (3 parts glacial acetic acid diluted
> with 8 parts distilled water)
> 7.5 gm silver nitrate
> distilled water to make 1000 ml

Store in a tightly stoppered brown bottle away from strong light. The solution causes dark stains; avoid contact with hands, clothing, or prints.

Drying and mounting. Dry on fiberglass drying screens. Leave unmounted or slip print corners into white photo corners (used for snapshot albums) attached to mounting stock, then overmat (see pages 166–167). An archival-quality mounting stock is available in art supply stores; ask for 100% rag, acid-free boards. Separate prints with sheets of 100% rag, acid-free paper.

How long does a photograph last? Some very early prints, particularly platinum prints that were produced around the turn of the century, have held up perfectly. Platinum paper has a light-sensitive coating that contains no silver and produces an extremely durable and very beautiful image in platinum metal. Other photographs not nearly so old have faded to a brownish yellow, their scenes lost forever.

Conventional prints, which have a silver-based image, have a long life if they are processed in the ordinary way with even moderate care. But today, many museums and individuals are collecting photographs, and, understandably, they want their acquisitions to last.

Archival processing provides maximum permanence for fiber-base silver prints. Resin-coated (RC) paper is not recommended for archival purposes. Archival processing is not very different from the customary method of developing, fixing, and washing. It is basically an extension of the ordinary procedures and involves a few extra steps, some additional expense, and careful attention to the fine details of the work.

Archival processing eliminates residual chemicals, those that washing alone cannot remove entirely. Among the substances that are potentially harmful to a print are the very ones that create the normal black-and-white image: salts of silver, such as silver bromide or silver chloride. During development, the grains of silver salts that have been exposed to light are reduced to black metallic silver, which forms the image; but unexposed grains are not reduced and remain in other parts of the print in the form of a silver compound. If not removed, they will darken when struck by light and will darken the image overall. The chemical used to remove these unexposed grains is fixer, or hypo as it is sometimes called, which converts them into soluble compounds that can be washed away.

Fixer, however, must also be removed. It contains sulfur compounds, which if allowed to remain in a picture will tarnish the metallic silver of the image just as sulfur in the air tarnishes a silver fork. Also, fixer can become attached to silver salts and form complex compounds that are themselves insoluble and difficult to remove. When these silver-fixer complexes decompose, they produce a brown-yellow sulfide compound that may cause discoloration.

Protective toning converts the silver in the image to a more stable compound, such as silver selenide. This protects the image against external contaminants that may be present in air pollution. Selenium toner is used most often. Gold toners used to be recommended for maximum protection but are much more expensive than selenium, and there is now some evidence that they are not as effective as once believed. Experts don't always agree on which is the best method of archival processing. One widely accepted procedure is summarized at left. See the Bibliography for more detailed sources of information.

Toning for Color and Other Effects

Toning can make a significant change in print color. By immersing a print in a chemical toner solution, you can change a black-and-white print to a color such as sepia (yellowish brown), brown, red, orange, blue, or bluish green (see box below left). You can selectively color different areas of a print by coating part of the print with rubber cement or artist's frisket, toning the print, then peeling up the coating. You can add more than one color by repeating the process: coating other areas, then toning the remainder with another color.

Computer software is another way to change print colors. Compared to chemical toning, digital-imaging software provides access to more colors and the ability to color smaller and more defined areas of a print. However, the look of a toned silver print may be richer and more appealing than all but the most expensive computer-generated ones.

Toning for intensification changes the print color only a little—just enough to remove the very slight color cast present in most prints and to leave a neutral black image (see box below right). This type of toning increases the density of the dark areas of a print, which also increases the richness and brilliance of the print. Negatives can also be toned for intensification to increase their contrast.

Most toners help increase the life of a print. The silver in an image can deteriorate in much the same way that a piece of silver jewelry tarnishes. A toner increases the stability of the silver in the print by combining it with a more stable substance, such as selenium.

FREDERIC OHRINGER Coco, 1994. Sepia-toned print

Toning black-and-white prints

Paper and development. Changes during toning depend not only on the toner but on the type of paper, type of developer, development time, and even print exposure time. Sepia toners lighten a print slightly, so start with a slightly dark print. Bluish toners containing ferric ammonium citrate darken a print, so start with a slightly light print. Test the effect of a toner on your particular combination of paper and chemistry.

Fixing and washing. Prints will stain if they have not been properly fixed and washed before toning. Two fixing baths are recommended (see page 147). Different toners require different procedures. Following is a general procedure for toning using Kodak Rapid Selenium Toner, which produces chocolate brown tones on warm-tone papers, purplish brown tones on neutral-tone papers, and little or no change on cold-tone papers.

Toning. Follow the manufacturer's instructions for diluting the toner. Set out three clean trays in a well-lighted area. Ideally, light should be similar to that under which the finished print will be viewed. A blue tungsten bulb will show the color under daylight viewing conditions. Place the prints in water in one tray, the diluted toner in the middle tray, and water in the third tray—gently running, if possible.

Place a print in the toning solution. Agitate constantly until the desired change is visible. As a color comparison, particularly if you want only a slight change, place an untoned print in a tray of water nearby. Changes due to residual chemicals can take place after a print has been removed from the toner, so remove prints from toner just before they reach the tone you want.

Final Wash. After toning, treat fiber-base prints with fresh washing aid and give a final wash. Do not reuse the washing aid; it may stain other prints. Resin-coated prints need only a 4-min wash after toning.

Caution: Use gloves or tongs to handle prints in any toner. Use toners only in a well-ventilated area; fumes released during processing may smell bad or even be toxic if ventilation is inadequate. Read and follow manufacturer's instructions carefully.

How to tone for intensification

This formula for a selenium toner slightly deepens blacks and produces a rich, neutral black image. The formula incorporates a washing aid, which eliminates its use as a separate step. See also the general toning instructions at left.

Dilute 1 part Kodak Rapid Selenium Toner with 10 to 20 parts washing aid (such as Kodak Hypo Clearing Agent) at working strength. Some papers react more rapidly than others to toning, so adjust the dilution if you get too much—or inadequate—change.

Toning. Fix prints in a two-step fixing bath (see page 147). You can transfer prints directly from the fixer to the toning solution, but this is not always a workable procedure. Instead, prints can be rinsed thoroughly and held in a tray of water until a batch is ready for toning, or they can be completely washed and dried for later toning. Soak dry prints in water for a few minutes before toning. Keep RC prints wet for as little time as possible.

Place a print in the toning solution. Agitate until a slight change is visible, usually within 3 to 5 min. Very little change is needed—just enough so the print looks neutral or very slightly purplish in the middle-gray areas when compared to an untoned print. Immediately rinse the print in clean water. Wash for the recommended time.

More about . . .

• Toning to add contrast to a negative, page 127
• Digital imaging to change colors, pages 260–262

Olivia Parker's still life pairs a real pear with its abstracted outline and verbal definition. As in this assemblage, Parker often incorporates aged or weathered objects, illustrations, and type into constructions that she then photographs. Split toning expands the apparent depth of the photograph. Shadow areas become very dark brown, while lighter areas are a contrasting and cooler black.

OLIVIA PARKER Bosc, 1977

How to split tone

Paper. Silver-chloride contact printing papers, such as Kodak AZO, work best.

Negative. You'll need a negative the same size as the print you want. You can either make a large-format negative using a view camera, or enlarge a smaller negative using a film such as Kodak Professional B/W Duplicating Film SO-339.

Paper developer. Develop the print in Kodak Selectol-Soft, diluted 1:1. The temperature of the print developer is important. Keep the developer temperature between 73° and 77° F by putting the developer tray inside a larger tray filled with water at the recommended temperature. Fix the print after development and put it in a tray of water until you are ready to tone. Frequently change the water and circulate the prints to avoid later staining.

Water. The hardness or softness of the water with which you dilute the developer can affect the toning. Experiment to see if your water produces good results. Unfortunately, water can vary at different times of the year, and distilled water, which would be consistent, does not produce a good split.

Toning. Fix the prints in a second fixing bath for 4 min. Transfer into a toner-clearing bath of 70 ml selenium toner, 30 ml Heico Perma Wash, and 20 g Kodak Balanced Alkali or sodium metaborate, plus water to make 1 liter of solution. Agitate in the toner until the desired effect is achieved, usually 4 min or more. After toning, wash for at least 20 min.

If you have problems with staining, try separating the toning ingredients. Immerse the prints for 5 min in 30 ml Perma Wash and 20 g Kodalk in 1 liter of water. Then transfer to the toning bath of 70 ml selenium toner in 1 liter of water.

Caution: Use gloves or tongs to handle prints. Use in a well-ventilated area. Read and follow manufacturer's directions.

ROBERT HOLMGREN Carnival Ride

Finishing and Mounting 8

Much pleasure lies in taking pictures, but the real reward is in displaying and viewing the results. Yet some photographers never seem to finish their images; they have a stack of dog-eared workprints but few pictures that they carry to completion. Finishing and mounting a photograph is important because it tells viewers the image is worth their attention. You will see new aspects in your photographs if you take the time to complete them.

Your choice of mounting materials depends on the degree of permanence you want for a print. Archival-quality materials last the longest but are the most expensive. They are preferred by museums, collectors, and others concerned with long-term preservation. Most prints, however, can be happily mounted on less-expensive but good quality materials available in art supply stores.

The gelatin, silver, and paper in a photographic print can be seriously damaged by contact with masking tape and other materials that deteriorate in a relatively short time and generate destructive byproducts in doing so. If you want a print to last for even a few years, avoid long-term contact with ordinary cardboard, brown wrapping paper, brown envelopes, manila folders, and most cheap papers, including glassine. (The archivally minded would say to avoid all contact of prints with such materials.) Also avoid attaching to the print pressure-sensitive tapes, such as masking tape or cellophane tape, brown paper tape, rubber cement, animal glues, and spray adhesives.

◀ *Robert Holmgren used a 35mm panoramic camera to make four shots of a carnival ride, then mounted the prints together, with as much tilting as you'd feel on the carnival ride itself.*

Spotting to Remove Minor Flaws

Spotting corrects small imperfections in a print. White specks on a print are the most frequent problem, caused by dust on the negative or printing paper. You may also find dark specks or hairline scratches. Most spotting is done after the print has been completely processed and dried. The exception is local reduction or bleaching, which is done on a wet print.

Practice is essential with all these techniques. Work on some scrap prints before you start on a good print. Do the minimum amount of spotting needed to make the blemish inconspicuous. Too much spotting can look worse than not enough.

Digital-imaging software gives you the computer equivalent of spotting. Once you correct a photograph using digital imaging, you can make a permanent record of the change, so that any future prints are automatically corrected.

Spotting

White spots are removed with dyes, which are added to the print until the tone of the area being spotted matches the surrounding tone. Liquid photographic dyes, such as Spotone, sink into the emulsion and match the surface gloss of unspotted areas. They are usually available in sets of at least three colors—neutral, warm (brown-black), and cool (blue-black)—so that the tones of different papers can be matched.

You'll also need one or more very fine brushes, such as an artist's watercolor brush, size 000 or smaller; facial tissue to wipe the brushes; a little water; a small, flat dish to mix the colors; and a scrap print or a few margin trimmings to test them.

1. Match the dye to the color of your print. Pick up a drop of the neutral black on a brush and place it in the mixing dish. Spread a little on a margin trimming and compare the dye color to the color of the print to be spotted. If necessary mix in some of the warmer or cooler dyes until the spotting color matches the print.

2. Spot the darkest areas first. Dip the brush into the dye, wipe it almost dry, and touch it gently to any spots in completely black areas of the print. Use a dotting or stippling motion with an almost-dry brush; too much liquid on the brush will make an unsightly blob.

3. Now work in lighter areas. Spread out the dye in the mixing dish and add a drop of water to part of it to dilute the dye for lighter areas. The dyes are permanent once they are applied to the print, so it is safer to spot with a light shade of dye—you can always add more. Spot from the center of a speck to the outside so that the dye doesn't overlap tones outside the speck.

Etching

Etching can remove a small or thin black mark that obviously doesn't belong where it is, such as a dark scratch in a sky area. Gently stroke the sharp tip of a new mat knife blade or a single-edge razor blade over the black spot until it blends into its surroundings. Use short, light strokes to scrape off just a bit of silver at a time so that the surface of the print is not gouged. Etching generally does not work as well with RC papers as with fiber-base papers.

Local reduction

Local reduction or bleaching lightens larger areas. Farmer's Reducer (diluted 1:10) or Spot Off bleaches out larger areas than can be etched and also brightens highlights in a print. Prints are reduced while they are wet. Squeegee or blot off excess water and apply the reducer with a brush (used for this purpose only), a cotton swab, or a toothpick wrapped in cotton. If the print does not lighten enough within a minute or so, rinse, blot dry, and reapply fresh reducer. Refix the print for a few minutes before washing as usual. Do not use reducer in combination with toner; stains are likely to result.

More about . . .

• Digital imaging for spotting, page 263

There are various ways to mount a print, as shown on the following pages. Dry mounting bonds a print to a backing board. Bleed mounting trims the edges of a dry-mounted print even with the edges of the mounting board. Mounting with a border dry mounts the print with a wide border around the edges. An overmat provides additional protection for a print.

Mounting materials

Mount board or mat board is available in many colors, thicknesses, and surface finishes.

Color is usually neutral white, because it does not distract attention from the print. Off-white, gray, or black mount board are sometimes used.

Thickness or weight of the board is stated as its ply. Smaller prints can be mounted on 2-ply (single-weight) board. More expensive 4-ply (double-weight) board is better for larger prints.

Surface finish ranges from glossy to highly textured. A matte, not overly textured, surface is neutral and unobtrusive.

Size. Boards are available precut or an art supply store can cut them for you, but it is less expensive to buy a large piece of board and cut it down yourself. A full sheet is usually 30 x 40 inches.

Quality. Archival-quality mount board, sometimes called museum board, is free of the potentially damaging acids usually present in paper. It lasts the longest, but is not a necessity for most prints. Less expensive but still good-quality stock can be found in art supply stores.

Dry-mount tissue is a thin sheet of paper coated on both sides with a waxy adhesive that becomes sticky when heated. Placed between the print and the mount board, the tissue bonds the print firmly to the board.

Several types of dry mount tissue are available, including one for fiber-base papers and one used at lower temperatures for either RC or fiber-base papers. Some are removable, which lets you readjust the position of a print; others make a permanent bond.

Cold-mount tissue does not require a heated mounting press. Some adhere on contact, others do not adhere until pressure is applied, so that they can be repositioned if necessary.

Cover sheet protects the print or mount from surface damage. Use a light-weight piece of paper as a cover sheet between each print in a stack of mounted prints to prevent surface abrasion if one print slides across another. Use a heavy piece of paper or piece of mount board as a cover sheet over the surface of the print when in the mounting press.

Release paper can be useful, for example, between the cover sheet and a print in the mounting press. It will not bond to hot dry-mount tissue in case a bit of mounting tissue extends beyond the edge of the print.

Tape hinges a print or an overmat to a backing board. Gummed linen tape is best and should always be used for hinge mounting a print. Ideally, use linen tape to hinge an overmat to a backing board, but less expensive tape is also usable.

If you are mounting prints from digital-imaging output, overmatting or cold-mount tissues are best. Heat can physically damage a dye-sublimation or thermal-wax print. Heat-mounting will not physically damage an ink-jet print, but may shorten the display life of its colors.

Mounting equipment

Mounting press has a heating plate hinged to a bed plate. The press heats and applies pressure to bond the print, dry-mount tissue, and mounting board together. It can also flatten unmounted fiber-base prints, which tend to curl.

Tacking iron heat bonds a small area of the dry-mount tissue to the back of the print and the front of the mounting board to keep the print in position until it is put in the press.

Utility knife with sharp blade trims the mounting stock and other materials to size. A paper cutter can be used for lightweight materials, but make sure the blade is aligned squarely and cuts smoothly.

Mat cutter holds a knife blade that can be rotated to cut either a perpendicular edge or a beveled (angled) one. It can be easier to use than an ordinary knife, especially for cutting windows in overmats.

A cutting surface underneath mount boards or prints will let you cut them without damaging table or counter tops. Plastic self-healing cutting boards are made, or you can use a piece of cardboard or scrap mounting board.

Metal ruler measures the print and board and acts as a guide for the knife or mat cutter. A wooden or plastic ruler is not as good because the knife can cut into it.

Miscellaneous: pencil, soft eraser, razor blade. A T-square makes it easier to get square corners. For archival or other purposes where extra care is required, cotton gloves protect the print or mat during handling.

More about . . .

- Dry mounting: bleed mounting, mounting with a border, pages 164–165
- Overmatting, pages 166–167

Bleed mounting

A bleed-mounted print has no border. After mounting, the print is trimmed to the edges of the image.

1 **Heat the press** to 200° F or as instructed with the printing paper or dry-mount tissue. The resin coating of RC prints can melt at temperatures higher than 210° F; use a dry mount tissue suitable for them, one that bonds at temperatures lower than 210° F. If you are mounting a digital image, 200° is probably safe, but check the manufacturer's recommendations.

Make sure the materials are clean. Even a small bit of dirt trapped between print and board will cause a visible lump in the print.

Predry a fiber-base print and its mount board, with cover sheet on top, for about 30 sec in the press. Do not predry RC prints, just the mount board and cover sheet.

2 **Tack the dry-mount tissue to the print.** Heat the tacking iron (same temperature as in step 1). With the print face down and mounting tissue on top of it, tack the tissue to the print by moving the tacking iron from the center of the print to the sides. Do not tack at the corners.

Trim off any mounting tissue that extends beyond the print, so that the print doesn't unintentionally stick to the cover sheet.

3 **Tack the dry-mount tissue and print to the board.** Place the print and tissue face up on the mount board. Slightly raise one corner of the print only. Tack the tissue to the board with a short stroke of the tacking iron toward the corner. Repeat at the diagonal corner, then the other two. Keep the tissue flat to prevent wrinkles.

4 **Mount the print.** Put the sandwich of board, tissue, and print (with cover sheet on top) into the press. A fiber-base print should bond in about 35–40 sec. Don't leave the print in the press excessively long or the tissue may dry out and not stick.

Keep an RC or digital print in the press for the least time that will fuse the dry-mount tissue to the print and board.

5 **Trim the mounted print.** Put the print face up on a suitable cutting surface. Trim the edges of the mounted print with the utility knife or mat cutter, using the ruler or a metal straight edge as a guide. The blade must be sharp to make a clean cut. Several light slices often work better than only one cut. Press down firmly on the ruler so it does not slip—and be careful not to cut your fingers.

6 **The finished print.** Because the edges of a bleed-mounted print come right up to the edges of the mount board, be careful when handling the mounted print so you don't accidentally chip or otherwise damage the edges.

Mounting with a border

Mounting with a border protects the edges of the print and sets off the image against the mounting board.

1 **Predry the materials.** Follow instructions in step 1, page 164, for drying the materials.
Tack the dry-mount tissue to the print, as in step 2, page 164.

2 **Trim the print and dry-mount tissue.** Place the print and dry-mount tissue face up on a suitable cutting surface. Use the utility knife or mat cutter, with the ruler or metal straight edge as a guide, to trim off the white print borders plus the tissue underneath. Cut straight down so that the edges of print and tissue are even. Watch your fingers.

3 **Position the print on the mount board.** It is convenient to mount your prints on boards of the same size: 8 x 10-inch prints are often mounted on 11 x 14-inch or 14 x 17-inch boards. Position the print so the side margins are even. Then adjust the print top to bottom. Often the print is positioned so that the bottom margin is slightly larger than the top.

4 **Tack the dry-mount tissue and print to the board.** Without disturbing the position of the print, slightly raise one corner of the print only. Tack the tissue to the board with a short stroke of the tacking iron toward the corner. Repeat at the diagonal corner, then the remaining two. Keep the tissue flat against the board to prevent wrinkles.

5 **Mount the print.** Put the sandwich of board, tissue, and print (with cover sheet on top) into the press. A fiber-base print should bond in about 30–45 sec. Don't leave the print in the press excessively long or the tissue may dry out and not stick.

Keep an RC or digital print in the press for the least time that will fuse the dry-mount tissue to the print and board.

6 **The finished print.**

An overmat provides a raised border around a print. It consists of a cardboard rectangle with a hole cut in it, placed over a print that has been mounted to a backing board. The raised border protects the surface of the print emulsion, which can be easily scratched by something sliding across it—such as another print. If the print is framed, it prevents the print emulsion from sticking to the glass in the frame. Since the overmat is replaceable, a new one can be cut and mounted if the original mat becomes soiled.

One of the great pleasures of photography is showing your prints to other people—but one of the great irritations is having someone leave a fingerprint on the mounting board of your best print. Prevent problems by handling your own and other people's pictures only by the edges.

Practice cutting the inner corners. It takes some skill to cut the inner edges of an overmat with precision. It becomes easier after a few tries, so spend some time practicing with scrap board to get the knack of cutting perfectly clean corners.

An overmatted print

Overmat

Window

Hinge

Photo corner

Backing board

Attaching an overmatted print to a backing board

There are several ways to attach the print to the backing board. You can dry mount the print with a border, as shown on page 165. Cornering and hinging, shown below, let you remove the print from its backing board, in case the board needs replacing.

Cornering. Photo corners, like the ones used to mount pictures in snapshot albums, are a convenient means of mounting. The corners are easy to apply and are hidden by the overmat. The print can easily be slipped out of the corners if you need to remove it from the backing. You can buy gummed photo corners or make your own (see below) and attach them to the backing board with a strip of tape.

← Cut

Crease

Second fold

First fold

Hinging. Hinging holds the print in place with strips of gummed tape attached to the upper back edge of the print and to the backing board.

Back of print

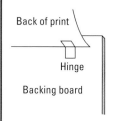

Hinge

Backing board

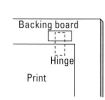

Backing board

Hinge

Print

A folder hinge is hidden when the print is in place.

A folded hinge can be reinforced by a piece of tape.

A pendant hinge is hidden if an overmat is used.

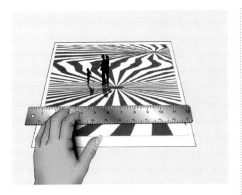

1 **Measure the image area.** Decide on cropping and measure the resulting image. If the picture won't be cropped, measure just within the image area so that the print margin will not show. This picture was cropped to 5 3/4 inches high by 9 1/2 inches wide. The overmat crops the print; you don't have to cut the print down.

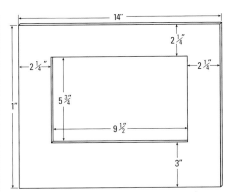

2 **Plan the mount dimensions.** The print above mounted horizontally on an 11 x 14-inch horizontal board leaves a 2 1/4-inch border on the top and sides, a 3-inch border on the bottom. The window in the overmat will be cut to the size of the cropped image. Two 11 x 14-inch boards are needed: one for the backing, one for the overmat.

3 **Mark the cuts on the mat board.** With a pencil, mark the back of one board for the inner cut, using the dimensions of the image that you want visible. Measure with the ruler, but in drawing the lines, a firmly braced T-square aligned with the mat edge is the best way to ensure that the lines will be square.

4 **Cut the overmat.** Using a metal ruler or straight edge as a guide, cut each of the inside edges, stopping just short of the corners. Finish the corners with the razor blade, taking care to maintain the angle of the cut. Erase any remaining pencil marks from the backing board so that they don't transfer to the print.

5 **Position and attach the print.** Slip the print between the backing board and the overmat, then align the print with the inner edges of the overmat. Remove the overmat and attach the print to the backing board. Ways of attaching the print to the backing board are shown, opposite, right.

6 **Attach the overmat to the backing board.** Hinge the overmat to the backing board with a strip of gummed linen tape, shown opposite, left. This isn't necessary if you plan to frame the print; the boards will be held together by the frame.

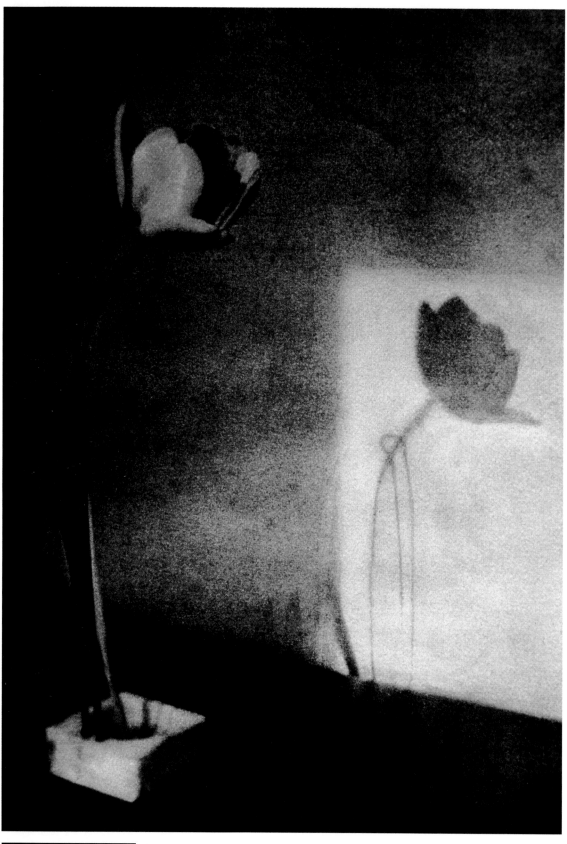

ALMA DAVENPORT DE LA RONDE Tulip. Color monoprint

Special Techniques 9

◀ ***Color monoprinting begins with a color transparency.***
Four black-and-white negatives are made, enlarged to the size of the desired print. The negatives are filtered so each corresponds to the amount of red, yellow, blue, or black in the image. The paper is coated with a pigmented emulsion, then contact printed with the corresponding negative—red emulsion with the negative that corresponds to the red in the image, yellow with yellow, and so on. Multiple impressions can be made, and the print can be varied in other ways, making each monoprint a unique image. Monoprint materials are extremely stable, so prints are archival, unlike many other color printing processes.

This chapter shows some of the alternative ways of taking photographs or making prints. You can manipulate a photograph and radically change the image formed in the camera (or make a print entirely without a camera) in order to make a print that is more interesting or exciting to you, to express a personal viewpoint that could not be conveyed by conventional methods, or just to see what the print will look like.

 The main pitfall in manipulating a print is changing it merely for the sake of change. You need to experiment with special techniques to see what they do and what their potential is with your own photographs. Once you have gained experience with various techniques, it's important first to have an idea about what you want to communicate, then use special techniques, if desired, to strengthen an image, solve a problem, or communicate a visual idea more clearly. See also Chapter 12, Digital Imaging (pages 253–279).

Making Close-Up Photographs

A close-up subject is focused closer than normal to the camera. If you want to make a large image of a small object, you can, at the simplest level, enlarge an ordinary negative. However, this is not always satisfactory because image quality deteriorates in extreme enlargements. A much better picture results from using close-up techniques to get a large image on the negative to begin with.

This is done by using a macro lens that is designed for close-up work, by fitting a supplementary lens over the front of the regular lens, or by increasing the distance from lens to film with extension tubes or bellows inserted between the lens and the camera back (see page 172).

Working close up is somewhat different from working at normal distances. After roughly focusing and composing the image, it is often easier to finish focusing by moving the entire camera or the subject farther away or closer rather than by using just the lens. During shooting, a tripod is almost a necessity because even a slight change in lens-to-subject distance changes the focus. A magnified image readily shows the slightest camera movement, so a tripod also keeps the camera steady.

Depth of field decreases as the subject is focused closer to the lens. Depth of field is very shallow at close working distances, so focusing becomes critical. A 50mm lens at a distance of about 12 inches from the subject has a depth of field of one-sixteenth inch when the aperture is set at f/4. At f/11 the depth of field increases—but only to one-half inch.

The depth of field may be distributed differently, too. In a close-up it may extend about half in front and half behind the plane of focus. At normal working distances it may be more like one-third in front and two-thirds behind the plane of focus.

A single-lens reflex or view camera is good for close-ups, because of its through-the-lens viewing. You can see exactly where the lens is focused and preview depth of field by stopping down the lens, an important ability with shallow depth of field. You can frame the image exactly and see just how the subject relates to the background. Many single-lens reflex cameras have through-the-lens metering, which makes close-up metering easier.

Rangefinder and twin-lens reflex cameras are less convenient because it is difficult to see the image exactly as the lens does. With these cameras the viewfinder or viewing lens is next to the taking lens. You see a slightly different view than the taking lens does, and the difference increases the closer you move to the subject.

How big is a close-up? In normal photographic situations, the size of the image produced on the film is less than one-tenth of the size of the object being photographed. Close-up images where the subject is closer than normal to the camera can range from about one-tenth to about 50 times life size. Beyond about 10 times life size, however, it is often more practical to take the photograph through a microscope. The term "photomacrograph" (or "macrophotograph") refers to close-ups that are life size or larger. Pictures through a microscope are photomicrographs.

The relative sizes of image and subject are expressed as a ratio with the relative size of the image stated first: a 1:10 ratio means the image is one-tenth the size of the subject. Or the image size can be stated in terms of magnification: a 50x magnification means the image is 50 times the size of the subject. The magnification of an image smaller than life size (actually a reduction) is stated as a decimal: a .10x magnification produces an image one-tenth life size.

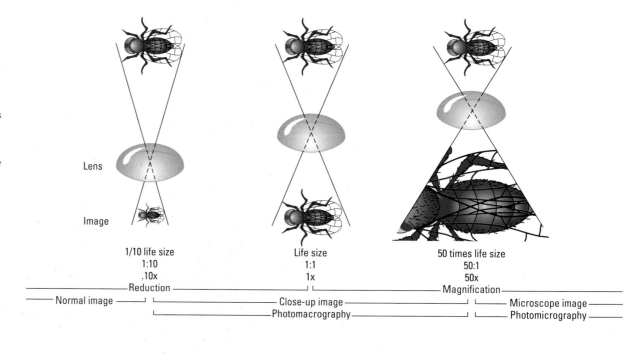

Lens

Image

1/10 life size	Life size	50 times life size
1:10	1:1	50:1
.10x	1x	50x

——————— Reduction ——————— | | —————— Magnification ——————

——— Normal image ——— | | —————— Close-up image —————— | | — Microscope image ———
| —————— Photomacrography —————— | | — Photomicrography ———

Close-up photographs can produce effects beyond simple magnification. *A kohlrabi is a vegetable related to the common cabbage, but in this close-up Ralph Weiss has shown it in an uncommon way. Isolating it against black separates it and causes the viewer to examine its shape in detail. There are no visual clues to its actual size (though the caption will tell you), and it is shown upside down from the way it grows. The photograph presents it as a visual experience rather than as something to eat. It can become a sea creature, with trailing tentacles undulating through dark waters.*

RALPH WEISS Kohlrabi, 1996. Magnified 0.6x, here enlarged to 3.4x

A macro lens is your best choice for sharp close-ups. It produces a very sharp image at close focusing distances, whereas an ordinary lens produces its sharpest image at normal distances. A 50mm macro lens without any accessories will focus as close as 9 inches and produce an image about half life size (a 1:2 ratio). Image size can be increased even more by inserting extension tubes or bellows between the lens and the camera body.

A macro-zoom lens has the zoom lens's variable focal lengths and will focus relatively close, although not as close as a macro lens of fixed focal length. It can produce an image of about one-quarter life size (1:4).

One inconvenience is that a macro lens's widest aperture is relatively small; f/3.5 is a typical maximum aperture for a 50mm macro. Adding an extension tube or bellows also cuts the amount of light reaching the film. This means that a relatively slow shutter speed may be needed.

Reversing a lens produces a sharper image when an ordinary lens is used very close to the subject. At a short focusing distance, the lens is being used under conditions for which it was not designed

and, as a result, image sharpness decreases. Reversing the lens improves sharpness. An adapter ring couples the lens to the camera in reversed position.

A close-up lens attaches to the front of an ordinary camera lens. It is something like a magnifying glass that enlarges an image by adding its own power to that of the regular lens. It also changes the focusing distance of the camera's lens so that it can focus closer than normal.

Close-up lenses come in different strengths or diopters. The higher the diopter number, the closer you can focus and the larger the image. A +1 diopter lens will focus on a subject about 1 meter away; a +2 diopter lens focuses at half that distance and magnifies twice as much; a +3 diopter lens focuses at one-third the distance and magnifies three times as much, and so on. Image size depends both on the strength of the diopter and the focal length of the camera lens; the longer the lens, the greater the image size with a given diopter.

There are pluses and minuses. The lenses are relatively inexpensive, small, and easy to carry in your camera bag. They do not require extra exposure as do extension tubes and bellows. However, they provide acceptable sharpness only when used with small apertures, and overall sharpness decreases at +5 diopters or stronger.

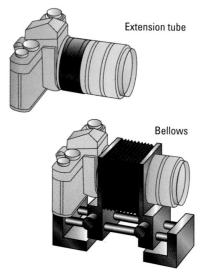

Extension tube

Bellows

Extension tubes and bellows fit between the lens and the camera. They increase the distance from the lens to the film; the greater the distance, the closer you can bring the lens to the subject and the larger the resulting image will be. Extension tubes are rings of metal that come in graduated sizes; they can be used in various combinations to make close-ups of different sizes. Bellows have a flexible center and can be expanded to different lengths.

Pluses and minuses. Tubes and bellows maintain better optical quality than close-up lenses. Using either one requires increasing the exposure. They can be used only with cameras that have interchangeable lenses. Inserting them between lens and camera can interrupt automatic exposure functions.

55mm macro lens at medium distance

The closer a lens comes to a subject, the bigger the image will be. The magnifications produced by moving closer to a subject with a 55mm macro lens are shown at right. Here, the picture was taken from 5 ft away. The resulting image (slightly enlarged here) was about 1/25 life size.

55mm macro lens at closest distance, 10 inches

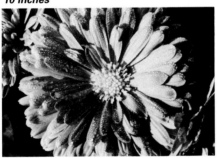

Setting the lens to focus as close as possible and moving the camera about 10 inches from a flower produced an image one-half life size.

55mm macro lens with extension tube, 8 inches

Adding an extension tube, which moved the lens to only 8 inches from the flower, produced a life-size image.

More about . . .
• Reciprocity effect, page 100
• Substitution readings, page 102

To get an accurate close-up exposure, you first need to get an accurate light reading. Then you need to adjust that reading when the lens is extended farther than normal from the film or when the exposure is longer than about a second.

The small size of a close-up subject can make metering difficult. The subject is usually so small that you might meter more background than subject and so get an inaccurate reading. A spot meter reading is one solution; it can accurately read even very small objects. You could also make a substitution reading from a gray card, or use an incident-light meter to read the light falling on the subject.

You need to make an exposure increase with bellows or extension tubes. Placing a bellows or extension tube between the lens and the camera body moves the lens farther from the film. The farther the lens, the dimmer the light that reaches the film, and the more you must increase the exposure so that the film will not be underexposed.

A camera that has a through-the-lens meter will read the light that actually reaches the film. If the object is magnified enough to fill the viewing screen (or that part of the screen that shows the area being read), the meter will calculate a corrected exposure by itself.

Manually set exposures. Your bellows or extension tube may break the automatic coupling between lens and camera. If so, or if you are using a hand-held meter, adjust the exposure yourself. To do so, follow the recommendations given by the manufacturer of the tubes or bellows, or use the method shown below.

Very long exposures also require additional exposure. You need to compensate for reciprocity effect if your final shutter speed is longer than 1 second.

Bracket—to be sure. Any exposure problem with close-ups is likely to be underexposure. So, for safety, first determine what you think is the right exposure, then make additional shots at wider apertures or slower shutter speeds.

Calculating the exposure increase for close-ups

If your camera does not increase the exposure automatically for close-ups, you can find the increase needed by measuring the long side of the subject that appears in the viewfinder. Find the exposure increase needed in the chart.

If the long side of the area viewfinder measures:

in inches	11	5 1/8	3 1/4	2 1/4	2	1 3/4	1 3/8	1
open lens aperture this number of f-stops	1/3	2/3	1	1 1/3	1 1/2	1 2/3	2	2 1/2
or multiply exposure time by	1.3	1.6	2	2.5	2.8	3.2	4	5.7

Increase applies to a lens of any focal length used with a 35mm camera

Copying Techniques

Copying a flat object, such as an old family portrait, a painting, or book page, requires more than just casually snapping the picture. You will encounter many of the same technical concerns that you do with close-up photography—the need for considerable enlargement if your original is small, the need for camera support, and so on. Plus, you need to align the camera squarely and provide an even, shadowless lighting. The techniques are not difficult but do demand some attention to detail.

The film to use depends on the copy (the term for the original material to be reproduced)—continuous tone or line copy, black and white or color. Black-and-white continuous-tone copy has black, white, and gray tones. Ordinary photographs, pencil drawings, and paintings are examples. Fine-grain, panchromatic film is best for black-and-white reproductions of these objects.

Black-and-white line copy has no gray tones, only black and white ones (like Little Red Riding Hood, opposite). Ink drawings, charts, and black-and-white reproductions in books are examples. The clean whites and crisp blacks of line copy are most easily reproduced using high-contrast lith film like Kodak Kodalith Ortho. If high-contrast film is not available, use ordinary black-and-white film processed for higher-than-normal contrast. Underexpose the film by one stop, develop for 1 1/2 times the normal development time, then print on contrasty paper.

If you want a color reproduction, select film balanced for your light source. Use tungsten film for ordinary tungsten lights, Type A film for 3400K photolamps (or tungsten film with an 81A filter on the camera lens), daylight film for daylight or flash.

A camera with through-the-lens viewing is best because it lets you accurately position the copy and check for glare and reflections. A 35mm or medium-format single-lens reflex is fine for most work. Use a view camera, which produces a 4 x 5-inch or larger negative, when you want maximum detail. With an SLR, if the copy is small, you will need to use extension tubes, bellows, or a macro lens to enlarge the image enough to fill the film format. A view camera has its bellows built in. It is usually preferable not to use supplementary close-up lenses; they often display aberrations that are more noticeable in copy work than with ordinary close-ups.

A steady support for the camera is vital because even a slight amount of motion creates unsatisfactory softness in copy work. A tripod or copy stand provides stability. A cable release to trigger the shutter prevents camera motion at the moment of exposure.

The copy and the camera must be parallel to each other, otherwise your reproduction will be distorted. A copy stand (this page, top) holds the copy horizontally; once the camera is attached and leveled, it can be moved up and down the central column while the film plane of the camera remains parallel to the copy. Oversize objects can be hung on a wall (this page, bottom). Mount the copy flat against the wall. Move the camera close to the wall and adjust the tripod height so the lens is lined up with the center of the copy, then move the camera straight back from the wall. A view camera often has lines on the ground-glass viewing screen that let you check the image's alignment. You can use the edges of a 35mm camera's finder frame to check the alignment.

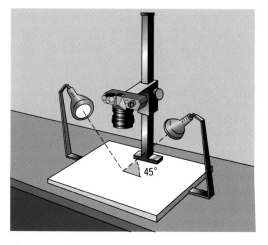

A copy stand is a convenient way to photograph a small object like a book or small print, which is placed flat on the baseboard. The camera mounts on the central column and can be moved up or down to adjust the framing of the image. Sometimes lights are attached to the sides to provide illumination at an angle to the baseboard.

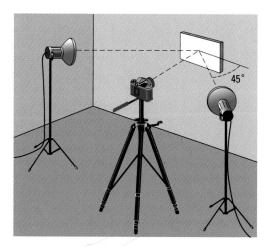

Wall mounting can be used for a larger item, such as a painting. The object to be copied is hung on the wall. The camera is positioned on a tripod squarely in front of the object. Lights on each side are at a 45° angle to the wall.

Your choice of film depends on the object being copied. *Line copy, such as an engraving (above), black-and-white book page, or ink drawing, has only black tones and white tones, no grays. High-contrast lith film will produce the best reproduction. Continuous-tone originals, such as an ordinary black-and-white photograph or a pencil drawing, has a range of gray tones, as well as black and white, and should be copied on fine-grain, general-purpose film.*

If the object being copied is behind glass, you may see a reflection of your camera in the glass. *Eliminate the reflection by shielding the camera behind a large black card or cloth with a hole cut in it for the lens.*

More about . . .

- Exposure increase with extension tubes or bellows, page 173
- Exposure increase due to reciprocity effect, page 100
- Metering with a gray card, page 102

Your goal for lighting should be even, shadowless light over the entire surface of the copy. Although it is possible to use existing daylight if you have a bright area of diffused light to work in, it is usually more practical to set up lights. Position two identical lights, one on each side of the copy at about a 45° angle to it, aimed so the lighting overlaps at the center of the copy. Continuous light sources, such as photofloods, are easier to use than flash to judge the effect of the lighting. Ideally, the lights should be the same age because light output can weaken or change color as a bulb ages.

Check the evenness of the illumination by metering the four corners and the middle of the copy. With black-and-white or color negative film, there should be no more than 1/2 stop difference in any area, even less with color slides. You can use an incident-light meter (held close to the copy and pointed toward the camera). Or you can use a reflected-light meter (pointed toward the copy). Take reflected-light readings from a gray card and not from the copy itself so that the tones of the copy do not affect the readings.

Reflections can be a problem if you need to place a piece of glass over your copy to hold it flat or if the copy itself is shiny. You may have to adjust the position of the lights so that you do not get light reflecting off the copy directly into the lens. A polarizing filter on the camera lens will eliminate most such reflections. In some cases, you may need to use polarizing screens on the lights plus a polarizing filter on the lens. You will also need to check for reflections of the camera itself in

the glass. If you see them, hide the camera behind a piece of black card or cloth with a hole cut in it for the lens (left, bottom). Always look through the lens when checking for light or camera reflections. Even if you are right beside the camera, you may not see them otherwise.

Meter the copy using an incident-light meter, or a reflected-light meter and a gray card. Select a medium aperture. Depth of field is very shallow if your focusing distance is close, and a medium aperture provides enough depth of field to allow for slight focusing error. Also, you will get a sharper image at a medium aperture than at the lens's smallest one.

You may need to increase your basic exposure, for example, if you are using extension tubes or bellows that extend the lens farther than normal from the film the same as you would for a close-up. You also need to increase the exposure if you are using a polarizing filter (1 1/3 stops). Is your exposure longer than 1 second? If so, another increase is needed—for reciprocity effect. A reflected-light meter that is built into the camera and reads through the lens has the advantage of directly adjusting for everything but the reciprocity effect. If you are using an automatic camera, be sure that it is set to its manual exposure mode.

Bracketing your exposures will insure your work pays off. Once you have made the initial exposure, make a few more at varying exposures: one stop more and one stop less with black-and-white film, 1/2 stop more and less with color film. If possible, leave your camera and the copy set up and develop a test exposure so you can reshoot, if needed, with minimum effort.

Pinhole Photography

Would you like to make a picture that shows a truly unique view of the world? Use a one-of-a-kind camera? Have your pictures be more or less sharp from up close to infinity? Make negatives on film or paper? Don't buy another expensive camera or lens—just reach for a handy box and construct a pinhole camera. All you need for pinhole photography is a light-tight container (the camera body), a pinhole aperture (instead of a lens) to let in light, and a light-sensitive material (film or paper).

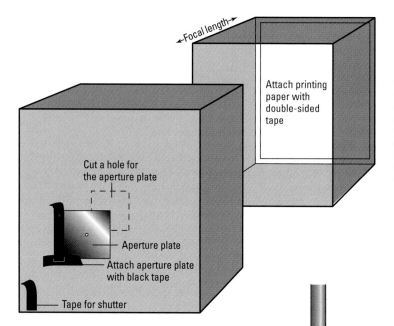

Focal length

Attach printing paper with double-sided tape

Cut a hole for the aperture plate

Aperture plate

Attach aperture plate with black tape

Tape for shutter

Constructing a pinhole camera. *You can use any existing box with a tight-fitting lid, like an oatmeal box or a squarish gift box with a deep lid. A shoe box can be used but because the lid is shallow, you'll have to tape the box shut every time you use it to make sure it is light tight. You can also construct a box from heavy mounting stock, as shown here. This box is versatile because you can move the two sections farther apart or closer together to adjust the angle of view (see diagrams at bottom). Paint the inside of the box flat black.*

Pinhole exposures

Exposing a paper negative

Select a paper. A contrast grade 1 or 2 paper gives the best results. You can use a double-weight paper if you want only a negative image. But, if you want to contact-print the negative to make a positive, use a single-weight paper so that it will be thin enough to print through.

Load the paper into the camera in complete darkness. Close the camera and, if necessary, seal the closure with black tape. Make sure your "shutter" (a piece of black tape over the pinhole) is in place.

Start by working outdoors in midday sun. Paper has a slow "film speed," and the relatively dim light indoors can make the exposure impractically long.

Keep the camera stationary during the exposure. Everything from about 3 inches to infinity will be equally sharp (or equally unsharp, depending on how you look at it), so you can try including objects that are very close as well as far away.

Start with a trial exposure of 1 minute. Peel back the tape covering the pinhole, then replace the tape at the end of the exposure time. Develop the paper and evaluate the exposure. If the negative is too light, try double (or more) the exposure time. If too dark, cut the exposure time to half (or less).

Exposing a film negative

Calculating an exposure with film. Film is much faster than paper, so ideally with film, you should meter the scene. To calculate the exposure, you'll need to determine your f-stop (which is determined by the size of your box) and then your shutter speed, depending on the brightness of the scene and the film speed.

To find your f-stop, divide the diameter of the aperture (the size of your pinhole) into the focal length of the camera (the distance from the pinhole to the film). Don't mix your measurement systems. Use either millimeters or use inches, not both.

Or, simply make a trial exposure. If you are using a film with a speed of ISO 100, try a 4 sec exposure with the camera diagrammed above, constructed about 8 inches square.

Dealing with light leaks

If a large part of the negative turns black during development, your camera probably has a light leak. To check for leaks, place the loaded camera in the sun for a minute or two without opening the shutter and then develop the negative. If the negative has exposed areas, check for light leaks to fill or seal with tape, or repaint the inside of the camera with black paint.

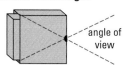

To drill the aperture, *cut a 1-inch square piece from an aluminum beverage can, or use a piece of very thin brass. Pierce the metal with a needle. Try a size 8 U.S. sewing needle, which has a diameter of 0.57 mm. Keep the needle perpendicular to the metal and gently rotate it to pierce a small hole. To get a better grip on the needle, you can insert it in an X-Acto blade holder. Sand the back of the metal with fine sandpaper until the hole is smooth and round.*

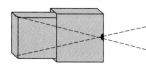

Normal focal length

angle of view

Long focal length

To increase the focal length, *slide the front and back sections farther apart. You may need to use black tape to prevent light leaks.*

Short focal length

Short focal length

For a wider angle, *shorten the focal length by building up the interior of the box, or curve the paper inside the box.*

Pinhole photographs characteristically are softly focused overall from immediately in front of the camera to the farthest distance. *Notice how the grass close to the lens is about as sharp as the house in the background. For this picture, Peggy Jones placed the camera on the grass.*

Pinhole photography fulfills Jones's interest in transforming reality instead of just recording it. She uses paper negatives for both aesthetic and practical reasons. She likes the paper texture that prints through from a paper negative, and paper negatives are more economical than film for larger cameras.

One of the advantages of constructing your own camera is the possibility of design variations to create unique images. *Instead of having a flat film plane parallel to the aperture, this camera was designed with an angled film plane to create distortion.*

"This camera does have its problems though," says Jones, namely, the inverse square law. The light must travel an increasingly greater distance to reach the farthest part of the film plane, and in doing so gets dimmer. The far end of the film plane gets less exposure than the near end, so printing the positive requires considerable dodging and burning to balance the exposure overall.

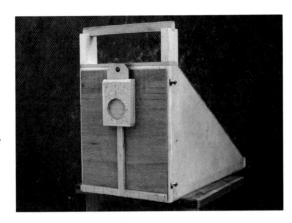

The same site as in the pinhole photograph, far right, but this time taken with a conventional 35mm camera and 50mm lens. The round object is a small well in Spyglass, a housing development in southern California. Compare the shape of the well to the pinhole image.

More about . . .

• Pinhole photography, page 36

PEGGY ANN JONES Spyglass Well, 1985. Photograph taken with pinhole camera. Silver print with hand coloring

A photogram is a kind of contact print, made by placing objects, instead of just a negative, on a piece of light-sensitive material and exposing it to light. In the 1920s, about 80 years after the first camera photographs were made, photograms and other print manipulations such as solarization became popular with the painter-photographers Man Ray and László Moholy-Nagy, who sought to explore the "pure" actions of light in space.

Any object that comes between the light source and the sensitized material can be used. You can try two-dimensional objects like cut paper, three-dimensional ones, opaque objects that block the light completely, transparent or translucent objects like a pitcher or a plastic bottle that bend the light rays, objects laid on glass and held at different levels above the paper, moving objects, smoke blown over the surface of the paper during the exposure—the possibilities are limitless. All these objects are light modulators—they change the light on its way to the paper. Light can be added to the paper as well as held back. For example, you might try a penlight flashed at the paper or suspended from a string and swung across the surface.

A photogram can be made on printing paper or film. If film is used, the developed negative can then be printed. Color photograms can be made by exposing color paper through different color filters or by using translucent, tinted objects to modulate the light.

Man Ray arranged string, a toy gyroscope, and the end of a strip of movie film on a piece of photographic paper, then exposed the paper to light. The resulting image is as open to interpretation as you wish to make it. You can see it simply as an assemblage of forms and tones. Or if you see the large black background as a person's head in silhouette (like the silhouetted head in the movie film), then the strip of film might be a dream seen by the internal gyroscope of the brain.

MAN RAY Rayograph, 1924

In a photogram, objects are arranged directly on light-sensitive material. *Here a simple photogram is being made by placing a piece of marsh grass on a sheet of high contrast (grade 5) printing paper. The head of the enlarger is positioned far enough above the baseboard to light the paper completely. After exposure, the paper is developed, fixed, and washed in the usual manner to produce a life-size print of the grass. Experiment with different exposures—longer ones will penetrate some objects more and create a different effect.*

You can combine several layers to make a photogram or use just one. *Jack Sal sandwiched together a matzo cracker and a piece of very slow printing-out paper that darkens on exposure to sunlight. He put the two in his window for about a month, then fixed the paper like an ordinary print to prevent further darkening. The holes in the cracker appear large because during the day the sun changed position in the sky and shone into the holes from different angles. Studio proof paper is no longer made, but the effect could be simulated by an ordinary printing paper with a much shorter exposure.*

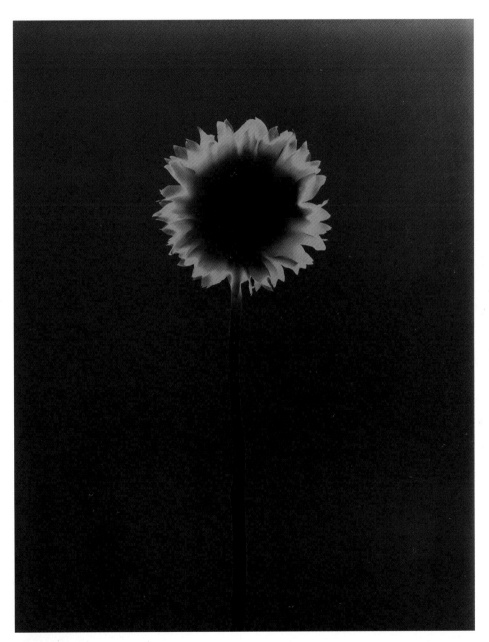

Adam Fuss has made photograms of flowers, water, animals, and other objects placed on printing paper. Here, a single sunflower was placed on reversal color printing paper (ordinarily used to make a positive print from a positive color transparency). The flower seems to radiate light as if backlit or glowing from within. Compare the sunflowers at the start of Chapter 1.

A Sabattier Print: Part Positive, Part Negative

A Sabattier print is made by reexposing paper to light during processing. This gives a print both negative and positive qualities and adds halolike Mackie lines between adjacent highlight and shadow areas (see opposite and page 363). The technique is commonly known as solarization, although, strictly speaking, solarization (which can look somewhat similar) takes place only when film is massively overexposed. The correct name for the phenomenon shown here is the Sabattier effect.

The unusual appearance results from a combination of effects. When the print is reexposed to light during processing, there is little effect on the dark areas of the print because most of the crystals there have already been exposed and reduced to black silver by the developing process. The bright areas, however, still contain many sensitive crystals that can respond to light and development. The bright areas therefore turn gray but usually remain somewhat lighter than the shadows. Between the light and dark areas, chemicals remaining from the first development retard further development; these border regions remain light, forming the Mackie lines.

There are several way to produce a Sabattier print. The simplest way, but the most difficult to control, is simply to turn on a light briefly while the print is in the developer. A procedure that gives much more control is described in the box at right.

Printing from a negative will give a positive image plus negative effects from the second exposure, as in the print opposite. You can also print from a positive color slide, which will give a negative image plus some positive effects. Black-and-white printing paper responds differently to colors in the slide: blue prints as black, yellow prints as white.

Making a Sabattier print

Basic procedure

Materials needed. A negative of normal to high contrast. Normal print processing chemicals. High-contrast paper (grade 5 or 6).

First exposure. Put negative in enlarger and focus. Expose a test print with a slightly lighter than normal series of text exposures. (Test print, opposite left, received first exposures of 5, 10, 15, and 20 sec.)

First development. Develop for the standard time in normal developer.

Rinse. Wash in water for 30 sec to remove the surface developer. Do not use an acid stop bath. Remove excess water from the front and back of the print with a squeegee or soft paper towels. Handle gently to avoid scratching the fragile surface of the wet print.

Second exposure. Remove the negative from the enlarger. Stop down the aperture about two stops. Reexpose the test print in strips at right angles to the first exposures. (Test print, opposite left, was given second exposures of 5, 10, 15, and 20 sec.)

Second development. Develop for the standard time in normal developer.

Finish processing. Treat print with stop bath and fixer; wash and dry as usual.

Final print. Examine the test print and choose the square that gives the desired effect. Note the combination of exposure times, apertures, and development times. Make a print under these conditions.

Variations on the basic procedure

—

Set the enlarger slightly out of focus. This will broaden the Mackie lines without making the image noticeably out of focus. The Mackie lines will also be broader with a less contrasty negative.

Develop for less than the standard time. Remove the print quickly from the developer when the desired effect is visible.

Develop in a more dilute developer (if the normal dilution is 1:2, try 1:4, 1:10, or even greater dilutions to produce color shifts).

Develop in two different developers. A cold-tone developer for one development and a warm-tone developer for the other will give color shifts.

Some photographers report better results if the print is aged at this point in a dark place (a photo blotter book works well). Aging times vary from 15 min to a week.

—

See variations under first development.

—

Dodging or burning in during the first and/or second exposure will give different results. The Mackie lines can be lightened by bleaching. The reducing formula given by Ansel Adams in his book *The Print* is recommended. You can also try local reduction or an overall immersion in Farmer's Reducer (diluted 1:10).

This test for a Sabattier print *was given first exposures of 5, 10, 15, and 20 sec (left to right). After a first development, the print was exposed again to light from the enlarger but without the negative in place. The second exposures were 5, 10, 15, and 20 sec (bottom to top). The test was then developed again, fixed, and washed.*

The exposures for the final print *were chosen from the test print at left: a first exposure of 20 sec and a second exposure of 5 sec (the bottom right square of the test). The enlarger was deliberately set very slightly out of focus to broaden the very light Mackie lines, and the print was later bleached to lighten them.*

Hand-Applied Emulsions

Special printing techniques offer many different choices when you want more than a straight black-and-white or color print. A cyanotype utilizes light-sensitive iron salts to form an image (see below). The process is simple, inexpensive, and quite permanent. The following pages show platinum printing, image transfers, hand coloring, and mixed media work, plus how to make the enlarged negatives needed for many of these processes.

As a starting point for work that incorporates various printing processes, hand coloring, and other techniques, Betty Hahn used a publicity photograph of those mythic heroes the Lone Ranger and Tonto. Each print is enjoyable in its own right; when various versions are placed together, the eye jumps back and forth between them, comparing skies colors, and other traces of the artist's intervention in the original photograph. A cactus growing out of the Lone Ranger's head is a bonus.

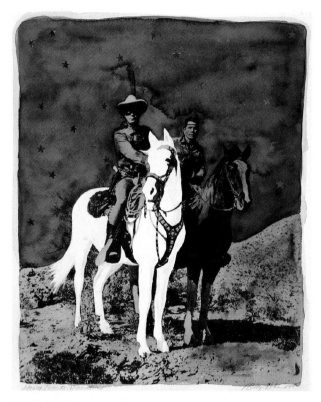

BETTY HAHN **Starry Night III, 1975. Cyanotype with watercolors and applied stars**

LR #29, 1977. Cyanotype with Magic Marker

Making a cyanotype

Materials needed. A negative the same size as the print to be made. A support for the emulsion: rag paper (such as artist's watercolor paper) or any natural-fiber cloth (such as cotton, wool, or silk).

 Chemicals: potassium ferricyanide and ferric ammonium citrate (green scales). Optional: 3 percent hydrogen peroxide solution.

 Scale for weighing the dry chemicals, graduated container, stirring rod, contact printing frame or large piece of glass. A dimly lit room in which to coat the material and let it dry; cyanotype is not as light sensitive as ordinary printing paper, so darkroom safelights are not required.

 Cyanotype chemicals stain; use newspapers to protect your working surfaces, plus gloves and an apron to protect your hands and clothing.

Prepare the light-sensitive solution.

Mix solution A

| Ferric ammonium citrate (green scales) | 1 oz (31 g) |
| Distilled water | 4 oz (116 ml) |

Mix solution B

| Potassium ferricyanide | .5 oz (15.5 g) |
| Distilled water | 4 oz (116 ml) |

Mix together equal parts of solution A and solution B. When mixed together the chemicals lose potency in about 12 hours, so mix only as much as you will need during one printing session.

Coat the paper or cloth. Use the brush to apply an even coating of solution to the surface to be exposed. Coat enough material to make some test strips, as well as final prints. Let dry in a dark area. A fan or hair dryer at cool setting will speed the drying. Make sure the coated surface is completely dry; cloth takes longer to dry than paper, at least several hours. The dry surface will be bright yellow.

Assemble the sensitized support and the negative. Place the emulsion side of the negative against the coated side of the dry support. Assemble in a contact printing frame or under a large sheet of glass as shown in step 5, page 139.

Expose. Exposure times will vary depending on the light source. A few minutes in direct sunlight, perhaps 15 minutes under a sunlamp or in a contact printer—hence the need for test strips.

 The coated surface will be yellow before exposure, green as it is exposed, and finally blue-gray when full exposed.

Wash and dry the print. Wash in running water for 5–10 min or until the water shows no trace of color. Let dry.

Optional: Intensify the print. After washing, the blue can be darkened by immersing the wet print in an intensifier of equal parts of 3 percent hydrogen peroxide and water. Immerse in enough solution to cover the print. Agitate for about 30 sec. Wash for 5 min.

More about . . .

- Alternative processes, see publications listed in the Bibliography

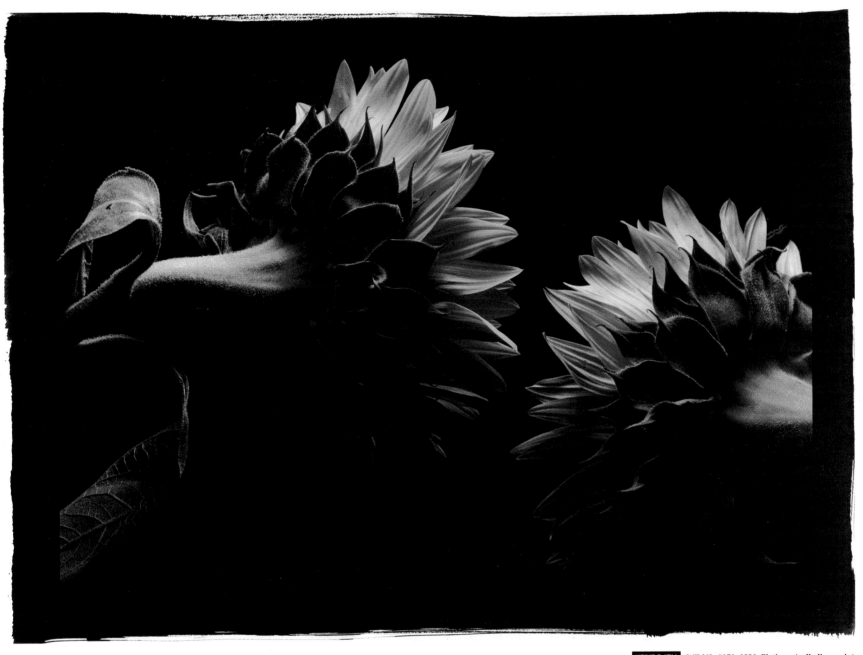

Platinum (and similar palladium) printing produces very beautiful and stable photographic images.
Platinum paper has a light-sensitive coating that yields an image of platinum metal instead of silver. Its subtle gradations of tone give unsurpassed delicacy and depth to a print, and because platinum is chemically stable, the prints are extremely long lasting. Images produced around the turn of the century, when the platinum process was originally popular, still retain their richness and subtle detail. A book reproduction can only hint at the beauty of an original.

Kenro Izu has been working in platinum since he saw a vintage Paul Strand platinum print. "At the time I didn't know it was platinum, but I was overwhelmed by the beauty of what black-and-white photography could be." The main disadvantage of platinum prints is cost; platinum is more expensive than silver. Like cyanotyping and certain other processes, the paper is not very sensitive to light, so enlargements can't be made. Negatives have to be contact printed, which requires either using a large-format camera or making an enlarged negative.

Izu coats his own paper (you can see the edges of the coated area in the print above). He believes enlarged negatives lead to loss of quality, so he photographs using a specially constructed view camera that holds 14 x 20-inch film cut to that size for his use. If you want to try platinum printing, commercial platinum paper is available from The Palladio Company, Inc., P.O. Box 28, Cambridge, MA 02140, (617) 393-0814. You can also buy the chemicals and coat your own.

Image Transfer

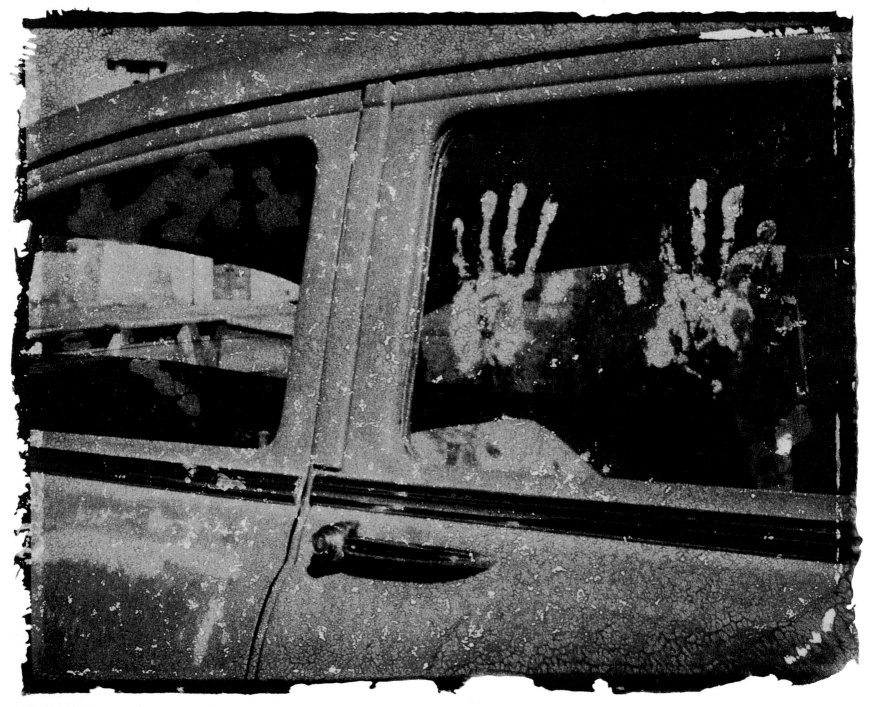

ELAINE QUERRY Dos Manos Blancas, 1995. Image transfer

Image transfers and emulsions transfers peel apart the layers of various Polaroid films and deposit them on another surface. *Elaine Querry likes the possibilities available with transfer processes, which let you go beyond a straightforward image to a more interpretive one. Querry also likes the unpredictabil-*

ity of the processes; you don't know exactly what the results will be until the transfer is made. Above, Querry found these hands imprinted on a car window at an abandoned movie set near Taos, New Mexico just before the set was to be torn down. Nobody was there but Querry, a dog, and the hands.

For detailed technical information on how to make an image transfer using Polaroid materials, call Polaroid at 800-225-1618 for a free copy of their booklet A Step-by-Step Guide, *which, in addition to image transfer, tells how to make emulsion transfers and manipulate SX-70 prints.*

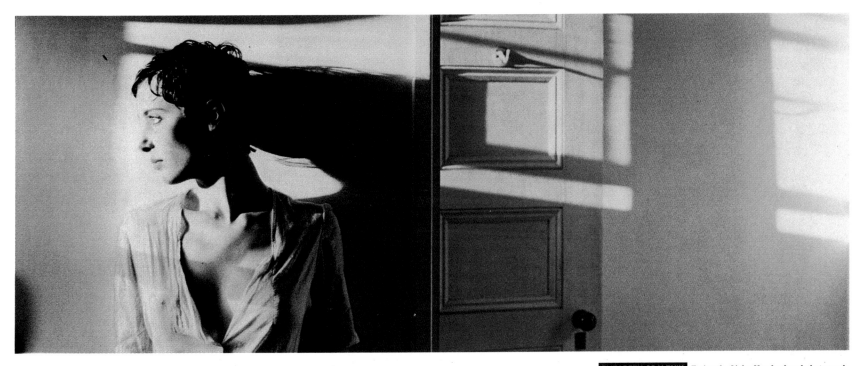

Facing the Light. Hand-colored photograph

Hand coloring can add subtle effects to a photograph that make it unlike an ordinary color photograph. *Many materials can be used to hand color an image, including oil paints, watercolors, acrylics, colored pencils, and pastels. Elizabeth Opalenik (above) used Marshall's Photo Oils on an infrared photograph to make a soft image with muted details.*

Heavy deposits of graphite from pencil lead will produce a shiny surface on matte paper. Duane Monczewski (right) often uses minimal color, but creates a clearly manipulated surface. Here he used colored pencil, charcoal, and pastel.

DUANE MONCZEWSKI San Francisco, 1985. Hand-colored photograph

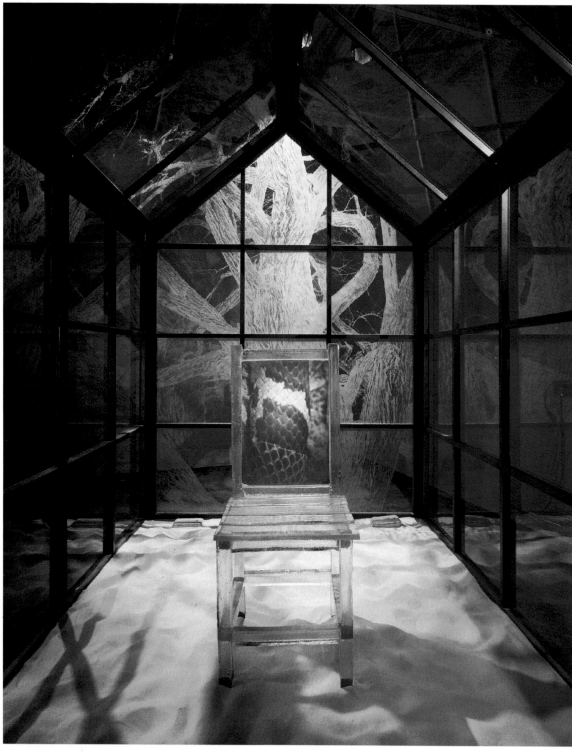

MERIDEL RUBENSTEIN Oppenheimer's Chair, 1995. Photo/video/glass installation

Meridel Rubenstein's 10 ft x 7 ft x 9 ft installation Oppenheimer's Chair *is a response to the detonation near White Sands, New Mexico, of the first atomic bomb in 1945. A video is projected onto a glass chair that sits on white sand. Behind the chair a glass wall carries a sandblasted image of a tree. Part of the text on the wall by the installation reads, "J. Robert Oppenheimer was the head of the Manhattan Project. I had been looking at a photograph I made of his Los Alamos director's chair. We all sit in Oppenheimer's chair. It's made of glass."*

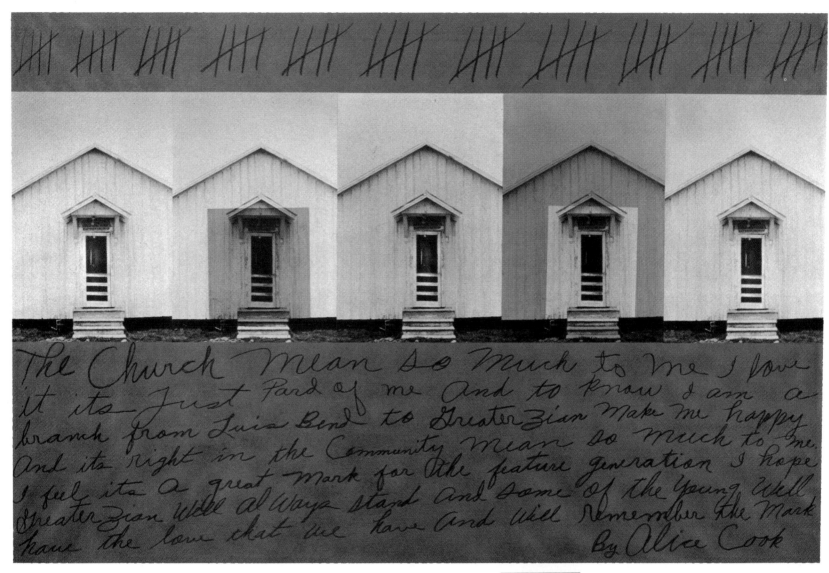

NANCY O'CONNOR Footprints of the Mark, 1980. Title and text written by Alice Cook

Nancy O'Connor was raised in a ranching family and for many years has recorded life in a community of black cowboys in Luis's Bend, Texas. Her ongoing work combines photographs, writing, and audio tapes to document a way of life that is no longer being carried on by a new generation and is rapidly being forgotten. The written commentary that accompanies the photographs is by the individuals of the community. The marks across the top of the piece show the way cattle used to be counted, and in another sense might count the time that has passed for the people there.

Making an Image on High-Contrast Film

Many alternative processes like cyano-typing or platinum printing require contact printing. Enlargements cannot be made because the materials respond too slowly to light. If you are working from an existing small-format negative, you will have to make an enlarged negative. For a high-contrast image, you can make a high-contrast negative. If you want an enlarged continuous-tone negative, you can enlarge an existing negative onto materials such as Kodak Professional B/W Duplicating Film SO-339.

High-contrast film converts the many tones in an ordinary continuous-tone negative to either black or white. The enlarged transparency can then be contact printed on ordinary black-and-white or color paper, or used with an alternative printing process, such as cyanotyping (see the prints on page 182).

The original negative is enlarged onto lith film, a high-contrast copying film sold under various trade names (such as Kodak Kodalith Ortho) for use in photo-offset printing. This produces a dropout, an image with only black or white areas and no intermediate gray tones. By changing the exposure time in the copying process, you can produce images with different amounts of black—even to the extreme of a practically solid black image pierced only by the brightest highlights.

FRED BURRELL Portrait of Ann Ford, 1971

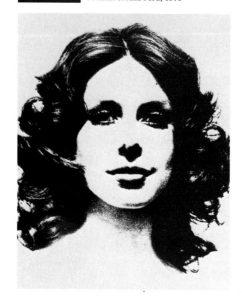
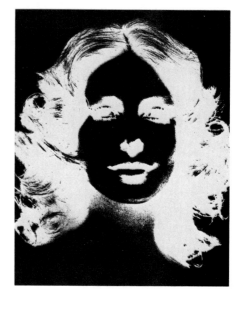

High-contrast positive and negative transparencies (left and right) were made from an ordinary continuous-tone image (above). The high-contrast images have no middle-gray tones, only black and white. The transparencies were enlarged to 8 x 10 inches, for use in contact printing.

Making a high-contrast positive and negative

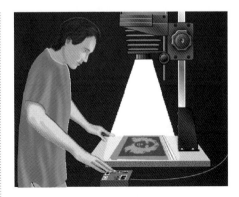

1 **Set up the enlarger.** To make a high-contrast transparency, place the original continuous-tone negative in the enlarger's negative carrier. The negative will be printed onto a high-contrast graphic arts (lith) film such as Kodak Kodalith Ortho Film 2556, Type 3. If the manufacturer describes the film as ortho or orthochromatic, it can be processed under red safelight, and you will be able to see what you are doing and how the film is developing. Check the instructions.

2 **Expose a high-contrast positive.** Just as if you were making an enlarged print, the negative is projected onto a printing easel, but one containing an 8 x 10 sheet of lith film. The first reproduction will be a positive transparency; from that a negative transparency can be contact printed.

3 **The more exposure you give the film, the darker the image will be.** Try an exposure time of 10 to 20 sec with the enlarger lens wide open. Make a test strip to check the effects of different exposures; slight increases in exposure extend the dark areas.

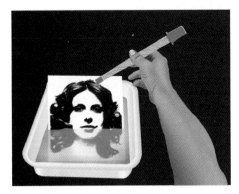

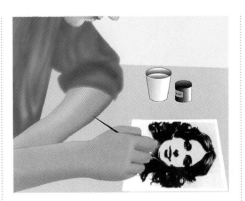

4 **Develop the film using a developer designed for lith film.** Check the instruction sheet for development time. Process like conventional film with stop bath, fixing, washing aid, washing, and drying.

5 **Check for pinholes**—clear specks in the dark areas caused by dust on the film or by under-exposure. Paint them out with a fine brush dipped in opaque, a gooey blocking-out material. Larger areas can also be painted out, if desired. Black specks or large black areas can be removed with a strong solution of Farmer's Reducer, a chemical bleaching agent.

6 **Make a high-contrast negative.** A negative can be produced from the high-contrast positive by contact printing. Raise the enlarger head enough so the light will cover a contact printing frame. Insert a sheet of lith film emulsion side up, the (dry) high-contrast positive emulsion side down, finally the glass of the printing frame on top. Try an exposure of 5 to 10 sec with the aperture wide open; a test strip will give an exact exposure.

SUSAN GOLDMAN Bouillabaisse

KEVIN CLARK Fresh Peppers

A realistic or at least pleasing color balance is important in food photography, where the intention is usually to appeal to the appetite by way of the eye. Stylists are often used in food photography to prepare the food, usually in multiple, so the photographer always has a fresh dish to shoot. Lighting, focus, composition, and items that won't wilt are arranged before the food is ready, using a mock-up of the main dish. An image-perishable dish is the last thing to hit the set. Timing, coordination, and teamwork are critical, because the ideal is to photograph the food as soon as possible after it is done, before it melts, congeals, dries up, bleeds water, or otherwise visually deteriorates.

Left, every ingredient was carefully placed in this complex setting to illustrate a recipe for bouillabaisse (a highly seasoned fish chowder). Above, the backlit colors and shapes are the main attraction.

Color photography can sometimes produce unexpected results. We tend to ignore slight shifts in color balance when we look at a landscape or other scene, but film can only record colors at a given moment. Consequently, color photographs may appear to be more reddish or bluish than seems natural, or flesh tones in a photograph can take on an unappealing color cast from nearby objects, such as light reflected from green leaves. The colors were probably there to begin with, but they are easy to ignore if you don't know what to look for. This chapter deals in depth with how to control color balance both when film is exposed and later during printing.

Color: Additive or Subtractive

All colors can be created either by adding or subtracting the primary colors. The additive process was employed for early color photography. The subtractive method, while requiring complex chemical techniques, has turned out to be more practical and is the basis of all modern color films.

In additive mixing (right, center), the basic or primary colors are red, green, and blue lights (each providing about one-third of the wavelengths in the total spectrum). Mixed in varying proportions, they can produce all colors—and the sum of all three primaries is white.

In the subtractive method (right, bottom), the primaries are cyan (a bluish green), magenta (a purplish pink), and yellow, the pigments or dyes that absorb red, green, and blue wavelengths, thus subtracting them from white light. These dye colors are the complementary colors to the three additive primaries of red, green, and blue. Used together the subtractive primaries absorb all colors of light, producing black. But, mixed in varying proportions, they can also produce any color in the spectrum.

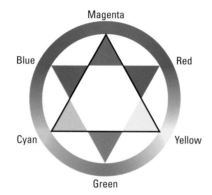

The color wheel. The color primaries for the subtractive process are yellow, cyan, and magenta. The additive primaries are green, red, and blue. Removing colors (in the subtractive process) or adding them (in the additive process) can create all other colors. Notice that the color often called blue is named cyan.

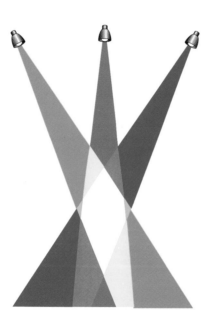

In the additive method, separate colored lights combine to produce various other colors. *The three additive primary colors are green, red, and blue. Green and red light mix to produce yellow; red and blue light mix to produce magenta; green and blue mix to produce cyan. When equal parts of all three of these primary-colored beams of light overlap, the mixture appears white to the eye. A color television produces its color by the additive system. The picture tube consists of green, red, and blue phosphors that can be mixed in various combinations to produce any color, including white.*

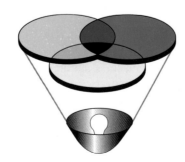

In the subtractive process, colors are produced when a dye absorbs some wavelengths and so passes on only part of the spectrum. *White light is a mixture of all wavelengths. Here, the three subtractive primaries—yellow, cyan, and magenta—have been placed over a source of white light. Where yellow and cyan overlap, they pass green; where cyan and magenta overlap, they pass blue; where magenta and yellow overlap, they pass red. Where all three overlap, all wavelengths are blocked and black is produced. All modern photographic materials utilize the subtractive process.*

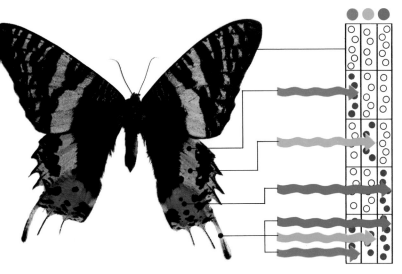

Color film consists of three layers of emulsion, each sensitive to blue, green, or red (as diagrammed here by color dots over a film cross section). *During exposure, light of each color of the butterfly shown here produces an invisible latent image on the emulsion layer or layers sensitive to it. Where the butterfly is black, no emulsion is exposed; where it is white, all three layers are exposed equally. This results in three superimposed latent images.*

A color photograph begins as three superimposed black-and-white negatives. Color film consists of three layers of emulsion, each layer basically the same as in black-and-white film but responding to only one-third of the spectrum. The top layer is sensitive to blue light, the middle layer to green light, and the bottom layer to red light. When this film is exposed to light and then developed, the result is a multi-layered black-and-white negative.

Colors are created during development. The developer converts the light-sensitive silver halide compounds in the layers of emulsion to metallic silver. As it does so, the developer oxidizes and combines with dye couplers that are either built into the layers of emulsion or added during development. Three dye colors are formed—the subtractive primary colors of yellow, magenta, and cyan—one in each emulsion layer. The blue-sensitive layer of the film forms a yellow image, the green layer forms a magenta image, and the red layer forms a cyan image. A bleach then removes all the silver, and each layer is left with only a color image. This basic process is used in the production of color negatives, positive color transparencies (slides), and color prints.

During development of the film, each latent image is converted into a metallic silver negative image. Thus, three separate negative images indicate by the density of the silver they contain the amount of each primary color. The images are shown separately here but are, of course, superimposed on the film.

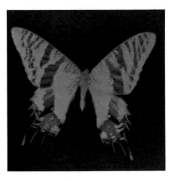

When exposed color negative film is developed, a colored dye is combined with each black-and-white negative image. The dyes are cyan, magenta, and yellow—the complements of red, green, and blue. The silver images are then bleached out, leaving three layers of superimposed negative dye images (shown separately here). The color negative also has an overall orange color or "mask" to compensate for color distortions that would otherwise occur in printing.

To make a positive print from a negative, light is passed through a color negative onto paper containing three emulsion layers like those in film. Developing the paper produces three superimposed positive images of dye plus silver. The silver is then bleached out of the print leaving the final color image.

The positive color image of a transparency or slide is created by a reversal process. After a first development, the emulsion is either exposed a second time to light or is treated with a chemical that produces the same effect. Silver is deposited by a second development to form black-and-white positive images in the emulsion. Dyes then combine with the metallic silver positive images to form three superimposed positive color images. In each layer the dye produced is the complement of the color of the light that was recorded there—yellow dye is formed in the blue-sensitive layer, magenta in the green-sensitive layer, and cyan in the red-sensitive layer. The black-and-white silver images are then bleached out, leaving the positive color images in each layer (shown separately here).

In reversal printing, light is passed through a positive color transparency onto reversal paper; the result is a positive image.

Choosing a Color Film

The look of color films is linked to film speed. Slower films appear sharper, have more saturated colors with a fuller range of tones and more contrast, and have less apparent graininess. Faster films appear less sharp, with less color saturation, less contrast, and more apparent graininess.

Even within the same speed range, different films produce different color balances. One film may have an overall warm reddish cast, while another may look slightly cooler and blue-green. It is useful to compare different films by exposing a roll of each to the same subject under identical conditions. This is particularly important with color slides because their tones cannot be manipulated after development as can a color negative when it is printed. Magazines such as *Popular Photography* regularly feature such comparisons. The difference between films can be surprisingly large.

Color film characteristics

Negative film. Produces an image that is the opposite in colors and density of the original scene. It is printed, usually onto paper, to make a positive color print. Color negative film often has "color" in its name (Agfacolor, Fujicolor, Kodacolor).

Reversal film. The film exposed in the camera is processed so that the negative image is reversed back to a positive transparency with the same colors and density of the scene. Positive transparencies can be projected or viewed directly and can also be printed onto reversal paper to make a positive print.

Color reversal film often has "chrome" in its name (Agfachrome, Ektachrome, Fujichrome), and professional photographers often refer to a color transparency, especially a large-format one, as a chrome. A slide is a transparency mounted in a cardboard holder so it can be inserted in a projector for viewing.

Professional films. The word "professional" in the name of a color film (Kodachrome 64 Professional Film) means that the film is designed for professional photographers, who often have exacting standards, especially for color balance, and who tend to buy film in large quantities, use it up quickly, and process it soon after exposure. Kodak manufactures its professional color films so that they are at optimum color balance when they reach the retailer, where—if the retailer is competent—the film will be refrigerated.

Kodak makes its nonprofessional color films for a typical "amateur" or "consumer," who would be more likely to accept some variation in color balance, buy one to two rolls at a time, and keep a roll of film in the camera for days, weeks, or longer, making exposures intermittently. Thus Kodak nonprofessional color films do not have to be refrigerated unless room temperatures are high. In fact, they are manufactured to age to their optimum color balance sometime after they reach the retailer and after room-temperature storage.

Color balance. Daylight films produce the best results when exposed in the relatively bluish light of daylight or electronic flash. Tungsten-balanced films should be used in the relatively reddish light of incandescent bulbs. Type A film is made for the slightly different balance of 3400K tungsten photolamps.

Type S/Type L films. A few films are designed to produce the best results within certain ranges of exposure times, as well as with specific light sources. Type S films (S for "short"), such as Kodak Vericolor III Professional Film, Type S, are balanced for daylight or electronic flash at exposure times of 1/10 second or shorter. Type L films (L for "long"), such as Vericolor II Professional Film, Type L, are balanced for the warmer light of tungsten 3200K lamps and for exposure times of 1/50 second to 60 seconds.

More about ...

- Color balance, pages 198–199
- Film speed and other characteristics common to all films, pages 66–71

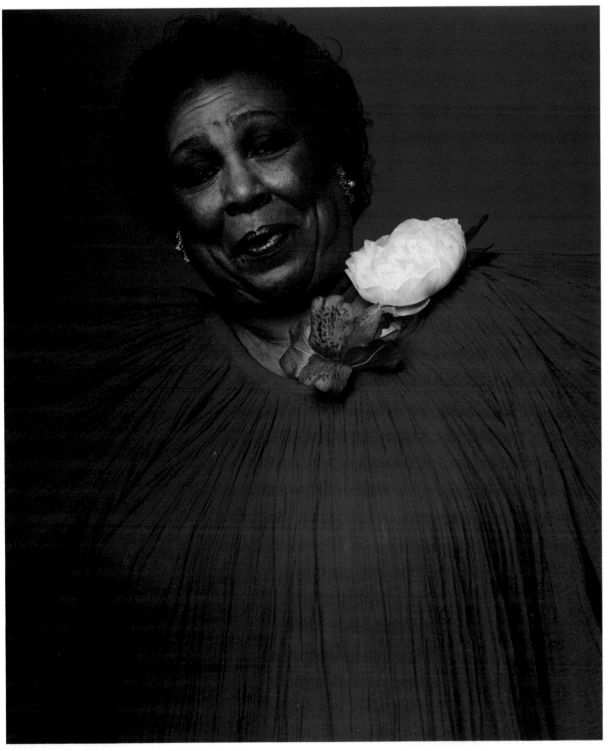

Instant color pictures are a favorite with photographers because the processing takes care of itself, and within seconds a finished print is ready. Although processing instant color film is very simple for the user, the chemistry on which the film is based is extremely complex. It involves a multi-layered negative of light-sensitive silver halides and developer dyes that are sandwiched with printing paper and an alkaline developing agent when the print is pulled from the camera. Integral films such as Polaroid's Spectra and Time-Zero films are even more complex; the processing takes place within the print itself.

Seeing results right away can be reassuring to someone having their portrait made. Barbara Bordnick (photograph left) particularly likes Polaroid for portraits of celebrities. "You're asking these people to perform in the one capacity they're least comfortable in, and that is the role of themselves. They feel very naked." With Polaroid, Bordnick turns the shoot into a more reassuring one for the sitter. "The image comes out right away, my assistant who sees it first exclaims, 'Ohhh!' Then we all go running back and look at it, and the subject hears this whole hullabaloo and it's sort of like telling somebody, 'Look at this fabulous image of you!'"

Polaroid makes a variety of instant color films. Print films are made for Polaroid's Spectra and other instant-print cameras. Polachrome 35mm slide film can be used in any 35mm camera. Polacolor 3 1/4 x 4 1/4 and 4 x 5 print films are used in view cameras; they require a special film holder and processor for development. And when you want something really big and right away, a 20 x 24-inch print film is available for use in an oversize view camera that can be rented from Polaroid.

More about . . .

• Polaroid image transfers, page 184

Exposure Latitude: How Much Can Exposures Vary?

Accurate exposure is particularly important with color reversal film because the film in the camera becomes the final transparency or slide. This type of film has very little exposure latitude; that is, it tolerates very little under- or overexposure. With as little as one-half stop underexposure, colors in a transparency begin to look dark and murky; there is even less tolerance for overexposure before colors begin to look pale and washed out.

Color negative film has more exposure latitude, and a picture can be lightened or darkened when the negatives are printed. You will have a printable negative even with about one stop underexposure or one to two stops overexposure, although best results come from a correctly exposed negative.

In contrasty lighting, color film is not able to record color and details accurately in both very light highlights and very dark shadows because the range of tones in the scene is greater than the usable exposure range of the film. If the lightest areas are correctly exposed, the shadows will be too dark. If shadows look good, highlights will be too light. Try exposing for the most important part of the scene, then bracket additional exposures. Sometimes you can use a reflector or a flash unit to add fill light to even out the contrast in a scene.

It is easier to get good exposures with color if lighting is flat, with relatively little difference between the lightest and darkest areas (see photograph, right). With such a scene it is less likely that areas will be much too light or much too dark.

Shooting in soft, diffused light is a bit simpler than working in contrasty light, because the range of tones from light to dark is not so extreme. Diffused light is also kind to the human face, creating soft shadows that are often more complimentary than the hard-edged, dark ones of direct light.

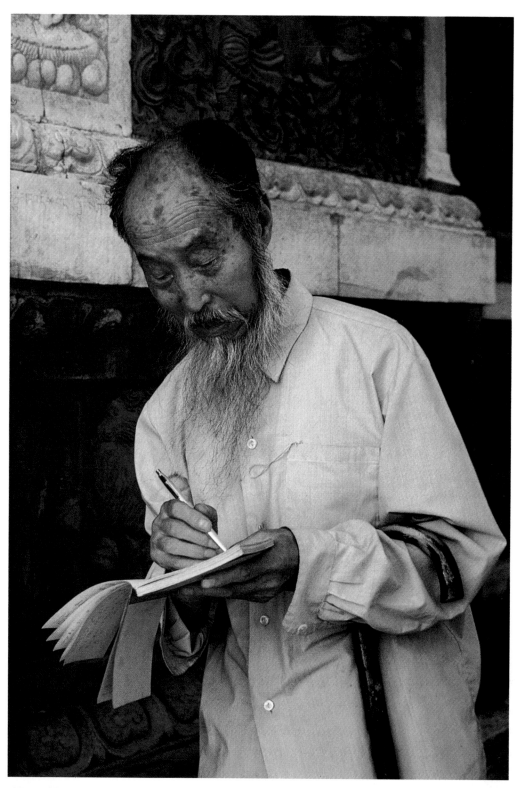

EVE ARNOLD Traditional Doctor, China, 1979

More about . . .

• Exposure, pages 89–103
• Fill light, pages 234–235

Contact sheet from negatives

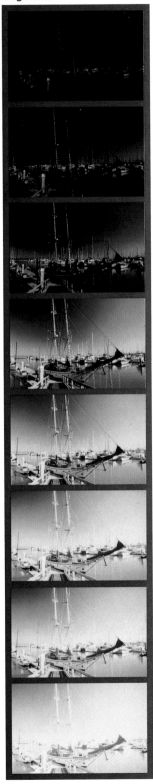

Machine-made prints from negatives at left

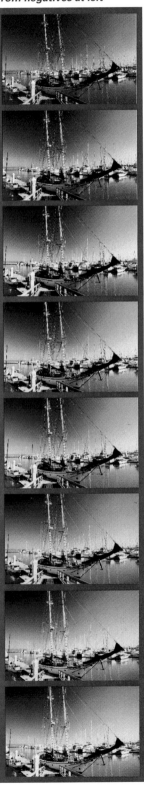

Slides

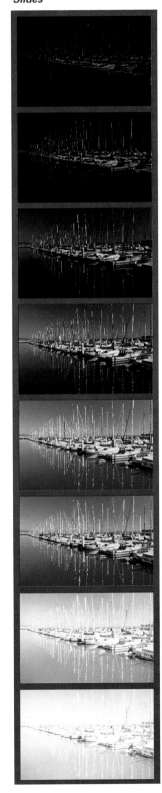

Color negative film has considerable exposure latitude. The best results are from a correctly exposed negative, but you will be able to get some sort of image from even a badly overexposed or underexposed frame.

Here, exposure varied by one stop for each negative. Near right, an uncorrected contact sheet made from the negatives. Next to them, prints that were corrected for the variations in exposure.

Color transparency film has little exposure latitude. Even slight overexposure or underexposure is readily visible, especially in contrasty lighting. Exposure varied by one stop for each of these color slides.

Color Balance

Color films sometimes record colors that the photographer did not see when the shot was made. Though the picture may look wrong, the film is not at fault. Although a white shirt looks white both outdoors in daylight and indoors in artificial light, light from ordinary tungsten bulbs has a different color balance—more red wavelengths and fewer blue wavelengths—than daylight; thus the white shirt reflects more red light indoors than outdoors and has a golden cast. Color film records such subtle differences.

The balance of colors in light is measured as color temperature on the Kelvin scale. This scale is commonly used by physicists and serves as a standard measure of wavelengths present in light (see chart, right). The warmer (redder) the light, the lower the Kelvin temperature.

Different color films are made for different color temperatures. Daylight films are balanced for a 5500K light source, and so give good results with the relatively high color temperature of midday light, electronic flash, and blue flashbulbs. Indoor films are balanced for incandescent light sources of lower temperatures. Most indoor films are tungsten balanced—designed specifically for light of 3200K color temperature but producing acceptable results in any tungsten light, such as ordinary light bulbs. A few (Type A) films have a slightly different balance for use with 3400K photolamps.

Color balance is more important with reversal films than with negative films. With a color reversal film, transparencies (such as slides) are made directly from the film that was in the camera, and they have a distinct color cast if the film was not shot in the light for which it was balanced or if it was not shot with a filter over the lens to balance the light (see opposite and page 200). With a color negative film, color balance can be adjusted when prints are made.

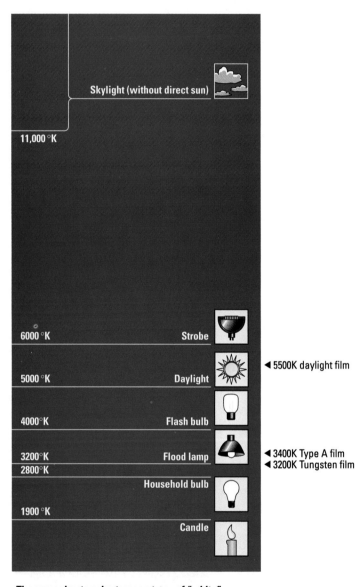

The approximate color temperatures of "white" light sources are shown on the Kelvin scale. *The ordinary description of colors as warm or cool doesn't match their actual color temperature. Red is often called a warm color, but the color temperature of reddish light is low on the scale. Blue is called a cool color, but its color temperature is high on the scale.*

Within chart:
Skylight (without direct sun)
11,000 °K
6000 °K — Strobe
5000 °K — Daylight — ◀ 5500K daylight film
4000°K — Flash bulb
3200°K — Flood lamp — ◀ 3400K Type A film / ◀ 3200K Tungsten film
2800°K
Household bulb
1900 °K
Candle

▶ ***Different types of color film record different colors when exposed to the same light.*** *The top pictures opposite were all taken in daylight (color temperature 5500K). Photographed with daylight film (left), the colors of the bus look normal. When shot with indoor (tungsten) film designed for 3200K (center), the bus takes on a heavy bluish cast. If a corrective 85B filter is used, however, the colors produced by the indoor film improve significantly (right).*

The bottom pictures opposite were all taken indoors in 3200K light. The bride looks normal when photographed with indoor film (left), but daylight film in the same light produces a yellowish cast (center). A corrective 80A filter produces a near-normal color rendition with the daylight film (right).

Since the filters block part of the light reaching the film, the exposure must be increased (about 2/3 stop with an 85B filter, 2 stops with an 80A filter). This can create inconveniently long exposures, so it is more efficient to use the correct type of film.

Daylight film in daylight

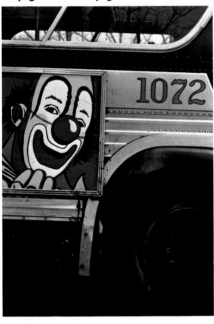

Tungsten film in daylight

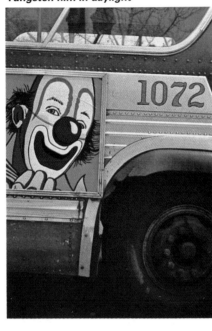

85B filter

Tungsten film in daylight with 85B filter

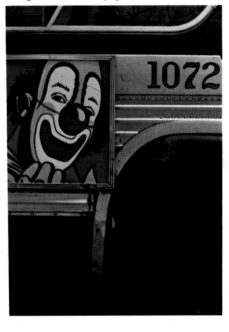

Tungsten film in tungsten light

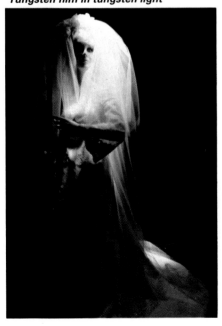

Daylight film in tungsten light

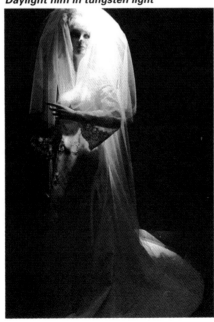

80A filter

Daylight film in tungsten light with 80A filter

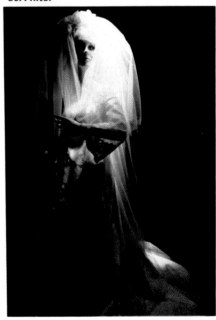

What happens if the color balance of light does not match the color balance of your film? Most color films are balanced to match the color temperatures of one of three possible light sources—midday sunlight (or electronic flash) and two types of incandescent lamp. Any other lighting conditions may give an unusual color balance. Sometimes you may want this imbalance. If not, you can use filters to correct to a more standard color balance.

Some natural light conditions do not match the color balance of any film. For example, the light is reddish late in the day because the low-lying sun is filtered by the earth's atmosphere to a color temperature lower than 5500K. You may want to photograph this scene unfiltered to keep a reddish cast that looks like sunset.

In a picture of a field of snow having sunlit and shadowed areas, the shadows will be illuminated mainly by clear blue skylight of a very high color temperature. Shadowed snow comes out blue when photographed with ordinary daylight film. A 1A "skylight" filter, designed to block some of the blue light, would reduce the bluish cast of the shadows as the film records it. Actually, if you look at a snowfield under such conditions, you can often see the bluish cast in the shadows—but ordinarily the brain adapts what the eye sees to what it expects the snow to look like.

Fluorescent lights create a similar problem: their light does not match the balance of any film. They emit large amounts of blues and greens relative to other colors, so their light does not match the balance of any film. Although the brain tends to disregard the imbalance and see the scene as normally colored, color films respond to the wavelengths that are actually there. Filtration helps (see below).

Color film in fluorescent light

Color film in fluorescent light with FL filter

Fluorescent light has a blue-green cast. *The penny arcade fortune-telling machine (left) was lit mostly with fluorescent lights, which have an excess of blue and green wavelengths, compared to other types of lighting. The result is a greenish cast to pictures taken under fluorescent light with daylight-balanced film, a bluish cast to pictures made with tungsten or Type A film.*

An FL (fluorescent) or magenta filter improves the color balance for fluorescent-lit scenes *by absorbing some of the green wavelengths so that the color image looks closer to normal (right). It is difficult to give exact filter recommendations for fluorescent light because the color balance varies depending on the type of lamp, the manufacturer, how old the lamp is, and even voltage fluctuations.*

Some light sources more closely match specific films. Electronic flash units are more or less balanced for daylight films, although the light they emit may be somewhat bluish; a light yellow filter helps if flash-lit pictures are often too blue. Tungsten film is balanced for 3200K light bulbs, Type A film for 3400K photolamps, but if you must shoot one type of film in the other type of light, a filter will correct the slight imbalance if you want an exact match. Color temperature meters are available if it is important to balance the light critically.

It is important to balance the light the way you want it when making color slides, because the film in the camera is the final product that will be projected for viewing. Exact balance is not so critical with color negative film used for color prints because corrections can be made during printing. Printing will be easier, though, with a properly balanced negative.

An exposure increase is needed with a filter. A filter removes some wavelengths of light, resulting in an overall loss of light intensity. If your camera meters through the lens, it will compensate for this automatically. If you are using a hand-held meter, increase the exposure as shown in the chart. Remember that increasing the exposure one stop means changing the shutter speed to half the original speed or opening the aperture to twice the size.

Filters for color film

Number or designation	Color or name	Type of film	Physical effect	Practical use	Increase in stops	Filter factor
1A	skylight	daylight	Absorbs ultraviolet rays	Eliminates ultraviolet that eye does not see but that film records as blue. Useful for snow, mountain, marine, and aerial scenes, on rainy or overcast days, in open shade.	—	—
81A	yellow	daylight	Absorbs ultraviolet and blue rays	Stronger than 1A filter. Reduces excessive blue in similar situations. Use with electronic flash if pictures are consistently too blue.	1/3	1.2
		tungsten		Corrects color balance when tungsten film is used with 3400K light sources.	1/3	1.2
82A	light blue	daylight	Absorbs red and yellow rays	Reduces warm color cast of early morning and late afternoon light.	1/3	1.2
		Type A		Corrects color balance when Type A film is used with 3200K light source.	1/3	1.2
80	blue	daylight	Absorbs red and yellow rays	Stronger than 82A. Corrects color balance when daylight film is used with tungsten light. Use 80A with 3200K sources and with ordinary tungsten lights. Use 80B with 3400K sources.	2 (80A) 1 2/3 (80B)	4 3
85	amber	Type A or tungsten	Absorbs blue rays	Corrects color balance when indoor films are used outdoors. Use 85 filter with Type A film, 85B filter with tungsten film.	2/3	1.5
FL	fluorescent	daylight or tungsten	Absorbs blue and green rays	Approximate correction for excessive blue-green cast of fluorescent lights. FL-D used with daylight film, FL-B with tungsten film. Or try a CC30M filter.	1	2
CC	color compensating			Used for precise color balancing. Filters come in various densities in each of six colors—red, green, blue, yellow, magenta, cyan (coded R, G, B, Y, M, C). Density indicated by numbers—CC10R, CC20R, etc.	Varies	
	polarizing	any	Absorbs polarized light (light waves traveling in certain planes relative to the filter)	Reduces reflections from nonmetallic surfaces, such as water or glass. Penetrates haze by reducing reflections from atmospheric particles. The only filter that darkens a blue sky without affecting color balance overall.	1 1/3	2.5
ND	neutral density	any	Absorbs equal quantities of light from all parts of the spectrum	Increases required exposure so camera can be set to wider aperture or slower shutter speed. Comes in densities from 0.10 (1/3 stop more exposure) to 4 (13 1/3 stops more exposure).	Varies with density	

Some manufacturers list the exposure increase needed with filters as a filter factor.

If the filter has a factor of ...	1	1.2	1.5	2	2.5	3	4	5	6	8	10	12	16
Then increase the exposure (in stops)	0	1/3	2/3	1	1 1/3	1 2/3	2	2 1/3	2 2/3	3	3 1/3	3 2/3	4

If you use two or more filters together, add the number of stops of change (1 stop + 1 stop = 2 stops) or multiply the filter factors (factor of 2 x factor of 2 = factor of 4, equivalent to 2 stops).

More about . . .

• Polarizing filters, page 85

Reflected light can also reflect colors. Almost every photographer has, at one time or another, found that in a picture a subject has taken on the colors reflected by a nearby strongly colored surface, like a wall or drapery. The eye tends to see almost every scene as if it were illuminated by white light, whereas color film reacts to the true color balance of the light. Color casts, or shifts of color, are less noticeable on objects that are strongly colored but are easy to see on more neutral shades, such as skin tones or snow.

A color cast may or may not be a desirable addition. In the picture on the this page, the bluish light adds an icy cold-ness to the snow. Opposite, the gold tones of the light make the portrait of the sculptor glow.

But sometimes the color shift can be a problem, as in a portrait shot beneath a tree. People photographed under such seemingly flattering conditions can appear a seasick green because the sunlight that reaches them is filtered and reflected by the green foliage.

Colors can add the impression of heat or weight in a picture. Because they trigger mental associations, golden yellows and reds appear distinctly warm, while blues and yellowish greens seem cool. But the impressions go beyond mere illusions of temperature. Warm colors, especially if they are dark, can make an object seem heavy and dense. Pale, cool colors, on the other hand, give an object a light, less sub-stantial appearance.

Color can affect the illusion of depth. Warm colors can appear to be far-ther forward, cool colors farther back. You can use this distance effect to increase the illusion of depth within a picture by plac-ing warm-colored objects against a cool-colored background.

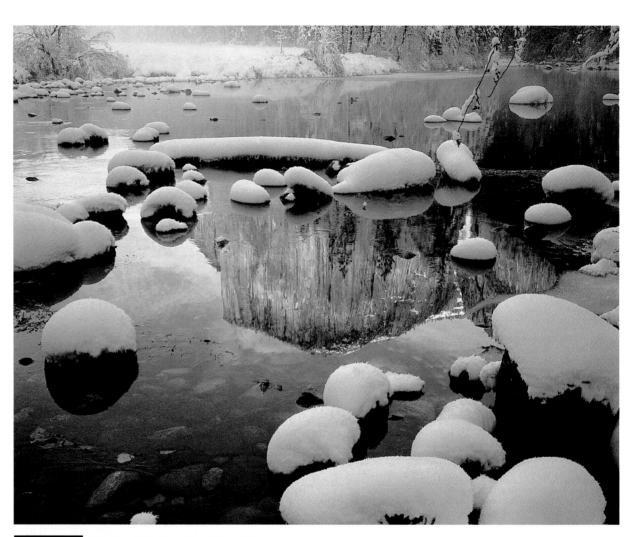

DAVID MUENCH Reflection of El Capitan in Merced River, 1970

Shadowed areas can appear surprisingly blue in a photograph, especially if the subject itself is not strongly colored. In this Yosemite landscape, the rocks and snow are shaded from direct light from the sun and are illuminated only by skylight, light reflected from the blue dome of the sky. Sunlight, direct rays from the sun, is much less blue. Compare the skylit snow to the sunlit—and less blue—granite outcropping of El Capitan, visible in the reflection in the water. Here, the contrast between the two tones adds interest to the picture, but for less of a bluish cast, a 1A (skylight) or 81A (light yellow) filter could have been used on the lens.

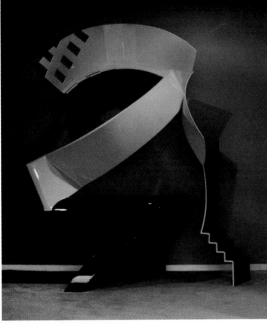

JERRY PEART Geisha with Waterfall, 1982. Sculpture

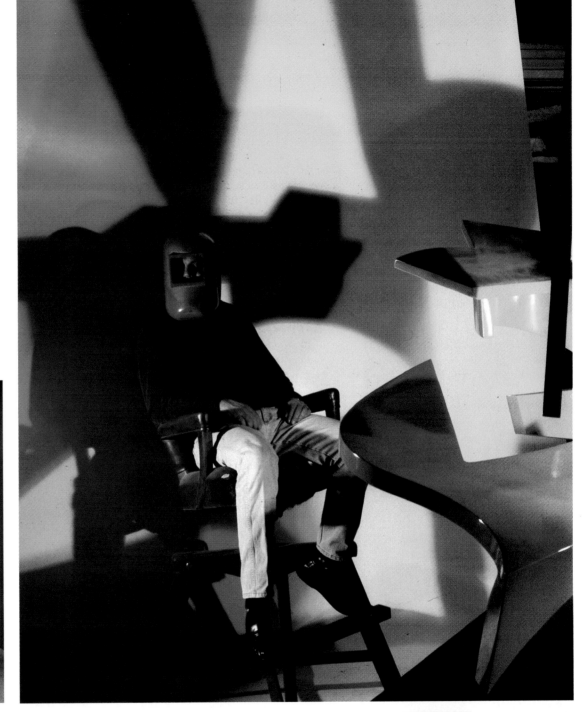

PATTY CARROLL Jerry Peart, Chicago, 1990

Patty Carroll's photograph of sculptor Jerry Peart is one of series of portraits Carroll made of Chicago artists. "I began this project," she said, "by thinking about issues of portraiture, and realizing that my interest lay in portraying the secret self-portrait everyone has inside themselves. It seemed natural to me to work on fantasy portraits with sitters who themselves have developed very personal, 'fantastic,' elaborate pictorial imagery. . . . Peart cuts metal into shapes like paper and dominates his material like a kid with big toys, but in a serious game."

Carroll photographed Peart in his studio, wearing his welding mask and surrounded by one of his large constructions. She lit the scene with studio lights and colored gels (colored filters placed over the lights).

Color Changes throughout the Day

Colors in your photographs will vary depending on the time of day that you made them. Photographing very early or late in the day can produce strikingly beautiful pictures simply because the light is not its usual "white" color.

In the earliest hours of the day, before sunrise, the world is essentially black and white. The light has a cool, shadowless quality. Colors are muted. They grow in intensity slowly, gradually differentiating themselves. But right up to the moment of sunrise, they remain pearly and flat.

As soon as the sun rises, the light warms up. Because of the great amount of atmosphere that the low-lying sun must penetrate, the light that gets through is much warmer in color than it will be later in the day—that is, more on the red or orange side because the colder blue hues are filtered out by the atmosphere. Shadows, by contrast, may look blue because they lack gold sunlight and also because they reflect blue from the sky.

The higher the sun climbs in the sky, the greater the contrast between colors. At noon, particularly in the summer, this contrast is at its peak. Film for use in daylight is balanced for the 5500K color temperature of midday sunlight, so colors appear accurately rendered. Each color stands out in its own true hue. Shadows at noon are more likely to be neutral black.

As the sun goes down, the light begins to warm up again. This occurs so gradually that you must remember to look for it; otherwise the steady increase of red in the low light will do things to your film that you do not expect. Luckily, these things can be beautiful. If the evening is clear and the sun remains visible right down to the horizon, objects will begin to take on a golden glow that is typical of sunset light. Shadows lengthen, so surfaces become strongly textured.

After sunset there is a good deal of light left in the sky, often tinted by sunset colors. This light can be used, with longer and longer exposures, almost up to the point of darkness, and it sometimes produces pinkish or even greenish-violet effects that are delicate and lovely. Just as before sunrise, there are no shadows and the contrast between colors lessens.

Finally, just before night, with the tinted glow gone from the sky, colors disappear, and the world once again becomes black and white.

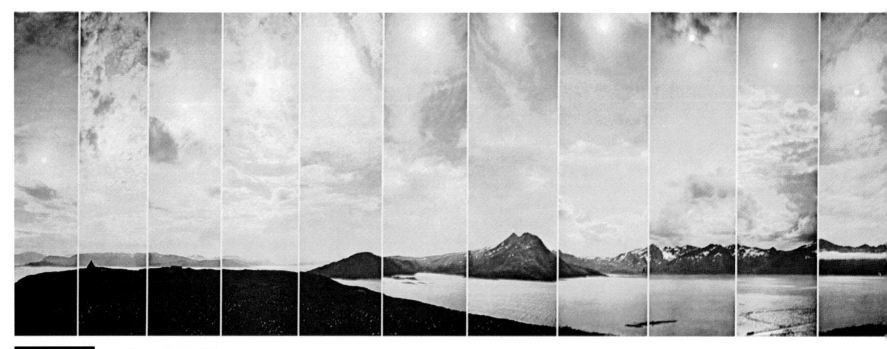

EMIL SCHULTHESS **A Day of Never-setting Sun, 1950**

Late in the day with the sun low in the sky, shadows are very long and colors are warm and golden. ▶

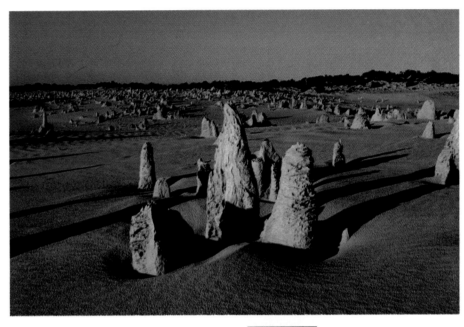

The sun never sinks below the horizon in this time-lapse sequence of photographs taken on a Norwegian island far above the Arctic Circle during the summertime period of the midnight sun. The changing colors of light are clearly visible, however, as the sun rises and sets. Objects seem to be more realistically colored when the sun is high in the sky than when it is close to the horizon; compare the color of the water in the segments on this page with its color in the segments on the opposite page. ▼

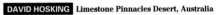

DAVID HOSKING **Limestone Pinnacles Desert, Australia**

Very long exposure times should be increased even more. At dusk, at dawn, sometimes indoors, the light may be so dim that exposure times become very long, even with the lens aperture wide open. Very long exposures with color film produce the same reciprocity effect that takes place with black-and-white films—the exposure must be increased even more or the film will be underexposed. Various types of color film react differently to long exposures; check the manufacturer's instructions for recommended exposure increases. Very long exposures are not recommended at all for some color films. In general, however, increase the exposure about one stop for a 1-second exposure, two stops for a 10-second exposure, three stops for a 100-second exposure. Bracket the exposures by making a shot at the calculated exposure plus another at one-half stop more and a third at one stop more. When exposures are very long, underexposure is more likely to be a problem than overexposure.

Very long exposures can change the color balance. Reciprocity effect with color films is even more complicated than with black-and-white films. Since color films contain three separate emulsion layers, each layer may be affected differently, and the varied speed losses will change the color balance of the film. The result can be color shifts like those shown here. Often the shifts are pleasing, but if you want a more accurate color rendition, use the color filters listed on the film's instruction sheet.

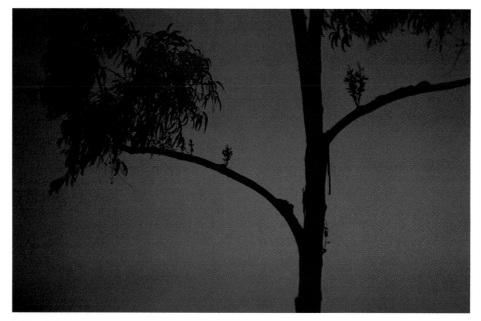

PETER deLORY Summer, 1970

Reciprocity can cause shifts in color balance during exposures that are longer than about 1 sec. *The two-toned sky in the picture above was shot in the dim light of dusk at a long exposure time that created color shifts in the film.*

More about . . .

- Reciprocity effect, page 100

Palace of Fine Arts, San Francisco, 1988

Reciprocity effect can be unpredictable. *The long exposures that create color shifts can intensify colors more than is apparent when you look at a scene.*

Developing Color Film

Process color materials carefully. Processing color materials is similar to processing black-and-white materials except that any change in the processing has a greater effect on the final product. Color materials are more sensitive to changes in processing times, temperatures, and other variables; color balance and density shift significantly with even slight variations in processing.

Many photographers use a commercial lab for developing color film. They feel that a commercial lab produces more consistent results than they could in their own darkrooms. In addition, some films, such as Kodak Kodachrome, have a complicated processing procedure that is designed for automated commercial equipment.

Some photographers prefer to do their own color film processing. Doing your own film processing may be less expensive than lab work. It may be faster than a lab if you are in a hurry to get your film developed. You may be able to main-

tain better quality control if your local lab is not geared for high quality. Some popular and readily available color negative films that you can develop are Agfacolor, Fujicolor, Kodak Vericolor, Ektapress Gold, and Gold Plus films. Among the reversal (slide) films that you can process yourself are Agfachrome, Fujichrome, and Kodak Ektachrome. See the film manufacturer's instructions for the processing chemicals and procedures to use.

Some individualized processing is possible when color reversal films are processed in Kodak's E-6 chemistry, or color negative films in Kodak's C-41 chemistry. Color balance, contrast, and grain are usually better with normal processing, but some adjustment can be made when you have no other options.

Film can be pushed (underexposed and overdeveloped) when you need to shoot at a faster-than-normal film speed. Kodak's Ektapress Multispeed and Ektapress 1600 films are specifically designed for pushing.

HAROLD FEINSTEIN Anthurium, 1981

Any subject—above and opposite, flowers—can be photographed in an infinite variety of ways. Above, Harold Feinstein boldly isolated one flower against the sky. He held the flower in one hand and a 35mm camera in the other, then moved around to get the best lighting and pattern of clouds. Opposite, Michael Geiger's seemingly casual arrangement was carefully set up. Geiger uses an 8 x 10 view camera because its large viewing screen makes it easier to see and control the complex arrangements that are his specialty. Notice how Feinstein wholly enclosed his flower within the frame of the picture format, while the center of Geiger's picture is almost empty, with the action taking place at the edges.

More about . . .

• Fill light, pages 234–235
• Pushing film, pages 124–126

Paper and chemicals for printing from a color negative

Color prints from color negatives can be made with negative/positive processes, for example Fuji Super FA paper or Kodak Ektacolor paper processed in Ektacolor RA chemicals.

Check the manufacturer's instructions. Not all processing chemistries can be used with all papers; make sure the paper and chemicals are compatible. See instructions regarding storage of unexposed paper. Most papers should be stored in a refrigerator at 55° F or lower. Remove the package from the refrigerator several hours before opening it to bring the paper to room temperature and prevent moisture from condensing.

Equipment for printing

Enlarger. Any enlarger that uses a tungsten or tungsten-halogen lamp may be used. A fluorescent enlarger lamp is not recommended.

Filtration. The color balance of the print is adjusted by placing filters of the subtractive primaries—yellow (Y), magenta (M), and cyan (C)—between the enlarger lamp and the paper. The strength of the filtration is indicated by a density number: the higher the number, the stronger the filter. For example, 20M means a magenta filter 4 times denser than an 05M filter.

If your enlarger has built-in dichroic filters, the strength of each color is adjusted simply by turning knobs or other controls on the enlarger to dial in the desired filtration. Without dial-in filtration, some means must be provided to hold filters in place, as shown on page 152.

If your enlarger has a drawer for holding filters between the lamp and negative, acetate color printing or CP filters can be used. Filters of the same color can be added to provide a stronger density of a color: 20Y + 20Y gives the same density of yellow as a filter marked 40Y. Any number of filters can be positioned above the negative to create the color balance desired, although the least number that is feasible should be used.

If your enlarger is an older model that does not have a filter drawer, a filter holder can be attached below the lens. In this position, acetate filters cause optical distortions, so the more expensive gelatin color compensating or CC filters must be used. To preserve good optical quality, do not use more than three CC filters below the lens at any one time.

Kodak recommends the following CP or CC filters as a basic kit: one each 2B, 05Y, 10Y, 20Y, 05M, 10M, 20M; two each 40Y and 40R (a red filter equivalent to a 40Y + 40M). Occasionally you may need cyan filtration.

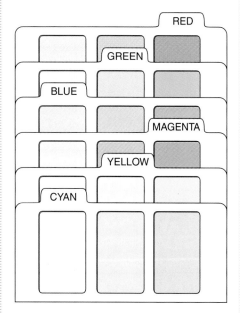

Color print viewing filter kit is an assortment of graded color filters used for viewing a print. It helps you determine any changes needed in filtration when you make the next print.

Heat-absorbing glass. The light sources of many enlargers give off enough heat to damage color negatives and filters unless some of the heat is absorbed. To prevent this, a piece of heat-absorbing glass should be placed in the enlarger head if it isn't built in. See enlarger manufacturer's instructions.

Voltage control. Electric current varies in voltage from time to time, and a change of less than 5 volts will cause a change in the color of the enlarger light—and a visible change in the color of the print being made. So although you can print without it, some type of voltage control is desirable. A voltage stabilizer or regulator automatically maintains a steady output of power if the line voltage fluctuates. A manually adjustable variable transformer is less expensive; you turn a control knob as necessary to maintain uniform voltage. Either type plugs into a wall outlet, then the enlarger plugs into it. Some enlargers have built-in voltage control.

Analyzers and calculators. A color analyzer is an electronic device that reads the density and color balance of a negative, compares it to a preprogrammed standard, then recommends exposure and filtration. Good ones are very expensive, and while they make printing easier, you can work without one.

Another type of printing aid is a color matrix or subtractive color calculator. Some people find these useful, others do not. Briefly, you use this device to make a test print in which colors are scrambled to an overall tone. You compare this test to a standard tone to determine exposure and filtration.

Equipment to process the print

A variety of equipment can be used to process color prints, ranging from entirely manual to completely automatic.

For manual processing, a tube-shaped plastic processing drum is a popular device. Each print is processed in small quantities of fresh chemicals, which are discarded after use. This provides economical use of materials as well as consistent processing. Once the drum is loaded and capped, room lights can be turned on so you don't have to work in the dark.

The next step up is mechanized agitation. A motorized base for the processing drum provides a consistent agitation of the drum, which is important for color processing. The unit shown provides temperature control for the processing solutions and for the processing drum, as well as mechanized agitation of the drum. You add and drain the chemicals yourself.

A completely automated processor does everything for you. You feed in the exposed paper at one end, and a few minutes later a completely processed and dried print comes out at the other end. The unit controls solution temperatures, agitates the print in each solution, and transports the paper from one stage to the next at the correct time.

Miscellaneous items

Most of the other items needed are also commonly used in black-and-white printing.

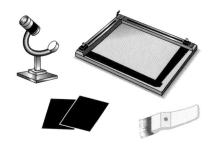

For printing. Timer with sweep-second hand, focusing magnifier, printing-paper easel, negative brush, two masking cards for test prints.

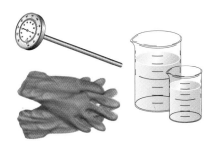

For processing. If you will be handling chemicals, rubber gloves, photographic thermometer, graduates for measuring solutions.

Record keeping. No matter what kind of equipment you use, record keeping will save you time, money, and frustration. Keep track of the filtration, enlarger aperture setting, and exposure time for each print, either in a notebook or on the back of the print, so you don't have to start all over again each time you make a print.

Your personal standard filter pack

The first step in color printing is to make test prints to establish a standard filter pack. The color balance of color prints is adjusted by inserting colored filters between the enlarger's beam of light and the paper. Paper manufacturers suggest combinations of filters to produce a print of normal color balance from an average negative or transparency. However, these suggestions are only a starting point for your own tests to determine a standard filter pack for your particular combination of enlarger, film, paper, processing chemicals, and technique. Personal testing is useful because so many variables affect the color balance of prints. Once your standard filter pack has been established, only slight changes in filtration will be needed for most normal printing.

 You will need a negative (or a transparency, if you are using reversal materials) that is of normal density and color balance. It should be a simple composition and contain a range of familiar colors, flesh tones, and neutral grays. Do not use a sunset or other scene in which almost any color balance would be acceptable.

 Make a note of the filtration that makes a good print from the negative. Use that filtration for your first prints from other negatives.

More about . . .

• Handling chemicals safely, page 109

The following pages show how to make prints from a color negative, and especially how to evaluate and adjust the color filtration so that you get the color balance you want. Read the manufacturer's current directions carefully, because filtration, safelight recommendations, processing, and so on vary considerably with different materials and change from time to time.

Keep darkroom light to a minimum. Kodak recommends handling color paper in total darkness, and you should eliminate stray light from such sources as the enlarger head, timers, or digital displays. If you must have some light, Kodak recommends a 7 1/2-watt bulb with a number 13 amber safelight used at least 4 feet from the paper.

Consistency is vital every time you make a print—more so than with black-and-white printing. The temperature of the developer is critical and must be maintained within the limits suggested by the manufacturer. The same agitation pattern should be used for all tests and final prints; even the time between exposure and development must be fairly uniform with some processes.

Contamination will cause trouble, so if you are handling chemicals, don't splash one chemical into another or onto the dry side of the darkroom. Be particularly careful not to contaminate the developer with bleach-fix or stop bath. Use a separate container for developer only, and wash mixing and processing equipment carefully after use.

Color chemicals are more toxic than black-and-white chemistry. Be particularly careful to read instructions on how to handle and dispose of chemicals safely.

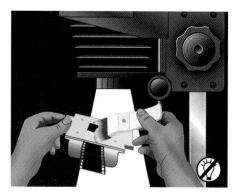

1 **Prepare the negative.** Clean any dust off the negative and enlarger carrier. Place the negative (dull, emulsion side toward paper) in the carrier and insert in the enlarger.

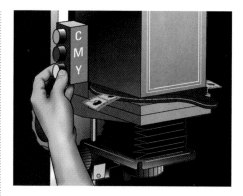

2 **Set up the enlarger.** Insert the heat-absorbing glass, if required. Dial in (or insert CP or CC filters with) the manufacturer's suggested filtration.

A test print

Five exposures of the same negative are made in the test print shown at right, producing a range of densities from light to dark. See the manufacturer's suggestions for a starting point for a filter pack. For example, for Ektacolor Ultra II paper, Kodak recommends a starting filter pack of 40M + 30Y.

When feasible, it is better to change the aperture while keeping the exposure time the same. This is because extremely long or extremely short exposures could change the color balance and make test results difficult to interpret (the same reciprocity effect that affects film). In this test each successive strip received one additional full stop of exposure, but the best exposure for a particular negative is often between two of the stops. Exposure times between 5 sec and 30 sec generally do not create noticeable reciprocity effect, so after you get an approximate exposure you can fine-tune by changing the time.

Keep notes of time, aperture, and filtration for each print if you want to save time and materials at your next printing session.

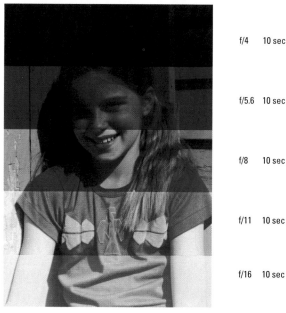

f/4	10 sec
f/5.6	10 sec
f/8	10 sec
f/11	10 sec
f/16	10 sec

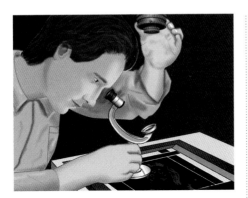

3 **Compose and focus the image.** If you use a focusing magnifier, focus on the edge of an object since a color negative has no easily visible grain.

4 **Set the lens aperture.** A test strip for a color print is made by changing the lens aperture, not the time (see box, opposite). Set the lens to f/16 as a starting f-stop for a 8 x 10 print made from a 35mm negative. Set the enlarger timer for 10 sec.

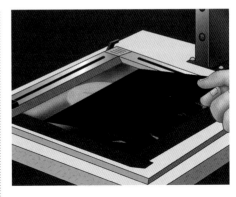

5 **Make the first test exposure.** Place a sheet of printing paper in the easel, emulsion side up. Hold a masking card over all but one-fifth of the paper, and expose the first test section. Cover the first section with another card. Move the first card to uncover the next one-fifth of the paper.

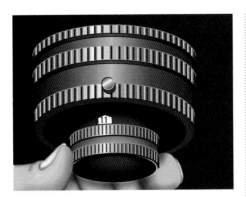

6 **Continue making the test exposures.** Open the aperture one stop, and expose the next section for 10 sec. Continue moving the cards, opening the aperture one stop, and exposing until the last one-fifth of the paper is exposed.

7 **Process the paper.** Here the exposed paper is being fed into a processing machine. The machine fully processes the print, which can then be examined in ordinary room light. If you develop the paper by hand using a processing drum, room lights can be turned on once the paper is loaded in the drum with the cap secured so that you can perform the processing steps in the light.

8 **Evaluate the print.** Color prints are judged and corrected first for density, then for color balance. Finally, evaluate the print for areas that might be dodged or burned. See next pages.

Judging Density in a Print Made from a Negative

Color prints are judged—and adjusted—first for density (the darkness of the print), then for color balance. This is something like black-and-white prints, which are evaluated first for density, then for contrast.

The color balance of a test print will probably be off, so try to disregard it and evaluate just the density. Look for the exposure that produces the best overall density in midtones such as skin or blue sky. Important shadow areas should be dark but with visible detail, textured highlights should be bright but not burned-out white. Some local control with burning and dodging may be needed.

The illumination for judging a color print is important. It affects not only how dark the print looks but also its color balance. Ideally you should evaluate prints using light of the same intensity and color balance under which the print finally will be viewed. Since this is seldom practical, some average viewing conditions have been established. Fluorescent tubes, such as Deluxe Cool White bulbs (made by several manufacturers), are recommended. You can also combine tungsten and fluorescent light for a warmer viewing light with one 75-watt frosted tungsten bulb used for every two 40-watt Deluxe Cool White fluorescent tubes. Examine prints carefully, but when judging density, don't view a print very close to a very bright light. Average viewing conditions are likely to be less bright, and the final print may then appear too dark.

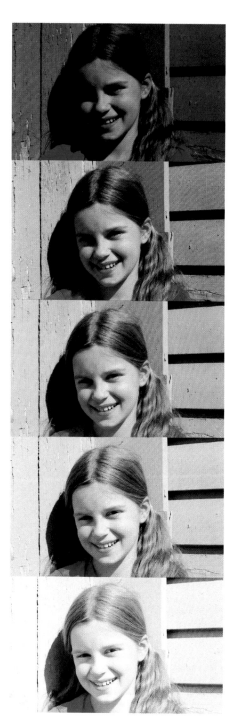

1 stop too dark
Give 1/2 the previous exposure: close enlarger lens 1 stop or multiply exposure time by 0.5

1/2 stop too dark
Give 3/4 the previous exposure: close enlarger lens 1/2 stop or multiply exposure time by 0.75

Correct density

1/2 stop too light
Give 1 1/2 times the previous exposure: open enlarger lens 1/2 stop or multiply exposure time by 1.5

1 stop too light
Give twice the previous exposure: open enlarger lens 1 stop or multiply exposure time by 2

More about . . .

• Dodging and burning in, pages 154–155

Using viewing filters to correct the color balance

Viewing filter kits help you determine any changes needed in the color balance of a print. With Kodak's Color Print Viewing Filter Kit, hold the white side of the card containing the filters toward you to view prints made from color negatives.

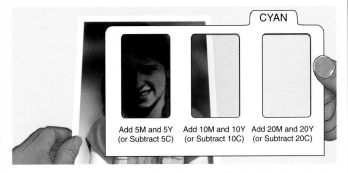

Add 5M and 5Y | Add 10M and 10Y | Add 20M and 20Y
(or Subtract 5C) | (or Subtract 10C) | (or Subtract 20C)

Hold the filter a few feet away from the print. Flick the filter in and out of your line of vision as you look at light midtones in the print, such as light grays or flesh tones, rather than dark shadows or bright highlights. When you find the filter that makes the print look best, make the changes to the enlarger filter pack that are printed below each filter.

A color wheel arranges the primary colors of light in a circle. Each color is composed of equal amounts of adjacent colors (red is composed of equal parts of magenta and yellow). Each color is complementary to the color that is opposite (magenta and green are complementary).

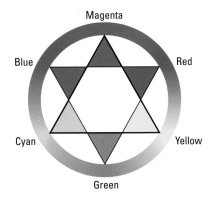

Magenta

Blue Red

Cyan Yellow

Green

The first print you make from a negative usually needs some change in the color balance. This is done by changing the filtration of the enlarger light. If your enlarger has a dichroic head, just dial in the filter change. If you are using CP or CC filters, you must replace individual filters in the pack. Decide what color is in excess in the print and how much it is in excess, then change the strength of the appropriate filters accordingly. Ordinarily it is best to evaluate dry prints, since wet prints have a bluish color cast and appear slightly darker than they do after drying.

You can check your print against pictures whose colors are shifted in a known direction, such as the ring-around test chart on page 216. The chart helps identify basic color shifts, although printing inks seldom exactly match photographic dyes.

A better method for evaluating prints is to look at them through colored viewing filters to see which filter improves the color balance. Kodak makes a Color Print Viewing Filter Kit for this purpose. See Using Viewing Filters to Correct Color Balance, left.

To correct the color balance of a print made from a negative, make the opposite color change in the enlarger filtration from the color change you want in the print. In other words, if you want to remove a color from a print, add that color to the enlarger filtration. Almost always, you should change only the magenta or yellow filters, either subtracting the viewing filter color that corrects the print or adding the complement (the opposite on the color wheel) of the viewing filter color that corrects (see chart and color wheel below). Kodak's Color Print Viewing Filter Kit also tells you which colors to change.

The cure for a print with too much magenta is to add—not decrease—the magenta in the filter pack; more magenta in the printing light produces a print with less of a magenta cast. A green viewing filter visibly corrects a print that is too magenta; add magenta (the complement of green) to the filter pack.

Similarly, excess blue is corrected by lightening the filter that absorbs blue, the yellow filter; the filter pack will then pass more blue light, so the print (reacting in an opposite direction) will show less blue. A yellow viewing filter visibly corrects a too-blue print; subtract yellow (the complement of blue) from the filter pack.

Balancing a print made from a negative

To adjust the color balance of a print made from a negative, change the amount of the subtractive primary colors (magenta, yellow, and cyan) in the enlarger printing light. Usually, changes are made only in magenta and yellow (M and Y).

Print is	Do this	Could also do this
Too magenta	Add M	Subtract C + Y
Too red	Add M + Y	Subtract C
Too yellow	Add Y	Subtract C + M
Too green	Subtract M	Add C + Y
Too cyan	Subtract M + Y	Add C
Too blue	Subtract Y	Add C + M

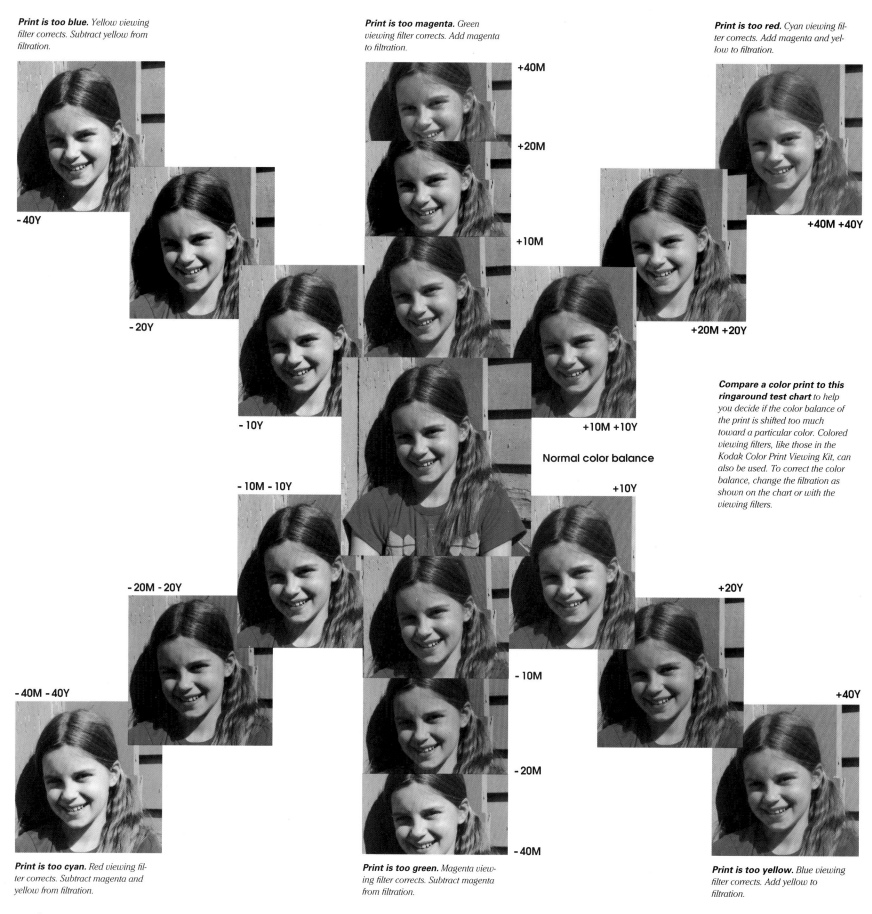

Print is too blue. *Yellow viewing filter corrects. Subtract yellow from filtration.*

Print is too magenta. *Green viewing filter corrects. Add magenta to filtration.*

Print is too red. *Cyan viewing filter corrects. Add magenta and yellow to filtration.*

+40M

+20M

+10M

− 40Y

− 20Y

− 10Y

+40M +40Y

+20M +20Y

+10M +10Y

Normal color balance

Compare a color print to this ringaround test chart *to help you decide if the color balance of the print is shifted too much toward a particular color. Colored viewing filters, like those in the Kodak Color Print Viewing Kit, can also be used. To correct the color balance, change the filtration as shown on the chart or with the viewing filters.*

− 10M − 10Y

+10Y

− 20M − 20Y

+20Y

− 40M − 40Y

− 10M

− 20M

+40Y

− 40M

Print is too cyan. *Red viewing filter corrects. Subtract magenta and yellow from filtration.*

Print is too green. *Magenta viewing filter corrects. Subtract magenta from filtration.*

Print is too yellow. *Blue viewing filter corrects. Add yellow to filtration.*

After you change the filtration of a test print, you may then need to make a final exposure change, because the filtration affects the strength of the exposing light and thus the density of the print. When feasible, adjust aperture rather than time.

Dichroic filters need minimum exposure adjustment. CP or CC filters require exposure adjustment for changes in both filter density and the number of filters. See the manufacturer's literature either with the paper or the viewing filter kit. Kodak's Color Darkroom Dataguide contains a computing dial that simplifies calculation of new exposures with Kodak materials. As a rough guide, ignore yellow changes, adjust exposure 20 percent for every 10M change, then adjust 10 percent for changes in the number of filters (including yellow).

Do not end up with all three subtractive primaries (Y, M, C) in your filter pack. This condition produces neutral density—a reduction in the intensity of the light without any accompanying color correction—and may cause an overlong exposure. To remove neutral density without changing color balance, subtract the lowest filter density from all three colors.

70Y	30M	10C	*If pack contains three primaries*
−10Y	−10M	−10C	*Subtract to remove neutral density*
60Y	20M		*New pack*

Dodging and burning in a color print is feasible to some extent, as in black-and-white printing, to lighten or darken an area. For example, you may want to darken the sky or lighten a face or shadow area. If you dodge too much, an area will show loss of detail and color (one description of the effect is smoky-looking), but some control is possible.

You can also change color balance locally. To improve shadows that are too blue, which is a common problem, keep a blue filter in motion over that area during part of the exposure. Burning in can cause a change in color balance in the part of the print that receives the extra exposure. If a burned-in white or very light area picks up a color cast, use a filter of that color over the hole in the burning-in card to keep the area neutral. Try a CC30 or CC50 filter of the appropriate color.

Color prints may need spotting to remove white or light specks caused by dust on the negative. Retouching colors made for photographic prints come in liquid or cake form. Either can be used to spot out small specks. The dry cake dyes are useful for tinting large areas. Black spots on a print are more difficult to correct. One way is to apply white opaquing fluid to the spot, then tint to the desired tone with colored pencils.

Mount prints to protect them and to give a finished look. Overmatting eliminates the need for heat mounting. Dry-mount tissue is usable, but a low temperature of 180° F is recommended. Since the thermostat settings on dry-mount presses are seldom accurate, use the lowest setting that is effective. Preheat the press and mount board. When the print, dry-mount tissue, and board are positioned, insert in the press for the minimum time that will fuse the tissue to both print and mount.

Protect color prints from excess light. Color prints fade over time, particularly on exposure to ultraviolet light. Prints will retain their original colors much longer if protected from strong sources of ultraviolet light such as bright daylight or bright fluorescent light, or by using UV-filtering glass or plastic in frames.

More about . . .

• Dodging and burning in, pages 154–155
• Mounting, pages 163–167
• Spotting, page 162

Making a Color Print from a Transparency

Color prints can be made from transparencies (slides) using reversal color print materials. Make your first print a test to determine basic exposure and filtration. See the manufacturer's suggestions for a starting filter pack.

Clean the transparency carefully before you place it in the enlarger. Specks of dust on it will appear on the print as black spots, which are more difficult to deal with than the white spots normally caused by dust.

For best results, print from a fully exposed transparency with saturated colors and low to normal contrast. Starting with a contrasty transparency often leads to considerable print dodging or burning in. Ilford makes a low-contrast

paper, but reducing excess contrast can also require masking, sandwiching the transparency in register with a black-and-white panchromatic contact negative.

Be careful if you handle any color processing chemicals. Mix chemicals in a very well-ventilated area. Wear protective gloves to prevent contact of chemicals with your skin. Safety goggles will protect your eyes. Do not pour chemicals directly down the drain; the bleach is corrosive and must be mixed with the other solutions to neutralize it for disposal. This is done by draining the spent processing solutions into the same plastic in the order that they are used. If you then dispose of them down the drain, follow with a generous amount of water. See the manufacturer's guidelines.

Materials and equipment needed for printing from a transparency

You can make a positive print directly from a positive color transparency with reversal materials like Ilford's Ilfochrome Classic paper processed in P30 P chemicals.

Several types of print materials are available. A resin-coated (RC) paper is available in a glossy and pearl finish. The pearl finish is not as likely as the glossy surface to show fingerprints or surface scratches. Also available is a glossy surface material on a polyester base, which dries to a high-gloss. The polyester base provides better color stability and is the preferred choice for archival preservation. Medium- and low-contrast papers are available.

The equipment for printing from a transparency is basically the same as that for printing from a negative. Prints must be handled in total darkness until processing is complete.

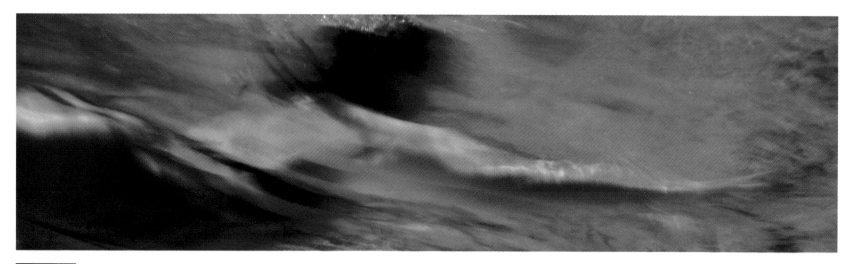

SUDA HOUSE Flight in the Water without Wings, 1991

Suda House used a 4 x 5 view camera to photograph a swimmer through a pool observation window, then cropped the image to a long, narrow format. The image is five feet wide, almost life size, printed using an enlarger tipped horizontally and projected onto paper taped to the darkroom wall. To create a feeling of the pool, the final print is enclosed in a plexiglas box, black on three sides, clear on the top.

More about . . .

- Equipment needed, pages 210–211
- Handling chemicals safely, page 109
- Print finishing, page 217

Print is too magenta. *Green viewing filter corrects. Subtract magenta from filtration.*

Print is too blue. *Yellow viewing filter corrects. Add yellow to filtration.*

Print is too red. *Cyan viewing filter corrects. Subtract yellow and magenta from filtration.*

◄ **Normal color balance**

Print is too cyan. *Red viewing filter corrects. Add yellow and magenta to filtration.*

Print is too yellow. *Blue viewing filter corrects. Subtract yellow from filtration.*

Print is too green. *Magenta viewing filter corrects. Add magenta to filtration.*

Unlike printing from a negative, reversal print materials respond the same way that slide film does when you expose it in the camera. If the print is too dark, increase the exposure (don't decrease it). If the print is too light, decrease the exposure.

Adjust the color balance by making the same change in the filter pack that you want in the print. Adding a color to the filter pack will increase that color in the print; decreasing a color in the pack will decrease it in the print. For example, if a print is too yellow, remove Y from the filtration (see chart and prints, left).

Evaluate and adjust density first, because what looks like a problem in filtration may simply be a print that is too dark or too light.

Then evaluate color balance by examining the print with viewing filters or by comparing the print against ringaround test chart (left). With Kodak's Color Print Viewing Filter Kit, hold the black side of the cards containing the filters toward you.

When overall density and color balance are good, look for areas that need dodging or burning in. If an area is too dark, add exposure and burn in the area, instead of dodging it as you would with negative/positive printing. If an area is too light, dodge the area to reduce the exposure.

Whatever you do, keep notes—on the print, with the transparency, or in a notebook.

Balancing a print made from a transparency

To adjust the color balance of a print made from a positive transparency, change the amount of the subtractive primary (yellow, magenta, and cyan) filtration. Avoid neutral density when changing the filtration; don't have all three colors in the filter pack.	Print is	Do this	Could also do this
	Too dark	Increase exposure	—
	Too light	Decrease exposure	—
	Too magenta	Subtract M	Add Y + C
	Too red	Subtract Y + M	Add C
	Too yellow	Subtract Y	Add C + M
	Too green	Add M	Subtract Y + C
	Too cyan	Add Y + M	Subtract C
	Too blue	Add Y	Subtract C + M

What makes a good advertising photograph? For Clint Clemens, the answer is simplicity, and he thinks that many photographers lose sight of that. "They complicate it too much," he says. "Too often there isn't a simple statement or any purity of thought."

Lighting can be dramatic in Clemens's pictures, but it always looks natural. "In nature, there is only one source of light—the sun. Lighting in a photograph should have that single-source feeling, whether it is indoors or outdoors." Clemens likes to give light a direction so that it comes from one area and moves across the picture. A viewer's eye tends to go to the lightest part of a picture first, which means that light, especially when it contrasts with a darker background, can direct attention where the photographer wants it to go.

Clemens always visualizes a photograph before he begins to shoot. He has a clear idea in advance of how the product should be presented, how it should relate to the type in the ad, how the picture will be cropped for the layout, and so on. "You have to be able to see the picture beforehand and be able to describe it to others. You would drive everyone crazy if you didn't have a good idea of what you wanted it to look like." He isn't rigidly tied to his ideas and will take advantage of something that happens spontaneously, but often the final picture is exactly what he visualized before the shoot.

Clemens feels that advertising is a very personalized business. He gets to know his clients and lets them know that their job is the most important one he has. More than that, he makes sure that every job is his most important one. "You never, never blow a job. You always have to give it your best, and that requires preplanning and constant attention to detail, especially when you are shooting. But don't get so bottled up and rattled that you can't think. You have to be willing to take chances, too."

Instead of being studio based, Clemens works mostly on location. He has one assistant who takes care of the equipment, then hires freelance help on individual shoots. He rents a studio, as needed, or hires a production crew to work at a site. When he used to work mostly in his studio, he often took on apprentices, as many advertising photographers do. He recommends apprenticeship as a good way to learn. His apprentices stayed six weeks, got no pay, worked intensely, and got the kind of experience that is impossible to get in a school or from a book.

Clemens says that if you want to be an advertising photographer, you have to be businesslike: "You have to learn how to deal with people, how to go out and get work, how to present and promote yourself, what to put in a portfolio, and many other things." But the most important attribute is a desire to understand every aspect of photography. "You have to want to learn. That is absolute."

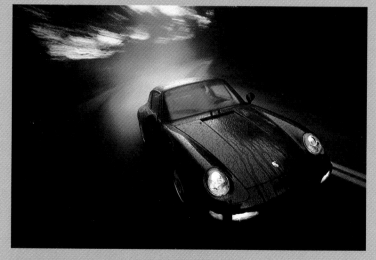

CLINT CLEMENS Photograph for Porsche, 1996

Clint Clemens believes that to get an advertising message across effectively you have to understand the psychology of your audience: how people perceive themselves and what intangibles the product might supply to them. For example, imparting a feeling of power for the a Porsche ad is as important as showing its design.

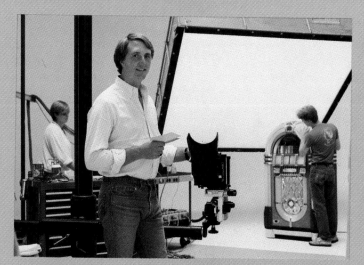

VITO ALUIA Clint Clemens, 1984

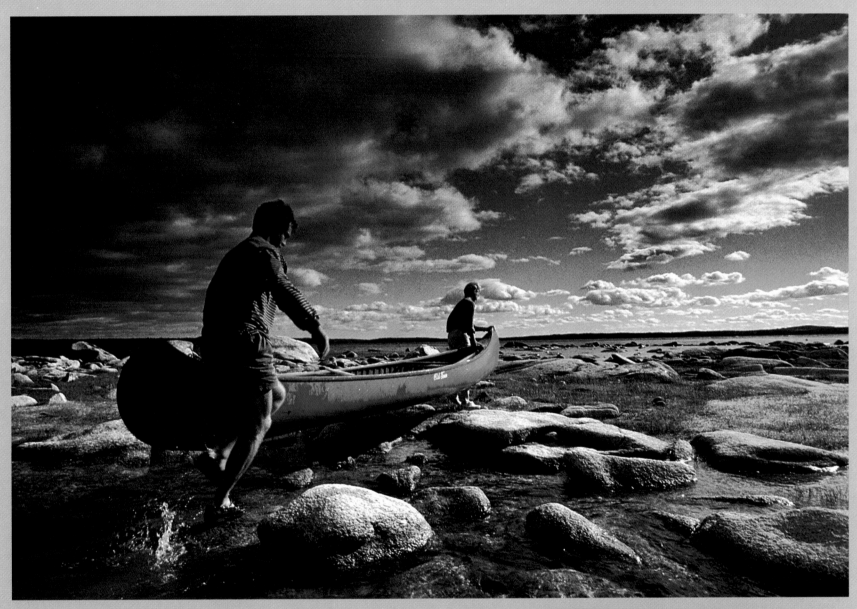

CLINT CLEMENS Photograph for Sportswear Manufacturer Sperry Top-Siders, 1996

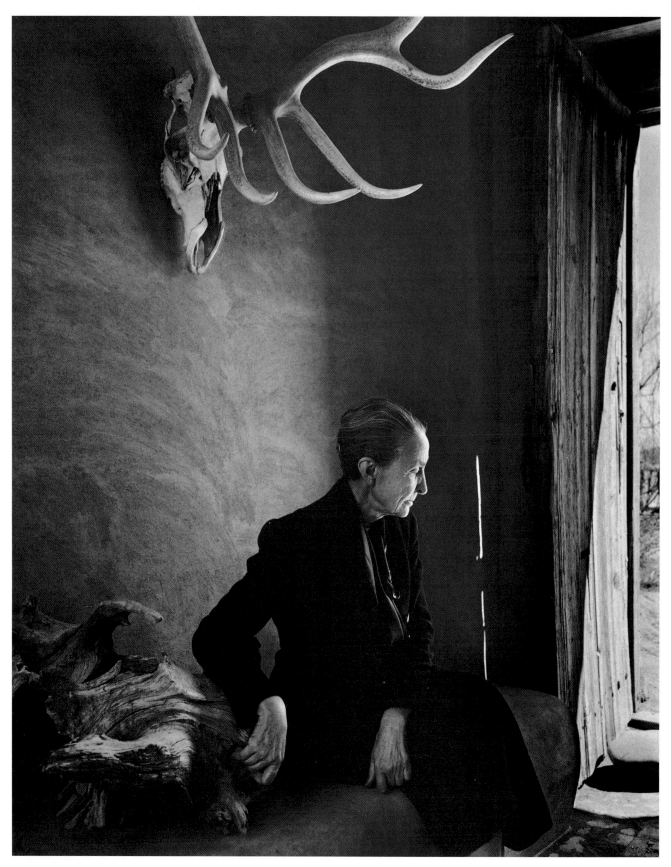

YOUSUF KARSH Georgia O'Keeffe, 1956

Lighting 11

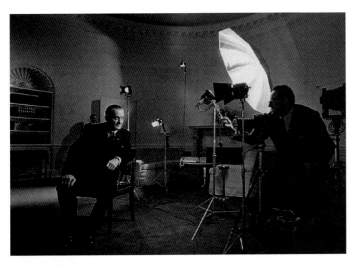

Y.R. OKAMOTO Arnold Newman Photographing President Lyndon B. Johnson, 1963

When Arnold Newman was asked to make a portrait of President Lyndon B. Johnson in the Oval Office at the White House, Newman covered the windows with cloths to block unwanted light, mounted two view cameras—a 4 x 5 and an 8 x 10—and arranged his lights and reflectors.

The lighting setup looks complicated, but its intention is simple—to illuminate the subject in a way that resembles ordinary daytime lighting. This type of lighting looks natural and realistic because it is the kind people see most often. It consists of one main source of light coming from above, usually from the sun but here from the large umbrella reflector. It also has fill light that lightens shadow areas. In nature, this is light from the entire dome of the sky or from other reflective surfaces; here it comes from the smaller lights.

◄ *Yousuf Karsh's portraits include presidents, popes, and most of the century's greatest musicians, writers, and artists, including the painter Georgia O'Keeffe (opposite). This portrait is typical of Karsh's work, conveying very strongly the sitter's public image, that is, what we expect that particular person to look like. Karsh generally photographs people in their own environments but imposes on his portraits his distinctive style: carefully posed and lighted setups, rich black tones, often with face and hands highlighted.*

Notice the lighting on your subject. Soft, relatively diffused light is the easiest to handle because it is kind to faces and won't change much, even if you change your position. But stronger lighting, as here, can add interest and emphasis. Move around your subject, or move them around, to take a look at how the light on them changes.

Changes in lighting will change your picture. Outdoors, if clouds darken the sky, or you change position so that your subject is lit from behind, or you move from a bright area to the shade, your pictures will change as a result. Light changes indoors, too. Your subject may move closer to a sunny window, or you may turn on overhead lights or decide to use flash lighting.

Light can affect the feeling of a photograph so that a subject appears, for example, brilliant and crisp, hazy and soft, harsh or smooth. If you make a point of observing the light on your subject, you will soon learn to predict how that light will affect your photographs, and you will find it easier to use existing light or to arrange the lighting yourself.

Direction of Light

The direction of light is important because of shadows, specifically those that are visible from camera position. Light, except for the most diffuse sources, casts shadows that can emphasize texture and volume or can diminish them. The main source of light—the sun, a bright window in a dark room, a flash unit—illuminates the side of the subject nearest the light and casts shadows on the opposite side.

When looking at the lighting on a scene, you need to take into account not only the direction of the light (and the shadows it casts), but also the position of the camera (will those shadows be visible in the picture?). Snapshooters are sometimes advised to "stand with the light over your shoulder." This creates safe but often uninteresting front lighting in which the entire subject is evenly lit, with few shadows visible because they are all cast behind the subject. Compare front lighting with side or back lighting in which shadows are visible from camera position (photographs, this page and opposite). There is nothing necessarily wrong with front lighting; you may want it for some subjects. Nor does side or back lighting enhance every scene.

Before you shoot, take a moment to consider your alternatives. Will moving to another position show the scene in a more interesting light? Can you move the subject relative to the light, or maybe move the light to another position? Outdoors, you have little control over the direction of light, except for waiting for the sun to move across the sky or in some cases by moving the subject. If you set up lights indoors, you have many more options.

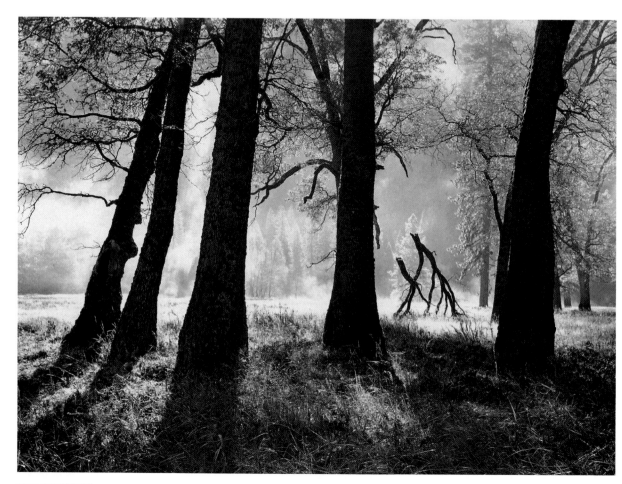

RAY McSAVANEY Yosemite National Park, 1983

Back lighting comes toward the camera from behind the subject *(or behind some part of the subject). Shadows are cast toward the camera and so are prominent, with the front of the subject in shadow. Back lighting can make translucent objects seem to glow and can create rim lighting, a bright outline around the subject (see the last photo on page 233).*

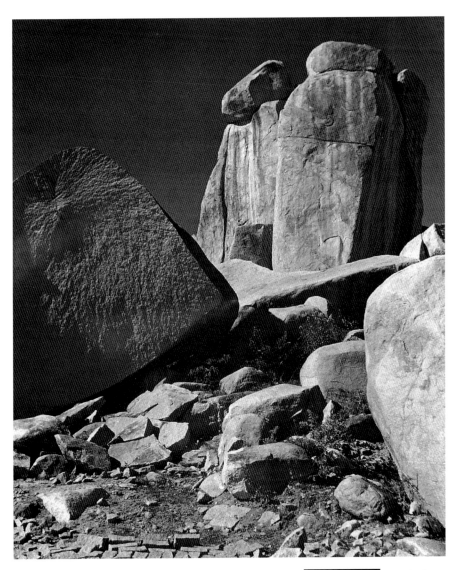

Rocky Landscape

Side lighting comes toward the side of the subject and camera. *Shadows are prominent, cast at the side of the subject, which tends to emphasize texture and volume. Early morning and late afternoon are favorite times for photographers to work outdoors, because the low position of the sun in the sky produces side lighting and back lighting.*

Cactus

Front lighting comes from behind the camera toward the subject. *The front of the subject is evenly lit with minimal shadows visible. Surface details are seen clearly, but volume and textures are less pronounced than they would be in side lighting where shadows are more prominent. Flash used on camera is a common source of front lighting.*

Degree of Diffusion: From Hard to Soft Light

Another important characteristic of lighting is its degree of diffusion, which can range from contrasty and hard-edged to soft and evenly diffused. When people refer to the "quality" of light, they usually mean its degree of diffusion.

Direct light creates hard-edged, dark shadows. It is specular: its rays are parallel (or nearly so), striking the subject from one direction. The smaller the light (relative to the size of the subject) or the farther the light is from the subject, the sharper and darker the shadows will be. The sharpest shadows are created by a point source, a light small enough or far away enough that its actual size relative to the size of the subject is irrelevant.

A spotlight is one source of direct light. Its diameter is small, and it often has a built-in lens to focus the light even more directly. If you think of a performer on stage in a single spotlight, you can imagine an extreme case of direct light: lit areas very light, shadows hard-edged and black unless there are reflective areas near the subject to bounce some light into the shadows.

The sun on a clear day is another source of direct light. Although the sun is large in actual size, it is so far away that it occupies only a small area of the sky and casts sharp, dark shadows. It does not cast direct light when its rays are scattered in many directions by clouds or other atmospheric matter. Then its light is directional-diffused or even fully diffused.

Diffused light scatters onto the subject from many directions. It shows little or no directionality. Shadows, if they are present at all, are relatively light. Shadow edges are indistinct, and subjects seem surrounded by light.

ETTA CLARK Bicycle Champion, 1985

Direct light has hard-edged shadows. It illuminates subjects such as those that are in the sun on a clear day.

FREDRIK D. BODIN Young Girl, Norway, 1975

Directional-diffused light combines qualities of direct and diffused light: shadows are visible, but not as prominent as in direct light. Here, the girl was indoors with the main light coming from a large window to the left, but with other windows bouncing light into the shadows.

Sources of diffused light are broad compared to the size of the subject—a heavily overcast sky, for example, where the sun's rays are completely scattered and the entire sky becomes the source of light. Fully diffused light indoors would require a very large, diffused light source close to the subject plus reflectors or fill lights to further open the shadows. Tenting (page 249) is one way of fully diffusing light.

Directional-diffused light is partially direct with some diffused or scattered rays. It appears to come from a definite direction and creates distinct shadows, but with edges that are softer than those of direct light. The shadow edges change smoothly from light to dark, and the shadows tend to have visible detail.

Sources of directional-diffused light are relatively broad. Indoors, windows or doorways are sources when sunlight is bouncing in from outdoors rather than shining directly into the room. Floodlights used relatively close to the subject are also sources; their light is even more diffused if directed first at a reflector and bounced onto the subject (like the umbrella light on page 223) or if partially scattered by a diffusion screen placed in front of the light. Outdoors, the usually direct light from the sun is broadened on a slightly hazy day, when the sun's rays are partially scattered and the surrounding sky becomes a more important part of the light source. Bright sunlight can also produce directional-diffused light when it shines on a reflective surface such as concrete and then bounces onto a subject shaded from direct rays by a tree or building.

DANNY LYON Sparky and Cowboy (Gary Rogues), 1965

Fully diffused light provides an even, soft illumination. *Here, the light is coming from above, as can be seen from the somewhat brighter foreheads, noses, and cheekbones, but light is also bouncing in from both sides and to some extent from below. An overcast day or a shaded area commonly has diffused light.*

Available Light—Outdoors

What kind of light will you find when you photograph in available light, the light that already exists in a scene? It may be any of the lighting situations shown here or on the preceding pages. Stop for a moment before you begin to photograph to see how the light affects the subject and to decide whether or not you want to change your position, your subject's position, or the light itself.

A clear, sunny day creates bright highlights and dark, hard-edged shadows (this page, top). On a sunny day, take a look at the direction the light is coming from. You might want to move the subject or move around it yourself so the light better reveals the subject's shape or texture as seen by the camera. If you are relatively close to your subject—for example, when making a portrait—you might want to lighten the shadows by adding fill light or by taking the person out of the sun and into the shade where the light is not so contrasty. You can't change light outdoors, but you can at least observe it and work with it.

On an overcast day, at dusk, or in the shade, the light will be diffused and soft (this page, bottom). This is a revealing light that illuminates all parts of the scene. It can be a beautiful light for portraits, gently modeling the planes of the face.

The light changes as the time of day changes. The sun gets higher and then lower in the sky, affecting the direction in which shadows fall. If the day is sunny, many photographers prefer to work in the early morning or late afternoon, because when the sun is close to the horizon, it casts long shadows and rakes across the surface of objects, increasing the sense of texture and volume.

Directional side light

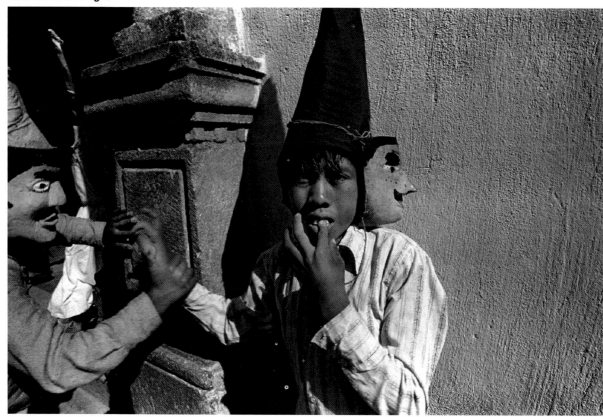

PEDRO MEYER **The Double Mask, Mexico, 1980**

Direct light outdoors can produce prominent shadows, *so it is important to notice how such light is striking a subject.*

Diffused light

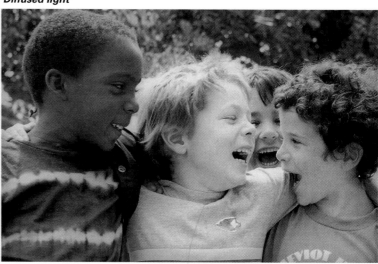

PENNY WOLIN **Four Children, Los Angeles, 1989**

Diffused light outdoors, such as in the shade of a building, *is soft and revealing. You can shoot from almost any position without the light on the subject changing.*

Directional back light

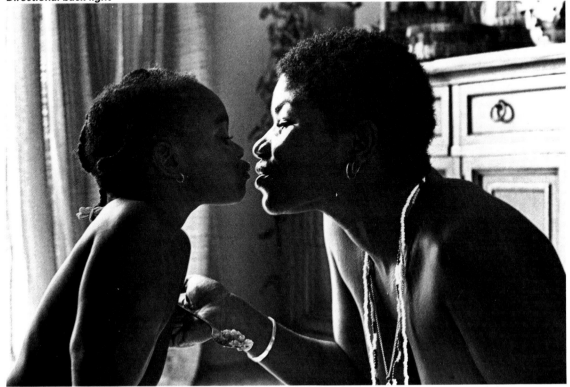

Shooting toward a bright window or lamp indoors creates contrasty light. The side facing the light source is much brighter than the side facing the camera.

Diffused light

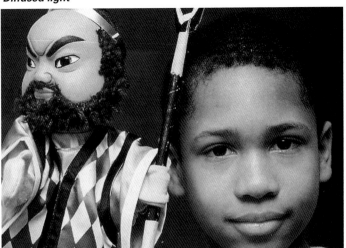

Diffused light indoors occurs when light comes from several different directions, such as from windows on more than one side of a room or from numerous light fixtures.

Available light indoors can be contrasty or flat, depending on the source of light. Near a lamp or window, especially if there are not many in the room, the light is directional, with bright areas fading off quickly into shadow (this page, top). The contrast between light and dark is often so great that you can keep details in highlights or shadows, but not in both. If, however, there are many light fixtures, the light can be softly diffused, illuminating all parts of the scene (this page, bottom).

When shooting indoors, expose for the most important parts of the picture. The eye adapts easily to variations in light; you can glance at a light area then quickly see detail in a nearby dark area. But there will often be a greater range of contrast indoors than film can record, so rather than making an overall meter reading you need to select the part of the scene that you want to see clearly and meter for that.

Light indoors is often relatively dim. If you want to use the existing light and not add flash or other light to a scene, you may have to use a slow shutter speed and/or a wide aperture. Use a tripod at slow shutter speeds or brace your camera against a table or other object so that camera motion during the exposure does not blur the picture. Focus carefully, because there is very little depth of field if your lens is set to a wide aperture. A fast film speed, ISO 400 or higher, will help.

Types of light

Photofloods have a tungsten filament, like a household bulb, but produce more light than a conventional bulb of the same wattage. The bulbs put out light of 3200K or 3400K color temperature for use with indoor color films. The bulbs have a relatively short life, and put out an increasingly reddish light as they age.

Quartz-halogen bulbs contain a gas that prolongs the life of their tungsten filament. They (and their lamp housing fixtures) are much more expensive than photofloods, but they last much longer and maintain a constant color temperature over their life. Quartz bulbs are color balanced for indoor color films.

Flash equipment ranges from large studio units that power multiple heads to units small enough to clip onto or be built into a camera. Flash is used with daylight-balanced color films.

Depending on its housing, any of the above can be a floodlight, which spreads its beam over a wide angle, or a spotlight, which has a lens in its housing that focuses the light into a concentrated beam. A spotlight often is adjustable so the light can be varied from very narrow to relatively wide.

Reflectors and light-control devices

Bowl-shaped reflectors are used with photo lamps to concentrate the light and point it toward the subject. Some bulbs have a metallic coating on the back of the bulb that eliminates the need for a separate reflector.

Snoot is a tube attached to the front of a lamp housing to narrow its beam. It is used to highlight specific areas.

Umbrella reflector is used with a light to produce a wide, relatively diffused light. The light source is pointed away from the subject into the umbrella, which then bounces a broad beam of light onto the scene. Umbrella reflectors come in various surfaces such as silvered for maximum reflectivity, soft white for a more diffuse light, and gold to warm skin tones. See the lighting setup with umbrella on page 245, bottom right.

Reflector flat is a piece of cardboard or other material used to bounce light into shadow areas.

Flag or gobo is a small panel usually mounted on a stand and positioned so it shades some part of the subject or shields the camera lens from light that could cause flare.

Barn doors are a pair (or two pairs) of black panels that mount on the front of a light source. They can be folded at various angles in front of the light and like a flag are used to block part of the illumination from the subject or from the lens.

Diffusers and filters

Diffusion screen, often a translucent plastic, placed in front of a light will soften it and make shadows less distinct. The material must be heat resistant if used with tungsten bulbs. The screen may clip onto a reflector or fit into a filter holder.

Tent is a translucent material that wraps around the subject instead of around the light source. Lights shine on the outside of the tent, producing a very diffused and even illumination. See the tent diagrammed on page 249.

Lightbox or softbox completely encloses one or more lamps and produces a soft, even light. See the very large lightbox shown on page 220.

Filter holder accepts filters or gels that change the color of the light, diffusion screens that soften it, or polarizing screens to remove glare or reflections.

Supports for lights and other devices

Light stands hold a lamp, reflector, or other equipment in place. The basic model has three folding legs and a center section that can be raised or lowered.

Cross arm or boom attaches to a vertical stand to position a light at a distance from the stand.

Umbrella mount attaches to a light stand and has a bracket for an umbrella reflector, plus another for the light that shines into the umbrella.

Background paper or seamless is not strictly speaking lighting equipment but is a common accessory in a studio setup. It is a heavy paper that comes in long rolls, 4 feet or wider, in various colors to provide a solid-toned, nonreflective backdrop that can be extended down a wall and across the floor or a table without a visible break. If the paper becomes soiled or wrinkled, fresh paper is unrolled and the old paper cut off. The roll is supported on two upright poles with a cross piece that runs through the hollow inner core of the roll.

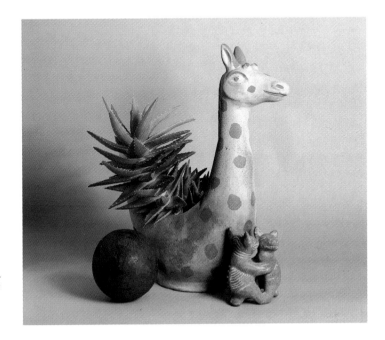

A softbox provides a very soft and diffused illumination. The light scatters over the subject from many directions providing almost shadowless lighting. Photographers often use a softbox or an umbrella reflector to produce the natural look of a broad, diffused window light.

A floodlight produces directional lighting. Notice how dark and hard edged the shadows are compared to the photo above.

The same properties are present in artificial light as in available light. The direction of light and the amount of its diffusion can create a hard-edged light or a soft and diffused light. Because you set up and arrange artificial lights, you need to understand how to adjust and control them to produce the effect you want.

The bigger the light source relative to the subject, the softer the quality of the light. The sun, although large, produces hard-edged, dark shadows because it is so far away that it appears as a very small circle in the sky. Similarly, the farther back you move a light, the smaller it will be relative to the subject and the harder the shadows will appear. The closer you move the same light, the broader the light source will be, the more its rays will strike the subject from different angles, and the softer and more diffused its lighting will appear.

The more diffused the source, the softer the light. A spotlight focuses its light very sharply on a subject producing bright highlights and very dark, hard-edged shadows. A floodlight is a slightly wider source, but still one with relatively hard-edged shadows, especially when used at a distance. A softbox or umbrella reflector is much more diffused and soft.

Use the type of light and its distance to control the light on your subject. If you want sharp, dark shadows, use a directional source, such as a photoflood, relatively far from the subject. If you want soft or no shadows, use a broad light source, such as a softbox or umbrella reflector, close to the subject.

The Main Light: The Dominant Source

Where do you start when making a photograph with artificial light? Using lights like photofloods or electronic flash that you bring to a scene and arrange yourself requires a bit more thought than making a photograph by available light where you begin with the light that is already there and observe what it is doing to the subject.

The most natural-looking light imitates that from the sun—one main light source casting one dominant set of shadows—so usually the place to begin is by positioning the main light. This light, also called the key light, should create the only visible shadows, or at least the most important ones, if a natural effect is desired. Two or three equally bright lights producing multiple shadows create a feeling of artificiality and confusion. The position of the main light affects the appearance of texture and volume (see pictures below). Flat frontal lighting (first photograph) decreases both texture and volume, while lighting that rakes across surface features (as seen from camera position) increases it. Natural light usually comes from a height above that of the subject, so this is the most common position for the main source of artificial light. Lighting from a very low angle can suggest mystery, drama, or even menace just because it seems unnatural. The monster in a horror movie is often lighted from below.

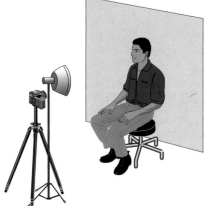

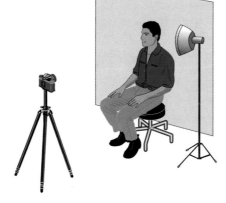

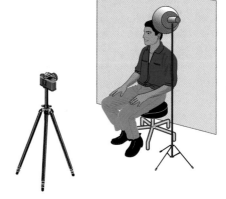

Front lighting. *With the light placed as near the lens axis as possible (here just to the right of the camera), only thin shadows are visible from camera position. This axis lighting seems to flatten out the volume of the subject and minimize textures.*

Side lighting. *Sometimes called "hatchet" lighting because it can split a subject in half. This type of lighting emphasizes facial features and reveals textures like that of skin. The light is at subject level, directly to the side.*

High side lighting. *A main light at about 45° to one side and 45° above the subject has long been the classic angle for portrait lighting, one that seems natural and flattering. It models the face into a three-dimensional form.*

Some types of lighting have been traditionally associated with certain subjects. Side lighting has long been considered appropriate for masculine portraits because it emphasizes rugged facial features. Butterfly lighting was often used in the past for idealized portraits of Hollywood movie stars. The lighting is named for the symmetrical shadow underneath the nose, similar to, though not as long as, the one in the top-lighting photo-graph, below left. The main light is placed high and in front of the subject, which smoothes the shadows of skin texture, while producing sculptured facial contours (see page 247, far right).

Lighting can influence the emotional character of an image. The pictures below show how the mood of a photograph can be influenced merely by changing the position of one light. If photographs never lie, some of those below and on the opposite page at least bend the truth about the subject's personality.

Most photographs made with artificial light employ more than one light source. Almost always a fill light or reflector is used to lighten shadows. Sometimes, an accent light is used to produce bright highlights, and a background light is added to create tonal separation between the subject and background.

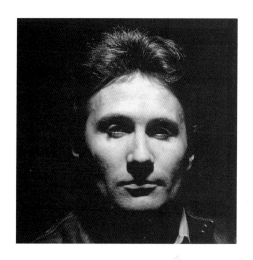

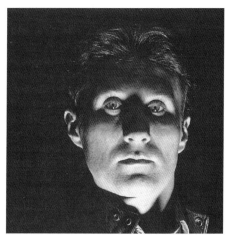

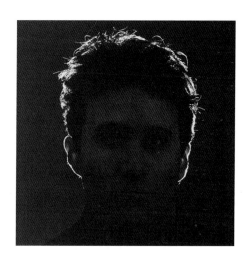

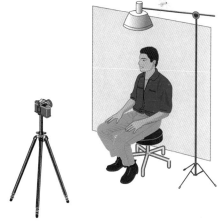

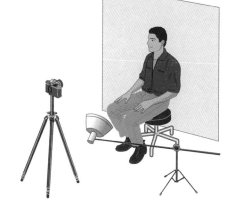

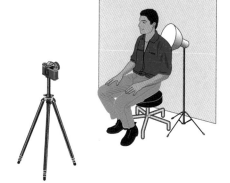

Top lighting. *A light almost directly above the subject creates deep shadows in the eye sockets and under the nose and chin. This effect is often seen in pictures made outdoors at noon when the sun is overhead.*

Under lighting. *Light from below produces odd-looking shadows because light in nature seldom comes from below. Firelight is one source. High-tech scenes, such as by a computer monitor, are a modern setting for under lighting.*

Back lighting. *A light pointing at the back of a subject outlines its shape with a rim of light like a halo. Position a back light carefully so it does not shine into the camera lens and fog the film overall, and so the fixture itself is not visible.*

More about . . .
• Fill light, pages 234–235
• Multiple-light portraits, pages 246–247

Fill light makes shadows less dark by adding light to them. When you look at a contrasty scene, your eye automatically adjusts for differences in brightness. As you glance from a bright to a shadowed area, the eye's pupil opens up to admit more light. But film cannot make such adjustments; it can record detail and texture in brightly lit areas or in deeply shadowed ones, but generally not in both at the same time. So if important shadow areas are much darker than lit areas—for example, the shaded side of a person's face in a portrait—consider whether adding fill light will improve your picture.

Fill light is most useful with color transparencies. As little as two stops difference between lit and shaded areas can make shadows very dark, even black, in a color slide. The film in the camera is the final product when shooting slides, so corrections can't be made later during printing. Color prints are also sensitive to contrast, though less so than slides.

Fill light can also be useful with black-and-white materials. In a black-and-white portrait of a partly shaded subject, shadows that are two stops darker than the lit side of the face will be dark but still show full texture and detail. But when shadows get to be three or more stops darker than lit areas, fill light becomes useful. You can also control contrast by, for example, printing on a lower contrast grade of paper, but, results are often better if you add fill light, rather than trying to lighten a too-dark shadow when printing.

Artificial lighting often requires fill light. Light from a single photoflood or flash often produces a very contrasty light in which the shaded side of the face will be very dark if the lit side is exposed and printed normally. Notice how dark the shaded areas are in the single-light portraits on pages 232–233. You might want such contrasty lighting for certain photographs, but ordinarily fill light would be added to make the shadows lighter.

Some daylight scenes benefit from fill light. It is easier to get a pleasant expression on a person's face in a sunlit outdoor portrait if the subject is lit from the side or from behind and is not squinting directly into the sun. These positions, however, can make the shadowed side of the face too dark. In such cases, you can add fill light to decrease the contrast between the lit and shadowed side of the face. You can also use fill light outdoors for close-ups of flowers or other relatively small objects in which the shadows would otherwise be too dark.

A reflector is a simple, effective, and inexpensive way to add fill light. A reflector placed on the opposite side of the subject from the main light bounces the main light into shadow areas. A simple reflector, or flat, can be made from a piece of stiff cardboard, 16 x 20 inches or larger, with a soft matte white finish on one side. The other side can be covered with aluminum foil that has first been crumpled and then partially smoothed flat. The white side will give a soft, diffused, even light suitable for lightening shadows in portraits, still lifes, and other subjects. The foil side reflects a more brilliant, harder light.

A floodlight or flash can also be used for fill lighting. A light source used as a fill is generally placed close to the lens so that any secondary shadows will not be visible. The fill is usually not intended to eliminate the shadow altogether, so it is normally of less intensity than the main light. It can have lower output than the main light, be placed farther away from the subject, or have a translucent diffusing screen placed in front of it.

A black "reflector" is useful at times. It is a sort of antifill that absorbs light and prevents it from reaching the subject. If you want to darken a shadow, a black cloth or card placed on the opposite side of the subject from the main light will remove fill light by absorbing light from the main light.

Fill light ratios

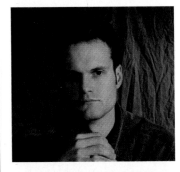

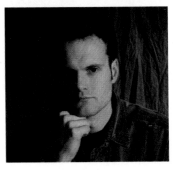

The difference between the lit side of a subject and the shadow side can be stated as a ratio. The higher the ratio, the greater the contrast. Doubling the ratio is equivalent to a one-stop change between highlights and shadows.

1:1 ratio. The lit side is no lighter than the "shadow" side—in fact, there are no significant shadows. If an exposure for the lit side metered, for example, 1/125 sec at f/5.6, the exposure for the shadow side would meter the same.

2:1 ratio. The lit side is twice as light as the shadow side (a one-stop difference between meter readings), which will make shadows visible but very light. If the lit side metered 1/125 sec at f/5.6, the shadow side would meter one stop less at f/4.

4:1 ratio. The lit side is four times—two stops—lighter than the shadow side, which will render shadows darker, but still show texture and detail in them. If the lit side metered 1/125 sec at f/5.6, the shadow side would meter two stops less at f/2.8. Portraits are conventionally made at a 3:1 to 4:1 ratio, with the lit side of the face between one and one-half and two stops lighter than the shadowed side.

8:1 ratio. The lit side is eight times—three stops—lighter than shadows. At 8:1 (or higher), some detail is likely to be lost in highlights, shadows, or both. If the lit side metered 1/125 sec at f/5.6, the shadow side would meter three stops less at f/2.

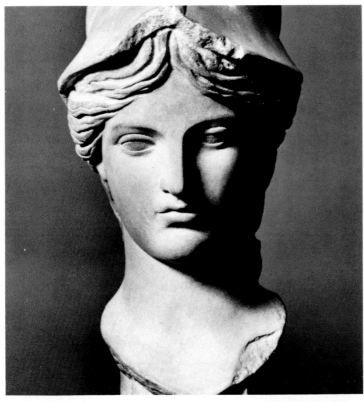

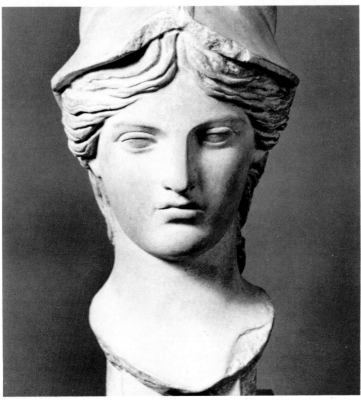

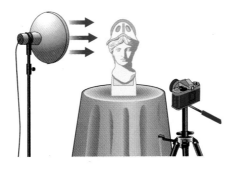

To measure the difference between highlights and shadows, meter the lit side and note the combination of f/stop and shutter speed. Then compare that to the f/stop and shutter speed combination for the shadow side. If there is too much difference between the lit side and shadows, move the fill closer to the subject or move the main light farther away.

With a reflected-light meter (see below), you can meter directly from the subject or from a gray card held close to the subject. You need to get close enough to meter only the lit (or shadow) area, without getting so close that you cast—and meter—your own shadow.

With an incident-light meter, point the meter first toward the main light from subject position, then toward the fill.

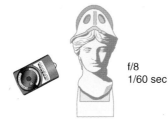

f/8
1/60 sec

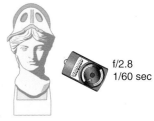

f/2.8
1/60 sec

No fill light. Side lighting from a single photoflood leaves one side of the face darkly shadowed. The lit side meters f/8 at 1/60 sec.

The shadow side meters f/2.8 at 1/60 sec or 3 stops less than the lit side (f/8 to f/5.6 would be a one-stop difference, to f/4 two stops, to f/2.8 three stops), an 8:1 ratio.

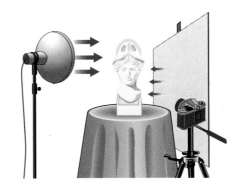

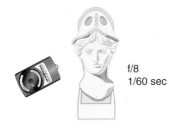

f/8
1/60 sec

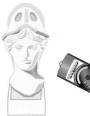

f/5.6 – f/4
1/60 sec

With fill light. A piece of white cardboard to the right of the head bounces light back into the shadow areas on the cheek and chin to lighten the shadows. The lit side now meters f/8 at 1/60 sec.

The shadow side meters between f/5.6 and f/4, a one-and-a-half-stop difference, or a 3:1 ratio.

Flash units provide a convenient means of increasing the light, indoors or out. An electronic flash unit, sometimes called a strobe, has a tube filled with xenon or other inert gas that emits a brief burst of light when subjected to a surge of electricity. The unit may be powered by batteries built into a camera, by batteries or an AC connection built into the flash unit, or by a separate power pack.

Professional photographers find flash particularly useful. Photojournalists often have to work fast in an unfamiliar setting to record action while it is happening. Not only does flash stop the motion of a moving subject, but it prevents any blur caused by hand-holding the camera. The light is portable and predictable; flash delivers a measured and repeatable quantity of light anywhere the photographer takes it, unlike available light, which may be too dim or otherwise unsuitable. Studio photographers like flash because it stops motion, plus it has easily adjustable and consistent output and is cooler than heat-producing tungsten lights.

A camera-mounted flash unit is convenient to carry and use. The light from the flash illuminates whatever is directly in front of the lens. But flash-on-camera (or any single light that is positioned very close to the lens axis) creates a nearly shadowless light. The result is a flatness of modeling and lack of texture that may not be desirable for every subject. A flash unit that you can use from an off-camera position offers more lighting options.

The burst of light from electronic flash is very brief. Even 1/1000 second, which is a relatively long flash duration, will show most moving subjects sharply, a great advantage in many situations (see photograph, this page). The disadvantage is that the flash is so brief that you can't see how the light affects the subject—for example, where the shadows will fall. Larger units provide a modeling light, a small tungsten light built into the flash unit and used as an aid in positioning the flash. Even without a modeling light, however, you will eventually be able to predict the effects of various flash positions.

Flash must be synchronized with the camera's shutter. A sync cord (or other electronic connection such as a hot shoe) links the flash and the camera so that the flash fires when the shutter is fully open. A camera with a leaf shutter (for example, a view camera) can be used with flash at any shutter speed when the shutter is set to X sync. A camera with a focal-plane shutter (such as a single-lens reflex camera) may have to be used with flash at relatively slow shutter speeds since the shutter curtains on some models are fully open only at 1/60 sec or slower. Many newer models, however, sync with flash at faster speeds.

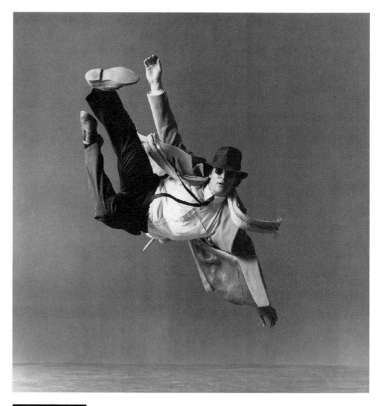

LOIS GREENFIELD Dancer David Parsons, 1983

Flash stops motion—an understatement for the photograph above. The burst of light from a flash is so brief—usually faster than the fastest shutter speed on a camera—that it shows most moving subjects sharply.

When Lois Greenfield photographed dancer David Parsons, she didn't want to photograph a choreographed moment from a particular dance. Instead, she set up an electronic flash and had him "hit shapes" so she could photograph the dancer's movement in the studio as a separate art. More work by Lois Greenfield appears on pages 32–33.

More about . . .

• Ways to position a flash, pages 238–239
• Getting the right flash exposure, pages 240–241

Types of flash units

Built-in flash is now part of many 35mm cameras.

Hot-shoe flash has a mounting foot that slips into the hot-shoe bracket on top of a camera. The hot shoe provides an electrical connection that fires the flash when the camera shutter is released. Some units, like the one shown here, have a head that tilts so the flash can be used on the camera but still provide indirect bounce light.

Handle-mount flash puts out more light than a typical hot-shoe unit. Its handle serves as a grip and can hold batteries to power the unit.

Studio flash units are powerful devices that can fire one or more flash heads that are connected by cable to the power pack. On some units, power output can be adjusted for individual flash heads.

Self-contained flash heads have a built-in power pack.

Flash metering

Automatic flash has a light-sensitive cell and electronic thyristor circuitry that determine the duration of the flash needed by measuring the light reflected back from the subject during the exposure. Some units can also be operated manually.

Dedicated (or designated) flash is always an automatic flash and is designed to be used with a particular camera. In automatic operation, the flash sets the camera's shutter to the correct speed for flash and activates a signal in the viewfinder when the flash is ready to fire. Do not use a flash unit dedicated for one camera on any other unless the manufacturer says they are compatible. The camera, flash, or both may be damaged.

Through-the-lens metering has a sensor inside the camera that reads the amount of light that actually reaches the film. Better systems can read the ambient light as well as the flash and can adjust the flash to provide fill lighting.

Flash meter is a light meter capable of measuring the brief burst of light from flash so that the camera lens can be set to the correct f-stop.

Flash accessories

Sync cord connects a flash to a camera so that the flash fires when the camera's shutter is released. Not all cameras have a terminal that accepts this cord.

Flash slave unit fires an auxiliary flash when it detects a pulse of light from a primary flash that is synchronized with the camera.

Modeling light, a small tungsten light built into the flash head, helps in positioning the direction of the flash.

Light modifiers, such as a softbox diffuser or an umbrella reflector, can be used with flash, just as they can with tungsten light, to control the diffusion of the light.

The easiest way to light a scene with flash is with direct flash on camera, a flash unit mounted on the camera and pointed directly at the subject (shown this page). More likely than not, you will get an adequately exposed picture if you just follow the simple instructions that come with the unit. The trouble is that this type of lighting is rather bland; the subject looks two-dimensional with texture and volume flattened out by the shadowless, frontal lighting. The fault lies not with the flash but with its position close to the camera lens.

You can get more varied and interesting lighting with the flash in other positions, as shown opposite. The goal is the same as with photofloods, to make the lighting resemble natural illumination. Since almost all natural lighting comes from above the subject, good results come from a flash held above the level of the subject or bounced in such a way that the light comes from above. Light that comes from one side is also effective and is usually more appealing than light that falls straight on the subject from the direction of the camera.

Natural lighting, whether indoors or outdoors, rarely strikes a subject exclusively from one direction. For example, shadows may be filled in by light bounced off the ground or other surfaces. You can do the same with flash, although the main light should still be dominant. Bouncing the main light onto the subject from another surface will diffuse some of the light and create softer shadows (see opposite, center and right). A diffusing screen over the flash head has a somewhat similar effect.

Aim the flash carefully so that the light doesn't create odd shadows or distracting reflections. The duration of a flash burst is too short to see the effect of different positions while shooting.

Direct flash on camera. *This is the simplest method, one that lets you move around and shoot quickly. But the light tends to be flat, producing few of the shadows that model the subject to suggest volume and texture. Flash on camera may produce red eye, a reddish reflection from the eye caused by light bouncing off the blood-rich retina.*

◄ *Flash on camera is popular with photojournalists and is useful in any situation where you have to provide the lighting and shoot quickly, too.*

MARILYN STERN Halloween Parade, New York City

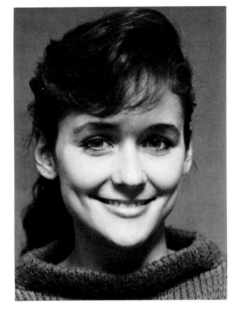

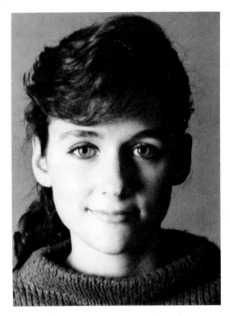

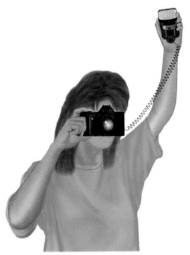

Direct flash off camera. *Compared to on-camera flash, this produces more texture and volume. The flash is connected to the camera by a long sync cord and held at arm's length (or attached to a light stand) above and to the side. Point the center of the flash head carefully at the most important part of the subject. You can't see the results as you shoot, so it's easy to let your aim wander. This technique works best relatively close to the subject. As you move back you are more likely to mis-aim the flash.*

Flash bounced from above. *Bounce light is softer and more natural-looking than direct flash. The flash can be left on the camera if the flash has a head that swivels upward. In a room with a relatively low ceiling, the flash can be pointed upward and bounced off the ceiling (preferably neutral in color if you are using color film). A bounce-flash accessory simplifies bounce use; a card or mini-umbrella clips above the flash head and the light bounces off that.*

Flash bounced from side. *For soft lighting, with good modeling of features, the light can be bounced onto the subject from a reflector or light-colored wall (as neutral as possible for color film). See also the umbrella reflector setup on page 245 right.*

Automatic Flash Exposures

Automatic flash units react to the amount of light reflected back from the subject during the exposure. After the flash is triggered, light striking the subject reflects back to a light-sensitive cell, or sensor, mounted on the flash unit or in the camera. When enough light is received by the sensor, it cuts off the flash.

Dedicated flash units are designed to be used with a particular camera. They usually offer more features than a non-dedicated automatic unit, such as balancing the amount of flash to that of the existing light on the scene. A more sophisticated version utilizes multiple sensors to meter and compare the light on different parts of the scene, so that you are more likely to get a correct exposure even if, for example, the subject is not in the center of the frame.

When doesn't automatic flash work well? Unless you have a multiple-sensor unit, the subject may be underexposed and too dark if it does not fill enough of the center of the frame and is close to a much lighter background, such as a white wall. The subject may be overexposed and too light if it is against a much darker background, such as outdoors at night. For such scenes you can set the exposure manually, or at least bracket your exposures, making an initial shot, then others with less and more exposure.

Bounce flash presents a special situation. The flash is not pointed directly at the subject, but at a wall or other reflecting surface. Some automatic flash units have a sensor that remains pointed at the subject even though the flash head is swiveled to the side or above. This type of unit can automatically calculate a bounce flash exposure because the sensor will read the same light that the camera receives. Cameras that measure flash through the lens (TTL) can also be used automatically with bounce flash. Without such equipment, you must calculate the exposure manually.

Sensor on flash meters the light

An automatic flash that controls exposure with a sensor on the flash unit monitors the light reflected from the subject during the exposure and cuts off the flash when the exposure is correct. The flash will have a calculator dial or other readout giving a choice of distance ranges and matching lens f-stops. You can move closer to or farther from the subject, as long as your lens is set to the suggested f-stop and you are within the distance range.

An automatic flash does the exposure calculations for you, but models vary in design and operation, so check the manufacturer's instruction book for your model before shooting.

Sensor in camera meters the light

A camera that automatically controls flash exposure through the lens (TTL) monitors the light reflected from the subject using a sensor (or sensors) in the camera and can compare the light from the flash with the existing light on the scene. Depending on how you set the camera, the camera can then make the flash the dominant light on the subject, balance the existing light evenly with the flash light, or let the existing light dominate with the flash providing fill light.

Recommended f-stop (step 4)

Choose the distance range (step 3)

Set the film speed (step 2)

1. Set the camera's shutter to a speed that will synchronize with the flash. This may be marked on the camera in red or with a lightning bolt.

2. Set the flash to the film speed you are using (here, ISO 100).

3. Choose the distance range within which you want to shoot (here, 3–15 ft). The range of distances is often color coded, and you may have to input that color on a dial or other selector on the flash.

4. Set the camera to the recommended f-stop for the selected distance range (here, f/5.6).

5. Compose the picture and push the shutter release button.

1. Set the camera (and flash, if needed) to TTL operation.

2. Depending on your camera, you may be able to select such features as setting the ratio of flash to existing light.

3. Compose the picture and push the shutter release button.

Using a flash unit's calculator dial

Your flash can calculate a manual flash exposure for you if it has a calculator dial or other readout giving exposure information. It will tell you what lens aperture to use for a given film speed and subject distance.

1. Set your film speed into the flash (here, ISO 100). Set your shutter speed to one that will synchronize your camera with flash.

2. Find the distance from flash to subject (here, 15 feet). You can estimate the distance or read it off the lens's distance scale after you focus on the subject.

3. Set your lens to the aperture that is opposite that distance on the calculator dial (here, f/5.6). With digital readout, you enter the film speed and the distance, and the unit displays the aperture to use.

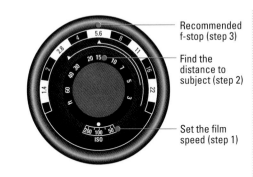

Recommended
f-stop (step 3)

Find the
distance to
subject (step 2)

Set the film
speed (step 1)

Using a guide number

A guide number is one way of describing a flash unit's power. Flash manufacturers measure the power of a unit and assign it a guide number, a rating for the flash when used with a given film speed. The higher the guide number the more powerful the flash. To calculate a flash exposure manually, you can divide the distance from flash to subject into the guide number. The result is the lens aperture to use.

The inverse square law is the basis for manual flash exposures. The farther that light travels, the more the light rays spread out and the dimmer the resulting illumination. The level of light drops rapidly as the distance increases between light and subject. At twice a given distance from a light source, an object receives only one-fourth the light. This is the inverse square law: Intensity of illumination is inversely proportional to the square of the distance from light to subject.

If flash guide number is 80 with ISO film

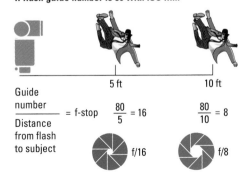

$$\frac{\text{Guide number}}{\text{Distance from flash to subject}} = \text{f-stop} \qquad \frac{80}{5} = 16 \qquad \frac{80}{10} = 8$$

f/16 f/8

Bounce flash

Bounce flash travels an extra distance. The flash-to-subject distance is measured from the flash to the reflecting surface to the subject, not straight from flash to subject. You must also open the lens a bit more to allow for light absorbed by the reflecting surface. A white painted wall or ceiling might need an extra one-half stop or full stop of exposure, and dark surfaces even more. Bracket your exposures to be safe.

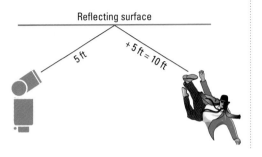

Reflecting surface

5 ft

+ 5 ft = 10 ft

Manually controlled flash units emit light for a fixed length of time. Exposure is controlled by the photographer adjusting the size of the lens aperture; the greater the distance from flash to subject, the weaker the illumination that reaches the subject and the wider the lens aperture needs to be. The correct lens f-stop can be determined either by using a flash meter or by calculating the f-stop based on the power of the flash and the distance to the subject.

A flash meter is often used by studio photographers or other professionals. It is similar to an ordinary hand-held exposure meter but is designed to read the brief, intense burst of light from flash, which ordinary exposure meters cannot. A flash meter simplifies exposure calculations in situations such as multiple-light setups, with bounce flash, or if cumulative firings are used to build an exposure. Flash meters, like ordinary exposure meters, may read reflected light (the meter is pointed toward the subject from camera position) or incident light (the meter is positioned near the subject and pointed toward the camera).

Fill Flash: Flash Plus Daylight

Flash can be used as a fill light outdoors. A sunny day is a pleasant time to photograph, but direct sunlight does not provide the most flattering light for portraits. Facing someone directly into the sun will light the face overall but often causes the person to squint. Turning someone away from the light can put too much of the face in dark shadow.

Flash used as an addition to the basic exposure can open up dark shadows so they show detail (photographs, top). It is better not to overpower the sunlight with the flash, but to add just enough so that the shadows are still somewhat darker than the highlights—for portraits, about one or two stops.

Flash can increase the light on a fully shaded subject that is against a brighter background, in much the same way as it is used to light shadows on a partly shaded subject (photographs, bottom). Without the flash, the photographer could have gotten a good exposure for the brighter part of the scene or for the shaded part, but not for both. Flash was used to reduce the difference in brightness between the two areas.

Color reversal film particularly benefits from using flash for fill light. The final transparency is made directly from the film in the camera, so it is not possible to lighten shadows by dodging them during printing.

There are other uses for flash plus daylight. Flash used outdoors during the day is usually simply a means to lighten shadows so they won't be overly dark. But you can also combine flash with existing light for more unusual results (see opposite page, right, and page 251).

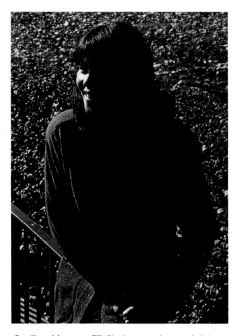

Sunlit subject, no fill. *Shadows can be very dark in a sunlit scene, so dark that film will not record details in both the shadows and brightly lit areas.*

Sunlit subject with flash fill. *For portraits or for close-ups, such as flowers in nature, fill light will lighten the shadows and preserve detail.*

Exposed for shaded foreground, no flash. *Flash is useful to lighten a nearby, fully shaded subject that is against a much lighter background. Simply exposing the foreground correctly makes the background too light.*

Exposed for sunlit background, no flash. *Exposing the background correctly makes the darker foreground too dark.*

Exposed for sunlit background, flash lightens shaded foreground. *By adding flash fill you can get a good exposure for both the shaded foreground and lighter background.*

Flash-plus-daylight exposures

You can use flash outdoors during the day to decrease the contrast between shaded and brightly lit areas (see illustrations opposite). You will need to balance the existing light on the subject with the light from the flash. Some basic instructions follow, but see your flash manufacturer's instruction book for details about your unit.

Manual operation if a flash has adjustable power settings.
1. Set the camera and flash to manual-exposure operation. Set your camera shutter speed to the correct speed to synchronize with flash. Focus on your subject.

2. Meter the lighter part of the scene using the camera's built-in meter or a hand-held meter. Set your lens to the f-stop that combines with your shutter synchronization speed to produce a correct exposure for the existing light.

Let's assume that your film speed is ISO 100, your basic exposure is 1/60 sec at f/16, and the subject is 5 feet away.

3. Set the film speed (100 in this example) on the flash calculator dial.

4. Line up on the dial the flash-to-subject distance (5 ft) with the camera f-stop (16).

5. Note the power setting that the dial indicates (such as full power, 1/2 power, 1/4 power). This setting will make the shaded area as bright as the lit area, such as in the photograph opposite, bottom right.

 Suppose you wanted the flash-filled shadows one stop darker than sunlit areas (such as in the photograph opposite, top right). Set the flash to the next lower power setting (for example, from full power to 1/2 power).

If a manual flash does not have adjustable power settings. Do steps 1, 2, and 3. Locate the f-stop (from step 2) on the flash calculator dial and find the distance that is opposite it. If you position the flash that distance from the subject, the light from the flash will equal the sunlight.
 To decrease the intensity of the light from the flash, drape one or two layers of white handkerchief over the flash head. Sometimes it's possible to step back from the subject (although this will change the framing of the scene) to decrease the amount of light reaching the subject. Multiply the original distance by 1.4 for a one-stop difference between lit and shaded areas.

Automatic flash. If your camera meters light from a flash through the lens, it will read the light from the flash and the existing daylight. It will automatically provide as much illumination as is needed from the flash. Depending on the particular combination of flash and camera, you may be able to select the balance of light—for example, having the areas lit by the flash about as bright as those areas that are sun-lit, or having the flash lighten the shadows slightly, but not have them as bright as the rest of the scene.
 If your camera does not meter flash through the lens, set it manually, as above.

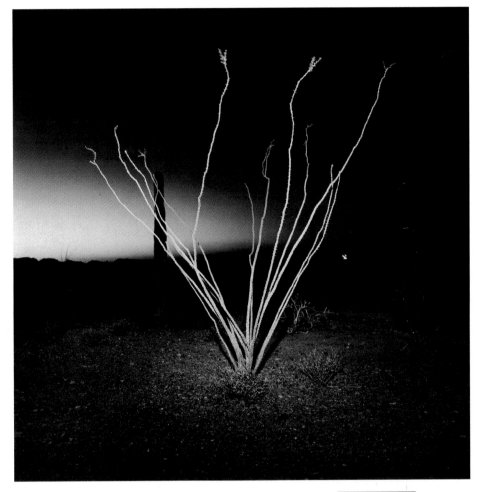

RICHARD MISRACH Ocotillo, 1975

Two exposures—one with existing light, the other with flash—created this image of a desert plant in its own pool of light. First, Richard Misrach made a 5-sec exposure with the light existing at dusk after the sun had gone down but while there was still a glow in the sky. Then he "fried" the plant in the foreground with a flash exposure. If he had exposed just for the sky, the plant would have been only a silhouette against the sky. If he had exposed just with flash, the sky would have been black. The combined exposures record a scene that is only visible with a camera. The brown tones in the image are the result of split toning (see page 159).

Simple Portrait Lighting

You don't need a complicated lighting arrangement for portraits—or many other subjects. In fact, often the simpler the lighting, the better. Many photographers prefer to keep portrait setups as simple as possible so the subject is relaxed. Lights, tripods, and other paraphernalia can make some subjects overly conscious of the fact that they are being photographed, resulting in a stiff, awkward expression.

Outdoors, open shade or an overcast sky provides a soft, even light (photograph this page). The person is not lit by direct sunlight, but by light reflected from the ground, from clouds, or from nearby surfaces such as a wall. Open shade or overcast light is relatively bluish, so if you are shooting color film, a 1A (skylight) or 81A (light yellow) filter on the camera lens will warm the color of the light by removing excess blue.

Indoors, window light is a convenient source of light during the day (photograph opposite, left). Contrast between lit and shaded areas will be very high if direct sunlight falls on the subject, so generally it is best to have the subject lit only by indirect light bouncing into the room. Even so, a single window can be a contrasty source of light, causing those parts of the subject facing away from the window to appear dark.

A main light plus reflector fill is the simplest setup if you want to arrange the lighting yourself (photograph opposite, right). Bouncing the light into an umbrella reflector, rather than lighting the subject directly, softens the light, makes it easier to control, and may even eliminate the need for fill.

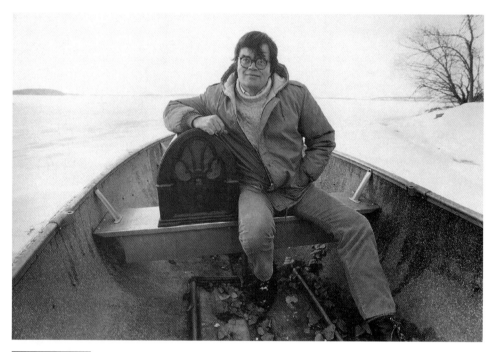

MARC POKEMPNER Garrison Keillor

In open shade outdoors, a wall, tree, or other object blocks the direct rays of the sun. In this case, an overcast sky diffused the light so it bounced onto the subject from different directions.

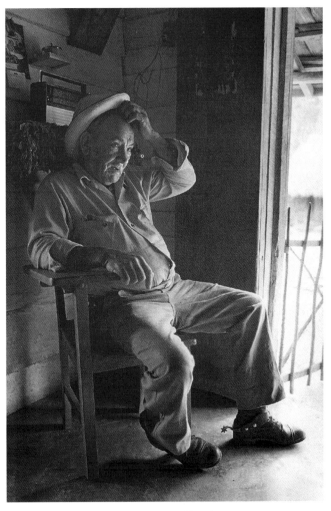

Campesino, Cuba

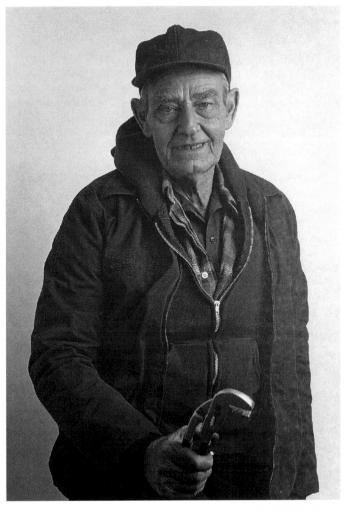

Jim

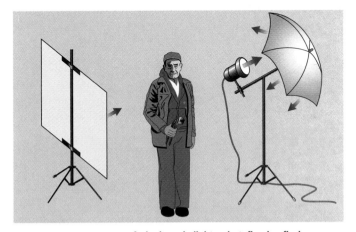

Window light *(or in this case, light from an open door) can be quite contrasty, so keep an eye on the amount of contrast between lit and shaded areas. Light bouncing off the walls provided some fill light for this picture. A reflector opposite the window can bounce even more fill light onto the side of the subject away from the window.*

A single main light—photoflood or flash— bounced into an umbrella reflector, with reflector on the other side, *is a simple lighting setup indoors. The position commonly used for a portrait main light is about 45° to one side and 45° above the subject.*

Multiple-Light Portrait Setups

Conventional portrait lighting is realistic but flattering. If you have ever gone to a commercial portrait studio to have your picture made, the photographer may have arranged the lights somewhat as in the diagrams shown here. These lighting setups model most faces in a pleasing manner and can be used to improve some features—for example, using broad lighting to widen a thin face.

A typical studio portrait setup uses a moderately long camera lens so that the subject can be placed at least 6 feet from the camera; this avoids the distortion that would be caused by having the camera too close to the subject. The subject's head is often positioned at a slight angle to the camera—turned just enough to hide one ear.

Your choice of main light affects the quality of the light. Direct light from photofloods is shown here, creating relatively hard-edged shadows. A diffused light (such as a soft box or umbrella reflector) used as the main light would create a more gradual transition between highlights and shadows.

Another common portrait lighting is virtually shadowless. A typical setup is a highly diffused main light placed close to the camera, plus a fill light. Such lighting is soft, attractive, and easy to use. However, when you don't want such even, shadowless lighting, you can use lights to create a more dramatic effect.

Flash units, direct or diffused, can be used, although when you are learning lighting, the effects of different light positions are easier to judge with a continuously burning source such as a photoflood.

Setting up the lights for short lighting

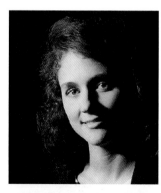

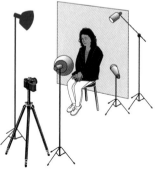

The main light in a short lighting setup is on the side of the face away from the camera. Here a 500-watt photoflood is placed at a 45° angle at a distance of about 4 feet. The main light is positioned high, with the catchlight, the reflection of the light source in the eyes, at 11 o'clock.

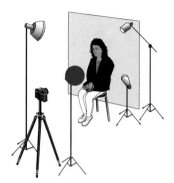

The fill light is close to the camera lens on the opposite side from the main light. Here it is a diffused 500-watt photoflood. Since it is farther away than the main light, it lightens but does not eliminate the shadows from the main light. Catchlights from the fill are usually spotted out in the final print.

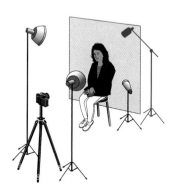

The accent or back light (usually a spotlight) is placed high behind the subject, shining toward the camera but not into the lens. It rakes across the hair to emphasize texture and bring out sheen. Sometimes a second accent light places an edge highlight on hair or clothing.

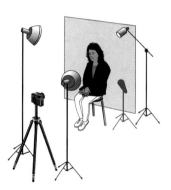

The background light helps separate the subject from the background. Here it is a small photoflood on a short stand placed behind the subject and to one side. It can be placed directly behind the subject if the fixture itself is not visible in the picture.

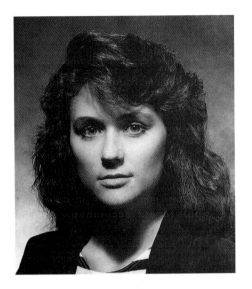

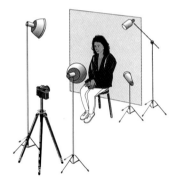

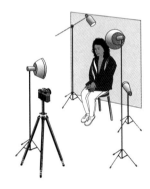

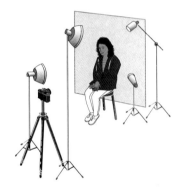

Short lighting places the main light on the side of the face away from the camera. *This is the most common lighting, used with average oval faces as well as with round faces to thin them down. The photographs opposite show the separate effect of each of the four lights in this setup.*

Broad lighting places the main light on the side of the face toward the camera. *This tends to widen the features, so it is used mainly with thin or narrow faces. The main light is high so that the catchlight reflected in the eye is at 1 o'clock. The main light in this position may make the side of the head, often the ear, too bright. A "barn door" on the light (see page 230) will shade the ear.*

Butterfly lighting places the main light directly in front of the face. *This type of lighting is conventionally used as a glamour lighting. The light is positioned high enough to create a symmetrical shadow under the nose but not so high that the upper lip or the eye sockets are excessively shadowed.*

Lighting Textured Objects

Lighting for a textured object depends on whether you want to emphasize texture. In the photograph at right top, the light is raking across the scene at a low angle to the surface, creating shadows that underline every bump and ripple. The same principle can be put to work with any textured object, such as rocks, textured fabrics, or facial wrinkles. Simply aim a source of direct light so it skims across the surface, choose a time of day when the sun is at a low angle in relation to the object, or arrange the object so light strikes it from the desired direction.

Shadows must be seen if the texture is to be prominent, which is why side or back lighting is used when a pronounced texture is desired—the shadows cast will be visible from camera position. Front lighting (also called axis lighting) minimizes textures. The light points at the subject from the same direction as the lens, so shadows are produced, but they won't be very visible from camera position (photograph, right bottom). If you want to minimize textures in a portrait because your subject is self-conscious about facial wrinkles, place the main light close to the lens so the subject is lit from the front.

Side lighting emphasizes texture. *The light skims across the subject's surface at a low angle, producing shadows on the subject's surface that are visible from camera position. Back lighting can have the same effect.*

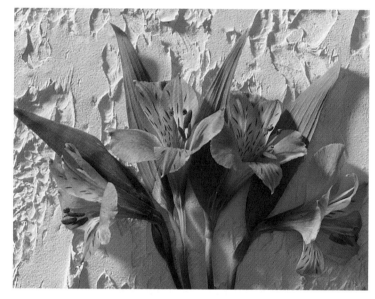

Front lighting minimizes texture. *The light comes from camera position, producing few of the visible shadows that delineate texture.*

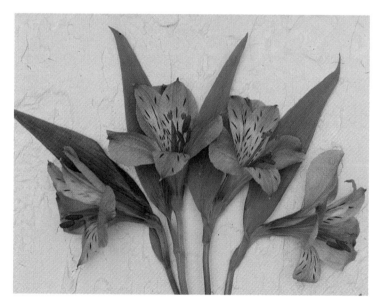

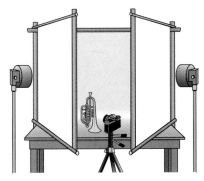

Tenting removes unwanted reflections from glossy surfaces *by replacing them with reflections of the tent itself. The cornet (left) was so shiny that it reflected images of the camera and lights that the photographer needed to shoot it. To solve the problem, Fil Hunter isolated the horn inside a light tent (see drawing above).*

The horn and its background are evenly and diffusely lit by two lights shining through the thin material of the tent, which itself makes a pleasing and simple pattern of reflections in the horn's shiny surfaces. The camera, looking in through the opening in the tent from the shadows outside, stays out of the picture, as do other potentially distracting reflections.

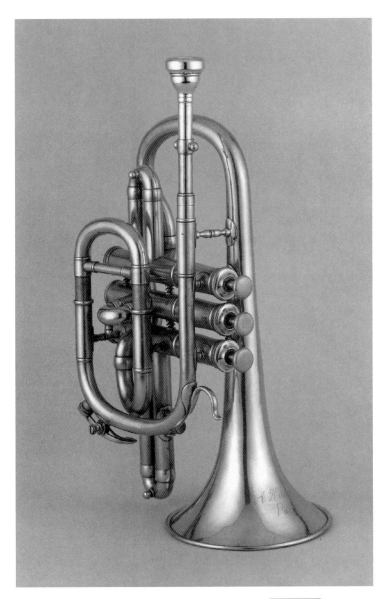

FIL HUNTER Cornet, 1982

Photographing objects with glossy surfaces can be like photographing a mirror. Highly polished materials such as metal, ceramic, or plastic can reflect every detail of their surroundings, a distracting trait when the surroundings include such irrelevant items as lights, photographer, and camera. Sometimes reflections work well in a photograph, making interesting patterns or giving information about the surface quality, but often it is necessary to eliminate at least some of them.

Reflections can be controlled in various ways. To some extent this can be done by moving your equipment or the object around until reflections are no longer distracting. You can also hang strips of paper just outside the picture area to place reflections where you want them. A special dulling spray available in art supply stores can reduce reflections, but use it sparingly to avoid giving the surface a flat, lifeless look.

A polarizing filter will help if the reflections are not from a metallic surface. Sometimes polarizing screens are used on the lights as well.

Tenting an object surrounds it partially or completely with plain surfaces like large sheets of translucent paper that are then lit to produce soft, diffused reflections (shown at left).

Using a camera with through-the-lens viewing is the best way to keep track of reflections. Even a slight change in the angle at which you view a shiny object can change the pattern of visible reflections.

More about . . .
- Polarizing filters, page 85

Lighting Translucent Objects

Try lighting translucent or partially transparent objects from behind—glassware, ice, thin fabrics, leaves and flowers, for example. The light can seem to shine from within, giving the object a depth and luminosity that could not be achieved with flat frontal lighting (see peppers, page 191). If you illuminate the background (as in the lighting setup below) instead of shining the light directly on the object, the lighting will be soft and diffused. Glassware is almost always lighted from behind since frontal illumination usually causes distracting reflections.

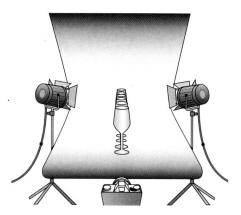

Lighting translucent objects from behind adds visual interest. *A row of crystal glasses (right) is softly lighted from the back by two large spotlights whose joined beams bounce off a sheet of seamless white paper, as shown above. The shadow that surrounds the bases of the glassware provides contrast with the brilliance of the reflected light and lends an air of cool elegance to the photograph.*

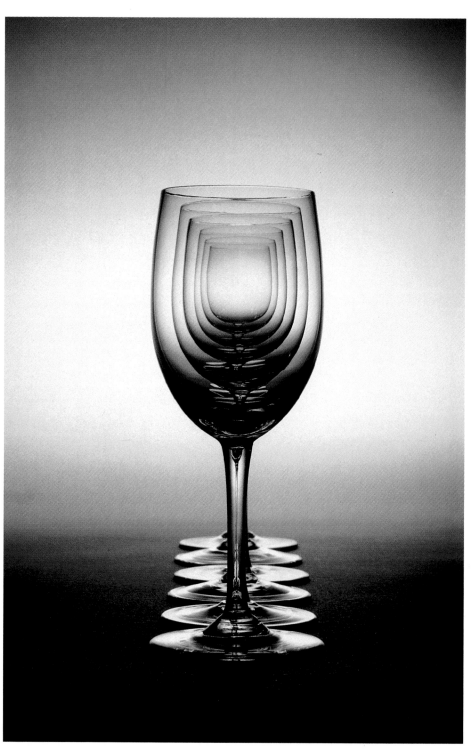

ERICH HARTMANN Crystal Glassware

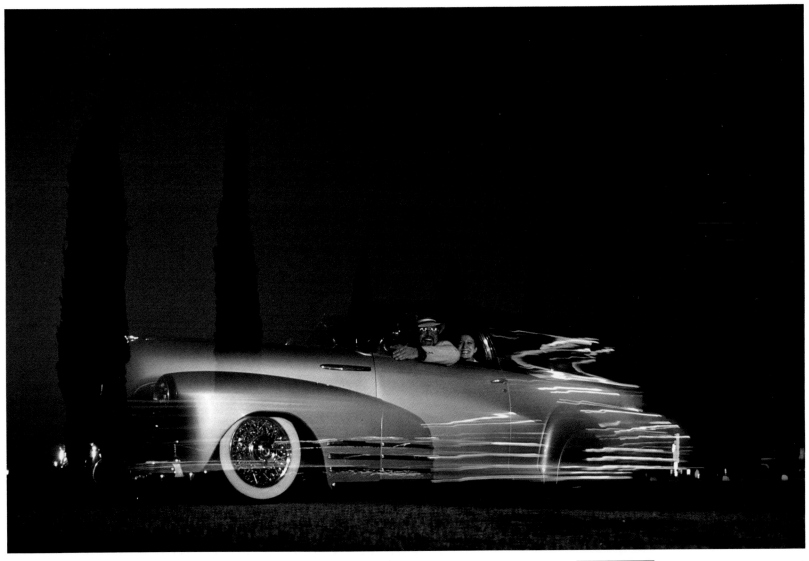

GREGORY HEISLER Low Riders, Santa Ana, California, 1979

Electronic flash and available light combined to make this glossy portrait of two people and their 1947 Fleetline Chevrolet. *Gregory Heisler made the picture in dim light at dusk. While the car slowly backed up, Heisler set off two battery-powered flash units, then left the shutter open for 2 sec more. The image is sharp where the car and riders were lit by the flash; the image is streaked and blurred where available light provided the illumination, as on the front fender and in the reflections in the chrome strips.*

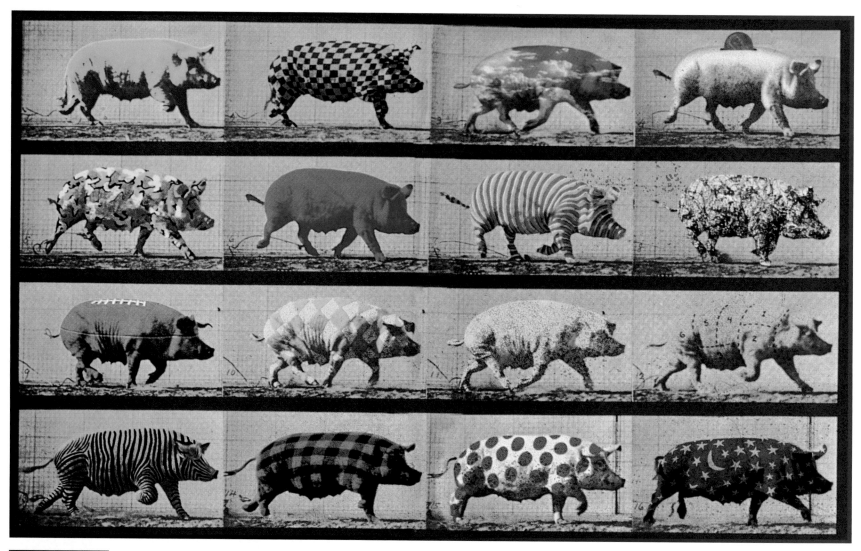

EADWEARD MUYBRIDGE Motion Study, c. 1885. Digital paint job by Michael Kerbow, 1990

High tech from the 19th century meets that of the 20th century. *Eadweard Muybridge pioneered the study of motion with his multiple photographs of horses running, humans walking, birds flying—and here, a pig trotting (another Muybridge photo appears on page 352).*

Michael Kerbow appropriated the photograph to demonstrate some of the variations possible with digital imaging. He scanned the Muybridge photograph to convert it to digital form, then sent that to his computer. He digitally added coloring and patterns, and to retain a realistic modeling, allowed the tones of the underlying black-and-white images to show through.

Digital Imaging 12

Digital imaging speeds up and simplifies many photographic processes. Newspapers are phasing out their chemical darkrooms and training their staff photographers to use electronic cameras, send pictures over phone lines directly to the home office, and use digital imaging to prepare pictures for publication. Advertisers use digital imaging to manipulate images for commercial purposes. Some artists see digital imaging as a useful tool, either to facilitate the production of the kinds of photographs they already make or to generate images that are completely different. Schools are increasingly teaching digital imaging. This chapter will give you an introduction to digital imaging and show you how photographers of every kind are using it.

Digital Imaging: An Overview

Capture. If you start with conventional negatives, slides, or prints, a scanner can convert the images into the digital form that a computer can use. Once digitized, images can be transmitted directly to the computer or stored for later use, for example on a Photo CD.

Capture. There are several types of filmless electronic cameras that can be used instead of a conventional camera and film. A digital camera records an image directly in digital form.

To understand digital imaging, compare it to conventional photography. Think of the steps you take in conventional photography: exposure, development, and printing. With digital imaging, instead of ordinary exposure and development, you capture an image by recording a scene with an electronic camera or, more often, by using a scanner to read the image from a conventional negative, slide, or print into the computer. In either case, the image is digitized, that is, recorded in a numerical form that is usable by the computer. You can then direct the computer to edit the image, using software commands to change the image either subtly or drastically. The computer can display the current version of the image on a monitor screen or print it onto paper or film. The computer can also electronically store the image or transmit it to another location.

There are many advantages to electronic imaging. Digitizing an image lets you use image-editing software to make changes that are often difficult and tedious to do by conventional means. Because images are stored electronically as digital data, a database can be created within which many images can be stored, indexed, searched for, and quickly retrieved. Unlike film and prints, electronic files can be copied without loss of quality, so a second- or third-generation file will be identical to the original. You can use ordinary telephone lines to send a digital image around the world, in some cases faster than you can carry a print to the office next door.

Some costs accompany all the advantages. There is a time investment in learning how to use equipment and software skillfully. There is also a financial investment: the better the quality you want, the more money you have to spend on your scanner, printer, and other equipment. However, as with most electronic technologies, prices tend to come down at the same time that performance improves.

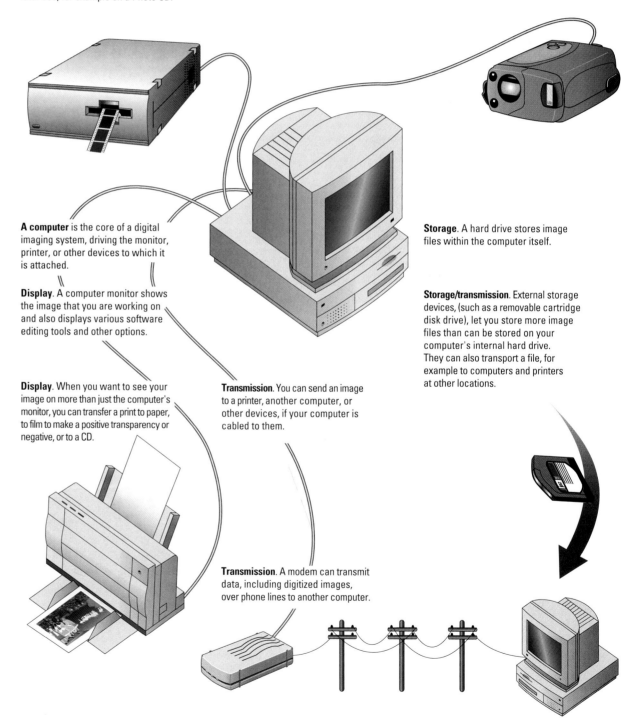

A computer is the core of a digital imaging system, driving the monitor, printer, or other devices to which it is attached.

Display. A computer monitor shows the image that you are working on and also displays various software editing tools and other options.

Display. When you want to see your image on more than just the computer's monitor, you can transfer a print to paper, to film to make a positive transparency or negative, or to a CD.

Storage. A hard drive stores image files within the computer itself.

Storage/transmission. External storage devices, (such as a removable cartridge disk drive), let you store more image files than can be stored on your computer's internal hard drive. They can also transport a file, for example to computers and printers at other locations.

Transmission. You can send an image to a printer, another computer, or other devices, if your computer is cabled to them.

Transmission. A modem can transmit data, including digitized images, over phone lines to another computer.

The pictures that you take with an ordinary camera and film are in analog form, that is, on a continuously variable scale, like the volume on a stereo, which changes in smooth gradations from soft to loud. Similarly, the image on a film negative has a continuous scale of tones, with unbroken gradations from light to dark.

For computer use, the picture is converted to digital form. The image is sampled at a series of positions, with each position recorded as a solid-toned pixel (short for picture element). The pixels that make up the image are arranged in a grid, like the squares on a sheet of graph paper. You can see the pixels if you enlarge an image enough on your computer (see illustration left, bottom). The original analog image is recorded in digital form by assigning each square in the grid a set of numbers to designate its position, brightness, and color. Once the image is digitized, you can use image-editing software to select and change any group of pixels in order to add or change color, to lighten or darken, and so on. The computer does this by changing the numbers for each pixel.

To put an image into digital form, the image area is divided into a grid containing many tiny segments called pixels. The location, brightness, and color of each pixel are recorded as a series of numbers that are then saved by the computer for later use.

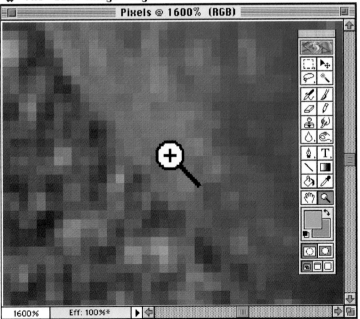

To see pixels on your computer's monitor, simply select a part of the image and enlarge it. If you are using Adobe Photoshop, for example:

- *Open a picture file.*

- *Select the Zoom tool (shown in the tool palette as a magnifying glass) by clicking on it.*

- *Place the magnifying glass on the image. Click on the image to see it at various enlargements.*

- *Double-click on the magnifying glass in the tool palette to return the image to the original size.*

Each square is a pixel. Notice that each contains a solid tone; the color or brightness may vary from pixel to pixel, but not within a pixel.

The greater the number of pixels per inch (dots per inch, or dpi), the more detail the image shows. This is something like the connection between ordinary film grain and image detail: the finer the film grain, the greater the detail that the film can record.

Bits and bytes

Computers record information in binary form. They use combinations of the digits one (1) and zero (0) to form all other numbers.

A bit is the smallest unit of information, consisting of either a one or a zero. A byte is a sequence of bits, usually eight.

$$\underbrace{\underset{\text{bit}}{0} \quad 0 \quad 1 \quad 0 \quad 1 \quad 0 \quad 0 \quad 0}_{\text{byte}}$$

The size of an image file is usually described by the number of bytes that it contains.

bit	The smallest unit of digital information
byte	8 bits
kilobyte	1,000 bytes
megabyte	1,000,000 bytes
gigabyte	1,000,000,000 bytes

(The numbers are rounded off. A binary kilobyte, for example, actually contains 1,024 bytes.)

Equipment Needed for Digital Imaging

There are two major systems or platforms for working with digital imaging on a personal computer. One is based on Apple Macintosh computers, the other on IBM computers—or their clones. You won't need to purchase every part of the system yourself. If you are taking a class, equipment may be made available to you. Computer service bureaus in many towns (often in stores that used to do only photocopying or small printing jobs) give you access to computers, scanners, printers, and other devices. Computer technology changes fast, so it is useful to have someone to help you who is already familiar with computers.

Input. You'll need some means of entering the image into the computer in digital form. You can work from conventional negatives, slides, or prints by using a scanner. Kodak's Photo CD puts your pictures onto a compact disc that can be read into the computer by using a CD drive compatible with Photo CD.

Computer manipulates an image, once the image is in digital form. The more powerful the computer, the faster it operates. Popular choices are either a Macintosh-compatible Power PC, or an IBM-type computer capable of running Windows-based software.

24-bit video display card installed in the computer will give you the 16 million colors required for exacting color control.

RAM (random-access memory) holds files temporarily while you are actually working on them. A rule of thumb for RAM size is that image-editing software like Photoshop needs about three times the size of an individual file or the computer will work slowly. If your files are about 8 megabytes each, then 24 megabytes of RAM will be useful with Photoshop. Live Picture software requires much less RAM.

Storage can be on a hard drive built into the computer. Or it can be on removable external storage, for example, an optical disk drive or SyQuest, Jaz, or Zip cartridge disk drive. Removable storage not only stores files outside your computer, it also lets you transport them, such as to a printer at another location.

Monitor displays the image while you are working on it. A 17-inch or larger high-resolution color monitor lets you see the image well.

Keyboard and mouse enter your commands into the computer.

Image-editing software like Adobe Photoshop or Live Picture contains the editing commands that change the image.

Output. To get your results into hardcopy, a printer transfers the image to paper. A film recorder produces a positive transparency or negative. A CD writer puts the image on a computer-readable compact disc.

Bit depth

The technical quality of a digital image is determined by the number of pixels and the amount of information each pixel holds. The greater the number of pixels (the dots per inch, or dpi) at the time an image of a given size is digitized, the greater the amount of detail that is recorded. Also, the more information (the bit depth or number of bits) per pixel, the smoother the gradation from one pixel to another, because each pixel will be able to render a greater selection of possible colors and tones. Other factors also affect quality, such as how much the image is enlarged, but in general, the more data in the computer's file for that image, the better the final image.

Unfortunately, you can get too much of a good thing. As the total number of pixels and the amount of information stored in each of them increases, the computer has to process and store more data about the picture. If the file for the image is extremely large, this can cause problems by greatly increasing the time the computer takes to execute each command or by increasing to an unwieldy size the amount of computer storage space needed. Tradeoffs may have to be made between the quality desired and the file size that can be conveniently handled by your computer.

Bits per pixel	Number of colors		
1	2	The image can have only two tones, black or white.	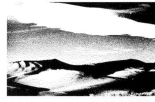
8	256	The image has available 256 black, white, and gray tones (enough for excellent black-and-white rendition) or 256 colors (enough for a limited color representation).	
24	16,777,216	The image can display more than 16 million colors and produce a digital image that has smooth gradations and full tonality, and is comparable to a conventional color film photograph.	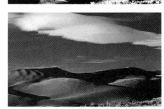

To capture an image, you have to get it into a digital form that a computer can utilize. To do this you can either use an electronic camera or you can make a conventional film negative, transparency, or print and then scan it into digital format.

The advantage of filmless electronic cameras is that you don't need to develop film before you can see a picture. Images are usable as soon as you shoot them, something that news photographers value when they are working on a fast-breaking story at a distant location. You can view and edit images immediately, then electronically transmit them to your editor as soon as you can get to a telephone. Some commercial photographers make use of this instant feedback to show an image to the client and get approval on the spot.

However, unless speed of communication is essential, film is still the most common starting point for digital imaging. Film is capable of recording much more information than all but the most expensive electronic cameras. A single 35mm film negative can record the equivalent of about 15 million pixels of information, many times more than the typical electronic camera. That makes sharpness, color quality, and tonal range much better when you start with film.

Scanners convert a conventional film image into electronic form. Small desktop scanners for 35mm film are relatively inexpensive. Flatbed scanners accept prints up to 8 1/2 x 14 inches. Drum scanners are expensive, but produce the highest quality image.

Kodak's Photo CD is an inexpensive way to scan slides and negatives. As many as 100 35mm images can be placed on a compact disc. Images are stored in five different file sizes, from about .1 megabyte for quick viewing to about 18 megabytes for the most detailed and highest quality reproduction. Computer service bureaus are the most likely places to find this service.

Electronic cameras do not use film. Instead they use electronic circuitry to capture an image. Point-and-shoot digital cameras are the least expensive. Their biggest attraction is speed. Image quality is mediocre, and important features such as exposure control or interchangeable lenses are often lacking.

Single-lens reflex digital cameras are expensive, but their quality and flexibility approaches that of conventional 35mm cameras. A computer or accessory viewer lets you see what you have just shot.

Studio digital cameras can surpass the quality of film. Most are actually attachments that replace the ordinary film holders on large-format cameras. One drawback is that most models operate relatively slowly by moving an array of sensors across the image. Flash can't be used and pictures of moving subjects will be distorted.

Still video cameras record an analog (continuous-tone) image. The image is converted to digital form by a computer accessory called a frame grabber. Ordinary video cameras can be used in the same way. They have poor image quality, but can capture action and can store a much larger number of images than other types of electronic cameras.

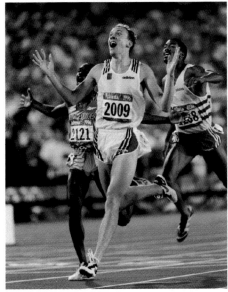

Photojournalists make good use of digital imaging's rapid capture and transmission. At the 1996 Olympics, digital cameras were used routinely by many news organizations. Reuters' electronic picture desk system (far right) enabled it to send pictures world wide within minutes of being taken at any Olympics location.

WOLFGANG RATTAY Men's 800, 1996 Olympics

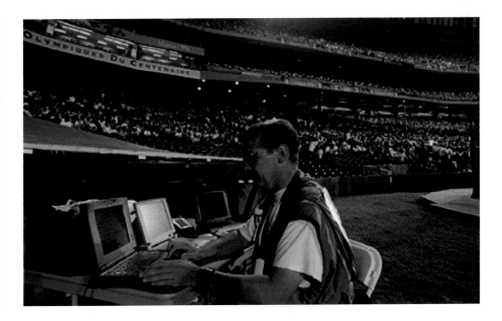

Storing a digital image keeps it available for later use. A hard disk in the computer is useful for storing pictures when you are not working on them—that is, if you have enough storage space on the disk.

Floppy disks, commonly used to store electronic data like word processing files, are useful for relatively small image files, such as for black-and-white images or low-resolution color images. High-resolution image files, however, occupy so much space that attempting to save one on even high-capacity 1.4 megabyte floppies requires too many disks for practical storage. Compression software helps.

A removable cartridge disk drive, such as a SyQuest, Zip, or Jaz drive, lets you expand your storage, plus take data to another location, for example, to a computer service bureau for printing. With a capacity of 100 to 1000 megabytes or more, you can store much more on this type of disk than you can on a floppy.

Optical disks are economical for the amount of data they hold. A CD-ROM (Compact Disc Read-Only Memory) is like an audio CD: data is written onto a disk once; the disk can be read any number of times, but not rewritten. A CD writer is an optical device that lets you write files and make your own CD-ROMs. Stock photographers and agencies are increasingly using CD-ROMs to publish catalogs of their stock work, and in some cases to supply the work itself to users.

Compression software makes the size of image files more manageable. The software squeezes the files into more compact form, which reduces the amount of space needed for storage and the time needed for transmission. The image is decompressed to its original size for editing or printing. A file can be compressed to 1/50 of its original size or even less, although the more you compress an image, the more likely that irregularities, called artifacts, will appear when the image is decompressed.

There are several ways to transfer an image from one device to another, such as from a computer to a printer. You can cable one machine to the other. If you can't connect by cable, you can use what is humorously called SneakerNet: save the file in some portable way, for example, on a cartridge disk drive, then walk it to the service bureau or wherever the printer is.

Modems, transmission devices connected by phone lines or a communications satellite, are now regularly used to transmit news photographs and other photographs that have to get someplace in a hurry. They are also used to get photographs to and from the Internet. Some computers, especially at large organizations, are connected to networks, groups of computers that can share information, including image files.

Digital imaging has literally added a new dimension to Barbara Kasten's work. For Over the Guadalupe *four photographs were montaged on the computer, then painted by computerized jet spray on 25 x 7.5 ft seamless canvas.*

Kasten's photographs have often played with space, shape, and light. She has created large constructions in her studio that she photographed, and she has worked at architectural and natural sites. She freely changes the visual space of these settings by tilting the camera, using intensely colored lights, and sometimes positioning mirrors that reflect other parts of the scene. "I want to change a viewer's perception of the space, and these things do that by disorienting you, especially with an architectural subject, which you expect to be upright and realistic. They reorganize your preconceived idea of what the space should look like."

BARBARA KASTEN Over the Guadalupe, San Jose, California, 1992

Computer printers let you print directly from the computer to paper, plastic, or other surfaces. These printers use colored pigments (usually cyan, magenta, yellow, plus sometimes black) to create the image.

Color laser printers operate somewhat like ordinary copy machines. They use electrostatic charges to position colored powders (toners) onto the surface of the paper, then fuse them in place with heat.

Dye sublimation printers pass the print medium beneath a multi-colored ribbon. Tiny heating elements vaporize dyes in the ribbon and the resulting colored gas condenses on the surface of the print.

Inkjet printers squirt very small dots of colored ink onto the print.

Print quality vs. cost. Dye sublimation prints cost the most, but match the color and tonal depth of photographs almost perfectly. Inkjet prints can appear inferior because each of the inks represents only a few colors and a narrow range of brightnesses. Inkjets are closing the gap, however, and some are nearly as good as dye sublimation prints. Laser prints are the least expensive. Their colors are less vivid than those of dyes or inks, with some graininess in areas of uniform tone.

Printing speed. Laser printers print very quickly. Dye sublimation printers take 5 to 20 minutes to print an 8 1/2 x 11-inch page. Inkjet printers take over 12 minutes. Printers can be even slower when attached to slow computers.

Digital technology also lets you print your image onto film, which you can display directly or use to make a print. Film recorders turn digital files into transparencies and negatives up to 8 x 10 inches. Image setters are ordinarily used by printers to create large half-tone negatives (negatives with the dot pattern in them that is needed for press work). However, you can also use them to make the large-size negatives used in non-silver printing processes (see illustration, left).

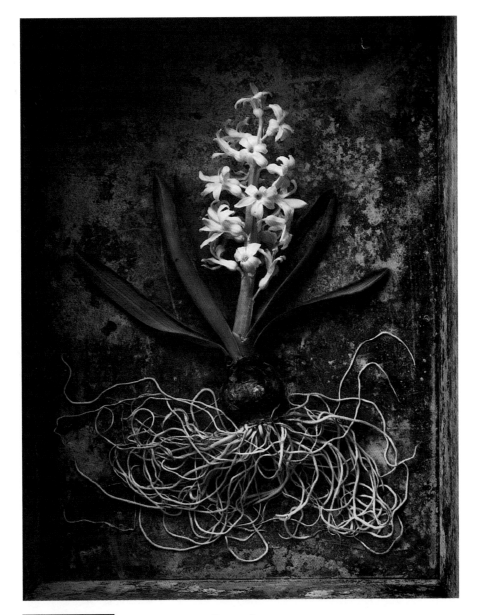

ROBERT J. STEINBERG **Hybrid Narcissus, 1991. Albumen print**

Digital imaging is being combined with older photographic processes.

Alternative printing processes like cyanotype, gum bichromate, Van Dyke, platinum, palladium, or albumen printing are contact printing processes and require a negative the size of the print you want to make. Digital film recorders can output a suitable negative much faster than making an enlarged negative by conventional means, although at somewhat greater cost. The color balance, density, and contrast of the negative can also be adjusted precisely and previewed on screen before making the negative.

More about . . .

- Alternative printing processes, pages 182–183

Editing a Digital Image

Almost any results that you can get in a conventional darkroom—and some that you can't—can now be achieved with the help of a personal computer. Software editing programs display a variety of tools (some are described below) that let you select an area and change its characteristics, such as its size, position, density, contrast, color, or sharpness. Using these editing tools has several advantages over creating the same effect in a conventional darkroom.

You do not lose image quality from one generation to the next with digital imaging, because each reproduction of an image is merely a set of numbers in the computer's memory. In effect, you start fresh at any stage, and a second-, third-, or fourth-generation image is just as good as a first-generation one. Using conventional darkroom techniques to execute major changes can require making a copy negative or other intermediate stage, which often results in a loss of image quality from one generation to the next.

Once the digital description of the final version is saved, every copy you make thereafter will be the same. When you complete a complex set of manipulations—even dodging and burning in a conventional print can involve several exposures of different times—you don't have to repeat the procedure every time you make a print. The computer saves your instructions and makes an identical print any time you tell it to do so.

Digital imaging can simply enhance an image or radically change it. You can use it to perform typical darkroom procedures, like changing contrast or lightening and darkening an image. Or you can use it to combine photographs, add color, posterize, draw, and so on. In effect, you can create a new image with qualities that are never permanently fixed, because you can always change them. Either route has its uses; the following pages show more about them.

The commands used to manipulate an image are part of image-editing software like Adobe Photoshop. They appear on screen as small symbols called icons, displayed in the toolbox (the series of small boxes seen here at the right of the screen). They also appear as word commands, such as Blur, Sharpen, and Stylize, that can be reached from the pull-down menus across the top of the screen.

You use the computer's mouse to move the screen pointer to an icon within the tool palette, then click the mouse to activate the tool. You can adjust the effect of many of the tools. For example, the Brushes Palette (seen here at the bottom of the screen) lets you adjust tool characteristics such as size or paint opacity.

One of the most important commands is called Undo (not shown here). Undo cancels your last command, returning the image to its previous state. This lets you try an effect, then undo it to see how it looked before. You can choose Undo again to reinstate the command.

With the Layers feature you can create and combine the equivalent of transparent overlays that you can modify at will. Without affecting the original image, you can draw, edit, and paste on separate layers, alter the color balance, and so on until you get the effect you want.

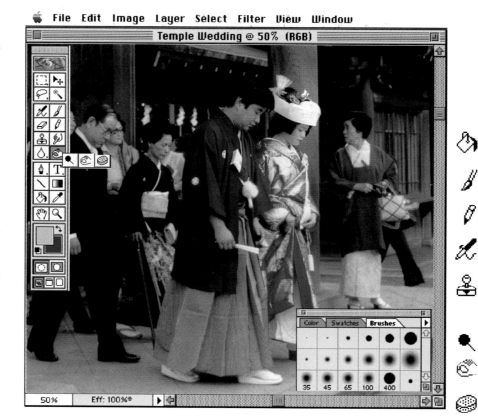

Various editing tools reside on-screen in the toolbox. They allow you to use the mouse to paint, draw, color, lighten, or darken parts of the image. After selecting a tool, click (or click and drag) the mouse to use the tool at the part of the image that you want to change.

Paint Bucket *fills a selected area with a color.*

Paintbrush *applies a color to any area it is dragged over.*

Pencil *also colors any area it touches, but with a harder edge.*

Airbrush *lays down a diffused spray of color.*

Rubber Stamp *paints with a copy of some other part of the picture, in effect cloning a part of the image.*

Dodge/Burn tools, *like dodging and burning tools in a conventional darkroom, lighten or darken part of an image.*

Sponge *saturates or desaturates colors, making them more intense or less so.*

File Edit **Image** Layer Select Filter View Window

Mode	▶

Adjust	▶
Duplicate...	
Apply Image...	
Calculations...	
Image Size...	
Canvas Size...	
Crop	
Rotate Canvas	▶
Histogram...	
Trap...	

Levels...	⌘L
Auto Levels	⇧⌘L
Curves...	⌘M
Color Balance...	⌘B
Brightness/Contrast...	
Hue/Saturation...	⌘U
Desaturate	⇧⌘U
Replace Color...	
Selective Color...	
Invert	⌘I
Equalize	
Threshold...	
Posterize...	
Variations...	

Changes that you might make in a wet darkroom, such as lightening or darkening parts of a print or changing contrast, can be done with digital imaging. *The pull-down menus across the top of the screen offer access to many of these commands. For example, the Image menu (shown at left) contains the item Adjust, which offers a set of submenus. Here, Color Balance is being selected.*

Brightness/Contrast

Brightness:	0	OK
Contrast:	20	Cancel
		☒ Preview

Changing the brightness or contrast. *Selecting Adjust from the Image menu and then choosing Brightness/Contrast from the submenu brings up a dialog box (above) that lets you lighten or darken the image or change the contrast.*

Use the mouse to click on and slide the triangle along the horizontal Brightness line; the results will be somewhat like changing the exposure time during printing. Sliding the Contrast triangle increases or decreases the contrast, somewhat like changing the contrast grade of paper during ordinary printing.

The Preview button lets you see the results on screen as you make changes. You can alter selected parts of the image as well as make changes overall (see page 262).

Levels

Channel: RGB ▼	OK
Input Levels: 0 1.00 255	Cancel
	Load...
	Save...
	Auto
Output Levels: 0 255	☒ Preview

Changing brightness and contrast more exactly.
There are other, more precise, controls of brightness and contrast in the Image/Adjust menu. The Levels dialog box (above) displays the brightness values of the pixels in the image in a graph called a histogram. The slider bars let you adjust the brightness or contrast separately for dark, middle-gray, or light pixels (shadows, midtones, or highlights). For example, you can lighten just the midtones without making the highlights overly light and losing detail in them. The Curves dialog box also lets you adjust brightness and contrast, but even more precisely, at any point along the image's gray scale.

Changing the color balance. *One way to adjust the color balance is to select Adjust from the Image menu and Variations from the submenu. The Variations dialog box (shown above) displays the current image, plus a ringaround of possible color balance changes.*

The Variations dialog box also lets you view and make changes in contrast or saturation. (Saturation refers to the purity of a color. Saturated red is an intense, brilliant red. A less saturated red is mixed with other colors and is duller and grayer.) You can make changes overall, in selected areas, or separately in dark areas, midtones, or highlights.

More exact changes can be made with the Color Balance and Hue/Saturation commands, also in the Image/Adjust menu.

Changing a Selected Area

Suppose that instead of wanting to change an image overall, you want to change only part of it. Perhaps you want to darken an overly bright sky or lighten someone's shadowed face. You can do this in a conventional darkroom by ordinary burning in or dodging. Digital imaging lets you extend those techniques so that you can, for example, lighten just the eye sockets or darken a meandering, irregular shape. You can go even further and, for example, completely change the color of an area, sharpen it, blur it, duplicate it, relocate it, or take it out altogether.

The first step is to learn how to use one or more of the editing tools that select an area. You use the tools to select an area of any size, as small as one pixel, then direct the software to change it.

Selection tools, such as these in Photoshop, let you select portions of the picture for editing. Click on a tool to activate it, then drag the mouse to outline a part of the image. The selected area will be surrounded by a line of moving dashes.

 Rectangular Marquee tool captures rectangular areas.

 Elliptical Marquee tool captures rounded areas.

 Lasso lets you draw shapes freehand.

 Magic Wand doesn't select by dragging over areas. Click it at any part of the picture, and it selects all connected areas that have a similar color and brightness.

 Pen tool (in the pull-down menu Window/Show Paths) clicks or drags to select irregular shapes precisely.

The Magic Wand selects connected areas that are similar in color and brightness to the area that the wand touches. Here, clicking the tool on the body of an apple caused it to select all similar connected tones in the image. The Magic Wand can be customized to select a wider or narrower range of values.

The Lasso tool lets you draw the area to be selected. It operates by clicking down and dragging the mouse. The tip of the Lasso onscreen will draw a line following the motion of the mouse. Various methods let you refine any selected area by adding to or subtracting from it.

Once you have selected an area, you can make a mask that lets you alter the selected area or its surroundings. Quick Mask (part of the toolbox) lets you view both the mask and the rest of the image. Here, the selected area consists of the two apples (but not the label on one of the apples). The rest of the image, including the label, is protected from change and displayed on screen with a color overlay.

Retouching. You can use the Rubber Stamp tool (the rubber stamp icon in the tool box) to retouch defects or areas you want to change by painting over them with another part of the image. The Brushes dialog box lets you choose options such as the size of the area to be changed with each stroke.

Here a damaged historical photograph is being restored by painting over the scratch showing on the man's coat with a duplicate of the image from another part of his coat. Once you have retouched an image to your satisfaction, you can save it and use it for all future printing. In conventional photography, you would ordinarily have to spot such an area with dyes on each print you made.

Cloning part of an image. You can make a duplicate of a shape or object and paste it back into the image. Often you'll need to soften the edges of the duplicate object slightly, or it will look too obviously pasted in. Feathering blurs the edges of a selection to make a gradual transition to the new surrounding area. The same technique is useful if you composite a part of one photograph into another one.

Here a red-hot bolt was selected, feathered, copied, and pasted behind its original. Other changes were made, such as darkening the cloned bolt slightly and changing some of its markings.

STEPHEN JOHNSON Wind Generators, Altamont Pass, California, 1985

REMY POINOT Running Shoe Advertisement, Paris, 1992

Digital imaging can add realistic effects to a photograph in ways that may not even be evident. Digital imaging can be used to combine objects in a realistic manner, to remove glare, to add a highlight to a model's eyes, and for other enhancements. The image still looks realistic, and in this sense, "reality" is anything that looks like an unaltered photograph made with conventional camera and film.

We are used to the notion that a blurred imaged shows that the subject moved during the exposure, so digital imaging was used (opposite page) to add blur to an otherwise sharp photograph to give the illusion of motion. We are used to size differences between near and far objects, so (above, right) two photographs were combined to create a scene that utilized those differences. Photographs are commonly spotted to remove small defects; digital imaging can be used for that purpose instead of a brush and spotting dyes (above, left).

◀ *During prepress work, photographs are prepared for printing. Stephen Johnson was the designer and editor of the book* The Great Central Valley: California's Heartland, *as well as one of the photographers. He used image-editing software for color correction, to remove dust specks, to correct cropping and alignment, and for other work that is often done by the printer. One advantage of digital imaging in book production is the control it gives photographers over how their work looks. "After a while," Johnson says, "you get tired of what other people do to your photographs."*

▲ *For an ad for a running shoe, Remy Poinot created a "foot like a mouse can see it, from underneath, very big." For the background, he used a photograph of a group of runners at the Place de la Concorde in Paris. Instead of digging up the street to get a shot of the shoe from mouse level, he made a studio shot of the shoe, with his model standing on a chair. The images were then combined digitally. "It's a picture totally impossible to take in a normal camera," he says, "but it doesn't appear composited."*

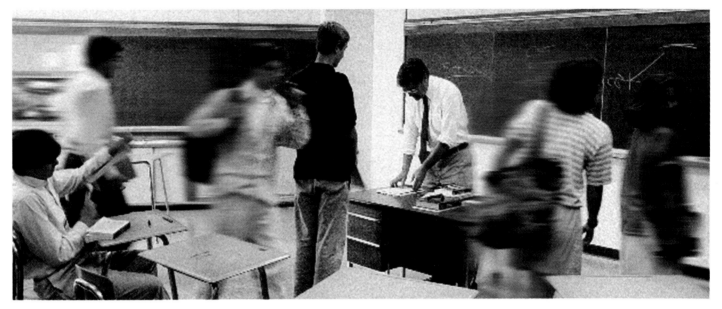

To create a feeling of activity in a photograph for a school brochure, graphic artist Paul Kazmercyk added blur to some of the figures.

GABRIEL AMADEUS COONEY Schoolroom. Digital manipulation by Paul Kazmercyk, 1992

Kazmercyk began by using the Lasso tool (in Adobe Photoshop software) to select the area he wanted to blur.

To avoid a hard edge between the area he was going to modify and its surrounding, he feathered the edges. Choosing Feather from the Select menu brought up a dialog box that let him limit the extent of the feathering to 36 pixels.

He then selected Blur from the Filter menu and Motion Blur from the submenu. He specified a blur that would look realistic based on the student's position by designating a blurring angle of 4° and a distance of 30 pixels.

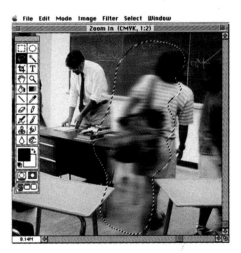

The result is a blur that could have occurred if the student had moved during the actual exposure and blurred the original film. Kazmercyk then repeated the procedure on several other figures.

Digital imaging can also step beyond reality, creating an image that obviously didn't come that way straight out of the camera. Many software programs are available that let you add (or remove) colors, textures, and shapes to make an image that merges photography with drawing, painting, or collage.

Keith Hampton, a computer graphic artist, often uses digital imaging to manipulate photographs. "In the beginning," Hampton says, "computer art was exactly that—art that looked like it was created on a computer." But, he says, "Today's computer art doesn't necessarily look like it's been generated on a computer." You can create a work that looks realistically photographic or one that looks manipulated.

For this sample of an Elvis album cover, he says, "I wanted to show how a simple photo could be manipulated to get a completely new and interesting look." Starting from a straight photo, he used a scanner to get the image in digital form. He used editing software to filter the image in different ways, then layered the resulting textures to give the look of an aged and tattered poster.

PHOTOGRAPHER UNKNOWN Elvis. Illustration by Keith Hampton, 1990

In the years before digital imaging, photographer Douglas Kirkland often felt that the camera was an incomplete tool, delivering only part of what he saw and imagined. "How frequently I have wanted to make the sky bluer, the grass greener." He feels that computers are the next step for him, making it possible to realize anything he can imagine.

Even though computers give you the ability to do anything at all to a photograph, Kirkland prefers to use that ability carefully. He believes that an overly manipulated image can become weak if it completely loses its connection to straight photography. He added posterized color to his portrait of physicist Stephen Hawking, but otherwise retained the elements in the original photograph.

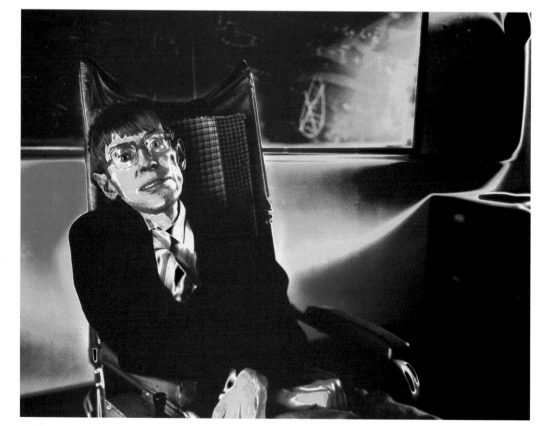

DOUGLAS KIRKLAND Stephen Hawking, 1983. Digital enhancement, 1993

Bonny Lhotka uses her 35mm camera as a sketchbook, carrying it with her to record textures such as rusted metal or worn painted surfaces. She then uses digital imaging to scan and combine the items, often layering one image over another. "It's almost as if you had loose materials on a desktop," she says, "and can grab pieces to put together."

BONNY LHOTKA Moon Beam, 1996

Photographer at Work: Merging Photography and Illustration

John Lund started working with digital imaging as a way to add interest to his advertising work. He had already been experimenting with manipulations, such as sandwiching transparencies, but when he saw Adobe Photoshop in operation in 1990, he realized that image-editing software would be much more flexible to use in order to get the results he wanted. Two years later he had become one of the first commercial photographers to fully integrate digital imaging into their work. He went from doing just photography to being an imaging service bureau—a combination photographer, illustrator, and retoucher. He can't remember the last time he made a "straight photograph."

Lund added the creation of stock images to his work. This has grown to be a large part of his annual revenue and has resulted in a changed relationship with his stock agency. "Traditionally," he says, "stock images were leftovers from another shoot. Then photographers began to shoot specifically for stock use. Now with digital imaging, you can create stock images of any kind." Often his agency's senior art director, Chris Chapin, will call him to discuss trends in the kinds of images clients are buying. The result is a creative collaboration, with ideas, images, and suggestions for their improvement going back and forth until Lund has a final image that he knows will appeal to buyers. To create his pictures, Lund now uses both Photoshop, an extremely flexible software package, and Live Picture, which has fewer options but is faster than Photoshop, "as fast as finger painting," according to Lund.

"The computer," says Lund, "provides an almost incomprehensible creative potential by removing the barrier between imagination and execution. But it has some pitfalls; with every image, there are so many possibilities that you can spend a lot of time sitting at the computer just trying things out. There comes a point when you have to have the discipline to say, 'Enough.'"

JOHN LUND Money Flying Out the Window

John Lund works with his stock agency's art director to create images for sale to advertisers, publishers, and others in need of ready-made imagery. Their collaboration has been fruitful because the art director has day-to-day contact with the changing needs of photo buyers. This picture of money flying out the window, is an update of a popular Lund image of flying $100 bills.

John Lund and Staff

Lund uses three computers and a staff of three for image editing, plus regular studio assistants. That's not a digitized clone sitting with Lund. It's his twin brother Bill.

More about . . .

• John Lund's work can be seen at his Web site http://www.teamdigital.com

1. To work on the head of the dragon, Lund began with one of the studio shots he had made of the iguana.

2. He intensified the colors and created a white mask around the iguana's head in Photoshop, then imported the file into Live Picture.

3. He temporarily erased the lower jaw and used Live Picture's Distort Brush to push the nose into a longer snout. The cross hairs and circle show the position and size of the brush as it is being used.

4. He cloned the tip of the snout to make it longer and give the dragon two horns, then used the Distort Brush to create a lower jaw.

5. He made a temporary layer of another picture of the iguana's body, pasted it over the jaw, and used the Distort Brush to push the spines into position as teeth.

6. He erased the rest of the body, revealing the jaw underneath. He repeated the process to make teeth on the top jaw.

JOHN LUND Dragon 1996

As a child, John Lund spent many hours drawing dragons and other fanciful creatures, so when his brother Bill challenged him to turn Bill's pet iguana into a digital dragon, John liked the idea. They made over a dozen studio shots of the iguana, then John used Live Picture and Photoshop image-editing software to merge the pictures into a dragon. Lund is now considering creating a book of digital mythological creatures.

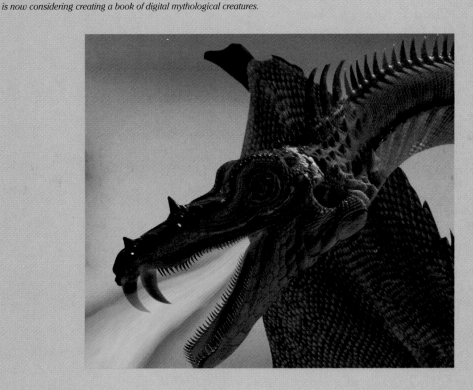

Photographer at Work: A Photojournalist Uses Digital Imaging

Stephan Savoia didn't start out to be a photographer. He studied sociology, but when he took a photography class, "I saw photography could allow you to look at the same issues and topics that sociologists do, but be able to communicate them in a way that more people could understand. I was still interested in sociology, but let's say I found a delivery system—photography."

Savoia works for the Associated Press, covering everything from natural disasters to the Olympics, plus stories of his own devising. The AP provides stories and pictures to newspapers, magazines, and television stations all over the world.

Digital imaging gives Savoia more control over his pictures than he would have if he simply delivered unedited rolls of film. When he uses a digital camera, he can view the pictures immediately, instead of waiting to develop the film. He can load the pictures into a laptop computer on the spot, adjust the contrast, dodge and burn, crop, and even create captions. The completed work is sent by modem to the nearest AP hub, then sent by satellite to the AP's more than 7000 subscribers. Savoia can't control how subscribers will use his pictures, but digital imaging lets him select what the subscribers get. "I'm not handing this off to other people to edit. I'm deciding what pictures I want to put out, and then I'm cropping them the way I think they should be. If a newspaper uses one of my images, they will have to use the picture that I select as representative of what was happening."

Sometimes Savoia uses conventional cameras. He chooses his equipment to maximize his ability to cover a story. If speed is most important, digital has the edge, even though the cameras are larger and technically more demanding than conventional cameras. But if he wants to be inconspicuous or shoot in low light, "I pull my Leicas out. If I'm at a strategy meeting with a Presidential candidate I want to fade into the background."

Whatever equipment he uses, for Savoia the goal is being able to have something to say and being able to put it into a visually stimulating form. "Making good visual images is important because that is what motivates the viewer to try to understand the content. I consider myself to be first a journalist and second a photographer. You are practicing journalism with a photographic medium as opposed to practicing journalism with words. The work is the same whether it's visual or written—it's journalism."

What Savoia doesn't do is manipulate his pictures digitally beyond the cropping or other controls that take place during conventional printing. "Basically the one thing that journalists have to rely on is their credibility. Anything that damages your credibility will damage your ability to be an effective journalist. Don't do it."

His advice for someone who might want to be a photojournalist is first to learn about the world. "Take classes in philosophy, sociology, physics, math, home economics, music, anthropology—in as many different areas as possible. Have a little bit of information on a lot of things so that you can put the world in some kind of perspective. If you don't understand the subject matter you are photographing, what you communicate on that issue is going to be of very little importance."

Then learn about photography, and learn it well. Technique has to be second nature so you don't have to stop and think about it. If you are covering an earthquake, for instance, "you've got other things to think about besides f-stops and shutter speeds. That has to be something you can do in your sleep."

Savoia's work was part of an AP portfolio that won the Pulitzer Prize in 1993. "Contests motivate me to sit down and review everything I've done that year." It's a useful task for any photographer. "Putting together a year-end portfolio forces you to evaluate what you did right, what you did wrong, what you could have done that would have been better. That is the best learning experience I have every year. We don't have time to stop when we're out there working. This forces me to sit down and do that."

STEPHAN SAVOIA A Long, Strange Trip

On assignment to make a portrait of a doctor who specializes in LSD flashbacks, Stephan Savoia found that the doctor's office had four white walls, a lamp, and a chair, not a very expressive background for the subject matter. He noticed the shadow of blinds on the wall and positioned the doctor so the diagonal, imprisoning bars fell across one side of his face while the other side of his face was in shadow—Savoia's way of representing the psychological nature of the story.

Photojournalists, says Savoia, "Don't have the luxury of being able to control environments in studios. Often we have to bring some kind of order out of chaos and do it quickly, thinking on your feet. That's actually one of the things I find exciting about photojournalism. The challenges and problems you overcome are always different."

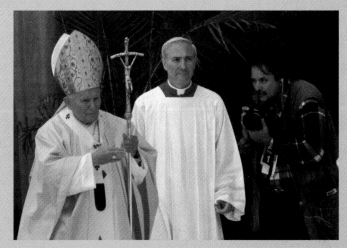

MARK LENNIHAN Stephan Savoia at Work, 1995

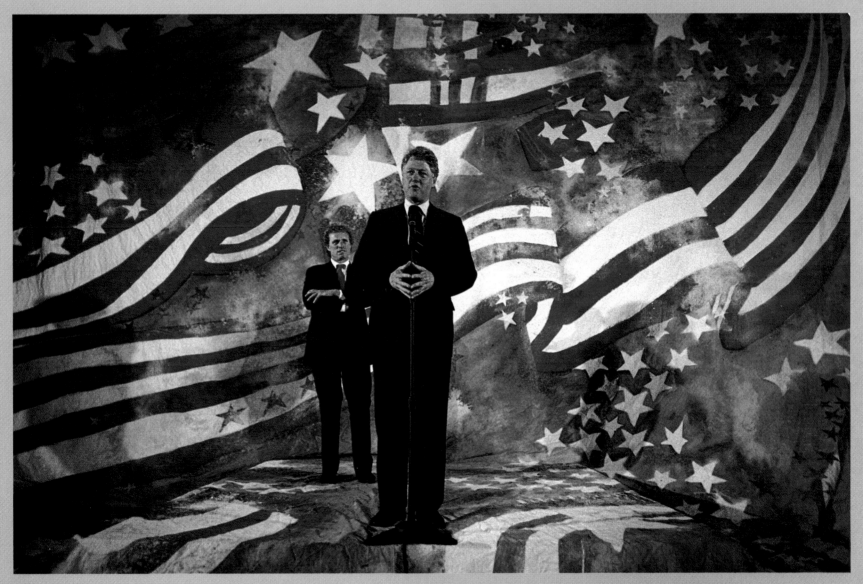

STEPHEN SAVOIA Creating a Candidate, 1992

Savoia's experience with political campaigns is that they spare no expense to get you to perceive something the way they want you to perceive it, in this case Bill Clinton campaigning for the presidency surrounded by star-spangled colors with a Kennedy in the background. "What I saw was the lengths that campaigns will go to try and create an image." The picture became the signature photograph for an AP portfolio that won the Pulitzer prize.

Digital Imaging Used for Personal Expression

Women, 1996

Digital imaging was a natural medium for Sharon Franz. "I've always loved mixing media and doing multilayered photography," she says. "Digital imaging gives you unlimited possibilities." Franz looks for interesting textures to photograph and objects she can scan into her computer. "I've scanned leaves, bolts, nuts, screws, matches, rocks, roots, wood—organic materials interest me most." Many of her images imply a kind of story. "I like storytelling, and many stories I hear inspire me."

Earliest Memory

Melanie Walker's earliest memory is of being strapped in a hospital bed, alone with a patch over one eye. "I was three, and I was terrified. I looked out into the hall to see a monkey riding on a tricycle in a band leader's uniform." In her work, the monkey emerges from the background, like the memory dimly seen. Many years later, the memory was confirmed by someone whose daughter had been in the same hospital, had the same operation, and had seen the same monkey.

Victor Masayesva, Jr. was raised in the Hopi village of Hotevilla on Third Mesa and finds his subject matter within the Hopi world. His photographs are complex and layered with references to other Native American cultures and to mainstream America. "My images question whether or not ancient wisdom and knowledge can continue to shape and direct contemporary life in a mechanized world." In Touma (Singing) drought ends as a Long Hair kachina (a spirit of the invisible forces of life) drifts over the parched landscape singing up green plants by bringing the blue-black rainstorms that make the corn grow. Each image begins as a patch of grainy earth, not unlike the process of making a sandpainting, upon which Masayesva assembles multiple images using digital imaging.

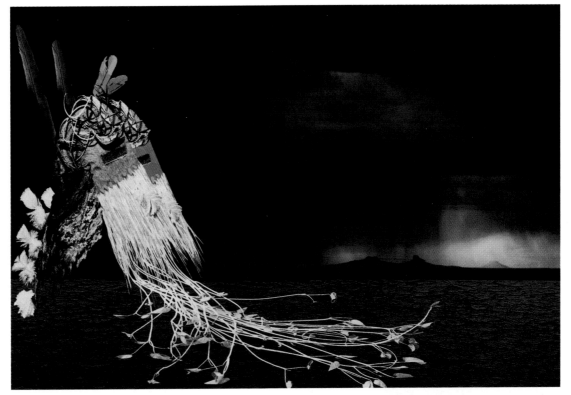

VICTOR MASAYESVA, JR. Touma (Singing), 1996

Using video and computer graphics, Michael Brodsky's Dark Passages explores the darker side of technology and personal relationships. "Television images seem to move, but seldom move us," Brodsky wrote. "Mostly we sit passively and watch for something to happen." Brodsky finds low-resolution digital imagery well suited to his exploration of the media. "Portions of these images are taken from broadcast airwaves and reconfigured, much in the way that our minds capture, process, and reconstruct our own perceptions of reality."

MICHAEL BRODSKY Sweet Dreams: Core Memory from *Dark Passages*, 1991

Digital Imaging Used for Advertising

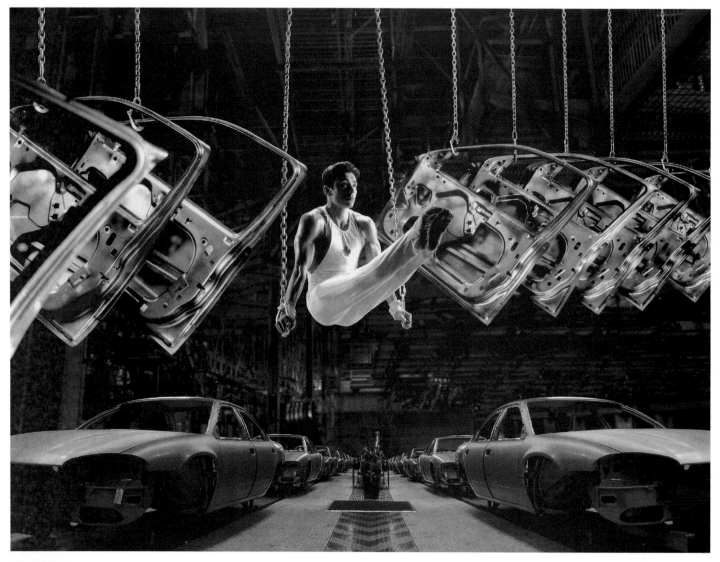

SHIN SUGINO **Chrysler Advertisement for the Olympics, 1996**

As one of the sponsors of the Olympics, Chrysler wanted Shin Sugino to create an ad that would relate to the games. Sugino toured a Chrysler plant where he saw door panels dangling from chains. He immediately imagined a gymnast performing among them. To create the image, he began by shooting interior photographs at the plant. He matched the lighting at the plant when he photographed the door panels and the gymnast in his studio. He combined all the images using digital imaging.

MICHAEL KIENITZ Nicaragua, 1982

How much change is acceptable? During a survey of 1,600 magazine and newspaper editors, communications professor Shiela Reaves presented the two photographs above. She asked: "This photo was edited to eliminate the person in the background so that he wouldn't be distracting. Do you agree with the computer-editing change?" About half of the magazine editors found the change acceptable, compared to only 10% of the newspaper editors who did.

As it becomes easier and easier to seamlessly alter photographs, will more and more of them be changed, incorporating everything from a little enhancement to all-out fabrication? Will anyone still believe that the camera does not lie? Should anyone ever have believed that?

Are there times when an image should not be changed, even though it is possible to do so? Now that it is much easier to make extensive changes in a photograph, and much harder—sometimes impossible—to detect them, a host of questions have arisen. Some of them are discussed below; the answers are still being hotly debated.

Advertisers often take considerable leeway with their illustrations. We even expect some exaggeration from them, as long as they don't outright misrepresent their products. Few people would object to the advertising photograph opposite, even if the advertiser didn't explain how the image was made. But would the photograph have been acceptable without explanation accompanying a news story about the corporations that sponsor the Olympics?

Photojournalists usually follow fairly strict rules concerning photographic alterations. Generally, they agree that it's acceptable to make changes such as dodging or burning in to lighten or darken parts of an image. However, it's not considered proper at many newspapers to use digital imaging to, say, remove a telephone pole that detracts from an otherwise good shot or, even worse, to insert something that wasn't originally there.

According to John Long, past president of the National Press Photographers Association, "There is a tacit agreement between us and the reader that says this set of conventions within a picture represents reality, and this set doesn't. Using a fill flash or a strobe in a picture has become accepted by society as a valid way of conveying a real picture. But going in with a brush and taking something out, has not."

As the use of digital imaging increases, will photography lose its reputation for accurate representation of reality? For a *National Geographic* cover, digital imaging was used to move a pyramid a little for the cover photograph so it would fit the magazine's vertical format better. When some readers objected to this, the change was defended as being merely "retroactive repositioning," no different than if the photographer had simply changed position before taking the shot. Or was it different?

What should we call the image of the gymnast opposite? Can you refer to it as a photograph, or do you need to add on some qualifiers, like "photo composite" or "computer-generated image"? Certainly the picture didn't come that way straight out of the camera, although as one photographer pointed out, "The notion of what constitutes a camera is broadening."

Working photographers are also concerned about financial matters. How can they protect their rights when images are easily accessible electronically? How can they collect reprint fees for use of their work when images can easily be electronically scanned, altered so as not to be identifiable, and then incorporated in a publication? Is it ever acceptable to appropriate someone else's image and use it without paying for it?

There are more questions than answers on these issues. The discussions will be going on for a long time.

Pictures on the Internet

Photographers are increasingly using the Internet. There are two good reasons why: there are interesting places to visit on the Net, and you can show your own work there. Many groups, companies and individuals have created sites that provide material such as on-line magazines, product advertising, educational information, and more. News groups let you post and receive material about photography. Some groups let you participate in an on-line discussions with people interested in topics like the history of photography and photographic techniques and equipment.

The World Wide Web is the part of the Internet that shows pictures. The Web, for short, or WWW can display text, graphics, photographs, sound, and video. You can view photographs from individuals, stock agencies, and museums. You can put your own work up for display. If you have a site on the Web, you don't need to convince a curator or gallery owner that your work should be shown. At a very low cost, you can create your own electronic gallery that people around the world can visit.

How do you get on the Internet? If you are a student, there are probably computers that you can use at your school that are connected to the Internet. If you want to access the Internet from your home, you need a computer, a modem, and an account with an Internet service provider such as America Online who will link your phone line to the Internet. Finally, in order to get to different sites and view text and graphics, you need browser software such as Netscape Navigator or Microsoft Internet Explorer.

Browser software, like Netscape, illustrated here, helps you get from one site to another on the Internet. It displays on your computer monitor the site you are currently visiting, plus the navigation tools and controls that let you get from one place to another.

Menus and toolbar buttons let you go forward or back, search for words in the text, save and print what you have seen, and perform other actions.

Location indicator gives the page where you currently are. Each Web site has its own address or location. For example, http://exo.com/~yoko/ connects you to this site about pinhole photography. The official name of these addresses is Uniform Resource Locators or URLs. When you type one, type it exactly, paying attention to upper-case and lower-case letters, spaces, and symbols.

Directory buttons give information on new sites, how to search, and other topics.

Links take you directly to another place— another page, even another Web site. Links can be icons (pictures or other graphic elements) or underlined words. For example, Netscape's own Welcome page describes what you can find at their site, including "The latest information on Netscape Navigator..." Click on the underlined words to jump to that information.

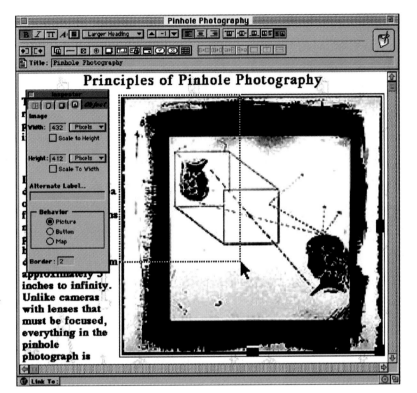

Web authoring software, like Adobe PageMill, helps you design your own Web page. With PageMill you can lay out a page, add text and illustrations, and create backgrounds. The software's drag-and-drop capability makes it easy to move elements from one part of the page to the another. Shown at the left of the screen is the Inspector palette, which is used to modify the appearance and actions of text and graphics.

You can create your own Web page. Do you have photographs you'd like to show to a wider audience? A personal Web page is one way to do so. Most Internet service providers let their subscribers have their own Web page; that part is easy. Now all you have to do is create your own page or pay someone else to do so. The simplest pages contain text, plus photographs and graphics. More advanced designs can include music, video, and animation. To design your page you can use software such as Adobe PageMill (illustrated at left) or Microsoft Front Page.

You must change your photo files into a form usable on the Internet. Software such as PageMill automatically converts a photograph that is already in digital form, for example in a Photoshop file, into a Web-compatible format. JPEG (Joint Photographic Experts Group) compresses your image file for the Web in low, medium, or high quality. The higher the quality, the bigger the file size. Try saving in all three and see which versions are acceptable. The goal is to use the smallest file size acceptable for viewing. GIF (Graphic Interchange Format) was developed for graphics, but works for Web photos also.

Keep your file size small. You need to keep file sizes small (no more than 30 kilobytes per picture) because a large file size increases the time it takes viewers to receive your Web page. Viewers can be impatient and may not be willing to wait several minutes for a page to download.

Photography on the Web

How do you find the photo sites on the Web?
You'll find some addresses listed in books and magazines, and you can link to many sites from other Web pages. Suppose you know a topic you are interested in but don't know the address. Try searching virtual libraries like Yahoo (http://www.yahoo.com/) or Lycos (http://www.lycos.com/). Visiting these sites is like doing a subject search in a library catalog. Type in a subject or key words, and a list of sites related to that topic will be displayed.

Photography sources
• The site for *Photography*, 6th edition, features a gallery of student photographs, a database of information on photographic techniques and processes, plus interactive activities such as a camera simulator and darkroom printing simulator (http://longman. awl.com/photosource).
• The on-line site for a popular photojournalism textbook, *Photojournalism: The Professionals' Approach* by Ken Kobre (http://www.gigaplex.com/photo/kobre/index.htm).

• The Web site for the magazine *Photo District News* features commercial photography and digital imaging (http://www.pdn-pix.com/).
• The National Press Photographers Association has issues of interest to news photographers, including information about NPPA workshops (http://sunsite. unc.edu/nppa).

Museums
• California Museum of Photography, Riverside (http://www.cmp.ucr.edu).
• George Eastman House, Rochester, New York (http://www.it.rit.edu:80/~gehouse/index.html).
• International Center for Photography, New York, New York (http://www.icp.org)
• Library of Congress Prints and Photographs Reading Room (http://lcweb.loc.gov/rr/print/).

Commercial
• The Photoflex company sells lighting equipment. Their Web site has on-line workshops about using commercial lighting (http://www.photoflex.com/).

Pictures on a CD-ROM

What is a CD-ROM? If you buy music CDs, you are already familiar with one kind of CD technology. A CD-ROM (compact disc read-only memory) stores information for computer use. CD-ROMs display information (the read-only part), but new data can't be written onto them.

In addition to music, CDs can hold information such as photographs, graphics, text, audio, and video. CD-ROMs are used for encyclopedias, language programs, software, training tutorials, books, games, and in many other ways.

Advantages of a CD-ROM. One advantage is the large amount of information the disc can hold. One CD-ROM can hold over 650 megabytes, enough for 12,000 images. By comparison, only 25 such pictures could fit on a floppy disk.

Other advantages are the low cost of reproducing CD-ROMs, compared to printing on paper, and the ease and minimal cost of shipping a small, light-weight product. The disk is read by a laser beam, so unlike a floppy it won't wear out. Since the disk can only be read, not written on, data can't be altered accidentally or infected by a virus.

CD-ROMs are popular because they can be multimedia and interactive. A basic definition of multimedia is a combination of two or more media such as text, illustrations, photographs, sounds, narration, animation, and video. Computers blend media with a new ingredient—interactivity.

Interactivity can range from simple to complex. A simple multimedia CD could include on-screen buttons that the viewer uses to move forward or back through a series of pictures, or to activate events such as audio narration or video. With more complex programming, a CD can seem personalized, with the content organized in different ways, depending on the viewer's choices.

Kodak's Photo CD puts your photographs on a CD. *The disk holds up to 100 photographs scanned at 5 different resolutions for use in various digital applications. Many photo finishers offer Photo CDs made at the time film is processed. You can also select individual negatives or transparencies (from 35mm to 4 x 5-inch film) to be scanned onto a Photo CD at a digital service bureau.*

You can create your own CD-ROM title. All you need are a moderate amount of computer skills and the time to learn the techniques. How you want people to view your disk will determine how many software programs you must learn.

If this is your first project, start simple. Suppose you have 30 photographs that you would like in CD-ROM form so you can send the disk to an editor or gallery. A relatively simple project could also include text (your resumé) and audio (background music and narration about your work).

Chocolate Camera Obscura is a multimedia CD-ROM created by Peggy Jones, whose pinhole photographs appear on pages 176–177. She used Macromedia Director, an authoring software, to combine photographs, graphics, text, video, and audio.

Director uses movie terminology to help you remember what its tools do. At the right of this screen are shown Score and Cast tools that let you organize all the parts of the presentation.

Making a multimedia CD-ROM

Begin with a storyboard. First decide what you want people to see, hear, and be able to do. List or sketch each component of the CD, and how you plan to present them. If you want the user to be able to skip around the material, you need to map out the different routes the user will be able to take.

Decide if you want your CD to play on either Macintosh or IBM (Windows) computers, or both. This affects your choice of authoring software and the way the material is assembled by the software.

Preparing photographs. You will need an image-editing program such as Adobe Photoshop to crop and resize your photographs, and to adjust the contrast, color balance, or other characteristics to look good on screen. You can also use Photoshop or any art software to create backgrounds or navigation buttons that take the viewer from one place to another on the CD.

Preparing text. Text such as titles and captions can be created either in Photoshop or Macromedia Director or imported from a word-processing program like Microsoft Word. Text can be imbedded in pictures by Photoshop.

Preparing audio. Macromedia Sound Edit is a fairly simple program that lets you produce sound narration on your computer. You need a good microphone and a computer capable of digitizing sound. Record in an area free from interference like echoes from walls or ceilings, the noise of computer fans, or the buzz from fluorescent lights.

Preparing video clips. Videos can be converted to digital QuickTime movies using an editing program like Adobe Premiere.

Use clip media. You can save time by purchasing source material for multimedia development, such as ready-made backgrounds and buttons, plus royalty-free music and sounds.

Putting it all together. Authoring software like Macromedia Director (shown here) lets you combine your media into a working CD-ROM title. For the CD to play by itself, you need to make a "projector," a stand-alone version of Director that you create with that software.

Getting it on the disc. For making test disks or small editions, a CD-R (CD-recordable) drive will record the material onto a CD blank. For larger editions, a master disk must be made professionally. After that, any number of disks can be produced at a very low cost per copy.

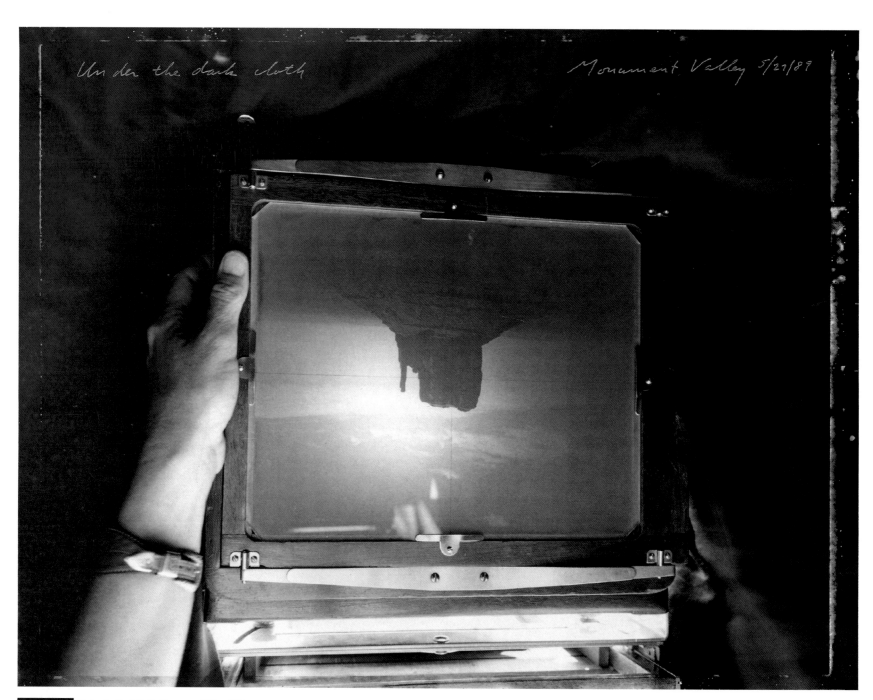

MARK KLETT Under the Dark Cloth, Monument Valley, 1989

View Camera 13

Why would a photographer use a bulky, heavy, slow-working view camera— a camera that has few or no automatic features, that has to be used with a tripod, that shows you an image upside down and backward and so dim that you need to put a dark cloth over the camera and your head to see it? The answer is that the view camera does some jobs so well that it is worth the trouble of using it.

A view camera's movements give you an extraordinary amount of control over the image. The camera's back (film plane) and front (lens plane) can be independently moved in a number of directions: up, down, or sideways, tilted forward or back, swiveled to either side. These movements can change the area of a scene recorded on film, the most sharply focused plane, the depth of field, and the shape of the subject itself.

The view camera's large film format is also an advantage. The most common size is 4 x 5 inches; 5 x 7, 8 x 10, and sometimes larger sizes are also used. While modern small-camera films (1 x 1 1/2 inches is the size of 35mm film) can make excellent enlargements, the greatest image clarity and detail and the least grain are produced from a large-size negative.

Inside a View Camera

A view camera's movements give it the ability to change and control an image. Unlike most cameras, which are permanently aligned so that lens and film are exactly parallel, a view camera can be deliberately unaligned. The movements and their effects, explained on the following pages, are easier to understand if you have a view camera at hand so you can demonstrate the effects for yourself.

To make full use of a view camera's movements, you must use it with a lens of adequate covering power, that is, a lens that produces a large image circle. As shown below, a lens projects a circular image that decreases in sharpness and brightness at the edges. If a camera has a rigid body, the image circle needs to be just large enough to cover the size of the film being used. But a view camera lens must produce an image circle larger than the film size so that there is plenty of room within the image circle for various camera movements. If the movements are so great that the film intersects the edge of the image circle, the photograph will be vignetted—out of focus and dark at the edges. Covering power increases—the usable image circle gets larger—as the lens is stopped down.

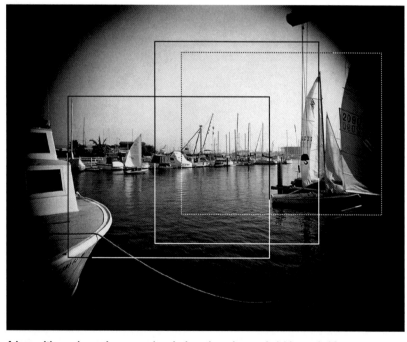

A lens with good covering power (producing a large image circle) is needed for view camera use. Camera movements such as rise, fall, or shift move the position of the film within the image circle (as shown above), so the lens should produce an image that is larger than the actual size of the film. The corners of the viewing screen should be checked before exposure to make sure the camera movements have not placed the film outside the image circle, vignetting the picture (dotted lines).

View camera movements

Rise and fall move the front or back of the camera in a flat plane, like opening or closing an ordinary window. Rise moves the front or back up; fall moves the front or back down.

Top view

Shift (like rise and fall) also moves the front or back of the camera in a flat plane, but from side to side in a motion like moving a sliding door.

Tilt tips the front or back of the camera forward or backward around a horizontal axis. Shaking your head yes is a tilt of your face.

Top view

Swing twists the front or back of the camera around a vertical axis to the left or right. Shaking your head no is a swing of your face.

Lens board, which holds the lens, can be moved independently up or down, forward or back, from side to side, or at an angle by loosening control knobs.

Bellows expand or contract so that the lens board and camera back can be moved closer together or farther apart.

Ground-glass viewing screen shows the image.

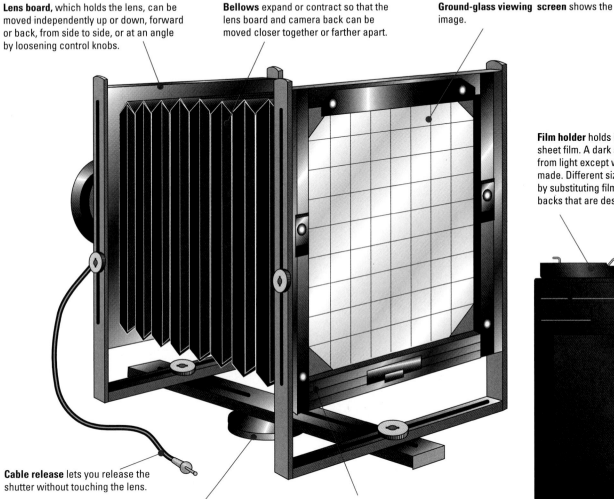

Film holder holds individual pieces of sheet film. A dark slide protects the film from light except when an exposure is made. Different sizes of film can be used by substituting film holders and camera backs that are designed for those sizes.

Cable release lets you release the shutter without touching the lens.

Tripod mount attaches the camera to a tripod.

Camera back, where the film holder is inserted, can (like the lens board) be moved independently up or down, forward or back, from side to side, or at an angle. It can be rotated to take a picture in either a horizontal or vertical format.

This simplified view camera shows its basic relationship to all cameras: it is a box with a lens at one end and a sheet of film at the other. Unlike other cameras, however, the shape of the box can be changed.

Rise, an upward movement, and fall, a downward movement, change the placement of the image on the film by changing the position of film and lens relative to each other. Moving the back moves the film to include various parts of the image circle. Moving the front moves the image circle so that a different part of it falls on the film.

Rise or fall of the back does not affect the shape of the subject. The effect is not unlike cropping a photograph during printing—the amount of the object shown or its position within the frame may change but not the shape of the object itself.

Rise or fall of the front changes the point of view and to some extent the shape. In the pictures at right, the change in shape is too slight to be seen in the cube, but the difference in point of view is visible in the change of relationship between the cube and the small post.

Why not just raise or lower the camera? That is a good solution, when you can do so, but rise and fall give you an extra edge of control when your tripod can't raise or lower any more. In addition, moving the camera, like front rise and fall, change the visual relation of objects (see last two illustrations, opposite). Back rise and fall give you the option of moving the image within the frame without changing the position of objects relative to each other.

Rise or fall of the camera's front or back changes the position of the image on the negative.

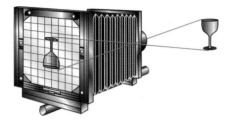

Controls zeroed. *The object being photographed appears in the center of the ground-glass viewing screen. It is inverted (upside down and reversed left to right). The camera back and front are centered.*

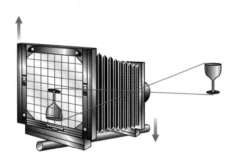

Back rise or front fall. *The object has been moved to the bottom of the viewing screen (the top of the picture when viewed right side up). This is done by either raising the back or lowering the front (lens board).*

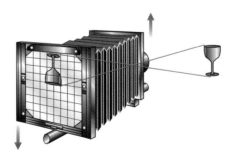

Back fall or front rise. *To move the object to the top of the viewing screen (the bottom of the actual picture), lower the back or raise the front.*

Rise and fall are up or down movements. *Rise or fall of the front or back changes only the position of the image in the frame. Rise or fall of the front also affects the position of foreground and background objects relative to each other.*

To see the effect of view camera movements on a photograph, look first at a picture where no movement is set into any part of the camera. If you compare the photograph of the reference cube this page, right, to the photographs of it that follow, you can see the changes in its shape, sharpness, and position that take place as a result of camera movements.

For the sake of clarity, the pictures and text here do not show the inverted (upside down and backward) image seen on the ground-glass viewing screen, but show the photograph as you would see it after it was printed. The diagrams at left show the image as you would see it while you were focusing and adjusting the camera.

The reference cube was shot with all camera adjustments at zero, *looking down from an angle of 45°. The cube was centered, with focus on the top front edge of the cube.*

The image falls in the center of the picture frame. The cube's top front edge, being closest to the camera, is the largest. It is also the sharpest. The cube is symmetrical, with the two visible surfaces of the cube falling away in size and sharpness at an equal rate.

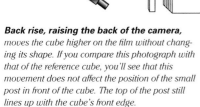

Back rise, raising the back of the camera, *moves the cube higher on the film without changing its shape. If you compare this photograph with that of the reference cube, you'll see that this movement does not affect the position of the small post in front of the cube. The top of the post still lines up with the cube's front edge.*

Back fall, lowering the back of the camera, *lowers the position of the cube on the film. Like back rise, there is no change in the shape of the cube or its relation to the post. This is because the film, though raised or lowered, still gets the same image from the lens, which has not moved relative to the original alignment of cube and post.*

Front rise, raising the lens, *lowers the image of the cube on the film, just as back fall does. However, moving the lens causes a change that does not occur with back movement: it changes the relation between cube and post because the lens is now looking at them from a slightly different position. The farther apart that near and far objects are, the more this will be evident. Compare the apparent height of the post here with its height in the pictures at left; the post has dropped below the edge of the cube.*

Front fall, lowering the lens, *raises the image on the film. Because the lens has moved, it also affects the relation of cube and post. Now the post appears to have moved above the front edge of the cube.*

Shift

Shift, a sideways movement, is the same as rise and fall except the movement takes place from side to side. If you were to lay the camera on its side and raise or drop the back, you would produce the same effect as back shift. The reason that rise and fall are the same as shift is that neither changes the angle between the planes of film, lens, and subject. Raise, lower, or shift the back of the camera, and the film is still squarely facing the lens; the only difference is that a different part of the film is now directly behind the lens.

Since shift is simply a sideways version of rise and fall, the results are similar. Back movement to the left moves the subject to the left; back movement to the right moves it to the right. Left or right lens movements have just the opposite results.

Spatial relationships change with front shift but not with back shift, because the lens now views objects from a different point. Lens shift has the same effect as moving the entire camera to the left or right. Back shift simply moves the entire image within the frame. The examples at right illustrate these movements, with the reference cube included for comparison.

Shift of the camera's front or back changes the position of the image on the negative.

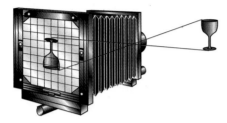

Controls zeroed. *The image is in the center of the viewing screen.*

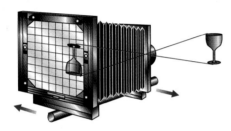

Back shift left or front shift right. *The object has been moved to the right side of the viewing screen (left side of the actual photograph) by moving the camera back to the left or the front to the right.*

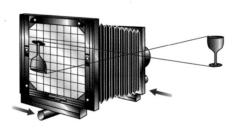

Back shift right or front shift left. *To move the object to the other side of the picture, move the back to the right or the front to the left.*

Shift is a sideways movement. *Shift of the front or back changes the position of the image in the frame. Shift of the front also affects the position of foreground and background objects relative to each other.*

Remember that the cubes are shown here right side up as they would appear in the final prints. On the ground glass the image is inverted as shown in the diagrams at left.

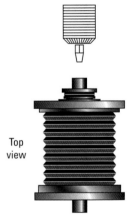

Top
view

Reference cube—all controls zeroed. *Shift, like rise and fall, has little perceptible effect on the shape of an object. Compare the reference cube with the four cubes to the right of it. While the cubes move back and forth on the film, they continue to look very much the same.*

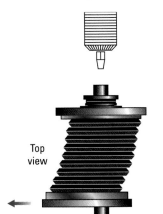
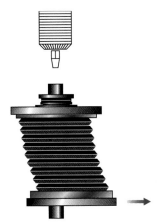

Top view

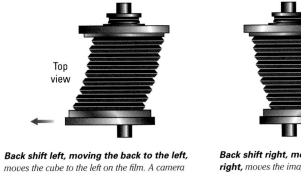
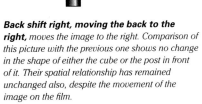

Back shift left, moving the back to the left, *moves the cube to the left on the film. A camera equipped with a back that can move the film from side to side, as well as up and down, can place an object wherever desired on a sheet of film.*

Back shift right, moving the back to the right, *moves the image to the right. Comparison of this picture with the previous one shows no change in the shape of either the cube or the post in front of it. Their spatial relationship has remained unchanged also, despite the movement of the image on the film.*

Front shift left, moving the lens to the left, *moves the image on the film to the right. It also changes the relationship of post to cube. Since the lens actually moves to the left, it views the two objects from a slightly different position, and so one object appears to have moved slightly with respect to the other. The farther apart that near and far objects are, the more that a change will be seen. Check the position of the post against the vertical lines on the cube in this picture and the next to confirm this change.*

Front shift right, moving the lens to the right, *moves the image to the left and changes the relationships in space between objects. To summarize: If you want to move the image on the film but otherwise change nothing, raise, lower, or shift the back. If you want to move the image and also change the spatial relationship of objects, raise, lower, or shift the lens.*

Tilt, a forward or backward movement, can change both the shape and the focus of the image on the film. The preceding pages show that rise, fall, and shift have little or no effect on the shape of an object being photographed because they do not change the angular relationship of the planes of film, lens, and object. But what happens with tilt, an angling of either the camera front or camera back? That depends on whether you tilt the front or back of the camera. Tilting the back of the camera changes the shape of the object considerably and changes the focus somewhat. Tilting the front of the camera changes the focus significantly without changing the shape of the object.

Tilting the back changes the shape. To understand why this happens, look again at the reference cube. The bottom of the film sheet is the same distance from the lens as the top of the film sheet. As a result, light rays coming from the lens to the top and the bottom of the film traveled the same distance, and the top back edge and the bottom front edge of the cube are the same size in the photograph. But change those distances by tilting the camera back, and the sizes change.

The rule is: The farther the image travels inside the camera, the larger it gets. Since images appear upside down on film, tilting the top of the camera back to the rear will make the bottom of an object bigger in the photograph; tilting the top of the camera back to the front will make the top of an object bigger.

Tilting the front changes the focus. A tilt of the camera front does not change distances inside the camera and thus does not affect image size or shape, but it does affect focus by altering the lens's focal plane. Tilting the lens will bring the focal plane more nearly into parallel with one cube face or the other, improving the focus on that face and worsening it on the other.

Tilt of the camera's back changes the shape of objects.

Controls zeroed. *The two objects being photographed appear the same size on the viewing screen.*

Back tilt toward the back. *With the camera back tilted to the back, the image has to travel farther from the lens to reach the top of the viewing screen than it does to reach the bottom of the screen. As the light rays travel, they spread apart, increasing the size of the object on the top of the viewing screen (the bottom of the actual photograph) compared to the size of the object on the bottom of the screen.*

Back tilt toward the front. *With the camera back tilted to the front, the size of the object on the bottom of the viewing screen increases compared to the size of the object on the top of the screen.*

Tilt is an angled forward or backward movement. *Tilt of the back mostly affects the shape of an object, and so helps to control convergence (the apparent angling of parallel lines toward each other in a photograph). Tilt of the front mostly affects the plane of focus, and so helps to control depth of field.*

Reference cube—all controls zeroed. *The 45° angle of view has produced an image that falls off in both size and sharpness at an equal rate on both the top and the front faces. As a result the two faces are exactly the same size and shape. Note also that the vertical lines on the front face, which are actually parallel on the cube, do not appear parallel in the photograph, but converge (come closer together) toward the bottom.*

Back tilt, moving the camera back toward the back. *The back of the camera is tilted so that the top of the film is farther away from the lens than in the reference shot. This movement enlarges the bottom of the cube and tends to square up its front face, bringing its lines more nearly parallel. At the same time, this tilt has moved the bottom of the film closer to the lens than it was in the reference shot, shrinking the top back edge of the cube so that it converges more than before.*

Back tilt, moving the camera back toward the front. *If the back of the camera is tilted the other way, so that the top of the film is forward and the bottom is moved away from the lens, the top of the cube tends to square up and the front bottom converges more. Squaring up one face of the cube results in increasing light loss and increasing fuzziness toward the far edge of the squared face. In this case the back edge of the top face is affected. In the picture at left the bottom edge of the front face is affected.*

Front tilt, moving the camera front toward the back. *When the lens is tilted, there is no change in the distance from lens to film; thus there is no change in the shape of the cube. However, there is a distinct change in focus. Here the lens has been tipped backward. This brings its focal plane more nearly parallel to the front face of the cube, pulling all of it into sharp focus. The top of the cube, however, is now more blurred than in the reference shot.*

Front tilt, moving the camera front toward the front. *If the lens is tilted forward, the top of the cube becomes sharp and the front more blurred. The focus control that lens-tilt gives can be put to good use when combined with back-tilt. Look again at the two back-tilt shots at the left; their squared—and blurry—sides could have been made much sharper by tilting the lens to improve their overall focus.*

Swing

Swing, an angled left or right movement, can change the shape or focus of the image. Like tilt, it has different effects depending on whether the front or back is moved.

Swinging the back of the camera changes the shape. Like tilting the back, it moves one part of the film closer to the lens while moving another part farther away. This produces changes of shape in the image plus some change in focus.

Swinging the front of the camera changes the focus. It swivels the lens to the left or right and as a result skews the focal plane of the lens to one side or the other. The general effect is to create a sharply defined zone of focus that travels at an angle across an object. A close look at the two right-hand cubes on the opposite page reveals this. There is a narrow diagonal path of sharp focus traveling across the top of each cube and running down one side of the front.

Swinging the camera's back changes the shape of objects.

Top view

Controls zeroed. *The two objects being photographed appear the same size on the viewing screen.*

Left swing of the camera back. *If one side of the camera back is swung toward the back, part of the image will have to travel farther to reach the camera back and so will increase in size. Here the image on the left side of the viewing screen (the right side of the scene and of the photograph) has been increased in size by swinging the left side of the camera back toward the back.*

Right swing of the camera back. *With the right side of the camera back swung toward the back, the size of the image on the right side of the viewing screen (the left side of the scene and of the photograph) will increase in size.*

Swing is an angled left or right movement. *Swing of the back mostly affects the shape of an object, and so helps to control convergence. Swing of the front mostly affects the plane of focus, and so helps to control depth of field.*

Top view

Reference cube—all controls zeroed. *Comparing the reference cube to the pictures at right shows the distortions in shape that can be made by changing the angle of film to lens. If you didn't understand the process by which such changes can be made, it would be hard to know that these swing shots—or the two back-tilt shots on the previous page—are all of the same object, taken from the same spot with the same camera and lens.*

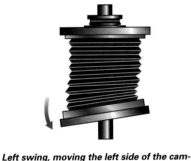

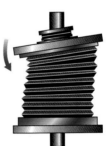

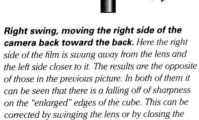

Left swing, moving the left side of the camera back toward the back. *This movement of the camera back swings the left side of the film away from the lens and the right side closer to it, making the left side of the cube smaller and the right side larger. (Remember, the image is inverted on the ground glass.) This effect is the same as tilt, but sideways instead of backward or forward.*

Right swing, moving the right side of the camera back toward the back. *Here the right side of the film is swung away from the lens and the left side closer to it. The results are the opposite of those in the previous picture. In both of them it can be seen that there is a falling off of sharpness on the "enlarged" edges of the cube. This can be corrected by swinging the lens or by closing the aperture a few stops to increase depth of field.*

Left swing, moving the left side of the camera front toward the back. *Since it is the lens that is being swung, and not the film, there is no change in the cube's shape. However, the position of the focal plane has been radically altered. In the reference shot it was parallel to the near edge of the cube, and that edge was sharp from one end to the other. Here the focus is skewed. Its plane cuts through the cube, on a course diagonally across the top and down the left side of the cube's face.*

Right swing, moving the right side of the camera front toward the back. *Here is the same phenomenon as in the previous picture, except that the plane of sharp focus cuts the cube along its right side instead of its left. This selectivity of focus, particularly when tilt and swing of the lens are combined, can move the focal plane around very precisely to sharpen certain objects and throw others out of focus. For a good example of this, see page 293 bottom.*

Using a View Camera to Control the Image

The practical applications of the view camera's ability to rise, fall, shift, tilt, and swing are virtually endless. You can control the plane of focus, which determines the parts of the scene that will be sharp. You can control the shape of an object by adjusting its horizontal or vertical perspective. You can control the placement of the scene within the image frame. The effects of these movements are summarized here and illustrated on the following pages.

Controlling the plane of focus and depth of field

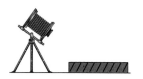

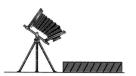

Suppose you need to increase the depth of field from the front of a subject to the back.

Tilt the front of the camera forward so that the lens plane is more nearly parallel to the subject plane. Stop down the lens to increase the depth of field even more.

Controlling horizontal perspective when shooting at a side angle to the subject

This technique is useful when the camera is pointing at a left-to-right angle to the subject, such as in architectural, product, or still-life photography.

The subject looks like this on the ground glass, with converging horizontal lines.

Correct the perspective by swinging the camera back (a) parallel to the face of the subject. Correct the focus by swinging the camera front (b) parallel to the camera back. Refocus, if needed.

The perspective will be corrected so that horizontal lines will no longer converge.

Controlling vertical perspective when shooting from a low camera angle

This technique is useful when the camera is pointing upward, such as when photographing buildings from a low angle.

The subject looks like this on the ground glass, with converging vertical lines. (Remember that the image is upside down on the ground glass.)

Correct the perspective by tilting the camera back (a) parallel to the face of the subject. Correct the focus by tilting the camera front (b) parallel to the camera back. Refocus, if needed.

The perspective will be corrected so that vertical lines will no longer converge.

Controlling the vertical placement of a subject in the image frame

If the subject looks like this on the ground glass.

Or like this.

Move the subject image within the frame by using the front rise or fall or the back rise or fall.

The placement of the subject within the frame will be corrected. This technique can also be used to remove reflections by not photographing the subject head on.

Controlling vertical perspective when shooting from a high camera angle

This technique is useful when the camera is pointing downward, which often happens in still life and product photography.

The subject looks (upside down) like this on the ground glass, with converging vertical lines.

Correct the perspective by tilting the camera back (a) parallel to the face of the subject. Correct the focus by tilting the camera front (b) parallel to the camera back. Refocus, if needed.

The perspective will be corrected so that vertical lines will no longer converge.

Controlling the horizontal placement of a subject in the image frame

If the subject looks like this on the ground glass.

Or like this.

Move the image within the frame by shifting the front or back.

The placement of the subject within the frame will be corrected. The technique can also be used to remove reflections.

Adjusting the plane of focus to make more of the scene sharp

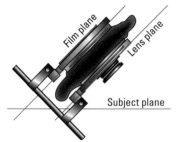

The book is partly out of focus because the lens plane and the film plane are not parallel to the subject plane.

Instead of a regular accordion bellows, the diagrams show a bag bellows that can bring camera front and back closer together.

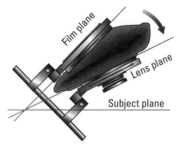

Tilting the front of the camera forward so that the lens plane is more nearly parallel to the subject plane brings the entire page into sharp focus. The camera diagram illustrates the Scheimpflug rule, explained at right.

Adjusting the plane of focus to make only part of the scene sharp

Top
view

Here the photographer wanted just the spilled beans sharp, not those in the foreground and background jars.

A swing of the camera front to the right brought the lens plane parallel to the receding pile of beans. The photographer opened up the lens to its maximum of f/5.6, which throws the other jars out of focus and directs attention to the beans.

A view camera's movements let you control sharpness in an image, an advantage that becomes evident when photographing something that is not parallel to the camera, like the rare book shown here. If you focus on the part of the book close to the camera, the top of the book is blurred and vice versa. A compromise focus on the middle of the page might not give enough depth of field even if you stopped the lens all the way down.

With a view camera you can adjust the plane of focus. The plane of the subject that is most nearly parallel to the plane of the lens will be the sharpest in the picture. You can make more of the book page sharp by tilting the camera front forward so that the lens is more nearly parallel to the page. If the page is still not completely sharp, stopping down the lens aperture will increase the depth of field so that even more of the page will be sharp.

Scheimpflug makes it even better. If you adjust a view camera so that the planes of film, lens, and subject all meet, the subject plane will be completely sharp, even if the plane of the subject is not parallel to the plane of the lens and if the lens is opened to its widest aperture. This phenomenon (named the Scheimpflug rule, after its discoverer) is diagrammed above, left. Fortunately, you don't have to calculate the hypothetical meeting point of the planes (you will be able to see on the ground glass when the image is sharp), but it does explain why a plane can be sharp even if it is not parallel to the lens.

If you want only part of the picture to be sharp, this too is adjustable with a view camera. By swinging or tilting the camera front, the plane of focus can be angled across the picture, as in the photographs of the spilled beans.

Correcting converging lines: The keystone effect

A view camera is often used in architectural photography for controlling perspective. It is almost impossible to photograph a building without distortion unless a view camera is used. You don't have to correct the distortion, but a view camera provides the means if you want to do so.

Photographing a building head on isn't always as simple as it seems. Suppose you wanted to photograph the building at right with just one side or face showing. If you leveled the camera and pointed it straight at the building, you would show only the bottom of the building (photograph, near right).

Tilting up the camera shows the entire building but introduces a distortion in perspective (photograph, far right): the vertical lines seem to come together or converge. This happens because the top of the building is farther away and so appears smaller than the bottom of the building. When you look up at any building, your eyes also see the same converging lines, but the brain compensates for the convergence and it usually passes unnoticed. In a photograph, however, it is immediately noticeable.

The view camera's cure for the distortion is shown in the photograph opposite, left. The camera is adjusted to remain parallel to the building (eliminating the distortion), while still showing the building from bottom to top.

Another problem arises if you want to photograph a building with two sides showing. In the photograph opposite, center, the vertical lines appear correct but the horizontal lines converge. They make the near top corner of the building seem to jut up unnaturally sharp and high in a so-called ship's-prow effect. Swinging the back more nearly parallel to one of the sides (usually the wider one) reduces the horizontal convergence and with it the ship's prow (opposite, right).

Standing at street level and shooting straight at a building produces too much street and too little building. Sometimes it is possible to move back far enough to show the entire building while keeping the camera level, but this adds even more foreground and usually something gets in the way.

Tilting the whole camera up shows the entire building but distorts its shape. Since the top is farther from the camera than the bottom, it appears smaller; the vertical lines of the building seem to be coming closer together, or converging, near the top. This is named the keystone effect, after the wedge-shaped stone at the top of an arch. This convergence gives the illusion that the building is falling backward—an effect particularly noticeable when only one side of the building is visible.

Correcting converging lines: The ship's-prow effect

To straighten up the converging vertical lines, keep the camera back parallel to the face of the building. *To keep all parts of the building in focus, make sure the lens is parallel to the camera back. One way to do this is to level the camera and then use the rising front or falling back movements or both.*

Another solution is to point the camera upward toward the top of the building, then use the tilting movements—*first to tilt the back to a vertical position (which squares the shape of the building), then to tilt the lens so it is parallel to the camera back (which brings the face of the building into focus). You may need to finish by raising the camera front somewhat.*

Photographing at an angle to a building can also create distortion. *In this view showing two sides of a building, the camera has been adjusted as in the preceding picture. The vertical lines of the building do not converge, but the horizontal lines of the building's sides do, since they are still at an angle to the camera. This produces an exaggeratedly sharp angle, called the ship's-prow effect, at the top left front corner of the building.*

Top View

To remove the ship's-prow effect, two more movements are added. *The ship's-prow effect is lessened by swinging the camera back so it is parallel to one side of the building. Here the back is parallel to the wider side. The lens is also swung so it is parallel to the camera back, which keeps the entire side of the building in focus. It is important to check the edges of the image for vignetting when camera movements are used.*

Equipment You'll Need

Camera equipment

You may already have some of the equipment below.

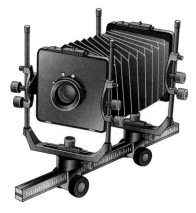

4 x 5 view camera is the most popular size. The term 4 x 5 ("four by five") describes the size of film the camera accepts—4 x 5 inches. Most camera bodies are made of metal. A few are made of wood, which is lighter to carry around—an advantage when working outdoors.

Lens is mounted in a lens board that slips into the camera's front standard. The lens should be suitable for large-format use, that is, produce an image circle large enough to allow for camera movements. For a 4 x 5 format, a normal focal length is 150mm, long focal length 300mm or longer, short focal length 90mm or shorter.

Sheet film holders for 4 x 5-inch film. At least six holders will be useful. Each holder accepts two sheets of film, which gives you twelve exposures before you have to reload.

4 x 5 film of your choice. Like roll film, sheet film is made in black and white or color, in various film speeds, and for negatives or transparencies. Polaroid makes instant films that are usable in special film holders.

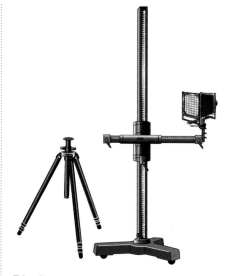

Tripod is essential. Use a tripod sturdy enough for your camera, not a tiny one designed for 35mm use. For studio use, a camera stand on wheels makes it easy to move the camera around.

Focusing cloth goes over your head and the ground glass. The cloth blocks extraneous light so you can see the ground-glass image better.

Focusing magnifier or loupe lets you fine-tune the focusing.

Hand-held light meter is needed for exposure calculations. Automatic exposure is not a view camera feature.

Cable release lets you release the shutter without touching the camera. It's possible to release the shutter without a cable release, but if you do you are likely to introduce camera movement and consequent blur.

Carrying case usually holds everything but your tripod. A case is essential for field work and convenient even in a studio.

Many optional accessories are available.

Polaroid back is needed for exposing and processing instant films.

Bag bellows (shown on page 293) is useful when the lens board must be brought very close to the camera back, such as with a very short-focal-length lens. The bellows takes up less space than a standard accordion-type bellows.

Bellows extensions and rail extensions let you move the lens board farther than normal from the camera back, such as in close-up work.

Changing bag will let you reload your film holders when you are in the field and a darkroom is not available.

Equipment and chemicals for processing sheet film

Sheet film hangers hold individual sheets of film for processing.

Processing tanks hold enough chemicals so you can process a number of sheets of film at a time.

Developing trays (such as you use for processing printing paper) can be used instead of hangers and tanks if you have only a few sheets of film to process.

Film processing chemicals are the same ones used in processing roll film.

More about . . .

• Film processing chemicals, page 107

Because a view camera is so adjustable, its use requires the photographer to make many decisions. A beginner can easily get an I-don't-know-what-to-do-next feeling. So here are some suggestions.

1. Set up the camera and zero the controls. Set the camera on a sturdy tripod, attach a cable release to the shutter mechanism, point the camera toward the scene, zero the controls, and level the camera (below left). Open the shutter for viewing and open the lens aperture to its widest setting. A focusing cloth is usually needed to see the image clearly (center).

2. Roughly frame and focus. Adjust the back for a horizontal or vertical format and roughly frame the image on the ground glass. Roughly focus by adjusting the distance between the camera front and camera back. The closer you are to the subject, the more you will need to increase the distance between front and back.

3. Make more precise adjustments. To change the shape or perspective of the objects in the scene, tilt or swing the camera back. You may also want to move the position of the image on the film by adjusting the tripod or using the rise, fall, or shift movements. Now check the focus (right). If necessary, adjust the plane of focus by tilting or swinging the lens. You can preview the depth of field by stopping down the lens diaphragm to the aperture you intend to use to make an exposure.

4. Make final adjustments. When the image is the way you want it, tighten all the controls. Check the corners of the viewing screen for possible vignetting. You may need to decrease some of the camera movements (especially lens movements) to eliminate vignetting.

5. Make an exposure. Close the shutter, adjust the aperture and shutter speed, and cock the shutter. Now insert a loaded film holder until it reaches the stop flange that positions it. Remove the holder's dark slide to uncover the sheet of film facing the lens, make sure the camera is steady, and release the shutter. Replace the dark slide so the all-black side faces out. Your exposure is now complete.

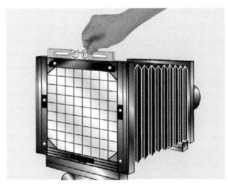

Leveling the camera. *Zero the controls and level the camera before making any other adjustments. Zeroing is important because even a slight tilt or swing of the lens, for example, can distinctly change the focus. A spirit level, like a carpenter uses, levels the camera. Many cameras come with built-in spirit levels. Vertical leveling is important if you want the camera to be parallel to a vertical plane such as a building face. Horizontal leveling (above) is vital; without it the picture may seem off balance even if there are no horizontal lines in the scene.*

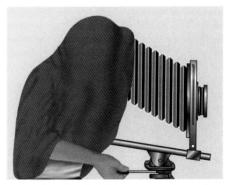

Using a focusing cloth. *The view camera's ground glass shows a relatively dim image. A focusing cloth that covers the camera back and your head makes the image much more visible by keeping out stray light. You may not need the cloth if the subject is brightly lighted in an otherwise darkened room, but in most cases it is a necessity. Some photographers like a two-layer cloth—black on one side and white on the other—to reflect heat outdoors and to double as a fill-light reflector.*

Checking the focus. *A hand-held magnifier, sometimes called a loupe, is useful for checking the focus on the ground glass. Check the depth of field by examining the focus with the lens stopped down. Examine the ground glass carefully for vignetting if camera movements (especially lens movements) are used. If the ground glass has cutaway corners, like the one shown here, you can check for vignetting by looking through one of the corners at the shape of the lens diaphragm. If there is no vignetting, the diaphragm will appear oval and symmetrical.*

Loading and Processing Sheet Film

Film is loaded in total darkness into sheet-film holders that accept two sheets of film, one on each side. Each sheet is protected by a light-tight dark slide that you remove after the holder is inserted in the camera for exposure. After exposure, but before you remove the holder from the camera, insert the holder's slide with the all-black side facing out. This is the only way to tell that the film has been exposed and to avoid an unintentional double exposure.

The film must be loaded with the emulsion side out; film loaded with the backing side out will not produce a usable image. The emulsion side is identified by a series of notches; when the film is in a vertical position, the notches are in the upper right-hand (or lower left-hand) corner when the emulsion side of the film faces you.

Developing sheet film follows the same basic procedure as developing roll film, except three tanks or trays are used—for developer, stop bath, and fixer. Many photographers add a fourth step, a water presoak before development. The film is agitated and transferred from one solution to the next in total darkness; it is not feasible to do this with just one tank as is possible with roll film. Fill tanks with enough solution to more than cover the film in the hanger. Fill trays deep enough for the number of sheets to be developed—one inch is probably a minimum.

Check the instructions carefully for the proper development time. The time will depend on whether you use intermittent agitation in a tank or constant agitation in a tray.

Loading sheet film

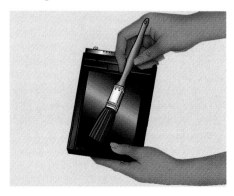

Dusting holders. *It is a good idea to dust the film holders each time before loading them. This is much less trouble than trying to etch off a dark spot on your print caused by a speck of dust on the unexposed film. A soft, wide paintbrush (used only for this purpose) or a negative brush works well; canned air or a bulb syringe also helps. Dust both sides of the dark slide, under the film guides, and around the bottom flap. Tapping the top of the holder can help dislodge dust inside the slot where the dark slides are inserted.*

Finding the notches. *Sheet film has a series of notches on one edge—different for each type of film—so you can identify it and determine the emulsion side. The notches are always located so the emulsion side is facing you when the film is in a vertical position and the notches are in the upper right-hand corner. Load the film with the holder in your left hand and the film in your right with your index finger resting on the notches. (If you are left-handed you may want to load with the holder in your right hand and the film in your left.)*

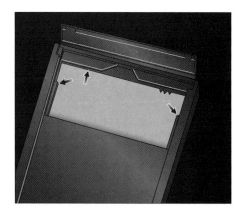

Checking film insertion. *The film is inserted in the bottom (flap) end of the holder underneath narrow metal guides. If you rest your fingers lightly on top of the guides you can feel even in the dark if the film is loading properly. Also make sure that the film is inserted all the way past the raised ridge at the flap end. When the film is in, hold the flap shut with one hand while you push the dark slide in with the other.*

Unexposed/exposed film. *The dark slide has two different sides—one all black, the other with a light band at the top—so you can tell if the film in the holder is unexposed or exposed. When you load unexposed film, insert the slide with the light side out. After exposure, reinsert the slide with the all-black side facing out. The light band also has a series of raised dots or a notch so you can identify it in the dark.*

Processing sheet film

Loading hangers. *Tank processing using film hangers is a convenient way to develop a number of sheets of film at one time. The hanger is loaded in the dark. First spring back its top channel. Then slip the film down into the side channels until it fits into the bottom channel. Spring back the top channel, locking the film in place. Stack loaded hangers upright against the wall until all the film is ready for processing. Even safer against accidental damage would be to use a clean, dry processing tank to collect the hangers as you load them.*

Tank processing. *Hold the stack of loaded hangers in both hands with your forefingers under the protruding ends. Don't squeeze too many hangers into the tank; allow at least 1/2 inch of space between hangers. To start development, lower the stack into the developer. Tap the hangers sharply against the top of the tank to dislodge any air bubbles from the film (this is not necessary if the film has been presoaked in water before development). Make sure the hangers are separated.*

Tank agitation. *Agitation for tank development takes place for 6 to 8 sec, once for each minute of development time. Lift the entire stack of hangers completely out of the developer. Tip it almost 90° to one side to drain the developer from the film. Replace it in the developer. Immediately lift the stack again and tilt almost 90° to drain to the opposite side. Replace in solution. Make sure the hangers are separated. Remove and replace hangers slowly to avoid overdevelopment around the holes in the hanger's edge.*

Tray processing. *If you have just a few sheets of film to develop, you can process them in trays. Fan the sheets so that they can be grasped quickly one at a time. Hold the film in one hand. With the other hand take a sheet and completely immerse it, emulsion side up, in the developer. Repeat until all sheets are immersed. (A water presoak before development is useful to prevent the sheets from sticking to each other.) If you are chemically sensitive, you may find tank development easier; individual sheets of film are not always easy to handle while wearing protective gloves.*

Tray agitation. *All the film should be emulsion side up toward one corner of the tray. Slip out the bottom sheet of film and place it on top of the pile. Gently push it under the solution. Continue shuffling the pile of film a sheet at a time until the end of the development period. If you are developing only a single sheet of film, agitate by gently rocking the tray back and forth, then side to side. Be careful handling the film; the emulsion softens during development and scratches easily. As with roll film, complete the processing with stop bath, fixer, and a washing aid.*

Washing and drying. *Commercial film washers do the job best, but a few loose sheets of film at a time can be washed in a tray. Regulate the water flow carefully to avoid excessive swirling that could cause scratching. Film in hangers can be washed and then hung up to dry right in the hangers or it can be dried on a line as shown above. Separate the film enough so that the sheets do not accidentally stick together.*

Using a View Camera

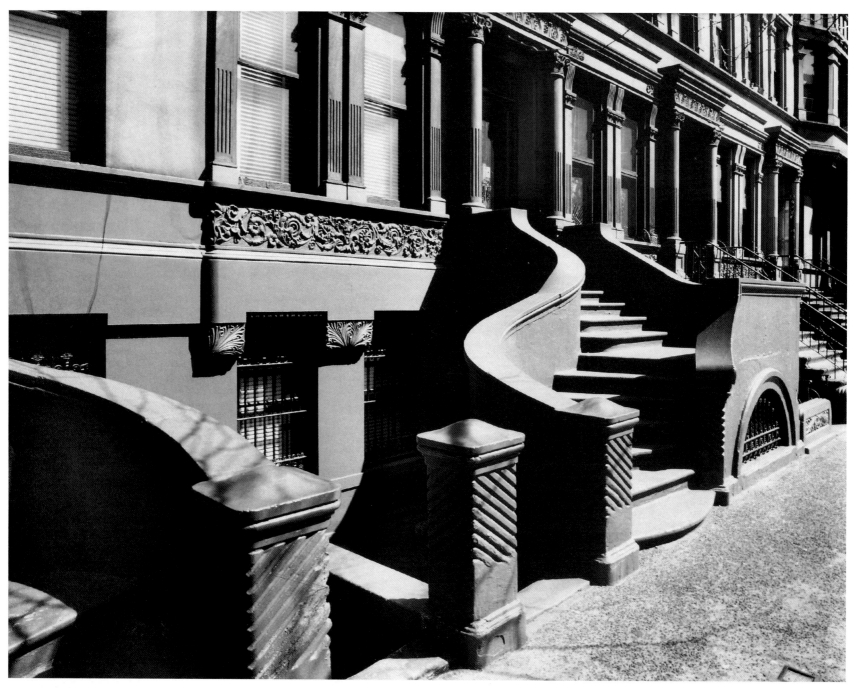

New York, 1979

This photograph demonstrates some of the view camera movements that give control over the perspective and sharpness of an image. *Phil Trager raised the front instead of tilting up the camera, which gave the height he wanted to show but prevented convergence of vertical lines; then he swung the camera back to the left to avoid excessive convergence of horizontal lines. He swung the camera front to the left to align the plane of focus with the front of the buildings so that the entire row of buildings was sharp.*

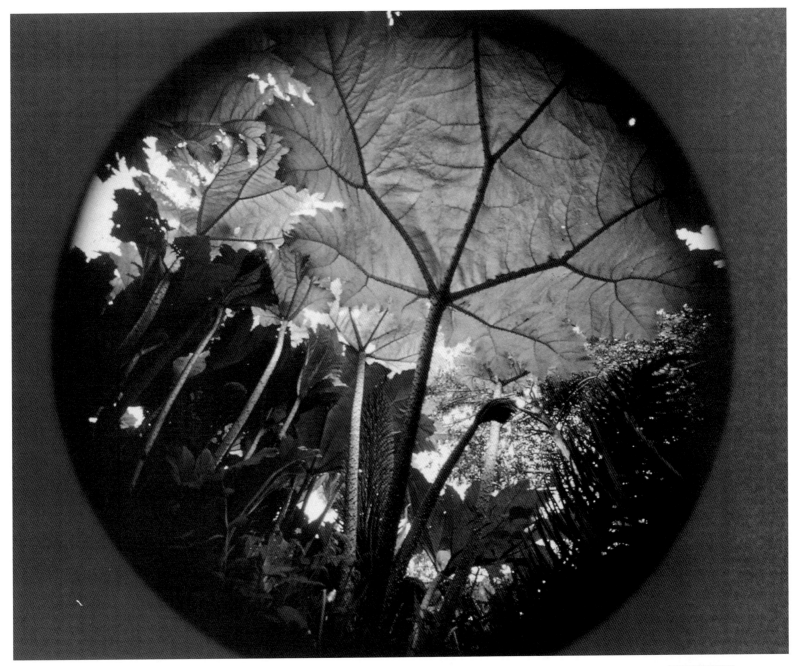

Photographers usually—but not always—want a lens with enough covering power to completely fill the size of the film being used. *Emmet Gowin fitted an 8 x 10 view camera with a 90mm lens designed for a 4 x 5 camera. The image formed by the lens would have been big enough to cover 4 x 5-inch film, but the 8 x 10-inch film showed almost the entire image circle. At first he cropped the image down to a rectangle, but then saw the potential in the image circle itself. "I realized that such a lens contributed to a particular description of space and that the circle itself was already a powerful form."*

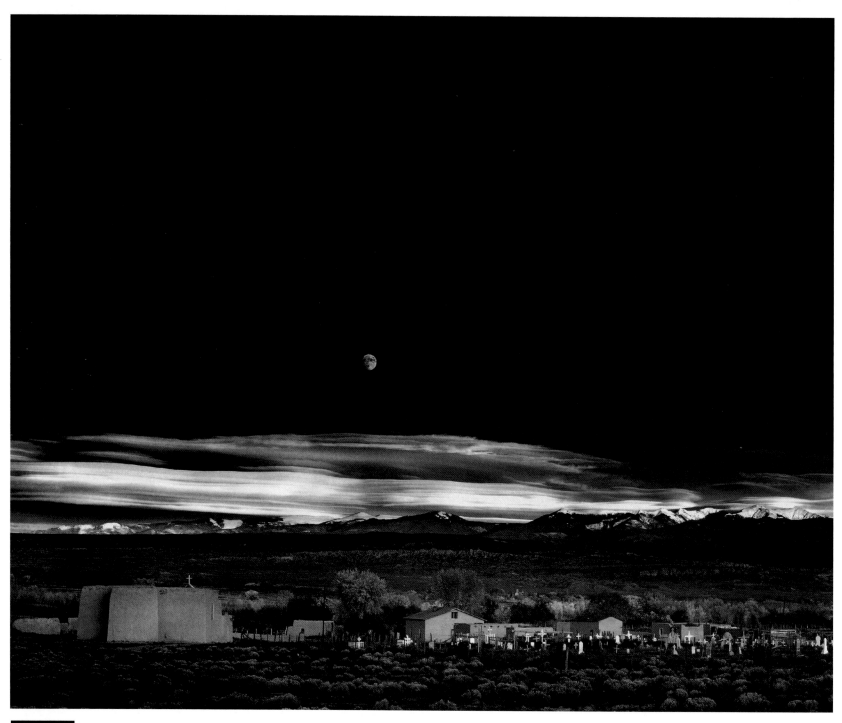

ANSEL ADAMS Moonrise, Hernandez, New Mexico, 1941

Zone System 14

◄ *Ansel Adams remains the acknowledged master of the grand landscape. His great vistas are mythic images that reinforce our romantic ideals of nature. Adams was a superb technician who controlled his medium completely to amplify and bring to life the tonalities in an image. No book reproduction can convey the range of tones in the original print, from the glowing brilliance of the clouds and crosses to the subtle detail in the dark shadows. The photograph is everything that we imagine such a scene might look like in reality, and for many of us it will forever serve as a substitute for the actual experience of being there to see it ourselves.*

Have you ever looked at a scene and known just how you wanted the final print to appear? In the Zone System, this is called visualization. Sooner or later every photographer has this experience. Sometimes the image turns out just the way you expected, but as often as not for the beginning photographer, the negative you end up with makes it impossible to produce the print you had in mind. For example, the contrast range of a scene (the difference between its lightest and darkest parts) is often greater than the contrast range of normally processed photographic materials. The result is highlights so light and/or shadows so dark that details in them are completely lost.

The Zone System is a method for controlling the black-and-white photographic process. Conceived by Ansel Adams and Fred Archer, it applies the principles of sensitometry (the measurement of the effects of light on light-sensitive materials) to organize the many decisions that go into exposing, developing, and printing a negative. Briefly, it works this way: You make exposure readings of the luminances (the lightness or darkness) of important elements in a scene. You decide what print values (shades of gray) you want these elements to be in a final print. Then you expose and develop the film to produce a negative that can, in fact, produce such a print.

The Zone System allows you to visualize how the tones in any scene will look in a print and to choose either a literal recording or a departure from reality. Even if you continue to use ordinary exposure and development techniques, understanding the Zone System will help you apply them more confidently. This chapter is only a brief introduction to show the usefulness of the Zone System. Other books that tell how to put it into full use are listed in the Bibliography.

The Zone System Scales

The Zone System has four scales that describe how light or dark an area is. See the scales shown at right.

Subject values describe the amount of light reflected or emitted by various objects in a scene. Subject values can be measured by a reflected light meter. A low or dark subject value produces a low meter reading; a high or light subject value produces a high meter reading. Each division of this scale is one stop away from the next (it produces either half or twice the negative exposure). Subject values are easiest to meter with a hand-held meter, but with a little number juggling you can determine them with a meter built into a camera (see box on page 306).

Negative-density values describe the amount of silver in various parts of the negative after it has been developed. Clear or thin areas of a negative have little or no silver; dense areas have a great deal of silver. These values can be measured by a densitometer, a device that gauges the amount of light stopped or passed by different portions of the negative.

Print values describe the amount of silver in various parts of a print. The darkest areas of a print have the most silver, the lightest areas have the least. These values can be measured by a reflection densitometer if desired but are ordinarily simply evaluated by eye in terms of how light or dark they appear.

The Zone scale is crucial because it links the values on the other three scales. It provides descriptions of values to which subject values, negative-density values, and print values can be compared. Familiarizing yourself with the divisions of the zone scale (opposite page) gives you a means of visualizing the final print. The zones aid you in examining subject values, in deciding how you want them to appear as print values, and in then planning how

to expose and develop a negative that will produce the desired print.

The zone scale has 11 tones, based on Ansel Adams's description in his book *The Negative*. There are more than 11 shades of gray in a print—Zone VII, for example, represents all tones between Zones VI and VIII—but the 11 zones provide a convenient means of visualizing and identifying tones in the subject, the negative, and the print.

In Ansel Adams's original version of the Zone System, he divided the zone scale into ten segments (0–IX). When he retested newer film and paper, he revised the zone scale to eleven segments (0–X). The information here is based on the current version of the system.

Some commonly photographed surfaces are listed on the opposite page in the zones where they are often placed if a realistic representation is desired; average light-toned skin in sunlight, for example, appears realistically rendered in Zone VI.

Zone 0 (zero) is the deepest black print value that photographic printing paper can produce, resulting from a clear area (a low negative-density value) on the corresponding part of the negative, which in turn was caused by a dark area (a low subject value) in the corresponding part of the scene that was photographed.

Zone X is the lightest possible print value—the pure white of the paper base, a dense area of the negative (a high negative-density value), and a light-toned area in the scene (a high subject value).

Zone V corresponds to a middle gray, the tone of a standard-gray test card of 18 percent reflectance. A reflected-light exposure meter measures the lightness or darkness of all the objects in its field of view and then gives an exposure recommendation that would render the average of those tones in Zone V middle gray.

The Zone System's scales describe the lightness or darkness of a given area at the various stages in making a photograph. The divisions of the scales are labeled with roman numerals to avoid confusion with f-stops or other settings.

Low meter reading **High meter reading**

Subject values are measured when metering a scene and range from dark shadows to bright highlights. Each value meters one stop from its neighbor. Only eleven subject values are shown here, but more will be present in a high-contrast scene, such as a brightly sunlit location that also contains deeply shadowed areas. The same location on a foggy or overcast day will contain fewer than 11 values.

Little or no silver **Dense silver**

Negative-density values are those present in the developed negative. Film can record a somewhat greater number of values than the 11 shown here.

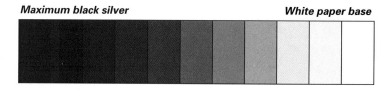

Maximum black silver **White paper base**

Print values are visible in the final print. Printing paper limits the usable range of contrast. Black-and-white printing paper can record about 11 steps from maximum black to paper-base white.

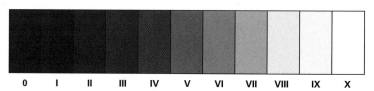

| 0 | I | II | III | IV | V | VI | VII | VIII | IX | X |

Zones tie the other scales together. They permit you to plan how light or dark an area in a subject will be in the final print.

Zone X. *Five (or more) stops more exposure than Zone V middle gray. Maximum white of the paper base. Whites without texture: glaring white surfaces, light sources.*

Zone IX. *Four stops more exposure than Zone V middle gray. Near white. Slight tonality, but no visible texture: snow in flat sunlight.*

Zone VIII. *Three stops more exposure than Zone V middle gray. Very light gray. High values with delicate texture: very bright cement, textured snow, highlights on light-toned skin, the lightest wood at right.*

Zone VII. *Two stops more exposure than Zone V middle gray. Light gray. High values with full texture and detail: very light surfaces with full sense of texture, sand or snow with acute side lighting.*

Zone VI. *One stop more exposure than Zone V middle gray. Medium-light gray. Lighted side of average light-toned skin in sunlight, light stone or weathered wood, shadows on snow in a scene that includes both shaded and sunlit snow.*

Zone V. Middle gray. *The tone that a reflected-light meter assumes it is reading and for which it gives exposure recommendations. 18 percent reflectance neutral-gray test card, clear north sky, dark skin.*

Zone IV. *One stop less exposure than Zone V middle gray. Medium-dark gray. Dark areas with full texture and detail: dark stone, average dark foliage, shadows in landscapes, shadows on skin in sunlit portrait.*

Zone III. *Two stops less exposure than Zone V middle gray. Dark gray. Darkest shadow areas with texture and detail: very dark soil, very dark fabrics with full texture, the dark boards at right.*

Zone II. *Three stops less exposure than Zone V middle gray. Gray-black. Darkest area in which some suggestion of texture will appear in the print.*

Zone I. *Four stops less exposure than Zone V middle gray. A near black with slight tonality but no visible texture.*

Zone 0. *Five (or more) stops less exposure than Zone V middle gray. Maximum black that photographic paper can produce. The opening to a dark interior space, the open windows at right.*

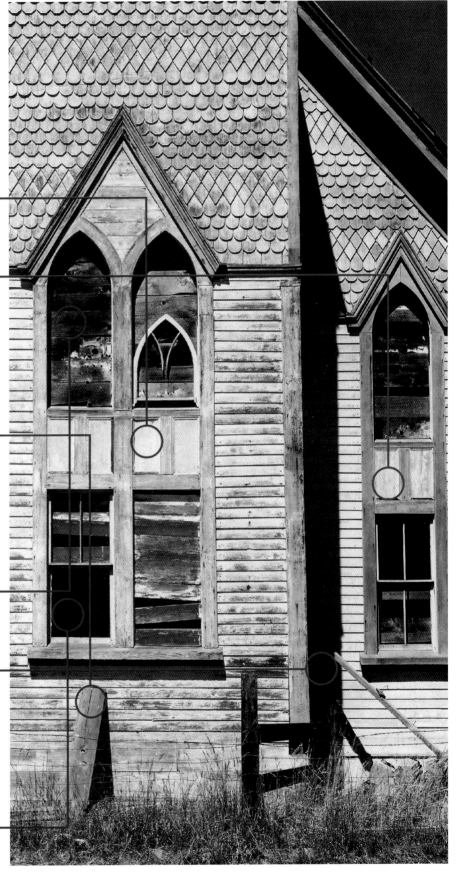

Know the limits of your materials. When you are standing in front of a subject and visualizing how it might look as a black-and-white print, you have to take into account that ordinary photographic materials given normal exposure, development, and printing cannot record with realistic texture and detail the entire range of luminances (subject tones) in many scenes. For example, a scene in bright sunlight can generally be rendered with texture and detail in either dark shadows or bright highlights but not both. Usually, you have to choose those areas in which you want the most detail in the print and then expose the negative accordingly.

With practice, you can accurately visualize the black-and-white tones in the final print by using the zone scale described on the preceding pages plus a reflected-light exposure meter, either hand-held or built into a camera. (An incident-light meter cannot be used because it measures the light falling on the scene, and you will need to measure the luminances of individual areas.)

When you meter different areas, you can determine where each lies on the zone scale for any given exposure. Metering must be done carefully to get consistent results. Try to read areas of more or less uniform tone; the results from an area of mixed light and dark tones will be more difficult to predict. It is important to move in close enough to the subject to make readings of individual areas, but not so close that you cast a shadow on an area as you meter it. A spot meter is useful for reading small areas or those that are at a distance.

The meter does not know what area is being read or how you want it rendered in the print. It assumes it is reading a uniform middle-gray subject tone (for example, a neutral-gray test card of 18 percent reflectance) and gives exposure recommendations accordingly. The meter mea-

sures the total amount of light that strikes its light-sensitive cell from an area, then, taking into account the film speed, it calculates f-stop and shutter speed combinations that will produce sufficient negative density to reproduce the area as middle gray in a print.

If you choose one of the f-stop and shutter-speed combinations that are recommended by the meter, you will have placed the metered area in Zone V. It will reproduce as middle gray in the print (print Value V). By altering the negative exposure you can place any one area in any zone you wish. One stop difference in exposure will produce one zone difference in tone. For example, one stop less than the recommended exposure places a metered area in Zone IV; one stop more places it in Zone VI.

Once one tone is placed in any zone, all other luminances in the scene fall in zones relative to the first one. Where tones fall depend on whether they are lighter or darker than the tone you placed, and by how much. Suppose a medium-bright area gives a meter reading of 7 (see meter, right, and photograph, opposite). Basing the exposure on this value (by setting 7 opposite the arrow on the meter's calculator dial) places this area in Zone V. Metering other areas shows that an important dark wood area reads two stops lower (5) and falls in Zone III, while a bright wood area reads three stops higher (10) and falls in Zone VIII.

A different exposure could have been chosen, causing all of the zones to shift equally lighter or darker (opposite, far right). For instance, by giving one stop more exposure you could have lightened the tones of the dark wood, placing them in Zone IV instead of III, but many of the bright values in the lightest wood would then fall in the undetailed white Zone IX. The Zone System allows you to visualize your options in advance.

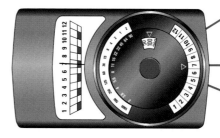

Each position on an exposure meter gauge measures a luminance (subject value) one stop or one zone from the next position. Suppose that metering a medium-toned area gives a reading of 7. Setting 7 opposite the arrow on the calculator dial places this area in Zone V. A lighter area meters 10, so it falls three zones lighter, in Zone VIII. A dark area meters at 5 and falls in Zone III. The first area metered will appear in the print as middle-gray print Value V, the bright wood as very light gray print Value VIII, and the dark wood as dark-gray print Value III (with standard negative development and printing).

How to count zones with a meter built into a camera

How do you read the difference in subject values (and so, the difference in zones) if you are using a meter built into a camera? In many cameras, the viewfinder displays the exposure setting—the aperture and shutter-speed combination—for a given reading. You can find the various zones if you count the number of stops between exposure settings for different areas.

Suppose that metering the scene at right suggests exposures of f/5.6 at 1/60 sec for one area and f/16 at 1/60 sec for a lighter area. The area that metered f/16 is three stops (or zones) lighter than the area that metered f/5.6 (f/5.6 to f/8 is one stop; f/8 to f/11, two stops; f/11 to f/16, three stops). Placing the darker area in Zone V will cause the other to fall in Zone VIII, three zones higher.

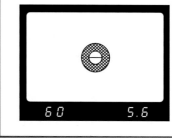
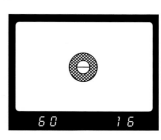

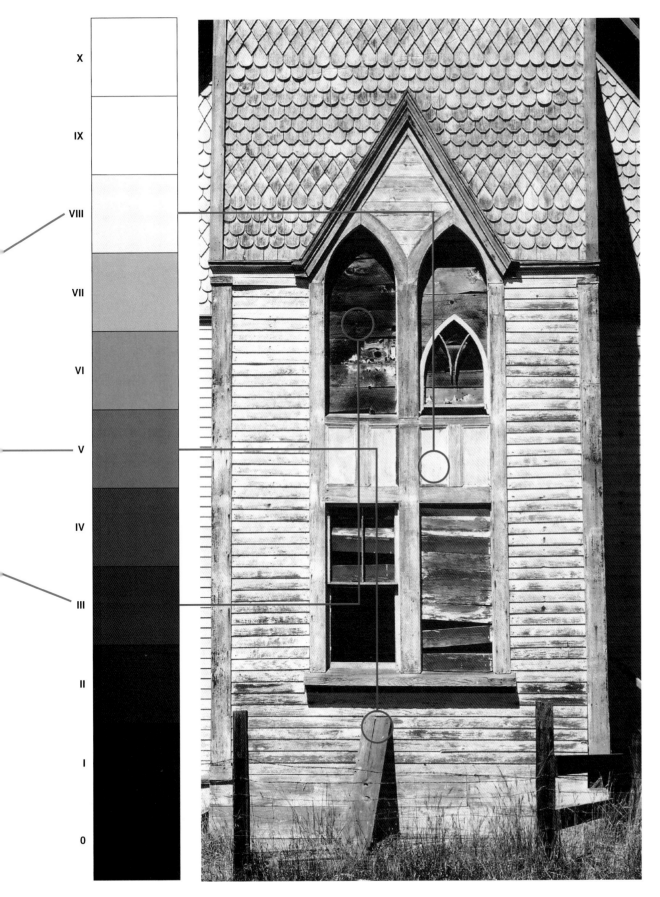

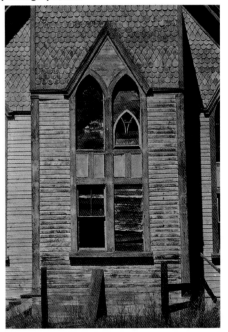

One stop less negative exposure than photograph, left

One stop more negative exposure than photograph, left

One stop difference in negative exposure creates one zone difference in all areas *(if other factors remain the same). The negative exposure for the top print was one stop less than that given to the photograph at left. The negative exposure for the bottom print was one stop more than that for the photograph at left. All the values changed one zone with one stop difference in exposure.*

How Development Controls Contrast

Exposure plus development affect the tones in a scene. You can place any one subject value in any zone you desire. You can also predict in which zones the other subject values will fall. But exposure is still only half the story in producing a negative. You may want to decrease contrast if the subject has too great a range of values. Or if the subject has only a narrow range of values, you may want to increase contrast so that the print doesn't look flat and dull.

Development can change the highlights and, as a result, control the overall contrast of the negative. The most common way to adjust contrast is to change the contrast grade of the paper—print a high-contrast negative on low-contrast paper and vice versa. But another way to change contrast is to change the development time of the negative.

Increasing development increases contrast, decreasing development decreases contrast. High values shift considerably with changes in development time, but low values change little or not at all. Middle values change somewhat, although not as much as the upper ones.

This happens because the developer quickly reduces to silver the relatively few silver halide crystals that were struck by light in the slightly exposed shadow areas. Development of shadow areas is completed long before all the crystals in the greatly exposed highlight areas convert to silver.

The longer a negative is developed (up to a limit), the greater the silver density that develops in high values, while the shadow densities remain about the same. And the greater the difference between high-value and low-value densities, the greater the contrast.

There are advantages to adjusting the negative's contrast. A negative that prints with a minimum of dodging and burning on a normal-contrast paper is easier to print than, for example, a contrasty negative with dense highlights that require considerable burning in.

Normal development *was given to the negative.*

Increased development *created more contrast by increasing the density of the high values in the negative. High values, such as the sidewalk, are lighter now in the print.*

Decreased development *reduced the contrast by decreasing the density of high values, which now appear darker in the print.*

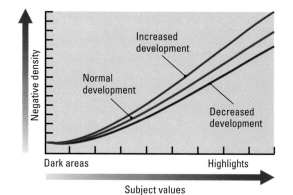

The length of time a negative is developed has an important effect on the contrast. *The three versions of this scene received identical negative exposures and identical printing. Only the development time was changed. The highlights got lighter when development was increased and became darker when development was increased.*

Hence, the old photographic rule: Expose for the shadows, develop for the highlights. You can change the density of highlights (and the contrast) by changing the development, but low shadow values are set during exposure and remain about the same with any development.

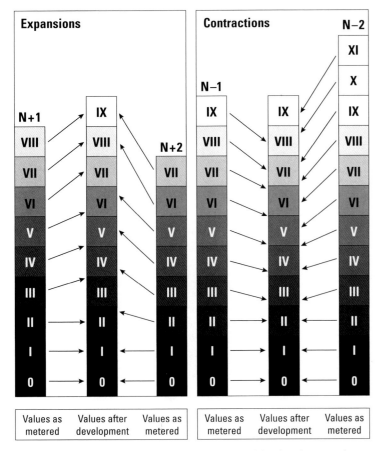

Values as metered	Values after development	Values as metered

Values as metered	Values after development	Values as metered

Changing the development time changes mostly the high values in a negative.
Development control of high values can be quite precise. If an area is placed in Zone VIII during exposure, it will appear as a negative density Value VIII if the film is given normal development. That same area could be developed to a Value VII with less development or to a Value IX with more development.

In Zone System terms, N stands for normal development. Values remain where they were placed or fell during an exposure. An area falling in Zone VII would appear as a negative-density Value VII and (given normal printing) as print Value VII.

An expansion (Normal-Plus development) is produced by increasing development time. As development time increases, subject values increase to higher values on the negative and contrast is increased. With N + 1 (normal-plus-one) development, a high value such as Zone VII would be increased one zone to Zone VIII. N + 2 indicates a greater expansion; a Zone VII value would be increased two zones to Zone IX.

A contraction (Normal-Minus development) is produced by decreasing development time. Subject values (and contrast) are reduced by decreasing the development time. With N–1 (normal-minus-one) development, a Zone IX value moves one zone down to Zone VIII. N–2 development is a greater contraction, down two zones.

Testing is the best way to determine your own development times. The tests, covered in detail in the books listed in the Bibliography, establish five standard elements for the individual photographer: actual film speed, normal development time, expanded development times, contracted development times, and standard printing time. Personal testing is recommended since cameras, meters, films, enlargers, papers, developers, and personal techniques all affect the results.

However, here are some rough guidelines for expanded and contracted development that you can use without testing and that will be helpful for approximate control of contrast.

• Use the manufacturer's stated film speed rating to calculate the exposure.

• For normal development, use one of the manufacturer's suggested time and temperature combinations.

• For N + 1 expanded development, increase the development time 25 percent. If the recommended development time is 8 minutes for a given combination of film, developer, and temperature, then the high values can be shifted up one zone each by a 10-minute development. For N + 2 expansion, increase the time 50 percent.

• For N–1 contracted development, which will shift the high values downward one zone each, develop for 80 percent of the normal time. For N–2 contraction, develop for 60 percent of the normal time.

• Compared to other films, Kodak T-Max films require less of a change in development time to produce a comparable change in negative density; change the time about half as much as you do with other films.

Changing the development time is simple with sheet film, since each exposure can be given individual development. With roll film, changing the contrast grade of the paper is often more practical.

The Zone System has four basic steps.

1. Visualize the final print. Decide how you want the print to look. For example, which dark or light areas do you want to show good detail.

2. Meter the most important area in the scene and place it in the zone where you want it rendered. Often this is the darkest area in which you want full texture (usually Zone III 1/2 or IV). Where you place a value determines your exposure.

3. Meter other areas (especially the lightest area in which you want full texture) to see in which zones they fall in relation to the area you have placed.

4. Make development choices. If you want the negative-density values to correspond to the relative luminances of various areas in the scene, develop the negative normally. Change the development time if you want to change the densities of the upper values while leaving the lower values about the same. Increasing the time increases the negative densities of the high values (which will make those areas lighter in the print) and also increases the contrast. Decreasing the development time decreases the negative densities of the high values (they will be darker in the print) and decreases the contrast.

You could also plan to print on a contrast grade of paper higher or lower than normal to control densities and contrast. A change of one printing paper contrast grade causes about a one-zone shift in the high values (when low values are matched in tone).

MORLEY BAER Window Cornice Detail, San Francisco, 1966

Using the Zone System makes it possible to plan exposure and development to get the tonal range you want. Morley Baer made this photograph for a book on Victorian houses in San Francisco. He often expanded contrast when shooting in the hazy sunlight that is common in San Francisco.

He metered the shadow just under the window cornice, an area that he wanted to be dark but still showing detail, and placed that area in Zone III. Then he metered the lightest area in which he wanted to retain good detail; it fell only in Zone VI, which could have made the scene too flat. To correct this, Baer increased the development time to give the scene a one-zone expansion. Another option would have been to plan to print the scene on a higher contrast grade of paper.

KEN KOBRÉ Malaysia, 1993

Using the Zone System with roll film

Changing the development time is also an option with roll film. Changing the development time is easy with view camera photography, where sheets of film can be processed individually. But it can be valuable with roll film even though a whole roll of exposures is processed at one time. Sometimes a single image or situation is so important that it deserves special development; the other images on the roll will probably still be printable, possibly on a different grade of paper. Or an entire roll may be shot under one set of conditions and so can be exposed and processed accordingly. Be cautious with increased development of roll film, grain will increase too.

With roll film, you can plan on changing printing paper contrast. It is essential to give enough exposure to dark areas to produce printable densities in the negative while at the same time attempting to keep bright areas from becoming too dense to be printable. For example, if trial metering indicates about one stop too much contrast (that is, with shadows placed in Zone III, the high values in which you want full detail fall in Zone VIII or IX), contracted development for the entire roll will be useful. Most of the frames shot will print on a normal-contrast grade of paper; those shot under more contrasty conditions will print on a low-contrast grade; those shot in the shade (now low in contrast because of contracted development) will print on a high-contrast grade.

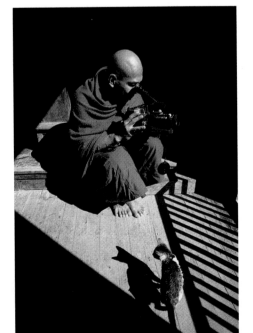

KEN KOBRÉ Burma, 1993

Using the Zone System with color film

With color materials, the Zone System provides a way to place a specific value and check where other values will fall. Changing development time to control contrast is somewhat less feasible for color materials than it is for black and white because beyond a certain point it produces unpredictable shifts in the color balance.

With color negatives, place the most important shadow value, just as you would with a black-and-white negative. Overly bright highlights can usually be burned in later during printing. You can expand or contract contrast approximately one zone without getting major color shifts. As a trial, to increase contrast try increasing the time in Kodak C-41 developer by about 20 per-cent; to decrease contrast try decreasing the time about 20 percent. Some color printing papers, such as Ilford Ilfocolor Deluxe or Kodak Ektacolor, also permit some contrast control.

With color transparencies, correct exposure is vital because the film in the camera is the final viewing product. High values in a transparency lose texture and detail more easily than shadows do, so meter and place the most important light area rather than a dark area as you would with negative film. If you want a light area to retain texture, place it no higher than Zone VII. If you are not sure about the exposure, underexpose a bit rather than overexpose.

Photographer at Work: Using the Zone System

John Sexton was a photo student when he first encountered the Zone System. He attended an Ansel Adams lecture and then a workshop. Later, he became one of Adams's darkroom assistants, and now photographs and teaches photography workshops himself.

Sexton sees the Zone System as a communication process. The collaborators are the photographer and the materials. "But," he says, "most people don't listen to what the negative and the paper say to them visually. They don't really look at the results."

"The Zone System is simple," Sexton says, "once you understand that it's all about visualization," in other words, thinking ahead to how you want the print to look. There's nothing exotic about that, he says: "Everybody visualizes, from someone with a disc camera to someone with an 8 x 10 view camera. It's the only reason you press the shutter release. And most of us visualize something that is outside of the limitations of the material. If you start thinking, 'I may have to burn in the upper right corner,' you are visualizing. I used to hope a negative 'turned out.' I was really thinking about the print it might make."

"If people understand nothing else," he says, "they should understand that when you point a reflected-light meter at something, you are going to get middle gray. Exposure is the only way you can control shadow density, while exposure and development control the highlights."

He recommends, "If in doubt, don't underexpose. If in doubt, don't overdevelop. Make a negative that gives you options. Your options are limited if you have thin shadows or bulletproof highlights. If you've got shadow detail and highlight detail, there's a lot you can do in the darkroom."

Using torn paper tests for dodging and burning

When making a print, John Sexton almost always dodges to lighten some areas and/or burns in to darken other areas. The question is: How much should a print be dodged or burned for best results? He begins by making a test strip to determine his basic print exposure, then makes a straight print without any dodging or burning.

Making a set of test patches. He examines the print and decides where he might want to dodge or burn. He tears a fresh sheet of printing paper into pieces to go over the areas he wants to see manipulated, fitting together a sort of jigsaw puzzle of the print. On the back of each piece of paper, he writes the planned amount of dodging or burning for that area. Once all the pieces are in place on the printing easel, he gives the exposure that produced a good straight print, dodging the appropriate areas as planned. He then burns in where planned.

Making a second set of patches. He sets aside the pieces of paper, then repeats the procedure with another set of torn pieces, doubling every manipulation. For example, if he had planned to dodge an area for 5 seconds, he now dodges that same area for 10 seconds. He gathers all the pieces of paper and develops them.

Evaluating the patches. After fixing, he turns on the white lights, puts his straight print on his print viewing area (shown right, bottom) and positions the torn pieces around the print. If he wants to see what the area dodged for 5 seconds looks like, he positions that piece over the print. If it's not light enough, he'll try the piece dodged for 10 seconds. And so on. Once he has assembled a print that begins to feel fairly close to the image he wants, he turns the torn pieces over to find the time for dodging or burning each area, creating a plan for the final print.

The benefit of this torn-paper procedure is that you can try various combinations of dodging and burning-in, without using sheet after sheet of paper. Lay a manipulated area over the straight print, look at it for a while, then quickly peel it off. You'll know right away which looks better, and much more accurately than if you had simply dodged or burned without testing.

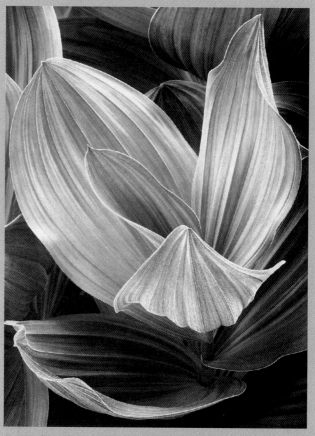

JOHN SEXTON Corn Lily, Eastern Sierra Nevada, 1977

Sexton photographed these corn lily leaves on an overcast, rainy day, with light diffused by high clouds and again by heavy forest overhead. He wanted more contrast than the scene provided, so he gave the film an N + 1 expanded development. Later he intensified the negative in selenium toner to expand the contrast a little further, then printed it on a grade 3 paper.

PATRICK JABLONSKI John Sexton in His Darkroom, 1990

More about . . .

• Selenium toning of negatives, page 127

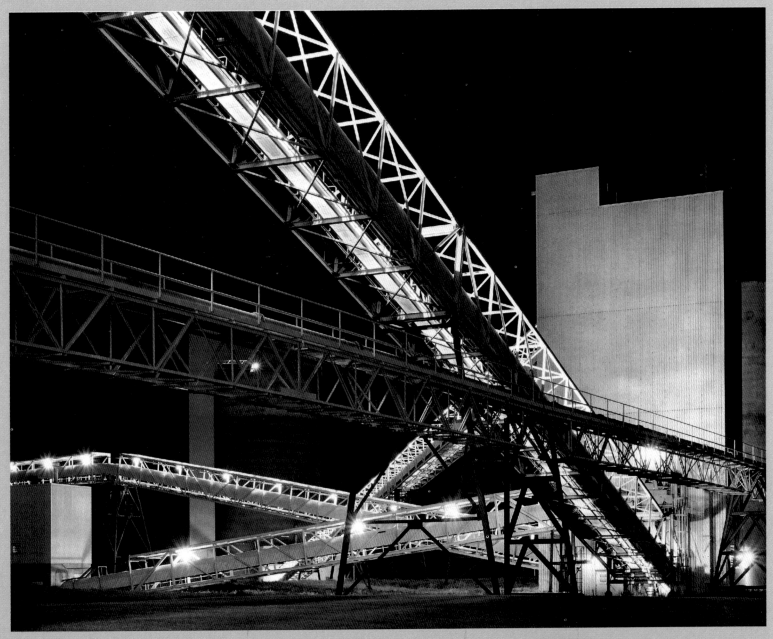

JOHN SEXTON Coal Conveyor at Night, Alma, Wisconsin, 1987

Contracted development made this contrasty scene more printable. *The lighting on this coal conveyor at night was extremely contrasty. The lights on the coal conveyor provide the only illumination, and are themselves in the photograph. The 30-minute exposure that was required made the scene even more contrasty due to the reciprocity effect of a very long exposure (explained on page 100). In order to keep detail in both shadows and highlights, Sexton gave ample exposure and greatly reduced development to the negative.*

Sexton advises students to use the same tool that is the most important one in his darkroom: the trash can. "That's where most of my prints end up," he says. "Most of the prints I make are for my eyes only. As a photographer, I think you need to be constantly making mistakes: technical mistakes and aesthetic mistakes. As soon as you're no longer making either, you're probably done with that body of work. By risking mistakes, now I can get things on film that ten years ago I wouldn't have known how to handle."

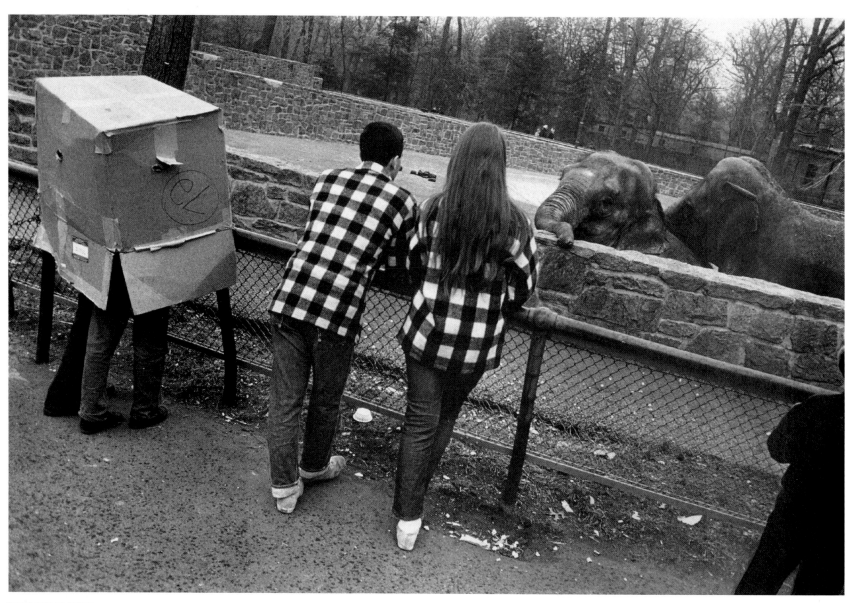

GARRY WINOGRAND Zoo, New York, 1962

Seeing Photographs 15

Many of Garry Winogrand's pictures involve unusual confrontations. This one depicts a three-way face-off between humans and animals at the Bronx Zoo, with all participants apparently equally intrigued by the event. Winogrand exploited the camera's ability to collect facts. He said, "Photography is about finding out what can happen in the frame. When you put four edges around some facts, you change those facts. The frame creates a world and photography is about (that) world." When asked why his images were tilted, he replied, "What tilt? There's only a tilt if you believe that the horizon must be parallel to the horizontal edge. That's arbitrary."

How do you learn to make better pictures? Once you know the technical basics, where do you go from there? Every time you make an exposure you make choices, either deliberately or accidentally. Do you show the whole scene or just a detail? Do you make everything sharp from foreground to background or have only part of the scene in focus? Do you use a fast shutter speed to freeze motion sharply or a slow shutter speed to blur it?

Your first step is to see your options, to see the potential photographs in front of your camera. Before you make an exposure, try to visualize the way the scene will look as a print. Looking through the viewfinder helps. The scene is then at least reduced to a smaller size and confined within the edges of the picture format, just as it will be in the print. As you look through the viewfinder, imagine you are looking at a print, but one that you can still change. You can eliminate a distracting background by making it out of focus, by changing your position to a better angle, and so on.

Try to see how a picture communicates its visual content. Photography transforms a three-dimensional event into a frozen instant reduced in size on a flat piece of paper, often in black and white instead of color. The event is abstracted, and even if you were there and can remember how it "really" was, the image in front of you is the tangible remaining object. This concentration on the actual image will help you visualize scenes as photographs when you are shooting.

Basic Choices
Content

One of your first choices is how much of a scene to show. Whether the subject is a person, a building, or a tree, beginners often are reluctant to show anything less than the whole thing. People often photograph a subject in its entirety—Grandpa is shown from head to toe even if that makes his head so small that you can't see his face clearly. In many cases, however, it was a particular aspect of the subject that attracted the photographer's attention in the first place, perhaps the expression on the face of the person, the peeling paint on the building, or a bent branch of the tree.

Get closer to your subject. "If your pictures aren't good enough, you aren't close enough," said Robert Capa, a war photographer known for the intensity and immediacy of his images. This simple piece of advice can help most beginning photographers improve their work. Getting closer eliminates distracting objects and simplifies the contents of a picture. It reduces the confusion of busy backgrounds, focuses attention on the main subject, and lets you see expressions on people's faces.

What is your photograph about? Instead of shooting right away, stop a moment to decide which part of a scene you really want to show. You might want to take one picture of the whole scene, then try a few details. Sometimes you won't want to move closer, as in photographing a prairie landscape where the spacious expanse of land and sky is important or in making an environmental portrait where the setting reveals something about the person.

Try to visualize what you want the photograph to look like. Then move around as you look through the viewfinder. Examine the edges of the image frame. Do they enclose or cut into the subject the way you want? In time, these decisions come more intuitively, but it is useful at first to work through them deliberately.

U.S. DEPARTMENT OF AGRICULTURE Rancher's Hands

A detail of a scene can tell as much as and sometimes more than an overall shot. *Right, part of the life of a working cowboy, a buckaroo, from Paradise Valley, Nevada. Below, the end of a cattle drive to the 96 Ranch's Hartscrabble camp in Paradise Valley.*

RICHARD E. AHLBORN Boots, Paradise Valley, Nevada, 1978

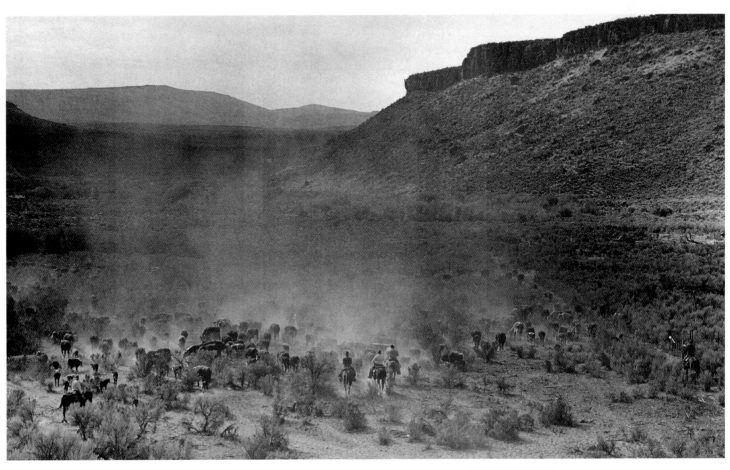

CARL FLEISCHHAUER Herding Cattle, Paradise Valley, Nevada, 1978

The frame (the edges of a picture) isolates part of a larger scene. Photography is different from other visual arts in the way in which a picture is composed. A painter starts with a blank canvas and places shapes within it. A photographer generally uses the frame of the viewfinder or ground glass to select a portion of a scene.

Every time you make an exposure you make choices about framing—consciously or not. How do the edges of the picture relate to the part of the scene that is shown? You can leave considerable space between the frame and a particular shape, bring the frame very close so it almost touches the shape, or use the frame to crop or cut into the shape. You can position an edge of an object or a line within an object so that it is parallel to one edge of the frame or position it at an angle to the frame. Such choices are important because the viewer, who can't see the surroundings that were left out of the picture, will see how the frame meets the shapes in the print.

There is no need to be too analytical about this. Try looking at the edges of the viewfinder image as well as at the center of the picture and then move the frame around until the image you see through the viewfinder seems right to you. You can also cut a small rectangle in an 8 x 10-inch piece of black cardboard and look through the opening at a scene. Such a frame is easier to move around and see through than a camera and can help you visualize your choices.

Judicious cropping can strengthen a picture but awkward cropping can be distracting. Ordinarily it is best not to cut off the foot of someone in motion or the hand of someone gesturing, but the deliberate use of such unconventional cropping can be effective. Some pictures depend on the completion of a gesture or motion and make it difficult or impossible to crop into the subject successfully.

Portrait photographers recommend that you do not crop a person at a joint, such as a wrist or knee, because that part of the body will look unnaturally amputated or will seem to protrude into the picture without connection. It can also seem awkward if the top of a head or an elbow or a toe just touches the edge of the frame. Generally, it is better to crop in slightly or to leave a space.

Should your picture be horizontal or vertical? It is common for beginners to hold a 35mm camera horizontally, and only occasionally turn it to a vertical position. Unless you have a reason for doing otherwise, hold the camera horizontally for a horizontal subject, vertically for a vertical one. Otherwise, you are likely to create empty space that adds nothing to the picture. A horizontal format shows width side to side (see page 328), while a vertical format shows height or depth near to far (see page 321).

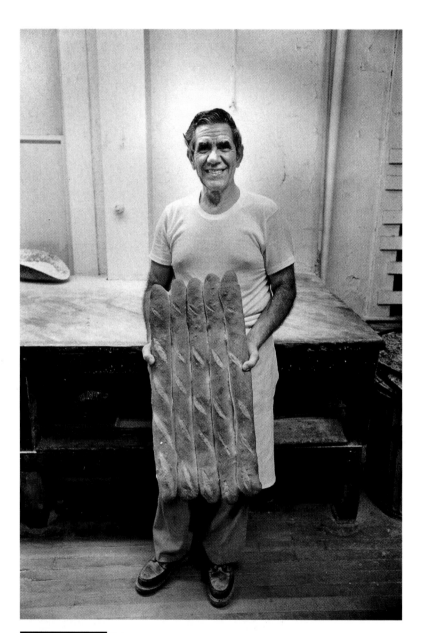

JONAS DOVYDENAS Baker

How does the frame of a photograph (its edges) enclose a subject? How much space, if any, is needed around a subject? You may overlook framing when you are shooting, but it will be immediately evident in the final picture. Above, would you crop anything in this picture, or do you like it as it is?

More about . . .

• Framing the subject, pages 332–333

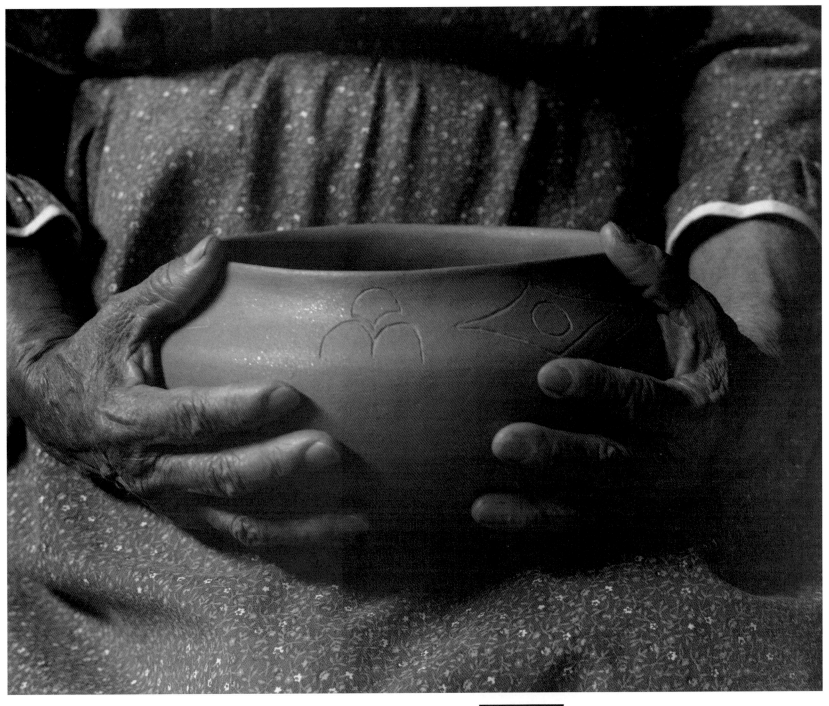

TOBA PATO TUCKER Ignacia Duran, Traditional Potter, Tesuque Pueblo, New Mexico, 1996

Toba Tucker traveled through Native American communities, photographing artists and their work. Many of her photographs were of just the artist's hands and the work. Here the hands enclose the pot and the frame encloses both.

The background is part of the picture— obvious, but easy to forget. Most photographs have a particular object or group of objects as a center of interest. When we look at a scene we tend to focus our attention on whatever is of interest to us and ignore the rest, but the lens includes everything within its angle of view.

What do you do when your subject is in front of a less interesting or even distracting background? If background objects don't add anything to a picture except visual clutter, do what you can to eliminate them or at least to minimize their importance. Usually it is easiest to change your position so that you see the subject against a simpler background. Sometimes you can move the subject instead.

A busy background will call less attention to itself if it is blurred and indistinct rather than sharply focused. Set your lens to a wide aperture if you want to make the background out of focus while keeping the subject sharp. This works best if the background is relatively far away and you are focused on a subject that is relatively close to the camera. The viewfinder of a single-lens reflex camera shows you the scene at the lens's widest aperture; if you examine the scene through the viewfinder you will get an idea of what the background will look like at that aperture. Some lenses have a preview button that stops down the lens so you can see how much of the scene will be sharp at any aperture.

Use the background when it contributes something. Even though many photographs could be improved by shooting closer to the subject, don't always zero in on a subject or you may cut out a setting that makes a picture come alive. An environmental portrait like the one on page 222 uses the background to tell you something about the subject. Backgrounds can give scale to a subject, or vice versa. And some backgrounds are what the picture is all about (see opposite page).

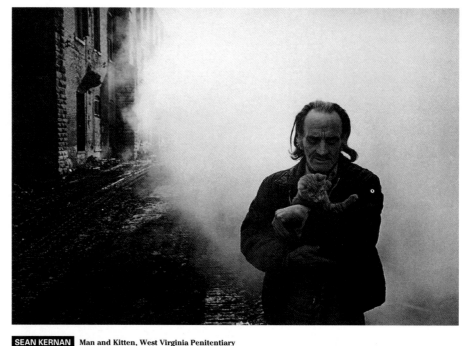

SEAN KERNAN Man and Kitten, West Virginia Penitentiary

Sean Kernan was photographing in the yard of a prison when he saw a grizzled convict playing with a kitten. Kernan made a few exposures where the man was standing (frames 3 and 4), then asked him to move near a steam vent that was blowing white into the winter air. Kernan says, "Now, after the fact, the steam seems like a crescent of purity cut into the midst of this devastation. I think the picture is of a moment when everything touched—the light, the lives, the violence and the tenderness. I had about enough presence to remember to use the camera."

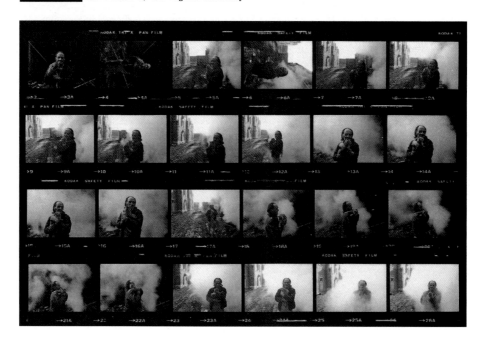

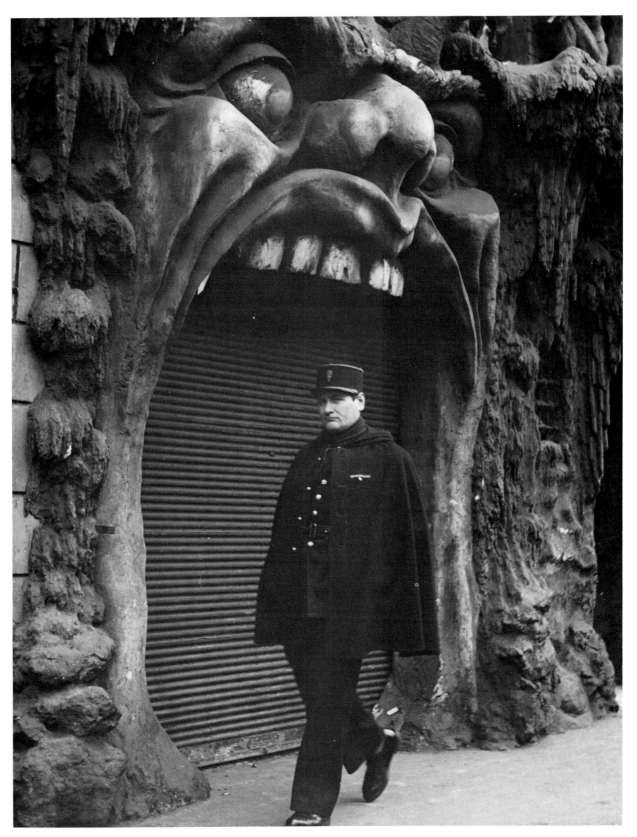

Some backgrounds make it worthwhile to set yourself up and wait until someone walks in front of them. Right, a Paris policeman crosses the entrance to an abandoned night spot, L'Enfer (Hell).

ROBERT DOISNEAU Cabaret L'Enfer, Boulevard de Clichy, Paris, 1952

What good is design? Most photographs are not constructed but are taken in a pre-existing environment from which the photographer, often working quickly, must select the best views. Nevertheless, it is still important for photographers to understand design concepts such as spot, line, shape, pattern, emphasis, and balance because certain elements of design are powerful in their ability to direct a viewer's attention.

Knowing, for example, that a single small object—a spot—against a contrasting background attracts attention will help you predict where attention will go in a photograph. Even if you want to work fast and intuitively rather than with slow precision, basic knowledge about design will fine-tune and speed up your responses and will make you better able to evaluate your own and other people's work.

A single element of design seldom occurs in isolation. Although one can talk about the effect of a spot, for example, other design elements are almost always present, moderating each other's effect. Attention might be drawn by a spot and then attracted away by a pattern of lines elsewhere in the print. The simpler the subject, the more important any single element becomes, but one element rarely totally dominates any composition. The human element may attract the most attention of all; people will search out human presence in a photograph despite every obstacle of insistent design.

Any small shape, not necessarily a round one, can act as a spot or point. The word spotlight is a clue to the effect of a single spot against a neutral or contrasting background: it draws attention to itself and away from the surrounding area. This can be good if the spot itself is the subject or if in some way it adds interest to the subject. But a single spot can also be a distraction. For instance, a small bright object in a dark area can drag attention away from the subject; even a tiny, dark dust speck can attract attention if it is in a blank sky area.

The eye tends to connect two or more spots like a connect-the-numbers drawing. If there are only two spots, the eye continues to shift back and forth between them, sometimes a confusing effect if the eye has no place on which to settle attention. If there are three or more spots, suitably arranged, the brain will make shapes—a triangle, a square, and so on—out of them.

A line is a shape that is longer than it is wide. It may be actual or implied, as when the eye connects a series of spots or follows the direction of a person's gaze. Lines give direction by moving the eye across the picture. They help create shapes when the eye completes a shape formed by a series of lines. In a photograph, lines are perceived in relation to the edges of the film format. This relationship is impossible to ignore, even when the lines are not near the edges of the print.

According to some theories, lines have psychological overtones: horizontal (calm, stability), vertical (stature, strength), diagonal (activity, motion), zigzag (rapid motion), curved (gracefulness, slowness). Horizontal objects, for example, tend to be stable, so we may come to associate horizontality with stability. In a similar way, yellows and reds conventionally have overtones of warmth by way of their associations with fire. However, such associations vary from person to person and are as much dependent on the subject as on any inherent quality in a line.

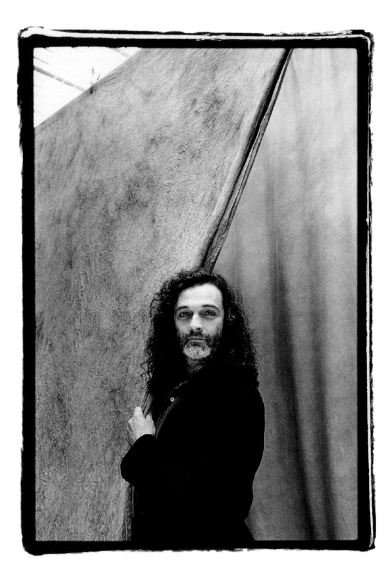

TIMOTHY GREENFIELD-SANDERS | **Mark Morris, 1995**

A line can make a strong path that is easy for the eye to follow. The line of a cloth backdrop focuses attention on the subject in this portrait of dancer-choreographer Mark Morris. This is a skillful use of what can be a problem if the intersection of line and subject is unintentional (see page 7, center).

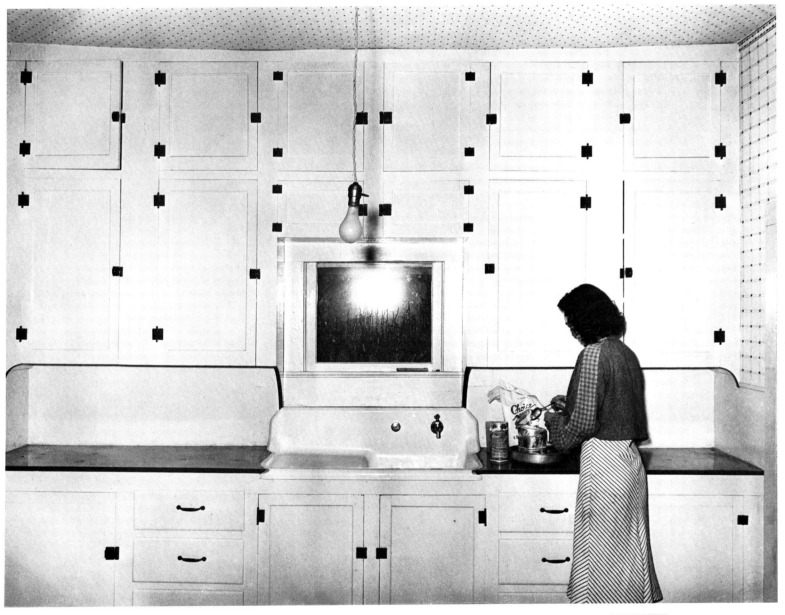

Hidalgo County, Texas, 1939

The eye tends to connect two or more spots into a line or shape. Above, the spots formed by the dark hardware against the light cabinets are an insistent element. Russell Lee often used direct flash on camera, especially in his work, as here, for the Farm Security Administration (see page 354). Lee liked direct flash because it rendered details sharply and was easy to use. It also produces minimal shadows and so tends to flatten out the objects in a scene into their graphic elements. The scene above has a harsh, clean brightness that is appealing in its austerity and to which the direct flash contributed.

A shape is any defined area. In life, a shape can be two-dimensional, like a pattern on a wall, which has height and width; or three-dimensional, like a building, which has height, width, and depth. In a photograph, a shape is always two-dimensional, but tonal changes across an object can give the illusion of depth. Notice in the illustration at right how flat the large leaf, with its almost uniform gray tone, looks compared with the light and dark ridges of the smaller leaf. You can flatten out the shape of an object entirely by reducing it to one tone, as in a silhouette. The contour or edge shape of the object then becomes dominant, especially if the object is photographed against a contrasting background (see page 103, top).

A single object standing alone draws attention to its shape, while two or more objects, such as the leaves at right, invite comparison of their shapes, including the shape of the space between them. The eye tends to complete a strong shape that has been cropped by the edge of the film format. Such cropping can draw attention repeatedly to the edge or even out of the picture area. Try cropping just into the left edge of the large leaf to see this effect.

Objects that are close together can be seen as a single shape. Objects of equal importance that are separated can cause the eye to shift back and forth between them, as between two spots. Bringing objects closer together can make them into a single unit; for example, the women on the opposite page. Portrait studio photographers try to enhance the feeling of a family as a group by posing the members close together, often with some physical contact, such as placing one person's hand on another's shoulder.

Groupings can be visual as well as actual. Aligning objects one behind the other, intentionally or not, can make a visual grouping that may be easy to overlook when photographing a fast-moving scene but which will be readily apparent in a photograph.

Multiple shots, lines, or shapes can create a pattern that adds interest and unites the elements in a scene, as do the small, dark squares in the photograph on page 323. A viewer quickly notices variations in a pattern or the contrast between two patterns, in the same way that contrast between colors or between light and dark attracts the eye.

PAUL CAPONIGRO Two Leaves, 1963

What route does your eye follow when it looks at a photograph? One path in the photograph above might be up the right edge of the larger leaf, up the curved stem, around the smaller leaf to its bright tip, then down again to make the same journey. Take a small scrap of white paper and put it over the bottom tip of the larger leaf. Does your eye follow the same path as before, or does it jump back and forth between what are now two bright spots?

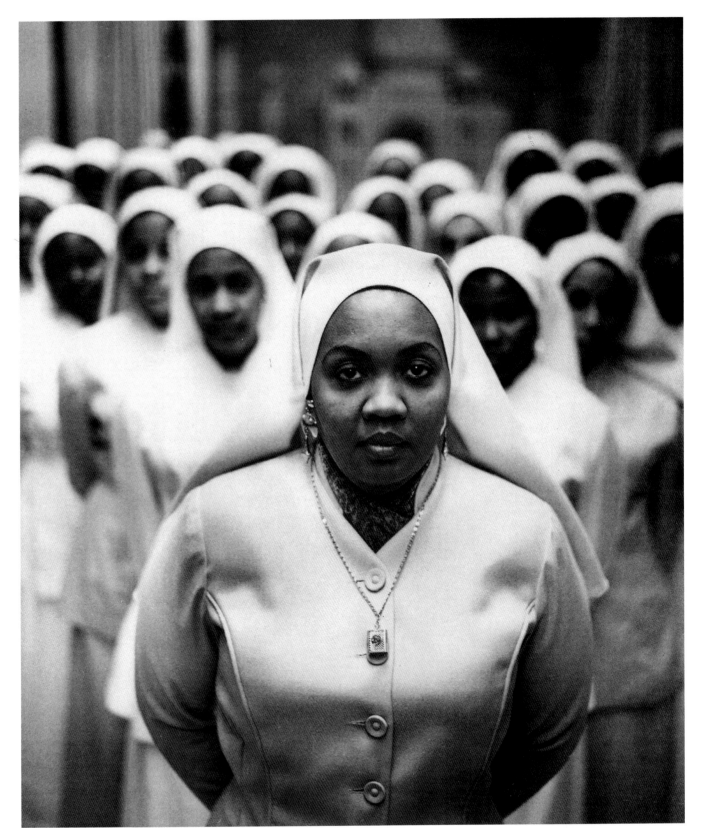

Repeated shapes can form a pattern. *A group of Black Muslim women form a solid band behind one of their leaders. Gordon Parks photographed relatively closer to the woman in front than to the others, which made her appear larger. Being closer to her also reduced the depth of field so that when Parks focused on her, only she was sharp. The individual identities of the other women have been submerged by their being out of focus and by the repeated shapes of their head-dresses forming a pattern. The picture clearly identifies the leader and makes a visual statement about the solidarity of her followers.*

GORDON PARKS Muslim Women, 1962

How do you emphasize some part of a photograph or play down another so that the viewer knows what is important and what isn't? If too many parts of a photograph demand equal attention, a viewer won't be sure what to look at first.

Contrast attracts attention. The eye quickly notices differences such as sharp versus unsharp, light versus dark, large versus small. If you want to emphasize a subject, try to show it in a setting against which it stands out. Viewers tend to look at the sharpest part of a picture first, so you can call attention to a subject by focusing it sharply while leaving other objects out of focus (see pages 328–329). The contrast of light and dark also adds emphasis; a small object can dominate a much larger background if it is of a contrasting tone or color.

Camera angle can emphasize a subject. If unnecessary clutter draws attention away from your subject, get closer. Shooting closer to an object will make it bigger while eliminating much of the surroundings. Sometimes shooting from a slightly higher or lower angle will remove distracting elements from the scene.

Use surrounding parts of the scene to reinforce emphasis. Objects that are of secondary interest, such as fences, roads, or edges, can form sight lines directed to the subject (right, top). The point at which two lines (real or implied) intersect attracts notice (see page 331), as does the direction in which people are looking. You may be able to find something in the foreground to frame the main subject and concentrate attention on it (see opposite page). A dark object may be easier than a

light one to use as a frame because lighter areas tend to attract the eye first, but this is not always the case.

People know when a picture is in balance even if they can't explain why. A picture that is balanced does not call attention to that fact, but an unbalanced one can feel uncomfortably off center or top-heavy. Visually, dark is heavier than light, large is heavier than small, an object at the edge has more weight than at the center (like a weight on a seesaw), and a picture needs more apparent weight at the bottom to avoid a top-heavy feeling.

Except in the simplest cases, however, it is difficult to analyze exactly the weights and tensions that balance a picture, nor do you need to do so. A viewer intuitively weighs complexities of tone, size, position, and other elements, and you can do the same as you look through the viewfinder. Ask yourself if the viewfinder image feels balanced or if something isn't quite right that you would like to change. Move around a bit as you continue to look through the viewfinder. Even a slight change can make a big difference.

Some tension in a picture can be an asset. A centered, symmetrical arrangement, the same on one side as it is on the other, will certainly feel balanced and possibly satisfyingly stable, but it also may be boring. Perfect balance, total harmony, and exact symmetry make little demand on the viewer and consequently can fail to arouse interest. Try some off-center, asymmetrical arrangements; they risk feeling unbalanced but may succeed in adding impact (right, bottom).

ROY CLARK Troublesome Creek, Kentucky, 1965

Lines formed by the sides and planks of the bridge focus attention on the man, as does his placement near the center of the picture. The quiet scene gets added interest from the man's dark form against the lighter boards of the bridge, his foot just raised in midstep, and the house in front of him as his visible destination.

R.O. BRANDENBERGER Skier, Idaho, 1966

An off-center, asymmetrical composition can have a dynamic energy that is absent from a centered, symmetrical one. Take some sheets of white paper and lay them over the bottom and right side of the photo above so that the skier is centered in the frame. The picture is still interesting but lacks the headlong rush that it has when the long slope of the hill is visible.

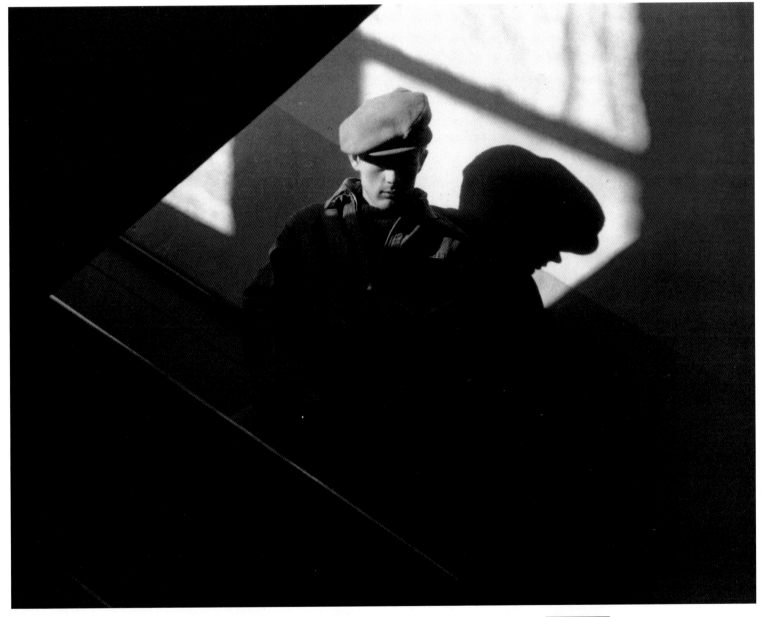

DENNIS STOCK James Dean in Light and Shadow, 1955

To emphasize your main subject, you can use a foreground object as a frame. *A portrait of the actor James Dean, made in the year of his death, uses the dark shadows of a stairwell to frame him in a diamond-shaped patch of light. Dean's image was full of contradictions—tough and sensitive, boyish and manly, polite and wild—and the photograph echoes this in its split between light and dark, face only half visible, head shown both straight on and profiled in the shadow cast on the wall.*

The sharpness of a photograph or of its various parts, is immediately noticeable. This is unlike ordinary life where, if your eyes are reasonably good, you seldom have to consider whether things are sharp or not.

People tend to look first at the sharpest part of a photograph. If a photograph is sharp overall, the viewer is more likely to see all parts of it as having equal value (this page, top). You can emphasize some part of a subject by making it sharper than the rest of the picture (see opposite).

Depth of field affects sharpness from near to far. If you focus on an object and set your lens to a wide aperture, you will decrease the depth of field (the acceptably sharp area) so that the background and foreground are more likely to be unsharp. Or you can use a small aperture to have the picture sharper overall.

Motion can be photographed either sharp or blurred. In life, moving objects appear sharp unless they are moving extremely fast, such as a hummingbird's wings. In a photograph, you can use a fast shutter speed to freeze the motion of a moving object. Or you can use a slow shutter speed to deliberately blur the motion—just enough to indicate movement or so much that the subject's shape is altered (this page, bottom). Although the sharpest part is usually emphasized because the viewer tends to look there first, occasionally, blurred motion attracts attention because it transmits information about how fast and in what manner the subject is moving.

A gain in motion sharpness can mean a loss in depth of field. If you change to a faster shutter speed to render motion sharply, you have to open to a larger aperture to keep the exposure the same. Since a larger aperture gives less depth of field, you may have to decide whether the motion sharpness is more important than the sharpness of depth of field. It may be impossible to have both.

U.S. DEPARTMENT OF AGRICULTURE Family and Food, 1981

Pictures that convey data are often sharp overall. The United States Department of Agriculture photographed (left to right) Cynthia, John, Clint, and Valerie Schnekloth of Eldridge, Iowa, surrounded by the two-and-a-half tons of food an American family of four can consume in a year.

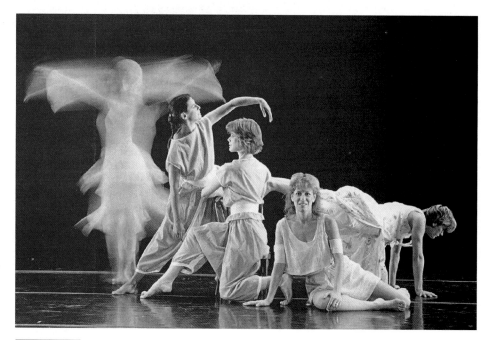

BONNIE KAMIN Dancers

Even a "still" photograph can give an impression of time and movement. In this photograph of dancers, Bonnie Kamin used a relatively slow shutter speed. The contrast between the blur of the moving dancer and the sharpness of those that are not moving makes the blurred area look even more in motion than if all the dancers had been blurred.

More about . . .

- The relationship between shutter speed and aperture, pages 24–25

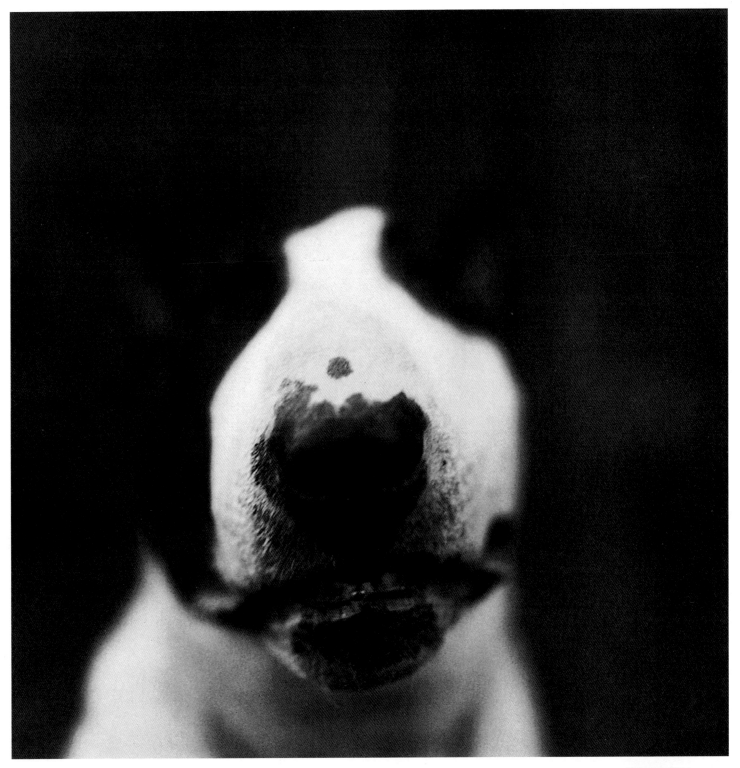

You can give importance to some part of a subject by making it sharper than the rest of the picture. *What is more important to a dog than its nose? "I try not to be too serious," says Carter, "but give [the subject] dignity, and hope some sort of magic creeps in and makes it more than appears to the eye." See also the Carter photograph on page 49.*

Contrast between light and dark draws a viewer's eye. A farmer's hands against a dark background, the outline of a leafless tree against a bright sky, a rim of light on someone's hair, a neon sign on a dark street—light not only illuminates a subject enough to record it on film but by itself can be the subject of a photograph.

Contrast sets off one part of a scene from another. Would you put a black ebony carving against a dark background or a light one? The dark background might make a picture that would be interesting for its somber tones. The light one would make a setting against which the carving would stand out prominently, just as a dark background contrasts with and sets off light tones (photograph, right). If you squint as you look at a scene, you can often get a better idea of what the tones will look like in a print and whether you should change your angle or move the subject to position it against a better background.

Contrast between two objects may be more apparent in color than in black and white. A red flower against green leaves is distinctly visible to the eye but may merge disappointingly into the foliage in a black-and-white print. The brightness of the flower is very similar to that of the leaves even though the colors are different. A lens filter can adjust the relative darkness of different colored objects.

Light along the edge of an object can make its shape stand out. If you chose to work with a dark background for an ebony statue, you could use edge lighting to make sure the statue didn't merge into the shadows behind it. Studio photographers often position a light so that it spills just over the edge of a subject from the back, making a bright outline that is effective against a darker background. Outdoors, the sun can create a similar effect if it illuminates the back or side of an object rather than the front.

Shadows or highlights can be shown as separate shapes. The contrast range of many scenes is too great for photographic materials to record realistically both dark shadows and bright highlights in one picture. This can be a problem, but it also gives you the option of using shadows or highlights as independent forms.

You can adjust contrast somewhat during film processing and printing. Once film has been processed, the relative lightness or darkness of an area is fixed on the negative, but you can still change tones to some extent during printing by such techniques as changing the contrast grade of the paper or printing filter, burning in (adding exposure to darken part of a print), and dodging (holding back exposure to lighten an area). Contrast control with black-and-white prints is relatively easy; color prints allow less manipulation.

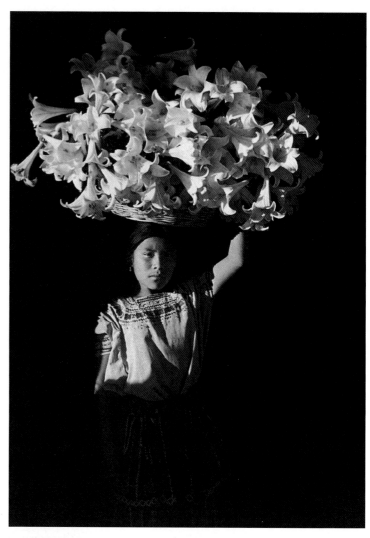

FLOR GARDUÑO Basket of Light, Guatemala, 1989

Film may show shadows as darker than they seemed during shooting. Our eyes make adjustments for differences in light level, but film can emphasize details in only a fixed range of brightnesses. So a photograph may emphasize shapes of light and dark that in life do not seem so prominent.

More about . . .

• Filters to control contrast in a black-and-white photograph, pages 82–84

BILL HEDRICH Oakton Community College, Des Plaines, Illinois, 1981

Contrast between light and dark attracts the eye. *The photographer chose a time of day and vantage point that emphasized the diagonal line of the stairs crossing with the building's own shadow. Notice how he placed two people at the crossing point and positioned the people at right so their shadows line up with the edge of the building. Bill Hedrich's architectural photographs are noted for being dramatic, but they are also truthful renditions of a building's features.*

Placing the Subject within the Frame

Careful placement of a subject within the frame can strengthen an image. If you look at a scene through a camera's viewfinder as you move the camera around, you will probably see several choices for positioning the subject within the frame of the film format: dead center or off to one side, high or low, at one angle or another. Placement can draw attention to or away from a part of a scene. It can add stability or create momentum and tension. Some situations move too fast to allow any but the most intuitive shooting, but often you will have time to see what the effect will be with the subject in one part of the frame rather than another.

The most effective composition arises naturally from the subject itself. There are traditional formulas for positioning the center of interest (see box, right), but don't try to apply them rigidly. The goal of all the suggestions in this chapter is not to provide a set of rules but to help you become more flexible as you develop your own style. The subject may also have something to say if you can hear it. Minor White, who was a teacher as well as a photographer, used to tell his students to let the subject generate its own composition.

The horizon line—the dividing line between land and sky—is a strong visual element. It can be easy, without much thought, to position the horizon line across the center of a landscape, dividing a scene into halves. Some photographers divide a landscape this way as a stylistic device, but unless handled skillfully, this can divide a picture into two areas of equal and competing interest that won't let the eye settle on either one. One suggestion for placement is to divide the image in thirds horizontally, then position the horizon in either the upper or lower third (photograph, this page). You can also try putting the horizon very near the top or the bottom of the frame.

Stop for a moment to consider what you want to emphasize. A horizon line toward the bottom of the frame emphasizes the sky. A horizon toward the top lets you see more of the land but still includes the strong contrast of sky. Omitting the horizon altogether leaves the eye free to concentrate on details of the land. Even if no horizon line is visible, a photograph can feel misaligned if the camera is tilted to one side. Unless you want to tilt a picture for a purpose, always level the camera from side to side; for a tilt on purpose, see page 314.

Motion should usually lead into, rather than immediately out of, the image area. Allow enough space in front of a moving subject so it does not seem uncomfortably crowded by the edge of the frame. The amount of space depends on the scene and your own intention. In a photograph, the direction in which a person (or even a statue) looks is an implied movement and requires space because a viewer tends to follow that direction to see what the person is looking at. Although it is usually best to allow adequate space, you can add interest to some scenes by framing a subject so that it looks or moves directly out of the picture area.

A subtler tension may be added by movement of a subject from right to left. For example, for people whose written language reads from left to right, a subject with strong left-to-right movement may seem slightly more natural or comfortable than a subject with strong right-to-left motion. You can see if you get this effect by looking at the photograph of the skier on page 326 and then looking at it in a mirror to reverse the subject's direction.

ROBERT BRANSTEAD Along the Snake River, Wyoming, 1971

The conventional placement for a horizon line in a landscape is more or less in the upper (or lower) third of the picture. (The lightness of the grass and trees is due to the use of infrared film. See pages 80–81.)

Compositional formulas

Rules of photographic composition were proposed in the 19th century based on techniques used by certain painters of the period. The rule of thirds, for example, was (and still is for some photographers) a popular compositional device. Draw imaginary lines dividing the picture area into thirds horizontally, then vertically. According to this formula, important subject areas should fall on the intersections of the lines or along the lines. A person's face, for example, might be located on the upper left (theoretically the strongest) intersection, a horizon line on either the upper or lower horizontal line, and so on.

Try such formulas out for yourself. Experimenting with them will make you more aware of your options when you look at a scene, but don't expect a compositional cure-all for every picture. Look at photographs that work well, such as the one opposite or on page 41, to see if they fit a particular rule. If they don't, what makes them successful images?

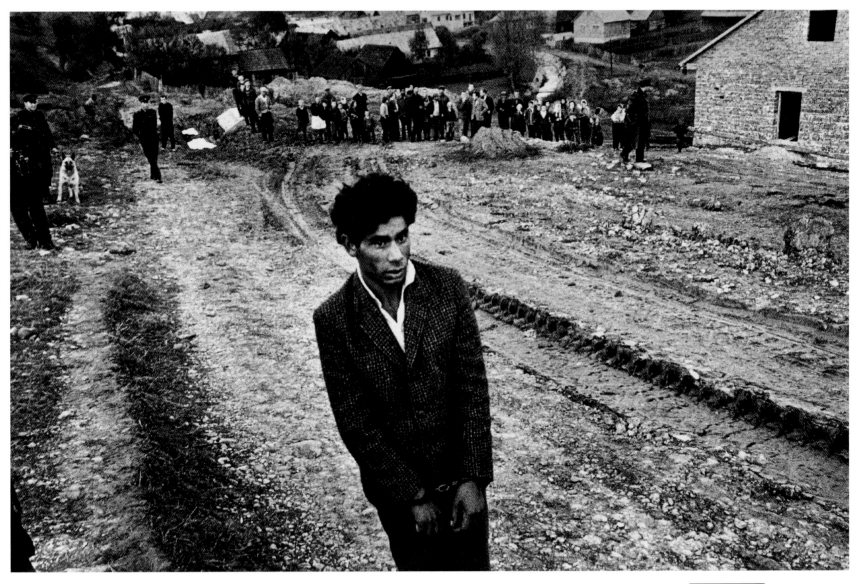

The most extraordinary photographs merge composition with content on a level that rules do not explain. *Above, one of many photographs made by Josef Koudelka showing Gypsies of Eastern Europe. The man, having been found guilty of murder, is on the way to the execution ground.*

John Szarkowski wrote about this photograph, "The handcuffs have compressed his silhouette to the shape of a simple wooden coffin. The track of a truck tire in the earth, like a rope from his neck, leads him forward. Within the tilted frame his body falls backward, as in recognition of the terror."

The relative distance of objects from the lens and from each other affects perspective, the illusion of three dimensions in a two-dimensional photograph. The brain judges depth in a scene mostly by comparing the size of objects in the foreground with those in the background; the bigger the apparent difference in the size of similar objects, the greater the distance between them seems to be. Move some object (or some part of it) very close to the lens, and it will look much bigger and therefore much closer than the rest of the scene. Parallel lines that appear to converge (to meet in the distance) are another strong indicator of depth (see photograph, page 81). The convergence is caused by the nearer part of the scene appearing bigger than the farther part.

Other factors affect perspective to a lesser degree. A sharply focused object may appear closer than out-of-focus ones. Side lighting enhances the impression of volume and depth, while front lighting or a silhouette reduces it. The lower half of a picture appears to be (and generally is) closer than the upper half. Overlapping objects also indicate which is closer. Warm colors (reds and oranges) often appear to come forward, while cool colors (blues and greens) appear to recede. In general, light-toned objects often appear to be closer than dark ones, with an important exception: atmospheric haze makes objects that are farther away lighter in tone than those that are closer, and a viewer recognizes this effect as an indication of distance in a landscape. Another factor is less consciously perceived by many people but still influences their impression of depth: objects appear to rise gradually relative to a viewer's position as they approach the horizon (see landscape, this page).

Photographs of landscapes often gain from an impression of depth. When depth is absent, for example in most people's vacation snapshots, they have to tell you how wonderful the scenery was because their pictures make even the Grand Canyon look flat and boring. To extend the impression of depth, especially in landscapes but also in any scene, try some or all of the following. Position some object in the foreground; if similar objects (or others of a known size) are farther away, the viewer will make the size comparisons that indicate depth. Position the horizon line in the upper part of the picture. Introduce lines (particularly converging ones), such as a road or a fence, that appear to lead from foreground to background.

Your point of view or vantage point can have a strong influence. An eye-level point of view is unobtrusive in a photograph, but shooting from higher or lower than eye level is more noticeable. Photographing an object by looking up at it can give it an imposing air as it looms above the viewer. Vertical lines, as in a building, appear to converge when the camera is tilted up, increasing the feeling of height. Looking straight down on a subject produces the opposite effect: objects are flattened out.

A moderate change in camera angle up or down can give a slight shift to the point of view, making a subject appear somewhat bigger or somewhat smaller without unduly attracting the viewer's attention. When you approach a scene, don't always shoot at eye level or in the first position from which you saw the subject. Look for interesting angles, the best background, or other elements that could add interest.

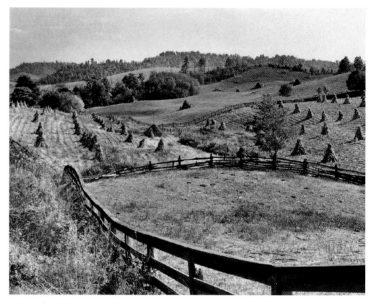

MARION POST WOLCOTT Fields of Shucked Corn, West Virginia, 1940

A standard recommendation for landscape photography is, "Put something in the foreground to give the scene depth." The reason that this device is used so often is that it does give a feeling of depth. Our perception of depth is mostly due to size comparisons between near and far objects, and in the photograph above, it is easy to compare the size of the fence rails in the foreground with those at the end of the field.

It is your handling of whatever you put in the foreground that can rescue a well-used device of this sort from being a cliché. So many photographers have sighted along a fence or randomly included a branch of a tree across the top of a scene that it can be hard to see past the device itself. Here, the device gains interest because the line of the fence also draws the eye from the foreground deeper into the scene, and then down the rows of corn even farther away.

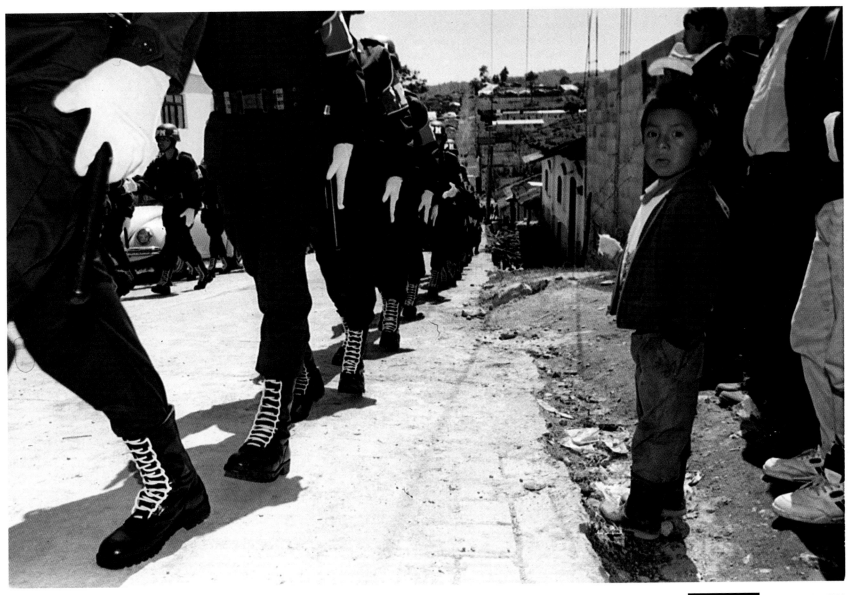

Chiapas, Mexico, 1996

Shooting from the subject's point of view can create an intimacy with the subject. *The photograph—and so the viewer— join the scene instead of impassively observing it from above. Here, a local child stands by as troops arrive to take position around a building prior to the start of negotiations between government officials and Zapatista rebels. The viewer sees the rifles and boots from the child's point of view, a much more emotional view than seeing the scene with the grownups.*

Looking at—and Talking About—Photographs

Photographs are made in order to convey a certain vision or idea, perhaps the beauty of a transcendent landscape or the gritty look of a downtown street. Even snapshots are not made randomly: "I was in Paris" is a typical message from a snapshot. What vision or idea can be found in a particular photograph, and what graphic elements convey it to the viewer? You may never know exactly what the photographer intended, but you can identify the meaning that a photograph has for you. Following are some questions you can ask yourself when you look at a photograph. You don't need to ask every question every time, but they can give you a place to start. The box at right lists some terms that can help describe visual elements.

1. **What type of photograph is it?** Sometimes this is clear from the context: an advertising photograph in an ad, a news photograph on the front page. A caption or title can provide useful information, but look at the picture first so that the caption does not limit your response.

2. **What can you tell (or guess) about the photographer's intention?** For example, is an advertising photograph intended to convey specifics about the product? Or is it meant to say something about the beautiful (or macho or lovable) people who use this product, with the implication that if you use it you will look and feel just like they do?

3. **What emphasis has the photographer created and how has that been done?** For example, has selective focus been used so that the most important part of the scene is sharp, while less important parts are not?

4. **Do technical matters help or hinder the image?** For example, is the central element—perhaps someone's expression—lost in extraneous detail because the photographer was not close enough?

5. **Are graphic elements such as tone, line, or perspective important?** What part of the photograph do you look at first? How does your eye move around the photograph? Does it skip from one person's face to another, follow a curved line, keep returning to one point?

6. **What else does the photograph reveal** besides what is immediately evident? If you spend some time looking at a photograph, you may find that you see things that you did not notice at first. A fashion photograph may give information about styles but say even more about the social roles that men and women play in our culture. A scientific photograph of a distant star cluster may have been made to itemize its stars but can also evoke the mystery of the universe.

7. **What emotional or physical impact does the photograph have?** Does it induce sorrow, amusement, peacefulness? Does it make your skin crawl, your muscles tense up, your eyes widen?

8. **How does this photograph relate to others** made by the same photographer, in the same period, or of the same subject matter? Is there any historical or social information that helps illuminate it? Is there a connection to art movements? Such knowledge can lead to a fuller appreciation of a work.

One caution when talking or writing about photographs: Eschew obfuscation. In other words, speak plainly. Don't try to trick out a simple thought in fancy dress, especially if you don't have much to say. See how you actually respond to a photograph and what you actually notice about it. A clear, simple observation is vastly better than a vague, rambling dissertation.

Visual elements

Following are some of the terms that can be used to describe the visual or graphic elements of a photograph. See the page cited for an illustration (and often a discussion) of a particular element.

Light
Frontlit: Light comes from camera position, few shadows (page 225 right)
Sidelit: Light comes from side, shadows cast to side (page 225 left)
Backlit: Light comes towards camera, front of subject shaded (page 224)
Direct light: Hard-edged, often dark, shadows (page 226 left)
Directional-diffused light: Distinct, but soft-edged shadows (page 226 right)
Diffused or revealing light: No, or almost no, shadows (page 227)
Silhouette: Subject very dark against light background (page 103 top)
Glowing light: Light comes or seems to come from subject (page 191)

Tone and contrast
High key: Mostly light tones (page 103 bottom)
Low key: Mostly dark tones
Full scale: Many tones of black, gray, and white (page 149 top right)
High contrast: Very dark and very light areas, with few middle grays (page 327)
Low contrast: Mostly middle grays (page 151 top right)

Texture
Emphasized: Usually due to light hitting the subject at an angle (page 248 top)
Minimized: Usually due to light coming from camera position (page 248 bottom)

Focus and depth of field
Sharp overall: (page 328 top), **soft focus** (page 361 top)
Selective focus: One part sharp, others not (page 329)
Shallow depth of field: Short distance between nearest and farthest sharp areas (page 51)
Extensive depth of field: Considerable distance between nearest and farthest sharp areas (page 50)
Frame: The way the edges of the photograph meet the shapes in it (pages 318–319)

Viewpoint
Eye-level (page 334)
Overhead, **low level** (page 335 right), or other **unusual** point of view

Space and perspective
Shallow space: Most objects seem close together in depth (page 51)
Deep space: Objects seem at different distances in space (page 203)
Positive space or figure: The most important form.
Negative space or ground: That which surrounds the figure. Figure and ground are not always fixed and can reverse.
Compressed perspective or telephoto effect: The scene seems to occupy an unusually shallow depth (page 58)
Expanded perspective or wide-angle distortion: Parts of the scene seem stretched or positioned unusually far from each other (page 59)

Line
Curved (page 324), **straight** (page 322), **broken** (page 327)
Horizontal (page 302), **vertical** (page 321), **diagonal** (page 331), **implied** such as by the direction someone is looking (page 337)

Balance
An internal, physical response. Does the image feel in balance or does it tilt or feel heavier in one part than another?

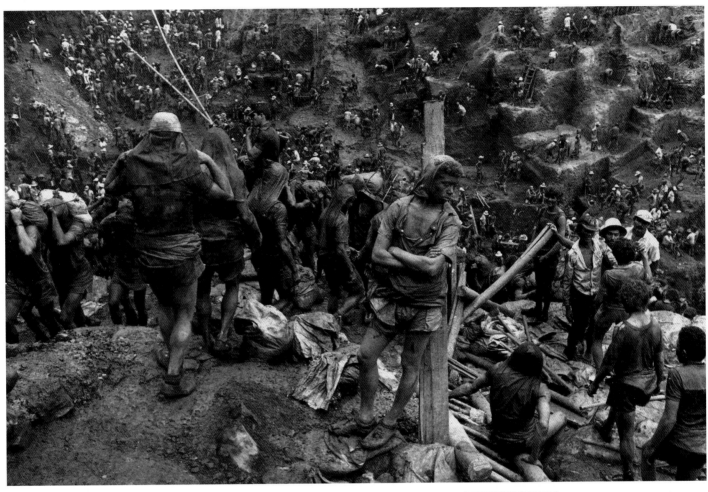

What does a photograph say to you? *Suppose you didn't know anything about this photograph. What does it reveal? What do you notice first when you look at the picture? What do the workers, especially at a distance, remind you of? What does that say about their activity? Does this photograph feel like it was made a long time ago? Does it remind you of past civilizations? Which ones?*

How does your knowledge, culture, and life experience affect your interpretation? Are you horrified to imagine yourself working day after day in this way? Are you inspired by the power of human spirit, strength, and perseverance? Is there a tension created by how the photograph might be interpreted?

How does the photographer's technique affect the image? How does the depth of field (everything sharp

from near to far) and scale of the objects (normal size in the foreground to tiny figures in the background) affect your perception? Does the photograph being in black and white rather than color have any effect?

How does the composition move your eye? Is there one part of the photograph that draws your attention? The man at the post is looking at an angle. Is there an implied diagonal line along the direction he is looking that also extends to the upper left side? What other shapes in the picture contribute to the implied line?

Does the man at the post symbolize or suggest anything to you? How might that affect the meaning of the photograph?

Sebastião Salgado has pursued personal projects such as photographing laborers throughout the world, including those in sugar fields in Cuba, slaughterhouses

in the American Midwest, and a steel plant in the Soviet Union. In the Amazon region of northern Brazil, he photographed workers excavating an open pit gold mine. Fifty thousand men swarm over the manmade hole the size of a football field. The mine is divided into small concessions 20 ft square, each worked by a team of 10 people, including diggers, carriers, and supervisors. As the men dig deeper into the muddy pit looking for good nuggets, unwanted soil is shoveled into sacks weighing as much as 130 lb, then carried up to the top of the crater.

In an introduction to Salgado's book An Uncertain Grace, Eduardo Galeano wrote "This is a stripped-down art. . . . The profoundest sadness of the universe is expressed without offering consolation, with no sugar coating. In Portuguese, salgado means 'salty.'"

Showing Your Work to Editors and Others

Suppose you decide to show your work to an editor, agency, potential client, gallery, or museum. What kind of work should you show? Editors, agents, and clients are looking for specific types of work, and you should tailor your portfolio to show them pictures they can use. Gallery and museum people, on the other hand, want to see your personal point of view. All of them give the same advice: Don't pad your portfolio. Putting mediocre pictures in with good ones produces a mediocre portfolio.

Mel Scott, Freelance Picture Editor. Formerly an Assistant Picture Editor at *Life* magazine, Scott now works on a variety of picture-editing assignments. "Never," Scott advises, "pad a portfolio. Show your absolute best, not your whole life's work. Don't show one great landscape with ten mediocre ones; the bad ones will only dilute the impact of the great one." He says that photographers should show the kinds of pictures the magazine uses. For example, *Life* now publishes very little news, so there is no point in showing them news pictures. Professionalism is important; editors' days are tightly scheduled, so arrive on time if you are given an appointment.

Scott files a 3 x 5 card for every photographer he sees and then uses that file as a source of names when looking for a photographer. Picture editors often pass names on to each other, so he says not to be discouraged if no work comes right away.

Bob Lynn, Assistant Managing Editor/Graphics, *The Virginian-Pilot*, Norfolk, Virginia. Lynn (above, right) oversees photography, among other tasks, for his newspaper. When he opens a portfolio, he hopes he will find images that surprise him, not clichés or even good but standard work. "I want someone who can see ordinary events in a different way, yet still tell the story." He suggests that photographers show only work of which they are proud. People often try to prove to him that they can shoot sports, spot news, general features, and every other photojournalism category, and as a result they include lesser pictures. When they do, he wonders if they can tell good work from bad. "If you don't have it, don't show it."

Andy Grundberg, Director, The Friends of Photography, San Francisco. For shows at The Friends' Ansel Adams Center for Photography, Grundberg says he is looking for "work that is not safe and conventional, for things that I haven't seen before." Grundberg says that photographers must put their own work in context. "Look at everybody else's work—how it is presented, the quality of it." He recommends that you don't make your portfolio physically difficult to see. Wrapping prints individually, putting a tissue under an overmat, and introducing other protective barriers can be time consuming and frustrating to viewers, especially when they might have 20 other portfolios to look at that day.

Mary Virginia Swanson, Swanstock. Swanstock is a photographic stock agency that specializes in selling fine-art photographs to magazines, advertising agencies, and other commercial users. Stock photographs are those that a photographer already has made, as opposed to photographs done on assignment for a particular job. She suggests that if you want to get the attention of art directors and other commercial users, you should target your market very specifically. "Pay attention to the commercial uses of photography that you respond to and like. Get the name of the art director. It's easy to do. Call the company and ask for the corporate communications department or marketing and get someone to tell you who does their advertising and who the art director is. Those are your future mailing list names. Build a 50-name targeted mailing list. I don't believe in buying mailing lists. Why send out a lot of flyers to people whose tastes you don't know?"

Suppose you want to sell to book publishers. "Go to bookstores and look for people who used pictures well on book jackets, not layered or sliced and diced. Don't waste your time with competitions to be in a big book. Do targeted marketing to people who make sense to you."

She suggests you do the same thing with internships. "Find the ten photographers you respect the most and write them first. One of them might say, Yes. If you need to take a day job, "Choose something that will influence you in a positive way. If you make mural prints, get a job at a lab or facility that makes big prints. Think about what is going to help your work, then try to pick a day job that will feed you."

Andrew Smith, Owner and Director, Andrew Smith Gallery, Santa Fe. Smith doesn't look at individual portfolios at his gallery, but will do so at public events where groups of portfolios are on display. Shows like the Houston FotoFest are excellent places to show work. "You're there one on one with a variety of people in the field," Smith says. "It's an opportunity to find out what's really going on."

Try to avoid the commonest mistakes people make. For example, if you have two pictures that are pretty much the same, don't put both in your portfolio. "That's the sin of not editing."

Get familiar with the history of photography. It's a mistake to copy what has already been done, even if you are doing so inadvertently. If you are making landscapes, you need to know the work of people like Minor White, Paul Caponigro, and Elliot Porter. "Student work is often influenced by their teachers, so you need time to find your own voice. See what your teachers didn't teach you."

Smith advises that you have to promote your work actively. Show it to editors and book publishers, show at smaller or non-profit galleries, open your own gallery with some colleagues. He cautions, "Embrace rejection. You're likely to get rejected until you get well along in your career. Be prepared for long suffering."

Elizabeth Kay, Curator, Andrew Smith Gallery, Santa Fe. Kay suggests that you keep showing your work even if several galleries have turned you down. "It's hard for anyone to go into a gallery to show work. Keep entering your work in shows, build up your resumé, assemble any articles about yourself in a press kit, put galleries on your mailing list and send them items like announcements about a show. It's important for them to see that you are active. There are as many personalities out there as there are galleries; it may take a while until you find the one that clicks with you. Persistence counts."

When you bring work to a gallery, Kay suggests that you show only your strongest work. "It's better to bring in five great images than 35 of mixed quality. Gallery people have been looking at photographs for a long time. They can discern quality—or the lack of it—in a split second. If you're the slightest bit doubtful about an image, don't show it."

What should a photographer expect a gallery to do when they do offer a show? "Every gallery is different. You might have to pay for your own frames and shipping, plus half of any advertising. Negotiation may be possible, so don't be afraid to offer, for instance, a trade of some prints for ads. Typically, galleries today take 50 percent of any sales."

Coni Kaufman, Picture Editor, Delta Air Lines *Sky* Magazine. Magazines like *Sky* are the ones you find on the airplane in the pocket of the seat in front of yours. Kaufman advises that technical considerations like color quality and presentation are important. "I really like color saturation—sharp, true color." She notes that an image is easier to see in large format. If you shoot in 35mm, a 70mm dupe makes the viewing easier and often more likely to be picked simply because it can be seen better.

Arthur Ollman, Director, Museum of Photographic Arts, San Diego. Showing your work to a museum (and many galleries) almost always involves a drop-off. You bring or mail your portfolio to the museum, then get it back in a week or two. The experience may feel cold, but, says Ollman, the problem is time. He and his staff receive about 40 portfolios a month and look at all of them. He doesn't have the time to meet with each photographer, nor does he feel it is his job to critique work. If Ollman is interested, he will request more information. He does include a standard thank-you letter when he returns a portfolio; some museums don't do that much.

Ollman looks for a distinctive body of work that focuses on some idea with intensity. He feels that many photographers show work without having first employed much self-criticism. Museum and gallery people are thoroughly familiar with the history of photography. "It's not enough to show work that looks like Ansel Adams's. You have to produce your own ideas." He advises photographers to show only their best, and not to get discouraged. "If your work doesn't fit here, it may fit somewhere else."

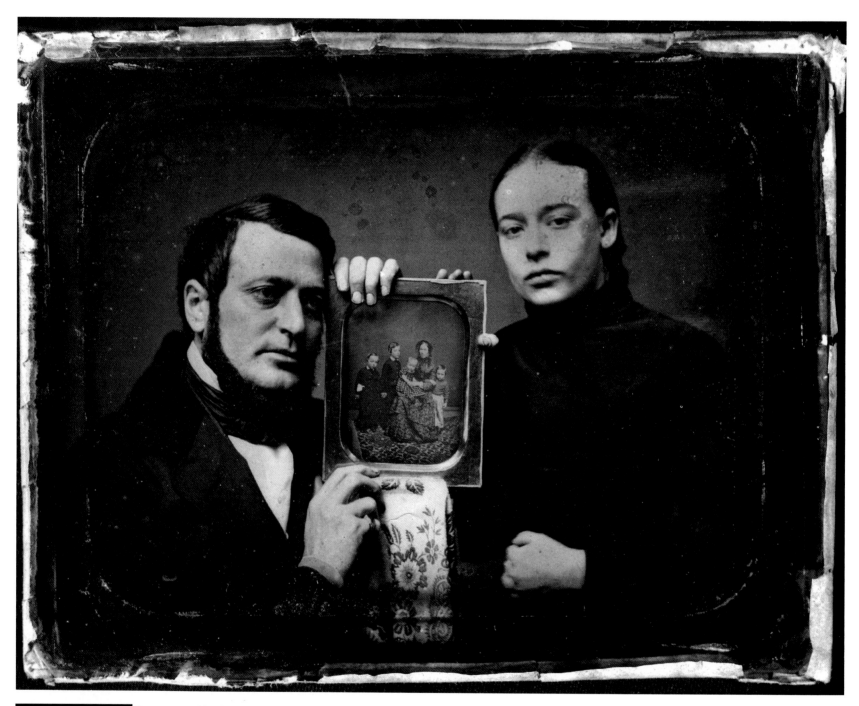

PHOTOGRAPHER UNKNOWN Daguerreotype of Couple Holding a Daguerreotype, c. 1850

In the 19th century, photographs of people who were dead or unable to be present were often included in family photographs. *It is tempting to try to interpret the relationships among the people shown here. The man holds the daguerreotype carefully, his fingers loose and relaxed; he even touches his head to the frame. The woman makes a minimum of contact with the photograph with her right hand and clenches her left hand into a fist. She stares directly into the lens, the corners of her mouth pulled down, unlike the man, who softly gazes into space as if recalling a dear memory. The photograph is revealing, but still unexplained.*

Photography was one of the many inventions of the 19th century—the electric lamp, the safety pin, dynamite, and the automobile are just a few—and of all of them, photography probably created the most astonishment and delight. Today most people take photographs for granted, but early viewers were awed and amazed by the objective records the camera made.

Photography took over what previously had been one of the main functions of art—the recording of factual visual information, such as the shape of an object, its size, and its relation to other objects. Instead of having a portrait painted, people had "Sun Drawn Miniatures" made. Instead of forming romantic notions of battles and faraway places from paintings, people began to see first-hand visual reports. And soon photography became an art in its own right.

This chapter explores some of the rich variety of materials and images in the history of photography. See the Bibliography for other sources.

The Invention of Photography

They said it couldn't be done. "The wish to capture evanescent reflections is not only impossible, as has been shown by thorough German investigation, but the mere desire alone . . . is blasphemy." Thus thundered a German publication, *Leipziger Stadtanzeiger,* in 1839 in response to the first public announcement of the invention of a successful photographic process. Such disbelief is surprising, since most of the basic optical and chemical principles that make photography possible had long been established.

The camera obscura was the fore-runner of the modern camera. Since at least the time of Aristotle, it had been known that rays of light passing through a pinhole would form an image. The 10th-century Arabian scholar Alhazen described the effect in detail and told how to view an eclipse of the sun in a camera obscura (literally, "dark chamber"), a darkened room with a pinhole opening to the outside.

By the time of the Renaissance, a lens had been fitted into the hole to improve the image, and the room-sized device had been reduced to the size of a small box that could easily be carried about. The camera obscura became a drawing aid that enabled an artist to trace an image reflected onto a sheet of drawing paper.

What remained to be discovered was a way to fix the camera obscura image permanently. The darkening of certain silver compounds by exposure to light had been observed as early as the 17th century, but the unsolved and difficult problem was how to halt this reaction so that the image would not darken completely.

The first permanent picture was made by Joseph Nicéphore Niépce, a gentleman inventor living in central France. Niépce's experiments with lithography led him to the idea of attempting to take views directly from nature using the camera obscura. He first experimented with silver chloride, which he knew darkened on exposure to light, but then turned to bitumen of Judea, a kind of asphalt that hardened when exposed to light.

Niépce dissolved the bitumen in lavender oil, a solvent used in varnishes, then coated a sheet of pewter with the mixture. He placed the sheet in a camera obscura aimed through an open window at his courtyard and exposed it for eight hours. The light forming the image on the plate hardened the bitumen in bright areas and left it soft and soluble in dark areas. Niépce then washed the plate with lavender oil. This removed the still-soft bitumen that had not been struck by light, leaving a permanent image (right, top). Niépce named the process heliography (from the Greek *helios*, "sun," and *graphos*, "drawing").

News of Niépce's work reached another Frenchman, Louis Jacques Mandé Daguerre. Daguerre had been using the camera obscura for sketching and had also become interested in trying to preserve its images. He wrote Niépce suggesting an exchange of information, and by 1829 had become his partner.

The mid-19th century was ripe for an invention like photography. In Western countries a rising middle class with money to spend wanted pictures, especially family portraits, which until then only the rich had been able to afford. In addition, people were interested in far-away places; they traveled to them when they could and bought travel books and pictures when they could not. Niépce did not live to see the impact that photography was to have. He died in 1833, several years before Daguerre perfected a process that he considered different enough from Niépce's to be announced to the world as the daguerreotype (right, bottom).

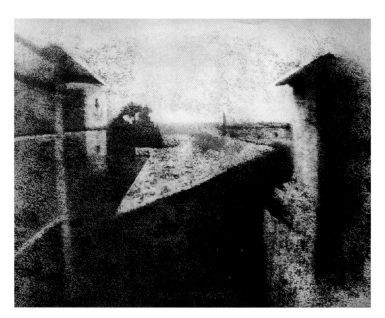

JOSEPH NICÉPHORE NIÉPCE View from His Window at Gras, c. 1826. Heliograph

Niépce produced the world's first photographic image—a view of the courtyard buildings on his estate in about 1826. It was made on a sheet of pewter covered with bitumen of Judea, a kind of asphalt that hardened when exposed to light. The unexposed, still soft bitumen was then dissolved, leaving a permanent image. The exposure time was so long (eight hours) that the sun moved across the sky and illuminated both sides of the courtyard.

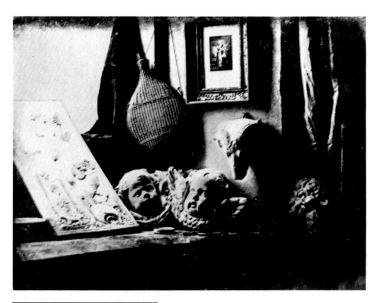

LOUIS JACQUES MANDÉ DAGUERRE Still Life in the Artist's Studio, 1837. Daguerreotype

The earliest known daguerreotype is by the inventor of the process, Louis Daguerre. The exposure was probably several minutes long—much less than the eight hours required by Niépce's heliograph, and the results were far superior—rich in detail and tonality. The enthusiastic reception of Daguerre's process extended to poetry: "Light is that silent artist / Which without the aid of man / Designs on silver bright / Daguerre's immortal plan."

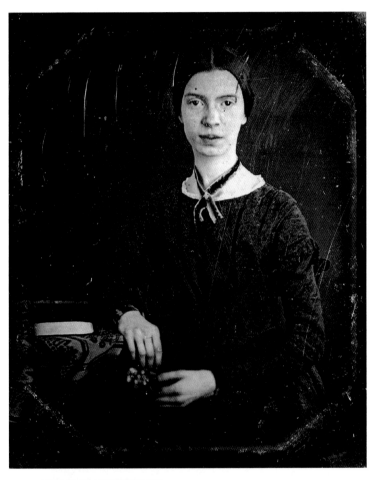

PHOTOGRAPHER UNKNOWN Emily Dickinson at Seventeen, c. 1847. Daguerreotype

The daguerreotype reached the height of its popularity in America. Millions of Americans, famous and obscure, had their portraits made. Although the exposure time was reduced to less than a minute, it was still long enough to demand a quiet dignity on the part of the subject. This portrait, taken by an itinerant daguerreotypist, is the only known photograph of the 19th-century poet Emily Dickinson. Just like her poems, it seems direct on the surface but elusive on more intimate levels. Dickinson later described herself as "small, like the wren; and my hair is bold, like the chestnut burr; and my eyes, like the sherry in the glass that the guest leaves."

The response to the daguerreotype was sensational. After experimenting for many years, both with Niépce and alone, Daguerre was finally satisfied with his daguerreotype process, and it was announced before the French Academy of Sciences on January 7, 1839. A French newspaper rhapsodized: "What fineness in the strokes! What knowledge of chiaroscuro! What delicacy! What exquisite finish! . . . How admirably are the foreshortenings given: this is Nature itself!" A British scientist was more specific: "The perfection and fidelity of the pictures are such that on examining them by microscopic power, details are discovered which are not perceivable to the naked eye in the original objects: a crack in plaster, a withered leaf lying on a projecting cornice, or an accumulation of dust in a hollow moulding of a distant building, are faithfully copied in these wonderful pictures." A daguerreotype viewed close up is still exciting to see. No printing process conveys the luminous tonal range and detail of an original.

Almost immediately after the process was announced, daguerreotype studios were opened to provide "Sun Drawn Miniatures" to a very willing public. By 1853 an estimated three million daguerreotypes per year were being produced in the United States alone—mostly portraits but also scenic views.

The daguerreotype was made on a highly polished surface of silver that was plated on a copper sheet. It was sensitized by being placed, silver side down, over a container of iodine crystals inside a box. Rising vapor from the iodine reacted with the silver, producing the light-sensitive compound silver iodide. During exposure in the camera, the plate recorded a latent image: a chemical change had taken place, but no evidence of it was visible. To develop the image the plate was placed, silver side down, in another box containing a dish of heated mercury at the bottom. Vapor from the mercury reacted with the exposed areas of the plate. Wherever light had struck the plate, mercury formed a frostlike amalgam, or alloy, with the silver. This amalgam made up the bright areas of the image. Where no light had struck, no amalgam was formed; the unchanged silver iodide was dissolved in sodium thiosulfate fixer, leaving the bare metal plate, which looked black, to form the dark areas of the picture.

The daguerreotype was very popular in its time, but it was a technological dead end. There were complaints about the difficulty of viewing, for the image could be seen clearly only from certain angles. The mercury vapor used in the process was highly poisonous and probably shortened the life of more than one daguerreotypist. But the most serious drawback was that each plate was unique; there was no way of producing copies except by rephotographing the original. What was needed was a negative-positive process where any number of positive images could be made from a single negative.

Calotype: Pictures on Paper

Another photographic process was announced almost at once. On January 25, 1839, less than three weeks after the announcement of Daguerre's process to the French Academy, an English amateur scientist, William Henry Fox Talbot, appeared before the Royal Institution of Great Britain to announce that he too had invented a way to permanently fix the image of the camera obscura. Talbot was a disappointed man when he gave his hastily prepared report; he admitted later that Daguerre's prior announcement "frustrated the hope with which I had pursued, during nearly five years, this long and complicated series of experiments—the hope, namely, of being the first to announce to the world the existence of the New Art—which has since been named Photography."

Talbot made his images on paper. His first experiments had been with negative silhouettes made by placing objects on paper sensitized with silver chloride and exposing them to light. Then he experimented with images formed by a camera obscura, exposing the light-sensitive coating long enough for the image to become visible during the exposure.

In June 1840 Talbot announced a technique that became the basis of modern photography: the sensitized paper was exposed only long enough to produce a latent image, which then was chemically developed. Talbot reported that nothing could be seen on the paper after exposure, but "the picture existed there, although invisible; and by a chemical process . . . it was made to appear in all its perfection." To make the latent negative image visible, Talbot used silver iodide (the light-sensitive element of the daguerreotype) treated with gallo nitrate of silver. He called his invention a calotype (after the Greek *kalos*, "beautiful," and *typos*, "impression").

Talbot realized the value of photographs on paper rather than on metal: reproducibility. He placed the fully developed paper negative in contact with another sheet of sensitized paper and exposed both to light, a procedure now known as contact printing. The dark areas of the negative blocked the light from the other sheet of paper, while the clear areas allowed light through. The result was a positive image on paper resembling the natural tones of the original scene.

Although the calotype's reproducibility was a major advantage over the one-of-a-kind daguerreotype, it never became widely popular because viewers were disappointed that the calotype lacked the sharp detail of the daguerreotype. The calotype is beautiful in its own way, however, with the fibers in the paper producing a soft, slightly textured image that has been compared to a charcoal drawing.

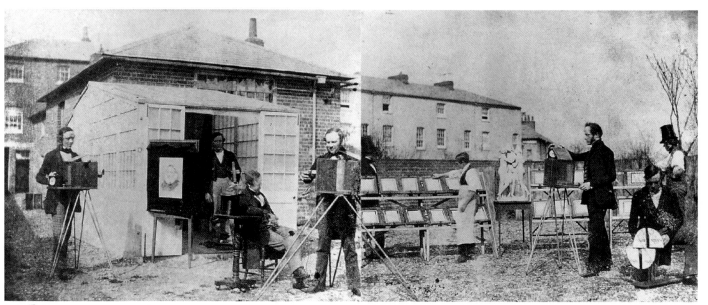

WILLIAM HENRY FOX TALBOT Talbot's Photographic Establishment, c. 1844. Calotype

The activities at Talbot's establishment near London are shown in this early calotype taken in two parts and pieced together. At left, an assistant copies a painting. In the center, possibly Talbot himself prepares a camera to take a portrait. At right, the man at the racks makes contact prints while another photographs a statue. At far right, the kneeling man holds a target for the maker of this photograph to focus on.

The prints for the first book to be illustrated with photographs, The Pencil of Nature *had a "Notice to the Reader." Talbot gave his assurance that, "The plates of the present work are impressed by the agency of light alone, without any aid whatever from the artist's pencil. They are the sun pictures themselves, and not, as some persons have imagined, engravings in imitation."*

The collodion wet-plate process had the best feature of the daguerreotype—sharpness—and the best of the calotype—reproducibility. And it was more light sensitive than either of them, with exposures as short as five seconds. It combined so many advantages that despite its drawbacks virtually all photographers used it from its introduction in 1851 until the development of the gelatin dry plate.

For some time, workers had been looking for a substance that would bind a light-sensitive emulsion to a glass plate. Glass was better than paper or metal as a support for emulsion because it was textureless, uniformly transparent, and chemically inert. A cousin of Niépce, Abel Niepce de Saint-Victor, found that egg white could be used, but since his albumen glass plates required very long exposures the search for a better substance continued. One suggested material was the newly invented collodion (nitrocellulose dissolved in ether and alcohol), which is sticky when wet and dries into a tough, transparent skin. Frederick Scott Archer, an English sculptor who had been making calotypes of his sitters to use as studies, discovered that the collodion was an excellent basis for an emulsion.

The disadvantage of collodion was that the plate had to be exposed and processed while it was still wet. Coating a plate required skill—nimble fingers, flexible wrists, and practiced timing. A mixture of collodion and potassium iodide was poured onto the middle of the plate. The photographer held the glass by the edges and tilted it back and forth and from side to side until the surface was evenly covered. The excess collodion was poured back into its container. Then the plate was sensitized by being dipped in a bath of silver nitrate. It was exposed for a latent image while still damp, developed in pyrogallic acid or iron sulfate, fixed, washed, and dried. All this had to be done right where the photograph was taken, which meant that to take a picture the photographer had to lug a complete darkroom along (below).

Collodion could be used to form either a negative or a positive image. Coated on glass, it produced a negative from which a positive could be printed onto albumen-coated paper. If the glass was backed with a dark material like black velvet, paper, or paint, the image was transformed into a positive, an ambrotype, a kind of imitation daguerreotype. Coated on dark enameled metal it also formed a positive image—the durable, cheap tintype popular in America for portraits to be placed in albums, on campaign buttons, and even on tombs.

One of the most popular uses was to make stereographic photographs. If two photographs are taken side by side and then viewed through a stereoscope (a device that presents only one photograph to each eye), the impression is of a three-dimensional image. Looking at stereos became a popular home entertainment during the 1850s and 1860s, rather like television today.

By the 1860s the world had millions of photographic images; 25 years earlier there had been none. Photographers were everywhere—taking portraits, going to war, exploring distant places and bringing home pictures to prove it.

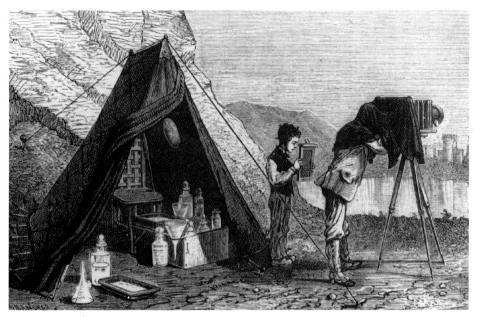

A Photographer in the Field, c. 1865

The collodion wet-plate process had many advantages, but convenience was not among them. The glass plates on which the emulsion was spread had to be coated, exposed, and developed before the emulsion dried, which required transporting an entire darkroom to wherever the photograph was to be made.

A photographer described a typical load that an amateur might use: "I reached the railway station with a cab-load consisting of the following items: A 9" x 11" brass-bound camera weighing 21 lbs. A water-tight glass bath in a wooden case holding over 90 ozs. of solution [nitrate of silver] and weighing 12 lbs. A plate box with a dozen 9" x 11" plates weighing almost as many pounds. A box 24" x 18" x 12" into which were packed lenses, chemicals, and all the hundred-and-one articles necessary for a hard day's work, and weighing something like 28 lbs. [A tripod] over 5 ft in length. It weighed about 5 lbs. Lastly, there was the tent, that made a most convenient darkroom, about 40" x 40" and 6 1/2 ft high, with ample table accommodation; the whole packed into a leather case and weighed over 40 lbs . . . a load of about 120 lbs."

Gelatin Emulsion/Roll-Film Base: Photography for Everyone

Until the 1880s, few photographs were made by the general public. Almost everyone had been photographed at one time or another, certainly everyone had seen photographs, and probably many people had thought of taking pictures themselves. But the technical skill and the large quantity of equipment needed for the collodion wet-plate process restricted photography to the professionals and the most dedicated amateurs. Even they complained of the inconvenience of the process and made many attempts to improve it.

By the 1880s, the perfection of two techniques not only made possible a fast, dry plate but also eliminated the need for the clumsy, fragile glass plate itself. The first development was a new gelatin emulsion in which the light-sensitive silver salts could be suspended. It was based on gelatin—a jellylike substance processed from cattle bones and hides. It retained its speed when dry and could be applied on the other invention—film in rolls. Roll film revolutionized photography by making it simple enough for anyone to enjoy.

Much of the credit for popularizing photography goes to George Eastman, who began as a bank clerk in Rochester, New York, and built his Eastman Kodak Company into one of the country's foremost industrial enterprises. Almost from the day Eastman bought his first wet-plate camera in 1877, he searched for a simpler way to take pictures. "It seemed," he said, "that one ought to be able to carry less than a pack-horse load."

Many people had experimented with roll film, but no one was able to produce it commercially until Eastman invented the equipment to mass-produce film. The result was Eastman's American Film, a roll of paper coated with a thin gelatin emulsion. The emulsion had to be stripped from the opaque paper backing to provide a negative that light could shine through for making prints. Most photographers had trouble with this operation, as the negative often stretched when removed from the paper, so the film was usually sent back to the company for processing.

The new gelatin emulsion created a great stir among photographers, but it had little immediate meaning for the general public since the heavy, expensive view camera was still necessary for taking pictures. But roll film made possible a new kind of camera—inexpensive, light, and simple to operate—that made everyone a potential photographer. Eastman introduced the Kodak camera in 1888. It came loaded with enough film for 100 pictures. When the roll was used up, the owner returned the camera with the exposed film still in it to the Eastman company in Rochester. Soon the developed and printed photographs and the camera, reloaded with film, were sent back to the owner. The Kodak slogan was, "You push the button, we do the rest."

The Kodak camera became an international sensation almost overnight. With the invention by Hannibal Goodwin of a truly modern roll film (a transparent, flexible plastic, coated with a thin emulsion and sturdy enough to be used without a paper support), a new photographic era, of simple, light cameras and easy-to-handle roll film, had begun. The Eastman Kodak Company knew very early who would be the main users of its products, and it directed its advertising accordingly: "A collection of these pictures may be made to furnish a pictorial history of life as it is lived by the owner, that will grow more valuable every day that passes."

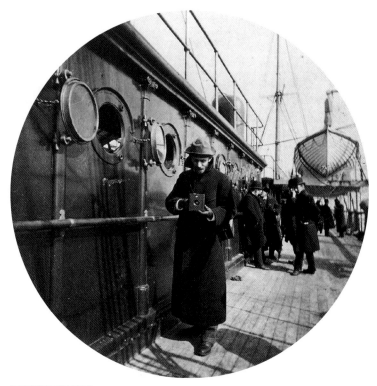

FREDRICK CHURCH George Eastman with a Kodak, 1890

George Eastman, who put the Kodak box camera on the market and thereby put photography into everybody's hands, stands aboard the S.S. Gallia in the act of using his invention. Roll film made the camera small enough to carry easily. Fast gelatin emulsions permitted 1/25-sec exposures so subjects did not have to strain to hold still.

LOUIS DUCOS du HAURON　View of Angoulême, France, 1877.　Three-color carbon print

The three-color carbon process required three separate black-and-white nega-tives, *one for each of the primary colors red, green, and blue. Each image was dyed the color of its primary and then superimposed to form a full-color image.*

ARNOLD GENTHE　Helen Cooke Wilson in a California Poppy Field, c. 1908. Autochrome

The Autochrome process was popular at the turn of the century with pictorialists *who liked its graininess and subdued colors. The dots of color that composed the image blended at a normal viewing distance into a full range of colors, not unlike the effect that pointillist painters created with individual dots of paint.*

More about . . .

• Additive and subtractive color, page 192

Daguerre himself knew that only one thing was needed to make his wonderful invention complete—color. "There is nothing else to be desired," he wrote, "but the presentation of these children of light to the astonished eye in the full splendour of their colors."

After several false starts, one of the first successes was demonstrated in 1861 by the British physicist James Clerk Maxwell. To illustrate a lecture on color vision, he devised a way to recreate the colors of a tartan ribbon. He had three negatives of the ribbon made, each through a different color filter—red, green, and blue. Positive black-and-white transparencies were made of the three negatives and projected through filters like those on the camera. When the three images were superimposed, they produced an image of the ribbon in its original colors.

Maxwell had demonstrated additive color mixing, in which colors are produced by adding together varying amounts of light of the three primary colors, red, green, and blue. In 1869, an even more significant theory was made public. Louis Ducos du Hauron and Charles Cros, two Frenchmen working independently of each other, announced almost simultaneously their researches in subtractive color mixing. In subtractive mixing, the basis of present-day color photography, colors are created by combining cyan, magenta, and yellow dyes (the complements of red, green, and blue). The dyes subtract colors from the "white" light that contains all colors. There were many variations of Ducos du Hauron's basic subtractive process in which three separately dyed images were superimposed to form a full-color image.

They include his own three-color carbon process (left, top), the carbro process, and modern dye transfer printing.

The first commercially successful color was an additive process. In 1907, two French brothers, Antoine and Louis Lumière, marketed their Autochrome process. A glass plate was covered with tiny grains of potato starch dyed red-orange, green, and violet, in a layer only one starch grain thick. Then, a light-sensitive emulsion was added. Light struck the emulsion after passing through the colored grains. The emulsion behind each grain was exposed only by light from the scene that was the same color as that grain. The result after development was a full-color transparency (left, bottom).

Kodachrome, a subtractive process, made color photography practical. It was perfected by Leopold Mannes and Leopold Godowsky, two musicians and amateur photographic researchers who eventually joined forces with Eastman Kodak research scientists. Their collaboration led to the introduction in 1935 of Kodachrome, a single sheet of film coated with three layers of emulsion, each sensitive to one primary color (red, green, and blue). A single exposure produces a color image.

Today it is difficult to imagine photography without color. The amateur market is huge, and the ubiquitous snapshot is always in color. Commercial and publishing markets use color extensively. Digital imaging, which lets colors be altered at will, is becoming increasingly accessible. Even photojournalism and photography as an art form, which have been in black and white for most of their history, now often are in color.

Early Portraits

People wanted portraits. Even when exposure times were long and having one's portrait taken meant sitting in bright sunlight for several minutes with eyes watering, trying not to blink or move, people flocked to portrait studios to have their likenesses drawn by "the sacred radiance of the Sun." Images of almost every famous person who had not died before 1839 have come down to us in portraits by photographers such as Nadar and Julia Margaret Cameron (right). Ordinary people were photographed as well—in Plumbe's National Daguerrian Gallery, where hand-tinted "Patent Premium Coloured Likenesses" were made, and in cut-rate shops where double-lens cameras took them "two at a pop." Small portraits called cartes-de-visite were immensely popular in the 1860s (opposite). For pioneers moving West in America, the pictures were a link to the family and friends they had left behind. Two books went West with the pioneers—a Bible and a photograph album.

Photographs had an almost mystical presence. After seeing some daguerreotype portraits, the poet Elizabeth Barrett wrote to a friend in 1843, "several of these wonderful portraits . . . like engravings—only exquisite and delicate beyond the work of graver—have I seen lately—longing to have such a memorial of every Being dear to me in the world. It is not merely the likeness which is precious in such cases—but the association and the sense of nearness involved in the thing . . . the fact of the very shadow of the person lying there fixed for ever! . . . I would rather have such a memorial of one I dearly loved, than the noblest artist's work ever produced. I do not say so in respect (or disrespect) to Art, but for Love's sake. Will you understand?— even if you will not agree?" The man on the opening page of this chapter would have understood.

JULIA MARGARET CAMERON **Mrs. Duckworth, 1867**

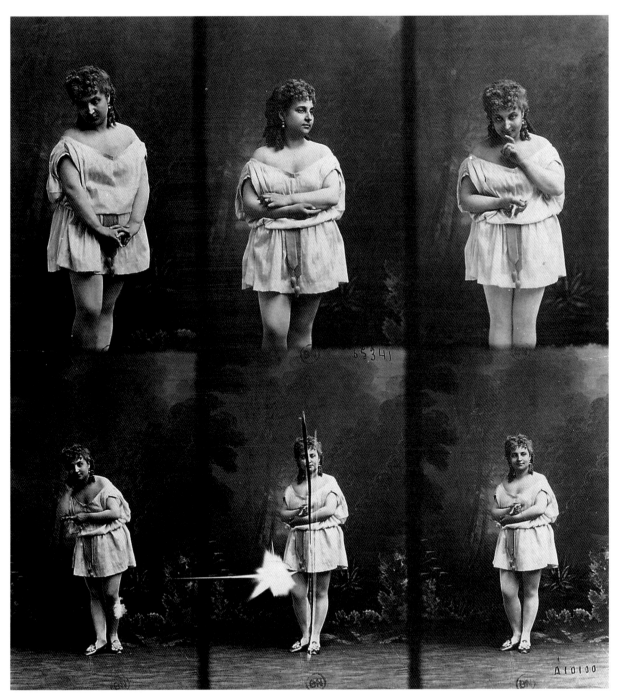

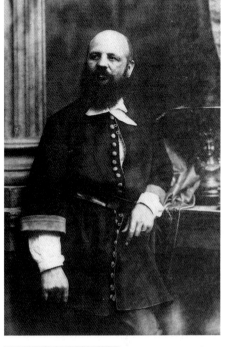

Cartes-de-visite were taken with a camera that exposed only one section of the photographic plate at a time. *Thus the customer could strike several different poses for the price of one. At left is shown a print before it is cut into separate pictures. People collected cartes-de-visite in albums, inserting pictures of themselves, friends, relatives, and famous people like Queen Victoria. One album cover advised: "Yes, this is my Album, but learn ere you look; / that all are expected to add to my book. / You are welcome to quiz it, the penalty is, / that you add your own Portrait for others to quiz."*

André Adolphe Disdéri, who popularized these multiple portraits, is shown above on a carte-de-visite. Carte portraits became a fad when Napoleon III stopped on the way to war to pose for cartes-de-visite at Disdéri's studio.

Early Travel Photography

Early travel photographs met a demand for pictures of faraway places. In the mid-19th century, the world seemed full of unexplored wonders. Steamships and railroads were making it possible for more people to travel, but distant lands still seemed exotic and mysterious and people were hungry for photographs of them. There had always been drawings portraying unfamiliar places, but they were an artist's personal vision. The camera seemed an extension of one's own vision; travel photographs were accepted as real and faithful images.

The Near East was of special interest. Not only was it exotic, but its association with biblical places and ancient cultures made it even more fascinating. Within a few months of the announcement of Daguerre's process in 1839, a photographic team was in Egypt. "We keep daguerreotyping away like lions," they reported, "and from Cairo hope to send home an interesting batch." Since there was no way of reproducing the daguerreotypes directly, they had to be traced and reproduced as copperplate engravings. With the invention of the calotype and later the collodion processes, actual pictures from the Near East were soon available.

The most spectacular scenery of the western United States was not much photographed until the late 1860s. Explorers and artists had been in the Rocky Mountain area long before this time, but the tales they told of the region and the sketches they made were often thought to be exaggerations. After the Civil War, when several government expeditions set out to explore and map the West, photographers accompanied them, not always to the delight of the other members of the expeditions. "The camera in its strong box was a heavy load to carry up the rocks," says a description of a Grand Canyon trip in 1871, "but it was nothing to the chemical and plate-holder box, which in turn was featherweight compared to the imitation hand organ which served for a darkroom." Civil War photographers Timothy H. O'Sullivan (opposite) and Alexander Gardner both went West with government expeditions. William Henry Jackson's photographs of Yellowstone helped convince Congress to set the area aside as a national park, as did the photographs of Yosemite made by Carleton Eugene Watkins.

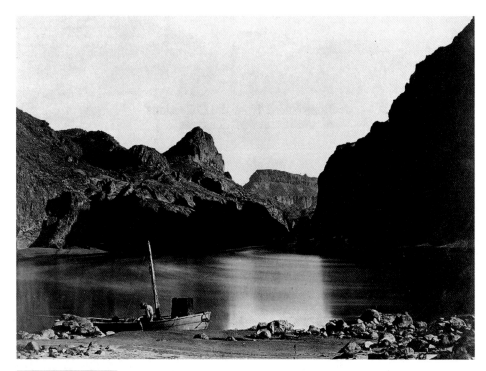

TIMOTHY H. O'SULLIVAN Black Canyon, Colorado River, 1871

Expeditions were made to take photographs of distant places almost as soon as the invention of photography was announced. In addition to all the materials, chemicals, and knowledge needed to coat, expose, and process their photographs in remote places, expeditionary photographers also had to have considerable fortitude.

Timothy H. O'Sullivan, whose darkroom on a boat appears at left, described an area called the Humboldt Sink: "It was a pretty location to work in, and viewing there was as pleasant work as could be desired; the only drawback was an unlimited number of the most voracious and particularly poisonous mosquitoes that we met with during our entire trip. Add to this . . . frequent attacks of that most enervating of all fevers, known as the 'mountain ail,' and you will see why we did not work up more of that country."

Photographs made war scenes more immediate for those at home. Until the invention of photography, wars often seemed remote and rather exciting. People learned details of war only from delayed news accounts or even later from returning soldiers or from paintings or poems. The British campaigns in the Crimean War of the 1850s were the first to be extensively photographed. It was a disastrous war for Great Britain. The ill-fated Charge of the Light Brigade was only one of the catastrophes; official bungling, disease, starvation, and exposure took more British lives than did the enemy. However, Roger Fenton, the official photographer, generally showed views of the war that were scenic and idealized rather than realistic.

Photographs from the American Civil War were the first to show the reality of war (below). Mathew B. Brady, a successful portrait photographer, conceived the idea of sending teams to photograph the war. Photographing during a battle was hazardous. The collodion process required up to several seconds' exposure and the glass plates had to be processed on the spot, which made the photographer's darkroom-wagon a target for enemy gunners. Although Brady had hoped to sell his photographs, they often showed what people wanted only to forget. Brady took only a few, if any, photographs himself, and some of his men (Alexander Gardner and Timothy H. O'Sullivan among them) broke with him and set up their own operation. But it was Brady's idea and personal investment that launched an invaluable documentation of American history.

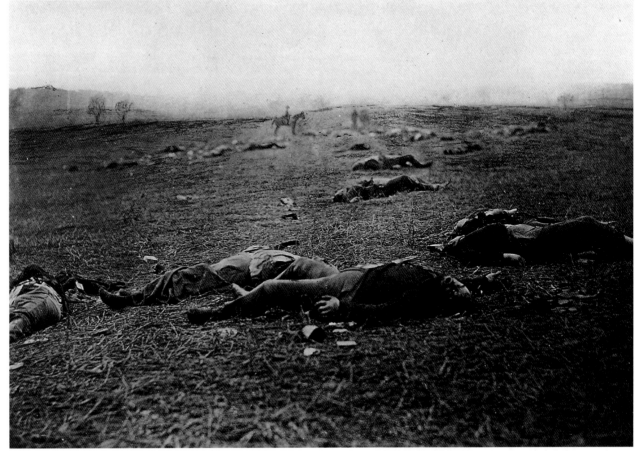

The first realistic view of war was shown by Civil War photographers such as Brady, Gardner, and O'Sullivan (right). Oliver Wendell Holmes had been on the battlefield at Antietam searching for his wounded son and later saw the photographs Brady made there: "Let him who wishes to know what war is look at this series of illustrations . . . It was so nearly like visiting the battlefield to look over these views, that all the emotions excited by the actual sight of the stained and sordid scene, strewed with rags and wrecks, came back to us, and we buried them in the recesses of our cabinet as we would have buried the mutilated remains of the dead they too vividly represented."

TIMOTHY H. O'SULLIVAN A Harvest of Death, Gettysburg, July 1863

Time and Motion in Early Photographs

The earliest photographs required very long exposures. Today, photographers using modern films consider a one-second exposure relatively long. But photographers using earlier processes had to work with much slower emulsions, and an exposure of several seconds was considered quite short. People or objects that moved during the exposure were blurred or, if the exposure was long enough, disappeared completely; busy streets sometimes looked deserted (above, near right) because most people had not stayed still long enough to register an image.

Stereographic photographs were the first to show action as it was taking place, with people in midstride or horses and carts in motion (half of a pair of stereo images is shown above, far right). This was possible because the short-focal-length lens of the stereo camera produced a bright, sharp image at wide apertures and thus could be used with very brief exposure times. "How infinitely superior to those 'cities of the dead' with which we have hitherto been compelled to content ourselves," commented one viewer.

These "instantaneous" photographs revealed aspects of motion that the unaided eye was not able to see. Some of the arrested motions were so different from the conventional artistic representations that the photographs looked wrong. A galloping horse, for example, had often been drawn with all four feet off the ground—the front legs extended forward and hind legs extended back. Eadweard Muybridge was a pioneer in motion studies. When his photographs of a galloping horse, published in 1878, showed that all four feet were off the ground only when they were bunched under the horse's belly, some people thought that Muybridge had altered the photographs. Using the new, fast gelatin emulsion and specially constructed multi-lens cameras, Muybridge compiled many studies of different animals and humans in action. A short sequence from one of his motion studies appears at right.

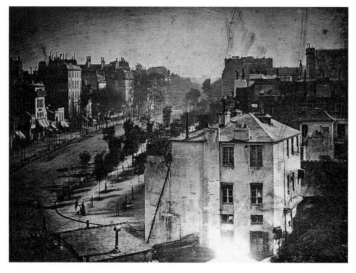

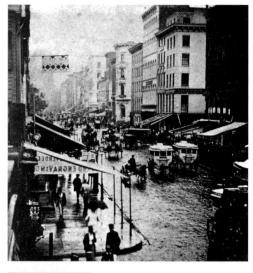

LOUIS JAQUES MANDÉ DAGUERRE Boulevard du Temple, Paris 1839

EDWARD ANTHONY Broadway, 1859

Two streets, both filled with people and traffic, have a different appearance.
The busy streets of a Parisian boulevard (above, left) appear depopulated because of the long exposure this daguerreotype required. Only a person getting a shoeshine near the corner of the sidewalk stood still long enough to be recorded; all the other people, horses, and carriages had blurred so much that no image of them appeared on the plate.
By contrast, the relatively fast collodion process combined with the fast lens of a stereo camera froze the action on another busy street (above, right, one of a pair of stereo views).

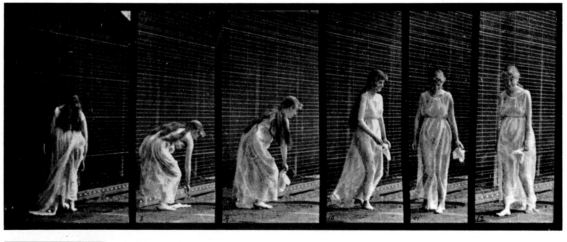

EADWEARD MUYBRIDGE Motion Study, c. 1885

The study of motion became technically possible as the sensitivity of photographic emulsions increased. The pictures above were part of Eadweard Muybridge's project Animal Locomotion, *which analyzed the movements of humans and many animals. Muybridge often used several cameras synchronized to work together so that each stage of a movement could be recorded simultaneously from different angles.*

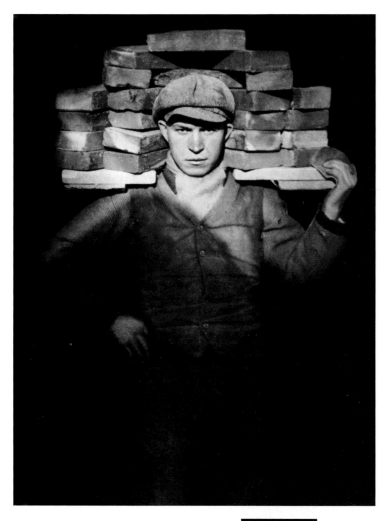

August Sander's photographs are documents of social types rather than portraits of individuals. This photograph of a laborer with a load of bricks was one of hundreds Sander made of the types he saw in pre-World War II Germany. Holding his pose as if standing for a portrait painter, the subject displays his trade with stoic strength. There is no indication of time or even place. In fact, the background is deliberately absent; Sander eliminated it from the negative.

Eugène Atget artfully revealed the essence of Paris while seeming merely to document its external appearance. An uncluttered street in the early morning, with its graceful trees, broad sidewalks, and empty cafés speaks of the pervasive charm and architectural harmony of the city.

More about . . .

• Documentary photography, pages 354–355

Photographs can be documents on many levels. Most snapshots record a particular scene to help the participants remember it later. A news photograph implies that this is what you would have seen if you had been there yourself. (Digital imaging may deal the deal the death blow to this belief; see page 275.) On another level, a photograph can record reality and at the same time the photographer's comment on that reality. Lewis W. Hine said of his work: "I wanted to show the things that had to be corrected. I wanted to show the things that had to be appreciated." His statement describes the use of photography as a force for social change and a style that came to be known as documentary.

Eugène Atget's work went beyond simple records, although he considered his photographs to be documents. A sign on his door read "Documents pour Artistes." Atget made thousands of photographs in the early 1900s of the streets, cafés (below), shops, monuments, parks, and people of the Paris he loved. His pictures won him little notice during his lifetime; he barely managed to eke out a living by selling them to artists, architects, and others who wanted visual records of the city. Many photographers can record the external appearance of a place, but Atget conveyed the atmosphere and mood of Paris as well.

August Sander chose to document a people—the citizens of pre-World War II Germany. His pictures were not meant to reveal personal character but to show the classes making up German society of that period. He photographed laborers (left), soldiers, merchants, provincial families, and other types, all formally posed. The portraits are so utterly factual and unsentimental as to be chilling at times; the individual disappears into class and social role.

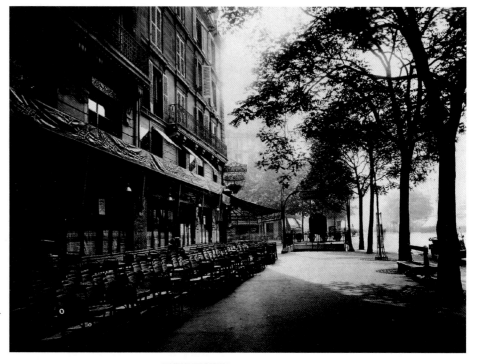

Photography and Social Change

Photography soon went from documenting the world to documenting it for a cause. Jacob Riis, a Danish-born newspaper reporter of the late 19th century, was one of the first to use photography for social change. Riis had been writing about the grinding brutality of life in New York City's slums and began to take pictures to show, as he said, what "no mere description could, the misery and vice that he had noticed in his ten years of experience . . . and suggest the direction in which good might be done."

Lewis W. Hine was a trained sociologist with a passionate social awareness, especially of the abuses of child labor (right). This evil was widespread in the early 20th century, and Hine documented it to provide evidence for reformers. With sarcastic fury he wrote of "'opportunities' for the child and the family to . . . relieve the over-burdened manufacturer, help him pay his rent, supply his equipment, take care of his rush and slack seasons, and help him to keep down his wage scale."

The photographers of the Farm Security Administration recorded the Depression of the 1930s, when the nation's entire economic structure was in deep trouble and farm families were in particular need. Assistant Secretary of Agriculture Rexford G. Tugwell realized that the government's program of aid to farmers was expensive and controversial. To prove both the extent of the problem and the effectiveness of the cure, he appointed Roy Stryker to supervise photographic coverage of the program. Stryker recruited a remarkable band of talent, including Dorothea Lange (see opposite), Walker Evans, Russell Lee, Marion Post Wolcott, Arthur Rothstein, and Ben Shahn. Their work produced a classic collection of documentary photographs.

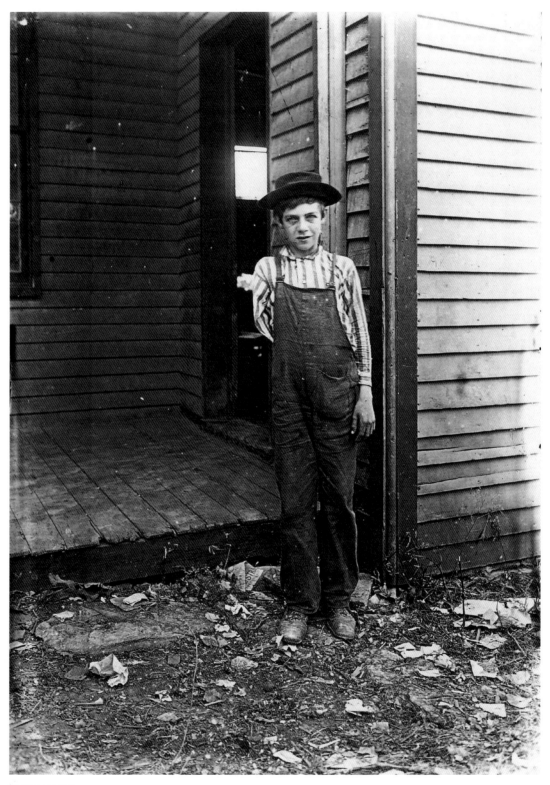

LEWIS W. HINE Victim of a Mill Accident, c. 1910

Lewis Hine documented the abuses of child labor between 1908 and 1921, making 5,000 pictures for the National Child Labor Committee. This one-armed boy, a casualty of a mill accident, posed for Hine in about 1910. "We don't have many accidents," one foreman said at the time. "Once in a while a finger is mashed or a foot, but it doesn't amount to anything."

The documentary photographers of the Farm Security Administration produced a monumental collection of images showing the plight of "one third of a nation" during the Depression of the 1930s. Dorothea Lange had a unique ability to photograph people at the moment that their expressions and gestures revealed their lives and feelings.

Lange's captions often supplied verbatim what her subject had told her. For the photograph at right, "The worst thing we did was when we sold the car, but we had to sell it to eat, and now we can't get away from here. . . . You can't get no relief here until you've lived here a year. This county's a hard county. They won't help bury you here. If you die, you're dead, that's all."

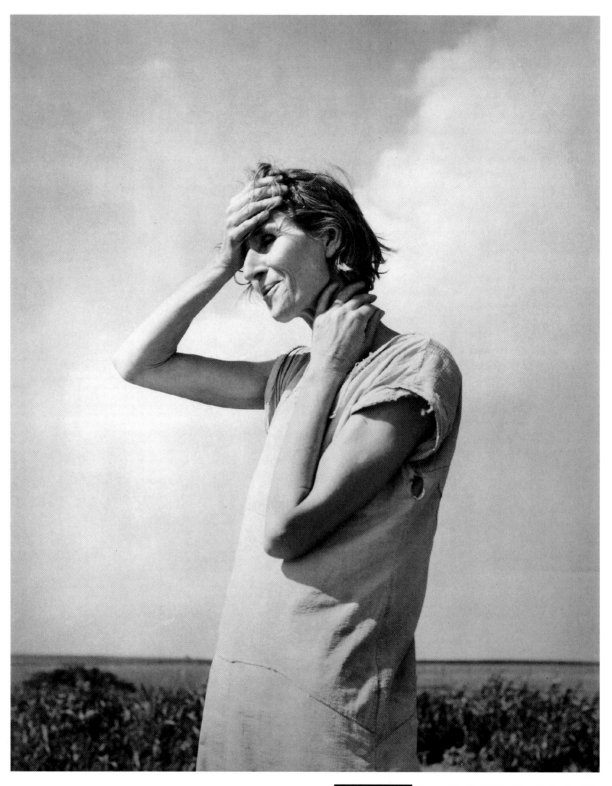

DOROTHEA LANGE Woman of the High Plains, Texas Panhandle, 1938

Photojournalism

Whatever the news event—from a prize-fight to a war—we expect to see pictures of it. Today we take photojournalism for granted, but news and pictures were not always partners. Drawings and cartoons appeared only occasionally in the drab 18th-century press. The 19th century saw the growth of illustrated newspapers such as the *Illustrated London News* and, in America, *Harper's Weekly*, and *Frank Leslie's Illustrated Newspaper*. Because the various tones of gray needed to reproduce a photograph could not be printed simultaneously with ordinary type, photographs had to be converted into drawings and then into woodcuts before they could appear as news pictures. The photograph merely furnished material for the artist.

The halftone process, perfected in the 1880s, permitted photographs and type to be printed together, and photographs became an expected addition to news stories. "These are no fancy sketches," the *Illustrated American* promised, "they are the actual life of the place reproduced upon paper."

The photo essay, a sequence of photographs plus brief textual material, came of age in the 1930s. It was pioneered by Stefan Lorant in European picture magazines and later in America by a score of publications such as *Life* and *Look*. Today, the heyday of the picture magazine has passed, due in part to competition from television. But photographs remain a major source of our information about the world and photo essays are making a comeback on the Internet.

ERICH SALOMON Visit of German Statesmen to Rome, 1931

Not until the 1920s did photographers get a small camera able to take pictures easily in dim light. Early cameras were relatively bulky, and the slowness of available films meant that using a camera indoors required a blinding burst of flashpowder. The first of the small cameras, the Ermanox, to be followed soon by the Leica, had a lens so fast—f/2—that unobtrusive, candid shooting became practical.

Erich Salomon was one of the pioneers of such shooting, with a special talent for dressing in formal clothes and crashing diplomatic gatherings. His camera let him record those in power while they were preoccupied with other matters, such as at the 1931 meeting of German and Italian statesmen. In tribute to Salomon, the French foreign minister, Aristide Briand, is said to have remarked, "There are just three things necessary for a League of Nations conference: a few foreign secretaries, a table, and a Salomon."

The halftone process converts the continuous shades of gray in a photograph (left) into distinct units of black and white that can be printed with ink on paper (right).

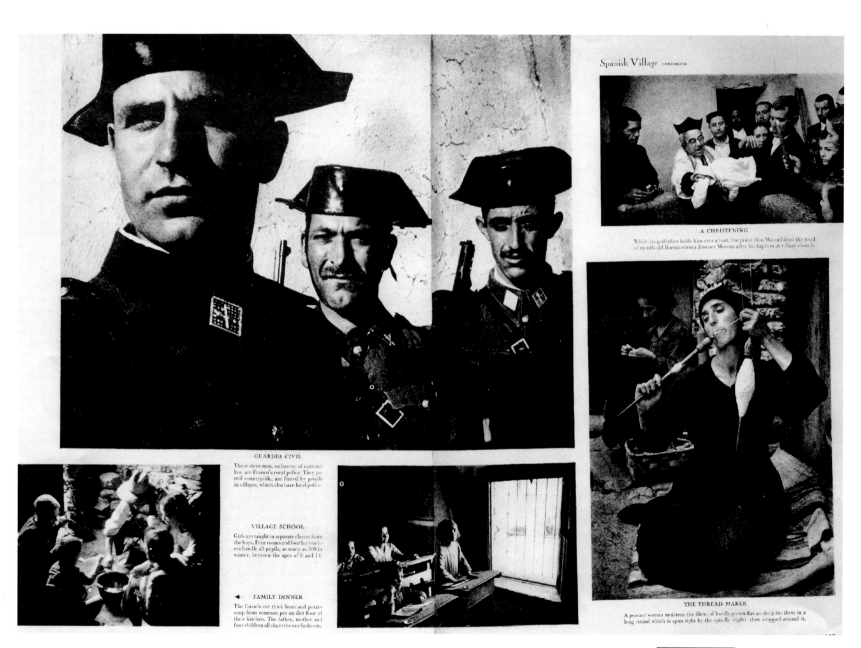

Spanish Village CONTINUED

A CHRISTENING
While his godfather holds him over a font, the priest Don Manuel dries the head of month-old Buenaventura Jimenez Moreno after his baptism at village church.

GUARDIA CIVIL.
These stern men, enforcers of national law, are Franco's rural police. They patrol countryside, are feared by people in villages, which also have local police.

VILLAGE SCHOOL
Girls are taught in separate classes from the boys. Four rooms and four lay teachers handle all pupils, as many as 300 in winter, between the ages of 6 and 11.

◄ **FAMILY DINNER**
The Curiels eat thick bean and potato soup from common pot on dirt floor of their kitchen. The father, mother and four children all share the one bedroom.

THE THREAD MAKER
A peasant woman moistens the fibers of locally grown flax as she joins them in a long strand which is spun tight by the spindle (right), then wrapped around it.

W. EUGENE SMITH From *Spanish Village,* 1951

The photo essay—pictures plus supporting text—was the mainstay of mass-circulation picture magazines *such as* Life *and* Look. *Above are two pages from* Spanish Village, *photographed for* Life *by W. Eugène Smith, whose picture essays are unsurpassed in their power and photographic beauty.*

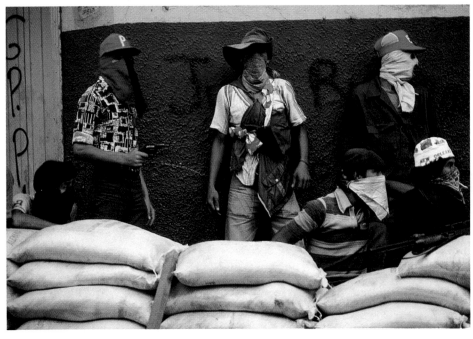

SUSAN MEISELAS Awaiting Counterattack by the Guard, Matagalpa, Nicaragua, 1978

War and social injustice are among the staples of news photography. *The best of these photographs go beyond the simple recording of an event. They become symbols of the time in which they occurred.*

Susan Meiselas photographed these men at a barricade awaiting attack by government troops during the Sandinista revolt in Nicaragua. She had to decide whether to stay and continue photographing or to leave to make the deadline for publication. "As a documentary photographer I would have liked to stay, but I had to leave to get the pictures out. It was the first time that I realized what it means to be a photojournalist and deal with a deadline."

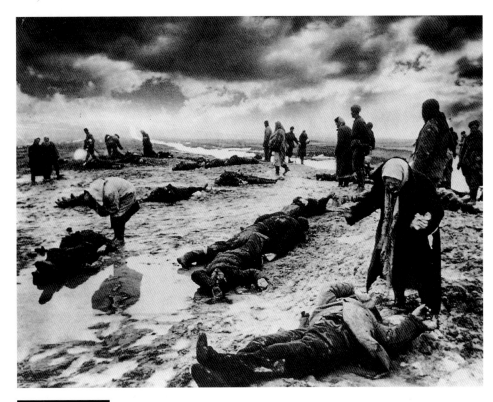

DMITRI BALTERMANTS Sorrow, 1942

In the Crimea after the retreat of German soldiers, grief-bowed Russian women, watched by soldiers of the Red Army, search for their relatives among the dead.

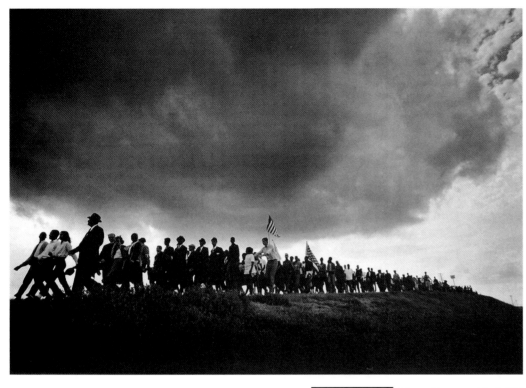

Civil Rights marchers stretch in a line to the far distance, silhouetted against a cloud-filled sky. The individuals in the picture are less important than the mass of marchers.

JAMES H. KARALES Selma to Montgomery March, 1965

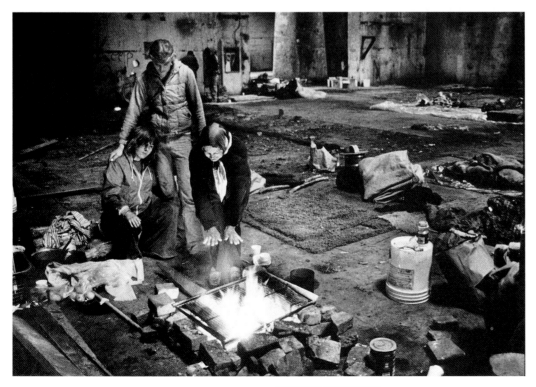

Michael S. Williamson has made many photographs of the homeless. "I have to convince people that we are our brothers' keepers," he says, "that their problems are our problems." This group of homeless people used an abandoned power plant in Sacramento as a shelter for some time before police discovered and evicted them.

MICHAEL S. WILLIAMSON Homeless, Sacramento, California, 1982

Was it just a photograph or was it art? Almost from the moment of its birth, photography began staking out claims in areas that had long been reserved for painting. Portraits, still lifes, landscapes, nudes, and even allegories became photographic subject matter. Some artists bristled at the idea of photography as an art form. In 1862 a group of French artists formally protested that photography was a soulless, mechanical process, "never resulting in works which could. . . ever be compared with those works which are the fruits of intelligence and the study of art."

Photographers resented such assertions, but they in turn simply regarded photography as another kind of painting. The oldest known daguerreotype (page 342), taken by Daguerre himself in 1837, reveals this clearly. It is a still life self-consciously composed in the style of neoclassical painting.

Many photographers adapted styles of painting to the photographic print. From the 1850s through the 1870s there was a rage for illustrative photographs similar to a storytelling style of painting popular at the time. Julia Margaret Cameron, in addition to producing elegant and powerful portraits (page 348), indulged in romantic costume scenes such as illustrations for Tennyson's *The Idylls of the King*. Oscar G. Rejlander pieced together 30 negatives to produce an allegorical pseudopainting entitled *The Two Ways of Life*—one way led to dissolution and despair, the other to good works and contentment.

At the time, the most famous and commercially the most successful of those intending to elevate photography to an art was Henry Peach Robinson. Robinson turned out many illustrative and allegorical composite photographs. These were carefully plotted in advance and combined several negatives to form the final print (right, top). Robinson became the leader of a so-

called High Art movement in 19th-century photography, which advocated beauty and artistic effect no matter how it was obtained. In his Pictorial Effect in Photography, Robinson advised: "Any dodge, trick and conjuration of any kind is open to the photographer's use. . . . It is his imperative duty to avoid the mean, the bare and the ugly, and to aim to elevate his subject, to avoid awkward forms and to correct the unpicturesque."

By the 1880s a new movement championed naturalism as artistic photography. Its leader, Peter Henry Emerson, was the first to campaign against the stand that "art" photographers had taken. He felt that true photographic art was possible only through exploiting the camera's ability to capture reality in a direct way (right, bottom). He scorned the pictorial school and its composite printing, costumed models, painted backdrops, and sentimental views of daily life.

Emerson laid down his own rules for what he called naturalistic photography: simplicity of equipment; no "faking" by means of lighting, posing, costumes, or props; free composition without reliance on classical rules; and no retouching ("the process by which a good, bad or indifferent photograph is converted into a bad drawing or painting"). He also promoted what he believed was a scientific focusing technique that imitated the way the eye perceives a scene: sharply focused on the main subject, but with the foreground and especially the background slightly out of focus.

Although Emerson later became convinced that photography was not an art at all but only "a handmaiden to science and art," his earlier ideas had already influenced a new generation of photographers who no longer felt the need to imitate painting but began to explore photography as an art in its own right.

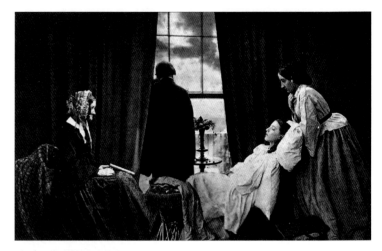

HENRY PEACH ROBINSON Fading Away, 1858

Henry Peach Robinson's High Art photography was inspired by romantic literature. *He developed a composite photographic technique that allowed him to produce imaginary scenes.* Fading Away *(above) was staged by posing models separately and piecing together the images.*

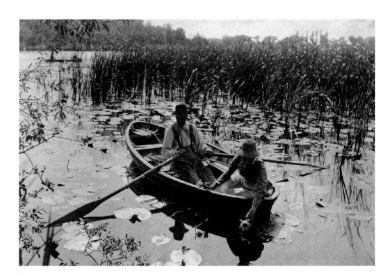

PETER HENRY EMERSON Gathering Water Lilies, 1885

Peter Henry Emerson rejected the methods of the High Art photographers. *He insisted that photography should not imitate art but should strive for a naturalistic effect that was not artificially contrived. He illustrated his theories with his own photographs of peasants on the East Anglian marshes in England.*

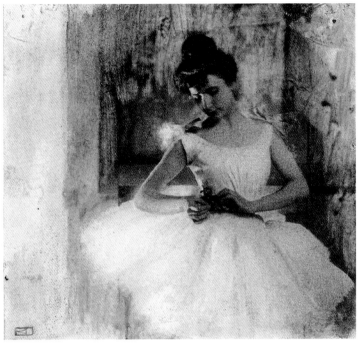

ROBERT DEMACHY Une Balleteuse, 1900

Pictorialist photography at the turn of the century often resembled impressionist paintings, with light and atmosphere more important than sharp details.

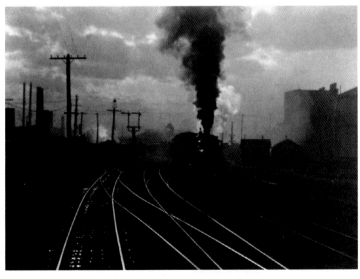

ALFRED STIEGLITZ The Hand of Man, 1902

Although Alfred Stieglitz championed pictorialist works that resembled paintings, his own photographs (except for a brief early period) did not include handwork or other alterations of the direct camera image.

Was photography an art? Photographers were still concerned with this question at the turn of the century. Art photographers, or pictorialists, wanted to separate their photographs from those taken for some other purpose—ordinary snapshots, for example. *The American Amateur Photographer* suggested: "If we had in America a dignified 'Photographic Salon,' with a competent jury, in which the only prizes should be the distinction of being admitted to the walls of the 'Salon,' we believe that our art would be greatly advanced. 'Art for art's sake' should be the inspiring word for every camera lover." The pictorial movement was international. Exhibitions where photographs were judged on their aesthetic merits were organized by the Vienna Camera Club, the Linked Ring Brotherhood in England, the Photo-Club de Paris, the American Photo-Secession, and others.

Many pictorialists believed that artistic merit increased if the photograph looked like some other kind of art—charcoal drawing, mezzotint, or anything other than photography—and they patterned their work quite frankly on painting, especially the work of the French Impressionists, for whom mood and a sense of atmosphere and light were important. The pictorialists favored mist-covered landscapes and soft cityscapes; light was diffused, line was softened, and details were suppressed (left, top).

To achieve these effects, pictorialists often used printing techniques to which handwork was added—for example, gum-bichromate printing, where the image was transferred onto a thick, soft, often tinted coating that could easily be altered as the photographer wished. One critic was delighted: "The results no longer have anything in common with what used to be known as photography. For that reason, one could proudly say that these photographers have broken with the tradition of the artificial reproduction of nature. They have freed themselves from photography. They have sought the ideal in the works of artists. They have done away with photographic sharpness, the clear and disturbing representation of details, so that they can achieve simple, broad effects." Not everybody agreed. This did not fit at all into Peter Henry Emerson's ideas of naturalistic photography: "If pure photography is not good enough or 'high' enough . . . by all means let him become an artist and leave us alone and not try and foist 'fakes' upon us."

In America, Alfred Stieglitz was the leader and catalyst for photography as an art form and his influence is hard to overestimate. For more than 60 years he photographed (left, bottom), organized shows, and published influential and avant-garde work by photographers and other artists. In his galleries—the Little Galleries of the Photo-Secession (later known simply by its address, 291), the Intimate Gallery, and An American Place—he showed not only what he considered the best photographic works but also, for the first time in the United States, the works of Cézanne, Matisse, Picasso, and other modern artists. In his magazine *Camera Work*, he published photographic criticism and works whose only requirement was that they be worthy of the word art. Not only did he eventually force museum curators and art critics to grant photography a place beside the other arts, but by influence, example, and sheer force of personality he twice set the style for American photography: first toward the early pictorial impressionistic ideal and later toward sharply realistic, "straight" photography.

The Direct Image in Art

Some photographers interested in art in the early 20th century made images directly related to the photographic process, even while pictorialists were making photographs that look very much like paintings. A movement was forming to return to the direct and unmanipulated photographs that characterized so much of 19th-century imagery. In 1917 Stieglitz devoted the last issue of *Camera Work* to Paul Strand, whose photographs he saw as representing a powerful new approach to photography as an art form. Strand believed that "objectivity is of the very essence of photography. . . . The fullest realization of this is accomplished without tricks of process or manipulation, through the use of straight photographic methods."

Stieglitz's own photographs were direct and unmanipulated. He felt that many of them were visual metaphors, accurate representations of objects in front of his camera and at the same time external counterparts or "equivalents" of his inner feelings. Since 1950, Minor White (page 81) carried on and expanded Stieglitz's concept of the equivalent. For White, the goal of the serious photographer was "to get from the tangible to the intangi-ble" so that a straight photograph of real objects functions as a metaphor for the photographer's or the viewer's state of mind.

Straight photography dominated photography as an art form from the 1930s to the 1950s, and is exemplified by Edward Weston. He used the simplest technique and a bare minimum of equipment: generally, an 8 x 10 view camera with lens stopped down to the smallest aperture for sharpness in all parts of the picture and contact-printed negatives that were seldom cropped. "My way of working—I start with no preconceived idea—discovery excites me to focus—then rediscovery through the lens—final form of presentation seen on ground glass, the finished print previsioned complete in every detail of texture, movement, proportion, before exposure—the shutter's release automatically and finally fixes my conception, allowing no after manipulation—the ultimate end, the print, is but a duplication of all that I saw and felt through my camera." Many other photographers, such as Ansel Adams (page 302), Paul Caponigro (pages 104, 324), and Imogen Cunningham (page 71) have used the straight approach.

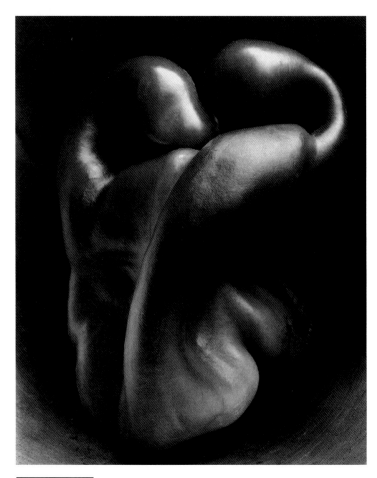

EDWARD WESTON Pepper No. 30, 1930

Edward Weston's direct photographs were both objective and personal. "Clouds, torsos, shells, peppers, trees, rocks, smokestacks are but interdependent, interrelated parts of a whole, which is life."

PAUL STRAND White Fence, 1916

Paul Strand's straight approach to photography as an art form combined an objective view with personal meaning. "Look at the things around you, the immediate world around you. If you are alive it will mean something to you, and if you care enough about photography, and if you know how to use it, you will want to photograph that meaningness."

The beginning of the 20th century saw great changes in many areas, including science, technology, mathematics, politics, and also the arts. Movements like Fauvism, Expressionism, Cubism, Dada, and Surrealism were permanently changing the meaning of the word "art." The Futurist art movement proposed "to sweep from the field of art all motifs and subjects that have already been exploited . . . to destroy the cult of the past . . . to despise utterly every form of imitation . . . to extol every form of originality."

At the center of radical art, design, and thinking was the Bauhaus, a school in Berlin to which the Hungarian artist László Moholy-Nagy came in 1922. He attempted to find new ways of seeing the world and experimented with radical uses of photographic materials in an attempt to replace 19th-century pictorialist conventions with a "new vision" compatible with modern life. Moholy explored many ways of expanding photographic vision, through photograms, photomontage (left), the Sabattier effect (often called solarization), unusual angles, optical distortions, and multiple exposures. He felt that "properly used, they help to create a more complex and imaginary language of photography."

Another artist exploring new art forms was Man Ray, an American expatriate in Paris. He was drawn to Dada, a philosophy that commented on the absurdities of modern existence. "I like contradictions," he said. "We have never obtained the infinite variety and contradictions that exist in nature." Like Moholy, Man Ray used many techniques, including solarizations (below).

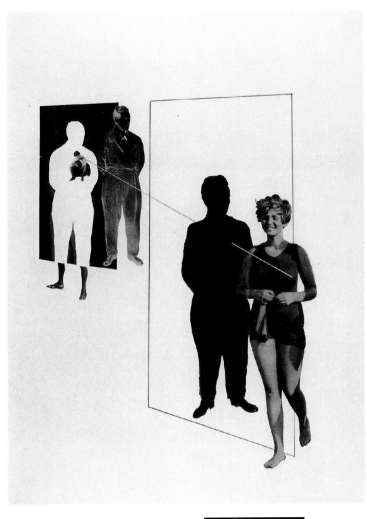

LÁSZLÓ MOHOLY-NAGY Jealousy, 1927

Photographers such as László Moholy-Nagy and Man Ray used many techniques in their explorations of real, unreal, and abstract imagery. *The photomontage (above) combines pieces of several photographs. Moholy defined photomontage as "a tumultuous collision of whimsical detail from which hidden meanings flash," a definition that fits this ambiguous picture.*

Right, the dark lines along the woman's hand, as well as other altered tones, are due to solarization, exposing the image to light during development.

MAN RAY Solarization, 1929

More about . . .

• Photograms, pages 178–179
• Solarizations, pages 180–181

Photography as Art in the1950s and Beyond

A tremendous growth has taken place in the acceptance of photography as an art form, a change that started in the 1950s. Since then, photography has become a part of the college and art school curriculum, art museums have devoted considerable attention to photography, art galleries opened to sell only photographs, while photography entered other galleries that previously had sold only paintings or other traditional arts, and magazines such as *Artforum* and *Art in America* began to regularly publish photographs and essays about the medium.

American work of the 1950s was often described in terms of regional styles. Chicago was identified with the often abstract work of Aaron Siskind (right) and Harry Callahan. The West Coast was linked to the so-called straight photographers, such as Ansel Adams (page 302) and Minor White (page 81). New York was thought of as the center for social documentation, such as by photographers in the politically active Photo League. Meanwhile, tied to no region, Robert Frank, a Swiss, was traveling across the United States photographing his own view of life in the 1950s (opposite).

An increasing number of colleges and art schools in the 1960s offered photography courses, often in their art departments where a cross-fertilization of ideas took place between photographers and artists working in traditional art media. Some painters and other artists integrated photographs in their work or sometimes switched to photography altogether. Some photographers combined their images with painting, printmaking, or other media. Older photographic processes were revived, such as cyanotyping (page 182) and platinum printing (page 183).

Minor White used to say that in the 1950s photographers functioning as artists were so few that they used to clump together for warmth. Today, photography continues to develop in many directions (some are shown on the following pages), but the long battle over whether photography was an art, a battle that had been waged almost from the invention of the medium, seems finally to have been resolved. The winners were those who said it could be.

AARON SISKIND Chicago 30, 1949

Aaron Siskind's best-known work consists of surfaces abstracted from their normal context such as peeled and chipped paint or posters on walls (above). The subject of the photograph is the shapes, tonality, and other elements that appear in it, not the particular wall itself.

Siskind was active as a documentary photographer during the 1930s, but as he later recalled, "For some reason or other there was in me the desire to see the world clean and fresh and alive, as primitive things are clean and fresh and alive. The so-called documentary picture left me wanting something."

ROBERT FRANK Bar, New York City, 1955

Robert Frank's ironic view of America exerted a great influence on both the subject matter and style of photography as an art form. *Like Frank's photographs, the works of Diane Arbus, Lee Friedlander, Garry Winogrand, and others were personal observations of some of the peculiar and occasionally grotesque aspects of American society. Above, a glimpse inside a New York bar is an unsettling comment on the emptiness of modern society. Jack Kerouac wrote in his introduction to Frank's book* The Americans, *"After seeing these pictures you end up finally not knowing any more whether a jukebox is sadder than a coffin."*

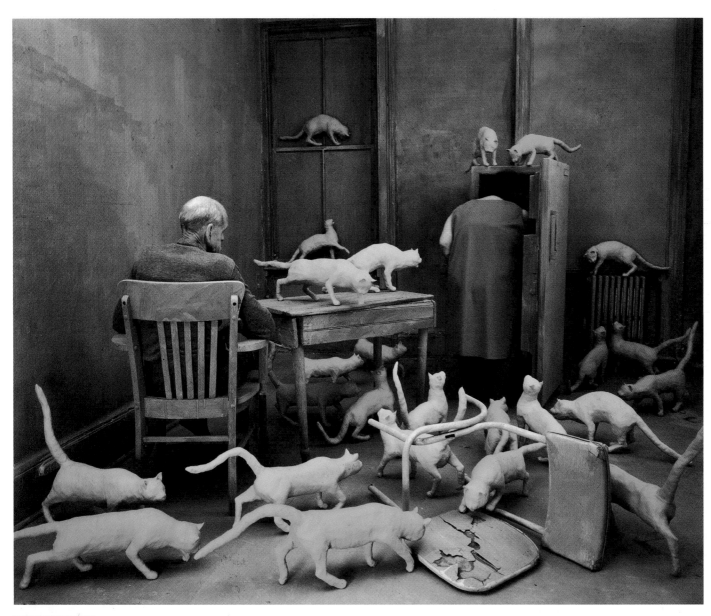

SANDY SKOGLUND Radioactive Cats, 1980

Sandy Skoglund constructs and then photographs life-size sets in which ordinary domestic scenes are transformed into bizarre or disturbing tableaux. "I like to stay in touch with reality," she says, "and at the same time try and interfere with it, like Magritte does. . . . You could call it making the familiar unfamiliar."

In Radioactive Cats, a troop of acid-green cats realistically molded out of plaster prowl around an elderly couple in a colorless kitchen. The result is unsettling and humorous at the same time. "I was thinking of what forms of life might best survive nuclear attack, and cats with their predatory nature, seemed likely," she says. "It's terrifying to think about the cat, and what it thinks about you."

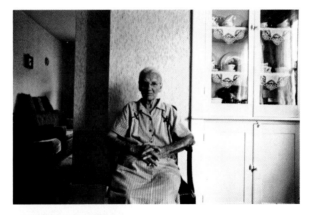

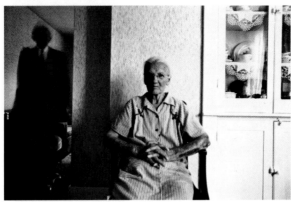

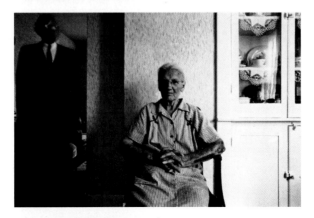

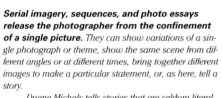

Serial imagery, sequences, and photo essays release the photographer from the confinement of a single picture. *They can show variations of a single photograph or theme, show the same scene from different angles or at different times, bring together different images to make a particular statement, or, as here, tell a story.*

Duane Michals tells stories that are seldom literal, but always relevant. "Photography to me is a matter of thinking rather than looking," he says. "it's revelation, not description." His photographs are often accompanied by titling or captions. Notice that you need the title of this story in order to understand it.

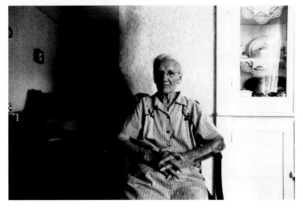

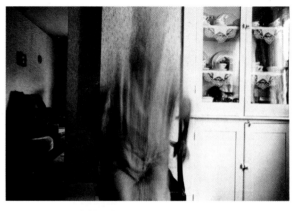

DUANE MICHALS Death Comes to the Old Lady, 1969

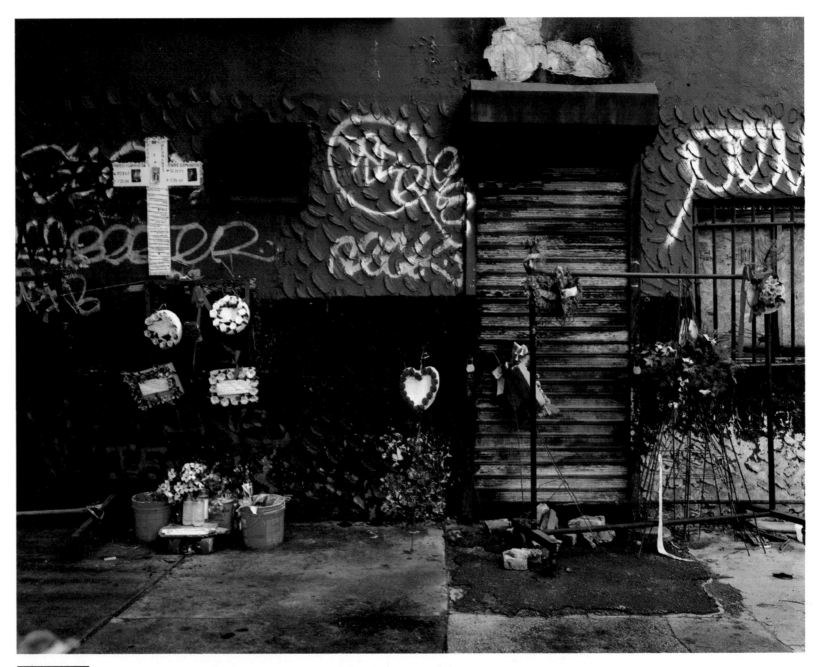

JOEL STERNFELD The Happy Land Social Club, 1959 Southern Boulevard, The Bronx, New York, June 1993

Joel Sternfeld's photographs extend the documentary tradition. After spending some time abroad, he wrote, "When I returned to the United States, I was struck by the accounts of violence that I read in the newspaper. . . . It occurred to me that I held something within: a list of places that I cannot forget because of the tragedies that identify them, and I began to wonder if each of us has such a list. I set out to photograph sites that were marked during my lifetime. Yet, there was something else that drew me to this work. I think of it as the question of knowability. Experience has taught me again and again that you can never know what lies beneath a surface or behind a façade."

The Happy Land Social Club was a popular, unlicensed Honduran social club. On March 25, 1990, Julio Gonzalez was thrown out of the club for quarreling with Lydia Feliciano, his girlfriend and a Happy Land employee. He bought a dollar's worth of gasoline, poured a trail of gas from the street through the single doorway, ignited it, and left. The fire killed eighty-seven people. Lydia Feliciano was one of five survivors.

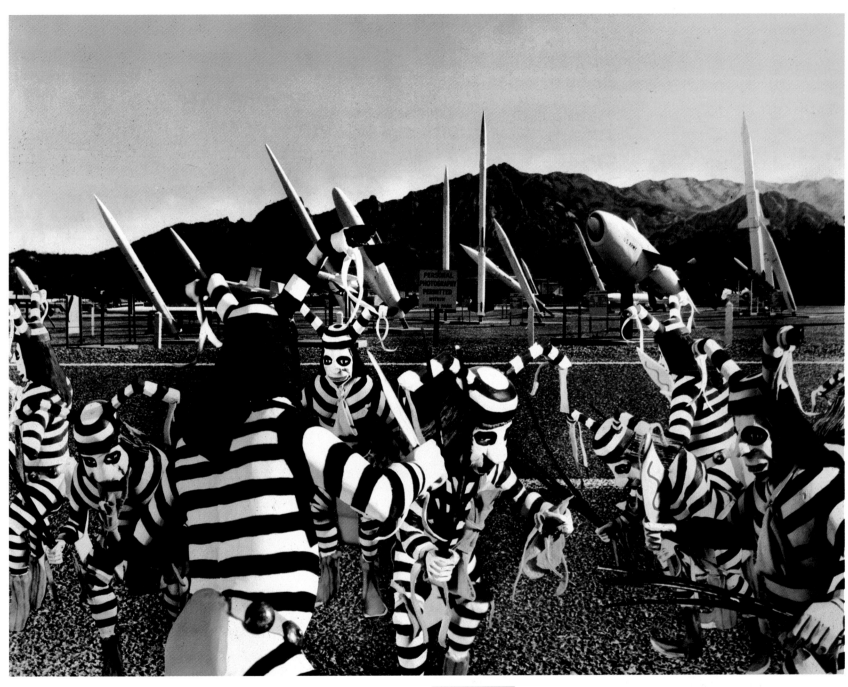

Koshare/Tewa Ritual Clowns, Missile Park, White Sands Missile Range, New Mexico, 1989

The role of clowns in Native American culture is to wake people up, to question and challenge them, to ridicule their improper behavior. Nagatani's series of photographs Nuclear Enchantment was intended to awaken those who still believe nuclear power poses no threat and that defense spending promotes the economy.

Above, black-and-white striped Tewa Indian koshares (clowns) dance in front of missiles, warning us of the social boundaries we have transgressed with weapons. Nagatani photographed the missile site in black and white, then hand colored it. The clowns were photographed in the studio in color, cut out, and collaged on top of the background.

*A*ll photographers occasionally encounter problems with their pictures, sometimes due to equipment failure, sometimes to human failure. If your pictures don't look the way you expected, see below. You'll find illustrations of various problems—and what to do about them.

No picture at all

Image area and film edges are clear in negative (dark in slide). Film frame numbers and manufacturer's name are visible.

The film was not exposed to light:

- **Film did not wind through the camera.** If the entire roll of fim is blank, an unexposed roll may have been processed by mistake. If you are sure you took pictures with the film in the camera, it probably did not catch on the film-advance sprockets and so did not advance from frame to frame. More about film loading and how to check for a proper load, page 3.
- **Lens cap was left on.** Possible with a viewfinder/rangefinder camera, but not likely with a single-lens reflex or view camera, which views through the lens.
- **Equipment failure.** Shutter failed to open, mirror in a reflex camera failed to move out of the way, or flash failed to fire. If problem recurs frequently, have equipment checked.

Image area and film edges are clear in negative (dark in slide). Film frame numbers and manufacturer's name do not show.

- **The film was put into fixer before it reached the developer.** Frame numbers and other data are exposed by the manufacturer along the film edges; they become visible only after development. If you use fixer first, this imprint, as well as the image, are removed from the film. If you developed the film yourself, review film processing, page 110–114. Label chemical containers so they don't get mixed up.

Image area and film edges are dark in negative (light in slide). Film frame numbers and manufacturer's name may be obscured.

Accidental exposure to light:

- **Camera back was opened before film was rewound.** Close the back immediately if this happens. Rewind the film and process it, because not all the film may have been affected. More about film rewinding, page 6.
- **Light reached the film after it was on the developing reel, but before it was put into a developing tank and covered.** Film must be loaded in total darkness, so be sure both room lights and safelights are off and there are no light leaks around doors or windows.

Camera/lens problems

Light streaks

Streaks along edges and/or in image area (dark in negative, light in print or slide).

Accidental exposure to light. A less damaging version of the previous problem. Other possible causes include:

- **Light leaked into camera back.** A damaged camera back or loose locking mechanism can let stray light enter and streak the film. Inspect the camera back along opening edges and hinges, and make sure the back locks securely and stays in place.
- **Light leaked into film cassette.** A bent film cassette or improperly secured end cap on a reuseable cassette can let in light and cause streaking. Inspect reusable cassettes carefully for damage before you refill them.
- **Camera loaded or film left in overly bright light.** In very bright light, even an apparently undamaged camera or cassette can leak, causing streaks on the film. In very bright light, load film in a shaded area or block direct light with your body. Keep undeveloped rolls of film away from light.

Flare or fogging

Image area flared or foggy looking overall (darkened in negative, lightened in print or slide), with film edges unaffected.

- **Direct light striking the lens surface.** Light that hits the front surface of the lens can bounce around inside the lens and cause an overall fogging of the image. Use a lens shade matched to your lens's focal length (see Vignetting, below) to block any light from shining directly on the lens.
- **A light source included in the image.** This can also produce ghosting, multiple images in the shape of the lens diaphragm and/or star points, streamers of light around the light source. The larger or brighter the light, the more ghosting you will get; distant or dim lights may not produce any. Difficult to cure because the cause is within the picture itself. Sometimes you can reduce the effect by changing your position.
- **Dirt, dust, scratches, and fingerprints on lenses or lens filters.** These imperfections increase the likelihood of flare. Clean a lens or filter before using it if it is dirty.

Vignetting

Image obscured around the edges.

- **Part of the image blocked by a lens shade or filter or both.** Use the correct size shade for your lens. Lens shades are made in sizes to match lens focal lengths. If the lens shade is too long for your lens, it can extend too far forward and partially block the image. Using more than one filter or a filter plus a lens shade can cause vignetting, especially with a short-focal-length lens. If necessary, take off the lens shade and use your hand to shade the lens. Just be sure your hand isn't visible.
- **With a view camera, caused by a lens with inadequate coverage for the film format.** See page 282.

Double exposure

Image areas overlap.

- **If images overlap on the entire roll, the film was put through the camera twice.** Rewind 35mm film entirely back into the cassette, including the film leader. If you leave the leader hanging out, you can mistake an exposed roll for an unexposed one and put it through the camera again.
- **If images overlap on one or a few frames, the film did not advance properly between exposures.** Accidentally pushing the film rewind button would let you release the shutter without having advanced the film. Check the way you grip the camera. It is diifficult to push the rewind button unintentionally, but it is possible to do so.
- **If frames frequently overlap or if spaces between frames are of different widths, your film advance mechanism is probably failing.** The camera should be repaired.

Torn sprocket holes, torn film

Sprocket holes on edges of 35mm film are torn and/or film is torn through an image frame.

- **Rewinding was forced without first engaging the rewind mechanism.** Some cameras rewind automatically at the end of a roll. Others require you to push a rewind button or lever. See manufacturer's instructions for how to rewind film with your camera.
- **Film was forcibly advanced after the end of the roll was reached.** Don't try to squeeze just one more shot onto the end of a roll. You'll probably just tear it off the spool, making rewinding impossible. If this happens, retrieve the film by opening the camera back in a totally dark room or in a light-tight film changing bag.

Specks, scratches, fingerprints on film or print

Dust specks

White specks or small white spots on print.

- **Dust is the culprit.** Dust on a negative, printing-frame glass, or glass negative carrier will keep light from passing through the negative and produce sharp white specks on the print. Fuzzy-edged spots may be due to dust on an enlarger's glass condensers. Dust all these surfaces carefully before printing, although it's almost impossible to keep them entirely free of dust. Dust loves wet negatives; hang just-washed film in a dust-free place to dry. White specks on a print can be darkened with dyes (see spotting, page 162).

Pinholes

Black specks in print (clear on negative).

- **Dust on the film during exposure.** Bits of dust on unexposed film will keep light from reaching that part of the film during the exposure. Keep the inside of the camera dust free by blowing or dusting camera surfaces when you reload film. With sheet film, dust film holders carefully and load film in a dust-free place. Dark specks can be etched or bleached to remove them (see spotting, page 162).
- **Stop bath too strong during film development.** The acid stop bath used between developer and fixer steps must be diluted to the proper strength or it can cause a chemical reaction that will lift off bits of the film emulsion. Check your film chemistry for proper dilution. Some photographers use a plain water rinse instead of a stop bath; the fixer won't last as long, but pinholes won't be a problem.
- **Scratches on enlarger's glass condensers.** This could be the cause of dark, fuzzy-edged spots. The only cure is to replace the condensers.

Dark scratch lines in print

- **Rough handling of film.** Scratching the film's emulsion side will scrape away the emulsion and make dark scratch lines visible in the print. Handle film with extreme care and avoid cinching roll film, sliding sheet film against a rough surface, or otherwise abrading the film. Check the film path in the camera for grit or unevenness. Do not drag film roughly in and out of negative preservers or an enlarger's negative carrier.
- **Rough handling of print.** If scratches can be seen only on the print, not on the negative, the cause is abrasion of the print emulsion. Prevent this by handling paper with greater care. If you use print tongs, don't slide them across the print surface; even light pressure can mark the surface of the print. Grip paper with tongs in the print margin so tong marks can be trimmed off if necessary.

Light scratch lines in print

- **Rough handling of film.** Hairline scratches on the backing side of the negative will make light scratch lines visible in the print. More careful handling or storage of the negative will prevent future problems. Check the film pressure plate on the camera back for damage or raised areas that might be scratching the film as it advances or rewinds.

 An already scratched negative can be improved somewhat by applying a light coating of oil. Edwal No-Scratch is an oily product that may at least partially improve the next print by temporarily filling in the scratch. A down-home remedy is to rub your finger on your nose or forehead to pick up a light coating of oil. Then gently smooth the oil over any fine scratches that are visible. Either method works only on scratches that print as white. The oil attracts dust, so clean the negative with film cleaner before storing.

Fingerprints

Fingerprints on film will appear oversize in an enlarged print; fingerprints caused by handling paper improperly will be lifesize.

- **Touching film or paper emulsion with greasy or chemical-contaminated hands.** Rinse and dry hands after they have been in any chemical solution. Be particularly careful to clean fixer off hands. Hold film and paper by edges.

 Fingerprints from grease might be removed by rewashing the film and treating it again with a wetting agent, or by cleaning the film with a cotton swab and film cleaner. Handling film with clean editing gloves is a sure way to prevent damage and is always done by curators and others concerned with film preservation.

Crescent-shaped marks

Dark crescents in negative (light in print).

■ **Crimping or creasing the film while loading it onto the developing reel.** Handle film with care, especially if you have trouble loading it onto a developing reel and have to reel it on and off several times. Make sure developing reels are completely dry to prevent the film from sticking during loading. Spotting a print that shows marks will help (see page 162).

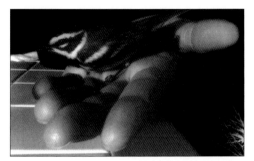

Static marks

Sparklike shapes dark in negative (light in print).

■ **Static electricity in the camera.** Winding film rapidly on a very cold, dry day can cause lightninglike marks. When humidity is very low, avoid snapping the film advance lever forward or otherwise advancing or rewinding film extremely rapidly.

■ **Static electricity in the darkroom.** Static marks in beadlike or other shapes can be caused by pulling undeveloped roll film rapidly away from its paper backing, pulling 35mm film through the cassette opening rather than taking the top off the cassette, ripping off rather than cutting off the tape that holds film on a spool, or passing film rapidly through your fingers. Handle film without rapid, friction-producing motions.

Film development problems

Blank patches

Patches usually opaque in negative (light in print), occasionally clear in negative (dark in print).

■ **Two loops of film stuck together during film processing.** Winding two loops of film onto one loop of developing reel (not hard to do with a stainless-steel reel) or squeezing reeled film (possible with either a plastic or stainless-steel reel) can keep part of one film loop in contact with another. This keeps chemicals from reaching the film emulsion at the point of contact. Most often the area will be totally unprocessed and opaque (see illustration). It will be clear if the film separates during fixing.

Check that film is winding correctly by feeling how full the reel is. Listen as you reel the film; any crackling or other unusual sound indicates a problem. If winding doesn't proceed smoothly, unwind a few loops and start again.

Air bells

Small, round dark spots in print (clear on negative). Air bells can also occur during print development, see Air Bells, page 375.

■ **Bubbles of air on the surface of the film during development.** The bubbles kept that part of the film from being developed. Vigorously tapping the film development tank at the start of the development period will dislodge any air bubbles from the film. See page 112, step 11.

Every frame only partially developed

One edge of the entire roll of negatives lighter than the rest (darker in print).

■ **Not enough developer to cover the film.** Check the amount of developer needed to cover the reel (or reels, in a tank that holds more than one). Fill the tank with water, pour the liquid into a graduate, and note the amount. Use this as your standard measure for the tank. Or simply fill the tank to overflowing when you add chemicals.

Film development problems...continued

Uneven, streaky development of negative

Lighter streaks in negative (darker in print).

■ **Too little agitation in developer.** Without adequate agitation, exhausted chemicals can accumulate and slide across the surface of the film, retarding development and causing streaks in those areas. Prevent this by agitating regularly. See step 12, page 112 for how to agitate film.

Overdeveloped areas around sprocket holes

Repeated streaks coming from sprocket holes appear dark on film (light on print). Most visible in lighter areas, such as skies.

■ **Too much agitation in developer.** The goal of agitation is to move the developer evenly across the film's surface. Excessive agitation can force too much fresh developer through the film's sprocket holes, causing those areas to be more developed than the rest of the film. See step 12, page 112 for how to agitate film.

Film surface appears cloudy

A milky white look with most films. A pinkish cast with Kodak T-Max film.

■ **Probably due to inadequate fixing.** If film appears cloudy when you remove it from the fixer, immediately replace it in the fixer, agitating vigorously at 30-sec intervals. If the milky appearance isn't gone after 5 min, your fixer is exhausted. Cover the tank, refix with fresh fixer.
■ **Possibly old, light-struck, heat-damaged, or X-rayed film.** No cure for this. Use fresh film next time.

Scum or gritty residue on film

■ **Inadequate washing or improper use of wetting agent.** Make sure wash water circulates well; dump wash water several times during the washing process, refilling the tank with fresh water. Dilute the wetting agent correctly; too strong a solution can leave a residue of its own on the film. Make sure film is completely dry before you work with it; damp film readily attracts dust and grit.
■ **Extremely hard water.** If you live in an area with very hard water, filtering your water at the tap can minimize problems with mineral particles depositing on the film. Mix wetting agent with distilled water to give a final clean rinse to the film.

Faint, watery looking marks on film

Usually running along the length of the film.

■ **Uneven drying or water splashed on film during drying.** Treat film in a wetting solution, such as Kodak Photo-Flo, just before hanging it up to dry. Hang the film from one end with a clip holding down the other end so that the water can drip straight off the film and not puddle up. Don't let water from one roll of drying film drip onto another. Rewashing the damaged film or using film cleaner may remove the streaks. Spotting a print where streaks show can help, see page 162.

Reticulation

Image appears crinkled or cracked overall.

■ **Extreme variations in temperature of processing solutions.** Very large changes, such as processing film in very warm developer, then putting the film in very warm stop bath can cause the effect illustrated. Less extreme variations can cause increased grain. Keep all solutions, from developer to wash, at or within a few degrees of the same temperature.

Printing problems

Image backwards in print

■ **Negative upside down in enlarger or printing frame.** Easy to identify. Easy to fix: flop the negative over and make another print.

Vignetted print, negative OK

White edges or corners on the print, or image appears within a circle.

■ **Light coming from the enlarger is obstructed.** Check the enlarger's condensers to make sure they are in the right position for the film in use. Check that any filters or filter holders are not obstructing the enlarger's light.

Mottled, mealy, uneven look to the print

■ **Too little time or inadequate agitation in print developer.** Develop prints with constant agitation in fresh developer for no less than the minimum time recommended by the manufacturer. Don't pull a print out of the developer if it appears to be becoming too dark too soon. It's better to make another print with less exposure.

■ **Use of exhausted or too cold developer.** Use fresh developer within the temperature range recommended by manufacturer. If darkroom is too cold to maintain the temperature, flood the sink with enough warm water to surround the developing trays, but not float them away.

Air bells

Small, round light spots in print, negative OK. Round dark spots on the print with matching clear spots on the negative are caused by air bells during film development. See Air Bells, page 373.

■ **Bubbles of air on the surface of the print during development.** If a print is immersed face down in the developer, then not agitated enough, bubbles of air can stick to the print and prevent the developer from working. Slide prints into the developer face up and agitate continuously during the development period.

Printing problems...continued

Black streaks appear across print edge and/or in the image

- **Exposure of printing paper to white light.** Black streaks are the result of white light leaking into a damaged paper container or accidentally reaching the paper by, for example, having the paper container open while you turn on the room lights or raise the enlarger lamp housing with the enlarger light on. Until your print is fixed, the only white light that should reach your paper is that from the enlarger during the exposure. Store your printing paper in its original wrapping, within its black bag and cardboard envelope or box.

Overall gray cast in highlights or paper margins

- **Fogging of printing paper by stray light.** Check for light leaking into darkroom from outside, stray light from enlarger, too strong a safelight, too long or too close an exposure to a proper safelight. Fogging affects highlights first, so prints may be reduced in brilliance before fogging is seen in print margins. The light from slight fogging alone may be too weak to cause any visible response in the paper's emulsion, but when added to the slight exposure received by the highlights, it can be enough to make the print grayish. Compare highlights that should be pure white in the print with the white test patch described on page 149.
- **Improper paper storage.** Fogging can occur if paper is stored near heat or in a package that is not light tight, or by use of outdated paper. Buy new paper and store properly.
- **Too much time in developer.** Remove print at the end of the recommended developing time. If the print is too light, don't keep it in the developer for extra time. Make another print with more exposure.
- **Room light on too soon after print in placed in fixer.** Give the fixer enough time to stop the action of the developer so the print isn't affected by exposure of the print to room light.

Yellow stains

- **Can be caused at a variety of processing stages.** Too long a time in the developer, exhausted or too-warm developer, contamination of developer with fixer, exposure of paper to air during development by lifting it out of the developer too often, exhausted stop bath or fixer, delay in placing print into fixer, and inadequate washing are all possible culprits. Review fixing and washing procedure (page 145–146) and information about contamination (page 108).

Brownish-purple stains

- **Inadequate fixing.** Review fixing (page 145).

Prints fade

- **Improper processing.** Prints that look faded immediately after washing were bleached by a too-strong or too-warm fixer or by too long a time in the fixer. Later fading is caused by inadequate fixing or washing. Review the recommended fixing and washing procedure (page 145–146).

Overexposed *Overdeveloped*

Density (overall lightness/darkness) problems

Negative dense looking, slide too light

■ **Most likely, the film was overexposed.** Overexposed film will have considerable shadow detail and dense, blocked highlights. Don't meter your own shadow when you move in close to meter a scene; the meter will assume the scene is dark overall and will give more exposure.

If negatives are frequently too dense, your meter might be giving you too low a reading. See Negative Thin Looking (below) for suggestions on setting the film speed and checking your meter. Double the film speed to give the film one stop less exposure; for example, using ISO 400 film, but setting the speed to ISO 800.

■ **Film was overdeveloped.** Overdeveloped film will have normal shadow detail, with excessively dense, blocked highlights, and will be high in contrast. Develop film for no more than the recommended time and temperature.

Underexposed *Underdeveloped*

Negative thin looking, slide too dark

■ **Most likely, the film was underexposed.** Underexposed film will have little detail in shadows. Tilt the camera down slightly when metering a scene that includes a bright sky so the meter doesn't assume the overall scene is very bright and give less exposure. Make sure your camera is set to the correct film speed. Some cameras set the film speed automatically; if you set it yourself, remember to check the speed setting. Film will be underexposed if you change from, for example, a fast ISO 400 film to as slower ISO 100 film and forget to reset the film speed setting.

If negatives are frequently too thin, your meter might be giving you too high a reading. Try comparing it to a meter that seems to be accurate. If the meter is reading too high, you can either get it repaired or, if your camera lets you do so, set the film speed lower than the film's actual rating. Halve the film speed to give the film an additional stop of exposure; for example, using ISO 400 film, but setting the speed to ISO 200. If the meter appears to be working correctly, review your metering techniques (pages 94–101).

■ **Film was underdeveloped.** Underdeveloped film will have normal detail in shadows, but little highlight density, and will be low in contrast. Develop film for the full time at the recommended temperature in fresh solutions at the correct dilution.

Print too light

■ **Most likely, print underexposed.** Make another print with more exposure.
■ **Print developed for much less than the recommended time.**
■ **Paper put in the easel with emulsion side down.**

Print too dark

■ **Most likely, print overexposed.** Make another print with less exposure.
■ **Print developed for much more than the recommended time.** This might cause some darkening of the print, but is more likely to cause staining.
■ **Print looks darker after drying.** This is a normal result with fiber-base papers. A dry fiber-base print may appear 6–10 percent darker than when it was wet. Often, the dry down is not enough to cause problems, but for critical printing, you can reduce the exposure slightly to make a slightly lighter print that will compensate for the effect.

Snow scene or other light scene too dark

Negative thin, difficult to make a light-enough print. Slide too dark.

■ **Film underexposed.** The meter computed an exposure for a middle-gray tone, but the scene was actually lighter than middle gray, so it appears too dark. When photographing scenes that are very light overall, such as snow scenes or sunlit beach scenes, give 1 or 2 stops more exposure than the meter recommends. More about meters and middle gray on pages 92 and 98.

Contrast problems

Print too contrasty

Print looks harsh. Difficult to get adequate texture and detail in highlights and/or shadows.

■ **Printing filter or paper contrast too high.** Make another print with a lower number printing filter or lower contrast grade of paper. Try dodging the shadows slightly, burning in the highlights (see dodging and burning in, pages 154–155).

If prints from many different scenes are too contrasty, you may be overdeveloping the film. Develop film for no more than the recommended time and temperature.

Print too flat

Print looks gray and dull, with no real blacks or brilliant whites.

■ **Printing filter or paper contrast too low.** Make another print with a higher number printing filter or higher contrast grade of paper.

If prints from many different scenes are too flat, you may be underdeveloping the film. Develop film for the full time at the recommended temperature in fresh solutions at the correct dilution.

Subject very dark against light background (or very light against dark background)

■ **Meter was influenced by the background.** If you make an overall reading when a subject is against a bright background such as a bright sky, your subject is likely to be underexposed and too dark. Occasionally you may have a related problem if your subject is small and light against a much larger, very dark background; the subject will be overexposed and too light. Move in close to meter just the subject, then set your shutter speed and aperture accordingly (see page 96). Some meters built into newer cameras avoid this problem; they have multiple sensors that meter and compare various parts of a scene, and automatically adjust the exposure.

Sharpness problems

Nothing in the negative is sharp. Easier to see in an enlarged print, but may be visible in the negative.

■ **Most likely, camera motion.** Too slow a shutter speed while you are hand holding a camera will blur the picture overall. As a rule of thumb, when hand holding the camera, use a shutter speed at least as fast as the focal length of your lens—1/100 sec with a 100mm lens, 1/250 sec with a 200mm lens, and so on. Use a tripod for slower shutter speeds. More about holding the camera steady on page 31.
■ **Extremely dirty lens.** This can reduce the crispness of the image overall, especially when combined with lens flare.
■ **Camera focus was completely wrong.** For example, when making a close-up, somehow the lens was focused on a far distance. Possible with an automatic-focus camera if you do not give the camera enough time to adjust the focus before you make an exposure.

Moving subject not sharp

Some other part of the scene is sharp, but moving subject is not.

■ **Too slow a shutter speed.** More about shutter speeds and moving subjects on pages 18–19.

Not enough of scene is sharp

■ **Not enough depth of field.** Too wide an aperture will result in shallow depth of field, making the scene sharp where you focused the camera, but not in front of or behind that part of the scene. More about depth of field on pages 22–23 and 50–55.

Wrong part of the scene is sharp

■ **Camera wasn't focused on the main subject.** For example, the subject moved, but you didn't refocus the camera. Possible with an automatic-focus camera if you do not give the camera enough time to adjust the focus before you make an exposure.

All or part of print out of focus (negative is sharp)

■ **If the entire print is out of focus, the enlarger vibrated during the exposure or was never focused properly.** Avoid jostling the enlarger or its base just before or during an exposure. A grain magnifier (shown on page 141) will help you focus the image sharply.
■ **If part of the print is out of focus, the negative may be buckling during the exposure.** Heat from the enlarger lamp can cause the negative to buckle and the image to go out of focus. A glass negative carrier will keep the negative flat. If you don't have one, avoid extremely long exposures or let the negative warm up by turning the enlarger on before you make the exposure, then refocus.

Only part of a completely sharp negative can be focused by enlarger

■ **Enlarger out of alignment.** If the enlarger's negative carrier and lens are not parallel to its baseboard (and hence to the printing easel), you may not be able to focus the entire negative sharply on the easel. Ideally, realign the enlarger. If that isn't possible, use a small enlarger lens aperture; it may provide enough depth of field to make the entire image sharp. As a last resort, try propping up one end of the printing easel to bring it parallel to the negative carrier.

Color problems

Bluish or reddish look to scene overall

■ **Color film not matched to the type of lighting used.** Tungsten-balanced or Type A film shot in daylight or with flash will give a bluish look to a scene; use daylight-balanced film when shooting in daylight or with flash. Daylight-balanced film shot in tungsten light will give a reddish look to a scene; use tungsten-balanced or Type A indoor film when shooting in tungsten light. See pages 198–199.

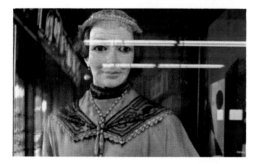

Greenish look to scene overall

■ **Scene shot in fluorescent light.** Fluorescent lighting fixtures emit large amounts of greenish light and will give a greenish look to a scene. An FL fluorescent filter on the lens helps. See page 200.
■ **Scene shot in light filtered by green foliage.** Most likely to be a problem with skin tones. See Unexpected Color Cast, below.

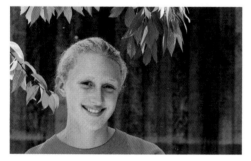

Unexpected color cast

■ **Light reflected from a nearby colored object gave a color cast to the scene.** Photographing someone in the shade of a tree can add an unexpected greenish look to skin tones because the light was filtered through the green leaves. Similarly, light bouncing off a strongly colored wall can tint the scene the color of the wall. The effect is most noticeable on skin tones or neutral tones like white or gray.

Flash pointed straight at reflective surface *Same scene shot at an angle*

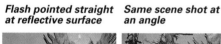

Flash problems

Unwanted reflections

■ **Light bouncing back from reflective surfaces.** Shooting straight at large windows, mirrors, metal surfaces, or shiny walls with the flash on the camera or close to it can cause light to be reflected from the flash back into the lens. When photographing scenes that include reflective surfaces, move the camera and/or the flash to one side so that you shoot or illuminate the scene at an angle to the reflecting surface. Eyeglasses can create the same problem; have the person look at a slight angle to the camera or move the flash off camera.

Red eye

Red or amber appearance to a person's or an animal's eyes.

■ **Light reflecting from the blood-rich retina inside the eye.** Have the person look away from the camera or move the flash away from the camera. Some cameras have a red-eye reduction mode: the flash lights up briefly before the main exposure so that the subject's iris contracts, reducing the amount of visible red.

Unwanted shadows

■ **Flash positioned at an angle that caused shadows you didn't predict.** Sighting along a line from flash to subject will help predict how shadows will be cast. A small tungsten light positioned close to the flash will also help; large studio flash units have such modeling lights built in for just this purpose. Move the subject away from a wall so shadows fall on the ground and out of the film frame, instead of visibly on the wall.

Moving subject partly blurred

■ **Flash used in strong existing light.** Most likely to occur when existing light is bright and the camera's shutter speed is slow. The film records two images during the exposure—a sharp one from the very short flash exposure and a blurred, ghost image created by strong existing light during the entire time the shutter was open. Make sure your shutter is set to the fastest speed usable with flash. Depending on the situation, you may also be able to dim the existing light, shoot when the subject isn't moving so much, or shoot at a faster shutter speed with the existing light alone. Consider deliberately combining the sharpness and blur, see page 251.

One side of the film frame is dark

Frame may be dark along an edge by the next frame (with a horizontally traveling shutter) or along an edge near the sprocket holes (with a vertically traveling shutter).

■ Too fast a shutter speed with a camera that has a focal-plane shutter, such as a single-lens reflex camera. The flash fired when the shutter was not fully open. If you set the shutter speed manually, check the manufacturer's instructions for how to set the camera for flash use. For most cameras, 1/60 sec is safe; faster speeds are usable with some cameras. The flash shutter speed may appear in a different color from the other shutter speeds, or may be marked with an X or lightning-bolt symbol. If the camera sets the shutter speed automatically with flash, and you have this problem, the camera needs repair.

Part of scene exposed correctly, part too light or too dark

■ **Parts of the original scene at different distances from the flash.** Parts that are farther away are darker than those that are close because the farther that light travels from the flash, the dimmer it becomes. Try to group important parts of the subject at about the same distance from the flash.

Subject appears too dark or too light

Manually setting the exposure for flash is more likely to cause problems than automatic operation with a camera that reads the illumination from the flash through the lens. More about automatic versus manual flash operation on pages 240–241.

■ **If the subject appears too dark, the scene was underexposed**—too little light reached the subject. If you manually set the exposure for flash, an occasional frame that is too dark probably results from setting the camera's lens aperture incorrectly. In manual operation, increase the exposure about a stop for scenes shot outdoors at night or in a large room like a gymnasium; the relatively dark surroundings absorb light that would otherwise bounce back to add to the exposure. If your flash pictures are frequently too dark, try setting the flash unit's film-speed dial to half the speed of the film you are using.

■ **If the subject appears too light, the scene was overexposed**—too much light reached the subject. Occasional overexposure in manual operation is probably due to an error in setting the camera's lens aperture. In manual operation, close down the aperture about a stop when shooting in small, light-colored rooms to compensate for excess light bouncing back from walls and ceiling. If your flash pictures are usually overexposed, try setting the flash unit's film-speed dial to twice the speed of the film you are using.

Farenheit vs. Celsius.

Fahrenheit thermometers are in common use in the United States, but those who use the metric system use the Celsius scale. Strictly speaking, Celsius is the correct term for the scale of temperatures commonly called centigrade.

To convert Fahrenheit degrees into Celsius: subract 32 from the Fahrenheit temperature, multiply by 5, divide by 9. To convert Celsius degrees into Fahrenheit: multiply by 9, divide by 5, add 32.

Following are metric conversions often encountered in photographic work.

Length

1 inch	25.4 millimeters or 2.54 centimeters
1 foot	0.31 meters
1 yard	0.92 meters
1 millimeter	0.039 inches
1 centimeter	0.39 inches
1 meter	39.37 inches or 3.28 feet or 1.09 yards

Volume

1 fluid ounce	29.57 milliliters
1 quart	946 milliliters
1 gallon	3.79 liters
1 milliliter	.034 fluid ounces
1 liter	1.06 fluid quarts

Weight

1 ounce	28.35 grams
1 pound	453.59 grams
1 gram	0.035 ounces
1 kilogram	2.20 pounds

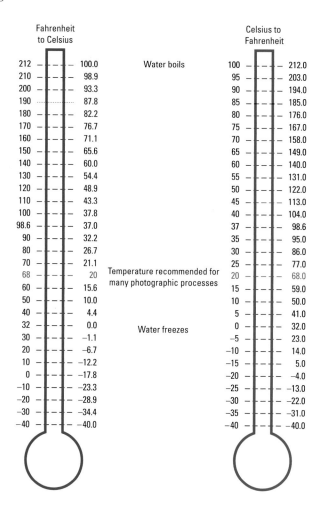

Fahrenheit to Celsius

212	100.0
210	98.9
200	93.3
190	87.8
180	82.2
170	76.7
160	71.1
150	65.6
140	60.0
130	54.4
120	48.9
110	43.3
100	37.8
98.6	37.0
90	32.2
80	26.7
70	21.1
68	20
60	15.6
50	10.0
40	4.4
32	0.0
30	−1.1
20	−6.7
10	−12.2
0	−17.8
−10	−23.3
−20	−28.9
−30	−34.4
−40	−40.0

Water boils

Temperature recommended for many photographic processes

Water freezes

Celsius to Fahrenheit

100	212.0
95	203.0
90	194.0
85	185.0
80	176.0
75	167.0
70	158.0
65	149.0
60	140.0
55	131.0
50	122.0
45	113.0
40	104.0
37	98.6
35	95.0
30	86.0
25	77.0
20	68.0
15	59.0
10	50.0
5	41.0
0	32.0
−5	23.0
−10	14.0
−15	5.0
−20	−4.0
−25	−13.0
−30	−22.0
−35	−31.0
−40	−40.0

aberration An optical defect in a lens causing it to form an image that is not sharp or that is distorted. *See also* astigmatism, barrel distortion, chromatic aberration, coma, field curvature, pincushion distortion, spherical aberration.

acid A substance with a pH below 7. Since an acid neutralizes an alkali, a stop bath is usually an acidic solution that stops the action of the alkaline developer.

additive color A way to produce colors of light by mixing light of the three additive primary colors—red, green, and blue.

AE *See* automatic exposure.

AF *See* automatic focus.

agitate To move a solution over the surface of film or paper during development so that fresh liquid comes into contact with the surface.

albumen Egg white; used in early photographic emulsions as a coating for glass plates and, more commonly, for printing paper.

alkali A substance with a pH above 7. Developers are usually alkaline solutions.

ambrotype A collodion wet-plate process in which the emulsion was coated on a glass plate. The negative image produced was visible as a positive image when the glass was backed with a dark material.

angle of view The area seen by a lens or viewfinder or read by a light meter.

aperture The size of the lens opening through which light passes.

aperture-priority A mode of automatic exposure in which the photographer selects the aperture and the camera sets the shutter speed that will produce the correct exposure.

archival processing Processing designed to protect a print or negative as much as possible from premature deterioration caused by chemical reactions.

artificial light Light from an electric lamp, a flash bulb, or electronic flash. Often describes lights that the photographer has set up to illuminate a scene.

ASA A film speed rating similar to an ISO rating.

astigmatism A lens aberration or defect that is caused by the inability of a simple lens to focus oblique rays uniformly.

automatic exposure A mode of camera operation in which the camera adjusts the shutter speed, the aperture, or both to produce the correct exposure. Abbreviated AE.

automatic flash An electronic flash unit with a light-sensitive cell and electronic circuitry that measures the light reflected back from the subject and terminates the flash when the exposure is correct.

automatic flash An electronic flash unit with a light-sensitive cell and electronic circuitry that measures the light reflected back from the subject and terminates the flash when the exposure is correct.

automatic focus A system by which the camera adjusts its lens to focus on a given area, for example, whatever is at the center of the image. Abbreviated AF.

ambient light *See* available light.

AV Abbreviation of aperture value. Used on some camera information displays as a shortened way to refer to aperture settings (f-stops).

available light The light that already exists where a photograph is to be made, as opposed to light brought in by the photographer. Often implies a relatively dim light. Also call ambient light or existing light.

axis lighting Light pointed at the subject from a position close to the camera's lens.

B *See* bulb.

back lighting Light that comes from behind the sub-ject toward the camera.

barrel distortion A lens aberration or defect that causes straight lines to bow outward, away from the center of the image.

bellows A flexible, light-tight, and usually accordion-folded part of a view camera between the lens board in front and the viewing screen in back. Also used on a smaller camera for close-ups.

bit The smallest unit of information usable by a computer.

bleed mount To mount a print so that there is no border between the edges of the print and the edges of the mounting surface.

blocked up Describes highlight areas that lack normal texture and detail. Due to excess contrast caused by, for example, overexposure or overdevelopment.

blotters Sheets of absorbent paper made expressly for photographic use. Wet prints dry when placed between blotters.

bounce light Light that does not travel directly from its source to the subject but is first reflected off another surface.

bracket To make several exposures, some greater and some less than the exposure that is calculated to be correct. Bracketing allows for error and permits selection of the best exposure after development.

brightness Strictly speaking, a subjective impression of the lightness of an object. The correct term for the measurable quantity of light reflected or produced by an object is luminance. *See also* luminance.

broad lighting Portrait lighting in which the main source of light illuminates the side of the face turned toward the camera.

built-in meter A reflected-light exposure meter built into a camera so that light readings can be made directly from camera position.

bulb A shutter setting marked B at which the shutter remains open as long as the shutter release is held down.

burn in To darken a specific area of a print by giving it additional printing exposure.

butterfly lighting Portrait lighting in which the main source of light is placed high and directly in front of the face.

byte A unit of digital data containing eight bits. *See also* kilobyte, megabyte.

cable release A long coiled wire with a plunger at one end and a socket at the other that attaches to a camera's shutter release. Pressing the plunger releases the shutter without touching (and possibly moving) the camera.

calotype The first successful negative/positive photographic process; it produced an image on paper. Invented by Talbot; also call Talbotype.

camera A picture-taking device usually consisting of a light-tight box, a film holder, a shutter to admit a measured quantity of light, and a lens to focus the image.

camera obscura Latin for "dark chamber"; a darkened room with a small opening through which rays of light could enter and form an image of the scene outside. Eventually, a lens was added at the opening to improve the image, and the room shrank to a small, portable box.

carte-de-visite A small portrait, about the size of a visiting card, popular during the 1860's. People often collected them in albums.

cartridge *See* cassette.

cassette A light-tight metal or plastic container that permits a roll of 35mm film to be loaded into a camera in the light. Also called a cartridge.

catchlight A reflection of a light source in a subject's eye.

changing bag A light-tight bag into which a photographer can insert his or her hands to handle film when a darkroom is not available.

characteristic curve A diagram of the response to light of a photographic material, showing how increasing exposure affects silver density during development. Also called the D log E curve, since density is plotted against the logarithm of the exposure.

chromatic aberration A lens defect that bends light rays of different colors at different angles and therefore focuses them on different planes.

chrome A color transparency.

chromogenic film Film in which the final image is composed of dyes rather than silver.

circle of confusion The tiny circle of light formed by a lens as it projects the image of a single point of a subject. The smaller the diameters of the circles of confusion, the sharper the image will be.

close-up A larger-than-normal image that is formed on a negative by focusing the subject closer than normal to the lens with the use of supplementary lenses, extension tubes, or bellows.

close-up lens *See* supplementary lens.

collodion A transparent, syrupy solution of pyroxylin (a nitrocellulose) dissolved in ether and alcohol; used as the basis for the emulsion in the wet-plate process.

color balance 1. A film's response to the colors of a scene. Color films are balanced for use with specific light sources. 2. The reproduction of colors in a color print, alterable during printing.

color cast A trace of one color in all the colors in an image.

color compensating filters Gelatin filters that can be used to adjust the color balance during picture taking or in color printing. More expensive than acetate color printing filters, they can be used below the enlarger lens if the enlarger has no other place for filters. Abbreviated CC filters.

color printing filters Acetate filters used to adjust the color balance in color printing. They must be used with an enlarger that can hold filters between the enlarger lamp and the negative. Abbreviated CP filters.

color temperature A numerical description of the color of light measured in degrees Kelvin (K).

color temperature meter A device for estimating the color temperature of a light source. Usually used to determine the filtration needed to match the color balance of the light source with that of standard types of color film.

coma A lens aberration or defect that causes rays that pass obliquely through the lens to be focused at different points on the film plane.

complementary colors 1. Any two colors of light that when combined include all the wavelengths of light and thus produce white light (*see* additive color). 2. Any two dye colors that when combined absorb all wavelengths of light and thus produce black (*see* subtractive color). A colored filter absorbs light of its complementary color and passes light of its own color.

condenser enlarger An enlarger that illuminates the negative with light that has been concentrated and directed by condenser lenses placed between the light source and the negative.

contact printing The process of placing a negative in contact with sensitized material, usually paper, and then passing light through the negative onto the material. The resulting image is the same size as the negative.

contamination Traces of chemicals that are present where they don't belong, causing loss of chemical activity, staining, or other problems.

continuous tone Describes an image with a smooth gradation of tones from black through gray to white.

contrast The difference in darkness or density between one tone and another.

contrast filter A colored filter used on a camera lens to lighten or darken selected colors in a black-and-white photograph. For example, a green filter used to darken red flowers against green leaves.

contrast grade The contrast that a printing paper produces. Systems of grading contrast are not uniform, but in general grades 0 and 1 have low or soft contrast; grades 2 and 3 have normal or medium contrast; grades 4,5 and 6 have high or hard contrast.

contrasty Describes a scene, negative or print with very great differences in brightness between light and dark areas. Opposite: flat.

convergence The phenomenon in which lines that are parallel in a subject, such as the vertical lines of a building, appear nonparallel in an image.

cool Refers to bluish colors that by association with common objects (water, ice, and so on) give an impression of coolness.

correction filter A colored filter used on a camera lens to make black-and-white film produce the same relative brightnesses perceived by the human eye. For example, a yellow filter used to darken a blue sky so it does not appear excessively light.

coupled rangefinder *See* rangefinder.

covering power The area of the focal plane over which a lens projects an image that is acceptably sharp and uniformly illuminated.

crop To trim the edges of an image, often to improve the composition. Cropping can be done by moving the camera position while viewing a scene, by adjusting the enlarger or easel during printing, or by trimming the finished print.

curvilinear distortion *See* barrel distortion; pincushion distortion.

cut film *See* sheet film.

daguerreotype The first practical photographic process, invented by Daguerre and described by him in 1839. The process produced a positive image formed by mercury vapor on a metal plate coated with silver iodide.

darkroom A room where photographs are developed and printed, sufficiently dark to handle light-sensitive materials without causing unwanted exposure.

dark slide *See* slide (2).

daylight film Color film that is balanced to produce accurate color renditions when the light source illuminating the photographed scene has a color temperature of about 5500K, such as in midday sunlight or with electronic flash or a blue flashbulb.

dedicated flash An electronic flash unit that when used with certain cameras will automatically set the correct shutter speed for use with flash and will trigger a light in the viewfinder when the flash is charged and ready to fire. Also called designated flash.

dense Describes a negative or an area of a negative in which a large amount of silver has been deposited. A dense negative transmits relatively little light. Opposite: thin.

densitometer An instrument that measures the darkness or density of a negative or print.

density The relative amount of silver present in various areas of film or paper after exposure or development; therefore, the darkness of a photographic print or the light-stopping ability of a negative or transparency.

depth of field The area between the nearest and farthest points from the camera that are acceptably sharp in an image.

depth of focus The small range of allowable focusing error that will still produce an acceptable sharp image when a lens is not focused exactly.

designated flash *See* dedicated flash.

developer A chemical solution that changes the invisible, latent image produced during exposure into a visible one.

development 1. The entire process by which exposed film or paper is treated with various chemicals to make an image that is visible and permanent. 2. Specifically, the step in which film or paper is immersed in developer.

diaphragm The mechanism controlling the brightness of light that passes through a lens. An iris diaphragm has overlapping metal leaves whose central opening can be adjusted to a larger or smaller size. *See also* aperture.

dichroic head An enlarger head that contains yellow, magenta, and cyan filters that can be moved in calibrated stages into or out of the light beam to change the color balance of the enlarging light.

diffuse Scattered, not all coming from the same direction. For example, sunlight on a cloudy day.

diffusion enlarger An enlarger that illuminates the negative by scattering light from many angles evenly over the surface of the negative.

digital imaging A method of image editing in which a picture is recorded as digital information that can be read and manipulated by a computer, and subsequently reformed as a visible image.

DIN A numerical rating used in Europe to describe the sensitivity of film to light. The DIN rating increases by 3 as the sensitivity of the film doubles.

diopter An optician's term to describe the power of a lens. In photography, it mainly indicates the magnifying power and focal length of a supplementary close-up lens.

distortion 1. A lens aberration that causes straight lines at the edge of an image to appear curved. 2. The changes in perspective that take place when a lens is used very close to (wide-angle distortion) or very far from (telephoto effect) a subject.

dodge To lighten an area of a print by shading it during part of the printing exposure.

dropout An image with black and white areas only and no intermediate gray tones. Usually made by using high-contrast lith film.

dry down To become very slightly darker and less contrasty, as most photographic printing papers do when they dry after processing.

dry mount To attach a print to another surface, ususally cardboard, by placing a sheet of dry-mount tissue between the print and the mounting surface. This sandwich is placed in a heated mounting press to melt an adhesive in the tissue. Pressure-sensitive tissue that does not require heat may also be used.

DX coding A checkered or bar code on some film cassettes. The checkered code can be automatically scanned by a suitable equipped camera for such information as film speed and number of frames. The bar code is read by automatic film processing equipment for film type, processing procedure, and so on.

easel A holder to keep sensitized material, normally paper, flat and in position on the baseboard of an enlarger during projection printing. It usually has adjustable borders to frame the image to various sizes.

EI *See* exposure index.

electromagnetic spectrum The forms of radiant energy arranged by size of wavelength ranging from billionths of a millimeter (gamma rays) to several miles (radio waves). The visible spectrum is the part that the human eye sees as light: wave lengths of 400 to 700 nanometers (billionths of a meter), producing the sensation of the colors violet, blue, green, yellow, and red.

electronic flash A tube containing gas that produces a brief, brilliant flash of light when electri-fied. Unlike a flashbulb, an electronic flash unit is reusable. Also called a strobe.

emulsion A light-sensitive coating applied to photographic films or papers. It consists of silver halide crystals and other chemicals suspended in gelatin.

enlargement An image, usually a print, that is larger than the negative. Made by projecting an enlarged image of the negative onto sensitized paper.

enlarger An optical instrument ordinarily used to project an image of a negative onto sensitized paper. More accurately called a projection printer because it can project an image that is either larger or smaller than the negative.

etch To remove a small, dark imperfection in a print or negative by scraping away part of the emulsion.

EV *See* exposure value.

existing light *See* available light.

exposure 1. The act of letting light fall on a light sensitive material. 2. The amount of light reaching the light-sensitive material; specifically, the intensity of light multiplied by the length of time it falls on the material.

exposure index A film speed rating similar to an ISO rating. Abbreviated EI.

exposure meter An instrument that measures the amount of light falling on a subject (incident-light meter) or the amount of light emitted or reflected by a subject (reflected-light meter), allowing aperture and shutter speed settings to be computed. Commonly called a light meter.

exposure value A system originally intended to simplify exposure calculations by assigning standardized number values to f-stop and shutter speed combinations. More often, used simply as a shorthand way of describing the range of light levels within which equipment operates. For example, a manufacturer may describe a meter as operating from EV -1 to EV 20 (4 sec at f/1.4 to 1/2000 sec at f/22m with ISO 100 film).

extension tubes Metal rings that can be attached between a camera body and lens for close-up work. They extend the lens farther than normal from the film plane so that the lens can focus closer than normal to an object.

factor A number that tells how many times exposure must be increased to compensate for loss of light (for example, due to use of a filter).

Farmer's Reducer A solution of potassium ferricyanide and sodium thiosulfate that is used to decrease the amount of silver in a developed image.

fast Describes 1. a film or paper that is very sensitive to light; 2. a lens that opens a very wide aperture; 3. a short shutter speed. Opposite: slow.

ferrotype To give a glossy printing paper a very high sheen by drying the print with its emulsion pressed against a smooth metal plate, usually the hot metal drum or plate of a heat dryer.

fiber-base paper Formerly the standard type of paper available; now being replaced to a certain extent by resin-coated papers.

field curvature A lens aberration or defect that causes the image to be formed along a curve instead of on a flat plane.

fill light A source of illumination that lightens shadows cast by the main light and thereby reduces the contrast in a photograph.

film The material used in a camera to record a photographic image. Generally it is a light-sensitive emulsion coated on a flexible acetate or plastic base.

film holder A light-tight container to hold the sheet film used in a view camera.

film plane *See* focal plane.

film speed The relative sensitivity to light of a film. There are several rating systems: ISO (the most common in the United States and Great Britain), DIN (common in Europe), and others. Film speed ratings increase as the sensitivity of the film increases.

filter 1. A piece of colored glass, plastic, or other material that selectively absorbs some of the wave-lengths of light passing through it. 2. To use such a filter to modify the wavelengths of light reaching a light-sensitive material.

filter factor *See* factor.

fisheye lens A lens with an extremely wide angle of view (as much as 180° and considerable barrel distortion (straight lines at the edges of a scene appear to curve around the center of the image).

fixer A chemical solution (sodium thiosulfate or ammonium thiosulfate) that makes a photographic image insensitive to light. It dissolves unexposed silver halide crystals while leaving the developed silver image. Also called hypo.

flare Unwanted light that reflects and scatters inside a lens or camera. When it reaches the film, it causes a loss of contrast in the image.

flash 1. A light source, such as a flashbulb or electronic flash, that emits a very brief, bright burst of light. 2. To blacken an area in a print by exposing it to white light, such as from a penlight flashlight.

flashbulb A bulb containing a mass of aluminum wire, oxygen, and an explosive primer. When the primer is electrically fired, it ignites the wire which emits a brief burst of brilliant light. A flashbulb is used once and then discarded.

flash meter An exposure meter that measures the brightness of flash lighting to determine the correct exposure for a particular setup.

flat 1. A scene, negative, or print with very little difference in brightness between light and dark areas. Opposite: contrasty. 2. *See* reflector.

floodlight An electric light designed to produce a broad, relatively diffused beam of light.

f-number A number that equals the focal length of a lens divided by the diameter of the aperture at a given setting. Theoretically, all lenses at the same f-number produce images of equal brightness. Also called f-stop or relative aperture.

focal length The distance from the lens to the focal plane when the lens is focused on infinity. The longer the focal length, the greater the magnification of the image.

focal plane The plane or surface on which a focused lens forms a sharp image. Also called the film plane.

focal-plane shutter A camera mechanism that admits light to expose film by moving a slit or opening in a roller blind just in front of the film (focal) plane.

focal point The point on a focused image where the rays of light intersect after reflecting from a single point on a subject.

focus 1. The position at which rays of light from a lens converge to form a sharp image. 2. To adjust the distance between lens and image to make the image as sharp as possible.

focusing cloth A dark cloth used in focusing a view camera. The cloth fits over the camera back and the photographer's head to keep out light and to make the ground-glass image easier to see.

fog An overall density in the photographic image caused by unintentional exposure to light or unwanted chemical activity.

frame 1. The edges of an image. 2. A single image in a roll of film.

f-stop The common term for the aperture setting of a lens. *See also* f-number.

full-scale describes a print having a wide range of tonal values from deep, rich black through many shades of gray to brilliant white.

gelatin A substance produced from animal skins and bones, it is the basis for modern photographic emulsions. It holds light-sensitive silver halide crystals in suspension.

glossy Describes a printing paper with a great deal of surface sheen. Opposite: matte.

graded-contrast paper A printing paper that produces a single level of contrast. To produce less or more contrast, a change has to be made to

another grade of paper. *See also* variable-contrast paper.

graininess In an enlarged image, a speckled or mottled effect caused by oversized clumps of silver in the negative.

gray card A card that reflects a known percentage of the light falling on it. Often has a gray side reflecting 18 percent and a white side reflecting 90 percent of the light. Used to take accurate exposure meter readings (meters base their exposures on a gray tone of 18 percent reflectance) or to provide a known gray tone in color work.

ground glass 1. A piece of glass roughened on one side so that an image focused on it can be seen on the other side. 2. The viewing screen in a reflex or view camera.

guide number A number used to calculate the f-setting (aperture) that correctly exposes a film of a given sensitivity (film speed) when the film is used with a specific flash unit at various distances from flash to subject. To find the f-setting, divide the guide number by the distance.

gum-bichromate process An early photographic process revived by contemporary photographers. The emulsion is a sensitized gum solution containing color pigments. The surface can be altered by hand during the printing process.

halftone An image that can be reproduced on the same printing press with ordinary type. The tones in the photograph are screened to a pattern of dots (close together in dark areas, farther apart in light areas) that give the illusion of continuous tone.

hanger A frame for holding sheet film during processing in a tank.

hard 1. Describes a scene, negative, or print of high contrast. Opposite: soft or low contrast. 2. Describes a printing paper emulsion of high contrast such as grades 5 and 6.

hardware The processor, monitor, printer, and other physical devices that make up a computer system.

heliography An early photographic process, invented by Niepce, employing a polished pewter plate coated with bitumen of Judea, a substance that hardens on exposure to light.

highlight A very bright area in a scene, print, or transparency; a very dense, dark area in a negative. Also called a high value.

hot shoe A bracket on the top of the camera that attaches a flash unit and provides an electrical connection to synchronize the camera shutter with the firing of the flash.

hyperfocal distance The distance to the nearest plane of the depth of field (the nearest object in focus) when the lens is focused on infinity. Also the distance to the plane of sharpest focus when infinity is at the farthest plane of the depth of field. Focusing on the hyperfocal distance extends the depth of field from half the hyperfocal distance to infinity.

hypo A common name for any fixer; taken from the abbreviation for sodium hyposulfite, the previous name for sodium thiosulfate (the active ingredient in most fixers).

hypo clearing agent or hypo neutralizing agent *See* washing aid.

illuminance The strength of light falling on a given area of a surface. Measurable by an incident-light (illuminance) meter.

illuminance meter *See* incident-light meter.

incandescent light Light emitted when a substance is heated by electricity: for example, the tungsten filament in an ordinary light bulb.

incident-light meter An exposure meter that measures the amount of light incident to (falling on) a subject.

indoor film *See* Type A film; tungsten film.

infinity The farthest position (marked ∞) on the distance scale of a lens. It includes all objects at the infinity distance (about 50 feet) from the lens or

farther. When the infinity distance is within the depth of field, all objects at that distance or farther will be sharp.

infrared The band of invisible rays just beyond red, which people perceive to some extent as heat. Some photographic materials are sensitized to record infrared.

instant film A film such as Polaroid Time-Zero that contains the chemicals needed to develop an image automatically after exposure without the need for darkroom development.

intensification A process increasing the darkness of an already developed image. Used to improve negatives that have too little silver density to make a good print or to increase the density of an existing print.

interchangeable lens A lens that can be removed from the camera and replaced with another lens, usually of a different focal length.

inverse square law A law of physics stating that the intensity of illumination is inversely proportional to the square of the distance between light and subject. This means that if the distance between light and subject is doubled, the light reaching the subject will be only one-quarter of the original illumination.

ISO A numerical rating that describes the sensitivity of a film to light. The ISO rating doubles as the sensitivity of the film doubles.

Kelvin temperature *See* color temperature.

key light *See* main light.

kilobyte A unit of digital data containing 1024 bytes. Used to describe the size of a computer file.

latent image An image formed by the changes to the silver halide grains in photographic emulsion on exposure to light. The image is not visible until chemical development takes place.

latitude The amount of over-or underexposure possible without a significant loss in the quality of an image.

leaf shutter A camera mechanism that admits light to expose film by opening and shutting a circle of overlapping metal leaves.

lens A piece or several pieces of optical glass shaped to focus an image of a subject.

lens shade A shield that fits around a lens to prevent unwanted light from hitting the front of the lens and causing flare. Also called a lens hood.

light meter *See* exposure meter.

light tight Absolutely dark. Protected by opaque material, overlapping panels, or some other system through which light cannot pass.

line print An image resembling a pen-and-ink drawing, with black lines on a white background (or white lines on a black background). It is made with high-contrast lith film. Also called tone line print.

lith film A type of film made primarily for use in graphic arts and printing. It produces an image with very high contrast.

local reduction *See* reduction (3).

long lens A lens whose focal length is longer than the diagonal measurement of the film with which it is used. The angle of view with such a lens-film size combination is narrower at a given distance than the angle that the human eye sees.

luminance The light reflected or produced by a given area of a subject in a specific direction measurable by a reflected-light (luminance) meter.

luminance meter *See* reflected-light meter.

macro lens A lens designed for taking close-up pictures.

macrophotograph *See* photomacrograph.

main light The principal source of light in a photograph, particularly in a studio setup, casting the dominant shadows and defining the texture and volume of the subject. Also called key light.

manual exposure A nonautomatic mode of camera operation in which the photographer sets both the shutter speed and the aperture.

manual flash A nonautomatic mode of flash operation in which the photographer controls the exposure by adjusting the size of the camera aperture.

mat A cardboard rectangle with an opening cut in it that is placed over a print to frame it. Also called an overmat.

mat knife A short knife blade (usually replaceable) set in a large, easy-to-hold handle. Used for cutting cardboard mounts for prints.

matte Describes a printing paper with a relatively dull, nonreflective surface. Opposite: glossy.

megabyte A unit of digital data containing 1,048,576 bytes. Used to describe the size of a computer file.

middle gray A standard average gray tone of 18 percent reflectance. *See also* gray card.

midtone An area of medium brightness, neither a very dark shadow nor a very bright highlight. A medium gray tone in a print.

modeling light A small tungsten light built into some flash units. It helps the photographer judge the effect of various light positions because the duration of flash light is too brief to be judged directly.

mottle A mealy gray area of uneven development in a print or negative. Caused by too little agitation or too short a time in the developer.

narrow lighting *See* short lighting.

negative 1. Any image with tones that are the reverse of those in the subject. Opposite: positive. 2. The film in the camera during exposure that is subsequently developed to produce a negative image.

negative carrier A frame that holds a negative flat in an enlarger.

negative film Film that produces a negative image on exposure and development.

nonsilver process A printing process that does not depend on the sensitivity of silver to form an image, for example, the cyanotype process, in which the light-sensitive emulsion consists of a mixture of iron salts.

normal lens A lens whose focus length is about the same as the diagonal measurement of the film with which it is used. The angle of view with this lens-film size combination is roughly the same at a given distance as the angle that the human eye sees clearly.

notching code Notches cut in the margin of sheet film so that the type of film and its emulsion side can be identified in the dark.

one-shot developer A developer used once and then discarded.

opaque Describes 1. any substance or surface that will not allow light to pass; 2. a paint used to block out portions of a negative so that they will not allow light to pass during printing.

open up To increase the size of a lens aperture. Opposite: stop down.

orthochromatic Film that is sensitive to blue and green but not to red wavelengths of the visible spectrum. Abbreviated ortho.

overdevelop To give more than the normal amount of development.

overexpose To give more than normal exposure to film or paper.

oxidation Loss of chemical activity due to contact with oxygen in the air.

pan 1. To follow the motion of a moving object with the camera. This will cause the object to look sharp and the background blurred. 2. *See* panchromatic.

panchromatic Film that is sensitive to all (or almost all) wavelengths of the visible spectrum. Abbreviated pan.

parallax The difference in point of view that occurs when the lens (or other device) through which the eye views a scene is separate from the lens that exposes the film.

PC connector *See* sync cord.

PC terminal The socket on a camera or flash unit into which a PC connector (sync cord) is inserted.

perspective The apparent size and depth of objects within an image.

photoflood An incandescent lamp that produces a very bright light but has a relatively short life.

photogram An image formed by placing material directly onto a sheet of sensitized film or printing paper and then exposing the sheet to light.

photomacrograph A close-up photograph that is life size or larger. Also called macrophotograph.

photomicrograph A photograph that is taken through a compound microscope.

photomontage A composite image made by assembling parts of several photographs.

pincushion distortion A lens aberration or defect that causes straight lines to bow inward toward the center of the image.

pinhole 1. A small clear spot on a negative usually caused by dust on the film during exposure or development or by a small air bubble that keeps developer from the film during development. 2. The tiny opening in a pinhole camera that produces an image.

pixel Short for picture element. The smallest unit of digital image that can be displayed, changed, or stored.

plane of critical focus The part of a scene that is most sharply focused.

plate In early photographic processes, the sheet of glass or metal on which emulsion was coated.

platinum print A print in which the final image is formed in platinum rather than silver.

polarizing filter A filter that reduces reflections from nonmetallic surfaces such as glass or water by blocking light waves that are vibrating at selected angles to the filter.

positive Any image with tones corresponding to those of the subject. Opposite: negative.

posterization An image with a flat, poserlike quality. High-contrast lith film is used to separate the continuous gray tones of a negative into a few distinct shades of gray.

presoak To soak film briefly in water prior to immersing it in developer.

press camera A camera that uses sheet film, like a view camera, but which is equipped with a viewfinder and a hand grip so it can be used without being mounted on a tripod. Once widely used by press photographers, it has been replaced by 35mm cameras.

primary colors Basic colors from which all other colors can be mixed. *See also* subtractive, additive.

print 1. A photographic image, usually a positive one on paper. 2. To produce such an image from a negative by contact or projection printing.

printing frame A holder designed to keep sensitized material, usually paper, in full contact with a negative during contact printing.

programmed automatic A mode of automatic exposure in which the camera sets both the shutter speed and the aperture that will produce the correct exposure.

projection printing The process of projecting an image of a negative onto sensitized material, usually paper. The image may be projected to any size, usually larger than the negative.

projector An optical instrument for forming the enlarged image of a transparency or a motion picture on a screen.

proof A test print made for the purpose of evaluating density, contrast, color balance, subject composition, and the like.

push To expose film at a higher film speed rating than normal, then to compensate in part for the resulting underexposure by giving greater development than normal. This permits shooting at a dimmer light level, a faster shutter speed, or a smaller aperture than would otherwise be possible.

rangefinder 1. A device on a camera that measures the distance from camera to subject and shows when the subject is in focus. 2. A camera equipped with a rangefinder focusing device. Abbreviated RF.

raster streak A dark streak in photographs of television-screen or computer-monitor images, caused

by using too fast a shutter speed.

RC paper *See* resin-coated paper.

rear nodal point The point in a lens from which lens focal length (distance from lens to image plane) is measured. Undeviated rays of light cross the lens axis and each other at this point.

reciprocity law The theoretical relationship between length of exposure and intensity of light, stating that an increase in one will be balance by a decrease in the other. For example, doubling the light intensity should be balanced exactly by halving the exposure time. In fact, the law does not hold true for very long or very short exposures. This reciprocity failure or reciprocity effect causes underexposure unless the exposure is increased. It also causes color shifts in color materials.

reducing agent The active ingredient in a developer. It changes exposed silver halide crystals into dark metallic silver. Also called the developing agent.

reduction 1. A print that is smaller than the size of the negative. 2. The part of development in which exposed silver halide crystals forming an invisible latent image are converted to visible metallic silver. 3. A process that decreases the amount of dark silver in a developed image. Negatives are usually reduced to decrease density. Prints are reduced locally (only in certain parts) to brighten highlights. Opposite: intensification.

reel A metal or plastic reel with spiral grooves into which roll film is loaded for development.

reflected-light meter An exposure meter that measures the amount of light reflected or emitted by a subject. Sometimes called a luminance meter.

reflector 1. A reflective surface, such as a piece of white cardboard, that can be positioned to redirect light, especially into shadow areas. Also called a flat. 2. A reflective surface, often bowl-shaped, that is placed behind a lamp to direct more light from the lamp toward the subject.

reflex camera A camera with a built-in mirror that reflects the scene being photographed onto a ground-glass viewing screen. *See also* single-lens reflex; twin-lens reflex.

relative aperture *See* aperture.

replenisher A substance added to some types of developers after use to replace exhausted chemicals so that the developer can be used again.

resin-coated paper Printing paper with a water-resistant coating that absorbs less moisture than uncoated paper, consequently reducing some processing times. Abbreviated RC.

reticulation A crinkling of the gelatin emulsion on film that can be caused by extreme temperature changes during processing.

reversal A process for making a positive image directly from film exposed in the camera; also for making a negative image directly from a negative or positive image from a positive transparency.

reversal film Film that produces a positive image (a transparency).

RF *See* rangefinder.

roll film Film that comes in a roll, protected from light by a length of paper wound around the film. Loosely applies to any film packaged in a roll rather than in flat sheets.

Sabattier effect A partial reversal of tones that occurs when film or paper is reexposed to light during development. Commonly called solarization.

safelight A light used in the darkroom during printing to provide general illumination without giving unwanted exposure.

selective-contrast paper *See* variable-contrast paper.

sharp Describes an image or part of an image that shows crisp, precise texture and detail. Opposite: blurred or soft.

sheet film Film that is cut into individual flat pieces. Also called cut film.

short lens A lens whose focal length is shorter than the diagonal measurement of the film with which it is used. The angle of view with this lens-film com-

bination is greater at a given distance than the angle seen by the human eye. Also called a wide-angle or wide-field lens.

short lighting A portrait lighting setup in which the main source of light illuminates the side of the face partially turned away from the camera. Also called narrow lighting.

shutter A mechanism that opens and closes to admit light into a camera for a measured length of time.

shutter-priority A mode of automatic exposure in which the photographer selects the shutter speed and the camera sets the aperture that will produce the correct exposure.

silhouette A scene or photograph in which the background is much more brightly lit than the subject.

silver halide The light-sensitive part of common photographic emulsions; the compounds silver chloride, silver bromide, and silver iodide.

single-lens reflex A camera in which the image formed by the taking lens is reflected by a mirror onto a ground-glass screen for viewing. The mirror swings out of the way just before exposure to let the image reach the film. Abbreviated SLR.

slave An electronic flash unit that fires when it detects a burst of light from another flash unit.

slave eye A sensor that detects light to trigger a slave flash unit.

slide 1. A transparency (often a positive image in color) mounted between glass or in a frame of cardboard or other material so that it may be inserted into a projector. 2. A protective cover that is removed from a sheet film holder when film in the holder is to be exposed. Also called dark slide.

slow describes 1. a film or paper that is not very sensitive to light; 2. a lens whose widest aperture is relatively small; 3. a long shutter speed. Opposite: fast.

SLR *See* single-lens reflex.

sodium thiosulfate Active ingredient in most fixers.

soft 1. describes an image that is blurred or out of focus. Opposite: sharp. 2. describes a scene, negative, or print of low contrast. Opposite: hard or high contrast. 3. Describes a printing paper emulsion of low contrast, such as grade 0 or 1.

software The programs, such as Adobe Photoshop, used to direct a computer to make desired changes in a digital image or other digital file.

solarization A reversal of image tones that occurs when film is massively overexposed. *See also* Sabattier effect.

speed 1. The relative sensitivity to light of film or paper. 2. The relative ability of a lens to admit more light by opening to a wider aperture.

spherical aberration A lens defect that causes rays that strike at the edges of the lens to be bent more than rays that strike at the center.

spot To remove small imperfections in a print caused by dust specks, small scratches, or the like. Specifically, to paint a dye over small white blemishes.

spotlight An electric light that contains a small bright lamp, a reflector, and often a lens to concentrate the light. Designed to produce a narrow beam or bright light.

spot meter A reflected-light exposure meter with a very small angle of view, used to measure the brightness of a small portion of a subject.

stereograph A pair of photographs taken side by side and seen separately by each eye in viewing them through a stereoscope. The resulting image looks three-dimensional.

stock solution A concentrated chemical solution that is diluted before use.

stop 1. An aperture setting on a lens. 2. A change in exposure by a factor of two. One stop more exposure doubles the light reaching film or paper. One stop less halves the exposure. Either the aperture or the exposure time can be changed. 3. *See* stop down.

stop bath An acid solution used between the developer and the fixer to stop the action of the developer and to preserve the effectiveness of the fixer. Generally a dilute solution of acetic acid; plain water is sometimes used as a stop bath for film development.

stop down To decrease the size of a lens aperture. Opposite: open up.

strobe 1. Abbreviation of stroboscopic. Describes a light source that provides a series of brief pulses of light in rapid succession. 2. Used loosely to refer to any electronic flash.

subtractive color A way to produce colors by mixing dyes that contain varying proportions of the three subtractive primary colors—cyan, magenta, and yellow.

sync cord An electrical cord connecting a flash unit with a camera so that the two can be synchronized.

synchronize To cause a flash unit to fire at the same time as the camera shutter is open.

synchro-sun A way to use flash lighting as fill light in a photograph made in direct sunlight. The flash lightens the shadows, decreasing the contrast in the scene.

T *See* time.

tacking iron A small, electrically heated tool used to melt the adhesive in dry-mount tissue, attaching it partially to the back of the print and to the mounting surface. This keeps the print in place during the mounting procedure.

taking lens The lens on a camera through which light passes to expose the film.

tank A container for developer or other processing chemicals into which film is placed for development.

telephoto effect A change in perspective caused by using a long focal length lens very far from all parts of a scene. Objects appear closer together than they really are.

telephoto lens Loosely, any lens of very long focal length. Specifically, one constructed so that its effective focal length is longer than its actual size. *See also* long lens.

tenting A way to light a highly reflective object. The object is surrounded with large sheets of paper or translucent material lighted so that the object reflects them and not the lamps, camera, and other items in the studio.

thin Describes a negative or an area of a negative where relatively little silver has been deposited. A thin negative transmits a large amount of light. Opposite: dense.

time A shutter setting marked T at which the shutter remains open until reclosed by the photographer.

tintype A collodion wet-plate process in which the emulsion was coated onto a dark metal plate. It produced a positive image.

TLR *See* twin-lens reflex.

tone 1. To change the color of a print by immersing it in a chemical solution. 2. The lightness or darkness of a particular area. A highlight is a light tone, a shadow is a dark tone.

transparency An image on a transparent base, such as film or glass, that is viewed by transmitted light. *See* slide (1).

tripod A three-legged support for a camera. Usually the height is adjustable and the top or head is movable.

tungsten film Color film balanced to produce accurate color renditions when the light source that illuminates the scene has a color temperature of about 3200K, as do many tungsten lamps. Sometimes called Type B film. *See also* Type A film.

tungsten light Light such as that from an ordinary light bulb containing a thin tungsten wire that becomes incandescent (emits light) when an electric current is passed along it. Also called incandescent light.

Tv Abbreviation of time value. Used on some camera information displays as a shortened way to refer to shutter speed settings.

twin-lens reflex A camera in which two lenses are mounted above one another. The bottom (taking) lens forms an image on the exposed film. The top (viewing) lens forms an image that reflects upward onto a ground-glass viewing screen. Abbreviated TLR.

Type A film Color film balanced to produce accurate color renditions when the light source that illuminates the scene has a color temperature of about 3400K, as does a photoflood. *See also* tungsten film.

Type B film *See* tungsten film.

ultraviolet The part of the spectrum just beyond violet. Ultraviolet light is invisible to the human eye but strongly affects photographic materials.

underdevelop To give less development than normal.

underexpose To give less than normal exposure to film or paper.

value The relative lightness or darkness of an area. Low values are dark; high value are light.

variable-contrast paper A printing paper in which varying grades of print contrast can be obtained by changing the color of the enlarging light source, as by the use of filters. Also called selective-contrast paper. *See also* graded-contrast paper.

view camera A camera in which the taking lens forms an image directly on a ground-glass viewing screen. A film holder is inserted in front of the viewing screen before exposure. The front and back of the camera can be set at various angles to change focus and perspective.

viewfinder 1. A small window on a camera through which the subject is seen and framed. 2. A camera that has a viewfinder, but not a rangefinder (which shows when the subject is focused).

viewing lens The lens on a camera through which the eye views the subject.

viewing screen In a reflex or view camera, the ground-glass surface on which the image is seen and focused.

vignette To underexpose the edges of an image. Sometimes done intentionally but more often caused accidentally by a lens that forms an image covering the film or paper only partially.

warm Reddish colors that by association with common objects (fire, sun, and so on) give an impression of warmth.

washing aid A chemical solution used between fixing and washing film or paper. It shortens the washing time by converting residues from the fixer into forms more easily dissolved by water. Also called hypo neutralizing (or cleaning) agent.

wet-plate process A photographic process in which a glass or metal plate was coated with a collodion mixture, then sensitized with silver nitrate, exposed and developed while the collodion was still wet. It was popular from the 1850s until the introduction of the gelatin dry plate in the 1880s.

wetting agent A chemical solution used after washing film. By reducing the surface tension of the water remaining on the film, it speeds drying and prevents water spots.

white light A mixture of all wavelengths of the visible spectrum. The human eye sees the mixture as light that is colorless or white.

wide-angle distortion A change in perspective caused by using a wide-angle lens very close to a subject. Objects appear stretched out or farther apart than they really are.

wide-angle lens *See* short lens.

working solution A chemical solution diluted to the correct strength for use.

zone focus To preset the focus of a lens so that some future action will take place within the limits of the depth of field.

zone system A way to plan negative exposure and development to achieve precise control of the darkness of various areas in a print.

zoom lens A lens adjustable to a range of focal lengths.

Bibliography

Prepared by Wendy Lewis

TECHNICAL INFORMATION

This book is a basic introductory text in photography, and you will find that other basic textbooks generally cover the same topics. However, you may wish to consult one or more additional beginners' texts because individual texts explain material in individual ways and may emphasize different points. The following books are of about the same level of difficulty.

Barnbaum, Bruce. *The Art of Photography: An Approach to Personal Expression.* Dubuque, IA: Kendall Hunt, 1994.

Davis, Phil. *Photography.* 7th ed. Madison, WI: Brown & Benchmark, 1995.

London, Barbara, and Jim Stone. *A Short Course in Photography.* 3rd ed. New York: HarperCollins, 1995.

Schaefer, John P. *Basic Techniques of Photography: The Ansel Adams Guide.* Boston: Bulfinch Press, 1992.

Warren, Bruce. *Photography.* Minneapolis-St. Paul: West Publishing, 1993.

Advanced or Specialized

A useful listing of information is available from the Eastman Kodak Company (Rochester, NY 14650. Telephone: 1-800-242-2424.) Their *Index to Kodak Information* lists the many books and pamphlets that they publish for a variety of photographic interests ranging from *Photographing Your Vacation* to *Oblique Aerial Photography.* Kodak publishes many technical data sheets with information on the use of specific products.

Adams, Ansel, with Robert Baker. *The New Ansel Adams Photography Series.* *The Camera,* 1980; *The Negative,* 1981 (has Zone System details); *The Print,* 1983. Boston: Bulfinch Press. Stresses full technical control of the photographic process as an aid to creative expression.

Anchell, Stephen G. *The Darkroom Cookbook.* Boston: Focal Press, 1994. A compendium of detailed information on more than 100 photographic formulas.

———. *Variable Contrast Printing Manual.* Boston: Focal Press, 1997.

DeCock, Liliane, ed. *Photo-Lab Index: Lifetime Edition.* Dobbs Ferry, NY: Morgan & Morgan, 1992. A storehouse of information about photographic products, including descriptions of materials and recommended procedures for their use.

Duren, Lista, and Billy McDonald. *Build Your Own Home Darkroom.* New York: Amherst Media, 1990.

Graves, Carson. *The Elements of Black-and-White Printing.* Boston: Focal Press, 1993. Excellent for the intermediate to advanced printer.

———. *The Zone System for 35mm Photographers: A Basic Guide to Exposure Control.* Boston: Focal Press, 1996.

Hunter, Fil. *Light: Science and Magic. An Introduction to Photographic Lighting.* 2nd ed. Boston: Focal Press, 1997.

Johnston, Chris. *The Practical Zone System: A Simple Guide to Photographic Control. 2nd ed.* Boston: Focal Press, 1994. A thorough and accessible zone system manual.

Keefe, Lawrence E., Jr., and Dennis Inch. *The Life of a Photograph: Archival Processing, Matting, Framing and Storage.* 2nd ed. Boston: Focal Press, 1990.

Kobré, Kenneth. *Photojournalism: The Professionals' Approach.* 3rd ed. Boston: Focal Press, 1995. A comprehensive and readable overview of equipment, techniques, and approaches used by photojournalists.

Meehan, Joseph. *Panoramic Photography.* Revised. New York: Amphoto, 1996. A well-illustrated guide to the techniques and aesthetics of panoramic photography.

Renner, Eric. *Pinhole Photography: Rediscovering a Historic Technique.* Newton, MA: Focal Press, 1994. Explains everything from creating pinhole cameras to manipulating pinhole images.

Stone, Jim. *A User's Guide to the View Camera.* New York: Addison Wesley Longman, 1996.

Stroebel, Leslie, et al. *Basic Photographic Materials and Processes.* Boston: Focal Press, 1990. Detailed sections on sensitometry, optics, visual perception, and chemistry.

———. *View Camera Technique.* 6th ed. Stoneham, MA: Focal Press, 1993.

Todd, Hollis N., and Richard D. Zakia. *Photographic Sensitometry: The Study of Tone Reproduction.* Dobbs Ferry, NY: Morgan & Morgan, 1969. Measuring, analyzing, and applying data on the effects of light on photographic materials.

White, Laurie. *Infrared Photography Handbook.* Buffalo, NY: Amherst Media, 1995.

Zakia, Richard and Leslie Stroebel. *The Focal Encyclopedia of Photography.* 3rd ed. Boston: Focal Press, 1996.

Alternative Processes

Arentz, Dick. *An Outline for Platinum Palladium Printing.* 2nd ed. Flagstaff, AZ: Self-published, 1992.

Blacklow, Laura. *New Dimensions in Photo Imaging: A Step-by-Step Manual.* 2nd ed. Boston: Focal Press, 1995. Detailed, easy to follow instructions for alternative processes including Polaroid transfers, Van Dyke, and gum bichromate.

Crawford, William. *The Keepers of Light: A History and Working Guide to Early Photographic Processes.* Dobbs Ferry, NY: Morgan & Morgan, 1979. An historical and technical guide to early processes such as ambrotype, cyanotype, and platinum.

Polaroid. *{Inspiration}: A Step-by-Step Guide.* Cambridge: Polaroid, 1995. A guide to the Polaroid transfer process.

Reed, Martin, and Sarah Jones. *Silver Gelatin: A User's Guide to Liquid Photographic Emulsions.* New York: Amphoto, 1996. Instructions for coating and printing on anything from paper and glass to metal, stone, fabric, and ceramics.

Reilly, James. *Albumen & Salted Paper Book: The History and Practice of Photographic Printing 1840-1895.* Rochester, NY: Light Impressions, 1980. One of the few technical descriptions of albumen printing.

Rice, Ted. *Palladium Printing, Made Easy.* Santa Fe, NM: Eagle Eye, 1994.

Scopick, David. *The Gum Bichromate Book: Non-Silver Methods for Photographic Printing.* 2nd ed. Boston: Focal Press, 1991.

Stone, Jim. *Darkroom Dynamics: A Guide to Creative Darkroom Techniques.* Stoneham, MA: Focal Press, 1979. Illustrated instructions on expanding your imagery with multiple printing, toning, hand coloring, high contrast, and other techniques.

Business Practices

Bodin, Frederick. *The Freelance Photographer's Handbook.* Amherst, NY: Amherst Media, 1993.

DuBoff, Leonard D. *The Law (in Plain English) for Photographers.* New York: Allworth Press, 1995.

Heron, Michael, and David MacTavish. *Pricing Photography: The Complete Guide to Assignment & Stock Prices.* New York: Allworth Press, 1993.

Kieffer, John. *The Photographer's Assistant: Learn the Inside Secrets of Professional Photography and Get Paid for It.* New York: Allworth Press, 1992.

Oberrecht, Ken. *How to Open and Operate a Home-Based Photography Business: An Unabridged Guide.* Old Saybrook, CT: Globe Pequot Press, 1994.

1997 Photographer's Market: Where and How to Sell Your Photographs. Cincinnati. Writer's Digest Books, 1997.

Color Photography

Colorbat Labs. *Colorbat Lab Pro Darkroom Handbook.* Millersville, PA: Darryl C. Nicholas, 1995. Packed with information.

Current, Ira. *Photographic Color Printing: Theory and Technique.* Boston: Focal Press, 1987. Fundamental and advanced color printing techniques.

Hirsch, Robert. *Exploring Color Photography.* 3rd ed. Madison, WI: Brown & Benchmark, 1996. Techniques, images, and history of color photography for the college level.

Horenstein, Henry. *Color Photography: A Working Manual.* Boston: Little, Brown and Company, 1993.

Wilhelm, Henry. *The Permanence and Care of Color Photographs: Traditional and Digital Color Prints, Color Negatives, Slides, and Motion Pictures.* Grinnell, IA: Preservation Publishing Co., 1993. The most comprehensive conservation guide to color materials available.

Digital Imaging

Aaland, Mikkel, with Rudolph Burger. *Digital Photography.* New York: Random House, 1992.

Bouton, Gary David, and Barbara Bouton. *Inside Adobe Photoshop 4.* Indianapolis: New Riders, 1997. Recommended for intermediate to advanced Photoshop users.

Burkholder, Dan. *Making Digital Negatives for Contact Printing.* San Antonio, TX: Bladed Iris Press, 1995.

Davies, Adrian, and Phil Fenessy. *Electronic Imaging for Photographers.* 2nd ed. Boston: Focal Press, 1996.

Farace, Joe. *The Photographer's Digital Studio.* Berkeley: Peachpit Press, 1996.

———. *The Photographer's Internet Handbook.* New York: Allworth Press, 1997.

Grotta, Sally Wiener, and Daniel Grotta. *Digital Imaging for Visual Artists.* NY: Windcrest/McGraw-Hill, 1994. A complete guide to digital imaging for both Window and Mac users.

Haynes, Barry, and Wendy Crumpler. *Photoshop Artistry: A Master Class for Photographers and Artists.* San Francisco: Sybex, 1995.

Johnson, Stephen. *Making a Digital Book.* Pacifica, CA: Self-published, 1993.

Kammermeier, Anton, and Peter Kammermeier. *Scanning & Printing Perfect Pictures with Desktop Publishing.* Boston: Focal Press, 1995. A comprehensive guide to scanning, printing, and picture editing.

Larish, John. *Photo CD. Quality Photos at Your Fingertips.* Torrance, CA: Micro Publishing Press, 1993. An informative introduction to Kodak's Photo CD.

Padova, Ted. *Macworld Photoshop 4 Bible.* Foster City, CA: IDG Books Worldwide, 1997.

Rich, Jim, and Sandy Bozek. *Photoshop in Black & White.* 2nd ed. Berkeley: Peachpit Press,1995. Covers advanced Photoshop techniques.

Ritchin, Fred. *In Our Own Image: The Coming Revolution in Photography.* New York: Aperture, 1990.

Weinman, Lynda. *Designing Web Graphics: How to Prepare Images and Media for the Web.* Indianapolis: New Riders Publishing, 1996.

Health and Safety

Clark, Nancy. *Ventilation.* New York: Lyons and Burford, 1990.

Rempel, Siegfried, and Wolfgang Rempel. *Health Hazards for Photographers.* New York: Lyons and Burford, 1992.

Shaw, Susan D., and Monona Rossol. *Overexposure: Health Hazards in Photography.* 2nd ed. New York: Allworth Press, 1991.

HISTORY AND CRITICISM

Aesthetics and Criticism

Adams, Robert. *Beauty in Photography: Essays in Defense of Traditional Values.* New York: Aperture, 1996. Reprint of 1981 edition.

Aperture. *Aperture 136. Metamorphoses: Photography in the Electronic Age.* New York: Aperture, 1994.

Barrett, Terry. *Criticizing Photographs: An Introduction to Understanding Images.* 2nd ed. Mountain View, CA: Mayfield Publishing, 1995. A guide to the analysis and interpretation of images.

Barthes, Roland. *Camera Lucida.* New York: Hill and Wang, 1981.

Berger, John. *Ways of Seeing.* New York: Penguin Books, 1985.

Burgin, Victor. *Thinking Photography.* London: Macmillan, 1982.

Coleman, A. D. *Critical Focus.* Munich: Nazraeli Press, 1994. An intelligent criticism of contemporary photography.

Edwards, Elizabeth, ed. *Anthropology and Photography 1860-1920.* New Haven, CT: Yale University Press, 1992.

Finn, David. *How to Look at Photographs: Reflections on the Art of Seeing.* New York: Harry N. Abrams, 1994.

Goldberg, Vicki. *Photography in Print: Writings from 1816 to the Present.* New York: Simon & Schuster, 1981.

Grundberg, Andy. *Crisis of the Real: Writings on Photography, 1974-1989.* New York: Aperture, 1990. Readable, stimulating essays on contemporary issues in photography.

Heron, Liz, and Val Williams, eds. *Illuminations: Women's Writings on Photography from the 1850s to the Present.* Durham, NC: Duke University Press, 1996.

Jay, Bill. *Occam's Razor: An Outside-In View of Contemporary Photography.* Munich: Nazraeli Press, 1992.

Kozloff, Max. *The Privileged Eye.* Albuquerque: University of New Mexico Press, 1987.

Lyons, Nathan, ed. *Photographers on Photography: A Critical Anthology.* Englewood Cliffs, NJ: Prentice Hall, 1996. Twenty-three well-known photographers (1880s to 1960s) discuss their own work and photography in general.

McLuhan, Marshall. *Understanding Media.* New York: NAL Dutton, 1966.

Mitchell, William J. *The Reconfigured Eye: Visual Truth in the Post-Photographic Era.* Cambridge: MIT Press, 1992. A critical analysis of digital imaging, including how it has affected what we see and the effects it may have.

Newhall, Beaumont, ed. *Photography: Essays and Images.* New York: Museum of Modern Art, 1980.

Scharf, Aaron. *Art and Photography.* Baltimore: Penguin Books, 1974. The interrelationship of photography and painting.

Sekula, Allan. *Photography Against the Grain.* Halifax: Press of the Nova Scotia College of Art and Design, 1984.

Solomon-Godeau, Abigail. *Photography at the Dock: Essays on Photographic History, Institutions, and Practices.* Minneapolis: University of Minnesota Press, 1991.

Sontag, Susan. *On Photography.* New York: Farrar, Straus and Giroux, 1977.

Szarkowski, John. *Looking at Photographs: 100 Pictures from the Collection of the Museum of Modern Art.* New York: Museum of Modern Art, 1976.

History

Coe, Brian. *Cameras: From Daguerreotypes to Instant Pictures.* New York: Crown, 1978. A well-illustrated and complete history of the camera.

Coote, Jack. *The Illustrated History of Colour Photography.* Surbiton, Surrey: Fountain Press, 1994.

Foresta, Merry, John Wood et al. *Secrets of the Dark Chamber: The Art of the American Daguerreotype.* Washington, DC: Smithsonian Institution Press, 1995.

Frizot, Michel. *Nouvelle Histoire de la Photographie.* Paris: Bordas, 1994. A comprehensive history.

Gernsheim, Helmut. *The Origins of Photography.* New York: Thames and Hudson, 1982. *The Rise of Photography 1850-1900. The Age of Collodion.* New York: Thames and Hudson, 1988. These two volumes are revised publications of Gernsheim's

classic history of photography published in 1955.

Green, Jonathan. *American Photography: A Critical History.* New York: Harry N. Abrams, 1984. A survey of American photography since 1945.

Jammes, André, and Eugenia P. Janis. *The Art of French Calotype.* Princeton, NJ: Princeton University Press, 1983. A scholarly work on Second Empire photography, elegantly produced.

Moutoussamy-Ashe, Jeanne. *View Finders: Early Black Women Photographers.* New York: Dodd, Mead, 1986.

Newhall, Beaumont. *The History of Photography from 1839 to the Present.* Rev. ed. New York: Museum of Modern Art and Boston: New York Graphic Society, 1982.

Rosenblum, Naomi. *A History of Women Photographers.* New York: Abbeville Press, 1994. ———. *A World History of Photography.* 3rd ed. New York: Abbeville Press, 1997.

Rudisill, Richard. *Mirror Image: The Influence of the Daguerreotype on American Society.* Albuquerque: University of New Mexico Press, 1971. Fascinating social history of the cultural, commercial, and social effects of the daguerreotype on mid-19th century America.

Sandweiss, Martha A. *Photography in Nineteenth-Century America.* New York: Harry N. Abrams, 1991. An extensive exploration of the relationship between photography and culture.

Schaaf, Larry J. *Out of the Shadows: Herschel, Talbot and the Invention of Photography.* New Haven, CT: Yale University Press, 1992.

Szarkowski, John. *Photography Until Now.* New York: Museum of Modern Art, 1989. The history of photography organized according to changing photographic technology.

Taft, Robert. *Photography and the American Scene.* New York: Dover Publications, 1964. Reprint of 1938 edition.

Westerbeck, Colin. *Bystander: A History of Street Photography.* Boston: Bulfinch Press, 1994.

Witkin, Lee, and Barbara London. *The Photograph Collector's Guide.* Boston: New York Graphic Society, 1979. Includes biographical entries with illustrations for over 200 photographers; lists of over 8000 other photographers, museums, and galleries; and other information.

Wood, John. *The Art of the Autochrome: The Birth of Color Photography.* Iowa City: University of Iowa Press, 1993.

Visual Anthologies

Billeter, Erika. *Canto a la realidad: Fotografía latinoamericana 1860-1993.* Madrid: Casa de América, 1993. A definitive anthology of works by Latin American photographers.

Davis, Keith F. *An American Century of Photography. From Dry Plate to Digital: The Hallmark Photographic Collection.* New York: Harry N. Abrams, 1995.

Druckrey, Timothy, ed. *Iterations: The New Image.* Cambridge: MIT Press, 1994.

Easter, Eric D., et al., eds. *Songs of My People: African Americans: A Self-Portrait.* Boston: Little, Brown and Company, 1992. Photographs and text from an African-American perspective.

Eauclaire, Sally. *The New Color Photography.* New York: Abbeville, 1981.

Edey, Maitland. *Great Photographic Essays from Life.* Boston: New York Graphic Society, 1978. Twenty-two photographic essays including work by Abbott, Adams, Bourke-White, and others.

Enwezor, Okwui, et al., eds. *In/sight: African Photographers 1940 to the Present.* New York, Harry N. Abrams, 1996.

Ferrer, Elizabeth, ed. *Shadow Born of Earth: New Photography in Mexico.* New York: Universe Books, 1993.

Foresta, Merry, et al. *Between Home and Heaven. Contemporary American Landscape Photography.* Albuquerque: University of New Mexico Press, 1992.

Fralin, Frances. *The Indelible Image: Photographs of War: 1846 to the Present.* New York: Harry N.

Abrams, 1985.

Green, Jonathan, ed. *Camera Work: A Critical Anthology.* Millerton, NY: Aperture, 1973.

Greenough, Sarah. *On the Art of Fixing a Shadow: 150 Years of Photography.* Boston: Bulfinch Press, 1989.

Grundberg, Andy, et al. *After Art: Rethinking 150 Years of Photography.* Seattle: University of Washington Press, 1995.

Grundberg, Andy, and Kathleen Gauss. *Photography and Art: Interactions Since 1946.* New York: Abbeville Press, 1987.

Hoy, Anne, ed. Fabrications. *Staged, Altered, and Appropriated Photographs.* NY: Abbeville Press, 1987.

Hurley, F. Jack. *Portrait of a Decade: Roy Stryker and the Development of Documentary Photography in the Thirties.* Baton Rouge: Louisiana State University Press, 1972.

Jenkins, William, ed. *New Topographics: Photographs of a Man Altered Landscape.* Rochester, NY: International Museum of Photography, 1975.

Köhler, Michael, ed. *Constructed Realities: The Art of Staged Photography.* Zurich: Edition Stemmle, 1995. An anthology of staged photography including Sandy Skoglund, Cindy Sherman, and others.

Livingston, Jane, Rosalind E. Krauss, and Dawn Ades. *L'Amour Fou: Photography and Surrealism.* NY: Abbeville Press, 1985.

Life Library of Photography. Rev. ed. New York: Time-Life Books, 1981-1983. Seventeen volumes plus yearbooks (1973-1981), all profusely illustrated. The books generally contain historical material and technical information.

Naef, Weston J., and James N. Wood. *Era of Exploration: The Rise of Landscape Photography in the American West, 1860-1885.* New York: Metropolitan Museum of Art, 1975. Extensive treatment of the subject with emphasis on Watkins, O'Sullivan, Muybridge, Russell, and Jackson.

Noriega, Chon, et al., eds. *From the West: Chicano Narrative Photography.* San Francisco: Mexican Museum, 1996.

Strong Hearts: Native American Visions and Voices. New York: Aperture, 1995.

Szarkowski, John, ed. *Mirrors and Windows: American Photography Since 1960.* New York: Museum of Modern Art, 1978.

Weaver, Mike, ed. *The Art of Photography 1839-1989.* New Haven, CT: Yale University Press, 1989.

Weiermair, Peter, ed. *Prospect: Photography in Contemporary Art.* Zurich, Edition Stemmle, 1996. Surveys work of numerous artists from the postphotographic period.

INDIVIDUAL PHOTOGRAPHERS

The photographers listed below have images in this book.

Ansel Adams
———. *Ansel Adams: Images 1923-1974.* Boston: New York Graphic Society, 1974.
———. *Yosemite and the Range of Light.* Boston: New York Graphic Society, 1979.

Richard Ahlborn
Marshall, Howard, and Richard Ahlborn. *Buckaroos in Paradise: Cowboy Life in Northern Nevada.* Lincoln: University of Nebraska Press, 1981.

Eve Arnold
———. *In Retrospect.* New York: Alfred A. Knopf, 1995.

Eugène Atget
———. *The Work of Atget.* New York: Museum of Modern Art and Boston: New York Graphic Society. Vol. 1: *Old France, 1981.* Vol. 2: *The Art of Old Paris, 1982.* Vol. 3: *The Ancien Régime, 1983.* Vol. 4: *Modern Times, 1984.*

Dmitri Baltermants
———. *Faces of a Nation: The Rise and Fall of the Soviet Union, 1917-1991.* Golden, CO: Fulcrum Publishing, 1996.

(JEB) Joan E. Biren
———. *Eye to Eye: Portraits of Lesbians.* Washington, DC: Glad Hag Books, 1979.

Werner Bischof
———. *Werner Bischof*. Boston: Bulfinch Press, 1990.

Bill Burke
———. *Mine Fields*. Atlanta: Nexus Press, 1995.

Fred Burrell
———. *Life's Greatest Miracle:* A Photomontage Celebrating Human Development from Conception to Birth. Ann Arbor, MI: Borders Press, 1995.

Julia Margaret Cameron
Gernsheim, Helmut. *Victorian Photographs of Famous Men and Fair Women*. Boston: David R. Godine, 1973.

Paul Caponigro
———. *Masterworks from Forty Years*. Carmel, CA: Photography West Graphics, 1993.
———. *The Wise Silence*. Boston: New York Graphic Society, 1983.

Patty Carroll
———. *Spirited Visions: Portraits of Chicago Artists*. Urbana: University of Illinois Press, 1991.

Keith Carter
Keith Carter Photographs: Twenty-Five Years. Austin: University of Texas Press, 1997.

Henri Cartier-Bresson
———. *The Decisive Moment*. New York: Simon & Schuster, 1952.
———. *Henri Cartier-Bresson: Photographer*. Boston: Bulfinch Press, 1992.

Etta Clark
———. *Growing Old is Not for Sissies II*. San Francisco: Pomegranate Books, 1995.

Clint Clemens
Samuelson, Marnie Crawford. *"On Location with Clint Clemens."* Photo District News, December 1991.

William Clift
———. *A Hudson Landscape*. Santa Fe, NM: William Clift Editions, 1993.

Imogen Cunningham
———. *Ideas Without End: A Life in Photographs*. San Francisco: Chronicle Books, 1993.
———. *Imogen!... Photographs 1910-1973*. Seattle: University of Washington Press, 1974.

L.J.M. Daguerre
Gernsheim, Helmut, and Alison Gernsheim. *L.J.M. Daguerre: The History of the Diorama and the Daguerreotype*. London: Secker & Warburg, 1956. U.S. edition, New York: Dover, 1968.

Louise Dahl-Wolfe
———. *A Photographer's Scrapbook*. New York: St. Martin's Press, 1984.

Joe Deal
———. *Southern California Photographs, 1976-86*. Albuquerque: University of New Mexico Press, 1992.

Robert Demachy
———. *Demachy: Photographe*. Paris: Contrejour, 1990.

Lisl Dennis
———. *Behind Adobe Walls*. San Francisco: Chronicle Books, 1997.

Robert Doisneau
———. *A Photographer's Life*. New York: Abbeville Press, 1995.

Peter Henry Emerson
Turner, Peter, and Richard Wood. *P.H. Emerson: Photographer of Norfolk*. Boston: David R. Godine, 1975.

Elliott Erwitt
———. *Personal Exposures*. New York: W.W. Norton, 1988.

Walker Evans
Evans, Walker. American Photographs. Boston: New York Graphic Society, 1988. Reprint of 1938 edition.
———. *The Hungry Eye*. New York: Harry N. Abrams, 1993.

Andreas Feininger
Andreas Feininger. Dobbs Ferry, NY: Morgan & Morgan, 1973.

Carl Fleischhauer
Marshall, Howard, and Richard Ahlborn. *Buckaroos in Paradise: Cowboy Life in Northern Nevada*. Lincoln: University of Nebraska Press, 1981. Photographs by Fleischhauer and others.

Robert Frank
———. *Les Américains*. Paris: Delpire, 1958. U.S. edition, *The Americans*. New York: Grove Press, 1959. Rev. eds., Millerton, NY: Aperture, 1969, 1978. D.A.P./Scalo Publishers, 1993.
———. *Moving Out*. New York: D.A.P./Scalo and Washington, DC: National Gallery of Art, 1994.

Adam Fuss
———. *Pinhole Photographs*. Washington, DC: Smithsonian Institution Press, 1995.

Miguel Gandert
———. *Crafting Devotions: Tradition in Contemporary New Mexico Santos*. Albuquerque: University of New Mexico Press, 1995.

Flor Garduño
———. *Witnesses of Time*. New York: Thames and Hudson, 1992.

Arnold Genthe
———. *As I Remember*. New York: Reynal & Hitchcock, 1936.

Scott Goldsmith
Line, Les. *"Silence of the Songbird."* National Geographic, June 1993.

Emmet Gowin
———. *Emmet Gowin: Photographs*. Philadelphia: Philadelphia Museum of Art, 1990.

Lois Greenfield
———. *Breaking Bounds*. San Francisco: Chronicle Books, 1992.

Betty Hahn
———. *Photography or Maybe Not*. Albuquerque: University of New Mexico Press, 1995.

Charles Harbutt
———. *Travelog*. Cambridge: M.I.T. Press, 1973.

Erich Hartmann
———. *In the Camps*. New York: W.W. Norton, 1995.

Bill Hedrich
———. *Hedrich-Blessing: Architectural Photography, 1930-1981*. Rochester, NY: George Eastman House, 1981.

Lewis Hine
———. *Passionate Journey: Photographs 1905-1937*. Zurich: Edition Stemmle, 1997.
———. *Photo Story. Selected Letters and Photographs of Lewis W. Hine*. Washington, DC: Smithsonian Institution Press, 1992.

Kenro Izu
———. *Photographs in Platinum*. New York: Howard Greenberg Gallery, 1995.

Jeff Jacobson
———. *My Fellow Americans...* Albuquerque: University of New Mexico Press, 1991.

Stephen Johnson
———. *The Great Central Valley*. Los Angeles: University of California Press, 1993.

Peggy Jones
"Pinhole Procession." Minolta Mirror, 1992.

Yousuf Karsh
———. *Karsh: A Sixty Year Retrospective*. Boston: New York Graphic Society, 1996.

Barbara Kasten
———. *Barbara Kasten 1986-1990*. Los Angeles and Tokyo: Research of Art Media, 1990.

André Kertész
———. *André Kertész: His Life and Work*. Boston: Bulfinch Press, 1994.
———. *Diary of Light*. New York: Aperture, 1987.

Mark Klett
———. *Revealing Territory: Photographs of the Southwest*. Albuquerque: University of New Mexico Press, 1992.

Josef Koudelka
———. *Exiles*. New York: Aperture, 1988.
———. *Gypsies*. Millerton, NY: Aperture, 1975.

Ellen Land-Weber
———. *The Passionate Collector*. New York: Simon & Schuster, 1980.

Dorothea Lange
———. *The Photographs of Dorothea Lange*. New York: Harry N. Abrams, 1996.
Lange, Dorothea, and Paul S. Taylor. *An American Exodus*. Oakland, CA: Oakland Museum and New Haven: Yale University Press, 1969.

Russell Lee
———. *Russell Lee: Photographer*. Dobbs Ferry, NY: Morgan & Morgan, 1978.

William Lesch
———. *Expansions*. Tokyo: Treville Press, 1992.

Herbert List
———. *Photographs 1930-1970*. Munich: Schirmer/Mosel, 1976.

John Lund
"Computer Artist: John Lund." Computer Artist, April/May 1993.

Danny Lyon
———. *The Bikeriders*. New York: Macmillan, 1968.

Peter Magubane
———. *Women of South Africa: Their Fight for Freedom*. Boston: Little, Brown and Company, 1993.

Ray McSavaney
———. *Explorations: A Photographic Journey*. Los Angeles: Self-published, 1992.

Man Ray
———. *Man Ray: 1890-1976*. New York: Harry N. Abrams, 1995.
———. *Self Portrait*. Boston: New York Graphic Society, 1988. Reprint of 1963 edition.

Susan Meisalas
———. *Nicaragua*. New York: Pantheon Books, 1981.

Pedro Meyer
———. *Truths and Fictions: A Journey from Documentary to Digital Photography*. New York: Aperture, 1995.

Duane Michals
———. *Now Becoming Then*. Altadena, CA: Twin Palms Publishers, 1990.

Richard Misrach
———. *Crimes and Splendors. The Desert Cantos of Richard Misrach*. Boston: Bulfinch Press, 1996.

László Moholy-Nagy
———. *Moholy-Nagy: Photographs and Photograms*. Pantheon, 1980.

David Muench
———. *Ancient America*. Boulder, CO: Roberts Rinehart Publishers, 1997.

Marc Muench
———. *Ski the Rockies*. Portland, OR: Graphic Arts Center Publishing, 1994.

Eadweard Muybridge
———. *Muybridge's Complete Human and Animal Locomotion*. 3 vols., reprint. New York: Dover, 1979.

Patrick Nagatani
———. *Nuclear Enchantment*. Albuquerque: University of New Mexico Press, 1991.

Arnold Newman
———. *Arnold Newman's Americans*. Boston: Bulfinch Press, 1992.

Nicéphore Niépce
———. *Lettres et Documents*. Paris: Centre National de la Photographie, 1983.

David Grant Noble
———. *Ancient Ruins of the Southwest*. Flagstaff, AZ: Northland Publishing, 1991.

Timothy O'Sullivan
———. *American Frontiers: The Photographs of Timothy H. O'Sullivan, 1867-1874*. Millerton, NY: Aperture, 1981.
Gardner, Alexander. *Gardner's Photographic Sketch Book of the War*. 2 vols. Washington, DC: Philip & Solomons, 1866. Forty-five albumen prints by O'Sullivan. Reprint, 1 vol. New York: Dover, 1959.

Olivia Parker
———. *Weighing the Planets*. Boston: New York Graphic Society, 1987.

Gordon Parks
———. *Gordon Parks: 40 Jahre Fotografie*. Schaffhausen, Germany: Edition Stemmle, 1989.
———. *Moments Without Proper Names*. New York: Viking Press, 1975.

Stephen Petegorsky
Wise, Kelly. *"The Expressive Power of Photography."* The Boston Globe, November 1991.

Elaine Querry
Querry, Ron. *I See By My Get-Up*. Albuquerque: University of New Mexico Press and Norman/London: University of Oklahoma Press, 1994.

Eli Reed
———. *Black in America*. New York: W.W. Norton, 1996.

Henry Peach Robinson
———. *Henry Peach Robinson: Master of Photographic Art: 1830-1901*. New York: Basil Blackwell, 1988.

Jeffrey Rotman
———. *Colors of the Deep*. Washington, DC: Thomasson-Grant, 1992.

Meridel Rubenstein
———. *Critical Mass: Meridel Rubenstein and Ellen Zweig with the Vasulkas*. Santa Fe, NM: Museum of Fine Arts, 1993.

Jack Sal
———. *Jack Sal: Mark/Making*. Greenfield Center, NY: Combinations Press, 1981.

Sebastião Salgado
———. *Workers: An Archaeology of the Industrial Age*. New York: Aperture, 1993.

Erich Salomon
———. *Dr. Erich Salomon 1886-1944*. Munich: Schirmer/Mosel, 1981.

Emil Schulthess
———. *Eternal Landscape*. New York: Alfred A.

Knopf, 1988.

John Sexton
———. *Listen to the Trees.* Boston: Bulfinch Press, 1994.

Aaron Siskind
———. *Harlem Document: Photographs 1932-1946.* Providence, RI: Matrix, 1981.
———. *Pleasures and Terrors.* Boston: New York Graphic Society, 1982.

Sandy Skoglund
———. *Sandy Skoglund.* Barcelona: Fundaçio La Caixa, 1992.

W. Eugene Smith
———. *Minamata.* New York: Holt, Rinehart and Winston, 1975.
———. *W. Eugene Smith: His Photographs and Notes.* Millerton, NY: Aperture, 1993.

Marilyn Stern
———. *Kval! Die Walfänger der Lofoten (The Whale Hunters of Lofoten).* Zurich: U. Bär Verlag, 1990.

Joel Sternfeld
———. *On This Site.* San Francisco: Chronicle Books, 1996.

Alfred Stieglitz
———. *Alfred Stieglitz: Photographer.* Boston: Bulfinch Press, 1996. Reprint of 1965 edition.
———. *Alfred Stieglitz: Photographs and Writings.* New York: Callaway Editions, 1983.

Paul Strand
———. *Paul Strand: An American Vision.* New York: Aperture, 1990.
———. *Paul Strand: A Retrospective Monograph.* Volume 1: *The Years 1915-1946.* Volume 2: *The Years 1950-1968.* Millerton, NY: Aperture, 1971.

Larry Sultan
Pictures from Home. New York: Harry N. Abrams, 1992.

William Henry Fox Talbot
The Pencil of Nature. New York: Hans P. Kraus, Jr., 1989. Facsimile of Fox Talbot's original book.
Buckland, Gail. *Fox Talbot and the Invention of Photography.* Boston: Godine, 1980.

Larry Towell
El Salvador. New York: W. W. Norton, 1997.

Philip Trager
———. *The Villas of Palladio.* Boston: New York Graphic Society, 1986.

Toba Tucker
———. *Heber Springs Portraits: Continuity and Change in the World Disfarmer Photographed.* Albuquerque: University of New Mexico Press, 1996.

Edward Weston
———. *The Daybooks of Edward Weston.* New York: Aperture, 1990. A one volume reprint of the original 2 volume set of Weston's diaries.
———. *Forms of Passion.* New York: Harry N. Abrams, 1995.

Minor White
———. *Mirrors Messages Manifestations.* Millerton, NY: Aperture, 1969.
———. *Minor White: The Eye That Shapes.* Princeton, NJ: The Art Museum, Princeton University, 1989.

Michael S. Williamson
———. *Journey to Nowhere: The Saga of the New Underclass.* Garden City, NY: Dial Press, 1985.

Michael Wilson
———. *I See That Hand.* Cincinnati: What Reindeer, 1992.

Garry Winogrand
———. *The Animals.* New York: Museum of Modern Art, 1969.
———. *Winogrand: Figments from the Real World.* Boston: New York Graphic Society, 1988.

Marion Post Wolcott
———. *Looking for the Light.* New York: Alfred A. Knopf, 1992.

Penny Wolin
———. *The Jews of Wyoming.* Washington, DC: Smithsonian Institution Press, 1992.

PERIODICALS

American Photo, Hachette Filipacchi Magazines, 1633 Broadway, 45th Floor, New York, NY 10019. Photography in all its forms; fame and fortune given an edge over fine art, with an emphasis on contemporary American work.
Aperture, 20 East 23rd Street, New York, NY 10010. A superbly printed quarterly dealing with photography as an art form.
Artforum, 65 Bleecker Street, New York, NY 10012. This magazine, *Art in America,* and *Artnews* have occasional articles about photography as an art form in addition to reviews of photographic shows.
Art in America, 575 Broadway, 5th Floor, New York, NY 10012. Included in the subscription is their annual guide to galleries, museums, and artists; a useful art-world reference.
Artnews, 48 West 38th Street, New York, NY 10018.
Blind Spot, Lexington Photo Labs, 49 West 23rd Street, New York, NY 10010.
Camera International, 51 rue de l'Amiral Mouchez, 75013 Paris, France.
Computer Graphics World, PennWell Publishing, 10 Tara Boulevard, 5th Floor, Nashua, NH 03062-2801. Features current developments in digital imaging and computer graphics, primarily for commercial applications.
Déjà-Vu, Photo-Planete Co., 3-21-14-402 Higashi, Shibuya-ku, Tokyo 150, Japan. An international quarterly with superb reproductions featuring new work by contemporary fine art photographers. Text in Japanese only.
Digital Creativity, Cowles Business Media, 11 River Bend Drive S, Box 4949, Stamford, CT 06097-0949.
DoubleTake, Duke University, Center for Documentary Studies, 1317 West Pettigrew Street, Durham, NC 27705. Concentrates on documentary photography.
Luna Cornea, Consejo Nacional para la Cultura y las Artes, Centro de la Imagen, Plaza de la Ciudadela 2, Centro Historico, 06040 Mexico DF, Mexico.
Photo Design, 1515 Broadway, New York, NY 10036. Publishes many examples of magazine illustration, fashion, commercial, and other current photographic work.
Photo District News, 1515 Broadway, New York, NY 10036. Emphasis on commercial and professional photography, including electronic media.
Photo Electronic Imaging, Professional Photographers of America, 57 Forsyth Street NW, Suite 1600, Atlanta, GA 30303. For commercial and industrial photographers with emphasis on electronic imaging.
Photo Techniques (formerly *Darkroom and Creative Camera Techniques*), Preston Publications, 7800 North Merrimac Avenue, Niles, IL 60714. Technical information on photographic materials, equipment, and processes.
Photographer's Forum, 511 Olive Street, Santa Barbara, CA 93101. Geared toward students and others seeking photographic careers; includes school profiles.
Pinhole Journal, Star Route 15, Box 1355, San Lorenzo, NM 88041. A quarterly publication on pinhole photography.
Popular Photography, Hachette Filipacchi Magazines, 1633 Broadway, New York, NY 10019. The editors also publish the *Photography Annual,* portfolios by well-known and emerging talent.
Shutterbug, Patch Publishing, 5211 South Washington Avenue, Titusville, FL 32780. Feature articles and technical data, but mainly new and used equipment for sale.
View Camera Magazine, 1400 S Street, Number 200, Sacramento, CA 95814.

Many institutions and nonprofit groups involved with photography publish periodicals for their membership. Many cater to a specialized or regional interest, and they often serve as a springboard to national visibility or younger photographers.

Afterimage, 31 Prince Street, Rochester, NY 14607. A tabloid-format monthly from the Visual Studies Workshop. Includes scholarly articles on photography, film, and video; listings of shows, events, publications, and opportunities nationwide.
Archive, The Center for Creative Photography, University of Arizona, 843 East University Boulevard, Tucson, AZ 85719. Scholarly and occasional.
ASMP Professional Business Practices in Photography, American Society of Media Photographers, 14 Washington Rd, Suite 502, Princeton Junction, NJ 08550-1033. A guide for the working professional published for ASMP members.
Camerawork: A Journal of Photographic Arts. 115 Natoma Street, San Francisco, CA 94105.
Center Quarterly, The Center for Photography at Woodstock, 59 Tinker Street, Woodstock, NY 12498.
Exposure, Society for Photographic Education, P.O. Box 222116, Dallas, TX 75222-2116. A periodical from an organization concerned with the teaching of photography, especially as a fine art.
News Photographer, National Press Photographers Association, 1446 Conneaut Avenue, Bowling Green, OH 43402-2145. For working and student photojournalists.
SPOT, Houston Center for Photography, 1441 West Alabama, Houston, TX 77006. Award-winning magazine of contemporary images, discussion, and opinion, featuring the works of regional and national photographers, writers, and critics.
Untitled, Friends of Photography, 250 Fourth Street, San Francisco, CA 94103. A quarterly publication, more often a beautifully printed monograph than a magazine.

Credits

Page abbreviations are: (t) top, (c) center, (b) bottom, (l) left, (r) right.

Cover photo: Ken Kay.

Title page photo: ©1997 Lorie Novak/Swanstock.

Chapter 1 viii: ©1997 William Lesch/Swanstock; 1: Paul Caponigro, (icon) John Moore for Scott Foresman - Addison Wesley; 7: (tl) (cl) Scott Goldsmith, (tc) (tr) Linda Bartlett, (bl) Fredrik D. Bodin, (br) U.S. Department of Agriculture; 8: (t) Larry Sultan, (b) ©1997 Michael Wilson/ Swanstock; 9: (t) ©1997 Jeff Jacobson/ Swanstock, (b) Peter Magubane; 10: (t) William Clift, (b) Louise Dahl-Wolfe; 11: (t) Joe Deal, (b) Jane E. Phillips.

Chapter 2 12: Andreas Feininger/Life Magazine © Time Inc.; 13: Canon USA, Inc., 14: (t) Pentax Corp, (b) Minolta Corp 15: (ctl) (ctr) Barbara London, (cbl) (cbr) Fredrik D. Bodin, Jack Sal/Michael Belenky/BL Books, Inc.; 16: John Upton; 17: (all) John Upton; 18: (both) Penny Wolin; 19: (t) Clifford Oto, (br) (bl) Penny Wolin; 20: Larry Towell; 22: (both) Duane Michals; 23 (both) Duane Michals; 24: George Krause. 25: (both) George Krause. 26 (t) Calumet Photographic, Inc.; (b) Nikon Inc.; 27: (t) Canon USA, Inc., (b) John Moore for Scott Foresman - Addison Wesley; 28: (tl) Joseph Ciaglia, (bl) John Moore for Scott Foresman - Addison Wesley, (r) Joseph Ciaglia; 29: (all) Jack Sal/ Michael Belenky/BL Books, Inc.; 30 (t) Jeff Rotman, (b) Timothy Hearsum; 31: (all) John Moore for Scott Foresman - Addison Wesley, 32: (both) Lois Greenfield; 33 Lois Greenfield.

Chapter 3 34: Andre Kertesz; 36: (all) Peggy Ann Jones; 40: Rafael Macia/Photo Researchers; 41:Henri Cartier-Bresson/ Magnum; 42: (both) Jack Sal/ Michael Belenky/BL Books, Inc.; 43: Bruce Ackerman, The Ocala Star-Banner, New York Times Regional Newspaper Group; 44: William G. Larson; 45: 1993 David Muench; 46: Ken Kobre; 47: (t) John Neubauer, (b) Marilyn Stern; 48: (l) Marc Muench/David Muench Photography, Inc., (r)(all) Jack Sal/ Michael Belenky/BL Books, Inc.; 49: (t) ©1997 Keith Carter/Swanstock; 49 (b) (both) U.S. Department Agriculture; 50 Marilyn Stern; 51: Eli Reed; 53: (all) Fredrik D. Bodin; 54: Elliott Erwitt; 55: Kenro Izu; 56: (both) David Arky; 57 (all) David Arky; 58: Andreas Feininger/Life Magazine © Time Inc.; 59: Art Kane.

Chapter 4 62: Charles Harbutt/Actuality, Inc.; 64: (all) John Moore for Scott Foresman - Addison Wesley; 65: Bonnie Kamin; 67: (all) John Moore for Scott Foresman - Addison Wesley; 68: Miguel Gandert; 69: Christopher A. Record; 70: David Grant Noble; 71: Photograph by Imogen Cunningham © 1970 The Imogen Cunningham Trust; 72: (l) Alan Ross, (r) Polaroid Corp.; 73: Joe Wrinn; 75: (both) Peggy Jones; 70: Arthur Taussig; 77: Ken Kay; 78: (r) John Moore for Scott Foresman - Addison Wesley, (l) Luther Smith; 79: (all) John Moore for Scott Foresman -

Addison Wesley: 81: Reproduction courtesy The Minor White Archive, Princeton University. Copyright (c)1982 The Trustees of Princeton University; 82 (all) John Senzer; 83: (all) Donald Dietz; 85: (both) Robert Walch; 86: (t) Ken Kobre, (b) Minolta Corp.; 87: Tom King 1985.

Chapter 5 89: (t) ©1997 Stephen Petegorsky/ Swanstock, (b) ©1997 Dianne Bos/Swanstock; 92: (all) David F. Warren/U.S. Department of Agriculture; National Park Service; 94: Walker Evans/Courtesy Library of Congress; 95: Jack Sal/ Michael Belenky/BL Books, Inc.; 96: (both) Fredrik D. Bodin; 97: (all) Flint Born; 98: (all) Rick Steadry; 99: John Upton; 101: Lisl Dennis; 102: (both) Jack Sal/Michael Belenky/BL Books, Inc.; 103: (t) George Tames, (b) Ellen Land-Weber.

Chapter 6 104: Paul Caponigro; 116: (all) Eastman Kodak Co., Kodak Research Laboratory, Rochester, New York.; 117 (all) Robert Walch; 118 (all) Robert Walch; 120: (both) Jim Stone; 121: (tl)(tr)(bl)(bcl) William Gedney, (bcr)(br) Sebastian Milito; 122: Suzi Jones/American Folklife Center; 123: (all) Peggy Ann Jones; 124: Michele McDonald; 125: Rick Steadry; 126: Scott Goldsmith; 127: (all) Sebastian Milito; 127: (t) Walter Iooss, Jr., (b) Dan Jenkins, Jr.; 129: Walter Iooss Jr.

Chapter 7 130: ©1997 Bill Burke/Swanstock; 131: (both) Arthur Taussig; 136: (both) Dmitri Kessel; 137: (both) John Moore for Scott Foresman - Addison Wesley; 139: Lois Bernstein/ Milken Family Foundation; 140: Lois Bernstein/ Milken Family Foundation; 143: Lois Bernstein/ Milken Family Foundation; 148: (both) Jim Stone; 149 (all) Jim Stone; 151: (all) Arthur Taussig; 152: (t) Janet Campbell; 152: (b) Ken Kay; 153: (t) Janet Campbell; (b) Ted Rice; 154: (l)(c) Ken Kay, (r) Chauncey Bayes; 155: (t)(bl) John Loengard, (br) Ken Kay; 158: Copyright © Frederic Ohringer Courtesy Houk Friedman; 159: ©1997 Olivia Parker/Swanstock.

Chapter 8 160: Robert Holmgren/Tony Stone Images;162: Rick Steadry.

Chapter 9 168: Alma Davenport de la Ronde; 169: (icon) Betty Hahn; 171: Ralph Weiss; 173: (all) Stephen Brown Fil Hunter; 175 Gustave Dore; 177: (all) Peggy Ann Jones; 178: © 1993 ARS, New York/ADAGP/Man Ray Trust, Paris; 179: (t) Sebastian Milito, (bl) Jack Sal, (r) Copyright © Adam Fuss, Courtesy Robert Miller Gallery, New York; 181: (both) Arthur Taussig and Carol Linam; 182: (both) Betty Hahn; 183: Kenro Izu; 184: © 1997 Elaine Querry/Swanstock; 185: (t) Elizabeth Opalenik, (b) Duane Monczewski; 186: Meridel Rubenstein; 187: Nancy O'Connor; 188: (all) Fred Burrell; 189 (tr) Fred Burrell.

Chapter 10 190: Susan Goldman; 191: Kevin Clark; 193: (all) Robert Crandall/ Herb Orth; 194: (t) Wendy Erickson; 195: Barbara Bordnick; 196: Eve Arnold; 197: (all) Ken Kobre; 199: (all) Sebastian Milito; 200: (both) Sebastian Milito; 202:

Richard Steinberg; 203(l) Jerry Peart, (r) Patty Carroll; 204: Emil Schulthess/ Black Star; 205 (t) David Hosking/Photo Researchers, (b) Emil Schulthess/ Black Star; 206: Peter deLory; 207: Nina Prantis, 208: Harold Feinstein; 209: Michael Geiger; 212 (b) Donald Dietz; 214 (all) Donald Dietz; 216: Donald Dietz; 218: Suda House; 219 Donald Dietz; 220: (t) Clint Clemens, (b) Vito Aluia; 221: Clint Clemens.

Chapter 11 222: Yousuf Karsh/Woodfin Camp & Associates; 223: Yoichi R. Okamoto/Courtesy Lyndon Baines Johnson Library; 224: Ray McSavaney; 225 (l) Werner Bischof/Magnum, (l) Sergio Larrain/Magnum; 226: (l) Etta Clark, from *Growing Old Is Not for Sissies*, (r) Fredrik D. Bodin; 227: Danny Lyon/Magnum; 228: (t) Pedro Meyer, (b) Penny Wolin; 229: (t) 1979 JEB (Joan E. Biren), (b) Bonnie Kamin; 231: Ted Rice; 232: (t) Jack Sal/Michael Belenky/BL Books, Inc.; 233: (t) Jack Sal/Michael Belenky/BL Books, Inc.; 234: (all) John Moore for Scott Foresman - Addison Wesley; 235: (l) Henry Groskinsky; 236: Lois Greenfield; 238: (l) Marilyn Stern, (tr) David Arkey; 239 (all) David Arky; 242: (all) Jack Sal/Michael Belenky/ BL Books, Inc.; 243: Richard Misrach; 244: Marc PoKempner; 245 (both) Marc PoKempner; 246: (all) David Arky; 247: (all) David Arky; 248: (both) John Moore for Scott Foresman - Addison Wesley; 249: Fil Hunter; 250: Erich Hartmann/Magnum; 251: Gregory Heisler.

Chapter 12: 252: Eadweard Muybridge/Michael Kerbow; 255: Barbara London/digital manipulation by Stephen Johnson/prints courtesy SuperMac Technology; 256: (all) Richard Frear, National Park Service; 257: (l) Reuters/Wolfgang Rattay/Archive Photos; 258: Barbara Kasten; 259: Robert J. Steinberg; 260: Barbara London; 261: (all) Barbara London/digital manipulation by Stephen Johnson/ prints courtesy SuperMac Technology; 262: (all) Barbara London/digital manipulation by Stephen Johnson/prints courtesy SuperMac Technology; 263: (t) Photographer unknown: *John Newton, Oklahoma,* c. 1910/digital manipulation by Stephen Johnson/prints courtesy SuperMac Technology; @ 1993 PhotoDisc, Seattle, Washington/digital manipulation by Stephen Johnson/prints courtesy SuperMac Technology, 263: (b) PhotoDisc/ Manipulation by Stephen Johnson; 264 (l) Stephen Johnson/prints courtesy SuperMac Technology, (r) Remy Poinot; 265: (all) Photo Gabriel Amadeus Cooney/digital imaging Paul Kazmercyk courtesy Hotchkiss School/Cheney and Co.; 266: (t) Keith J. Hampton (b) Douglas Kirkland; 267: Bonny Lhotka; 268: (both) John Lund; 269: (all) John Lund; 270: (t) Stephan Savoia, (b) Mark Lennihan; 270: Stephan Savoia; 271: Stephan Savoia; 272: (l) Sharon Franz, (r) ©1997 Melanie Walker/ Swanstock; 273: (t) Victor Masayesva, Jr., (b) Michael Brodsky; 274: Shin Sugino; 275: (both) 1978 Michael Kienitz; 276: Peggy Ann Jones; 277: Peggy Ann Jones WWW page/Joe Ciaglia; 278: Peggy Ann Jones; 279: Peggy Ann Jones.
Chapter 13: 280: ©1997 Mark Klett/Swanstock; 281: Calumet Photographic, Inc. 282: Arthur Taussig; 284: Ken Kay; 285: (t) Ken Kay; 286:

Ken Kay; 287: (t) Ken Kay; 288: Ken Kay; 289: (t) Ken Kay; 290: Ken Kay, 291: Ken Kay; 293: (tr) (tl) Donald Dietz, (bl) (br) Ken Kay; 294: (t) Philip Trager; 295: (t) Philip Trager; 300: Philip Trager; 301: Emmet Gowin.

Chapter 14: 302: Ansel Adams. Copyright © 1997 by the Trustees of the Ansel Adams Publishing Rights Trust. All rights Reserved.; 305: John Upton; 307: (all) John Upton; 308: (all) Rick Steadry; 310: Morley Baer; 311: (both) Ken Kobre; 312: (t) ©1977 John Sexton. All rights reserved, (b) ©1990 Patrick Jablonski. All rights reserved; 313: ©1987 John Sexton. All rights reserved.

Chapter 15: 314: ©1984 Estate of Garry Winogrand/ Courtesy Fraenkel Gallery, San Francisco, and Estate of Garry Winogrand; 315: Ted Rice; 316: Courtesy U.S. Department of Agriculture; 317: (t) Richard E. Ahlborn/American Folklife Center, (b) Carl Fleischhauer/American Folklife Center; 318: Jonas Dovydenas/American Folklife Center; 319: Toba Pato Tucker; 320: (both) Sean Kernan; 321: Robert Doisneau; 322: Timothy Greenfield-Sanders; 323: Russell Lee/ Courtesy Library of Congress; 324: Paul Caponigro; 325: Gordon Parks; 326: (t) Roy Clark U.S. Department of Agriculture, (b) R. O. Brandenberger/U.S. Department of Agriculture; 327: Dennis Stock/Magnum; 328: (t) U.S. Department of Agriculture, (b) Bonnie Kamin; 329: ©1997 Keith Carter/Swanstock; 330: Flor Garduno; 331: Bill Hedrich; 332: Robert Branstead/U.S. Department of Agriculture; 333: Josef Koudelka /Magnum; 334: Marion Post Wolcott/Courtesy Library of Congress; 335: Oriana Elicabe/ Agence France-Presse; 337: Sebastiao Selgado/Magnum; 338: (l) Mel Scott, (r) Bob Lynn; 339: (l) Duane Monczewski, (r) Arthur Ollman.

Chapter 16: 340: Untitled (Couple Holding Daguerreotype of Family). (c.1850). One-quarter plate daguerreotype, 3 1/4 x 4 1/4, Museum of Modern Art, New York, gift of Virginia Cuthbert Elliott;. Copy print ©1997 The Museum of Modern Art, New York. 341: Eddy Van der Veen/ Bibliotheque Nationale; 342: (t) Joseph Nicephore Niepce/Gernsheim Collection, Harry Ransom Humanities Research Center, University of Texas at Austin, (b) Collections Societe Francaise de Photographie; Platt D. Babbit/International Museum of Photography at George Eastman House; 343: Amherst College Library; 344: (lboth) William Henry Fox Talbot/Lee Boltin Picture Library; 345: Courtesy George Eastman House; 346: Fred Church/International Museum of Photography at George Eastman House; 347: (t) Louis Ducos du Hauron/International Museum of Photography at George Eastman House, (b) Arnold Genthe/courtesy Library of Congress; 348: Julia Margaret Cameron; 349: (both) Bibliotheque Nationale; 350:Timothy H. O'Sullivan/Courtesy Library of Congress; 351: Timothy H. O'Sullivan/ Courtesy Library of Congress; 352: (tl) Louis Jacques Mande Daguerre/Bayerisches National Museum, (tr) Edward Anthony/International Museum of Photography at George Eastman House, (b) Eadweard Muybridge/International Museum of Photography at George Eastman House; 353: (l) August Sander, *Laborer, 1927,* © August Sander Archiv/SK-Stiftung Kultur, Cologne; ARS; New York, (r) Eugene Atget, *Magasin, avenue des Gobelins.* (1925) PP: 83. Albumen-silver print, 9 3/8 x 7" (24 x18 cm). The Museum of Modern Art, New York. Abbott-Levy Collection. Partial gift of Shirley C. Burden. Copy print © 1997 The Museum of Modern Art, New York.; 354: Lewis Hine/International Museum of Photography at George Eastman House.; 355: Dorothea Langehe/The Oakland Museum; 356: Erich Salomon/Courtesy Bildarchiv Preussischer Kulturbesitz, Berlin; 357: W. Eugene Smith, Life Magazine © Time Inc.; 358: (t) Susan Meiselas, (b) Dmitri Baltermants; 359: (t) James H. Karales, (b) Photo © 1982 By Michaels S. Williamson/ The Washington Post; 360: (t) Collection Royal Photographic Society; Henry Peach Robinson/

Gernsheim Collection, Harry Ransom Humanities Research Center, University of Texas at Austin, (b) Peter Henry Emerson/Gernsheim Collection, Harry Ransom Humanities Research Center, University of Texas at Austin; 361: (t) Robert Demachy, (b) Alfred Stieglitz, *The Hand of Man* 93.XM X 25.7, The. J. Paul Getty Musum, Los Angeles, California, Copyright estate of Georgia O'Keeffe; 362: (l) Paul Strand, *White Fence,* 1916 from *Camera Work,* New York, Number 19*50, June 1917. Photogravure, 6 11/16 x 8 11/16" (16.9 x 22 cm.), The Museum of Modern Art, New York, Given anonymously, Copy Print © 1997 The Museum of Modern Art, New York, (t) Edward Weston © 1981 Center for Creative Photography, Arizona Board of Regents; 363: (l) Laszio Moholy-Nagy/courtesy Hattula Moholy-Nagy and International Museum of Photography at George Eastman House, (r) © 1993 ARS, New York/ ADAGP/Man Ray Trust, Paris; 364: Aaron Siskind; 365: Robert Frank/Collection Museum of Fine Art, Houston, Texas; 366: Sandy Skoglund; 367: Duane Michals; 368: Joel Sternfeld; 369: 1989 Patrick Nagatani.

Troubleshooting appendix: 371: (t) Sean Grout/Peggy Jones, (tc) Barbara London, (c) (bc) (c) Sean Grout; 372: (t) Barbara London, (tc) Sean Grout/Peggy Jones, (c) (bc) Sean Grout, (b) Misty Monteith; 373: (t) Sean Grout, (tc) Sean Grout/Peggy Jones, (b) Alan Oransky, (bc) Peggy Jones; 374: (tc) Jim Stone, (c) Sean Grout/Peggy Jones, (bc) (b) Sean Grout; 375: (t) Sebastian Milito, (tc) Bob Young, (c) (bc) Sean Grout, (b) Sean Grout/Peggy Jones; 376: Sean Grout; 377: (t) (tc) Peggy Jones, (c) (bc) Barbara London, (b) National Park Service; 378: (t) (tc) (b) Barbara London, (c) Ellis Herwig, National Park Service, (bc) Keke Steinberg; 379: (t) (bc) (b) Sean Grout, (tc) Thomas E. Forsyth; 380: (t) (tc) Sebastian Milito, (c) (b) Sean Grout, (bc) Elizabeth Hamlin; 381: (t) John Upton, (tc) (bc) Sean Grout, (c) Joe Ciaglia, (bl) Sean Grout, (br) Magi Sanchez.

Index

Note: Page numbers in italics refer to photographs by the photographer mentioned or to illustrations of the subject. Illustrations may also appear on text pages; these page numbers are not listed separately.

Cut out and assemble these light meter dials to see how film exposure is related to light intensity, film speed, shutter speed, and aperture.

Assembling the dials

1. Cut out the 3 dials and the 2 windows in the dials.

2. Connect the 3 dials by putting a pin first through the center point of the smallest dial, then the medium-size dial, and finally the largest dial. (A pushpin, with a piece of cardboard underneath the largest dial, works best.)

3. Line up the 2 windows so you can read the film speeds through them.

Using the dials

1. To calibrate your meter to your film, you set the arrow ▲ marked ISO to the speed of your film. For a trial, set it to ISO 100.

2. With a real light meter, you point its light-sensitive cell at a subject to get a reading of the brightness of the light. In one type of meter, a needle on a gauge (not shown here) indicates the brightness of the light. Suppose this light measurement reading was 17. Keep the film-speed arrow pointing to 100 while you set the other arrow ▲, which points to the light measurement, to 17.

3. Now you can see, lined up opposite each other, combinations of shutter speed and aperture that will produce a correct exposure for this film speed and this amount of light: 1/250 sec. shutter speed at f/8 aperture, 1/125 sec. at f/11, and so on. All these combinations of shutter speed and aperture let in the same amount of light.

4. Try increasing (or decreasing) the film speed to see how this affects the shutter speed and aperture combinations. For example, keep the light-measurement arrow at 17 while you move the film-speed arrow to 200. Now the combinations show a 1-stop change: 1/250 sec. of f/11, 1/125 sec. at f/16, and so on.

5. If the light gets brighter (or dimmer), how would this affect the shutter speed and aperture combinations? Suppose the light is dimmer, and you only get a light reading of 16. Set the light-measurement arrow to 16, while you keep the film-speed arrow at 200. What are the combinations?

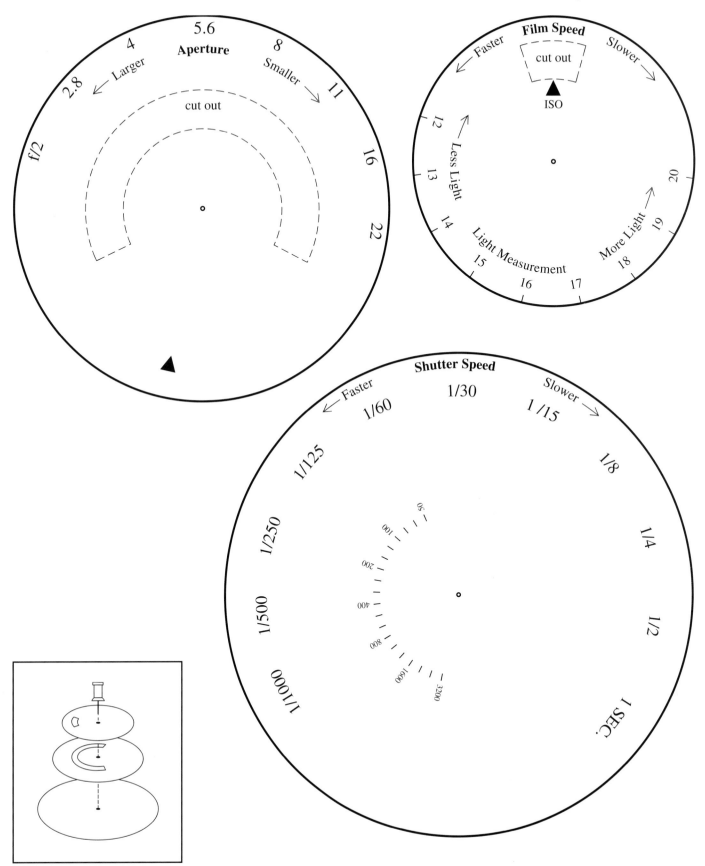